Mutiny and the Mainstream

TALK THAT CHANGED ART, 1975 - 1990

Edited by Judy Seigel

MIDMARCH ARTS PRESS
New York 1992

This book comprises Volume 16 and 17 of *Women Artists News*.

Library of Congress Catalog Card Number 90-064244

ISBN 1-877675-05-9

Published in 1992 by
Midmarch Arts Press
300 Riverside Drive
New York, New York 10025

Printed and bound in the United States of America

Dedication

*For all those young, old and maybe not yet born,
whose idea of a great night out is to sit on the floor
and listen to an ancient radiator clank on and off
in atonal accompaniment to artists arguing –
passionately, quirkily, peevishly, and, yes,
brilliantly – about art.*

*Also, for the countless others who'd just as soon
read about it.*

Contents

Acknowledgments

Cynthia Navaretta, publisher of this book, would prefer that I leave her name out of things like thanks. Since I always take her orders, I would, but those who know how much of the endless work she shared would consider me churlish. Suffice to say that at the darkest moment, when I felt there was no way the morass of material could be comprehended, let alone managed, she assured me, "The California book was longer." That was heartening, even though I knew it was a lie. Cynthia continued to listen, until long after deadline, giving really sound advice, yet indulging my decisions, as she has since she plucked me out of a meeting in 1974 to write it up. Thanks to the wonderful writers who made so much of this book possible belong here, and are also in my introduction. Thanks to my daughter, Jessica, for some really tough (and, I say in total, objective, impartiality – brilliant) editing on that introduction. Thanks to Sylvia Moore and dinner partners for the suggestion of combining two proposed titles as one. Thanks again to Sylvia for editing advice, moral support, and patience and virtue in reading a long – *very* long – early galley. Thanks, also, to Susan Schwalb for the same devoted reading, and a second opinion. Thanks to Barbara Bergeron for, not just expertise in type design, but patience and calm well above the call of duty. Thanks to Artists Talk on Art for the great good old days. Thanks to Lori Antonacci for help with history and thanks to Vernita Nemec for practical assistance. Thanks to Michelle Wilcox, who was an intern when we needed one. Thanks to Lara Ferb, who brought fresh strength in the crunch. Thanks to Elliott Barowitz for, first, *Artworkers News*, then, *Art & Artists*. And thanks to the lady in the audience who yelled out to the moderator, "You're ruining the panel!" She was an inspiration – a mini-mutiny.

J.S.

Introduction

Mainstream, USA

Numbers in brackets refer to panel reports. (See "Front Notes," following.)

If you played by the rules, 1974 was surely the deadliest moment in the history of art. About the only approved "mainstream" activity was waiting for the "inevitable next step in art" to arrive. In 1974 you could say it dropped from heaven directly onto the pages of *Artforum* – which might have slightly overstated the case, but would convey the flavor of the time: There was a real sense that art styles somehow just *arrived*, if not dropping from heaven, then at least propelled by the internal forces of history.

Certainly the art itself was less important than the *inevitable progression of art* – the gradual reduction to purity and "the essentials" of each medium. But in another strange mind-warp of the time, everybody was well aware that plenty of new art had nothing whatsoever to do with progression or purity — which is one reason we call this theory "the *myth* of mainstream modernism."

We also call it by terms like "orthodox modernism," "formalism," and "Greenbergian formalism." "Greenbergian" refers to Clement Greenberg, philosopher-in-chief and principal author of the inevitable progression theory (and apparently first to use the term "mainstream" in this context[1]). What was so painful, circa 1974, was that the idea was simultaneously obsolete, in that artists had lost interest in it, and powerful, in that critics and a wide range of henchpersons had not. (Another term, "mainstream sterility," was heard so often it began to sound like one word.)

This book tells the story, often in the artists' own words, of what happened next, as artists across the land launched a mutiny, defied modernist rules, jettisoned mainstream purity and set out for the uncharted seas of pluralism.

There are in fact several stories. One is the determined putting back into art of what had been taken out, re-inserting forbidden meanings and non-"essentials," like narrative, decoration, figuration and allegory. The most dramatic story is the one that takes us from the age of Janson, whose best-selling text, *The History of Art*, managed to cover 25,000 years of history without mentioning a single woman artist, to the present, when women – *and* African-Americans *and* "out" lesbians – control Janson's old College Art power base. In yet another radical departure, artists traveled from a world where "overt politics remained virtually the only taboo," to the recent moment when a senior critic discovered to his horror that political art had become "the latest rage."[2]

Today of course every undergraduate knows that developments in art are constructs, devised by humans in response to real world, art world, art historical, personal, and, yes, *market*

factors. Echoes of "inevitability" may still crop up from time to time,[3] but artists have stopped worrying about the inevitable next step, and learned to help themselves to art's past – at least for the present. The *content* of art is once more an issue as much as the form. Form-as-content, which had been the keystone of "formalist art,"[4] no longer satisfies our yearnings.

These changes didn't drop from heaven either, or even arrive on a simple swing of the pendulum. We know now, and the talk in this book shows, that in our time the pendulum gets pushed.

Recorded originally in the artists' "underground" press (especially *Women Artists News*, which I edited), these discussions, usually in panel format, are manifesto, progress report, soul search, shop talk, and, at times, celebration. They range from the fever of a rally to the intimate and exploratory (or, on a bad day, stuporific) musings of artists. They are clearly not a systematic history, other than being arranged chronologically, but on several levels they tell the truth in a way official art history does not.

Art movements of the 20th century tend to become marketing systems, quite removed from the original impulse and germinating ideas of the art in question. "Art history" compounds the error, by presenting styles and movements sliced, diced and stuffed into official terms and shapes. One recent book, a "guide" to contemporary art, has an Artchart showing all art since 1945 as exactly 58 movements in dots along a time line – "on" at one dot, "off" at another.[5] But even without a chart, the process of recording, the requirements of explanatory text, and the necessity of making selections from the welter of live events inevitably distort art – simplify, tidy, trim and squeeze it to fit the package, the theory – or some other purpose.

Indeed, "other purpose" may be the *greatest* peril of art history. Authors have their own agendas. If their theories catch on, major life-style changes may ensue for them; if not, they can promote the careers of friends or relatives, enhance the value of their own collections, and settle scores. Moreover, untidy reality can elude even the most devoted scholar, especially since artists have agendas too. They lie after the fact whenever possible, claiming to have been in groups they were peripheral to, or nowhere near, or otherwise improving history.

As Hilton Kramer put it:

> The wonder is not that distortions occur in the writing of . . .
> art history, but that anything remotely resembling a coherent
> and persuasive chronicle ever sees the light of day. Everybody
> knows that a friendship or a love affair or a divorce, a move to
> the country or a decision not to, an altercation with a dealer or

an affront to a critic or curator, can sometimes determine an artist's place in written history . . . The myth of "objectivity" is, I suppose, one of the fictions essential to the writing of such history, but it remains a myth all the same.[6]

The reports in this book are, for the most part, actual words spoken at actual events or written from notes taken on the scene, as artists and others convened to address their concerns. This makes them authentic and immediate in a way official texts rarely are. If a reporter missed a point or *the* point, accidentally, or on purpose, anyone could write a letter to the editor or even an article to set things right, or at least present their version, and many did. (Those that are still germane are included here.)

At first it was an act of mutiny just to say out loud in public that forces ranging from wrong thinking to market strategy had perverted art's course, and that there is no such thing as "art itself" or "historical necessity." Feminists in particular began to argue that the Correct, Beautiful, Meaningful or Essential in art are *choices* made by subjective and changing human criteria, not eternal verities.

Old forms, like story telling and decoration, were allowed to re-enter art, along with a range of new, or previously forbidden-in-art ideas, like "gender exploration" and appropriation. These concerns now replaced the metaphysical character of paint, which had been the meaning of art for the years of its American "triumph." Overt moralizing also became a factor, as artists and others argued that social and political issues must be addressed in art itself, not just in the political arena; this position eventually became respectable, then chic. (When some of the most "moral" art lately brought some of the highest prices, the irony was perhaps under-appreciated for an age when irony is de *rigueur* in art.)

In other words, art (or some of it) was infused (or re-infused) with a content that had been anathema to the artistically correct since the 1940s. This was greatly abetted by, if not entirely due to, artists resuming a voice (or voices) lost when market forces moved in on Abstract Expressionism.

Which is not to suggest that market forces simply evaporated. Even as mainstream *theory* collapsed of its own weight, a market mainstream flourished. In the 1980s, escalating auction prices and a fever of speculation kept the financial and mainstream press agog, and the roar of money threatened to drown out art's ordinary discourse. But a vital exchange remained alive and well in these talk events – literally an alternate universe of the intellect, where commodity value of art was held in contempt (or at least a noble attempt at contempt). The fact that the most penetrating and provocative commentary often came from artists who said frankly they had not succeeded in the market was salutary. And the fact that some artists went from this talk-world to dazzling financial success, or kept a foot in both camps, brought another perspective, an infusion of reality in both directions.

Live from New York

It all began, we are told, with an idyll, the Eighth Street Artists' Club that became the center of American art in the '50s ['77/#56; '82/#159, *et al.*]. Critics and dealers came to the Club to find out who and what was hot, and their presence attracted more artists. The overall American artist population grew rapidly, for many reasons, not least because both money and legend were clearly in the offing. By the 1970s, there were far too many artists to be managed by a single club, and art centers dotted the nation. New York alone, "capital of the art world" since the 1940s, had numerous art worlds bigger than the Club at its apogee. Indeed, artists were still arriving more or less hourly from all over the country and the world ['79/#121].

Which is to say that at the time our story opens, New York had more than ever the critical mass to fuel a golden age of art talk. It had the hordes of artists; it had the world's greatest congestion of dealers, critics, curators and collectors; and, now that *Artforum* had seen the Light in the East and departed L. A. for New York, it had every major American art publication as well. Withal, the city comprised a seemingly bottomless pit of speakers and a vast, avid, seemingly tireless audience. Stars, Brains, and Provocateurs sat on the floor one night and on the dais the next. And, lest I be accused of *excessive* New York chauvinism, I will point out that, if there were important panel discussions elsewhere during this time, aside from annual conferences of academic organizations, they went unrecorded and unremarked.

The New York *character* contributed, too. There are large tracts of the United States where it is considered impolite to contradict someone in public. In addition, "out-of-town" audiences tend to be awed by visiting celebrity: their "questions" to speakers range from diffident to adulatory. The New York audience, on the other hand, is fearless – and often integral to an event. Panelists address a roomful of colleagues and peers who challenge, incite, comment knowingly, and fill in particulars, contradicting the rostrum and each other, adding or eliciting key insights. Of course, annual migrations to College Art Association conferences provide many great speak experiences, but CAA is hardly a regional audience. (It might also be noted that even in supposedly regional, such as Midwest, meetings, New York people and issues tend to dominate.)

Perhaps I should add that, if the question is how much of contemporary American art originated in New York, I have no idea, and it's beside the point here. But if the question is how much of the *discourse* of art came from New York, the answer for this period is, probably most of it. (Even today I notice that a panel in, for instance, L.A., can't stop talking about the fact that it's not in New York. A New York panel doesn't talk about not being in L.A — and so, of course, has more time to get on with it.)

Wherever the art or artists originated, during the span of this book, the number of New York galleries doubled, and doubled again – there were *hundreds* of new shows, not each

year, but *every three weeks*, fanning the need to talk about it all. Douglas Davis noted from the rostrum one New York night that panels had become "a generic form" ['79/#115], serving to remind us that this wasn't always the case. But during the days of panel fever, they were also performance, promenade, soap box, sounding board, shop talk, *divertissement*, adult education, inspiration, news medium – and, on a few occasions, triumphal congress.

Still Greenberg After All These Years

Still, in the world of 1974, mere numbers of artists meant little. Actual power in art was held by relatively few institutions: Only two or three museums, a like number of glossy magazines, and a dozen austere galleries could bestow international cachet. Styles were also dispensed by authority. Selected continuations of Hard-Edge, Pop Art and Realism were tolerated, but "the market" was on Full Minimalism. The gallery scene looked like The Valley of The Grids. No matter if Soho real estate heated up, art was gelid.

Peter Plagens blamed the "Greenbergian juggernaut,"[7] meaning that Greenberg's inevitable progression of the mainstream into the "irreducible," "pure" properties of each medium, without external or real world references, was a major rationale for Minimalism.

But whatever metaphor was applied, artists who wanted to paint, as the majority still did, had very few options. "Story," or narrative or philosophical meanings in art were declared by this theory of modernism to be "literary" and consigned to literature. Thickness or texture was "sculptural," hence reserved for sculpture. The orthodoxy held that only flatness, color and rectangular shape were "essential" or "unique" to painting hence represented its highest form. Indeed, ultimately, even the all-purpose Soho grid was foreclosed – it was a "design"!

As noted, other art of various kinds was at hand; in fact writers of the day even called it a time of pluralism.[8] But the overarching and exalting rhetoric that attached to Minimalism inflated it, adding weight and momentum. Body art (very "west-coast," even when it wasn't, probably why *Artforum* was so interested) and earth art functioned rhetorically as extensions of Minimalism. Concepts held by contemporary artists interesting to painters, say Jasper Johns or Andy Warhol, didn't fit so handily into unifying slogans (although probably not for lack of trying), and seemed diffuse in comparison.

As the rhetoric advanced, so did frustration. Of course many artists had disputed Greenberg's formulaic modernism all along, but with very little ideological support from critics. Carter Ratcliff may have been the first; certainly his line-by-line exposé of the "fiction" of most critical schemes, including and especially Greenberg's, is still unsurpassed ['75/#9].

It's hard to say how much credit is due Ratcliff. Clearly, the time was ripe and the ideas were in the air. But the "reductionist myth" proceeded to collapse with amazing speed –

although, it must be added, it immediately embarked on a long and healthy afterlife, as "debunking" Greenberg and the formalism associated with his name became virtually an art-bar theme. "The Dictatorship of Clement Greenberg" was still being explained in *Artforum* in 1987.[9] Even in the 1990s, "proof" continues to arrive that the "Greenbergian" version of modernism does not and never did check out.

In a recently published essay, Robert Storr returned to Greenberg's original sources to document the rhetorical devices, misreadings, inconsistencies, distortions and omissions by which Greenberg constructed this critical fiction.[10] Step by step, he showed there is little in art history, contemporary art, social history, society, culture, or logic to support Greenberg's scheme. The job was done so well, in fact, that the author was promptly made a curator of the Museum of Modern Art. Only two questions remain:

(1) How did this philosophy of gossamer and lies prevail for so long?

(2) Are the dogmas of *post*-modernism, which replaced the dogmas of modernism, any more logical, authentic, demonstrable, credible and sincere?

Perhaps one day the full answer to question #1 will arrive in a work as scholarly and readable as Storr's. Meanwhile, we can but note that "inevitable progression" was a dandy marketing device (a guide to a continuing succession of winners), and also that *before 1975 non-believing artists had little opportunity and virtually no arenas for rebuttal.* As Storr pointed out, academicians show "an astonishing disinterest in and disregard for the stated intentions of the artists who fall victim to their attentions," and Greenberg himself "dismissed their often extensive theoretical texts as essentially irrelevant to their work." (Even in 1990, no less a champion of artists than Marcia Tucker said she was "interested in challenging the idea that the artist's own intentions are essential to understanding the work" ['90/#222].)

Question #2 has so far been neglected. "Post-modernist" catch-phrases are recited, either in triumph or despair, but rarely subjected to logical analysis.

Last Days of Modernism

In other words, by the mid-1970s, the most visible new art had, obedient to Minimalism, become nearly invisible, while, criticism, both cause and effect of the trend, became ever more obtrusive, overriding and opaque. Peter Plagens described it as "a critic's scene frosted over the art scene(s) . . . history, issues, power struggles, field theories and very little art."[11] Small wonder artists were outraged.

Today we could hardly imagine an art magazine holding a symposium to deflect the fury of its artist audience, but that was what the "Forum on *Artforum*" at Artists Space, October 15, 1974, seemed to be. Whether the magazine expected to make peace, justify itself, or perhaps sell subscriptions, was unclear. Maybe it simply filled a slot on the Artists Space schedule. As I thought about it recently, however, the epi-

sode took on another meaning. It was one of the last times the balance of power between artists and critics seemed so lopsided at a talk event, if for no other reason than that artists soon had their own talk arenas, where they set format and agenda.

Max Kozloff, whose masthead title was then Associate Editor of Books, Annette Michelson, Editor of Film/Performance, Senior Editor Robert Pincus-Witten, and John Coplans sat with several others in a row behind a long table.[12]

A sea of artists sat on the floor at their feet. Simmering with rage, envy, desire and frustration, they had only two questions: Why do you write impenetrable jargon[13] and why don't you write about me? Nothing from behind the table satisfied. Shouts began from the floor, climaxing in the ultimate insult to an editor: "I don't read any of that stuff, I just look at the pictures." (Critic Barbara Rose said the same thing about criticism in general five years later ['79/#116].) Annette Michelson read a hermetically sealed paper. Finally, Max Kozloff explained, "This is the *discourse* of art." Why art, supposedly still flowing down the mainstream, self-propelled and inevitable, needed any "discourse" at all, and why *this* discourse, might have made a lively discussion, had the format permitted, which this did not.

"Game Rules" of Modernism, Explained

I dwell on *Artforum* because its avant-garde stance and bouts of informality made it the magazine artists most loved to hate.[14] It could be counted on for the best outrages, including, at the time, the best *naked* outrages, which is to say the then-avant-garde, mostly west-coast body art. Not that used-lumber art, tarpaulin art or rusty-nail art were neglected, but that in this new reductionism (to the buff) naked young bodies jumped for art (Dan Graham), got sunburned for art (Dennis Oppenheim), played with cars for art (Chris Burden), bit themselves and wrapped their penises in dolls' clothes for art (Vito Acconci, who could forget?). However cretinous – or marvelous – the original act, all those small, grainy, black and white photographs looked great in the magazines, perhaps the real entry of photography into the art arena. (They didn't please everybody, though: Peter Plagens complained that the issue with "a guy burying himself" looked "like the *Auschwitz Gazette*."[15])

That the whole deal was like a "boys' club" goes without saying. It also probably goes without saying that frustration was especially high in New York, with its larger reservoir of artists who wanted to make serious art in the cherished traditions of art history – not in the reductive dead end of those cherished traditions, and not in the great outdoors, or in the altogether either.

The other mainstream art publications had other limitations. *Art in America* was relatively middle-of-the-road and covered a wider range of contemporary art, but kept its distance from artists. Being still a bimonthly, it was literally less on the scene and less immediate. *ARTS* emphasized reviews, either purely descriptive, or by friends of the artist, often printed in exchange for the artist's taking an ad. Although this policy recorded for posterity a better cross-section of art actually being done at the time than a more ideological orientation allowed, it was hardly compelling journalism. (I note that the other magazines also gave reviews to advertisers, albeit more whimsically, and that the *ARTS* policy became subtler in time.) *ARTS* did generate talk when Donald Kuspit attacked feminist art in its pages for being "repressive," "authoritarian," "intolerant," "bullying," "reactionary," "decadent," "brutally dominant," and a "metaphoric submission in the context of an absolute order."[16] But that was a rare breath of excitement. Finally, there was *ARTnews*, which had been the magazine of the Abstract Expressionists. It still tended to follow the old guard and had the highest proportion of articles about dead artists. Not many younger artists read it.

There were few other options or arenas for art discourse. The famous Artists' Club was long gone. A group called The Figurative Artists Alliance met at the Educational Alliance on New York's lower east side, but rarely transcended its own hierarchy and agenda. Any other venues that existed would have been even more parochial. The College Art Association had panels about contemporary art – for instance, in 1973, one on the teaching of Hans Hofmann, another titled, "What Is Black Art?," and a major event, "The Artists Club: The Makers' Forum Revisited" starred artists of the Ab-Ex pantheon — de Kooning, Gottlieb, Motherwell and Pavia — reminiscing. There were also several women's panels. [See "Before 1975," next chapter.] But control at College Art was still in the hands of conservative historians, meetings were held only once a year, usually in faraway cities, and applications to hold a panel had to be made *and approved* long in advance.

In other words, accessible, generative, immediate, on-going public discussion of art by artists had yet to begin (or, we might say, to resume).

Discussion in print was equally limited, especially for painters. For instance, from September 1973 to September 1975, 157 articles were published in *Artforum,* of which only 19, or 12%, were about contemporary American painting.

Perhaps sensing an oversight, the magazine published a Special Issue on Painting in September 1975. What came to be known as the "*Artforum* 'Is Painting Dead?' letter" was featured here. The letter said in part, "It appears that painting has ceased to be the dominant artistic medium [while] those understood to be making 'the next inevitable step' now work with any material but paint." It asked how this had "affected the need to [paint] today," what "possibilities" the medium seems to offer, and "what energies and ideas in painting strike you as worth attention." [See also '75/#11.]

The 23 replies from painters, who had received the letter in advance, were varied and eloquent – strikingly so, considering the stereotype of inarticulate visual artists.[17] Mario Yrissary declared "Hurray for other fields of art. The further they get away from painting, the better for painting," and "*Everything* lives, including the annual inclination to kill

painting." R. B. Kitaj said, "art about art needs a rest," and hoped there would soon be "figure inventions worth matching up to real people."

In an editorial essay in the same issue, "Painting and Anti-Painting: A Family Quarrel," Max Kozloff (who was now managing editor) defended magazine policy. It stemmed, he explained, from the nature of modernism itself.

The reason *critics* had "ceased orienting themselves to painting," Kozloff said, was not because of any "wholesale abandoning of paint by American artists. On the contrary, we're impressed by the overall increase in the number of painters." Critics' loss of interest in painting, he said, was because painting "was not rewardingly troublesome – it lacked the 'downward mobility' essential to the game rules of modernism. [I]t was simply not possible to void painting of its articulate residues or to make it look underprivileged enough." Modernism "often consciously reinforces technical deficits and augments formal handicaps." It likes "worthy outcasts" or "top underdogs." Such strategies as annealed surfaces, gouged-out earth or crude instamatic photographs now get the benefits that once accrued to painting, sculpture or photography, Kozloff explained.

So subtle a defense of modernism might seem like an indictment to the non-initiate. Certainly it was richer and more acute than Greenberg's "inevitable progression" of painting to a flat rectangle of pure abstract floating paint. But the basic scenario was the same – critic explains modernism to artists, tells "game rules." How, we might ask today, could one note an "overall increase in the number of painters," yet ignore the possibility that this *itself* might mean something about the inevitable next step in art? By believing that the course of art had its *own* imperatives – inevitable and independent of artists.

In the next year, *Artforum* proceeded to *decrease* its coverage of painting. From September 1975 through Summer 1976 (when I got tired of counting), it had 58 more articles, of which just four, or less than 7%, were about contemporary American painting.

The Club

There had been a time when artists were in charge of art and talk about art and painting was art's glory. Certainly painting had been the principal focus of talk at the Club, the artists' principal forum. But in any event, no story of artists' talk could fail to pay homage to the legendary Club, celebrated scene of the Abstract Expressionists, the greats who drank and schmoozed at "The Cedar" and talked and danced all night on Eighth Street, in that time and place where everybody knew everybody in the art world, all 200 of them, all brothers in art, an extended family of intellectuals. Right?

Ignoring the haze of nostalgia and pride in the time when America became Number One in art and simply examining the record, we see that the Club was also an instrument of

power, exclusion, and control, what in today's jargon would be called "hegemony." Consider the following:

The Club was founded by a small number of men, two or three of whom essentially ran it in the years of its greatest energy. They invited speakers, set ground rules, chose panel topics and controlled membership (while a wife ran the postcard-addressing machine). The 20 charter members of 1951 were all men. By the end of 1952, 20 more members had been admitted, including, after some pressure, two women, Elaine de Kooning and Mercedes Matter. It's hard to tell from fragmentary records whether male chauvinism in the Club was in fact greater than norms of the time, but let us recall that these *were* the guys who boasted about painting with their genitals.[18] (I quote without comment Dore Ashton's description of the Club as a place "to bring a woman."[19])

Club rules were made by the voting committee without consulting membership. In 1955 it was decided to limit membership to 150. New members had to be sponsored by a voting member and approved by the committee with no more than two negative votes. ("It had to be two because [Landes] Lewitin always voted no.") As it happens, I have it on unimpeachable hearsay that voting committee policy in the early years was *explicitly*, "no blacks, no homosexuals, no communists, no women." The rationale was that these groups had their own agendas and would "take over."

Irving Sandler, primary chronicler of the Club, reports that "members in good standing could bring guests [but] few outsiders, if persistent, were denied entry." I heard a different version – of course celebrities like Allen Ginsberg, the then-Leroi Jones [Amiri Baraka], poet Frank O'Hara, who was also curator at the Museum of Modern Art, and other friends of principals, were welcomed. But unknowns who were black or visibly gay were routinely turned away by a bouncer at the door on the grounds that "there would be trouble." Surprisingly perhaps, to those accustomed to today's climate, the few who attempted the gauntlet did not protest, but went away quietly. However, just having to be "persistent" would be discomfiting, if not humiliating, to most people – a significant barrier.

Panel topics were wide-ranging and such reports of them as appear in print suggest a high level of discussion, but Sandler tells us, and we have no reason to doubt, that the most consistent theme was the basis of group identity or "community." In a 1965 article on the Club, he says, "the hottest controversy was the problem of community, of defining shared ideas, interests and inclinations." Similarly, in his book on the period: "the most debated theme was the basis of group identity," and "the growing and changing community . . . preoccupied both the first and second generations."

Beyond such explicit issues of community, much of the dialog quoted or paraphrased involves definition and explication of the right way to paint and think about painting. Artists were permitted individual styles, but they were expected to have the right *attitudes*. For instance, "sincere" was good, "corrupt" bad, assuming you could tell the difference; "pure"

was of paramount importance, but criteria for pure were murky; ditto "natural" vs. "*un*natural" form. The painting had to be "authentic" and "felt," not "contrived" or "calculated," but there again definitions were mutable. Meanwhile, the gesture must show "emotion," but not "image." Emotion without image presumably was achieved by making the gesture look hasty – which the skeptic might see as contrived or calculated! And then there was "nature." It was supposed to be painted as a form of abstraction, that is to say, unrecognizably. Some artists even claimed to paint abstractly outdoors in front of nature. They also said things like, "[My painting] doesn't reproduce Nature; it is Nature"![20] All the while, however, the picture plane must remain flat, with no recognizable figuration, no readable "horizon," no intimations of landscape.[21]

Other maxims included, "a painting had to be found in the struggle of painting" (which inspired Rauschenberg to paint two identical "gesture" paintings). A related idea was to paint in "an unpremeditated method to avoid style," although somehow the artist's "look" – or style – always came through. An overall and pervasive theme was ongoing concern about where the future lay and the right way to reach it. In other words, far from being free, artists were obsessed with group-think, control and correctness, anxiously aware that even the right gesture could be made for the wrong reasons. There were a variety of painting styles, but a lot of pressure to accept group pieties. Indeed, it was the '50s. Group, community and consensus were culture ideals.

As the new discussion scene evolved in the '70s and '80s, "The Club" and "The '50s" became popular panel topics. Survivors relived their youth and newcomers yearned for that special time ['77/#57]. But looking at the record and re-examining the precepts of my teachers (members of that coterie) shows that art of the period made a fetish of anxiety. Indeed Harold Rosenberg cast this as a kind of virtue, titling a book, *The Anxious Object: Art Today and Its Audience.*[22] Certainly the surfeit of rules, simultaneously rigid and shifting, eliminated all but a narrow spectrum of artmaking – which was probably the point. These coalescings of community created the "mainstream" artists were searching for – the "mainstream" artists of the '70s fought so hard to get out of.

Artists Talk: 40% Painting

The Club, having lost momentum for several years, disbanded in 1962. Some of the original founders started up again in a loft on 23rd Street in 1964 and lasted there until 1967 (which so far doesn't seem to be on record). After that it was the mid-'70s before a newcomer from Illinois, Lori Antonacci, discovered that New York was Clubless, and joined with an artist-survivor of the original scene, Bob Wiegand, and a native New Yorker, Doug Sheer, to re-create it. The group they founded, Artists Talk on Art [see Appendix], began sponsoring panel discussions in Soho in January 1975, with the motto: "An opportunity for artists to meet, talk and listen to each other."

Like the Club, Artists Talk on Art followed the precepts of *its* time. By the '70s, *diversity* had become a culture ideal. Rather than group identity, the premise was now group *variety* – divergence, differentiation, peculiarities, offshoots, splinter groups, and *re*definitions of art. Although the Club had invited intellectuals from other arenas to speak, its essential concern was to validate, consolidate and explicate the rules of a coterie or "community." Artists Talk on Art had the opposite intent, to allow artists to define *themselves*, to validate mavericks and invalidate rules.

Artists *in general* were invited to suggest panel topics; no topic that seemed feasible was turned down; the mailing list began at 300 and rose to 3500. Announcement flyers had messages like, "we encourage you to participate. If you have ideas for future panels or want to be part of our program committee, please contact us." Whoever turned up and paid a dollar at the door was admitted, except for the few occasions when space was filled and latecomers were turned away.

Interestingly, the list of early ATOA panels suggests that, at least in Soho, at least at that time, the "dominant artistic medium" was none other than paint. By the end of the 1976-77 season, there had been 57 panels, 23 of which, or 40%, were about contemporary painting. Of the others, five were about sculpture, three about drawing, and the rest were about one-time topics ranging from politics to performance.

In other words, artists, or these artists, were interested in painting, and critics, or certain critics, were interested in anti-painting. No problem for critics, of course. They simply dismissed "these artists" as not the right artists. The critical canon decreed that no matter how barren the terrain or pointless the prize, the *right* artists soldier on for modernism. William Barrett described this cultural bind as "the paradox of an avant-garde, supposedly dedicated to the 'Tradition of the New,' dictatorially enforcing . . . the repetition of a narrow and confining style." Indeed, Barrett said, "Ideology is a cruel taskmaster and may require of us the sacrifice of our best perceptions."[23]

If this has not yet been called "the white-man's-burden view of modernism," let me be the one. More significantly, it exemplifies the Marxist belief in "forces" driven by the "necessity" of history, or what might be stated as a Marxist universe of self-impelled abstractions and ideas. This could have been Greenberg's Marxism at work, or simply a predisposition of the time. In the 19th century it would have been called the "pathetic fallacy." That is, the attribution of will or purpose to the non-human, the inanimate, or in this case, the immaterial (unfolding art styles), used to be chastised with that poetic title.

More to the point for this discussion, any decree about art's "necessary" course issuing from a seat of authority was bound to be a self-fulfilling prophecy, especially in a time of correctness and consensus. That is, with "x" declared the right form of art, and "a," "b" and "c" wrong forms, artists turned dutifully to "x." If any of them stubbornly persisted in early letters of the alphabet, the work would be ignored, and so, for all practical purposes, not done. As long as enough artists

made "x," the myth held. Ultimately, of course, "x" palled, and many artists, not just the nonconformist few, mutinied.

(Presumably artists today could more easily challenge notions of art on a course *independent of artists and out of their control.* As has been pointed out, perhaps a third of current glossy art publications are written by artists ['90/#22]. Artists also have a variety of other platforms and arenas, including several not-for-profit publications with national circulation. Atlanta's *Art Papers* and the Chicago-based *New Art Examiner* are two of the best.)

"Perils" of Pluralism

Although the demise of mainstream theory as such was unlamented, there was immediate debate about what might rightfully replace it. "Pluralism" was the demand of artists, not critics. One critic protested even the idea, because there could be no great "Master of Pluralism." His artist co-panelist shot back that what really bothered him was losing control, because there could be no great master *critic* of pluralism – surely one of the more revealing exchanges of any panel in this compendium ['78/#80]. But other discussions show that critics who just the day before had been directing the Forces of Modernism from horseback managed to switch positions in the blink of an eye. (I exaggerate. There were critics who opposed "inevitable progression," etc., all along. I just don't remember them.) However, pluralism was still seen as somewhat scandalous or "perilous" as late as 1978. On the panel cited above (titled "The Perils of Pluralism"), Robert Pincus-Witten called it "the style of bad art." Pincus-Witten of course had been Senior Editor at *Artforum.*

While the new artists' talk held intimations of reclaiming a broader heritage, and of putting things back into art, artists regardless of style were determined to regain the power and voice they felt had wrongly accrued to doctrinaire critics, fellow-travelling curators, all-powerful dealers, and museums run by scions of vast wealth. In 1969 they formed an Art Workers Coalition to confront power directly. Influenced by power-to-the-people currents in the wider society, AWC also set a precedent for artists groups that followed. Soon artists wanted, not only to speak for themselves in their own artists' and feminist publications, but to have artists' rights and artists' residual rights, artist-run galleries, even an artist-chosen "Whitney Biennial Counterweight" ['77/#59].

That we still needed or would accede to mainstream media and institutions was not so apparent at the time as it probably should have been. Nor could artists then imagine the role money, manipulation and marketing would play in the 1980s. Tremendous gains were made, but some dreams faded. (One lost dream – or illusion – was of the artist as romantic, impoverished, bohemian outcast. The comfort and romance of this self-image turned to gall for many when, in

the 1980s, some artists became national celebrities with movie-star wealth and glamor ['87/#192].)

Women and Politics

While art-critical insurrections were rocking modernism's boat, women artists, also affected by currents in the wider culture, where "women's liberation" was stirring, began to make waves of their own. Suddenly they awoke to the fact that their prospects in art academia, in matters of tenure, professorships, and studio teaching jobs, indeed in all but the most menial, underpaid positions (and not so good there either), were appalling and that their fortunes in the "gallery world" were, if possible, worse.

Neither world responded meaningfully to women's protests: statistics were dismissed, discrimination denied, and "women's art" derided. Women were told not to confuse politics with the higher realms of art and assured that if a woman artist was any good, she would succeed. (Successful women artists who had gained access through powerful art-world lovers or husbands seemed to agree.)

The first *cause célèbre* was an all-male Corcoran Biennial in Washington in 1971. Women artists, led by Mary Beth Edelson, picketed. In expiation, the Corcoran agreed to host a Conference on Women in the Arts the following year; women began to form alliances and define issues there. Also in 1972, the Women's Caucus for Art of the College Art Association was founded, with Ann Sutherland Harris first president. Women's panels continued to set agendas and define issues at CAA the following year. [See "Before 1975."] Also in 1973, the Ad Hoc Committee of Women Artists published a pamphlet of first-person accounts of art-world sexism and male chauvinism in their glory days; *The Rip-Off File*, compiled by Joyce Kozloff and Nancy Spero, could still bring the blood to a boil.

The non-response of those in power simply fueled the protest – which in this setting fell naturally into panel-discussion format. The Women's Caucus launched a barrage of College Art Week panels, still ongoing. A.I.R. Gallery, a woman's co-op founded in Soho in 1972,[24] also sponsored talk events. These often focussed on criticism and some included both men and women (the men being alternately grilled and toasted). Other co-ops, for instance Soho 20, a woman's co-op founded soon after A.I.R., also sponsored panels. In fact, women's groups and galleries around the country (as well, of course, as other artists' groups) turned to the panel format for making statements and articulating issues.

From the start, these women's panels were not just effective, but crucial, as they raised consciousness, spread information, framed positions, fostered alliances and tendered support. They also addressed other issues besides the missing pieces of pie. Miriam Schapiro and Judy Chicago had introduced feminist themes into their own art and into a teaching program at Cal Arts, and these ideas entered the discourse. Critic Lucy Lippard developed a thesis of circle shapes and

central voids being common denominators of women's art and, with Judy Chicago, travelled it across the nation (where it was, to put it mildly, vigorously debated). There was, however, no question that women were beginning to use personal material in their art. The cry became, "the personal is the political," as these ideas, too, were spread by talk. A few critics insisted that men as well as women were incorporating personal material into art, but the women's voices were the ones we heard – no doubt because of all those panels.[25]

At the same time, artists were searching for ways to connect their social and political concerns with art. In late 1975, Rudolf Baranik and Hans Haacke called a meeting at Baranik's Wooster Street loft to address issues of the Bicentennial, particularly the Whitney Museum's exhibition of the Rockefeller Collection, then being presented as "Three Centuries of American Art" ['76/#23]. The group, calling itself Artists Meeting for Cultural Change, continued meeting until 1978. After its initial protests about issues raised by the Whitney exhibition (and a book on the subject, *an anti-catalog,* in 1977), AMCC turned to other current issues.[26] Links were forged with such groups as Art & Language, and other venues, like the College Art Association's Caucus for Marxism and Art. Political art, which had been the "last taboo," gained acceptance and finally normalization.

In photography, however, or photography's academic wing, political concerns were still the focus of sharp controversy in 1990 ['90/#220].

Golden Age of Panels

Readers of these reports as originally published sometimes claimed to enjoy them more than the reality. That was a compliment to the writers, of course, but also because a condensed (i.e., edited) version can distill the fascinating crux of a meandering event and consolidate thoughts obscured by uncertain delivery, cross-comments or detours.

Certainly it's better to read, "speakers beat about the bush for a long time before finally getting to the point," or "the next half hour consisted of desultory whining and bickering," than to sit through it. Panels have bombed when artists failed to marshal and prepare their thoughts (one well-known Minimalist insisted, "my work is my statement"), or were so happy to show their art in slides they lingered excessively over size, medium and title of each of 40 works. And, it must be said, the occasional artist, quite possibly a famous one, is a long-winded bore – although most panels have their moments (even if provided by the audience).

Another pitfall of panels, especially in academia, is that normally wise and kind people prepare papers they know are too long for the allotted time and attempt to compensate by delivering them in a speed-of-light mumble. Such a paper in print, however, becomes accessible – even fascinating.

While sparing the reader many such hazards of panel-going, the reports collected here retain telling human details of live events: A group of panelists depose a moderator, neatly illus-

trating the anti-authoritarianism of their genre – mail art. A senior artist, whose subject is power, deftly silences a heckler. An artist in the audience strips naked to protest his lack of exposure. An artist in another audience calls out from the floor to a doctrinaire moderator: "You're ruining the whole panel!" A famous critic launches a bitter attack on the work of an equally famous architect, who just happens to be the co-panelist at his elbow. . . .

Such material, including the eccentric and the unresolved, may be a small counter to history's tendency to reduce a period to the concerns of its most famous or flamboyant and to smooth out the nuances or wrinkles that also contain art's meaning. Of the wide spectrum of ideas entertained by artists, few make it to the charts. Some of the most provocative or illuminating may come from artists of little acclaim or subsequent eclipse (maybe, like Hilton Kramer says, from making the wrong move or the wrong divorce). Promising beginnings get buried, either by happenstance or by other ideas, not necessarily better, maybe just better timed, or more effectively marketed. These reports put a gamut of ideas on record.

Of course the thesis of this book is that the panel has been a powerful "instrument of change" in art – and I daresay always has been: Surely those Club discussions about gesture, form, meaning and "community" had a profound prosyletizing effect. But there are special virtues, even at times a certain magic, in the format itself. A variety of voices may assemble into a range of meaning that a single voice cannot attain.

At some events, especially at the intimate and informal Artists Talk on Art series, hardly a word escapes contradiction. [See, for instance, '81/#156.] Other panels, suffering from an excess of good manners, team spirit, or inertia, could have used a dose of contradiction. But the rare, true glory of the form is when someone cogently contradicts a speaker, who contradicts back, in an exchange that, ideally, is a clarification and refinement of both points of view – or changes one of them. Pat Mainardi may have alerted both Robert Pincus-Witten and Joseph Masheck to new realities at the "Perils of Pluralism" panel. Not long afterwards both men negotiated the concepts of pluralism very handily. At "Figure/ Space/ Content" ['80/#150], an argument between a panelist and a member of the audience generated rancour – but also insight. Sometimes everyone bristles, but sometimes thinking is crystalized.

Another virtue of the panel format is that ideas do get corrected – or perhaps balanced. Many times we encounter a statement in a book or essay that is apparently, or clearly, wrong. Here the audience says so.

But there's an entirely different dimension of history in the early women's events. Something else happened. Panels were rallies, or clarion calls. The mass of human bodies in a defined space seemed to generate a current – and galvanize everybody. Surely a large part of the power of the women's movement in art came from ideas and feelings relayed this way, in person, over ever-widening circles. The sense of cor-

recting history, of willing a different future into being, was palpable.

Perhaps the most triumphant moment of this entire saga was at the second of two similar women's panels, just two seasons apart. At the first, Carter Ratcliff spoke for many of his colleagues when he said he knew of no art presenting itself as "women's art" that would be considered significant by mainstream critics ['75/#13]. Two years and four months later, on the dais of a Brooklyn Museum panel convened exactly to admire "women's art," Ratcliff joined the applause. When he said, "To be a vanguard feminist at this point puts you in a very good position to be a vanguard artist," he was no doubt being polite to his hostess, but he was also speaking for the moment ['77/#70].

Success, however, exacts its price. Even before that event, women were beginning to fear they had thrown off the yoke of Minimalism only to see it replaced by the imperative to do "women's art" ['75/#22 and '77/#66, *et al.*]. Now, as panels proceeded to replay "gender in art" *ad nauseum*, gender threatened to become more tedious and oppressive even than patriarchy. Fortunately, a whole range of issues evolved, and the threat passed.

Post-*Modern,* Not Post-Market

Even including such vicissitudes, much of the talk in these pages celebrates some form of escape from "modernism." Before long, "the bad old rules of modernism" had become a phrase, leaving us with the assumption that this must be post-modernism. But that was about the only consensus. At the first ATOA "Post-Modernism" panel, speakers refused even to *name* a post-modernist, let alone define one ['80/#132]. Ten years of palaver later, we have a raft of certified post-modernist artists, and a chorus of bragging or complaining about this one or that one, but still, little definitive analysis of the term.

We are, of course, coming to the time when post-modernism itself will have to be discarded, like all other isms before it. An interesting symposium of 1991, "Examining Post-Modernism,"[27] was assembled to question "the assumptions of post-modernism in photography." But panelist Donald Kuspit made a *leitmotif* of deploring Richard Prince because he "wants to be an artist but doesn't trouble to create meaningful art." Why not, I asked from the floor, blame the interlocking collusion of editors, critics, curators and collectors who elevate Prince? (Everyone wants to be an artist. There's a guy walking around the Village in red velvet and bells who wants to be an artist.) Kuspit allowed that "vested interests" look for what they perceive to be "avant-garde" art for investment potential, but had no appetite for that line of inquiry. Yet, surely, that's the crux of many questions about the course of art in our time. Why argue premises if the real power is in marketing?

Indeed, "vested interests" looking for the avant-garde sounds suspiciously like the old "inevitable next step" gang, the folks who followed Greenberg's tracks looking for large profits from "next" art. These phenomena, however, are usually camouflaged by theory, and virtually unexamined. One writer explained why:

> . . . an elaborate and powerful complex of art writers, collectors, dealers, scholars and museums interlocks to support the cash nexus in which contemporary art now dwells, apparently impervious to criticism. A surprising number of insiders frankly express revulsion that money has become the measure of contemporary art – but not for attribution. The museum director who complains publicly may be risking his or her job. The dealer who objects finds his or her artists overlooked when museums show surveys of contemporary art. The art writer who exposes insider dealing suddenly confronts ostracism by the sources he or she depends on.[28]

In a 1985 conference about the art market (held at a school of *business administration*), Alexandra Anderson-Spivy delivered a blunt and revealing paper on market and auction practices, perhaps a first ['85/#177]. The same year, panelists at "How the Marketplace Gives Form to Art" presented a knowing and highly entertaining (albeit relatively discreet) look at many of the same issues ['85/#180]. Still, the rest of the iceberg remains. Those who know all aren't telling – or haven't told yet. Art is certainly alive and well, and appears in many manifestations, but, for all the infinite parsings of art-theoretical nuance, the effects of market manipulation remain virtually unexplored.[29]

"It was important to buy in early, the earlier the better: a painting acquired for a moderate price now might be worth a small fortune in a relatively short time."[30] That description of the '50s still applies (or did until recently), arguably the engine driving the entire apparatus. The conventional wisdom once held that "most art finds its highest price at its first sale and only works of enduring importance appreciate in subsequent sales."[31] This is no longer the case, or no longer the *popular belief.* Maybe the secondary market phenomenon is what links modernism and post-modernism. I hope it's not overly optimistic to imagine inquiring minds of the next 15 years addressing these connections, and fearlessly examining the role of the avant-garde in marketing and myth (phenomena which may account, at least in part, for the fierce hatred many artists hold for "the art world").

But finally, the term "post-modernism," evokes a verbal style which to many artists *is* post-modernism, and no record of recent art discourse could be complete without addressing it. Consider, for example, the following phrases from the black hole of a Mary Kelly essay: "the homogeneity of the pictorial paradigm . . . encroachment of shapefulness and impending objecthood . . . existential recumbency . . . evasive discursivity . . . pictorial textuality . . . crisis of positionality . . . phenomenological insistence . . . polysemy of imaged discourse . . . epistemological obstacle," and so on at length, entirely straight-faced, without even so much as a wink. (Kelly concludes with a plea for "an accessible critique" – very touching.)[32]

Poggioli tells us that, since "the principal task for avant-garde criticism" is "to feel the process of history," we must "forth-

with condemn that type of modern criticism which prides itself on being more recondite and occult than the creation itself."[33] Aha! But he also points out that the avant-garde functions to separate "those who 'get it' from those who do not." Aha, again! The recondite and occult is *intended* to exclude outsiders, like pig latin or op language in children's clubs.

Still, we rarely encounter the form in panels (except for an occasional paper), perhaps because people don't *talk* that way – or perhaps because our reporters avoided such events. Cassandra Langer addresses *other* aspects of Kelly's language, including her use of Latin ['90/#219]. Craig Owens and his panel of post-modern painters and photographers spoke quite coherently ['83/#169]. One suspects in Michelle Cone's review of a Modern Language Association Conference that she has made a determined decision to translate at least selections into English ['78/#103]. Perhaps other events lacked translators.

I mention in passing that the opaque and occult does have one very practical application: It covers the gap where overreaching arguments don't reach – although there are cases where mere logic is irrelevant. For instance, the language of Rosalind Krauss's essay, "The Originality of the Avant-Garde," widely cited as linchpin of post-modernist theory, has many passages that are adequately clear. Yet its distortions, rhetorical devices and outright fallacies are so blatant they make Clement Greenberg look like the Bureau of Standard Weights and Measures.[34] But, as we see, College Art panels are still "debunking" Greenberg in 1991;[35] these claims may be exorcised in the year 2005.

Meanwhile, the art claimed by post-modernism or claiming to be post-modern is very various and will presumably evolve its own labels. It has been said that any art that takes back what modernism removed is *ipso facto* post-modern. Lately, some art seems determined to take back what *post-modernism* removed – that is, has granted itself permission to do abstract "formalist" painting. Then, again, it's been said that post-modernism isn't so much a "radical separation" from modernism as a "rendering transparent of [modernism's] sustaining myths."[36] Kay Larson suggests that "The Modernist impulse has not yet exhausted itself. What is 'post' is Greenbergian formalism." She amplifies this point with the astute observation that neither David Salle nor Eric Fischl could "sustain the tension" in his work if some of modernism's prohibitions did not remain "subliminally" present.[37]

Finally, it has been said that post-modernism makes criticism part of the subject and modernism doesn't. Re-reading some of the old "modernist" criticism, I reflect that the twinning of criticism and art is so far advanced in both that the distinction may be more technical than real. Poggioli says "language is our greatest historical revealer." We see that Kelly's supposedly post-modernist language bears a striking, indeed uncanny, resemblance to the modernist jargon of 15 years earlier, the *lingua franca* of *Artforum* of the early '70s, for instance Annette Michelson's (as in footnote #13).

We can only await further developments – and any insights or debunkments that come down the pike.

Title Search

Some notes on the evolution of *Mutiny and the Mainstream: Talk That Changed Art* may be of interest.

Gripped by the fantasy that the perfect title could make the rest of the world love this material as much as I do, I surveyed the genre. The most brilliant metaphor was *Bonfire of the Vanities,* but I lacked courage for *Bonfire of the Verities.* The folksiness of *Everything I Need to Know I Learned in Kindergarten* was appealing – but not true. In our "late capitalist society" (as Marxist speakers of the '80s so hopefully called it), art and all its interlocking arguments are in re-design continually – a regular cottage industry. What you needed to know last year may be less necessary this year and passé next.

My first working title was *For the Record: A Golden Age of Art Talk,* but there turned out to be six *For the Record*'s on record, not to mention that *other* golden age of art talk. After immersion in the material, however, I realized that, despite its great diversity, much of the talk was of mutinous intent; love-hate of the "mainstream" was a continuing theme. Moreover, use of the term "mainstream" seemed to change during the period, from approval to disparagement. Would an artist proclaim him or herself mainstream today? As we take our present pluralism (of which the "perils" were clearly exaggerated) more and more for granted, we may find the entire "mainstream" concept begins to sound like a holdover from the '50s. Or it may have become simply a phrase meaning "known to the wider public."

Re-reading the early panels was a vivid reminder of how many things *have* changed, although not as a rule in sudden waves like the '60s. With so many artists, schools, styles and substyles, so many new ideas coming onto the market, and old ideas being retrofitted with new meanings, change now occurs in wavelets, often lapping around outcroppings of loyalists who continue as they began. Speakers who presumably share a style sometimes disagree strenuously.

Style changes, however, aren't the changes I mean by "Talk That Changed Art," or not primarily. The overriding feeling at the outset of this period was that things had gone wrong artistically and socially – artistically because Minimal was a bore and dead end; socially because women, "others" and most concrete human concerns were excluded from art. Artists really did *set out to change* the philosophy and structure of the art world, to shovel yet another spadeful of dirt on the grave of formalism; to yank the limelight back to painting – but "pluralist" painting; to demolish any lingering resistance to women's grievances; to prosyletize for the acceptance, maybe ascendance, of women's art and ideas, as well as art by African-American and "Third World" artists; to celebrate formerly forbidden styles; and, perhaps *most* thumb-in-the-eye to art's conventional wisdom, to incorporate overtly political themes into art, because, "considering the state of the

world, how can you make art about anything else?" (The mutiny yet to have its day is the one that will end the ranking of "art," however vapid and perfunctory, over "craft," however sublimely conceived and made.)

Needless to say, not all this talk changed art. Some of it never twitched art's whisker. Many events were simply celebrations of arriving – or departing – styles. Others are included to register facets of history. In today's climate it's easy to forget that in 1979 Jimmy Carter presented the Women's Caucus awards in a ceremony at the White House. At the CAA that year, a panel of federal officials described the goals and achievements of their art-support institutions and *promised more*, because support for art was seen both as civic duty and vote-getter. As I write in 1991, such loving kindness from government is unimaginable. The deference New York State legislators once showed angry "minority" artists might be conceivable today for "minority," not for "artist" ['78/#95].

Sources

My conclusions about the art world of the Abstract Expressionists, particularly the Club, are drawn from secondary sources, reports of others who were there, and impressions filtered down from teachers and fellow students.

This book's version of 1975 to 1990 is clearly just that – a version with its own, obvious limitations – although in a way it was shaped by events themselves. If an idea was current, there were panels on it; if people cared about the panels, they offered to cover them. No matter what *I* thought of an idea, as an editor with no staff I accepted all offers eagerly. (My own strongest interest was in art critical issues, and I covered a lot of those panels myself.)

Reporters for *Women Artists News* were all volunteers, except for two seasons when we had a grant that allowed miniscule stipends. Most were artists, often recruited through the grapevine. Aside from their relative availability, we felt coverage by artists meant greater understanding and less mischief, that is, artists seemed less likely than critics to add a deceptive spin of their own. *Artworkers News* (which became *Art & Artists*), another source of material in this book, covered few panels, but ran a notable series of interviews, included here. Excerpts from papers delivered at a variety of events are also included. Some were highlights of an occasion, punctuating, even defining, their moment. These are rarely in print elsewhere, or not outside of academic journals.

On re-reading, I am struck by how well our volunteers, most of whom had never written for publication, conveyed flavor and particulars. I thank them again for lending a hand, perhaps with misgivings, but always coming through. Their personal voices, knowledge, reflections, wit, wisdom, and, above all, *feeling,* enhance these histories [see Ira Joel Haber, '77/ #58], antidote to the impersonal voice of authority that delivers most art history. At College Art conferences, when we few regulars were overwhelmed by the number of simulta-

neous events, Cynthia[38] or I would sometimes walk into a room where a panel was about to start, accost an early arrival and convince her to write it up. These "volunteers" came through, too.

From 1980 to 1985, panel coverage by *Women Artists News* was irregular. I had left editing to focus on my own work and subsequent editors were not as concerned with talk events as I had been. But panels with charisma still tended to come in over the transom. On my return to editing in 1986, there was a lull at Artists Talk on Art, although College Art, including the Women's Caucus, had a run of strong events.

The Future Lies Ahead

Late in 1990, as the stock market sank and the economy contracted, the word was that art prices had gone into "free fall."[39] Charles Saatchi announced that he would lose even more money in 1991 than he had in 1990 and would continue the selling from his collection begun the previous year.

The "free-fall" concept may have reflected the shock of discovering that art prices would not *necessarily* continue into the stratosphere forever, more than total collapse. A decline of art prices could even be therapeutic, if it amended the '80s obsession with money. After the *schadenfreud* of watching selected biggies reveal their wounds in public, artists' talk could regain some of the fervor it once had. Then again, "panel fever" may have burned itself out, at least for a while. Many of the original goals were achieved, some too well. [See my "Firing the Canon and Going Off Half-Cocked," '90/ #214.] Not that panels will cease; the format is thoroughly and widely institutionalized. But the sense of discovery, energy and urgency of art talk events in the late 1970s and early 1980s has, at least for the moment, subsided.

Still, as the "Angry" speakout showed, artists are always ready with a range of perfectly reasonable protests, from the unfairness of hunger in the world, to the unfairness of the low status of watercolors ['86/#184]. All else failing, the vitamin-fed, tooth-straightened and ivy-educated young can sit around with the hale, hearty and tenured middle-aged to decry elitism. Nor do I for a moment exempt myself from this line of work. My own protests are threaded throughout these pages.

The Moral, or Morals

When artists speak for themselves, it's amazing how many state their intentions with great clarity, whether or not academicians consider them relevant. They strike out eagerly in different directions, disagreeing with official dogmas, even declaring them unrecognizable. It's also amazing how charming critics can be. They say (and these pages show they say) true and wonderful things about art and the *zeitgeist*. We see, though, that those who best understand and speak for art are the least/most (choose one) guilty of creating their own fictions.

Further meta-theory I leave to specialists. Today no single institution has the cachet *Artforum* had in the early '70s, but artists have many more forums. These collected dispatches, eye-witness reports, manifestos, reflections and diversions are from some of them – for the record.

Judy Seigel, 1991

Notes

1. Observed by Robert Storr in a 1990 essay on Greenberg. See footnote #10.

2. The "only taboo" phrase is from an essay by Lucy Lippard for a May Stevens catalog. The critic lamenting political art as "the latest rage" is Hilton Kramer, *The New York Observer*, March 18, 1991.

3. For instance, in a recent *New York Times* review of an Ad Reinhardt retrospective by Michael Brenson [May 31, 1991]. Describing Reinhardt's forms with high enthusiasm, Brenson says it is the "active – and dynamic – quality within the finality that can make their inevitability so powerful." Syntax aside, this sounds like our old friend "inevitability" in art, and still "powerful."

4. The philosophy of modern art dwelling on these aspects of art's form has come to be called formalism, or "Greenbergian formalism." By extension, the style and the art itself also become "formalism." By an even greater extension, "formalism" becomes almost any concern with the appearance of art, especially in the context of the speaker's preference for "content" art, or what Greenbergians used to call "literary content" in art. (In the early 20th century, Roger Fry and Clive Bell analyzed qualities of art's forms in a critique called "formalism," but their approach has been subsumed by Greenberg's.)

This, I should add, is my own sense of usage and change over the years of a term nearly as loose and contradictory as "modernism." I would also speculate that use of "formalism" in Soviet Russia as a label to condemn work that had aesthetic, rather than Socialist Realist intentions, may have flavored our own discourse – given the claimed Marxism of so many art writers.

5. Robert Atkins, *ArtSpeak: A Guide to Contemporary Ideas, Movements and Buzzwords*, Abbeville Press, 1990.

6. "Art View," *The New York Times*, April 16, 1978.

7. The phrase is from Peter Plagens, "Peter and the Pressure Cooker," *Artforum*, June 1974. Plagens's report on a trip to New York from his then-California home conveys well the flavor of the period, while being vastly amusing – vintage Plagens.

8. The existing scene was called "pluralism" because several genres in addition to the official Minimalism were in production simultaneously. These were mostly relics of earlier approved styles – the rigid rules of acceptable art had yet to be overthrown.

9. Kay Larson, "The Dictatorship of Clement Greenberg," *Artforum*, Summer, 1987.

10. Robert Storr, "No Joy in Mudville: Greenberg's Modernism Then and Now," from *Modern Art and Popular Culture, Readings in High and Low*, edited by Kirk Varnedoe and Adam Gopnik, published by the Museum of Modern Art and Harry N. Abrams, 1990, in conjunction with MoMA's "High and Low: Modern Art and Popular Culture" exhibition.

The "High and Low" show examined cross currents between "high" and "low" art, or rather the entry of "low" or popular art motifs into "high" art. In his 1939 essay, "Avant-Garde and Kitsch," Greenberg had reviled "low" art forms, calling them kitsch. The Storr essay was intended to confirm the value of "low" art by exposing Greenberg's "'flawed dialectic' of high and low."

Having recently re-read "Avant Garde and Kitsch," however, I note certain other issues. Today we love kitsch, adoring the Warholian cookie jar and the Archie McFee catalog on principle. But Greenberg addressed, at least glancingly, real and dismaying phenomena. When he describes kitsch as "another mass product of Western industrialism" that has "flowed out over the countryside wiping out folk culture" as well as indigenous cultures around the world, I can't help reflecting that, still, in the 1990s, it's difficult to buy an air conditioner not stamped with wood-grain plastic "Regency" molding. I reflect also that the essay was written in 1939, when Hitler and Mussolini were brutally surpressing their countries' avant-gardes, as Stalin had done already, replacing them with state propaganda-kitsch, which seems to have been the crux of Greenberg's emotional involvement with the issue.

11. Plagens, *op. cit.*

12. The record shows also Lawrence Alloway, Rosalind Krauss, Joseph Masheck and Angela Westwater as "panelists"; Diane Kelder as "moderator."

13. Examples of which are such lines from *Artforum* as, "Theatricality may be put in tension with this received epistemology because the temporality is the logical corollary of the stability of sculptural space, as the undifferentiated space of the world at large is the corollary of the differentiated space of the painting," [Jeremy Gilbert-Rolfe, September 1974]; "a text for the polyphonic articulation of a critically dissident scrutiny," [Annette Michelson, September, 1974]; or, from a 163-word sentence: ". . . the subjectivization of the perception of art through the deliberate introduction of a systematic doubt of the presumably self-evident objectivity of its ground [continued similarly, until] the reviewing, under the auspices of the phenomenological epoché, of artistic intention as 'that *ultimate originality* which, once apparent, *apodictically masters* the will' to create art." [Donald Kuspit, January 1974]

14. But *Artforum* had art-world attention also for its attempts to engage powerfully with other contemporary art issues, such as the exigencies, or corruptions, of curating. I recall, for instance, Lawrence Alloway's mention of pressure from the Morris Louis estate, which, he said, would have withdrawn most of a museum show if the catalog told how many paintings the estate held. (They were being sold on the basis of scarcity.) There were various other attempts to hold museums and curators to the standards of the writers. After the Kozloff regime, as far as I know, such issues were not discussed in advertiser-supported press. Indeed the *rumor* was that galleries placed "over a hundred thousand dollars worth of new advertising" in the first *Artforum* after Kozloff's departure. (On the other hand, I'm not aware that such issues get a great deal of coverage in the non-profit press, either.)

15. Plagens, *op. cit.*

16. Donald Kuspit, "Betraying the Feminist Intention: The Case Against Feminist Decorative Art," *ARTS*, November, 1979.

17. Perhaps the stereotype belongs to an earlier generation. For instance, Harold Rosenberg found painters "lacking verbal flexibility" and quoted them saying things like "My painting is not Art; it's an Is" ["The American Action Painters," *ARTnews*, September 1952]. Then again, as late as 1973 a book aimed at the general public tells us, "[A]rtists are often inarticulate. The artist is a visual person. He expresses himself best visually. [A]t a seated dinner for twelve, he is often helpless . . . " [Sophy Burnham, *The Art Crowd*, David McKay, New York]

18. Irving Sandler, "The Club," *Artforum*, September 1965. Here Sandler lists 12 panels of the 1952 season. Seven had no women, three had one woman, one had two women, and on March 7, 1952, three women (Jane Freilicher, Grace Hartigan and Joan

Mitchell) were on a panel with four men. Only one woman is on record as invited guest speaker, Hannah Arendt.

Numbers and dates in this section are from the Sandler article cited above, but the information is fragmentary. Sandler's book, *The New York School* [Harper and Row, 1978], gives different information about membership, listing Helen Frankenthaler as a member by the end of the first year and Joan Mitchell, Grace Hartigan and Nell Blaine during the second.

19. Dore Ashton, *The New York School*, Viking, 1972

20. Rosenberg, op. cit., *ARTnews* 1952

21. Terms of the discussion about painting are from Sandler, *The New York School*, except the part about "no horizon line," which is from my own student-painter days.

22. *The Anxious Object: Art Today and its Audience* [Horizon Press, 1964]. Similar virtues are implied by a later title, *Art on the Edge* [Macmillan, 1975]. It might be added that this sense of anxiety has been characteristic of avant-garde or "modern" art since the 19th century. Early Pop Art mocked it, but the post-modernists seem to have "reified" it (to use their term), through their all-knowing, superior stance and intimidating language.

23. William Barrett, "The Painters' Club," *Commentary*, January 1982.

24. We called A.I.R. "the first Women's co-op," until Jeannette Feldman wrote us a letter about Gallery 15, a woman's co-op founded in 1958 at 59 West 54 Street. She had been an original member [*Women Artists News*, February, 1979].

Another A.I.R. program, the Great Goddess seminar organized by Mary Beth Edelson in 1976, was the art world's introduction to the "political ramifications of a primary sacred female," with ideas that ultimately threaded their way into a network around the world. In a brief history of the seminar, Edelson noted that "scores of panels, workshops, publications, and performances" followed and continue into the present.

25. In this summary of the early women's movement in art, I have listed primarily groups, events and themes important to the early panel discussions. For a more complete record, see Faith Wilding, *By Our Own Hands: The Women Artists' Movement, Southern California, 1970-1976*, Double X, Santa Monica, CA, 1977; Cynthia Navaretta, "The Second Wave of Feminism," *Women Artists in The United States, A Selective Bibliography and Resource Guide on the Fine and Decorative Arts, 1750-1986*, G.K. Hall, 1990; and *Guide to Women's Art Organizations and Directory for the Arts*, Midmarch Arts Press, NYC, 1982.

26. AMCC members included Carl Andre, Sarah Charlesworth, Peter Frank, Leon Golub, Joseph Kosuth, Sol LeWitt, Lucy Lippard and Pat Steir.

27. "Examining Postmodernism," sponsored by *Photographic INsight* at NYU, March 5 and 7, 1991. Moderator: Lynn Stern; panelists: Martin S. Bergmann, A. D. Coleman, Todd Gitlin, Max Kozloff, Donald Kuspit, Shelley Rice.

28. Alice Goldfarb Marquis, *The Art Biz*, Contemporary Books, Chicago, 1991.

29. Rudimentary beginnings appeared in complaints about the marketing of Julian Schnabel and a few Neo-Geo artists, but soon subsided.

30. Barrett, *op. cit.*

31. David d'Arcy, "Secondary Shocks," *The Art Newspaper #7*, April 1991.

32. Mary Kelly, "Re-viewing Modernist Criticism," anthologized in *Art After Modernism*, 1984, edited by Brian Wallis.

33. Renato Poggioli, *The Theory of the Avant-Garde*, Harvard University Press, 1968.

34. Rosalind Krauss, "The Originality of the Avant-Garde: A Postmodern Repetition," *October* #18, Fall 1981.

To illustrate the appalling level of "argument" that has been permitted, indeed celebrated, in art discourse, I summarize comments on "The Originality of the Avant-Garde" I have made elsewhere ["Editor's Post Script," *Women Artists News*, Winter 1988/89]:

First, Krauss coolly shuffles the meaning of "original" in the sense of *an* original, that is, something not a duplicate, copy, edition or reproduction, with "original" in the sense of originality, that is, independent thought, newness, innovation or creative ability. Then she notes Sherrie Levine's pirating of other artists' work, "explaining" that the pirated work is itself not "original" because it has been *influenced* by prior art. This example and the companion claim that *influence* means lack of originality became axioms of "post-modernism," endlessly cited and rarely contradicted – either in the belief that no rebuttal was necessary for such blatant trickery, or because familiarity had given it the ring of truth.

Krauss concluded by combining the idea that all art is "based on" other art, hence not "original," with her skewed definition of copying, then added in the fact that grids appear in many forms in modern art and presented this as "proof" that the "basic propositions of modernism," i.e., of its originality, are false. I don't know how she disposes of the fact that if there were no originality, art would not have begun and, once begun, would not have changed, because she ignores it.

It might be added that Krauss's premise that "originality" is a "basic proposition of modernism" is a matter of interpretation. One of the things artists found so obnoxious about modernist theory was that critics tended to couch it explicitly in terms of a group project, with everyone working away on approved problems of the moment, looking for that "next step," rather than in terms of individual, original genius. As Budd Hopkins put it, modernism's "emphasis on movements makes artists diminished and interchangeable. If one drops out, another can be brought in" ['75/#9].

In any event, Krauss's demolition derby was unnecessary. Artists had wearied of the Minimalist Slough of Despond; they wanted a way back and would have happily accepted just word that the modernist credo, "It is necessary to be absolutely modern," no longer applied (for the same reason it once applied – consensus of artists). Krauss's supposed "proof" is as fraudulent as any dogma of "discredited" modernism.

35. Most recently (as far as I know) at the College Art Association, February 22, 1991. "Rethinking Modernist Criticism: The Legacy of Clement Greenberg," Moderator: Johanna Drucker; Panelists: Nicole Dubreuil-Blondin, Francis Frascina, Amelia Jones, Rosalind Krauss; Discussant: John Tagg.

Having heard about the panel, I thought it must by this time be a *rehabilitation* of Greenberg, but according to reports, it was yet another "disproof." Again, apparently only Greenberg is the villain. The disciples, apparatchiks and epigones (not to mention curators!) who ran the "juggernaut" seem never to be named or blamed. Clearly, a large corps of formalist critics has escaped to tenured professorships without so much as a *mea culpa*. The "death of formalism" has been declared a thousand times, but I don't recall a single declaration of personal error.

36. Maureen P. Sherlock, "Charades: A Critique of Corridor Criticism," *Art Papers*, Nov-Dec., 1990

37. Larson, *op. cit.*

38. Cynthia Navaretta, publisher of *Women Artists News* and Midmarch Arts Press.

39. James Servin, "Soho Stares at Hard Times," *New York Times Magazine*, January 20, 1991.

FRONT NOTES

Numbers

Each report has an identification number based on the year of the event and its order in this book. For instance, '80/#78 is a panel that took place in 1980 and is the 78th report here (in this case "The Perils of Pluralism"). Unless the title has some particular relevance in context, cross references are made by number only. Follow-up material from the same event, such as excerpts from statements or other commentary, remains under the same number.

Titles

Each panel's original title is given on the line above the speaker list, set in bold-face and enclosed in quotation marks. For the purposes of this book, however, over-titles have been added in large type at the top of each report (just under the identification number). These incorporate a comment of some kind, and should be especially useful when panels have similar names.

Intros and Updates

Most of the introductions, updates and footnotes that I have written in the present for this book are evident from the material itself. But to make clear at a glance what has been added, present-day material is set in a different type face and indented.

Added introductions appear just above the panel title. Added post-scripts, foot-notes, or updates appear below the attribution line.

Order

Reports are arranged in chronological order by date of panel. Thus, a group of items concerning the same event appear consecutively, even if original publication was months apart. In a few cases, related material from different dates has also been placed consecutively; for instance, an interview is grouped with a series of interviews even it took place at a later date.

Editing

Copy has been edited for clarity and consistency. In some reports, purely local or ephemeral details without historical interest have been cut. Where monographs or papers have been excerpted, that fact is noted.

Panelist IDs

Some panel rosters identify speakers in such terms as "painter," "critic," "professor at X University," even on a few occasions by the style of art work. If the original report had this information, it has been retained. However, most did not – partly because we were short-sighted, partly because the information was often not given, but also because many speakers were so well known to our read-

ers it would have been insulting or redundant to identify them. Now, years later and for a much wider audience, this may no longer be the case. Tracking down some thousand panelists was beyond our resources, and, given the numbers involved, space was also a consideration. For similar reasons, most identifications have not been updated, although a few developments of particular interest are noted. That the intervening years have seen many other changes goes without saying.

"[sic]"

Until well into the 1980s, speakers so commonly said "man" and "he" to mean "people" or an unspecified person, that it tended to escape notice. Later, when the usage became relatively rare (although, amazingly, it still occurs), writers began to insert "[sic]" after the offending term. What was originally published without this comment remains that way here, so as not to chastise by hindsight. Where "[sic]" was added by the author (or perhaps the editors), it remains. When a speaker repeated the misdeed continuously, "[sic]" after each instance would have been intrusive; one or two presumably make the point.

Errors

I close with an apology for errors. When these names and dates were first committed to print, it was under conditions of the "alternative press." Not that errors weren't held against us, but that being out of print a month later made defects up to middle magnitude tolerable. This book is, of course, expected to join the pantheon of great art resources: fact checking and missing data became a major issue. A few "facts" and one or two names proved beyond our resources to verify. Among hundreds of points that *were* checked, it was discovered, for instance, that even *Art in America* has spelled Hans Hofmann's name wrong, that the Whitney Museum changed the title of a show retroactively under political pressure, and that what sounded on tape like a rock group named Caribou, was in fact the "garage band" Pere Ubu! Grateful to be spared the mortification of such errors, I nevertheless cringe at what may yet remain. I can but hope that no one person notices them all.

<div align="right">J.S.</div>

Before 1975

1975 is the opening date of this book because that was the year Artists Talk on Art began in NYC and the year panel fever hit full tilt. It was also the year of the founding of *Women Artists News,* which documented the panels. The 1990 shut-off, besides its convenient end-of-decade position, was never in question. Panel fatigue had been apparent for some time and now clear signs of the end-game of mutiny appeared. It was the year work started on this book, and, as a practical matter, it was the year our primary sources in the artists' "underground" press, *Women Artists News* and *Art & Artists,* died.

However, certain prior events were important. A number of women's panels at the 1973 College Art Association meeting in New York City introduced major themes and figures that should be put on record. Certainly it would be a shame not to preserve for posterity Walter Sparrow's 1905 declaration that no woman painter "will be able to borrow from men anything so invaluable as her own intuition and the prescient tenderness and grace of her nursery nature." I covered three of these panels (for *The Feminist Art Journal,* Spring 1973), of which the following are highlights:

The Sparrow quote was provided by **Cindy Nemser,** moderating "How the Art World Evaluates Women Artists." Speakers were **Miriam Brumer, Natalie Kampen, Lila Katzen, Lee Krasner, Jillen Lowe, Irene Moss, Howardena Pindell** and **Marcia Tucker.**

An opening statement at this panel became a refrain, almost a battle cry that day and the next – the emphatic rejection of all definitions of women's art in terms of organic forms, womb spaces, central focus, delicate colors and other "synthetic and superimposed" categories. Such notions may seem quaint today, but, conceived and carried coast to coast by Lucy Lippard and Judy Chicago, they were getting a lot of play at the time. When Miriam Brumer pointed out that "organic and natural forms have been part of the working vocabulary of art from antiquity to the present," citing as recent examples Miro's ameboid shapes and Frank Lloyd Wright's spiral-based Guggenheim Museum, she was roundly applauded.

Lila Katzen's statement that "Isolation and withdrawal is not the answer!" also drew applause. Katzen cited a recent study documenting discrimination against women in university art departments – the disparity in numbers of male and female faculty increasing sharply with increasing rank, until women were virtually absent at the top. "Let us not compound the evils of suppression by keeping out of the mainstream," she declared. "Women must not withdraw to an island of feminine sensibility. . . . They must be on the front lines, seen and accounted for." More warm applause.

Howardena Pindell described the "pecking order" of white men on top, then non-white men, white women, and non-white women at the bottom. Perhaps the unkindest cut, she said, was her discovery that black directors of exhibitions did not include black women either.

Marcia Tucker contributed two anecdotes, the first from the Whitney Museum, where she was still a curator. She and fellow curators (male) were selecting a series of shows; several men and a woman were under consideration. Tucker preferred the woman. The others protested, "You can't show three women in a row." "But you showed 20 men in a row," she replied. In this case her point carried and the men acceded.

Tucker's other anecdote is now quite famous. It involved a couple she knew: an artist-wife who, several years previously, had been having great difficulty getting a start, and her writer-husband, who conducted an experiment. He made up 10 résumés of a fictional artist, inventing a fantastic series of important shows, collections and reviews, and sent them to 10 top galleries – five over a man's name and five over a woman's. Every single résumé with the man's name received a response of some kind. Not one with the woman's name received a reply! Three weeks ago, Tucker said, he had repeated the experiment. *The result was exactly the same!*

In the second panel, "Women Artists in Action," women spoke about their activist groups: **Muriel Castanis** for Women Artists in Revolution (WAR); **Jacqueline Skiles** for Women's Interart Center; **Ann King** for Women in the Arts; **Blythe Bohnen** for Women's Ad Hoc Committee, **Mary Beth Edelson** for the Conference of Women in the Visual Arts, and Jerrolyn Crooks for Where We At.

"Women Artists Speak Out," the third panel, was moderated by painter **Pat Sloane,** with speakers **Beverly Buchanan, Martha Edelheit, Audrey Flack, Pat Mainardi, Louise Nevelson** and **Fern Stanford,** all artists.

Opening the discussion, Beverly Buchanan firmly refused to speak for black women, or blacks, or women. She made a point of speaking for herself only, determined to make it as herself, for her art, and to show "wherever, whenever, and however" she could.

Next, Audrey Flack testified that, "The prejudice against women in the art world is overwhelming, overriding, insidious and enormous. You have to look a certain way, come on a certain way. You *never* mention that you have two children." She herself had worked with a group of male peers who became stars, including Philip Pearlstein and Gabriel Laderman. "My good friend Sidney Tillim wrote articles that

read like lists of male names in *Artforum*. He never *once* mentioned my name in print. I thought this just happened."

Martha Edelheit said, "I had this innocent idea that if the work was great it was going to make it. The men I moved and showed with became stars – Claes Oldenburg, Red Grooms. I had the contacts and it didn't make a bit of difference. It never occurred to me this had anything to do with being a woman . . . I was dragged kicking and screaming into the woman's movement!"

Pat Mainardi pointed out that "white men define high art as what white men do," but Judy Chicago and Lucy Lippard's attempts to establish a "feminine sensibility" would stereotype and subjugate women anew. At the same time, Mainardi said, "so-called 'feminist art historians,' instead of teaching and researching accomplishments of women, are teaching bullshit courses called 'The Image of Women in Art' – a fancy title for another course on men's art."

In the question and discussion period that followed, Moderator Sloane raised a few howls with the remark that art history is "only for study," and has "nothing to do with art today." This was, of course, the voice of Modernism, or *a* modernism speaking – perhaps its last gasp. (Certainly postmodernism found art history ripe with goodies for "art today.")

What struck me at these panels, the first I'd ever attended, was the atmosphere. I described it as a "reciprocal awareness of intensely committed women in live communication with each other," and said it lent an "electric quality to the experience." However, I noted, "to a large degree we're talking to ourselves . . . *The New York Times*, in a small piece on the conference, mentioned in passing that there had been women's panels . . . The *Village Voice* had a story on the conference, written by a woman, which failed to mention that there had been women's panels at all."

As yet another measure of distance travelled, I cite the 1990 College Art Conference, again in New York City, covered by Grace Glueck for *The New York Times*. Her article ["The Art Minded Have a Field Day," 2/17/90] featured a panel on feminist art history as "a highlight of the conference" ["Firing the Canon," '90/#214].

Another group of panels that deserves to be on record took place in late 1974 when artists and specialists in business and law took up the newly hot topic of Artists Rights. Results haven't been as dramatic as from the women's panels, but are still in progress. A number of state legislatures have enacted artists' rights bills, and in 1990 Congress passed the Visual Artists Rights Act, granting such "moral rights" for visual artists as prevention of intentional destruction, distortion, or modification of a work.

What made the issue urgent was that prices of art by living artists had begun their steep climb and auctions in which dealers or collectors made huge profits on work by now-famous artists were very well publicized. Only once in the welter of panels that followed did one brave soul get up from

the floor and demur, asking, if artists get a cut of the profit, why shouldn't they give something back if the art is sold at a loss? In that heady moment, however, in the fervor of artists' liberation and artists' power to come, such notions were dismissed as frivolous.

The Artists' Rights panels were covered by the then-new artists' press. Here are excerpts from Donna Marxer's report on three panels held in one marathon day:

"Residual Rights for Visual Artists"

American Artist Publications, New York University, October 28, 1974

An array of worthies in and about the art world met at Loeb Student Center for three panels on the question of "rights" for the visual artist. The principal topic, the controversial 15% residual payment to the artist on resale of his or her work, is nothing new. However, last year's historic Sotheby Parke Bernet auction dramatized the issue.

That was when a Rauschenberg painting, originally bought by collector Robert Scull for $900, was re-sold by him for $95,000. Rauschenberg was enraged, publicly scrapped with Scull [Legend has it fisticuffs were exchanged: Ed.] and, with his accountant Rubin Gorewitz ("the artist's accountant") formed a foundation and went to Washington to lobby for an artists' rights bill.

The public had been invited to hear the pros and cons discussed. According to a show of hands, the audience consisted of perhaps 85% artists; they came and went in large numbers during the marathon event.

Panel #1
**Residual Rights for the Visual Artist –
Are They Desirable?**

Moderator: **Dr. S. Spencer Grin**, publisher of the *Saturday Review*; Panelists: **Paula Cooper**, Paula Cooper Gallery; **Lawrence Fleischman**, director, Kennedy Gallery; **Robert Scull**, collector; **Ron Gorchov, Nathaniel Kaz, Jacob Landau, Peter Max, Robert Rauschenberg**, artists

The panel got off to a late start because Robert Rauschenberg and Robert Scull were still out to dinner – together.

Then Lawrence Fleischman opened by objecting to the residual agreement, a not-unexpected position for a dealer. Artists would be more hurt than helped, he said; anyway, "90% of artworks go *down* in value." Paula Cooper was in favor of the 15%, but pessimistic about implementation. She has one artist who uses the voluntary contract, but says she meets buyer opposition.

Jacob Landau thought the only artists to benefit would be the ones who have already benefited from the art boom, the elite few. Rauschenberg was succinct. He was in favor, "and I don't want to argue about it." Scull, charming and soft-spoken, had apparently had a change of heart. He now favors

some sort of royalty for the artist and said he doesn't believe it will slow the art market.

Landau felt it would. He sees a world depression coming in which little art will be sold. Rauschenberg countered, "No artist can afford that kind of pessimism."

As for size of the royalty, panelists either agreed on 15% or hedged, except Ron Gorchov, who insisted on 50%. "Fifteen per cent is like a tip!"

Panel #2
Residual Rights –
Can the Concept Be Implemented?

Moderator: **Gerald S. Hobbs**, publisher, *American Artist*; Panelists: **Michael Botwinick**, director, Brooklyn Museum; **Martin Bressler**, attorney; **Herman Finkelstein**, attorney, former general counsel, American Society of Composers, Authors and Publishers (ASCAP); **Rubin Gorewitz**, financial consultant; **Carl Zanger**, attorney, Committee on the Arts; **Jeff London** and **James Rosenquist**, artists

Rubin Gorewitz, co-author of an artists' rights bill under study by Congress, noted that the Mafia is now buying art for profit and that his bill would discourage them. He also said it would deter thieves. (This reporter doesn't see how a thief would be prevented from selling to a secret buyer who wants the work only for himself. Moreover, work could still be held for ransom, a common purpose of art theft.) Gorewitz said the law would work well because it would be administered by the Internal Revenue Service.

Herman Finkelstein cited ASCAP, which has been extremely effective in controlling royalties for composers. Gorewitz described a system of "follow-up" payments in Europe. Since the 1920's, France has had a *droit de suite* law, returning 3% on resale to the artist, whether prices go up *or* down. It apparently isn't working too well, because the amount actually collected is very low compared to sales.

Robert Projansky, lawyer and author of the best-known transfer agreement, was invited up from the floor. He disagreed with panelists about government policing. Government intervention in the arts would be damaging, he said, while a voluntary transfer agreement would be effective if most artists used it.

Projansky pointed out that transfer agreements are used in real estate all the time, adding that artists could give up their royalty if they wished, keeping other provisions. He feels strongly that artists should maintain some control over their works after they are sold, even after their death. (The recent alteration of work in the David Smith estate by executor Clement Greenberg makes a strong case for this point.)

Panel #3
Can and Should Artists Group Together
for Their Mutual Benefit?

Moderator: **Rubin L Gorewitz**; Panelists: **Susan Bush**, **Sandy Relis**, **George Segal**, artists; **Barbara Nessim**, illustrator; **Ed Cramer**, president, Broadcast Music, Inc., **Joshua Cahn**, former counsel to Artists Equity; **Robert Wade**, general counsel, National Endowment for the Arts

George Segal said a certain amount of "cruelty" in the art world is necessary for the making of good art, although one could reply that sufficient cruelty would exist in the art world even if artists got 15% residuals.

Susan Bush, an organizer of the Boston Visual Artists Union, said Boston artists have *done* it, and, with totally open membership, now run the largest gallery in New England.

Sandy Relis, board member of the Foundation for the Community of Artists, said artists don't organize well. However, he noted that today we have allies – lawyers, accountants, and organizers prepared to give time and energy to our cause.

Unfortunately, the single issue of the 15% royalty was too narrow for nearly three and a half hours of talk, mostly by lawyers. Participation from the floor, which might have enlivened proceedings, was not encouraged.

The evening became more interesting when other ideas came up. For example, there was some discussion of the copyright law in New York State. Commercial artist Peter Max said his work has often been ripped off for reproduction and he has little recourse. Ed Cramer said artists should put the copyright sign (© or the word "copyright"), followed by year of publication, on any work in public exhibition and register it with Washington to gain protection of the reproduction law.

Since so much of the vitality of the artists' rights movement now comes from women's groups, it was strange that no panelists represented the women artists' view. Beyond that, residual rights is not an issue that will seriously concern many artists. Most of us have more immediate problems. The attendant publicity *is* raising public consciousness, however. Both *Time* Magazine and *Esquire* have recently had major articles on artists' rights. As Nathaniel Kaz said, "Artists, like Mozart, are tired of coming in at the servants' entrance."

– Donna Marxer

Artworkers News, November 1974 [Vol. 4, No. 8]

1975

'75 / #1

Opening at the Open Mind

Invitations to the first Artists Talk On Art panel, then as now at 8 PM Friday, went out by word of mouth and a borrowed mailing list. The event was written up for the fledgling artists' press by Pat Passlof, an artist who had been active in the original Club, surely more than a coincidence.

The Percent-for-Art Law, mandating a percent of construction funds for public art, was in the news, and the *idea* of public art had started to enter consciousness. The report shows that panelist-audience exchange was important right from the start, though a mere taste of exchanges to come – and so, in a sense, was the panel. Fourteen years later, Moderator Pekarsky had cast and choreographed a major grand-scale epic on "The Moral Imperative in Art" and presented it at the College Art Association to a wildly enthusiastic, standing-room-only audience ['89/#204]. Perhaps it's also no coincidence that, even at this modest beginning, some hint of "moral imperative" was already in the air.

"Whatever Happened to Public Art?"

Moderator: **Mel Pekarsky**; Panelists: **Will Insley, Hilda O'Connell, James Wines, Clement Meadmore, Athena Tacha**

Artists Talk on Art, NYC; January 10, 1975

The first in a series of Friday night panels was held at "The Open Mind" on Greene Street, an ideal hall for such forums.

Will Insley presented parts of a visionary sunken city ranging from 250 feet to four miles in size – ruthless structures dug into bleak landscapes, rising no more than 12 feet above ground. Hilda O'Connell's was a community-minded and educationally innovative approach, showing slides of her high school art students at work on murals in or on various public institutions, such as an emergency room and a methadone treatment center. O'Connell prearranges the sites and directs the murals' design and execution. James Wines has a going business concern which, as I understand it, gets paid to modify existing structures with a mischievous wrecker's ball. Clement Meadmore represented the point of view that every environmental sculpture ought to be independent of buildings, "to confront them." Athena Tacha preferred greater integration with the environment – tending to attach her terraced constructions to buildings or terrain. The moderator showed a number of painted city walls, some of them now familiar.

The audience was restrained, except for a challenge from Cindy Nemser, reminding the sometimes esoteric panel of their "obligation" to the public. Meadmore countered bluntly by asking, if she considers herself a member of the public, why attend such an elitist gathering? Another member of the audience asked about the panelists' need to see their ideas realized. Insley was willing to stand on his drawings, preferring to concentrate on new developments rather than invest time in supervision. Tacha said she could not judge whether her work was having the intended effect without its actual construction.

All in all, panelists were modest in comparison to some recent megalomaniacs.

– Pat Passlof

Women in the Arts Newsletter, January 1975 [Vol. 2, No. 4]

'75 / #2

The Wit and Wisdom of Harold Rosenberg

Art critic Harold Rosenberg was one of the triumvirate of "bergs" (with Green- and Stein-) who not only dominated their era, but were the first art critics in America to become important figures in the wider culture. Rosenberg coined the phrase "action painting," and even the titles of his books, like *The Tradition of the New,* and *The De-Definition of Art,* defined art of their time. Moreover, until his death in 1978 he was the charismatic center of the Abstract Expressionist/East Hampton art world, where his personal magnetism may have been as important as his writing.

Among sallies at this event, Rosenberg paid tribute to the women's movement, "probably the most important thing that's happened in the arts during the last few years," but declined to make the kind of predictions for which Clement Greenberg is still pilloried: "Art doesn't depend on its own self to decide its direction," but on external factors, including events and personalities. Which may be why we don't hear Rosenberg's name so much these days – there's no great sense of superiority in Rosenberg-bashing. In the long run, he's sure to be quoted, like Baudelaire, for his insights into art, culture and criticism. In the short run, see "Last Rites for Modernism" ['75/#7] and "Who Speaks for the Artist" ['90/#222] for a few more lines.

Harold Rosenberg at NYU

New York University Art-Critics-in-Residence Series, NYC; January 21, 1975

"Has the Women's Movement led to greater representation of women in the art world, and, as a result of this, are standards falling? What do you think has been the contribution of the Women's Movement to women's iconography in art?" The question, selected from those submitted by students, was put to Harold Rosenberg by Howard Conant, chairman of NYU's Art Education Department.

The line about standards falling drew a few hoots and groans from the audience. Rosenberg replied that the Women's Movement has been extremely effective and stimulating to women artists, and that the attention paid women artists is probably the most important thing that's happened in the arts during the last few years. He demurred on the part about there being a kind of painting typical of women, though. The statement itself could be interpreted as being for or against women, he observed, and made an analogy with the question of "Jewish Art." An anti-Semite says there's a Jewish art. That's anti-Semitic. Another anti-Semite says there's no Jewish art. That's anti-Semitic too!

Conant prefaced the next question with a word about the outspoken new generation. The question was: "Do you consider yourself a parasite who has made his living and reputation by hustling or otherwise feeding on works of art made by others?"

Declaring his disdain for the question – hostile *and* anonymous – Rosenberg asked the questioner to raise a hand and ask it in person. No hand. Laughter and applause.

"In a sense we're all parasites," Rosenberg continued. "But my accomplishments are my own and not contingent on anyone else's work. I don't write about individual artists. If I do, they don't need me. A lot of artists feel the function of the critic is to help them sell. The public feels the function of the critic is to give them tips about who will be important in 1980. But the only way to make this kind of prediction come true is to follow it up with a terrific promotion job."

Nevertheless, the public, including this one, wanted prophecy. "What direction will art take in the next 10 years?" "That's an invalid question. Art doesn't depend on its own self to decide its direction," said Rosenberg, citing social, political and economic conditions and the vicissitudes of individual personalities and events as being among the many external factors affecting art. As an example of surprises in history, he mentioned the discovery of a little piece of tape, "a miracle," that led to the saga of Watergate.

By this time questions were coming rapidly from the floor. Using his responses in lieu of a prepared paper, Rosenberg made the following points:

The basic issues in 20th-century art are the relations between thinking about art and doing it. A desirable balance between the two leads to good art. When the balance is lost, the craft or conceptual aspect of work is lost or overemphasized. At present there is a sense of relief at the fading of bad ideas, but a certain vacuum, since these ideas have not yet been replaced by good ones.

Duchamp was one of the most forceful and necessary figures in modern art, but his followers "worked too hard" and made too many things. Duchamp had an idea, put the idea in a form and was done with it. His followers found and supplied a market. Art has to involve thought, not just the production of commodities for rich people.

Conceptual art says all modern art ideas are used up, but you can't use up an idea. Superseded art movements are constantly producing new work and new personalities. Even bad or wrong ideas can produce great art, e.g., the great art produced during the Renaissance according to a mistaken understsnding of perspective. (Now we understand perspective, but nobody uses it much.)

Art is still interesting today, but it's dulled and obscured by veils of bad rhetoric. People who write museum catalogs can't write and almost everything written about art is calculated to make it boring.

Don't knock the Hirschhorn Museum. It has an interesting variety of work at different stages of development by artists who are "type cast" and "refined" elsewhere."

A young man wanting to know how artists in the '30s got onto the WPA art project explained that he didn't know anyone who'd been around then to ask. "You ought to meet some older people," Rosenberg advised, to heartfelt applause, then launched into a description of politics and aesthetics in the depression era. The audience stayed till the last word of the two-hour session, charmed by Rosenberg's wit and urbanity, as well as enlightened by his erudition and common sense. Who else could call someone a wretch (in this case Sophy Burnham*) and make it sound almost like a compliment?

– Judy Seigel

WIA Newsletter, February 1975 [Vol. 2, No. 5]

*Sophie Burnham wrote *The Art Crowd* [NY: David McKay Co., 1973]. Subtitled "The Inside Story of How a Few Rich and/or Powerful Figures Control the World's Art Market," it reported unattractive aspects of art world hustle, including tales of Rosenberg and company.

<u>'75 / #3</u>

Forbidden Fruit

Can young artists today possibly believe that, not so many years ago, the greatest stigma in art was to be thought "decorative"? That the art police roamed the corridors of mainstream discourse on the lookout for "decorative" tendencies? It was, and they did, until, to use the metaphor of our title, the mutiny was well under way.

I had gone to Joyce Kozloff's studio in January, 1975, to do an interview for *Women Artists News*, but when she mentioned "decoration," it started us on a conversation so long we couldn't fit it into the magazine until we had a larger format, nearly two years later.

Originally, this talk seemed very iconoclastic. By publication, as Joyce predicted, many such feminist ideas had worked their way into art and into the general culture – becoming accepted, perhaps even "obvious." In fact, at about the same time, October 1976, a Soho gallery had a show titled "Ten Approaches to the Decorative." It was still a provocative theme, but no longer beyond the pale.

Talk About Decoration

Joyce Kozloff with Judy Seigel

Joyce Kozloff's studio, NYC; January 1975

Seigel: Why *is* decoration such a dirty word today?
Kozloff: I think prohibitions like this are primarily sexist. When I had my first show in 1970, reviewers used adjectives like "sweet," "pretty," "decorative," and "lyrical." All "bad" words. I was in my first consciousness-raising group in Los Angeles then, and I was figuring out a lot of things about sexual stereotyping. I started going through art reviews and underlining adjectives. My friend Gilah Hirsch and I were going to do this incredible survey – we made lists and lists and pages and pages. It became too all-encompassing and we never brought it off, but we saw that words like "lyrical," "decorative," and "pretty" kept repeating in the women's reviews. Of course you'd have to go and see if the art actually fit the reviews, but I started to think about why these adjectives were *bad*. They were merely descriptive. "Tough," "strong," and "virile" were *other* descriptive words. There could be good decorative and bad decorative, good virile and bad virile.
Seigel: My theory is that anything *visually gratifying* in modern art is called decorative, and that the *gratification* is what's forbidden. But I remember you saying at an A.I.R. panel, "If it weren't just a little bit decorative, you wouldn't want to look at it."
Kozloff: A lot of artists and a lot of art that put down the decorative are secretly, blandly, vacuously decorative – something a lot of people can live with. It's a kind of art that doesn't assert itself very much. It's very elegant, very subtle, very subdued and refined. That's decorative. So I said what the hell! If you're going to be decorative, don't apologize.

I was in California when this idea about painting generally being a bad thing to do arrived, when conceptual hit its peak. Everybody was into plastics, or conceptual, or video or something. Suddenly there was a lot of work around denying that it was painting, or acting embarrassed to be painting. A little piece of paper pushed on the wall with pins, with a little, very little, oh, a pencil line. Or these *schmattas* hanging on the wall, with no color, very non-obtrusive. It wasn't sculpture. It wasn't conceptual. It was some kind of apology for painting, pretending not to be painting. "Don't get me wrong. I'm not interested in paint and color and that old stuff. I'm not decorative." It was such a horrible scandal to be painting on canvas. I didn't have the arguments for these people. I knew what I wanted to do, but they made me feel bad.
Seigel: I know the feeling, when everyone is repeating and agreeing on something absolutely contrary to your own thoughts and observations.
Kozloff: But artists have been a party to that too. Still, a lot of the work of the recent past was much more decorative than it admitted. Frank Stella's work, for instance, is very decorative.
Seigel: It looks decorative now. Did it look decorative at first?
Kozloff: Well, I accepted the way it was talked about then. But if we're going to re-evaluate the language, I think we can start with the fact that a two-dimensional object is, and should be, decorative.
Seigel: Or why put it on the wall if it's only a moral treatise or a didactic exercise? The crack in the plaster under it might have been more interesting.
Kozloff: Anyway, one starts to question modernist ideology. We've been told there's this mainstream which starts out with Western figurative painting since the Renaissance, getting more and more reductive, but I think outside sources and influences had more effect and interest for artists than they're given credit for.
Seigel: But there *is* the reduction.
Kozloff: Yes. I started to put more stuff into my work and to become more intricate just to keep myself interested. I figured, O.K., I can do that kind of painting, how do I make it more complicated? My work comes out of New York abstraction. I don't think I'd be doing this kind of work if I weren't aware of what has happened in New York in recent years. But I'm aware of other things too.
Seigel: Probably some of the same people who abhor the decorative in contemporary art collect decorative primitive art as valuable artifacts from other cultures.
Kozloff: Anything you hang on the wall becomes an object of decoration. I think we're talking about a specific kind of decoration – an art that acknowledges that it's decorative, that makes *that* the content, or part of the content. In the Bauhaus philosophy, the most beautiful form was the one that followed function. But painting has no "function" in the sense that architecture or objects do. In many cultures – the Islamic for instance – the ornamentation of buildings is central to their structure and function. These buildings and the repetitive, meditative patterns decorating them are aspects of a whole. The pattern is integral to the structure.

They don't build a mosque and then send in a whole bunch of other people to "decorate" it.

In Italy, in 1972, I saw the craft, the beauty, the care and love in 15th-century Italian painting – not just the painting, but the frame, and the painting within the frame. Sitting for a week making tiny dots wasn't the idea I had received about art-making, but I felt the value of these exquisite pictures. I began to realize the pleasure there could be in that kind of concentration, in putting love into a work with small brushes and exquisite strokes.

Now I find that each year I get more intricate and careful. The other night I suddenly realized I'm doing everything I was taught is bad – copying, filling in, being fussy – and, of course being decorative.

Seigel: But a lot of art approved by people who put down "copying" in that sense actually consists of copying. You can copy or lift something whole – number systems, memorabilia, ecological phenomena – as long as you maintain a certain point of view. It may be right out of *Scientific American*, understood dimly, if at all, and much diminished. I've seen gibberish using numbers that had garbled references to very creative and highly abstract mathematical systems.

Kozloff: All artists lift from everything that interests them and always have – from earlier art, other work that's around, or sources outside art. This isn't "original" or "not original." It's something people do to get outside of whatever limiting situation they're in, a kind of searching that happens at certain moments.

There's some relationship between this kind of thing and the women's movement. I don't make rhetorical or specifically feminist paintings, but there has been a tenuous coming together for me of things I'd been thinking about in the context of feminism and things I'd been thinking about in art. Practically every field – art, literature, sociology, psychology – is being re-examined by feminists within the field. Disciplines that had been ossified, bottled up with taboos and restrictions, suddenly got fresh input and ideas. Now women artists are examining the givens and taboos in *art*.

Seigel: Not all women. Many work in what you would still have to consider the Mainstream.

Kozloff: But the ideas that have come out of the women's movement are disseminating in all different ways into the culture and affecting the men, too. That's one reason something like being decorative, which had been taboo, can even be approached now.

Seigel: But sexism, or male chauvinism, or reductionism aren't the only things that gave decoration a bad name. There has been a lot of bad decoration – boring, clumsy, clichés; decayed motifs and gestures.

Kozloff: What passes for decoration in our culture is on a very low level today. We're at a very infantile stage to start, suddenly in 1975, making a high decorative art. We're coming out of a state of sensory deprivation in the visual arts.

Women Artists News, November, 1976 [Vol. 2, No. 5]

Portions of this interview appeared in December 1975 *Visual Dialog*.

SRO for Women on Women

In 1980, when Alessandra Comini was invited to give the College Art Convocation Address, she graced the honor with the recollection that never once during her entire undergraduate and graduate education "did the name of a single female artist pass the lips of any one of my instructors!" ['80/#179] That this laurel of academia had gone to a leading feminist historian was itself a sign of serious change, but soon Comini had another: She received word from Herschel Chipp, one of her former instructors, that "as penitence for past sins" he had begun to teach about women artists, "or at least to let their names pass my lips," and to similarly revise his text, *Theories of Modern Art* ['83/#167]. (My own art school experience was similar to Comini's, except that a few names did pass the lips – in order to be immediately dismissed.)

May Stevens's report here on one of the first "Women Artists Speak on Women Artists" panels is calm in tone – after all, *everything* was in ferment at the time. But neither her matter-of-factness nor our current (relative) riches in women's history should let us forget the thrill of these early chapters of "our hidden heritage" (title of Eleanor Tufts's 1974 history of women artists).

In a sense, the 1990 College Art conference saw a culmination of these efforts. A paper on another "hidden" woman artist – ex-slave Harriet Powers – presented her "Bible Quilt" and so credibly compared it to Michelangelo's Sistine Chapel ceiling that the story was featured in mainstream press coverage of the conference ['90/#214].

That change in vision, ours and theirs, didn't just happen; it took an infinite number and variety of preparatory studies My records show the first College Art panel in this vein was "Women in Art and Art History: Past Present and Future" chaired by Paula Hays Harper in 1973, but there were probably others. In any event, here, if not the opening chapter, is a crucial early episode in the (still ongoing) revision of art history.

"Women Artists Speak on Women Artists"

Moderator: **Joyce Kozloff**; Panelists: **Nancy Spero, Audrey Flack, Sylvia Sleigh, Barbara Zucker, Gilah Hirsch, Howardena Pindell, Camille Billops, May Stevens**

College Art Association, Washington, DC; January 22, 1975

One of the most successful panels at this year's College Art conference, "Women Artists Speak on Women Artists," organized by Joyce Kozloff, ran forty-five minutes overtime to standing room only. Art historians, artists looking for jobs and assorted friends and members of the CAA listened to women artists speaking about older women artists or women artists of the past who interested them. The fact that they felt a real affinity for the work of their subjects gave a special quality to the presentations.

Nancy Spero showed slides of some of her own paper scrolls collaged with hand-printing and images of her own devising along with tenth-century manuscripts illuminated by a Spanish nun, Ende. Audrey Flack found similarities between the polychrome sculpture of Luisa Roldan (17th-century Spain) and her own recently completed air-brushed self-portrait. Sylvia Sleigh spoke of the sensitive portraits Swiss-born Angelica Kauffman painted of Goethe, David Garrick and Sir Joshua Reynolds, as well as Kauffman's decorative paintings for English houses designed by Robert Adam. Florine Stettheimer's fantastical and autobiographical paintings were carefully analyzed by Barbara Zucker. Gilah Hirsch ended her talk on Emily Carr, a Canadian painter whose mystical landscapes grew out of her feeling for the Northwest Indians, with a "hug and a kiss" for Emily. Joyce Kozloff had visited Frida Kahlo's home-turned-museum during her stay in Mexico two summers ago. She traced the development in the Mexican artist's work of imagery related to the physical and emotional problems she suffered from age 16 until her death in 1954.

Howardena Pindell and Camille Billops reported on living African women, Colette Omogbai, Nigerian printmaker, and Tahia Halim, Egyptian painter. I closed the evening with an account of the non-portraits of Alice Neel, street scenes and windows in an empty apartment after sitters have gone home, leaving Alice alone in, as she says, "an untenanted house."

The 15-minute presentations carried the enthusiasm and conviction of artists speaking freely and personally about other artists whose aesthetic problems and/or problems as women making their way in a difficult environment had special meaning for them. The refreshing, non-academic event showed the women's movement in one of its best moments.

— May Stevens

WIA Newsletter, February 1975 [Vol. 2, No. 5]

'75 / #5

Not Just Another Ism

Eroticism, or rather explicit eroticism, was suddenly right out there in high-art country, courtesy in part of the new pluralism – and also of the women artist's movement. It's hard to say if Judith Bernstein's hairy screws would seem erotic in the present day of Mapplethorpiana, but a major charge of the movement was explicit material from *women*. Joan Semmel, for instance, painted larger-than-life-size photo-realist couplings in phosphor colors. John Kacere's close-up renderings of the buttocks of young women lying down in silky underpants and garters were, on the other hand, more what you might think of when you thought "erotic art."

Passlof says the panel was "reticent." Perhaps it was the topic. Or perhaps we hadn't yet learned the spill-everything style of the '80s.

"Eroticism in Art"

Moderator: **Joan Semmel**; Panelists: **John Kacere, Judith Bernstein, Bob Stanley, Charles Stark, Louise Bourgeois**
Artists Talk on Art, NYC; January 24, 1975

Slides of everyone's work and a film of Louise Bourgeois's were projected on a wall with a provocatively placed protruding pipe.

Joan Semmel began by citing Lucy Lippard: the more explicit the imagery, the less evocative the erotic work. Response from panelists was poor until John Kacere broke the ice with a meandering monolog on the mediocrity of porn: "If you're very hungry, it doesn't take much to turn you on." Panelists were asked if their own work turned them on; Kacere again: "You can't be horny for a month." Panelists agreed that, in effect, their work was not really porn or even erotic – it just referred to a "beautiful human experience."

Judith Bernstein said the political implications of her work are overlooked. Louise Bourgeois likes good-looking men who don't know they are – a rarity, says she. Kacere dominated the evening with a series of wry ramblings on his unrequited youth. Semmel described men's images of women as doll-like sexual objects. She prefers focusing on gestures that reveal the whole person. She told of a couple who found they could not live with her work. Unhappy with the thought of subject matter overwhelming painting, she resolved the issue with the idea that she had achieved the ultimate desire of every artist: disturbance of the viewer. (It has to be said here that the overpowering of the pictorial by subject matter constitutes a perfectly workable definition of pornography.) Semmel's recent work, however, has taken a leaf from Lippard: less explicit imagery with a brilliant play on exaggerated foreshortenings which flatten surreal perspectives. "When my work changed from abstract to figurative, the emphasis shifted from the drama of paint to that of volume."

From the audience, Burt Hasen brought up the biomorphic nature of the species: "Men are women and women men." Ignored as a drunk raving, Hasen was speaking well to the issue as others kept to popular theories of power role playing. Semmel deserves credit for carrying a reticent panel virtually single-handed (except for the voluble Kacere).

— Pat Passlof

WIA Newsletter, February 1975 [Vol. 2, No. 5]

'75 / #6

If the Avant-Garde is Dead, This Must Be Pluralism

Irving Sandler spoke on the avant-garde in the afternoon. A few blocks uptown, Harold Rosenberg spoke on Modernism in the evening. Rosenberg's appraisal, which follows this report, was bleak, a matter of "last rites." Sandler was more sanguine. Disposing handily of that oxymoron, the "tradition of the avant-garde," he said artists were now freed of the demand for constant novelty and could focus on expression. In retrospect, his talk suggests that Formalism was something like the Berlin Wall. It had been fierce and controlling, but once it began to go, it went quickly.

Irving Sandler on "The Nature of the Avant-Garde"

New York University Art-Critics-in-Residence Series, NYC; March 11, 1975

Irving Sandler opened the March 11 double-header (second half: Harold Rosenberg at the Great Hall, Cooper Union) with an address on the nature of the avant-garde, which he termed, "one of the most troublesome issues of our times." His lecture and slide show gave an overview of contemporary art so closely argued and broad in scope that a stray Culture Vulture not already seasoned in the subject would have had trouble digesting the material.

In the recent era, each successive style declared all other styles obsolete; value in art was a factor of its novelty. That idea, said Sandler, is now itself obsolete.

First, Courbet decided that one's own perceptions, or "the nature of the material," are the only truth in art. Gauguin decreed flatness the only honesty. The Symbolists chose an *inner* reality, and Mondrian and the Geometric Abstractionists sought pure form. The proliferation of new tendencies speeded up, each "ism" breaking a new barrier or pushing to a new limit. Dada attempted to go over the boundary of art into non-art (although people persisted in seeing it as art). Allan Kaprow in his media-mix attempted to erase the lines between the arts. John Cage erased the distinction between art and life. Pop Art and New Realism broke the barrier between "high" art and "low."

Opposed to these "impure" arts was "pure" art, as advocated by Greenberg and followers. For them, the essence of art was its medium – support, surface and pigment – developing through a formalist progression, pushing purism to its limit. Unacceptable today, according to Sandler, because it so narrowed aesthetic possibilities, this school set a criterion of "quality," while giving no criterion for quality beyond its own opinion.

Frank Stella rejected aesthetic generalizations and made objects for their own sake in programmed, predetermined formats. Donald Judd, Robert Morris and the Minimalists, Robert Smithson and the Earth Artists, invisible art, nonobject art – in the last six or seven years every remaining possibility has been explored and exhausted, Sandler said.

Innovations are now met with "nods of acceptance" as if they were forgone conclusions. Avant-garde, having become an established tradition, is no longer. The breaking of limits has, as Sandler sees it, reached its limit. Hence the newly sophisticated art audience must change its expectation of novelty and learn to value expression, quality and exploration. Whole areas were skipped in the rush to "the new." But, Sandler said, an artist's unique vision is new also.

Opening the question period, moderator Howard Conant, Chairman of the NYU Art Education Department, showed how effective women artists have been at consciousness-raising. "Why," he asked, "didn't you show any work by women artists?" Sandler blinked, than pointed out that he'd shown mostly early work, when women weren't so prominent. He apologized anyway.

In response to questions from an obviously knowledgeable audience, Sandler made these points: In the '60s, a time of stars and superstars, certain "isms" and critics got the limelight. Now, in a time of pluralism, other points of view can compete more equally. The notion that painting is dead was "kind of cute" in the '60's but is silly now. Critics, weary of formalism, are looking at psychological, social, and historical factors in art. The current Whitney Biennial might better be viewed as *young* art than as failed art. Artists are no longer alienated – the public is right up there with them. And, although we hope and yearn for quality, there never have been and still aren't any criteria for it.

While some observant critics have already noticed the current pluralism in art, they tend to be fretful about it, as if wondering where that next "ism" could be and what's taking it so long. Irving Sandler seems to welcome and appreciate this pluralism. He offers serious, scholarly, explicated proof of ideas that have been muttered about for some time by those outside critical authority – official word that it's OK to do art-art, since life-art leaves nothing to create, and that the old reductive – or formalist – imperative no longer applies. Is that all it took? Or is there, even now, a new Imperative gestating in a Jersey City loft? Whatever comes next, Sandler's paper suggests a solution to "the crisis in modern art." Declare the crisis over.

– Judy Seigel

WIA Newsletter. March 1975 [Volume 2 No.6]

'75 / #7

Last Rites for Modernism

Harold Rosenberg on "Modernism"

Cooper Union, NYC; March 11, 1975

Art-World mover Harold Rosenberg read a paper titled "Modernism" to a star-studded audience in Cooper Union's Great Hall. It was my first experience in the refurbished Great Hall of this historic building. Unfortunately, the rows of beautifully keyed stone arches and hard plaster surfaces create such a brittle and cacophonous tangle of echoes that Rosenberg's clear, poised and expressive delivery came out the other end of the PA system in waves of blurred croakings not much superior to the mysterious announcements by the NYC transit authority. This might not have been so painful were one not trying to listen to some of the most subtle and densely packed prose written, word by word keyed in like the stone curving above us – lose one and the arch falls. All this acoustical complaining by way of telling you that many a word eluded me. So, with apologies in advance to Harold Rosenberg

This lengthy and convoluted paper, one of the most comprehensive "packages" ever wrapped and delivered, embraced the last 100 years of art in all its ramifications – a cultural history of the significant influences which went into the molding of a dominant state of the contemporary mind, that is, modernism. Rosenberg traced its development from the first incursions of foreign material (Japanese) at the Impressionist end of the epoch through the establishment and reign of New York as a world art center.

What Rosenberg builds as a case for the *inevitability* of modernism may be taken as a case *for* modernism. He maintains a strict deadpan as he makes the knot tying Van Gogh to Warhol. He speaks as the voice of history itself. Since all other voices are those of advocacy, it is no surprise that the positions he analyzes are often assumed to be his own (i.e., Action Painting). Questions from the audience seemed to glance off and fall to the side. When asked why moral implications had not been discussed, Rosenberg playfully evaded the question by riffling through his papers until he found the *word* "moral." What was hard to grasp in the din and complexity was that the paper in its entirety *is* a moral statement.

Rosenberg's usual technique for revealing his own position is as direct as a glimpse of Hitchcock's bald head in a fast pan of a crowd scene. It's there, but it's up to you to find it. There is nothing he likes better than giving his subject enough rope to hang itself. This time he breaks the pattern. Perhaps because he sees Modernism's menacing grip on our time, Rosenberg feels compelled to warn: "I want to emphasize that this is not a benign philosophy. Its movements came into being in attempts to destroy their predecessors." He describes modernism as a destroyer, not only of the past,

but of the future, usurping the future rather than looking toward it. He compares its aesthetic flavor to that of strip mining or defoliation. This is strong language indeed, constituting for Rosenberg a virtual tearing of hair and gnashing of teeth; yet it is so tightly embedded in his prose style, so hedged by the paradoxes this master of irony coolly confronts and lays out for us, that it is easily lost on his straining listeners.

The indictment of modernism strikes in a compact bullet of a paragraph on the last of many pages of relentless analysis of Modernism's gathering forces. Rosenberg leaves us on a note of despair by blotting out the one ray of hope that may have been detected In recent months. He sees this remission, not as progress, but as "a relaxation, a return," a "sinking back into the past." Clearly he is accustomed to being misread, if read at all. The final beauty of this play upon plays is Rosenberg's well-kept secret. Having witnessed these "last rites" for an age, we are left to join him in a philosophical chuckle at ourselves and the ineluctable machines of history. And so into the chill of the night.

– Pat Passlof

WIA Newsletter, March 1975 [Volume 2 No.6]

'75 / #8

Formula is Not Revealed

The Monday Night Program at A.I.R., the exciting new women's co-op in Soho, began sponsoring feminist, artist and art-critical discussions almost from the gallery's founding. Soon the roster of artists, writers and critics was expanded to include men – and dealers. Here three women dealers and three A.I.R. artists talk shop.

"Artists, Dealers and Economics"

Moderator: **Maude Boltz** , artist; Panelists: **Rosa Esman, Betty Parsons,** and **Virginia Zabriskie,** dealers; **Rosemarie Castoro** and **Laurace James,** artists.

A.I.R. Monday Night Program, NYC; April 7, 1975

Three artists and three dealers opened the third year of A.I.R.'s Monday Night Programs. They offered the large audience relevant data and proof that dealers can be human, even charming. But if there is a formula for economic success in art, it was not revealed.

Betty Parsons, dealer-artist, began as a sculptor, showing at the Midtown Gallery. But she "went broke" and got a job there, soon running a small gallery in the basement. Then she got $5,000 together and opened a gallery of her own. Virginia Zabriskie had a $1,000 inheritance from her grandmother. She'd done graduate work in art history, but "hadn't been in a commercial gallery more than six times" in her life before opening the gallery she bought for $1 and $185 per

month rent. Rosa Esman, a relative newcomer (only three years in the business), started on borrowed money. She had been publishing a portfolio of artists' prints, and began by selling those at $100 each.

Rosemarie Castoro passed up an exhibition opportunity in 1965 because of a gallery's "rigid approach," but found herself being crowded out of her studio by accumulated work. She needed "a date and a space" to show, and found it at Tibor De Nagy in relatively short order. Laurace James had thought being in the 1970 Whitney Annual[1] would open a few doors, but when she took her slides around, the experience was so disheartening she turned to the co-op scene. James showed at 55 Mercer, then became a founding member of A.I.R., the first women's co-op.

After these brief personal histories, questions from the floor elicited the following details:

At the Betty Parsons Gallery, Saturday mornings are reserved for slide viewing. Of 24 artists with the gallery, eight or nine are women; Parsons says she's found no prejudice against them in selling. She takes a 40% commission and allows each artist $400 toward expenses of his or her show every two years. Artists she believes in are important to her, whether or not they sell. As for what will sell – there's no telling. She's constantly amazed. Some customers simply want the latest thing – "Have you got anything new?" Very few of her artists live from sales; most have jobs. As for "pushing" her artists, she entertains "a bit to get people in," calls up the museums, and so forth. It also helps, she advises the audience, to get a writer to write about your work.

The Zabriskie Gallery is now "heavily accented toward sculpture." Zabriskie said that, inevitably, she looks at slides more carefully when there is a personal introduction, and 15 or 20 slides tell her more than a single work in a group show. But she does go to shows, having found Pat Lasch in Philadelphia and Ann Healy at A.I.R. She looks for something she hasn't seen before, or an extension of what she knows. She has different arrangements for commissions (one third to one half) and advertising budgets with each artist. Three have stipends. Again, only three or four of her artists, "all old pros," live entirely from their art. She finds that collectors usually begin in response to a strong movement in art. At the moment there are fewer new collectors because the scene is so diffuse. She sells, she says, by being an exhibition gallery, and by having been in business a long time, knowing whom to call and whom to write. Some artists say they don't care if they sell, but she cares. "And remember, it's better to earn money doing what you like than by waiting on tables."

Rosa Esman asks that artists call before dropping by with slides, because "business has to be transacted also." Since her gallery is new, many of her artists are young. There were first one-person shows all this year. She launches a show with "the strongest press release possible," then gets on the phone to the *Times* and *Artforum,* collectors and corporations. "I don't wildly entertain for business. I should do more because you meet people and collectors." Like the others, she shows artists she hopes will sell, but "we love art and want to show it." Whether the general public can be educated to buy qual-

ity art is questionable, at least judging by Esman's experience with a *Vogue* Magazine article, "More Art Than Money," that showed five works on paper from her gallery. There was not one inquiry in response.

Castoro seems to have led a relatively charmed life in this arena, never experiencing "any of those bad experiences with galleries" artists talk about, and having gotten "every grant twice." She did note, however, that "*I* sold whatever sold out of my shows at Tibor, or seven-eighths of it," by just happening to be around without her coat when questions were asked.

The Artists' Residual Rights Contract question came up again, as well as the tale of the $100 painting that fetched $100,000 at Sotheby Parke Bernet, a legend which comes to life just often enough to torment artists. Laurace James argued convincingly that a contract gives an unknown artist, otherwise defenseless, rights and status. She recommended the Jurrist contract. However, the dealers observed, with a logic which failed to compel this audience, that lots of art goes down in value and the artist isn't expected to share in the loss.

The Whitney Annual came up, as it does. Parsons thought it was terrible: "Curators are historians. They don't relate to creativity, but to something in history, which makes a boring show, full of clichés. The dealers know about art – *they* should do the Annual." And from the audience – "Yes, but with other artists, not their own!"

The program ended with the question of how to get the "timid public" to respond to and buy art because they like it. No one had the answer to that.

– Judy Seigel

Women Artists News, April 1975 [Vol.1, No.1]

1. The Whitney Annual became the Whitney Biennial in 1973, but the old term was still in use.

2. A.I.R. Gallery was the first women's co-op of the 1970s, and we called it "the first women's co-op." But a letter from Jeannette Feldman, now of Texas, pointed out that she and others had founded a women's co-op gallery in NYC at 59 West 54 Street in 1958.

'75 / 9

Believing is Seeing

We had been enjoying the death of formalism. Now we had the autopsy, courtesy of Carter Ratcliff. The discussion was based on a series of essays by Ratcliff in *Art International,* analyzing passages by various authors to show that art criticism is often fiction. Ratcliff did not, however, claim criticism is *necessarily* fiction – a refrain the post-modernist chorus took up soon afterwards. In other words, at this point, the wish to throw out the bathwater of recent critical latherings was still tempered by the belief that there was a baby in there somewhere.

One ironic note might be added. The major target of this particular evening was Clement Greenberg. Not that much earlier, *Art International* had been considered "Greenberg's private newsletter."

"Strategies of Art Criticism"

May Stevens and **Budd Hopkins** Talk with **Carter Ratcliff**

Artists' Space, NYC; April 14, 1975

The topic was Carter Ratcliff's six-part series in *Art International* magazine on the history of art criticism, specifically Part Five on Clement Greenberg (December, 1974) and Part Six on Michael Fried, Robert Pincus-Witten, Lucy Lippard and Max Kozloff (January, 1975). Artists Budd Hopkins and May Stevens conducted a "conversation" with the author, but if you had read the articles, you might well have ended the evening with a deficit.

Or let's put it this way. When the accomodations consist of the floor, my advice to art-talk followers is, stick to anecdotal or polemical events. For finely calibrated abstraction, choose a forum with seats. However, for sheer virtuoso flow of compact articulate speech, Ratcliff has few peers. Moreover, his thesis – that most contemporary art criticism is meretricious, concocted of specious arguments spun over gaping holes – was a welcome one. A large art-world audience gathered to hear him, and those who hadn't read the series got a general overview of its intentions and an incentive to read it.

Of the five critics of Part Five, Ratcliff found only Max Kozloff provisionally innocent of serious critical wrongdoing. The others were indicted for sleight-of-mouth, that is, the use of sincerity, self-confidence, respectability, authority and rhetoric to promote their own aesthetic preferences, and hence, of course, themselves. Greenberg, by his "discovery" of the supposed autonomous trend to "pure opticality," outflanked all previous impresarios of formalist art criticism. His several heirs adopted their own outflanking strategies. By arrogance and persuasiveness, and a liberal use of jargon imported from Levi-Strauss, Wittgenstein, Piaget, et al., they succeeded in inducing a presumably literate and sophisticated art world to see lines in Olitski as not lines, shaped canvas by Stella as not shaped, Judd-made objects as not ob-jects, and, in the case of Pincus-Witten, in making "misuses of ordinary words a sign that new meanings are being gotten at."

Ratcliff points out that those supposedly unbroken chains of logic are in fact specious, full of missing links, fallacies and inconsistencies, in a word – fiction. His series systematically dissects out, analyzes and exposes the rhetorical maneuvers which, despite a gut-level rejection by many artists (as noted by Stevens) and most of the lay public, held the official art world in thrall for a decade or more.

In the discussion, Hopkins and Stevens were gracious and knowledgeable, Ratcliff offered some elaborations, and the audience slipped in a comment or two edgewise. Ratcliff described Greenberg's "uncanny ability to comfort a certain part of the art audience with certainties . . . gilding his articles with an air of logic, then coming out in favor of an artist who probably would have been popular anyway . . . importing jargon, then tacking it on to a winner at the end."

Agreeing with an audience comment that these certifications were very useful to the art market, Ratcliff (after vowing not to discuss the financial aspect) added that the *tone* of the judgements was always one of great disinterest. However, without the possibility of verifying right or wrong, true or untrue (as non-fiction can be verified or evaluated), the transition from disinterested critic to market manipulator was all too easy. Hopkins noted that with the formalist emphasis on *movements*, as "Cubist," "Surrealist," etc., individual artists are "diminished and interchangeable. If one drops out, another can be brought in."

In closing, Ratcliff referred to the subtitle of his published series, "Other Minds, Other Eyes." It's necessary to respect other minds and eyes, he said, suggesting a criticism that would *elucidate* the experience of art and the artist, not evaluate it. At its best, this would be "a slightly formalized version of what artists talk about anyway."

– Judy Seigel

WAN, May, 1975 [Vol. 1, No.2]

In "Art Writing and Criticism" ['79 / #117] Ratcliff describes himself as a journalist, not an advocate of art theories or art. "Fads in Art" ['83 / #169] covers a Ratcliff lecture on that topic.

'75 / #10

An Eastern Map for Beginners

Feeling some editor-like need to explain "dharma," I offer my dictionary's most likely choice, from Hinduism: cosmic principles, nature or righteous conduct. However, panelists seem to be speaking to some other sense of the word, or perhaps its (to a westerner) poetic connotations. Pat Passlof adds some cogent reflections on western artists' pursuit of these eastern experiences.

"Visual Dharma"

Moderator: **Barbara Aziz**; Panelists: **David Weinrib, Irving Kriesberg, Leonard Horowitz, Hank de Ricco**

Artists Talk on Art, NYC; April 18, 1975

This one might have been called, "Doing your own thing," an apparently benevolent philosophy in which those who have achieved inner peace generously tolerate the foolishness around them. I am sure panelists had no intention of being smug or patronizing, but reticence on the part of some became, in this context, anti-social. An audience of artists is neither classroom nor lecture hall, but an audience of peers.

Moderator Barbara Aziz is an anthropologist who has been to Tibet and collected work there. David Weinrib, a former sculptor, suddenly saw his work as "Eastern," went to India, copied cakras and is now working on "crafts, books and life." Irving Kriesberg, painter and teacher, disclaims knowledge or belief in Eastern doctrine, but found to his pleasure that Tibetans could read explicit Tantric meanings and devices in his series of "Walking Men" paintings. Leonard Horowitz showed a lyrical film in which the walking camera makes the Buddha walk, with halting step approaching and receding, laced with the leaves of a honey locust and a looming ghost of itself.

Horowitz spoke of letting his films "happen," without imposing himself or his ideas. While this film was structured, it was also preoccupied with recapturing an experience. That is, Horowitz is sensitive to what he encounters along the way but still imposes his intent. Hank de Ricco showed scrolls and objects which imitated to a remarkable degree the style and subject matter of Tantric work and which he feels arise spontaneously out of his personal experience. De Ricco sees the painter of Thankas, Tibetan or other, as having a purity and spiritual purpose denied the western artist – even though the Thanka painter sells his work, earns his living thereby and makes each Thanka to order for an individual customer. The rationale is that the Thanka is meant for use in meditation, that is, for spiritual development.

Most western artists would not presume to make claims on anyone else's spiritual development (Rothko is an exception), but many would take for granted that pursuing art is impor-

tant to their own spiritual development. What struck me was that the experiences described sounded much like the experiences of art. The differences are that the Tantric is new and foreign (exotic) to us and represents an elaborate system of named hierarchies of states of being, with descriptions and categories of every possible ramification, plus complete instructions, with maps and landmarks, on how to arrive at them and even to depict them. This *naming* seems to be the crucial ingredient.

Westerners pursuing this experience have had to feel their way through the dark by instinct. Arriving, we do not know what to call the state or how to speak of it coherently. We cannot even know, precisely, that we are there, having no measure with which to test ourselves. Perhaps the Eastern doctrines of Enlightenment, which seem to offer tremendous security and many conveniences for the spiritual pilgrim, can shed light on the Western voyage.

On the other hand, there is the possibility that this naming, when fully embraced, may rob or circumscribe the range and depth of experience for those whose goals and traditions are very different. Thus far, it has not occurred to us to seek inner peace or disengagement. We believe in our passions.

A word about the Tantric itself: It could be the first truly abstract art, that is, the first whose references are entirely internal and of the mind.

– Pat Passlof

Women Artists News, May 1975 [Vol. 1, No. 2]

'75 / #11

Next Question: Is Art Dead?

This early painting panel was one of the best – real feeling on urgent issues expressed to an audience of peers. Today we may smile complacently at the title question. At the time, art's higher authorities had declared painting dead *and* buried. Perhaps it was only some sense of a coming rebirth that gave painters courage to ask the question out loud. But when Nicholas Krushenick says, "I LOVE THE ACT OF PUTTING PAINT ON CANVAS!," we hear the voice of the votary since the Renaissance. (Will video artists some day say how they love clicking in that cassette and watching the little light come on?)

One other note: Artists reading this report in 1975 would have known that "The Article" referred to "The Painted Word," an article by Tom Wolfe which had recently missed the point about painting in *Harpers Magazine*. Shortly thereafter it was published as a book, achieving wide notoriety, if not acclaim. Today I had to think a moment to identify it.

"Is Painting Dead?"

Moderator: **Burt Chernow**; Panelists: **Nicholas Krushenick, Stuart Shedletsky, Shirlann Smith, Bob Wiegand.**

Artists Talk on Art, May 16, 1975

The subtitle of this panel, "Is Jerking Off Getting Out of Hand?," could mean anything from, "Once you've seen one jerk-off in an art context, you've seen them all, so a painting Renaissance is inevitable," to "Painting itself is the equivalent of jerking off, so why paint?" In either case, if you've been waiting tensely for the verdict, the panelists agreed that painting is not now, nor is it likely in the forseeable future to be dead. In fact, one assumes that the four painters convened exactly in order to reach that conclusion. It did, however, take them three-quarters of the evening to start to explain why.

For openers, the now-infamous query was projected onto the screen: "*Artforum* wishes to ask you as a painter what you consider to be the prospects of painting in this decade. [T]hose understood to be making the 'inevitable next step' now work with any material but paint . . ." A show of panelists' slides with commentary by each was followed by talk of *The Letter, The Article, The Critics, Other Painters*, and *The Situation.*

The Letter:
Shirlann Smith: It's a love letter from *Artforum* – the kind you'd write at the end of a long marriage. But the language is so literary – intellectual, not words I've ever heard artists use.
Bob Wiegand: Is *Artforum* dead? They never had to fish before. They came on Bang! Bang!

The Article [Tom Wolfe's *The Painted Word*]:
Stuart Shedletsky: It's a tantrum by an essentially literary person who doesn't "get" art.
Wiegand: There was a bit of truth on some levels and that made everybody a little uncomfortable, but he stretched it.
Nicholas Krushenick: I have *never* been to a party at Ethel Scull's.

The Critics:
Krushenick: I've enjoyed a certain amount of honesty from Harold Rosenberg. He admitted the critic is finished. Greenberg [apologetic tone] has been a constant champion of the abstract idea in art.
Shedletsky: The critics can tie up Brice Marden with Fragonard.
Wiegand: Rosenberg said, "It may be time to abandon, not art, but art criticism, which has become little more than a shopping list."

Other Painters:
Burt Chernow: Who are the painters today that keep painting alive?
Krushenick: Jasper Johns hasn't given us a new image in years. (My wife will kill me for saying this.) Stella is still about making art, and I respect him tremendously for that, whether it succeeds or fails. A lot of people just give us bricks and bunny rabbits. Noland is still making a fantastic try at making art . . . Richard Lindner, Alfred Jensen, Yrissary, Jo Baer.

Wiegand: D'Arcangelo, Chuck Hinman.
Audience: I don't hear any names of new people keeping painting alive.
Wiegand: There doesn't have to be something new every week.
Shedletsky: Heroes don't come along as often as *Artforum* would have us think. They change geniuses every week.
Krushenick: Work today is all intellect, no passion. Anyway, all artists are not created equal.

The Situation:
Chernow: Will new technology replace painting, or co-exist?
Wiegand: No one got excited when Rauschenberg got involved with dance. No one's going to get excited when I get into video.
Smith: There's a tendency to want to perform, to go where the action is.
Shedletsky: I sit in front of all those tapes and get terribly bored. I want to go home and watch television.
Audience: If painting is dead, it's dead in the colleges.
Krushenick: On 50% of any given faculty you have this meatball who makes a (lousy) watercolor every 2 years. And he has an *enormous* amount of power.
Audience A: Is *art* dead?
Audience B: That's next week!
Audience C: Art has never been more alive. It's travelling in all directions. They're waiting for that one direction, but we don't have to offer it to them.
Shedletsky: The impulse to make art is a very primal, basic human impulse, since the caves at Lascaux.
Audience: Is the idea all important? Are the hands that produce the idea interchangeable, or does art lose in translation?
Krushenick: They had assistants 400 years ago. BUT I LOVE THE ACT OF PUTTING PAINT ON CANVAS! I even stretch and prime the canvases myself. There's a delicious, beautiful factor to running a brush across a surface. I don't want to relegate that to someone else. If I did, I'd be standing around all day watching the schmuck.
Shedletsky: Works of a certain type, for example, Judd's, don't suffer from fabrication. But you couldn't imagine getting someone else to do a de Kooning.

About here a bona fide screaming match between Krushenick and a fellow in the audience who seemed not to care for abstract art attested to the success of the panel and the vigor of feelings about art:

Krushenick and **Fellow:** (Incoherent)
Krushenick: Fuck you.
Fellow: Your art lacks passion. It's an intellectual color exercise. It's like wrapping paper.
Chernow [calmly]: Do any of you ever sneak off into a room a do a little still life, or something?
Krushenick: Figurative painting outsells abstract painting six to one. I turned from it and never looked back. I want to die with my finger on the pulse of the 21st century. In a strange way it's the most delectable life style I've ever encountered. If you never get any success in your life, you could say on your deathbed, "I've had a wonderful life!"

Conclusion: *Artforum* can't be dead because artists hate it so much and read it so much and painting can't be dead because it gets reborn about every 15 minutes.

– Judy Seigel

Women Artists News, June/July 1975 [Vol. 1, No. 3]

'75 / #12

Goodby Minimal, Hello Personal and Sexual

Originally titled "Soho Letter," this report cited the veritable Niagara of women's panels that engulfed us in the spring of '75 – bringing a surfeit to the audience and exhaustion, or overexposure, to the principals. However, as became clear in the '80s, "overexposure" is perhaps the point. People like to sit in the same room as their heros, whether Lucy Lippard or Dennis Hopper.

"How Feminism Has Affected the Art of the '70s"

Moderator: **Cindy Nemser**; Panelists: **Barbara Haskell**, curator; **Gloria Orenstein**, historian; **Dorothy Gillespie**, artist; **Audrey Flack**, painter; **Lila Katzen**, sculptor

Artists Space, NYC; May 27, 1975

Let my small contribution to the coming season be the proposal of an Interim Moratorium on all women's art panels until a definite issue arises or at least until some more water seeps into the well. You could see them, before your very eyes, getting drained, worn and hoarse, no time to work, or even go to the dentist.

However, if you had been out-of-town, catatonic, or otherwise preoccupied all year, you could have caught up nicely at Cindy Nemser's "How Feminism Has Affected the Art of the '70s," one of the last panels of a panel-saturated spring.

Nemser declared that feminism has created new criteria of what makes a work of art – including the personal and the sexual. However, curator Barbara Haskell firmly held her ground when asked to agree. Turning inward for personal expression is a general trend, Haskell said. Feminism parallels the cultural turn, but did not necessarily invent it. (Ms. Haskell, who is new in town, will have to change her tune if she wants to make it on the feminist banquet circuit.)

Nemser went on to observe that by providing such voluminous information on women artists, feminists make sure they're going to be included in history from this point on. For example, Gloria Orenstein, "Lost Women of Surrealism"-finder, treated us to some slides of work by women who had confounded stereotypes by being very scholarly and by painting heroic, wise, powerful female figures – unlike the male Surrealists who painted women as mother, muse or erotic child.

Dorothy Gillespie said feminism had changed her work by letting her dare use pink and blue, do tiny pretty colorful paintings, and make dolls for voodoo figures. Lila Katzen was asked, "Is feminism part of your aesthetic conception?" and got a round of vigorous applause for declaring yes, because she's a woman making art, *not* because she has an arbitrary handling or aesthetic: "I don't believe in male or female art, but in art!"

Asked a similar question, Audrey Flack opened her mouth, paused, shut her mouth, and paused again, longer. Finally, she said, "the subject of feminism and the feminist art movement is very complicated." However, Flack thinks she's getting more "feministically inclined" all the time. Raised consciousness leads to many discoveries. For instance, halfway through the new Lehman collection at the Met, she found a Susan Valadon – and realized that was *it*. An important collection, a span of centuries, *one* work by a woman.

Flack described the pressure and cajolery exerted to get her to paint the kinds of "male" images that sell. "European collectors are motorcycle freaks." Nemser fingered Ivan Karp as the Commissar who dictates acceptable subject matter for Photo-Realism – tough and macho. (Flack may have the last word though. The first Photo-Realist painting bought by MoMA was hers.)

Getting the news about the new trend to personal-and-sexual, scores of Minimalists will now rush to the studio to get personal-and-sexual. There will be Personal-and-Sexual shows, panels, articles, critics and collectors. Still, it's logical to work both sides of the street: Explore women's "anti-establishment sensibility," and plot to co-opt the establishment. Doesn't "anti-art" sell in the galleries and fill the museums?

– Judy Seigel

Women Artists News, September, 1975 [Vol. 1, #4]

'75 / #13

Male Critics Grilled and Toasted

This is the first of a pair of panels that well illustrate the dramatic change in attitudes toward "women's art" that settled in during the next two years. The second event ['77/#70] was in a grand institutional setting, and everyone felt as triumphant as, on this June night, they felt frustrated.

"Male Critics Look at Women Artists' Work"

Moderator: **Blythe Bohnen**; Panelists: **Lawrence Alloway, Max Kozloff, Richard Martin, Carter Ratcliff**

A.I.R. Gallery, NYC; June 2, 1975

The fact that this panel of four male critics and editors drew the largest audience I have seen at any comparable woman's event tells all about power and the perception of power in the art world today. Intellectual exchange was secondary, the audience being less interested in what the panel had to say than in what it had to say to the panel.

Moderator Bohnen, perhaps better called moderator-advocate, was adroit and articulate, deftly catching some finely-parsed qualifications on the fly and tossing them back in the same breath, asking point-blank, "What are critics going to do to increase women's power in the art world? Can the decision-making that goes on be brought to consciousness? Can an equalization in articles and reviews be forced? Why is it that the women who have been developed as full artistic personalities are all dead, out-of-town, or non-existent? Many young men have had the critical build-up to super-star status: why not women?"

A similar insistent questioning came from the audience. May Stevens asked, "Why is there so little critical response to women's art? This is a movement with tremendous energy and thrust. Do you think it isn't intellectually or aesthetically significant? How do you justify remaining aside from this issue?"

Max Kozloff replied, "Feminism can't be considered a movement in modern art." Just as ethnic background, or place of origin are factors in an artist's work, sex is a factor which could only have "x" amount of relevance, he said. The feminist movement rightly insists on "the psychic origin of works of art," but many other factors, including social, biographical, economic and political ones have also been slighted. Since they are in the majority, "it seems odd to have a separate category for women." However, the effect of the movement is evident. "I look around this room and see work proudly exhibited that five years ago would have been called miniscule." Moreover, "a consciously womanly style or feminine subject can cause an alteration of looking."

Perhaps one day, Kozloff suggested, "we'll find 'tough' or 'virile' painting ugly, and say 'what a tough painting – ugh!'" But, as he sees the issues, critics are not the ones to obtain "social justice" for women. Critics' prime concern is "the laborious process of reacting to a work of art." Look to curators and chairpersons of art departments for justice, he said.

Carter Ratcliff: "I have shied away from political issues in art and I think Feminism is a political issue . . . I've written about a lot of women artists (eg., Agnes Martin, Jo Baer, Joan Mitchell) but they were artists before the feminist movement. If women come along with a theory of what significance in women's art is, it will be in order to get accepted, to get prestige. So far the definitions don't stand up, but they may gain support and become self-fulfilling prophecies. The problem is to find a good self-fulfilling prophecy for those women who feel that their self-interest or self-fulfillment lies as members of a group. . . . Specifically feminist conventions may be building, but that would 'conventionalize' women's art, as in art 'conventions.'"

Those critics who repudiate the old Greenbergian criticism would be more interested in women's work, which is outside the power structure, than formalist critics, as Ratcliff saw it. "The sensibility that makes one suspect that whole 'certification' process would respond to feminist consciousness, which also unhooks one from the power structure. [B]ut I can't think of any woman who presents herself as a woman artist who presents work that would seem to be of quality to a hardline formalist critic."

Richard Martin: "Being a Quaker, I was aware of the women's movement before I was aware of art criticism." The feminist movement was instrumental in breaking down the stereotype of the personal in art as "trivial." However, "I would consider it a mistake to orient the magazine *ARTS* toward one particular point of view. The priorities are to act as medium of record and to discriminate between various forms of art." It isn't possible to take a self-conscious equalizing attitude toward women, but "an ardent anti-feminist would not be engaged to do reviews." As Martin sees it, when women are properly represented with exhibitions, "recognition in other areas will follow."

Lawrence Alloway: "I hesitate to formulate general factors common to women's art, perhaps a theory may come later. There are proposals for a feminist aesthetic, something inherently feminine. That used to be considered sexist – now the women are saying it!" Alloway pointed out that none of the proposed criteria apply to more than a few small groups, but what matters is what's intended.

For instance, "Judy Chicago's painting reminds me of Billy Al Bengston first, and female genitalia second, but there can be specific feminist iconographies if women artists say they are." In other words, "the circle has been sexualized or politicized, but these things don't add up to an inherent sensibility." Of course, "I think of women's art in socio-cultural terms, but I think of everyone's art in socio-cultural terms." As for power, Alloway said, "I don't think the writer is so insignificant. Not only does he have the power to write, but

the power to withhold. I'm writing four pieces about women now. I'm preoccupied. If I had a brilliant idea about Brice Marden or Richard Serra, I wouldn't write it." And, on changing the system: "I'd like to see an expansion of co-ops."

Lucy Lippard's question-statement from the floor addressed the paradox which haunts these discussions: "Women's art is used as a synonym for feminist art, but they're not the same thing . . . Can you tell the difference?"

The answer was not clear. Meanwhile, we see that when the women say, "Write about women's art," the men say, "There is no feminine aesthetic." When the men say, "There is no feminine aesthetic," the women say, "But the movement is what's happening." And then the men say, "Feminist art is of no formal interest." So the women say, "Then write about more women artists."

Obviously, there's enormous pressure to make "women's art" into an aesthetic as well as a political development, and the more useful "women's art" is as a political configuration, the more likely it is to become an aesthetic one. Some women would benefit enormously, but the rest would be worse off than before, having undertaken the struggle in the first place to escape stereoptyping.

– Judy Seigel

Women Artists News, June/July 1975 [Vol. 1, No. 3]

'75 / #14

Second Generation Elegy

While artists were happy to shed the oppressions of "modernism," some of them had a keen sense of what had been lost in community and comity. The group gathered here mourns, not just a colleague, but a way of life, perhaps also an art form. George Segal poignantly and persuasively evokes the thrilling early Abstract Expressionism, when the style promised to reach metaphysical, indeed "apocalyptic" heights. Pat Passlof reports, remembers, and sets the record straight.

"Life, Work and Times of Jan Muller"

Speakers: **Wolf Kahn, George Segal, Robert Beauchamp, Max Spoerri**

Figurative Artists Alliance, NYC; April 4, 1975

Fifty slides of Jan Muller's work were commented on by his widow, painter Dody Muller. The panel was composed of friends and colleagues. Others in the audience included Dick Bellamy, Myron Stout, and Aristedemes Kaldis.

This evening stood in odd contrast to the Abstract Expressionist panel two weeks before. Both groups of artists might be broadly included in what Tom Hess dubbed the "second generation," though the group from the Hansa Gallery was somewhat older, thus on the scene earlier, in a period of rapid change. They reflected the sense of warmth, community, hardship, expectancy and high seriousness which prevailed in New York until the mid-fifties.

Wolf Kahn: I loved to go to Muller's studio – four flights up in an unheated loft on Bond Street. [There were] always marvelous surprises. He delighted in taking untenable and extreme points of view. And he won all arguments because the ticking [of the plastic valve in his heart] got louder and louder.

Max Spoerri: He was German through the worst times, never denied it, remained true to the noblest ideals. He was obsessed with his heritage.

Kahn: We felt we were in league together against the world. The derivation of Hansa Gallery was from "Hanseatic," a league of free and independent cities.

Robert Beauchamp: I first met Jan at the Hofmann School in Provincetown 25 years ago. He was tall, with a high forehead, shy, worked constantly. We lived across Bond Street from each other and continued at Hofmann's night and day, an intense, intellectual and emotional life. . . . I was walking down Second Avenue when Angelo Ascagni came out of a funeral parlor and told me Jan had died. I was dazed. I didn't go in.

George Segal: We were all very aware of Abstract Expressionism, all close to Hofmann. What sticks out is a rare body of original work [by Muller], both abstract and figurative, marked by sensuality, intelligence and high ambition – work not done casually. I don't agree with the approach taken by the last 10 years of abstraction in New York. Abstract Expressionists of that earlier time wanted to touch apocalyptic heights. Jan had a profound effect on me; he had the nerve, knowing the best painters in New York (and that means the world) were anti-figurative, to pursue figuration and the myth. I had just come out of art school, where I was pressured toward abstraction, but was reluctant to give up what I could touch.

Kahn: Many abstract painters drew a lot. They all reassured one another there was no difference between realism and abstraction. . . . De Kooning was very generous; he tried to interest the Modern in my very first show.

Segal: Abstract Expressionism was at its brilliant height, getting critical recognition after 20 years of neglect. They set out to conquer the School of Paris. Any art student had to sense the energy, the power of the work, whether he understood it or not. The Abstract Expressionists were the heroes of an art world just blossoming. It was new, incredibly persuasive, ambitious, tackling metaphysical heights.

From the audience, Kaldis said Segal had come to talk of the Gods of Olympus, and talked about art as if it were a battle. Then he lit into Segal for emphasizing the achievements of Abstract Expressionism. He thought it, first of all, unseemly in a discussion about Muller, and also an extension of what he, Kaldis, considered propaganda, or exaggerated claims, from the "enemy camp." But Segal had clearly raised these issues, not only to set the scene, but to point up the extent of his friend Jan Muller's courage and independence.

The panel caught the spirit, if not always the letter of the times. One important misconception should be corrected, however: that anyone here ever dreamt of "conquering the School of Paris." While such aggressions characterize much of what has occurred since then, they are a far cry from the desperate but respectful struggle to understand and build on the foundations of Cézanne and Cubism which absorbed the energies of what has since come to be known as "Abstract Expressionism." This distinction needs to be made, not to quibble with Segal, but to make clearer a philosophy in which the son did not have to kill the father.

– Pat Passlof

Women Artists News, September 1975 [Vol. 1, No. 4]

"If a woman paints while watching a soap opera, it's hobby art," Rose said. She also objected to a lack of professional standards. When a woman in the audience asked what constitutes quality, Rose antagonized many by answering that "the judgement of history takes hundreds of years."

The focus of the discussion was indeed Barbara Rose, who managed to antagonize both audience and panelists. Some in the audience resented her perspective on feminism, and may have came to the talk for a confrontation. After many interruptions from both audience and panelists, time ran out and Rose rushed off.

– Sophie Rivera

*An exhibition curated by Blum

Women Artists News, November 1975 [Vol. 1, No. 6]

'75 / #15

Barbara Rose Defies the Multitude

"What is Feminist Art?"

Moderator: **June Blum**; Panelists: **Lucy Lippard, Barbara Rose, Linda Shearer**

Brooklyn Museum; October 5, 1975

"Works on Paper: Women Artists" was a large event in the women artists' world, but got minor billing in the Print Gallery at the Brooklyn Museum. In fact, the women were outflanked by a major exhibit, "For Men Only," which had a major banner draped over the museum front, saying exactly that: "For Men Only."

June Blum defined feminism as "the theory, cult, or practice of those who advocate such legal and social changes as will establish political, economic and social equality of the sexes." But she used the terms "feminism," "feminist," "feminine" and "feminine sensibility" interchangeably in her introduction to the "Unmanly Arts"* exhibit. At the same time, "feminist art" is interpreted variously by artists, curators, galleries, and critics. There are those who insist on a literal interpretation, while others say anything a woman artist chooses to say is, in fact, a feminist statement.

Barbara Rose asserted that there are no radical politics in the feminist art world. Feminists, she said, are merely self-centered, self-promoting individuals who want a larger slice of the pie, i.e., "a bunch of women who want to be noticed." Blum countered with, "What's wrong with wanting a larger slice of the pie?" "Bad art is being encouraged by the feminist art community," Rose retorted, adding that the quality of art should not be determined by sex. Lucy Lippard said responses to art should be primarily a gut reaction followed by a rational appraisal.

'75 / #16

The Last Woman's Panel?

Despite Barbara Zucker's accusations of "boring" – or maybe because of them – this was a lively event, and the two responses [following] stirred things up a bit more. Perhaps now that we have lived another 16 years, any one of us would respond differently. For Barbara Zucker's afterthoughts, expressed at, yes, another woman's panel, also at A.I.R, see the Afterword.

"Women Artists: What Have They Got and What Do They Want?"

Moderator: **Corinne Robins**; Panelists: **Joyce Kozloff, Barbara Zucker, Nancy Spero, Phoebe Helman, Howardena Pindell, Mary Beth Edelson**

Artists Talk on Art, NYC; March 31, 1975

I think the best thing A.I.R. could do would be to have men. I hope there won't be any more women's panels and I hope this is the last one I'm on. You get what you want in this world by surprise, by doing the unexpected. They expect us to continue the way we are. . . . I don't think feminism is the real world any more. The point was to get women artists taken seriously. Women still aren't as equal as men, but I don't think women's galleries are helpful any more. I don't think it helps to be in A.I.R. [1]

– Barbara Zucker

That statement came midway in a brisk discussion by six well-known women of the art world, speaking to a full house at the Soho Exhibition Center, an audience which included the video eye of Ingrid and Bob Wiegand, and a noticeable proportion of men.

Moderator Robins began by noting that the six women artists "all benefited from the women's movement, as every woman has. But what happens when 'The Year of the

Woman' is over? Feminism is getting to be a tired issue to many people." (Robins added, however, that "the abuses are still there.")

The six women showed slides of their work and described their artistic concerns, which could have been an evening in itself. The perception of six disparate and developed sensibilities was already a dense experience. The transition from Nancy Spero's *Body Count* and *Torture in Chile* to "How much has the women's movement influenced the direction of your painting?" was as difficult as Spero could have wished. But then the discussion swung into matters of practical, political and social concern, and the visual experience faded.

Howardena Pindell: Without the women's movement I wouldn't have shown so soon. If I weren't part of the gallery [A.I.R.], I don't know if I'd be showing yet.

Mary Beth Edelson: I was dealing with feminist subject matter before the movement, but I don't think I understood why. Now I'm dealing in an overt way with feminist subject matter – pulled out and clarified by the movement.

Phoebe Helman: I think the women's movement, even though it was helpful in some ways, has nothing to do with my work. I haven't been affected in the studio at all.

Zucker: It's much easier for the work to grow if it's out there being shown. . . .

Nancy Spero: The feminist movement won't fizzle out. We could never go back to the old standards. The new knowledge is too pervasive . . . it's in our bones.

Helman: It took outrageous things like dirty Tampax at the Whitney to get attention – then, hopefully, the pendulum swings.

Joyce Kozloff: I can't imagine what my work or my life would be like if I hadn't gone through the women's movement. My work and the movement are very connected – they developed together. I see many feminist women whose work has grown, expressing their own growth and new confidence and sense of themselves as women.

Robins: Some of the work in the "Women Choose Women" show struck me as very timid. Then those women got more exposure. That gave them the guts to take chances – to be less timid, no longer second-hand artists.

Will there continue to be a need for A.I.R. and women's galleries?

Spero: Eventually there will be a reconciliation, but we still need outposts of independence.

Edelson: I still see a need for A.I.R. and Soho 20, but we need to go on to another plateau. [U]ntil we integrate, we won't have the main money and the main power.

Helman: It's a heterosexual world. There comes a time when this kind of support becomes a crutch.

Spero: It's not a heterosexual world. The art world is still male-dominated. To join the system is to join the *same old stuff*. I'd still be excluded from commercial galleries. . . . There are still under 23% women in the Whitney Annual. We still talk about "good artists" according to male standards. Our standards for all artwork are male-controlled.

Robins: As a writer and reviewer, I have more chance to speak and write about women's art because A.I.R. and Soho 20 exist. . . . In 1973, as a critic, I thought "Women Choose Women" was a major disaster.

Zucker: It's time for a major museum to do a major show of women – not one started and paid for by the women – but started and paid for by the *museum*.

[Quoting Vivian Gornick in the *Village Voice*]: "No one of us has the truth or the word or the only view or the only way. . . ." It would be very comfortable for me to still be with A.I.R. I feel very fragile now. I left with great difficulty, but it was very important for me to leave.

Audience: The world is so sick, it seems to me our only hope is bastions of what we'd like it to be – don't corrupt yourself with that other "reality."

Helman: Don't talk about Utopia! Are you aware of the politics that went on with the "Women Choose Women" show? That was *politics!*

Zucker: It takes a great toll on an artist to always have to do everything yourself, to schlepp, and call, and carry and photograph. . . . To survive, and do well, a gallery needs a *lot* of money. We got certain grants at A.I.R., but those were tokens.

Robins: But that's part of every cooperative gallery.

Edelson: I like doing some of the work you object to, but I'd like to have someone do a little of it. I have a dealer too, but he makes so many incredible mistakes . . . It's nice to have a little control.

Man in Audience: What is women's art?

Panel: Art done by a woman.

Man: Renoir dealt with the subject of women. Is he a woman artist?

Spero: That's a male's view. [W]omen are supposed to conform to his view. We want to see how we see ourselves.

My first comment is that, while the men never seemed to complain about the absence of women during all those years of "men only" galleries, many women found something missing in women's galleries almost from the start. Is that because it's a man's world, or a basic difference in the needs of men and women?

But the gallery in question, A.I.R., seems to have had a rather remarkable and nearly instantaneous success, considering that it is a cooperative and was initiated without "stars" or powerful patronage. It earned the respect and attention of the art world and the media from its inception and has had consistent review coverage that could be the envy of many a commercial gallery, let alone cooperative. Many of its artists have achieved prominence in the "establishment" and/or moved on from A.I.R. to "important" commercial galleries. . . . What *do* women want?

As for feminism being a "tired issue" – American culture does use up and throw away issues as rapidly as last week's *TV Guide*. But feminism seems to have more than a few twists and turns left before subsiding into its long-prophesied demise.

– Judy Seigel

19

1. Howardena Pindell, Mary Beth Edelson and Nancy Spero were members of the women's co-op gallery, A.I.R. Barbara Zucker was a former member. This statement of Zucker's was a shocker at the time. It wasn't just that A.I.R. was getting much attention. [See below.] The love affair between the women artist's community and A.I.R. was still going strong – much of the sympathetic art world, male and female, convened regularly at A.I.R. panels and openings. In retrospect, Zucker's remarks suggest that what she had in mind was a larger effect than, so far as I know, has been obtainable in a *co-op*, whatever its membership.

2. Lucy Lippard noted in a subsequent letter to *Women Artists News* that those were *clean* tampons.

A Panelist's Reply

Panelist Kozloff wrote a rebuttal to panelist Zucker, which ran in the same issue as the panel report. Aside from reviewing the controversy, which was a most urgent one at the time, Kozloff's commentary is interesting today for having forecast much art of the '80s.

I felt pained to hear co-panelist Barbara Zucker say that "women's panels are boring," "women's shows are boring," and "women's galleries are boring."

Clearly *ffeminism* is not boring and *women's art* is not boring – quite the contrary. Then why are these attitudes suddenly around? One reason is that the approaches to talking about and showing women's art have become repetitious and unimaginative. Why is it that women artists are always expected to talk only about "Is there a Feminine/Feminist Sensibility?" or "Do Women Artists want to be Part of the System or make Alternatives?," with panels divided between those who say "yes" and those who say "no," so there is no possibility for the development of ideas and theory?

I have observed that women who have been through consciousness-raising and the political activities of the last five years have become strong, highly individualized artists. Their work reflects (in many different ways) a sense of personal and group identity. I see new kinds of imagery and content emerging: exploration of female sexuality, reflections on personal history, fresh approaches to materials, new concepts of space, a re-examination of the decorative (and the *so-called* decorative) arts, a reaching out toward non-western sources and a non-paternalistic attitude toward the "primitive," direct political approaches to artmaking, and art which consciously parodies male stereotypes.

These are all vital subjects and none of them precludes the others. What is exciting to me is the diversity of ways in which women's art is emerging. We should not be confined to generalities and tired rhetoric. Let's talk about the art and the ideas around the art.

– Joyce Kozloff

Women Artists News, November 1975 [Vol. 1, No. 6]

Letter to the Editor

Over the years we received a number of angry letters-to-the-editor about such matters as having said a speaker was hard to understand or having run a cover cartoon in the style of a *male* artist. Therefore Zucker's letter seemed only mildly contentious. In any event, we duly printed it – and my reply:

I would like to clarify some points which were not accurately presented in the last issue of *Women Artists News* ["Women Artists: What Have They Got and What Do They Want"]. I was quoted by Judy Seigel as saying "You get what you want in this world by surprise, by doing the unexpected." Out of context, it sounds absurd. I amplified the remark to explain that (in political circumstances) guerrilla tactics, or constantly changing actions, are often those which produce results. I also said that I feel Feminism in Art has become a safe harbor, not only for the artists themselves, but for those who criticise it, or, even more reprehensibly, dismiss it. It has become an easy, predictable target. I do not believe our strengths will be reinforced by staying in this polarized oasis. Rather, I feel one's individual tenacity and visibility in the male and female world is more relevant.

I wish to also bring to light a fact Seigel excluded from her discussion of A.I.R., which is that, as a co-founder of the gallery, I know quite well it did not have the "remarkable and nearly instantaneous success" it allegedly enjoys without one solid year of slavish prepatory ground work and devotion on the part of all 20 women who first comprised its stable. In other words, A.I.R. didn't "happen," it was "made." I do not know what kind of effort women must now make in order to push for continued change and recognition. I do know that in comfortably pursuing the familiar, we talk only to ourselves.

– Barbara Zucker

Editor's reply:

"You get what you want by surprise, etc.," doesn't sound absurd to me, in or out of context. The amplifications Zucker supplies are, I think, implicit. It's not possible to repeat a two-hour panel verbatim.

As for her second point, I never meant, and doubt if the reader would think I meant, that A.I.R.'s success was unearned. I meant rather to admire a notable achievement. Obviously a project of this order, whether a gallery or a publication (even, for that matter, dinner-on-the-table), requires endless work, much of which never meets the eye.

So far as I know, by what I consider the relevant standards, A.I.R. has had an exemplary success. My question was whether Zucker's expectations for such an endeavor might not be unrealistic. My guess is that a mixed, or men-only gallery of similar provenance would not have fared so well.

Women Artists News, December 1975 [Vol. 1, No. 7]

'75 / #17

Five Husbands, But Who's Counting?

Lily Brody introduced her remarks with, "My husband was one of the best-known womanizers in Budapest. That's how I got time to do my art." Moment of silence, then gusts of delighted laughter from the audience.

That anecdote of the "70 Plus" panel, retold recently, years after the event, vividly evokes the scene. You could picture that gang of old ladies – so glowing, at ease, intense, eager, it was impossible to tell who was having a better time, speakers or audience. Our joy at meeting our predecessors in art was matched by theirs in the adulation, which artists, whatever their sex, seldom get enough of.

We printed two reports on the event written by artists of two generations. The first, by artist and arts administrator Evelyn Schwalb (whose daughter, artist Susan Schwalb, had also written for us) and the second by Shirley Fuerst. "Lil Looks Back" was taken from a copy of Lil Picard's remarks.

"Women Artists – 70 Plus"

Moderator: **June Blum**; Panelists: **Isabel Bishop**, **Lily Brody**, **Sari Dienes**, **Alice Neel**, **Lois Mailou Jones**, **Lil Picard**

Brooklyn Museum; November 2, 1975

These unusual women who have been, and still are, serious working artists always worked at their art and allowed nothing to interfere with their careers. Yet all led full lives (even rather spicy lives – like Alice Neel, who said she *thinks* she had "about five husbands"). They had the drive to overcome frustrations "without bitterness," and with a sense of humor. If their husbands played around with other women, some were glad just to have extra time in the studio. And they made it plain they felt they had had their own women's movement, preceding the present one.

Sari Dienes said "art has to do with life itself." Zen Buddhism taught her acceptance. The spirit of art, she said, has no age or sex. Lil Picard also is "in love with life." Seeing this lively, vivacious woman at 70 plus, we are in love with her! Lilly Brody studied in Paris, made money designing dolls, was included in "Women Painters of Hungary," and painted even while raising a family.

Alice Neel "painted for art itself," and to "paint a good picture." She found she could do as she pleased by living on her canvas.

Isabel Bishop didn't think of being a woman when painting – just of being an artist. She never felt discrimination – perhaps because recognition came early to her. She was the first woman on the Board of the National Academy of Arts and Letters. (However, it has been said that her recent retrospective at the Whitney was long overdue.)

Lois Mailou Jones suffered both the prejudice against women and against blacks. Still, she received numerous awards and prizes, which she sadly could never permit herself to accept *in person*. The revelation that she was black could, at that time, have hurt her career. She studied and gained recognition in France as outstanding and a "first black woman artist." Finally she has had a retrospective at the Boston Museum and will have a 1976 show in Paris.

For me – at age 56, overlapping the younger and older groups – the panel was a truly exciting experience. It was a privilege to meet these distinguished women, and the discussion was always lively. The audience would gladly have listened to them for double, even triple, the time of the program.

– Evelyn Schwalb

"Women Artists – 70 Plus"

"Does art promote longevity or does longevity promote art?" "Yes."

That question and answer opened a fabulous panel discussion. Moderator June Blum said these were women who "survived, competed and completed." And we, the audience, were caught up in the warmth and excitement, the charisma of these women who have faced our common problems and kept themselves focused on their art.

Alice Neel: I painted all the time. I had five unsuitable marriages – and this gave me more time to paint. I fight off disease to paint. I give up life to produce vital stuff to put on canvas. I painted people during Abstract Expressionism. Art is history – people. Every decade is different. It's important to paint the political climate. The human race is just as important as machinery.

Isabel Bishop: Women artists were wiped out of history because they didn't speak in their own voices. When a woman's voice appears, it will be a great contribution. . . . I arrived in New York when I was 18. The art world was just coming to, after the First World War. The Armory Show had thrown New York into a turmoil of ideas. I was thrilled by the challenging of tradition. Cubism was a great style . . . an austere concept, related to the Baroque.

Sari Dienes: Art has no age or sex. I accept and enjoy the process of life. My art is not separated from life. . . . My mother took me to feminist conferences, political events. [Now] men have to be liberated as well. The Women's Movement has given me great support and I support it!

Lily Brody: I've had a lucky life. I was always supported by men. I started to draw by making dolls for myself. I sold them and made money. My father sent me to Paris so I found out about modern art and Picasso before I went to the Academy. I graduated in 1931 and got married in 1932. My husband chased girls, so I had time to paint. . . . Painting kept me going.

Lois Mailou Jones: My mother said, "Lois, don't let anything interfere with your career!" To compete with white students I had to work twice as hard. . . . I was with Langston

Hughes, Countee Cullen and Henry Tanner in the Harlem Renaissance. But whites have left us out. I've been overlooked. It's so late . . . I've never had the contacts . . . I wanted to be an artist, not a black artist.

Lil Picard: If I had been a man it would have been easier. By today I would have exhibited in the Whitney . . . I wanted to go into a nightclub by myself, into a cathouse to see what it was like with my own eyes, but I couldn't. It's very hard to compete with a man. I can't do business at 3 AM in Max's Kansas City.

— Shirley Fuerst

"Lil Looks Back"

From Lil Picard's statement at the "Women Artists –70 Plus" Panel

The poet Heinrich Heine (born in Germany, 1797, died in Paris, 1856) said, "It's very terrible to be a German, but to be a German Jew is the worst that can happen to an intellectual."

I was born in Germany in 1899, three months before the start of the 20th century. When I was young I identified with Heine – the great Romantic Poet of the German Language, which I still speak and write. His fame is eternal, his poems foreverlasting in German literature. He wrote *Die Lorelei.* He lived with "'Mouche," his girl friend, in the *Matratzengruft,* the "mattress cave," as he called his long-lasting sick and death bed.

I am now an American, but I was a German Jewess. And to top that, I face two more handicaps, disquieting and disturbing facts in the social structure of the 20th century. I am a woman and 70 Plus. A senior citizen of female sex. That, my dear sisters, is a cruel position in a male-dominated, youth-dominated, power- and war-dominated world.

But as an artist, I hopefully, actively, strive to overcome my handicaps – to realize myself as a creative person, to live my dream, my ideals, to be young in spirit, active in life, to give what I have, and to learn and continue to liberate myself.

I started to write in Germany in the '20s, in Berlin – the city and times made famous by the film "Cabaret." That life was my life in the "Fabulous Twenties." I sat in the cafés with the artists and poets. I lived through all the "isms." I knew many of the Expressionists. The Dadaists of Berlin were my friends. I danced with George Grosz at the artists' balls. I talked to Richard Hulsenbeck every day in the Café Vienna. My first job was as a file clerk in Rowohlt's Publishing house, where I shared a desk with Moholy-Nagy, who also worked to make a little money to survive. I played in cabarets and theatres in the fabulous days of the Weimar Republic. I met Wieland-Herzfelde, Heartfield, the poetic political writers, the collagists and the politicians. That was my art education. Life taught me to be an artist.

The Nazis came to power in 1933, and I came to America in 1937. I prepared by reading Thomas Wolfe's *Of Time and the River.* I knew that New York would be a place where I could work, and be free and creative. I have a love affair with New York – now an unhappy one because the city is suffering. I've worked here in many different jobs to survive, but I've painted constantly since 1939.

I learned lettering in the Art Students League, studied with Jevza Model, husband of the photographer Lisette Model, teacher of Ann Arbus. I got shows on Tenth Street and uptown, made "Happenings" since 1964. I never made the Whitney. I never really made money with my art.

And here I am, on a panel in the Brooklyn Museum with my sisters. "Seventy Plus." A senior female citizen, an artist. Where am I going? In spring, 1976, I will have a retrospective here in New York. I believe in Art, in MYSELF, in the eternal dream of the poetic life . . . I think I believe in LIFE!

Women Artists News, December 1975 [Vol. 1, No. 7]

'75 / #18

In Advance of the Revolution

The glow of the "70 Plus" women last week is in sharp contrast to the calls for "radical revolution" this week, although there's a common theme – liberation. The older women made it clear that they had liberated themselves to make art. The younger generation wants liberation for its own sake. Their requirements (as far as can be heard through the jackhammer) include, "a guaranteed minimum wage for artists," "phasing out of the wife-mother role," and "creativity for everyone."

"Radical Change or a Piece of the Pie?"

Moderator: **Wylie Lucero**; Panelists: **Vito Acconci, Ian Burn, Carol Duncan, Lucy Lippard, Nancy Spero, May Stevens**

School of Visual Arts, NYC; November 10, 1975

Air of expectancy. Moderator Lucero opens by saying the panelists have all "worked actively for change." A jackhammer goes off in the street below and continues at irregular intervals, blotting out all speech for the duration of each blast. May Stevens reads a statement which we are able to obtain for publication. The rest is fragments.

Vito Acconci: My work treated the gallery or museum as a place for guerrilla action . . . now I use it as announcement, poster, slogan, or instrument toward something else.

Nancy Spero: Calling the art world "the underground" is a misuse of the term. It's been rather a kind of *elite* of the establishment. The *women* have been the underground.

Carol Duncan: The art world is not really anti-bourgeois. It reinforces the values of society. Instead of changing things, women artists are trying to create strong personal identities . . . for the market . . . prisoners getting to be trustees . . . Art is still the concern of few people, an enclave. The women's movement is middle class . . . but the wife-mother role is going to be phased out in an advanced society.

Lucy Lippard: You have to distinguish between a "liberated woman" who concentrates on making it in a male world and a feminist who wants to get totally out of the art world and set up a viable alternative. [We don't need] more art indistinguishable from art made by men . . . it's time for radical revolution.

Spero: But things that were revolutionary, or could have been, are so quickly picked up by the media.

Duncan: Art doesn't change things. It gives voice to the search for new ways of looking . . . gives conscious shape to feelings. . . .

Lippard: . . . a classic capitalist system . . . but feminism can transcend style. . . .

Duncan: We should have a society organized according to people's needs, a society where creativity can be expressed by everyone.

Spero: People on the outside think the art world is ideal . . . people being free and doing what they like – a kind of utopia.

Lippard: . . . a guaranteed minimum wage for artists and tithing on art world income for redistribution to artists. . . .

It wasn't just the jackhammer. No one seemed to know if the subject was the women's movement or social revolution. If there is a connection between the two phenonena, the panel didn't find it, except possibly, to lament the failure of the women's movement to be radical. The men had little to say on either subject. (That's the second – and last – time I've watched Vito Acconci fall asleep on a woman's panel.)

Having aligned myself with the huddled masses in mid-amphitheater, I was, with them, mostly cut off from the discussion shared by the front rows and the panel. As polite downtrodden masses, we called politely for Sound System. (Didn't work.) For Louder Please. (They wouldn't or couldn't.) Move Closer, they told us. (Let Them Eat Cake – there was scarcely an empty seat.) While the jackhammers of the Chauvinist Imperialists went coolly about their business, we sat helpless, unable to communicate, even with each other – a perfect paradigm of intellectuals talking "revolution."

Lucy Lippard was praised by women artists (myself among them) for appearing in an art publication photo *with her son.* Now they're "phasing out" the wife-mother role? I overheard Miriam Schapiro in the audience complaining about "antifeminism." That may be what she meant.

– Judy Seigel

Women Artists News, December 1975 [Vol. 1, No. 7]

"Social Change and Art"

A paper by **May Stevens** [Excerpted]

May Stevens's opening statement at the "Radical Change" panel remains among the most lucid and convincing on the issues to date. Illuminating points often obscured in a blaze of righteousness, she views aspects of art from technology to social class, yet insists on her own concern for "meditation and transcendance."

If social change is the primary goal, then there are more effective means than art.

If artists consider themselves a vanguard of the revolution, then painting, sculpture and drawing are peripheral; they should be superceded by mass communications media and, indeed, we all should be using video, film, television, photography and printing presses. We should also be using psychological and sociological research to learn how best to change consciousness. I have no objection to that kind of activity. But I am an artist in the traditionally-held notion of the artist. My work embodies my understanding and response to the world, or certain aspects of it, in forms that, hopefully, make it moving and memorable. Its ability to change people's consciousness is less measurably effective than verbal statements that I make – but that is in the nature of art.

Who is art for? First of all it is for myself. But I do not leave it in the studio. I send it out in the hope that it will mean something to others.

I object to the kind of linear thinking that says technology has replaced handwork, that painting has been superseded by photography, etc. We still like to walk and dance even though we can now fly. I see the relationship between painting and photography as much more complex and interesting than that one has superseded the other. Painters use photographs to obtain information; they have learned things about perception that were unknown before the advent of the camera. They combine painting and photography in countless ways. Movies and television have influenced the way we see and relate to images, and that shows up in art. And photography is shaped by the experience of art – of painted images; the two disciplines interact and continue side by side, in different but overlapping fields.

The idea of art as contaminated by its class origins, its bourgeois history, its status as an object, is a vulgar misreading. Successful revolutions do not throw out their national history and culture. They rethink them and, understanding the context in which they were created, still value them for their achievements. The fact that visual art usually exists in object form is of minimal significance. No matter that these objects can be bought and sold. They become art exactly to the degree that this object status is transcended, that they embody ideas and myths.

Perhaps it is possible to make an art that is more action-oriented, more action-producing than any we have yet had. But that is one form of art and does not negate the continuing need for art of meditation and transcendance.

Women Artists News, December 1975 [Vol. 1, No. 7]

'75 / #19

Not Censored

In retrospect, the call for censorship seems relatively civilized, and the response quite calmly judicious. But then the art in question was heterosexual, not homosexual, and the style delicately elegant, not rude or raunchy.

"Art Offends at Douglass"

Forum on Painted Lovemaking

Mabel Douglass College, Rutgers University, November 11, 1975

Bibi Lencek, 41st in the Women Artists Series at Mabel Douglass College Library at Rutgers, showed paintings of a young couple (modelled by herself and companion) in various positions of lovemaking. In a cool, realistic style, the paintings used such "banal" details as patterned sheets, tissue box, wall plug, and potted plant to give a "sense of place." Lencek says that although the figures are prominent, she considers them "merely a part of an indoor landscape."

In a letter to *Targum*, the Rutgers newspaper, Douglass student Barbara Ambler protested the show. It was, she said, distracting, "undermining the quality of my life" as a Christian. She wished to lead a life "pleasing to God," but sex "in the wrong situation . . . can destroy us." (Another letter from a more worldly student protested the portrait of Alexander in the Alexander Library, because "each time I see it I begin to fantasize about sex.")

Although most students seemed neutral or unconcerned, the distress of the minority was so acute that an open forum was held, November 11. Protestors included Ms. Ambler and other members of the Intervarsity Christian Fellowship. Espousing a "Christian Ethic," they objected to public display of work which aroused sexual fantasy. Sex is "a beautiful gift from God," they said, but belongs only within the bonds of "Holy Matrimony." One student read from the Bible of Adam and Eve's recognition of their nakedness and covering themselves, from which he inferred the sinfulness of the naked body. Turning to Lencek, he said, "The Devil speaks to us in many ways."

A more lenient faculty and administration noted that artists have for centuries depicted male and female nudes in secular and religious paintings, mentioning Titian, Rubens and Ingres. One faculty member observed, "These are not sweaty paintings," noting that no genitalia were portrayed. Reviewer Lynn Bershak said, "Lencek alters the positions of the lovers as one would reposition flowers or fruit in a bowl," and described the work as "genre painting," like nursing mothers or children at play. Robert Tanksley, Coordinator for Religious Affairs, noted that spiritual asceticism is achieved by confrontation and transcendance, not avoidance.

Assistant Professor Gloria Orenstein said that after her trip each day through the New Jersey oil fields, scenes of love

were a relief and reminder of good in humanity. Other staff members agreed that the art was a joyous distraction from grim reality, and that painting gas stations was more truly pornographic.

One student said that although he came to the library often, he hadn't noticed the art until he read about it in the paper. Lynn Miller, librarian, and director of the series, apologized to those whom the show had offended, but announced it would remain up.

— **Anne Marie Rousseau**

Women Artists News, January 1976 [Vol. 1, No. 8]

'75 / #20

Practiced Passions of Paint

"Painterly Representation"

Moderator: **Louis Finkelstein**; Panelists: **Rosemarie Beck, Paul Georges, Wolf Kahn, Raoul Middleman, Paul Resika**

Artists Talk on Art, NYC; November 21, 1975

I loved this panel for its warmth and camaraderie, even or especially for its practiced passions: Paul Resika rhapsodizing on a tear duct; Paul Georges in a funny and fiery attack on the Met, the French show, the academic mind and "naked representation"; Wolf Kahn in a confessional mood; Raoul Middleman in two hilarious anecdotes on the clues to likeness or how we recognize each other; Rosemarie Beck more reserved and thoughtful; Moderator Finkelstein saying affectionately, but probably meaning it, that if Georges were any more successful, he'd be unbearable.

I loved the panel's intimacy with the works which concerned it. Though I knew they'd fought these fights before, I could even empathize with their delight in landing a few blows on the dead horse of abstraction. Lastly, Georges on Leslie's second O'Hara*: "I was so happy to see the improvement – he finally got that big foot out. The trouble is, that painting *needed* a big foot!"

— **Pat Passlof**

WAN, January, 1976 [Vol. 1, No. 8]

*Alfred Leslie was one of several artists who idolized poet-curator Frank O'Hara and painted his portrait.

'75 / #21

Truth and Wishes

"Humanizing the Art World"

Moderator: **Joellen Bard**; Panelists: **Diane Burko, Richard Karp, Cindy Nemser, Jonathan Price, Jacqueline Skiles**

Auspices not recorded, NYC; December 13, 1975

The seemingly well-fed, well-dressed, well-educated "humanists" on this panel about "Humanizing the Art World" are evidently outraged at a system that has allowed them this much, but to date denied them the fame, wealth and power they see elsewhere in the art world.

Their talk mixed truth impartially with nonsense. The salient truth was Jackie Skiles's observation that the monies going into Arts Councils across the land have created thousands of middle-class jobs with fringe benefits *for arts administrators*, but have moved scarcely an artist into the middle class.

On balance, though, the foolishness annoyed me more than the truths roused me. Here are some of the panel's assertions and my mental replies:

Panel: Artists start with warm and spiritual, rather than pragmatic things.
Me: If crucifixions, flagellations, battle scenes, rapine and grids are warm and spiritual.
Panel: Humanism means warmth, tenderness, kindness to neighbors and sharing.
Me: Rage and aggression are only aesthetic effects.
Panel: Corporations promote abstract art because aesthetics are safe. Stripes and circles won't propagate revolutionary ideas.
Me: As history tells us, the Constructivists and Futurists did abstract art to support monarchy.
Panel: It is content that infuses art with vitality.
Me: Which is why the painting of the most beautiful object in the world is the most beautiful painting in the world.
Panel: What's wrong with being refused [from a co-op]? Rejection is humanistic, too.
Me: No comment.

If "humanizing the art world" is a code phrase to mean wrenching power from the fallible humans who now possess it, I'm interested, but this pious cant is distracting. Surely any extension of human thinking, from Fibonacci to the Pyramids, is "humanistic." Limiting art to "pictures," so-called "explorations of self" and a few other minor genres curbs art and intellect as much as "inevitable progression" ever did. Who needs a know-nothing backlash in the name of "humanism"?

– Judy Seigel

Women Artists News, January 1976 [Vol 1, No. 8]

'75 / #22

Three-way Combat

Although they were presumably on the road to "liberation," many women artists feared being forced into new stereotypes by "Gender in Art." Sophie Rivera's report on an evening of "gender dialog" is laced with her own objections. (OK, she *was* hostile.) Joan Semmel's "Thoughts After a Panel," are equally critical, but for more or less opposite reasons. Nancy Spero corrects both positions and adds some fierce commentary of her own. She is interested in "speaking up right now" in the real world, she says, and doesn't have "to make cunt art to prove it."

Semmel and Spero's intense, passionate declarations distill the arguments – and they were serious ones – of the time. Ultimately, matters were not so much resolved, as tired of, or worn out. Pluralism flourished, relaxing pressures to follow any particular theme, and "gender art" gave way to new, or more complex, manifestations.

"Gender in Art: An Ongoing Dialog"

Moderator: **Nancy Spero**, artist; Panelists: **Nancy Kitchel, Laurace James, Mary Miss, Rosemary Mayer**, artists; **Lucy Lippard**, critic; **Elizabeth Weatherford**, anthropologist

A.I.R. Gallery, NYC; December 15, 1975

A group of women decided to express their growing disenchantment with the women artists' movement. "Gender in Art – An Ongoing Dialog," was a title just vague enough to attract a large turnout.

Following a brief slide presentation, Moderator Nancy Spero set the tone with an opening statement full of vague references to a meeting the artists had held several years ago. She mentioned neither the topics discussed nor the conclusions formed, just that they had discussed "a common bond between women."

Panelists, trying to define "feminist," "feminine," and "female," were unable to agree, but initially opted for "female." According to Rosemary Mayer, "a feminist aesthetic is a very precise thing; a feminine aesthetic is a lousy term; and a female aesthetic could possibly have meaning."

Before Mayer could elaborate on the possibility of meaning, Elizabeth Weatherford challenged the choice of "female." She preferred "feminist" to describe women artists' work, but conceded that "certain stylistic choices are made."

Lucy Lippard said, "If a woman is thinking about her work as by a woman she is probably pre-feminist, post-feminist, or something-or-other-feminist."

Nancy Kitchel bemoaned the fact that "art has been separated by its terminology out of the stream of human activity" so far as to become a "separate category alien to the artist's intentions."

Spero pointed out that Rosemary Mayer's sculptures were titled with the names of great and powerful women. Yet Mayer claimed her intention was not really feminist.

"My work *was* feminist to the extent that I thought people should be aware of the lives and activity of those women. It was *not* feminist to the extent that I thought those forms were female," answered Mayer.

Several panelists commented on male dominance of the art world – a theme which surfaced early, got lost, then re-surfaced in response to sharp audience questioning. When the audience expressed feelings of powerlessness in a male-dominated society, Joan Semmel told them from the floor that women are our audience, that women have a gut response to art, and that her own art came out of a sense of powerlessness (although she no longer feels powerless). Spero strongly disagreed. One could not help feeling that we were hearing economic theory, and that many of the women were interested only in the marketing and marketability of "feminist art."

As to whether there is a specific female art form – a panelist asserted that the traditional female approach has been to reach out, while the male approach has been to look into himself to create. This was directly contradicted by statements of at least half a dozen women about their own ways of creating.

Someone mentioned that she had been reading a book claiming that people were pushed, because of education, away from the visual toward the verbal. This led to the speculation that female and male spatial perceptions are different – a useful idea, if true, but taken wholly out of context.

The discussion, which had little to do with the stated subject, might have been titled, "Disgruntled Artists Lower Consciousness." The ground had been gone over before.

– Sophie Rivera

Thoughts after a panel on Gender in Art

The impetus for the woman's movement in the art world was blatant discrimination, exclusion and isolation. It was important for many of us to see each other's work, and gain from each other the confidence to develop and expand. We could then return to our private worlds to work intensively, gradually gaining exposure, first in women's shows, then in wider contexts.

The profusion of women's panels this season is a signal that we are once again seeking nurturance from each other, and that the movement is readying itself for the next stage. Unfortunately, many of the panels have failed to deal with substantive issues and left us with an aftertaste of frustration and negation.

A panel that calls itself "Gender In Art – An Ongoing Dialog" and then refuses to deal with content, sources, or gender itself, except in terms of careerism, does a disservice to us all.

Because women's work has been discriminated against for years, many women are paranoid about having their art described as distinctively female, feminist, or feminine. Some think women's art should be accepted because it's the same, or as good as, men's. I want it to be accepted because it's different. Therein lie its power and its possibilities.

Is it not time that the female experience became part of the making of our collective history, of our supposedly collective culture, where it can serve to modify some of the anti-humanistic tendencies of that culture?

Some women are afraid that seeking the sources of our work will be ideologically coercive. I disagree. Self-knowledge stimulates self-definition.

If women's art encompasses a wide range of styles, are there similarities in content? What in our relationship to our space, to time, to materials, to our sexual roles, is different from men's and how does this affect our work? Why does so much of women's art deal with sexual motifs, organic form, autobiography, process and craft materials, highly personal and non-hierarchic form? How does this overlap with tendencies in women's writing?

The questions are endless. It is time for an ongoing dialog.

– **Joan Semmel**

Women Artists News, January, 1976 [Vol. 1, No.8]

Nancy Spero's reply:

Nancy Kitchel, Laurace James, Mary Miss, Rosemary Mayer and I met half a dozen times in the spring of 1973 to discuss and explore *anything* that interested us as women artists. After a hiatus of almost two years, we began to meet again this winter.

Our A.I.R. panel, "Gender in Art, An Ongoing Dialog," was intended to share and test some of these ideas with other women artists. In our meetings we had showed slides of work, talked about the directions it was taking, and explored what might be unifying factors among us. We speculated about alternate structures and ways of functioning within and perhaps outside of the art world, differences of approach and process, the problems of power, ramifications of money and influence, the "corruptions" of the art world, and the position of the arts in society. We examined the changing attitudes and position of women artists and their relationships, and the effects of repression, hostility and indifference. At A.I.R. we wanted to continue this low-key interchange in public, without the rhetoric that public appearances often evoke – reaching for a post-consciousness-raising dialog with other women.

Women Artists News published a review of the panel by Sophie Rivera and a commentary by Joan Semmel. Both were negative – downright hostile. But the expectations of the commentators (as well as of some of the audience) were contrary to our intentions. Semmel, a self-designated spokeswoman for the feminist movement, repeats the simplistic

language of those who most loudly proclaim themselves feminists, and then denigrates those who do not share her view.

She says, "I want [women's art] to be accepted because it is different." Does she imagine that there are two such simple categories as BOY ART and GIRL ART? What happens to those women artists who don't fit into the prepared categories for girl art? Are they to be excluded? Joan Semmel's art, if one did not know the artist, would not be recognizable as painted by a woman.

Semmel claims "some women are afraid that the seeking of those sources [of women's art] will be ideologically coercive." I am not hung up on seeking the "sources of our (my) work." I am interested in speaking up in the real world *right now*, and I don't have to make cunt art to prove it.

Semmel said the panel "does a disservice to us all." We were only speaking for ourselves. How can she speak for "us all"?

Rivera's garbled report was just that – garbled.

I once thought women could work together cleanly, regardless of political credo. Now I see a few women shouting their purity as feminists to the world. Such self-serving can stifle women's talking and probing.

There is a paradox in feminist ideologizing. Feminism embraces (or could embrace) every woman, a democratic non-elitist movement. But the moment one steps from the trusted dogma of women's liberation and sets up an individualized query into the nature and practical application of what one is about, one runs into prepared positions that inhibit dialog.

– Nancy Spero

Women Artists News, February 1976 [Vol. 1, No.9]

1976

'76 / #23

Most Well-Meaning Museum

Lucy Lippard reports that feelings at this demonstration were "warm and good," another reminder of another time.

Clouds Over the Whitney Again:
Rocky Times Ahead

Demonstration, Whitney Museum sidewalk, NYC; January 3, 1976

Picketing the Whitney on a rainy Saturday. Again. Shades of Winter, 1970. But this time the issue is not Women's Liberation, Black Liberation, or anti-capitalist politics alone. It's all three. The Whitney – New York's most well-meaning museum – has tripped again, this time by accepting as a package deal from the De Young Museum, a "Bicentennial" show of the John D. Rockefeller III Collection, an exclusive view with one woman (Susan McDowell, Thomas Eakins's wife) and no black artists, presented as "Three Centuries of American Art."

The American Revolution is to be commemorated by an exhibition selected and owned by archetypal members of a ruling class, people who have ruthlessly exploited America, in a personal history entirely counter to the principles of our long-lost Revolution.

The country's major museum of American Art has rejected the responsibility of organizing its own Bicentennial overview. In fact, Director Tom ("Strongarm") Armstrong, meeting with three of us in December, expressed amazement that "all this" was still going on. He said, "I do not want to enter a dialog with you or your groups."

A motley group of artists, now called Artists Meeting for Cultural Change wrote the De Young and the Whitney (no answer) and artists all over the country (who answered with ideological and financial support) and called a demonstration for January 3, the first in a series of Bicentennial Year Holiday picketings.

The demonstration was intended as a small-scale kickoff – communication with the public rather than with museum officials. Despite the weather and the low profile, about 100 people showed up; 50 or 60 were marching all afternoon, with others leafletting and soliciting petition signatures. The crowd looked even larger because everyone carried a poster – some made the night before (in a meeting I found rather touching in its combination of sophisticated theorizing and almost kindergarten concentration on far-from-professional lettering), others made on the spot, spread on the drawbridge

with the public gingerly stepping around scribbling demonstrators.

Signs included: "Some Yankee Doodlers, No Blacks, One Woman: Some Yankees Diddling Blacks and Women"; "Black Gold Buys No Black Art"; "See All Americans First"; "High Art, High Class, High Standard (Oil)"; "We Protest Rockefeller's Unamerican Activities"; "Whitney Capitulates to JDR III"; "Koordinated Kultural Kontrol"; "America the Beautiful in Picture Only"; "Rockefeller's Revolution?"

The cops had been warned. They showed up and watched, conferring at times with the Whitney security people. We had our own video coverage, and a network TV photographer was there. Public response seemed divided. From well-dressed denizens of the Upper East Side: "This shouldn't be allowed," and, "These are artists who aren't good enough to get into the Museum." (Untrue, as several "famous artists" were on hand, and Brenda Miller, though sick that day, had looked forward to telling people her show was In There.) "What's wrong with the Rockefellers?" "If it weren't for the Rockefellers there wouldn't be any Museum." And the rather ambiguous comment from a fur-coated woman, "You're picketing the wrong museum."

On the other hand, from young people going to galleries: "Right On." "Let me know next time." "Should I not go in now?" (Actually, we were not trying to keep people out, having nothing against shows there now, but a few people simply would not cross the line. One of them was Kurt Vonnegut, who started to get out of a cab, but, confronted by a picketer, got back in and left.)

The line sang "America the Beautiful" (less than beautifully), and chanted "We Don't Want No Rocky Show." It was a serious, orderly demonstration. The general feeling was warm and good – no rage. This was, after all, just the beginning of a long series of actions designed, not only to cancel the Rockefeller show, but to challenge the rule of the upper class over our cultural institutions, to set up alternatives within a system we resist and yet support by continuing to work in its confines – in spite of our convictions, in spite of ourselves.

Women artists' representation and the acknowledgement of recently discovered women's art history are only part of the agenda. These actions are part of a broader humanization of art and extension of the art audience which are crucial to the future of feminist art. If we are ever to overthrow the entrenched establishment that has kept women out of American culture for so many centuries, we must resist further inroads on the public consciousness of art and artists.

– Lucy Lippard

Women Artists News, February 1976 [Vol. 1, No. 9]

Update: The Rockefeller show was not cancelled, but there's an interesting footnote: The protests apparently had an effect – of a kind. That is, it seems that the *title* of the Rockefeller show was changed retroactively. This report called it "Three Centuries of American Art," and a subsequent panel called it "300 Years of American Art" ['76/#28], so a query was made to set the record straight. The Whitney Museum library now lists the title simply as "American Art from the Collection of Mr. and Mrs. John D. Rockefeller." The "Three Centuries of American Art" is apparently deleted from the record.

It might be added that, 15 years later, the "entrenched establishment" in several major institutions has begun to yield (although perhaps only to a new establishment). It's true that in 1990 a major travelling show of blacks in American art history was bitterly contested for focussing on depictions *of* blacks rather than *by* them, but still, Lippard's goal that art of the nation be more broadly bestowed and defined seems to have advanced since 1976.

'76 / # 24

Pure Karp

Soho in the '70s: You climbed the steep wooden stairs to an artist's top floor studio, past the fluted white paper cup of rat poison on every landing. True reverse chic. And $30,000 lofts. And Karp.

OK Harris Works of Art, founded by Ivan Karp in 1969, was the second gallery in Soho. (Paula Cooper was first.) Karp could usually be found sitting in his back room, amid the post cards, T-shirts, and other assorted art objects for sale, smoking a large cigar and seeing artists, thus earning a place in their lore (even their affections) rarely accorded a dealer. (A Soho shop carried a T-shirt with the legend, "I showed slides to Ivan Karp.")

The other source of Karp's fame was obviously from being quoted so much: The media knew he could be counted on for an apt and outrageous line on any occasion.

"The Gallery Business: The State of the Art"

Ivan Karp and **Audience**

Artists Talk on Art, NYC; January 9, 1976

Billed as "Ivan Karp and Audience," the evening was 99% Karp, talking faster than the speed of sound on:

The Mark of an Artist: The "magic moment" can come and go, but blazing ambition, powerful ego, sense of destiny, conviction of profound and unique vision, must be there on some level.

Choosing Artists: I see 50 or 60 artists a week. Over half are totally professional. At least 10 are innovative, intelligent – worth exhibiting. I choose work that reveals the character of our time, the secret visual wisdom of the moment.

Failed Vision: Perceptions fail constantly. . . . I climb six flights to a studio. . . . A triumphant moment – a major

force! (Even the plants are flourishing.) Back at the gallery I announce: This is it! This will resound as far as Pakistan! So the work is delivered. It's put up. And it's simply terrible. A complete and utter failure – sloppy, reactionary, useless. I can't face what I've done. I come in the back door.

Who knows when a fresh vision really occurs? I trust John Kacere. I trust myself. [B]ut there are moments of generosity in every exhibition schedule. I urge you to detect them.

The Public: Out of 210 million people, maybe 300,000 are interested in living art. Travel west and you won't experience important visual phenomena for long periods. But a Don Celender document (available at the gallery, half price to artists and students) shows that working people's attitudes to the arts are sympathetic. 98 or 99% said they were interested in fine art, that the arts are important, and that artists are good citizens. (When asked if they collected anything, most said they collected rocks.)

Collectors: In 1957 at the Hansa Co-op, Richard Bellamy and I worked three days a week for $12 plus commission. There were about five collectors in the country then. Today there are only about 75 major collectors of living art on a regular on-going basis. Castelli says only five people are buying art from him right now (two of them European). I count on eight to ten collectors loyal to my situation.

Art Styles: Some artists work totally unto themselves, out of their personal psychology, not part of the general visual culture. There's no dominant force today that will take the strength out of artists who work another way.

From 1950 to 1960 there was no other legitimate way to paint but a big juicy mark with a heroic gesture. Everything else was sissified, eccentric or European. After Abstract Expressionism came the "unsavory," "cancerous" development of Pop (my gallery was blamed). Lately, the freshest, most innovative, energetic art has been Realism. This wasn't a conspiracy to purge the world of Color Field – just the best thing I saw at the moment. When I first saw a Duane Hansen sculpture I didn't like it . . . I felt a twinge, a chill. So that meant something was going on – it needed to be exhibited. I like it now, but it's not the kind of work I prefer.

Until a few years ago, art teachers didn't want their students to paint realistically. Now they've relaxed, so we see more. There's a lot of documentary conceptualism – mostly very boring. . . . Frontal and symmetrical sculpture is beautiful and heroic – tough, strong, honest. (I don't enjoy "composed" sculpture – the Tony Caro look.)

Sexism: Every dealer is accused of some degree of sexism, be he male, female, or transvestite. I try not to look above the hand bolding the slide. I don't care if the organism doing the work is a scurrilous low-life Fascist . . . but I prefer beautiful girls. I'd like to show them all the time.

Genius Neglected: Given the circumstances of our community life, it's unlikely that an artist of major consequence will go totally undiscovered in his or her lifetime. I used to go to the "Delancey Street Museum" and see some wonderful art (by way of Rivington Street, the only place in the world where

you can see two men in the window of the Streits Matzoh factory making a living breaking matzohs).

We had no heat in the gallery yesterday – we had 300 visitors. (Mostly students. Art schools are constantly grinding out students.) There's a visual appetite, a need to look at things, at certain kinds of mysteries. But collecting doesn't hurt anybody. . . . If you know a major artist being neglected at this moment, please let me know.

Genius Triumphant. At Castelli we gave one man five shows. In the first three nothing sold. In 1963, one sold, to the ex-wife of the dealer (Ileana Sonnabend) for $235 less discount – and she got a big discount. We showed the same artist in 1965 and sold out the show. That was Cy Twombly, one of my favorite artists in the world. He was difficult and peculiar, not detected for a long time. But he was shown. His retail price is now $65,000.*

Myth Making. I'm reading in the magazines (I don't get them free because I don't advertise) an article on the *progress* of so-and-so's painting, by an important critic or museum director. There *is* no progress! He never *started* anywhere! He's terrible, a Sunday painter. It kills me. Six pages of *nothing* unfolding! How do these things happen? It's part of the general chaotic texture of life, plus certain minor conspiracies. If a critic has a strong voice and a coterie of disciples, certain dealers will agree, then certain museum directors will also agree, that this particular art is meaningful. The agreement doesn't make a fact, but it does make the art visible. In the late '60s, certain art was pronounced the only significant kind of art. Dealers and critics were looking for more artists to pour into the stew, so certain artists got more attention. . . . We have to try to maintain our equilibrium in the face of injustice – they call that maturity.

The Outlook. There are probably still 75 collectors. I haven't seen many of them lately. 1973 was a paragon year – probably never another like that – six of our 45 affiliated artists actually sustained themselves from the sale of artworks. Last year was the darkest year since 1945. This year improved, but I'm pessimistic about the future. In the '50s and '60s, 25 museums bought art on a regular basis; now only 5 or 6 do. MoMA has $20,000 a year to buy art. Albright-Knox has nothing. I haven't been in MoMA in 14 years – not spite, because they don't come to my gallery – but there's nothing to see. (I don't have to see Kupka. I know Kupka.) Right now the only place to see peculiar art is in a public gallery, but I don't think there's a great future for the commercial gallery as we know it. I don't have any other skills. I might go into politics.

The New York Times: The *arts* part of the *Times,* the world's greatest newspaper, is a shoddy piece of trash. John Russell is the worst instance of brain drain in the last 20 years. He doesn't know what he's talking about. (I worry terribly about the stamp page – they could be giving some really terrible advice.)

Co-ops. I started off in a co-op. I think it died from an excess of democracy. I run my gallery in a dictatorial manner. A certain degree of good central management holds it together.

Otherwise there's no reason a co-op shouldn't be as successful as a commercial gallery. I don't know why they're not. Good works will be sold to those who perceive them. There's no salesmanship possible. Maybe people prefer going into places of high style [but, for instance] Allan Stone is a holy mess. . . .

The Art Community. Writers despise each other and don't get together except to talk about how rotten some other guy is. Musicians and poets are troubled, turbulent and fragile. Painters and sculptors get together all the time . . . This particular district [Soho] in our time is going to be remembered as a fabulous time, an amazing thing. We're in the midst of it and should enjoy it.

Dealer Responsibility. I exhibit what's meaningful to me. That's not a public responsibility. A commercial gallery has no responsibility except to survive.

Lately doing the art-world equivalent of eating knishes – i.e. putting on Women's Shows – Karp is obviously planning to run for mayor. Equally obviously, a man who can say no to 60 artists a week and still get a round of warm applause in Soho, draw a full house on a bitter January night, and leave them starry-eyed, while telling some of the truth with such disarming candor, is wasted on Frontal and Symmetrical Sculpture.

— **Judy Seigel**

Women Artists News, February, 1976 [Vol.1, No. 9]

*In 1990, a Cy Twombly painting sold for over one million dollars.

And a note for non-New Yorkers: The line about "eating knishes" refers to the fact that NYC mayoral candidates traditionally eat ethnic food when campaigning. In past years, the knish, a kind of potato or grain dumpling of middle-European (especially Jewish) provenance, was emblematic. Today, there are specialities from around the globe to try the intestinally fortitudinous.

'76 / #25

Framing an Oxymoron

"Is Obsession Optional in Art?"

Moderator: **Sherman Drexler**; Panelists: **Judith Bernstein, Robert Delford-Brown, Mary Beth Edelson, Budd Hopkins, John Kacere, George McNeil**

Artists Talk on Art, NYC; January 16, 1976

There we were, sitting on the floor, surrounded by paintings of the New York skyline with penises and breasts shooting out of the rooftops, waiting to be enlightened about artists' obsessions.

Webster defines obsession as a persistent disturbing preoccupation with an often unreasonable idea or feeling. Everyone

on the panel seemed to be persistently disturbed by the dread possibility of being thought obsessive, even if, like Bernstein, they had depicted nothing but screws (hardware, that is) since 1969. The evening was a serious – if rambling – discussion of the semantics of the key word, which was variously defined as humanism, energy, intensity, commitment and compulsion, and included the following:

Judith Bernstein described her development from graffiti to screws, said she intends to repeat her theme until there is no energy left in the images, and answered the title question by observing that, obviously, if you have an *obsession*, it can never be optional.

John Kacere insisted he is not obsessive because he doesn't deal with his subject matter (women's backsides, legs, garters, etc.) for itself, but with life and sexuality as a creative force or energy.

Mary Beth Edelson protested the suggestion that obsession (or, as she saw it, repetition of subject matter) is somehow abnormal, and claimed obsessions can be forced on an artist by pressures of the art world: Galleries urge repetition for marketing purposes, or the artist may repeat himself louder and louder to get attention. Edelson's drumbeat comes from her anger at the omission of women from history and from art, its record.

Budd Hopkins, representing obsession in the abstract camp, said he needs a "dialog with an image" and invents ways to keep it. He cited Pollock and Albers as abstract artists who repeated an image, and told Al Jensen's story of Rothko, who said he couldn't forget the mass graves seen as a child in Russian pogroms, and may always have been painting them.

George McNeil added an historic perspective, noting that art changed with Blake and the late Goya when, for the first time, the artist became involved primarily with himself and his feelings, thereafter making art to "validate" himself. Such preoccupation with psyche could be called obsessive. McNeil said that after 1960 art changed again. Much of it is now externally oriented, even executed by others – no longer a strong expression of interior vision. But, "it is hard to think of anyone good who is not obsessive."

Robert Delford-Brown said his whole life is part of his art and that "energy" could be used instead of "obsession" to mean the life-force of the artist.

Audience contributions were more articulate and succinct. One woman commented that truly obsessive art, as done by psychotics, is repetitive without choice, while an artist may use repetition for emphasis, or to reach greater understanding. [*Applause*] And from a young man in the audience: "How can you be an artist and *not* have an obsession with art?"

– **Lynden B. Miller**

Women Artists News, February 1976 [Vol. 1, No. 9]

'76 / #26

Shake and Bake

"Changing and Stabilizing Directions in Women's Art"

Moderator: **Daria Dorosh**; Panelists: **Ellen Lubell, Peter Frank, Corrine Robins, June Blum**

A.I.R. Monday Night Program, NYC; January 28, 1976

After a couple of hours at A.I.R., one learned panelists had been talking about "Changing and Stabilizing Directions in Women's Art." Moderator Dorosh's questions *re* gender in art had little to do with panelists' answers. No one believed in Gender Art, though there were vague references to female sensibility, working small, being private, and so on. What did interest the panelists was the current drawing show at MoMA and what to do about it (five women out of 46 artists). Opinion here neatly divided: fight it or ignore it. Behind this split were differing responses to the establishment or, as it came to be called, the "pie." The fighters said MoMA is power and the place to show; the others argued "pie-ism" equals capitalism equals bad.

Which led to talk with the audience about alternative solutions to the big showcases. Same split here. Those indifferent to MoMA spoke of co-ops, changing the art (work small) and/or the audience (sell to feminists and the middle class). The picket-MoMA contingent countered that alternatives tend to be cut-rate versions of power. Who wants to show in Washington Square Park?, and, does your middle-class mother buy art?

As I left, the urge to *do* something had cut off stale talk. Sign-up sheets reflecting all possible positions from Slice the Available Pie to Bake Your Own were being circulated.

– **Susan Manso**

Women Artists News, March 1976 [Vol. 1, No. 10]

'76 / #27

Maybe Black and Blue

"Would a Yellow Artist Ever Paint Blue Balls?"

Moderator: **Anita Steckel**; Panelists: **Bernadette Hackett, Benny Andrews, Joan Semmel**

Artists Talk on Art, NYC; January 30, 1976

What began as another bland Friday night ended on the verge of a mass Primal, leaving the audience seething, but refreshed. "Would A Yellow Artist Ever Paint Blue Balls?"

was the mysterious – and never explained – title of an evening devoted to feminism, not eroticism, in art.

Anita Steckel, among whose phallus-sprinkled canvases the panel took place, began by asserting that "raised pinkies" and tasteful decorations don't constitute art, and capped a series of denunciations with "let them eat cock." Benny Andrews claimed, "There's little work around that really moves you." His images are based on the Klan and the American Flag – though we had to take his word for it, since he had no slides to show.

Bernadette Hackett showed slides of her "vaginal imagery" paintings, including a shower of red arrows around a vagina and a cactus to stand for painful intercourse, with a running commentary about women's gynecological miseries and humiliations. Joan Semmel showed faceless nudes, paintings of herself with intimate friends. All four said their work is not only inspired by real images, it's meant to project an individual, gut response to reality.

Prodded by Steckel's bitter wit, Hackett's sad, but true stories, and the general tone of the talk, many men in the audience were visibly disturbed by the time the panel asked for questions. In fact their display of anger, hurt, threatened feelings, even jealousy, was more interesting than the panel. One frustrated artist said his work was similar to Semmel's but less successful. Riled, he accused her of "hiding behind a banner of Women's Lib." He slipped and referred to the artist as "he," which brought a quick snap from Semmel – "She!"

Other comments: "This shows hatred of men." "Women are helping to fragment society." "You're neglecting the Oriental unifying pricipal [Yin & Yang]." A man told Semmel, "You're excluding men . . . portraying women, not a couple. The work is propaganda, *not* personal."

Semmel, whom we've never seen in better form, had roused the audience with eloquence, and been applauded for a well-displayed flash of temper. She replied (in seeming contradiction to earlier statements about individual gut response): "There is no such thing as an individual. We are all in a political-social situation. [T]he female has always been portrayed by men. You had all of history . . . calling it Greek Classicism, Orientalia . . . the whole genre of the female nude. Now it's women's turn, and we're hanging ours on Women's Lib."

On the way out my neighbor commented, "Those balls aren't blue – they're black and blue!"

– Bibi Lencek

Women Artists News, March 1976 [Vol. 1, #10]

American Art Is/Is Not Rockefeller Art

"Three Centuries of Rockefeller, or American Art at the Whitney"

Moderator: **Vivian Browne** [replacing Carol Duncan]; Panelists: **Carl Andre, Benny Andrews, Rudolph Baranik, Sarah Charlesworth, Carol Condé**

Artists Talk on Art, NYC; February 13, 1976

"Three Centuries of Rockefeller, or American Art at the Whitney" was another discussion in search of its subject. Panelists never found it. What came across instead was a general mood, a moral malaise about the state and status of art.

The ostensible subject of the panel, which attracted a big crowd, was the Whitney's planned Bicentennial, "300 Years of American Art," based exclusively on the Rockefeller collection.

Panelists objected to the show because American art is *not* Rockefeller art, because American art *is* Rockefeller art, because museums are mausoleums remote from "the people," because they are a symptom – or a cause – of art as commodity, and because museums perpetuate the very values, i.e. capitalist, sexist, racist, that art is against or *should* be against.

At least I think this contradictory summary indicates the range of panelist opinion. The talk was confused and the audience said so. The audience also soon got around to the ironic confession that, being corrupt creatures, they want to show in major museums. And, along with the panel, they noticed that minorities need museums. Black and Chicano artists use street walls to reach "the people," but their work is destroyed by the bulldozer in a civic act known as urban renewal.

Current art politics and the new left have much in common. Both have a vision of the good life that is somewhat dictatorial – in art's case about what to paint and for whom. Perhaps the panelists do not mean to legislate. But, even this simple protest raises complicated issues. The positions are familiar – from Sarah Charlesworth's preference for "a healthy society over beautiful objects" to Carl Andre's bid for *Kunsthalles*, like the Soho Center itself, to show living art, a "constant flow of art."

Some want museums to function as cathedrals. But museums are not cathedrals. They cannot reflect an integration that died with the Middle Ages. Art today is a commodity, just another object. Protesting Rockefeller's inordinate cachet makes political sense, but will not alter that fact. For our time, Rocky is God. Nor does the attempt to alter who shows what, where, and when question whether world transformation can be achieved by canvas.

I said the panelists' ground was familiar. So is mine. My source is Duchamp's work and I don't see how the more radical panelists (in this case, Sarah Charlesworth and Carol Condé) can fail to see that their logic takes them to his doorstep. From there, much of this talk sounds self-indulgent – and old-fashioned at that.

– Susan Manso

Women Artists News, March 1976 [Vol. 1, No. 10]

See also '76/#23 and footnote about change in the show's title.

'76 / #29

New Medium for Portraits: Paint

"Portraiture In Art"

Moderator: **John Perreault**; Panelists: **Tomar Levine, Sylvia Sleigh, Alex Katz, Shirley Gorelick**

Artists Talk on Art, NYC; February 20, 1976

Portraiture, that mirror of the soul, glorifier of patrons, vanished from the recent art scene, seems to be back with us. Several shows of works by portrait artists opened in February, followed by a spate of magazine and newspaper articles. A large crowd turned out to hear the topic discussed.

Three panelists showed slides of their work (the fourth hadn't known slides were to be shown) and discussed what they had been working for in specific pictures.

Sleigh and Gorelick showed large complex compositions including several people. Perhaps group interaction was really the subject, though they came across more as elegant compositions, revealing little of the people involved beyond physical particularities. Tomar Levine showed several portraits of women in smaller scale, including self-portraits, which seemed to capture an essence of her subjects. Alex Katz's stylized portraits are set in lovely landscapes, and though he didn't bring slides, he was a lively and knowledgable panelist, adding humor when things got stiff.

One of the more interesting questions from the audience was how painters feel about commissioned portraits. Gorelick and Sleigh, whose paintings dwelt least on their subject's personalities, felt they could not paint people they did not know and like. Levine and Katz said they find painting an unknown person a challenge – a proof of professionalism, perhaps.

Another vital question batted about was whether a portrait must be a character study as well as a likeness. Panelists seemed to agree likeness is important, but beyond that the

artist must decide what the object of the painting is. Katz pointed out that with the variety of styles around today, patrons have a choice, too – of what style they want to be painted in.

– Mary Smith

Women Artists News, March, 1976 [Vol 1, #10]

'76 / #30

The Curator's Lot

"Changing and Stabilizing Women's Art from the Curator's View"

Moderator: **Mary Beth Edelson**; Panelists: **Barbara Haskell, Marcia Tucker**

A.I.R. Monday Night Program, NYC; February 23, 1976

Back at A.I.R. again, there was at last an exception to panel chaos, perhaps because only two panelists, both of them Whitney curators, showed up. With Mary Beth Edelson moderating, their talk was focused. "Changing and Stabilizing Women's Art From the Curator's View" was the title, but discussion was about the woes of the curator.

Having asked that the curators be welcomed (this was not the night to attack the Whitney Bicentennial or museums in general), Edelson enumerated "areas of exploration" in gender art. But both curators swiftly scotched the notion, insisting that "really good art transcends all categories." "I try," said Marcia Tucker, "to look, not categorize. Analysis comes from staying with the work for a long time. There is no need to be self-conscious about women's art, as we were in '71. There's enough out there – good, bad and indifferent – to choose from."

Both agreed that the women's movement influenced the current open climate in art. Barbara Haskell thought, however, that this was simply one facet of a larger cultural shift, a turning inward reflected in everything from est to Jesus Freaks. "The personal integration of the individual is the new myth."

On the poor representation of women in museum shows, Tucker said current shows still reflect the past. "When they do the decade of the '70s, women will come into their own."

As for the museum's role and their own, neither curator was optimistic. "One thing this job provides you with is a certainty that you don't get to see art," said Tucker. She explained that curators are overwhelmed with extraneous work and are caught between the institution's Big Business approach – the razzle-dazzle show – and the Art Experience – getting good work shown. She stressed that the museum must preserve its autonomy. When the eggs and tampax hit

the windows some years back, "it messed us up. I feel a deep despair, because we're working for the same things that the artist wants, but we may not be able to work together."

The audience was unusually docile, perhaps because the speakers were both forthright, outspoken feminists. (Tucker dates her conversion to 1969 – "like St. Pauline on the road to Damascus.")

— Susan Manso

Women Artists News, March 1976 [Vol 1, No. 10]

'76 / #31

"Painting Now" Bombs

This report and the following one were originally published together under the title, "'Painting Now' Bombs, 'Whither Painting' Flies." But whatever the performance of individual talkers, a strong and growing interest in painting was evident. As Peter Pinchbeck put it, "Even art forms that pushed everything but painting are interested in painting again." Gregoire Muller disagreed, but then he had to concede that nothing else had the power, either. A man in the audience declared that the greatest painting is yet to be.

"Painting Now"

Moderator: **Carter Ratcliff**; Panelists: **Ernest Briggs, Howard Buchwald, Pat Passlof, Herb Schiffrin, Joan Thorne**

Artists Talk on Art, NYC; March 5, 1976

The Artists Talk on Art series is a Friday Night Trip Into The Blue – you pay your dollar and you take your chance; no refunds after the doors close. Fair enough. But a certain truth in packaging is in order. "Painting Now" opened with the announcement that Philip Guston and Edward Dugmore had "the flu." The overflow audience (more than 200 paid admissions, many turned away at the door) groaned in disappointment.

Philip Guston was in fact hanging his show, which opened the next day. The commitment should not have been made – or extracted from him. Edward Dugmore, questioned later by telephone, said he had refused the invitation outright, having "had enough panels."

Calling a talk by four Abstract Expressionists and one drawer in 7H pencil "Painting Now," an act of near-terminal wishful thinking, was not remedied by Carter Ratcliff's disclaimer that it was supposed to be simply an opportunity for painters to talk. Moreover, *talkative* is not a synonym for *articulate*, and even articulate is not enough. The obvious and inane, however clearly expressed, are not worth missing the re-run of *Blazing Saddles* for.

Ratcliff, usually the most knowledgeable and provocative of critics, spoke little, and did not moderate. Pat Passlof was good when somebody coughed and she could get a word in. Joan Thorne remains in memory for her announcement that she titles her paintings according to sounds she hears from them, as, for instance "'Ka,' a sound I heard from the center." The discussion was dominated by Howard Buchwald and Ernest Briggs. A fair sample is this from Buchwald:

"I haven't been very interested in what's been said because I'm a little uncomfortable taking an argument about painting at face value. . . . Anybody who tells you what they're doing is going to be boring, not boring [added quickly], but not interesting. I mean we've heard it before. You have to re-establish a way of dealing with banalities. It's a kind of boring act . . . "

The audience began tiptoeing out.

As a service to readers, I have culled from the long gelatinous mumble of unconsummated adverbial phrases and stray bits of encounter-group lingo a few nice points and relatively bearable moments. Do not think this means you missed a lively evening.

Briggs: I had to consider interiorly a response to a lot of stuff I categorically cannot think of as paintings, [things that use] an immigrant language from pseudo-science, half understood, half exploited and pretentiously presented. . . .
Ratcliff: You're talking about working through to a painting that has not been seen in a climate of things you don't see as painting?
Briggs: You can't talk about contemporary ideas by painting *pictures* . . . I can't deal with my own experience in terms of *representation*.
Passlof: We're all brainwashed into thinking artists have an audience Museums do things so they can have a bigger audience.

Then some other people get into the act and that's what happens to art. We're left with the clumsy notion from the '30s that art has to do with communication. . . It has *nothing* to do with communication.
Buchwald: Recurring strategies to the problem of working in a vacuum underlie all art since the '40s . . . You have very few outside props to support you in terms of belief.
Ratcliff: The problem is an incredible pluralism which gives the impression of a vacuum . . . but even if the same problems recur, they can't ever be the same. . . .
Audience: It seems to me, Carter, that the whole state of consciousness of the panel you've selected isn't any more advanced than 1965 . . . saying there isn't any place to go. You're a leading critic. Aren't you going to say something to sort of inspire us?

Laughter, at last. This also got Ratcliff part-way off the hook, letting him say he hadn't selected the panel. (Briggs had.)

Passlof: I don't feel I'm in a vacuum, but I don't feel in the spotlight. People looked at painting 10 or 20 years ago. Now they're not interested. In some ways that's better for painting, which isn't really suited to the media. We're really not

news. We have to be left alone. But some people feel they're failing [if they're not in the spotlight].

The audience stupor was such that the evening was three-quarters over before one of them thought to invoke that great Mexican artist, Sequeieros-Orozco-Rivera, as an example of how to communicate with the common people.

Ratcliff: You're demanding that people doing something in a particular way do it in a way you would like better, that someone who is a very private person go public.

Passlof: If you don't like [what we do], do it yourself . . . Everybody's work is their statement about what's wrong with everybody else's.

Briggs: You want painters to start the revolution.

Audience: Not necessarily start the revolution, but at least plant a few seeds – not just do Mannerist painting. . . . The Futurists were the only artists who tried to start the revolution. . . .

Briggs: The Futurists did really bad art.

– Judy Seigel

Women Artists News, April 1976 [Vol.2, No. 1]

'76 / #32

Whither Painting Flies

"Whither Painting?"

Moderator: **Edvins Strautmanis**; Panelists: **Frank Bowling, Marcia Hafif, Gregoire Muller, Peter Pinchbeck, Patricia Sutton**

Artists Talk on Art, NYC; March 12, 1976

Whether the painters of the "Whither Painting" panel are going to be the ones to take us "whither" is hard for a stranger even to speculate. They had agreed not to show slides, on the grounds that "slides vitiate the work," and in order to "remain theoretical" (Pinchbeck). But in an evening of crackling intelligence and contagious conviviality, the atmosphere was such that the phrasing of a question could be as satisfying as finding an answer. The panelists, who knew each other, and had done a warm-up the night before, were relaxed and self-confident enough to make connections and search for meanings. One felt ideas were fluid, evolving in response, not pre-set; and that questions were put out of genuine interest, not to score a point. The tone, expressions, accents, rapid-fire exchanges and asides – no small part of the charm of the event – are not transcribable.

We begin, again, with Abstract Expressionism:

Gregoire Muller: In the whole of modern art there are very few great artists, and they're beyond style. The forms of Abstract Expressionism weren't satisfying as such, although there were some very intense painters. [But] a faith in painting shared by all painters has been kept alive against the odds by New York painters.

Frank Bowling: We speak as if Abstract Expressionism was the first kind of painting style anyone experienced. There were others before that, but Abstract Expressionism brought, not just the style itself, but a whole new reference for painting, a tremendous catalyst.

Patricia Sutton: The new acrylic paints gave a somewhat different look [to Lyrical Abstraction] but the ideas were much the same. . . . For a visual person, painting is the ultimate thing. There's a tremendous desire to paint, to make a picture. For me to make a gorgeous sort of 18th-century oil painting, like a Gainsborough, is the most beautiful thing I can imagine. Today someone [must] get known for an intellectual or verbal talent. After they've gotten recognition, they can let their hair down and *paint.*

Bowling: You mean most conceptual artists are secret painters?

Muller: Why can't I paint like Gainsborough? . . . I haven't seen any landscape that has that kind of power.

Marcia Hafif: The intensity might be possible, but we're living in a different time.

Bowling: There are probably high rises near Salisbury.

Sutton: I really mean paintings like my grandmother had in her house when I was a little girl. They were magic to me . . . Today's children will remember something else.

Hafif: Like Motherwell!

Muller: The greatest painters sum up the knowledge and feeling of their time. They stand out more than any leaders or politicians, the way Vermeer and Picasso do, for example. You move colors, but you're also doing something with social potential.

Bowling: But I thought American abstraction operated in a total vacuum from outside pressure. Art may register some kind of temperature chart of what's going on, but it's not as articulate as reading the *New York Times* every morning. . . .

Hafif: Why do movements occur? By individuals who see a solution. But why do they happen, and why decline?

Muller: Artists tend to focus on particular concerns. For example, it's hard to say there is any true Minimal artist, although there is a Minimal period in New York. In painting there's a Minimal *feel,* even if the work isn't Minimal.

Sutton: I was working alone, doing a certain kind of painting, and someone came along and said oh that's Lyrical Abstraction. Then I looked at other people's work and found I was doing something similar.

Edvins Strautmanis: What about newness?

Peter Pinchbeck: Now we see the fallacy of the new. That's why conceptual art is on the wane. The idea was that you had to be shocked every time you went into a gallery. You went into a gallery and saw a man on horseback – after a while you just said oh yeah that's a man on horseback.

Hafif: But if you're working on something you thought you developed yourself, and then in a few years it seems like the whole world is doing it . . .

Sutton: Yes, then there's the urge to move someplace else.

Pinchbeck: Last week's panel kept referring to the vacuum. Yet now we have bigger galleries than ever before. At the

time of Abstract Expressionism there were a few poky little galleries on Tenth Street. Yet people really believed in *art*.

Sutton: I heard Motherwell say at a lecture that he enjoyed it more then, that now there's a show biz, circus atmosphere.

Pinchbeck: At the time of Abstract Expressionism there was a real gulf between the public and art. Most people didn't like that kind of painting. Then, we had Pop Art – and Andy Warhol pillows were everywhere. In the '60s the paintings looked like tie-dye, and the public felt at home with it.

Sutton: Now painting is becoming more private, as if painters are trying to push the public away.

Pinchbeck: Even art forms that pushed everything but painting are interested in painting again. [There was] a sense of missing something, of a vacuum.

Muller: I stopped painting because I saw other types of work which seemed to me to have so much more efficiency. Painting now doesn't seem to have the power to inspire the consensus – but nothing else does either. Five or six years ago it looked like other things had the power.

Pinchbeck: There's a kind of visual satisfaction in a painting you don't get in other forms.

Sutton: The role of the artist has changed from the time of the religious painters. Now there's a feeling of disappointment, that it doesn't matter very much. As a teenager I was so inspired – now I see it doesn't mean what I thought it could. You say nothing else does either, and that's the predicament.

Hafif: I paint because I like paint. The most satisfying thing is the experience – a very quiet, good thing to do. The real rewards of painting are painting itself.

Sutton: In the '60s I was so in love with painting I didn't realize the powerful statement I might make. Then I saw my painting at the Hirschhorn. People were looking at it – from Virginia, with Southern accents – and I thought, oh my God, that's a chance to express my sense of values, the things I care about.

Hafif: Painting develops an ethical way of viewing the world, a set of criteria for how things are *right*. . . .

Muller: If we can speak of ethics, or joy, love, responsibility, in art, then painting is not this thing it was reduced to after years of reductionism. It was overly purified by someone like Ad Reinhardt.

Strautmanis: Certain taboos exist, the idea that certain things can't be done at a certain time. Is it true that painting can't deal with humor, the self, literature, exoticism?

Sutton: I felt in the past certain sanctions about what's right and what's wrong. In the early '60s I loved Cornell. In the late '60s I got very hip and thought he was so *literary*. Later I realized that whole way of thinking was off – Cornell was a very good artist. There aren't any rules and it's a mistake to think that way. It's academic!

Muller: When you want to protest a certain aspect of society you may not want to see a painting that's only beautiful – but the painting is still beautiful.

Bowling: In order for painting to solve social problems, what we have to do is educate all the social-problem-solving types into painting.

Audience: I think painting now is like the two cavemen sitting around – one hummed a tune, and the other said, "that doesn't sound like a bird," and the first one said, "but it's *music*." I think we're just beginning to get to that point in abstract painting. It's all ahead of us – like Morris Louis did a scale

– Judy Seigel

Women Artists News, April 1976 [Vol. 2, No. 1]

'76 / #33

After Rembrandt

"Painting Oneself"

Moderator: **Selina Trief**; Panelists: **Robert Beauchamp, Sherman Drexler, Paul Georges, Marcia Marcus, Juanita McNeely, Robert Henry, Dee Slack**

Artists Talk on Art, NYC; March 19, 1976

When Philip Pearlstein says he paints only what he sees, he is mistaken. He paints a subjective reality, and inadvertently gives us a series of self-portraits. Alex Katz is another painter who reveals himself against his will. One of the more notable insights of this evening's discussion of self-portraiture was that a unique process is involved, which can be either conscious or unconscious.

Juanita McNeely starts very consciously with a specific aspect of herself or a specific feeling. Then she attempts to strip away cliché elements from the image and to play with its plastic qualities. Her ultimate intention is exploration of woman as individual and the shared experiences of women – a "universal" self-portrait.

For Sherman Drexler, self-portraiture is a reminder of who he is and who is engaged in the process, a way of staying in touch with himself during the act of painting. "In painting yourself you are forced to work with everything you've ever known."

Dee Slack paints herself rather than others as a device she finds forces her to greater honesty. (The question of the relative integrity or "morality" of self-portrait was raised several times.)

Robert Henry said artists turn to self-portraiture in a desperate effort to find any meaning at all in their work. Subjects that were once available to art are not now viable, he observed. There is no common myth, as glorification of religion or state once was, and we have run out of meaningful subject matter. Left with only the self, we glorify it for want of anything else to believe in.

Robert Beauchamp had been an Abstract Expressionist, but found that leading to a dead end. When the possibilities for

formal variation are endless, he said, they become meaningless. He turned to self-search – focussing on the way he breathes, stands, the way his muscles feel – and meaningful form came more easily. The limitations of his own existence are used to limit the possibilities of expression, to concentrate and focus energy.

The panel disagreed about whether turning inward entails greater risk than more exterior explorations. Paul Georges said there is no risk at all in self-portraiture – that if you painted 35 angels flying down to save mankind, *that* would involve risk. For McNeely, self-portrait is riskier than most other aesthetic enterprises. But a member of the audience quoted Alice Neel's statement that self-portrait is too self-indulgent. Drexler called it masturbation, a metaphor he didn't seem to intend negatively. It's part of the human condition to examine yourself, he said, and the act is both revealing and not revealing.

This is an interesting point, because it's often overlooked that self-portrait is not necessarily self-revelation. An artist can use her or his own visage to baffle, tease or seduce. Henry hinted at this in describing his decision, after having done uncomfortable, frightening pictures, to make the paint surface more seductive. Thus distancing the viewer from the subject made it less frightening.

Is it obscene to turn oneself inside-out in public? Must the artist gold-plate her or his guts so they become more attractive? Is there a market for public dismemberment or catharsis? Does the self-portraitist use the gallery as a confessional? Will the public pardon us, or will we be excommunicated, and which is preferable? Do we hope to confront and shock, or to share and comfort? What does any of this have to do with making art?

– Sharon Wybrants

Women Artists News, May 1976 [Vol. 2, No. 2]

'76 / #34

Milestone at the Met

It was a major milestone in the women artists' movement when major critic Lawrence Alloway lectured at the Metropolitan Museum on contemporary women artists. Sylvia Sleigh agreed to cover the event for *Women Artists News.* Citing other wives writing about their husbands, she said, "the difference is, this time a painter is writing about a critic." A far more significant difference was that this time the relationship was stated.

"Women Artists of the '70s: Lawrence Alloway at the Met"

Metropolitan Museum, NYC; March 21, 1976

I was pleased, but slightly shocked, to be asked to review Lawrence Alloway's lecture. There are precedents however: women critics have felt they can support their husbands' interests in their writing, in line with the tradition of women serving their men. Dore Ashton as Adja Junkers's wife and Barbara Rose, when she was Frank Stella's, were my models: the difference is that this time a painter is writing about a critic.

Some of the artists present that Sunday in the Grace Rainey Rogers Auditorium told me what a lift it was to see their work on the large screen at the Met. We hoped it was a presage of things to come.

Alloway started by remarking on the numerical density, stylistic diversity, and aesthetic excellence of women's art in the '70s. There is, he said, a substantial body of work, of which he could show only a small sample, in its scope unlike anything that could have been seen earlier. Using two projectors he divided the slides into five groups.

1. *Environmental works.* In implicit opposition to the cliché of small-scale domestic skills in women's art, Alloway showed women artists dealing with problems of scale and large spaces, including such big outdoor pieces as Anne Healy's *Lion Gate* in Hammarskjold Plaza; Pat Johanson's *Stephen Long,* a two-foot wide color-field sculpture slicing through 1600 feet of countryside; Athena Tacha's projected multi-step sculpture for the banks of the Charles River, and indoor environments by Cecile Abish, Kazuko, and Judith Bernstein.

2. *Modules and Fields.* Alloway argued that the formal terms of all-overness and of serial form are being brilliantly used by women artists. As examples of modular forms, he showed the work of Patsy Norvell, Blythe Bohnen, Joyce Kozloff, and Mary Grigoriadis.

Fields were exemplified by Michelle Stuart's huge graphite drawings, Kate Resek's pulverized pastel and acrylic grids, and Barbara Coleman's striated paintings of gravel bonded with plastic. Alloway included Helene Aylon here, showing two stages of one of her "paintings that change in time," in

which progressive stages in the paint chemistry modify the field.

3. *Subject matter (including sexual themes).* This section included Maureen Connor's breathing flowers, in which the rhythm of the body is transferred to giant flower forms, and Rosemary Mayer's *Galla Placidia* (a Roman Empress), a soft sculpture of abundant draperies, a mysterious, implied female presence. By comparison, May Stevens's use of the American flag as drapery shows the danger of flag waving: her pictures imply, not an enfolding female, but a covert male presence. Sharon Wybrant's *Self Portrait as Superwoman,* an over-life-size drawing, is part of a group of heroines projected for a Sister Chapel, which Alloway said could be a notable contribution to the long-awaited legible iconography of women in political terms.

4. *Realism.* Alloway took Cynthia Mailman, Lucy Sallick, Audrey Flack, and Susanna Shatkin as representatives of the various shades of realism in which women artists have excelled. Even an artist like Alice Neel, as old as the century, he argued, is now receiving belated recognition in part because of the changed values brought about by the pressure of younger women.

5. Alloway concluded by stressing paintings which manifest what he called the *Women's Viewpoint.* He showed Jane Kogan's *Interiorized Self Portrait* (a kind of female flasher image) and Martha Edelheit's male nudes, as well as Tomar Levine's *Night Bedroom* and a painting of mine, to represent women's desire, love, and affection as part of the content of women's art. Joan Semmel's more explicit erotics were cited as examples of the expansion of sensibility and iconography now available to women.

Alloway insisted on the freedom and relevance of women's art and reminded his audience, in his last slide, of the political potential of what he had been discussing. He showed a Nancy Spero collage, with the inscription, "Papa's little bed pal – lump of love," as a gaunt reminder of one of the ways in which male expectation of female compliance can be construed as "normal."

– Sylvia Sleigh

Women Artists News, April 1976 [Vol. 2. No. 1]

'76 / #35

Modern Art Is Really About Complexity

"Collage"

Moderator: **Budd Hopkins**; Panelists: **Fritz Bultman, Ira Joel Haber, Therese Schwartz, Marjorie Strider**

Artists Talk on Art, NYC; March 26, 1976

It was a small crowd, mostly couples sitting quietly up against the wall under large collages. The highlights of the evening were Budd Hopkins's thoughtful exposition of what he called a "collage aesthetic," and Ira Joel Haber's tense descriptions of his outlook on life and art. The rest consisted of attempts to define collage and observations on collage as a reflection of the incredible complexity of modern life.

In Hopkins's view, all 20th-century art (painting, poetry, etc.) has a common attitude. Since Picasso, he said, artists have been juxtaposing contradictory materials or thoughts within each work of art. He mentioned the growth of films (which are literally spliced together) as both an influence on and an expression of this phenomenon. As Hopkins sees it, the result is an uneasy relationship attempting to establish harmony. (However, the claim was made later from the audience that the goal of art is not harmony, but *tension.*) Clement Greenberg's theory of the reduction of elements is absurd, Hopkins said. In fact, collage and contemporary art itself are both about *complexity.*

Panelists showed slides of their work, demonstrating different uses of collage, however loosely construed. (One imagines the moderator may have stretched a point to include a friend or two.) Fritz Bultman does collage paintings which, he explained, were built from the center out with painted papers. Hopkins himself showed large collaged panels. Ira Joel Haber's sculptures are tiny villages of doll-sized houses and burned trees in boxed worlds. Marjorie Strider is a sculptor of fruits and vegetables, sometimes reacting to her environment with foam cascading down a staircase. Therese Schwartz showed collages that started with the *New York Times* and evolved into recent paintings of color areas. She accompanied the work with a statement about her life and art in the '60s and '70s.

In a style straight out of Woody Allen, Ira Joel Haber explained that he was motivated to do his tiny boxes by fear of the out-of-doors: "I feel my greatest strength is my paranoia." Asked how he would respond if Henry Geldzahler offered him a commission to do a ten-foot high piece for the Metropolitan, he paused, then said very softly, "Oh, I'd do it alright – but it would be only five inches high."

– Lynden B. Miller

Women Artists News, March 1976 [Vol. 2. No. 2]

'76 / #36

And Then We'll Dissolve the State

The "Marxist" viewpoints are familiar. What surprises is that in 1976 we could still print the term "social *man*" without comment – although whether the usage is Lippard's or the writer's is not clear.

"Art and Class: Some Marxist Viewpoints"

Moderator: **Patricia Hills**; Panelists: **Kevin Whitfield, Kay Brown, Alan Wallach, May Stevens, Lee Baxendall, Lucy Lippard, Amiri Baraka, Carl Andre, Leon Golub**

Artists Space, NYC; April 9, 1976

The panelists did not all profess to be Marxists, but each addressed the question of being an artist, art worker, or cultural worker within a class system. The function of art and its translation from a visual object to a Marxist statement were treated from various political and art-world points of view. As with most forums of this kind, alternatives were debated, but no course of action was ratified.

Patricia Hills enumerated three options for the artist in a class system: Acquiesce (produce what will sell); ignore the situation (work in the studio untouched by the needs of the working class); or fight (organize other artists, eliminate gallery middlemen, expand the art audience).

Kevin Whitfield said the class struggle will not succeed until we demolish the myth of superiority of the high priests and teachers who reign over all our cultural domains. The ideals of education are used to defend hurdles which block all but the most gifted, he said, while artists hustle without thought.

Kay Brown said that, as a black woman, she is reluctant to respond to either Marxism or feminism – white ideologies. For black women, single motherhood and women as heads-of-households have been givens for years, she pointed out, whereas for white women these are causes.

Alan Wallach discussed the ideological mystifications of art and class and the social institution of art, in which the art experience is a social practice, fulfilling social needs.

May Stevens introduced herself as a theoretical Marxist by presenting her family background. Her politics could be inferred from accounts of her government-employed "sexist, racist" pipefitter father, as well as her quotes from Susan Sontag.

Lee Baxandall said that, although the artist's vocation is voluntary, oppression is experienced from the first arrival of the work in the market, a market which changes the artist's labor into a commodity. He favors revision of the present U.S. Communist Party to advocate action within the American political system to dissolve the state.

Lucy Lippard considers herself first and foremost a feminist, not a Marxist. She spoke of "idea art" as a function of social man, tied to both life and the environment. This "art for separation and a certain audience" reflects a social function, and has little contact with other audiences, she said, adding that street art dragged into the gallery is no solution.

Amiri Baraka [the former Leroi Jones] advocated an art for the working masses which would raise the level of the people's consciousness. With quotes from Mao Tse Tung and other non-artist Marxists, Baraka offered no specific means of promulgating such non-gallery art, only a vague notion of more buttons and posters. Using the rhetoric of violence, he proposed the seizure of power by revolution, with artists taking an active role, literally fighting machine guns with machine guns. The violent wipe-out of the ruling class is necessary for change, he said: "Revolution first and foremost!"

Carl Andre presented an analysis of his own class position: worker *and* petty capitalist interested in his own product, member of bourgeoisie *and* working class. But, he said, he is a Marxist nonetheless. Andre, who sees no particular art as morally or politically correct, does not consider art a form of communication. He finds art's power to be *the art*, conveyed as it is meant.

Leon Golub said all Americans participate in the reward system of imperialist power. All art reflects its social origins; the success of American art is related to the success of American society. He discussed art as derived from surplus, which in turn becomes a commodity in the sale process, and speculated that much of the artist's familiar claim to freedom of action is bought at others' expense. The artist is "but a server, working in the cracks of the system."

— **Carol De Pasquale**

Women Artists News, May 1976 [Vol. 2 No. 2]

'76 / #37

Daring to be Decorative

Not that long ago, painting itself had been declared dead. Now permission to do *decorative* painting was being granted artists by themselves and a very few critics. This discussion is a reminder, lest we forget, of (a) just how fast things move in today's art world and (b) how wrong "they" usually are.

"Is Painting One of the Decorative Arts?"

Moderator: **Amy Goldin**; Panelists: **Robert Kushner, Brad Davis, Cynthia Carlson, Joyce Kozloff, Jane Kaufman**

Artists Talk on Art, NYC; April 9, 1976

The question of the evening was never answered.

Amy Goldin, the moderator, did not provide the necessary focus for this potentially exciting discussion, and the point was lost in a maze of minor side issues, undefined terms, and the defense of painting as a valid means of expression.

Members of the panel had divergent approaches to decoration in painting:
Robert Kushner: a sophisticated sensibility combined with kitsch nostalgia, enjoyably improbable patterns for costume design.
Brad Davis: baroccocco with a glance at Tibet.
Cynthia Carlson: heavily textured, obsessively gestured, impastoed grids.
Joyce Kozloff: intricate, closely painted patterns in a strongly formal context.
Jane Kaufman: subtle to the point of nearly invisible atmospheric paintings using metalflake.

Panelists showed slides and told how or why they came to investigate the use of decorative elements in art. Robert Kushner leapt with both feet into the field from the first. Brad Davis accepted decoration only gradually, then became a firm convert. Cynthia Carlson made her connection with decoration through a choice of painting tools – the tubes and nozzles used for applying icing on cakes. (Considerations of her work aside, Carlson does not seem to be a clear example of an artist using or promoting decoration. Jane Kaufman's presence was also a puzzler. Her work comes from such strongly formalist bases – Reinhardt, field painting – that only her use of a particular material in a recent series of paintings made her inclusion comprehensible.)*

Joyce Kozloff, who has at other times discussed decoration with perception and clarity, said "decorative" should be redefined to remove its pejorative meaning. This struck one of the resonant chords of the evening: the beleaguered artist using formal devices not in wide current use.

The point also suggested that the purpose of the panel was two-fold. The first object was to present the use of decoration as an innovative move for painters – a new direction. It was accurately observed that decoration has not been fully

expressed in Western art since Matisse. Clearly the field is wide-open for reinvestigation. The second object of the panel seemed to be to justify interest in an area that many consider lightweight. The justification was at times overly sentimental, with many references to the "myth of the noble savage." Links with Third World peoples were emphasized to imply a vigor, purity and political rightness in the use of pattern and ornamentation. It was left to audience member Max Kozloff to mention decoration in 20th-century art – the Symbolists and Fauves for example. Had these points been fully developed, the panel could have been explosive.

The group had met the previous evening and agreed on terms and definitions, which would become clear, the moderator assured a heckler, as discussion progressed. This never occurred. Words like "pattern," "decorative," "grid," and "rhythm" were used in a special way not shared with the audience.

Moderator Goldin opened the question period with, "Would you object if a chair were placed in front of your painting?," and the discussion was off to a slow and murky start. A pointed barb from the audience raised the issue of differentiating between paintings with patterning and wallpaper. The question, which was clearly hostile and sidetracked answers into a defense of painting, did call attention to the line on which artists must balance when using decorative elements.

Kozloff said she feels she is violating a taboo by using pattern, which separates her from other contemporary painters – a point almost instantly nullified by panelists who said most abstract artists are involved with decoration. (But are we really to believe that Kushner's costumes spring from the same impulse as Larry Poons's lozenges?)

When Goldin said the panelists were not involved with intellectual concerns in their work, Kaufman immediately disagreed, and Kozloff made one of the memorable quotes of the evening: "Just because a painting is grey doesn't make it intellectual." Tony Robin's summation from the audience – that the panelists were involved with a degree of visual pleasure, spatial complexity and pattern – was generally accepted, but many areas were left untouched.

How are these painters different from or similar to other contemporary abstract artists? What role, if any, does emotional expression play in their work? How do they feel about craft connotations? What is their aesthetic reference point? These issues have yet to be addressed.

– Lenore Goldberg

Women Artists News, May 1976 [Vol. 2, No. 2]

*Both Carlson and Kaufman went on to produce work that was clearly "decorative" or decorative-compatible. (Kaufman subsequently made screens and related decorative objects, then became a quiltmaker, having a one-person show at the Museum of Contemporary Crafts in 1990). However, these comments show that an art movement, especially one arising spontaneously, rather than as a marketing construct, can be various and contain many ambiguities, especially in the formative stages, before familiarity and "common knowledge" smooth things out.

'76 / #38

Nature Heightened and/or Flattened

"How Real Is Realist Painting?"

Moderator: **Pat Mainardi**; Panelists: **Robert Birmelin**, **Gretna Campbell**, **Lois Dodd**, **Charles Cajori**

Artists Talk on Art, NYC; April 30, 1976

"How Real is Realist Painting," was re-phrased by a member of the audience to, "does seeing resemble pictures?," and, "does the picture resemble what you see?" But the subject was dealt with only in a limited sense.

The panelists and the moderator were all in genial agreement with one another philosophically and in approach to painting. All were painters of landscapes or interiors who seem to feel it is neither possible nor desirable to accurately or objectively depict "nature" or "reality," that artists are guided by subjective impressions to an *interpretation* of reality.

A more diverse panel, including Photo-Realists, Trompe l'Oeil painters, Expressionists and Painterly Realists, some of whom might be trying to render things "just as they are," and others whose interpretation is *completely* subjective, might have sparked some disagreement to focus and deepen the discussion.

The Slides:
Birmelin: Interiors, scenes of furious domestic conflict, distortions of perspective, and figures in motion, as in photographic motion studies, "a puzzle concocted from memory in the studio."
Dodd: Man-made objects in a natural setting, forest scenes, a ladder leaning against a tree, a chair on pine needles, still life on a tree stump. "My work is done all from a spot, on that spot."
Campbell: Turbulently painted summer, autumn, snow, landscapes, painted at the same place in the same spot over the years, with changes coming from emotional involvements. "Memory reasons" for the paintings.
Mainardi: Summer paintings – cars in a junkyard. Winter paintings – interiors. Motion, flux and disintegration. Because of the "structure of the visual experience" certain paths in the set-up become more real than the objects, and parts become less important.
Cajori: Figures. Shapes fragmented, almost losing identity, working from direct observation into imagined situations. Some paintings "destroyed themselves."

The Discussion:
Campbell: It's impossible to copy nature. Anything we do is an interpretation, since nature is infinite. We participate and interpret as humans . . . through cultural structures.
Cajori [quoting Bonnard about painting flowers]: I work about one-half hour from the flowers and then they are too

much and I have to get away . . . Cézanne was fantastically armed against nature. You really paint and draw what you mean, not what is there.
Birmelin: There are certain heightened moments which one would like to be able to paint. . . . Sometimes, moving through a crowd, the whole world seems to come together in that moment.
Dodd: [I added objects to the landscape when] something about the natural setting wasn't satisfying. . . . I wasn't able to finish. The devices closed the space . . . helped solve the confusion. After a while I didn't need them, went back to the trees themselves.

Birmelin answered an audience question about the relevance of realist painting in the age of Watergate by expressing regret that we haven't produced artists to deal with the larger issues of society. Cajori responded that it's a sign of the still-humanness of art that it's involved in a deeper, extended kind of revolution, not short-range political motion.

Then more on seeing in painting:

Dodd: You take your trappings with you and force your seeing to see the painting which you then paint.
Mainardi: When you pass something you've painted . . . ?
Dodd: It's dead. I've used it up.

I wonder, in this discussion and others, why don't artists talk about the meaning of their work? Most respond in formal or technical terms only, evading questions of content. At least in a discussion of "How Real . . . etc.," might not the artists try to explore what the paintings are about, why and how they choose what they paint? Would it destroy the intensity of our images to analyze them?

– Marion Lerner Levine

Women Artists News, Summer 1976 [Vol. 2, No. 3]

'76 / #39

What You Mean – Or What You See

"Trends in Painting"

Moderator: **Lowery Sims**; Panelists: **Herb Aach**, **Shirley Gorelick**, **Howardina Pindell** and **William Haney**, painters; **Corinne Robins** and **Peter Frank**, critics

Jamaica Art Mobilization, Jamaica Art Center; May 1, 1976

At this "Painter's Media Day"[1] panel, speakers agreed there are today more viable alternatives than ever before. Peter Frank, describing himself as a pluralist, termed the '70s an "eclectic age *par excellence*," which, he said, "liberates the personality from the restrictions of history."

Corinne Robins showed slides of five abstract painters [Virginia Cuppaidge, Ed Clark, Joyce Kozloff, Gordon Hart and Deborah Remington] and discussed the quality of light (either surface or inherent in the picture), the perception of space (receding, holding the plane, or projecting), and the potential of the and other neglected sources.

Shirley Gorelick illustrated pluralism by presenting trends within contemporary realism, from Photo-Realism to Expressionism [work by Sylvia Sleigh, Lois Dodd, Janet Schneider, Lucy Sallick, Elena Borstein, Cynthia Mailman, Sharon Wybrants and Rosalind Shaffer]. Agreeing with Lawrence Alloway that "a likeness is an arrangement of forms that corresponds with some aspect of its subject," she said that, unlike the relatively homogeneous 19th-century realists, 20th-century realists share only their involvement with likeness.

Howardena Pindell showed slides of artists spinning highly personalized mythologies in non-orthodox materials and techniques, so their painting "becomes something other than painting" [Patsy Norvell, Alan Shields and William Riley]. A political stance is also implied in the rejection of a "high-art" approach.

William Haney's comments were introduced by Lowery Sims as, "How I Stopped Making Abstract Art and Learned to Love Figuration." His major concern is narrative representation; his ideal, the "marriage of Cézanne and David."

Herb Aach, discussing art education, lamented the fact that 50% of NYC's art teachers had been "excessed" (three times more than any other discipline) and faulted art education for attempting to assign quantities and qualities to creativity. There are no such specific criteria, he said.

The panel offered so much information in the meager hour and a half allotted that it took these reviewers four hours to read their copious notes!

— **Shirley Gorelick** and **Janet Schneider**

Women Artists News, Summer 1976 [Vol. 2, No. 3]

1. Jamaica Art Mobilization, a group of artists affiliated with Jamaica Art Center, initiated a series of "Media Days," 8-hour investigations of concepts and technical developments in a particular visual medium.

2. When budget cuts led to cuts in teacher positions in New York City public schools, the firing (or at times transferring) of those over the allotted number was called "excessing."

More Torture of Women

"Critics and Their Works in Progress"

Moderator: **Catherine Stimpson**; Panelists: **Corinne Robins**, **Lucy Lippard**, **Diane Bond**

A.I.R. Monday Night Program; Fall 1976

"Critics and Their Works in Progress" inaugurated A.I.R.'s 1976 Monday Night Program. Catherine Stimpson moderated, and A.I.R. artist Sylvia Sleigh introduced the speakers.

Corinne Robins read from her novel-in-progress, set in 1965 and written, as Robins put it, "from a man's point of view." The excerpt concerned a recently divorced male artist who wanders 57th Street, attempting to get into a gallery.

Lucy Lippard left copies of her fiction at the front desk for guests to take and read at home. She discussed the differences between "leaning on someone else's work" (e.g., writing criticism) and "writing from scratch, from within yourself." Having spoken of her concern with feminism as a function of the human condition, not as an end in itself, she told about having a novel she'd written with two female and two male characters rejected by Feminist Press because it contained too many men.

Substituting for Cindy Nemser, Diane Bond, a member of a women's political action group in Italy, spoke at length of the necessity for Italian women to form political splinter groups, since none of the five major parties left of the Communists concerns itself with women's issues. These nameless, offshoot groups are geared toward using art for statements more than "art-for-art's sake." They prefer "direct action and then talking about what was done" to the "just talking and more talking" of the male-oriented groups. Direct action has included painting on rags, aprons and other household items, and hanging them on clothespins in the town piazza. Once the group hung them in a psychoanalytical conference to protest the male-centered attitudes of those present. Bond was obviously intelligent, but having trouble articulating. Stimpson could have helped her, or asked for audience questions, but instead cut her off with something like, "Well, I can hear echoes of your feeling around the room, Connie would you like to read?"

Sitting amongst Nancy Spero's "Torture of Women," the subject of politics seemed *à propos*, but moderator Stimpson apparently didn't feel the need to establish a meeting ground between the "naming" of reality as done in fiction and Bond's cold, hard statements of political fact.

Yes, we have forums for women to say, Wow, we're finally getting it together, but feminism should mean more than having women become bank presidents. Discussion was lively, peppered with the wit of the inimitable Alice Neel.

Nevertheless, I walked out before the end, angry at the rudeness to Diane (loud whispers among panelists while she spoke, etc.), and upset that I'm not supposed to vent these feelings, lest I be accused of splitting the Movement.

– Janet Heit

Women Artists News, November 1976 [Vol. 2, No. 6]

'76 / #41

The "Museumification" of Photography

Gene Thornton on "Photography Today"

New York University Art-Critics-in-Residence Series, NYC; Fall 1976

Gene Thornton, former art columnist for *Time*, currently *New York Times* photography critic, presents a dour view of the future of photography.

Having studied painting at the Art Students League, Thornton gave up the traditional arts because he felt they had abandoned the great themes and basic functions of mass communication, such as binding a community, recording history, and maintaining tradition.

He began his talk by showing slides to illustrate the common ground between photography and the "old masters": fashion, leaders in commanding poses, battles, landscapes, beautiful female nudes, lovers. There were Tiepolo's Anthony and Cleopatra, and Nina Larson's John Kennedy and Jackie at their wedding; the first step of Europeans on American soil; and NASA photographs of the first step on the moon.

For all the similarities in lighting, composition and emotion (and, as a member of the audience pointed out, similarity of these images, as transmitters of ideas and history, which then become tradition and folklore), it was fascinating to note that photography was at times a less explicit record than painting. In a painting of the death of Caesar, for instance, the body lies in the foreground, while the Roman senators crowd through the chamber doors, guilt on their faces. Thornton compared this to a frame from the Zapruder film of Kennedy in Dallas – the car coming from behind an obstruction, the culprits not seen, much less explicit.

These photographs were all from the mass media, and Thornton, with a kind of nostalgia and frustration, said that as a critic he could not write about them. This introduced the paradox of photography today: As more and more of the photography intended for the mass media is exhibited in museums and galleries, that very photography, expressing the dreams, hopes, and fears of the masses, is on the wane, giving way to work intended for a very limited audience.

Deprived of the mass markets of the great magazines *Life* and *Look*, and with the advent of television, photography is loosed from its moorings in the great tales of emotion, history and tradition. Current imagery is strewn, like the litter in William Eggleston's pictures inaugurating the advent of color photography at MoMA, with artifacts of the most trivial, mundane and random kind. This, according to Thornton, is the photographic or "snapshot" aesthetic. To achieve a "purely photographic" vision, it seeks to eliminate all similarities between photography and other media.

The new photography will be less informational than the work of Eisenstadt or of Eugene Smith or Brassai. The functional supports of such journalistic or documentary photography are gone. Photographers now aim to be shown and collected, discovered by curators and critics. The "museumization," as Hilton Kramer called it, of photography has begun. "Nobody knows that art is art until it has been removed from everyday surroundings and placed in a museum, until it becomes something not for use but purely for aesthetic contemplation," said Thornton. "We live in strange times. Everyone is for the people and against the elite, but when art is produced for a broad and general public, it is despised even by its makers."

There has always been a photography for the elite, destined for galleries and museums – from Hill and Adamson and Julia Margaret Cameron to Ansel Adams, and many more. But today the balance, for Thornton, is gone.

As a photographer of journalistic bent, I feel the dilemma posed by Thornton to be a very real and painful one. Although he says photography, as other art forms, is created on the job for a client, and not in the void – citing Michelangelo's creation of his great work, the Sistine Chapel, for a client, the Pope – Thornton says he can only write about art shown in galleries and museums. He is not permitted at the *Times* to critique the *working* photographers of today, whose images reach out to a wide audience along the themes he traced.

– Diana Mara Henry

Women Artists News, December 1976 [Vol. 2, No. 6]

'76 / #42

Scientific American

Thomas Hess: "Toward a Taxonomy of Abstract Expressionism"

New York University Art-Critics-In-Residence Series, Fall 1976

Critics, like artists, follow the temper of the times. They used to be poetical. A review might be little more than a string of confused analogies. Lately they are scientific, quantifying and qualifying minutiae. When I was in art school, *ARTnews* was the only serious art magazine in English (or quasi-English); its vague poeticizing hastened my departure to advertising design. I find it ironic, therefore, that today Thomas B. Hess, editor of *ARTnews* from 1949 to 1972, instigator of and accomplice in that poesy, titles his talk, "Toward a Taxonomy of Abstract Expressionism." Emphasizing the scientific connotations of "taxonomy," he promises to "classify" and define this art "objectively."

A more tenable theme might have been "The '50s as seen from the '70s," well begun in his opening remarks:

"A rich and complicated scene with no idea of sales . . . money was not the question. People talked about art – of Rodin, Monet, Pissarro . . . re-evaluating Cubism, Futurism, Matisse. . . . Everybody went to museums, to see Renaissance art, Egyptian art. (The influence of art history on emerging Abstract Expressionism would be an interesting Ph.D. thesis.*) They talked of philosophy, poetry, music, of Kant and Kierkegaard. They were an audience for John Cage, Merce Cunningham and Paul Goodman. . . . There was a great sense of exhilaration and release – release from the ideological anxiety of the '30s, from guilt about the inconsequentiality of the act of painting. There was a new kind of art, different from what went on before. But *how* different? How to describe the specific differences?"

Discarding Clement Greenberg's theory of "natural evolution from Cubism to intense color on a flat plane" as "too tidy and reasonable," Hess also discounted Rosenberg's "act of art" approach for its failure to account for the fact that an artist's various paintings, presumably originating in various "acts of art," are nevertheless similar. One might ask why art theory need account for consistency of personality or habits, but Hess went on to other issues:

"The idea of an 'ethical image' is nice, but *hard to describe* . . . hardly a *scientific* language. . . . I'm going to *demonstrate objectively* that an important change did take place in American painting." [Emphasis added.]

"Hans Hofmann felt the secret was the picture plane, but the secret was *how the picture was painted*," Hess said, then apologized to artists in the audience, who, knowing how a picture is painted, might not see the mystery.

Showing slides of Piero della Francesca, da Vinci, Giorgione, Titian, speaking of "sense of surface," and "sfumato," Hess said that in the Old Masters, "even where the material is evident, how it was put on is difficult to see. Painting was a kind of marvel or wonder." When paint became looser, as in Poussin, Boucher and Fragonard, still, how it was applied was important.

But, "suddenly at the end of the 18th-century paint became articulated on the surface. . . . With Courbet, it became increasingly apparent what the brush was doing; the act of painting began to assume the subject matter and content of the painting." Impressionists and Cubists continued the process; in Bonnard, "the surface retains the pigment almost as if it were a palette."

But that is a phenomenon of recent European painting, Hess said. Beginning approximately with Gorky in America, it again "became difficult to tell the method of making. . . . Glazes, wet on wet, contradictory perspective," were part of a complicated technique. With de Kooning, you're almost back where you were with the Old Masters" – mysterious passages of mysterious method. "You can't follow the under-and-over of a Pollock. You get totally lost. Indeed part of the subject matter is that you cannot."

In Rothko, "the passage from one color to another becomes very problematical, also how the texture was achieved." With Reinhardt, "even the application of the paint is not evident from the image." For Frankenthaler, acrylics added to the "mysterious and secret quality." Kenneth Noland's "impenetrable surface" is almost like tempera painting of the Dutch 17th century." Hess quoted Stella as saying that one of his early ideas was that "the painting itself should not be available to the spectator." And Warhol "is the image of an artist as mysterious and unapproachable as he was 200 years ago."

Although the illusionist perspective and foreshortening of the Old Masters were gone, art became again "work that cannot be penetrated." In sum, said Hess, "you can tell by looking at a Soulages or Bazin [Europeans] exactly how it was made. With a Kline, Gottlieb, or Tomlinson [Americans], you cannot."

Following this argument, I could not ignore urgent contradictions or counter-arguments that came to mind: For instance, painters have reveled in mystery and sleight-of-hand since they escaped rapidly drying plaster. During 150 years of clear "articulation" in Europe, if such there was, the flattening of the picture plane was also happening. After World War II, European energies, artistic and otherwise, were at a low ebb; innovation and vitality in art moved to America. With the picture plane already flattened to a faretheewell, renewal of complex technique, if such occurred, would have happened wherever art was renewed.

Moreover, there must be passages in Bonnard's painting as mysterious and elusive as any in art. That one cannot trace a continuous line in Pollock does not mean his *technique* is mysterious – it is the ultimate in simplicity. Noland's "impenetrability of surface" seems scarcely greater than that of Mondrian, Herbin or Vasarely. Stella's *method* of the period cited was not so unavailable. His *picture plane* was the mystery. (Was it or wasn't it?) Warhol used prosaic commercial

44

printing processes. His theme, indeed his fetish, was ordinariness. And so on.

Perhaps sensing such contradictions, Hess seemed weary, even dispirited, as did the matinée audience, which dwindled steadily. A number of those remaining for the brief question period seemed to have done so in order to hold Hess personally accountable for modern art, of which they had a somewhat garbled notion. One woman asked brightly, "Do you mean the medium is the message?" To his credit, Hess replied gently: no, he hadn't meant that, and added that the statement was, in fact, meaningless.

– Judy Seigel

Women Artists News, December 1976 [Vol. 2, No. 5]

*A common conceit of "modernism" had been that art history was only for "study" and had nothing to do with modern art, so just the suggestion that art history had affected Abstract Expressionism was provocative. Coincidence or not, the very next NYU Art Critic in Residence, Barbara Rose, chose as her topic Abstract Expressionism's "roots" in 19th-century American art. However Rose's "connections" strained credulity ['76/#44] and even greater excesses were to follow [e.g., '86/#183].

'76 / #43

The Skeptic and the Visionary

Originally published under the title "The Great Debate," this event was another milestone in the women artists' movement, as well as a testament to the stature achieved by artist Miriam Schapiro: None of us doubted for a minute that she would meet and match Lawrence Alloway in argument. He, an eminent senior critic, was certainly more accessible and interested in women artists and their issues because his wife, artist Sylvia Sleigh, was active with women's groups. But he remained adamantly skeptical in the matter of "women's imagery." Our reporter, artist Joan Snyder, writing more or less as a third party to the debate, vehemently, *indignantly* disagreed with Alloway, scolding him for stubbornly missing the obvious. (Today, of course, or at least at this moment, "female imagery" seems remote as an art issue.) The curious question arose whether Alice Neel's pregnant nude was "in pain" – as if pregnancy per se were malignant. Too bad indeed, as Snyder points out, that Neel, *in the audience!*, wasn't asked.

Miriam Schapiro and Lawrence Alloway on "Women's Art"

A.I.R. Gallery, NYC; Fall 1976

Joyce Kozloff turned down this assignment for fear of not being objective enough. So they asked me, not exactly an objective bystander either. In 1973 Lawrence Alloway reviewed my show in *The Nation*, but since then has seemed reluctant to include me in his history of the contemporary women's art movement. (Could this be a blessing in disguise?)

As preparation for the debate between Miriam Schapiro and Alloway on women and their art, I read Alloway's article in May 1976 *Art in America*, "Women's Art in the '70s." (In the article he calls Schapiro "Schapiro-Chicago." It's well known that this once-prospering professional friendship has been severed.) I didn't have to prepare for Mimi. We have known, liked, and fought with each other for years.

Alloway continues to deny that a female sensibility does exist. Women are suggesting that they have a sensitive, beautiful, complicated anatomy. This makes Alloway uncomfortable, so he ignores it. And Schapiro dwells on it. I find both positions terribly uncom–fortable, but would opt for Mimi's if I had to choose. She seems to have learned her male art history well, and how to use it to make feminist interpretations. For example, when Alice Neel's painting of a pregnant nude was shown, Schapiro asked why this subject had never been part of the history of art. She answered her own question by explaining that it was considered uncouth to make art about uncomfortable subjects, adding that the subject of pregnancy is no longer taboo. However, when she insisted that the woman in Neel's painting is beautiful and does not appear to be in pain, I found myself and many others, including Alloway, in disagreement. (Alice Neel was in the audience that night. I wish they had asked her. We would finally have known if the lady was indeed comfortable or uncomfortable.)

Schapiro seemed to need to hold a firm line to battle this Goliath, Alloway. The conversation had the smell of five years ago. When Alloway cited historical examples of women's art as eclectic, she disclaimed any such knowledge or interest. To conceive a female art history she finds it necessary to discount most of the naming and teaching done in the past by men, ignoring what is not useful to her search for a female art history – and rightly so. Louise Nevelson put it rather simply: "I'm not a great academic scholar, but I relate to or feel close to certain cultures and I don't demand authenticity. If I relate to it, it becomes authentic to me."

Women are indeed tired of hearing men recite the "facts" of why their art isn't original. Alloway claims he can't accept what women now feel are the givens of female imagery, because there has not been extensive research to prove the point. He feels there may be just as many works by men with this very use of materials, process, imagery and content.

Perhaps such research will be necessary to convince the still non-believer/non-perceivers. I myself didn't go out looking

for a female sensibility in women's work. I just found it. Some women were conscious of what they were doing. Most weren't. My explanation is as simple as the discovery. If the quality and experience of women's lives are different from that of men's lives, and if the art that an artist makes is somehow connected to his/her life, even in the most round-about way, then the art is going to be different. I suspect that even the quality of the anger felt by men and women is different. If not, there would be no reason for a women's movement in this country. We are not the same as men and our art is not the same.

I came out of the event wondering what Alloway's support and interest in women's art are about, when he could say, "The continuity and content [of art] has obviously not been interrupted by women artists." At the very least, he must recognize the contribution made by women, especially in the last five years.

– Joan Snyder

Women Artists News, February 1977 [Vol. 2, No. 8]

'76 / #44

Once More, Up Against the Wallpaper

Barbara Rose on American Art

New York University Art-Critics-in-Residence Series, NYC; October 19, 1976

The previous lecture in this series had Tom Hess showing slides of European and American art side by side to prove that the distinguishing characteristic of modern American art is that you cannot tell, by looking at it, how it was made, whereas with European art, you can.

Barbara Rose also used two projectors to show European and American art side by side, but her thesis was broader – and fuzzier. After a carefully wrought opening, and the declaration that modern American art has certain distinctively American themes and images which can be traced back to 19th-century American art, she veered off into a rapid-fire survey and interpretation, in which demonstrable facts were overwhelmed by free-association.

She began by agreeing with those who see a continuity of transcendentalist vision between American Abstract Expressionists such as Rothko, Pollock and Newman, and epic landscape painting of 19th-century America. But, she said, the connections are more complex than the catalog of MoMA's "The Natural Paradise" show implies. "The whole tradition of American culture is a source of the ideas." This mystical vision is "the only heroic theme in American art," but it's not the only theme. There is the literal, factual, ob-

jective, "what you see is what you see" art of Flavin, Judd and Stella, rooted also in the American 19th century. "Both kinds of art exist in extreme versions in America, but we are given to extremes. The Golden Mean is not the American way of life."

Noting that immigrant artists de Kooning and Gorky felt reborn in America – "it was very liberating not to have all that Renaissance painting hanging around (although today our art space fills up with a tradition of our own, a burden to be rejected in its turn by conceptual artists)" – Rose showed de Kooning's *Woman II* next to the 1644 *Watermill* of another Dutchman, Hobbema, with whom he shared a "love of sensuous surface." Other juxtapositions included the American Blakelock's "brooding image" in *Brook by Moonlight*, as the forerunner of Clyfford Still, and the "swirling, turbulent, writhing movement" in Ryder, as an influence on Pollock.

Pollock's greatness, and a major innovation in American art, was "the synthesis of aspects of the modern tradition that were not Cubist, the 'all-over.' Signac had already explored 'all-over' in Neo-Impressionism. What was so astonishing, so American, about Pollock? . . . The single image, the mystery with no beginning or end, implying infinity."

The second major innovation of the Americans, Rose said, was their "attack" on the Cubist composition of internal relationships, as in Barnett Newman's "non-relational" paintings. These were not composed pictures, or *jolis objets*, but a "large field of color which draws the spectator into the canvas," demanding, encompassing, aggressive. "Americans are very aggressive people." The large scale, "in defiance of the bourgeois living room," was also an American innovation.

Gorky, de Kooning and Tomlin had been closer to the Europeans. Rothko, Gottlieb and Newman were more radically new. They emptied painting to a few shapes and colors of great drama and impact. "Americans are in a big hurry – if you don't hit 'em hard, you won't get them at all." These works you could "pick up immediately . . . if you got an inch, you got it all."

In the '60s, a kind of "inertia painting" set in, which declined to engage the viewer. Rose told us that critic Brian O'Doherty called Frank Stella "the Cézanne of Ennui." Jasper Johns, with a "beautiful impasto and control not seen since the 19th century," eliminated images or *depictions* altogether. He made *replications*. Wesselman's refrigerator door didn't "*allude* to plastic, it *was* plastic." Flavin made his light literal. There were no allusions to stations of the cross or anything else in Judd and the Minimalists. Rauschenberg also used life images and objects, but his composition was "so strictly Cubist that he could have been the last member of the School of Paris." Warhol's *images* (not depictions) had no antecedents in European art, and raised the question of the difference between painting and wallpaper, a distinction unknown to most people, "which accounts for the success of Miracle Realism." (Questioned later about her definition of wallpaper, and what *is* the difference between painting and wallpaper, Rose said she is "working on it.") "Pop Art was popular because it made people feel good – none of your ex-

istential nonsense." The fact that Pop later became satiric and biting was, Rose claimed, missed by its public.

The '60s were about breaking down barriers – between popular and high culture, commercial and fine art, reality and illusion. A Jasper Johns next to a *trompe l'oeil* painting by the 19th-century American, Harnett, was, Rose said, "what you see is what you see" versus "what you see is not what you see," in the tradition of the confidence man. . . . In America you don't know who anyone is."

Richard Tuttle's conceptual elements "didn't jettison the art, yet kept the literal quality of the material untransformed . . . not trying to be something else, not marble pretending to be flesh . . . an excessive candor which may be a reaction to the basic shell-game mentality that is a dominant theme in American culture."

Unfortunately, many of these characterizations seemed flimsy, or glib – perhaps a bit of the old American flim-flam themselves. Themes were more claimed than demonstrated, and "reasoning" seemed both forced and circular.

If American Epic Painting of the 19th century was transcendental, and Abstract Expressionism was transcendental, too, it doesn't mean there's any particular connection. If there is evidence that the Ab-Ex painters had a special interest in, or even consciousness of, the 19th-century movement, Rose didn't present it. Lacking that, it seems more likely that both groups evinced, each in the manner of its time, the visionary yearnings common to humanity, and most especially to artists. Certainly many of the "American" forms she cited had European corollaries, some predating ours, though not as widely touted. (Promotion of art, American "boosterism," was not mentioned.)

But in the question period, Rose jettisoned her package and showed a sharp wit, a flair for phrase-turning and a willingness to debunk latter-day saints that were a show in themselves.

On Funk art: "It's Buckeye Surrealism, out of Fantasia and Walt Disney. The Old Masters exist only on slides in America."

On realistic painting: "Alfred Leslie is devoted to bringing back the Davidian tradition, but he doesn't paint as well as David. It's hard for Americans to learn to paint. Early Pollocks were abysmal. Artists were forced into [modern] techniques because they couldn't get the painting straight."

Would she comment on the Wyeth show? "I wouldn't give Mr. Hoving that satisfaction. It's a Ringling Brothers kind of affair. New York is becoming a terrible provincial backwater because of museum policies. [Y]ou really have to be underground to see good art."

On the critic's function: "The public isn't interested in criticism. It's a time of rampant philistinism. [C]riticism has deteriorated – it's lousy, unreadable. The only critics I read are Tom Hess and Bob Hughes. They use ordinary words, like good and bad. If art only has to be interesting, not good,

there's no job for the critic to judge, and criticism becomes just promotion."

On photography: "Photography is for people who don't like abstract art."

Is it true you don't attend exhibitions limited to women? "Absolutely not. I was one of the biggest supporters of A.I.R. Gallery, which is a woman's gallery. I go there all the time and plug it whenever I can. What I may have said is that I'm not interested in art just because it's by a woman."

These two critics in a row, Tom Hess, then Barbara Rose, show a longing for "hallmarks of American art." One practical man, Ivan Karp, says modern art is now simply "International Style" and that even supposed regionalisms of the past, such as "West Coast" or "Northwest" art, were promotional fictions. Perhaps the next generation of critics will ponder whether the American *character* is more predisposed to monumentality than, say, the Russian or Chinese – beyond having the wherewithal, the wealth and space, to be monumental.

– Judy Seigel

Women Artists News, January 1977 [Vol. 2, No. 7]

'76 / #45

Speculate in Art? Not Us!

Re-reading this report in 1990, the notion of a "*Last World Art Market Conference*" comes to mind – what to do while the value of your collection bottoms out. Of course all this took place at the onset of gold fever, when it did not do to admit, at least in public, that one might indeed "speculate in art."

First World Art Market Conference *(Report #1)*

Speakers: **Thomas Hoving**, Director Metropolitan Museum of Art; **Milton Esterow**, Publisher *ARTnews and ARTnewsletter*; **Thomas Messer**, Director Guggenheim Museum; **Leo Castelli**, **Ivan Karp**, **Ruth Braunstein**, others, dealers
Sponsored by the New School and ARTnewsletter, NYC; October 29 & 30, 1976

Morning Session:
Billed as "The First World Art Market Conference," co-produced by the New School and *ARTnewsletter* – a bi-weekly hot-tip dispenser that you can pick up for a mere $60 a year – the show was, as John Everett, President of the New School, said in his opening remarks, about the "business of art." It appeared to be mostly a media event. The press was given the three front rows, fussed over with TLC. Some 400 others, dealers and collectors from around the country, and a few artists hoping to learn about "business," paid $200 each to see and hear the superstars of the art market. Those expecting a clear view of the crystal ball – specific investment

advice – were disappointed. But they got lots of encouragement and word that the art market is very good these days.

After the "welcoming continental breakfast," Everett told us there's money "itching" to be spent in art. Next, Milton Esterow, publisher of *ARTnewsletter* and *ARTnews*, co-sponsor and co-moderator, earnestly assured us that those who make money on art buy for aesthetic reasons only – that you can't make money speculating on art. Then we got down to the serious business of trying to find out how to do just that.

Keynote speaker Thomas Hoving, Director of the Metropolitan Museum of Art, bounded onstage for a rapid-fire delivery of his optimistic view of the future of museums, now changing, he said, from passive displayers of art, to active educators and conservators of art and culture (thus, not surprisingly, making a case for many of his own controversial changes at the Met).

Then the august directors of such institutions as Wildenstein, Park Bernet and Christie's sedately discussed trends in art-buying around the world, with an emphasis on pre-20th century painting and sculpture, and other art objects of increasing rarity, which, they agreed, will become even more expensive. Despite several years' slump, it seems there is still a lot of money around for art, particularly in the U.S. Southwest, Europe, and, more recently, Iran and the oil-producing countries. Milton Esterow tried manfully to elicit some inside information on specific items or periods for investment, but to no avail.

Afternoon Session:
After lunch, Thomas Messer spoke wittily of the museum director's difficulties in maintaining the excellence of a collection without money, and his efforts to get same.

The 2:30 pm panel discussion, with Leo Castelli, Andre Emmerich, Lawrence Rubin and Ivan Karp of New York; Portia Harcus of Harcus-Krakow, Boston; Ruth Braunstein of Quay Gallery, San Francisco; Richard Gray of Gray Gallery, Chicago; and Meredith Long of Meredith Long & Co., Houston; was considerably livelier than the morning's, and of greater interest to contemporary artists.

Ivan Karp, in flame-red opennecked shirt and black leather jacket, a well-calculated contrast to the banker's attire of his colleagues, began with a lament on the dearth of big-spending collectors while a wealth of exciting new art fails to sell, which brought howls of laughter and appreciation from the audience. Rubin, of Knoedler Gallery, and Emmerich said they found no exciting new art beating down their doors. There was also disagreement about the number of collectors, but it was clear from the discussion that there is a lot of money and art activity in what Castelli, with a wave of his hand toward the out-of-towners, referred to as "the provinces." He said he himself is looking for "stars, not activity."

Ms. Braunstein noted that the New York dealers on the panel, except for Karp, are the "establishment," so that perhaps little exciting new work comes to them. She said she finds much thrilling new work with new materials. She also asked Esterow why there were so few women participating,

which drew applause from the audience, particularly the press section, which was predominantly female. Esterow was ready for that; "25% of art dealers are women; two out of eight panelists equals 25%." (However he wasn't quite so careful introducing the panel, having named *first* all the men in order down the table, and *then* the two women seated among them. It also bears noting that no woman artist was mentioned by name in the entire day, though Karp did use the phrase "his or her artistic temperament" to indicate that the artist is of two possible sexes.)

The dealers seemed to agree that their major function is educational, as big sales are few and far between. All day there were pious protests from speakers that one would not, heaven forbid, speculate in art. Leo Castelli finally reminded his fellow dealers that such folk do exist.

The discussions would all have been more relevant and informative if moderators Esterow and Donald Goddard, managing editor of *ARTnews*, had asked better questions, or been more alert and articulate, or allowed some exchange with the audience. Nevertheless, Castelli's reminiscenses of the '60s, when he was a kingmaker, were colorful; Rubin's and Emmerich's snobbery was piquant; Karp was hilarious, irreverent and delightful, as when describing the "Hirschhorn Waltz" – an embrace from Mr. H. at the conclusion of a bargaining session. (All agreed that Hirschhorn was a keen bargainer.)

What did the audience, exceeding in numbers even the sponsors' fondest hopes, get for their tax-deductible $200? A simulated leather portfolio, suitably inscribed, crammed with promotional material for the New School and Parsons (now part of the New School), literature about NYC museums, advance copies of *ARTnews*, and, of course *ARTnewsletter*, which, begun one year ago, circulates to 1000 dealers and collectors; a catered buffet, where perhaps the concrete information about investments and the market not coughed up by panelists and speakers was exchanged off the record; and a glimpse of the movers and shakers of the art market world.

What did the sponsors get? $80,000 less costs; a lot of promotion with collectors and dealers, and, potentially, in 43 organs of the press; confirmation that there is indeed a lot of money "itching" to be spent on art, although perhaps not as much in New York as there used to be; and proof that there are a lot of people itching to make money off the people making money off art.

– Lynden B. Miller

Women Artists News, January 1977 [Vol. 2, No. 7]

Artworkers News. also covered the Art Market Conference. Its report featured other speakers and issues, while showing that what seems *witty* to one reporter may appear *distraught* to another – although a bounder is still a bounder.

First World Art Market Conference *(Report #2)*

Speakers: **Milton Esterow, Thomas Hoving, Thomas Messer, Clyde Newhouse, Leo Castelli, Ivan Karp, Ruth Braunstein, George Le Maistre, Ruben Gorewitz, Deborah Remington, Robert Indiana,** others

Sponsored by the New School and ARTnewsletter, NYC; October 29 and 30, 1976

"Works of art of course cannot be compared to stocks and bonds," warned Milton Esterow as he opened the first day's events.

The keynote address, delivered by Thomas Hoving, director of the Metropolitan Museum of Art, bounded quickly across the history of museum art buying in the United States and settled on the future role of the art museum. According to Hoving, whose own museum has escaped the financial crunch plaguing art institutions in the 1970s (the Met budget actually showed a modest surplus this year), all is changing for the better. He foresees an emerging "technotronic era" which will not, as Orwell warned, snuff out creativity, but enhance it.

"Our Western artistic manifestations will tend to diminish in importance, and we will begin to recognize a multiplicity of centers and styles," he said, adding that the tastes of a few critics and a small group of curators won't wield the power they do today. Hoving, whose cry for a larger art public and "museum without walls" seemed to leave many in the audience cold, concluded by predicting a greater role for art museums, proclaiming that art could become "the broadest and most powerful communicator" in history.

His exuberant optimism was countered later in the day by the somewhat distraught remarks of Thomas Messer, director of the Guggenheim Museum, who noted that if the economy remains in its present condition, museums might have to forego collecting and concentrate their energies on conservation.

"Museum directors may well be institutionalized dealers in the future, trading and deaccessioning to get new works and funds," Messer said. He has guided all buying and selling at the Guggenheim since the early '60s, and promised to remain "an activist," seeking services and funds from all available sources.

For the remainder of the opening-day session, two panels discussed specifics of the art market. Though all the dealers agreed that the boom in art buying of the 1960s is over, most hastened to add that the present mood of the market is a healthy one. Members of the panel, who collectively make up what one reporter termed "the sheiks of the oil-on-canvas market," emphasized the importance of the quality dealer (usually pointing to each other), the seller with a good reputation, and the importance of the dealer to the history of art.

"Every great collection has been formed by a dealer," boasted Clyde Newhouse, president of the Art Dealers Association and third-generation gallery owner.

"They're a monopoly, it's that simple," commented a young art consultant attending the conference as a reporter for *Wall Street Weekly*. "Price fixing is a given and 100% profits are commonplace."

At the afternoon panel, "What's Happening in Contemporary Art," discussion once again centered on the difference between the market of the 1960s and 1970s.

"I'm pessimistic," offered Leo Castelli, who amassed a fortune over the last decade through the sale of works by such contemporary heavyweights as Jasper Johns and Robert Rauschenberg. "There is art activity," he added, ignoring the audience's mock sympathy, "but no art business."

Ivan Karp, calling himself the only "downtown" gallery owner on the panel, accused fellow dealers of ignoring the surge of creativity among younger, lesser-known artists, whose work Karp claimed to spend "four hours a day" examining. The most outspoken member of the panel, Karp also denounced the auctioning of art ("the process distorts prices"), the role of critics, and the validity of the conference itself, since, in his words "there is no art market – my artists don't sell a thing." Karp, unlike many of his peers, didn't reap a fortune in Abstract Expressionism and Pop Art, and therefore had no reason to bemoan the current scene.

The four out-of-town dealers from Chicago, Dallas, Boston and San Francisco, made few comments, as talk centered on New York gossip. The one issue which finally involved the entire group stemmed from Castelli's assertion that it remains "essential" for all artists who take their work seriously to come to Manhattan.

"Nonsense. I just don't believe that," snapped Ruth Braunstein of San Francisco, who had drawn applause for noting the lack of women speakers. "If an artist feels he should be in New York, then he should be. If not, that's fine too."

The audience seemed more interested in hot tips and inside information than discussion of trends and comparisons.

"What's the best buy in modern American Art?" read one question put to Castelli, who refused to respond to that and others he said could only be answered speculatively. Most dealers noted, however, that such advice is usually given to customers as part of the rationale for buying a particular work.

"Let's face it," said a young Parsons art student working as an usher. "These characters paid a couple hundred bucks to learn how to make more. It's no different from buying a scratch sheet at the racetrack."

The second day began with an address by George A. Le Maistre, director of the Federal Deposit Insurance Corporation. Outlining the expanding role of banks in the art market, he said most banks remain hesitant to loan money for purchasing art. He listed some ways bankers' fears might be

assuaged. For instance, one Chicago bank, rather than lending exclusively to collectors, extends credit to artists themselves, usually to sculptors for cost of materials.

In the afternoon panel on Artists Rights, discussion, heated at times, focused on recent legislation in California guaranteeing artists a 5% royalty on work resold for over $1,000. Rubin Gorewitz, accountant and adviser to artists and art groups, said the law, which he helped draft, "will help the artist and help everyone else five times more."

Artist Deborah Remington doubted this, pointing out that there is no mechanism for enforcement. "I'd have to sue for my money," she said, adding angrily, "It's an elitist law anyway." Only artists of great stature, "the Chagalls and Miro's," would benefit, because only they have "secondary markets."

"Where we need help is when the artist is young and struggling," Remington said, not after he's "getting six figures." Robert Indiana, who spoke little during the royalty law discussion, emphasized that the real issue is the status of the artist in America.

"An artist is a non-person, a non-entity – just look at a museum board and see if you can find an artist. They're not even accepted by those in the art world."

Indiana also was critical of American copyright laws, which, he said, are the primary hazard for visual artists. "The copyright laws have been the tragedy of my own life," he lamented, referring to his LOVE painting, which was reproduced in thousands of posters without his permission and without royalties.

Both artists agreed that the country needs a federal "cabinet level" department of cultural affairs to give art a higher priority in the national life.

– Gerald Marzorati

Artworkers News, November 1976 [Vol. 6, No. 7]

It seems that Europeans were not so uptight about connecting art and money as Americans. In fact, a German newsletter of art economics had contrived, not just a list of the "top" 100 artists of the world, but an explicit buyer's guide to art as investment: who was "dear" and who "cheap" – exactly the advice skirted at the New School conference. We reported highlights from the *art aktuel* 1975-6 tabluation, and include them here, for the record.

"The 100 Biggest"

For those still at sea on the subject of investing in art, there is in print an ingenious survey which spells it all out – and then some. We have in hand an article from *art aktuel*, a German newsletter circulated to dealers and collectors, which causes us to marvel anew at "the German mind," although in this case we assume much computer assistance.

Die 100 Grossen is a chart of the "100 Biggest Artists in the World," ranked for 1975 and 1976, showing nationality,

style, least price for a small work, point score (about which more in a moment), price-point ratio (relationship of price to score) and a *Preisnote*, or evaluation ("very dear" through "very cheap").

For the point score, a numerical value was assigned (by whom is not mentioned) to each of 69 art books and publications, 68 museums, 12 collections, 12 "institutions," 150 group shows and a few miscellaneous biennales and other curatorial enterprises. (The list itself is an education.) The artists get points for each inclusion or mention. Their total "score" determines their rank on the chart!

For instance, under Museums, the highest number of points, 300, goes for MoMA and the Metropolitan in NYC and the National Gallery of Modern Art in Edinborough. The Albright Knox of Buffalo and the Kunstmuseum of Luzerne are next at 240. The Tate, Walker Art Center and Hirshhorn each get 200, as does the Power Institute of Fine Arts in Sidney. Brussels and Pasadena get 160 each.

The top score for Group Shows is 300 for Documenta's 1 thru 5. "Drawing Now" (NYC) got 200. The Metropolitan Centennial, "Responsive Eye," "Arte Povera" (Turin), "Art Now" (Washington), "Conceptual Art" (NYC) and the Whitney's "American Pop Art" rate 100 points each. Janis's "New Realists," the Carnegie Triennale, and Guggenheim International each get only 50. The Jewish Museum is the ranking "Institution" at 300 points. Musée des Arts Decoratifs, Paris, and Museum of Contemporary Art, Chicago, are among the lowest, at 75.

As for publications, *Dictionary of 20th Century Art* and Collins's *Modern Art* are biggies at 100, *Neue Formen des Realismus* by Sager and *Six Years* by Lippard show at 30. And, if my German serves, each mention in *Artforum* and *Studio International* is a lagniappe at 10 points. Ready with the checkbook? O.K. The 1976 top 10 are, starting with #1: Rauschenberg, Warhol, Oldenburg, Johns, Beuys, Tinguely, Lichtenstein, Stella, Yves Klein, and Christo. There are five women in the entire roster, beginning with Riley at #47; then Darboven, #53; Hesse, #79; St. Phalle, #81; and Bontecou, #86. Forty-six of the 100 are Americans, 13 are British, 12 German and 9 French.

The lowest price for a small Rauschenberg is 17,000 (Deutche Marks, presumably), rated "good value." Riley is "cheap" at 2,000; St. Phalle "very cheap" at 1,000; ditto Broodthaers, #71. Marden, #92, is "dear" at 6,000, and Rosenquist "very dear" at 18,000. Judd, #15, is "good value" at 7,500, as is Hesse at 6,000. It is also noted that the top artists are bound to increase in value.

We nominate this project for the Conceptual-Art-of-the-'70s Award (300 points), a brilliant blend of Art and Technology.

– Judy Seigel

Women Artists News, April 1977 [Vol. 2 No. 10]

Update: A similar or identical program was used to determine the "100 Biggest Artists" for 1988-90, now published as "Capital Kunstkompass" in the German business magazine, *Capital*. Georg Baselitz is rated #1 artist in the world, followed in order by Gerhard Richter, Frank Stella, Bruce Nauman, and

Mario Merz. Americans, who had four of the top five places in the 1975-6 list, now only have two, but women have increased from 5 to 10 – Jenny Holzer at #42 is the highest, followed by Cindy Sherman at #46.

Source for this recent data was a short item in *The Journal of Art*, October, 1990. The list, it said, was prepared by Linda Rohr-Bongard, widow of Willi Bongard, original creator (in 1970) of "Capital Kunstkompass."

'76 / #46

The Connoisseur

David Bourdon's Ten Best

New York University Art-Critics-in-Residence Series, NYC; November 1, 1976

What should an art critic look like? Elliot Gould? Lucy Lippard? Mark Twain? David Bourdon's chubby face is shiny clean-shaven; his steel-rimmed spectacles are definitely *not* granny glasses. He wears a button-down shirt, tan tie, and beige jacket over shiny gray slacks. He could come from Central Casting as the Proper Professor; or Associate Editor of *The Smithsonian*, which he was (1972-1974), or Assistant Editor of *Life* (1966-71), or even an art connoisseur. ("I've seen more art than most people. The more you look at, the more it tunes your eye. Familiarity does lead to connoisseurship.") But art critic for the *Village Voice*, super-cool consumer's guide to disco chic? Surprise!

In a manner matching his mien, pedantic almost to the point of parody (although stray wisps of wit kept cutting through), Bourdon presented ten "visual manifestations," or shows, "ten very exciting things that I wouldn't mind seeing again" of the past season. The multiplicity of styles means energy, not directionlessness, he said, beginning with an exegesis of Jasper Johns's paintings at Castelli Gallery in January 1976:

"An astonishing departure from his previous work The distinguishing feature of this painting, which makes it memorable, indeed fascinating, is the division into three panels. In Panel #1, an ongoing progression of matching segments. you can continually read the pattern from left to right"

A more exhaustive explanation and analysis of procedure, ratio, relationship, repeat, reversal and variation of *a bunch of cross hatches* is beyond imagining. My notes say, "this is the most deadly thing I ever sat through." I would have left, except for curiosity about the other nine.

Annoyance was compounded by Bourdon's remark that "this year there has been a sort of flurry of pattern painting," but here "Johns is showing once again that he had been there all along"!

I happen to find Johns's "patterns" wretched. The "pattern painters" whose work has recently come to Bourdon's attention probably approached the subject long before Johns did,

if that matters. They certainly do it with more flair, as have myriad artists and artisans for most of world history, which does very much matter. Nor is the brush *per se* nobler than needle and thread, or clay and glaze – the brush may simply be the lazy man's way.

But, as I said, I had to sit through to the bitter end to get the list (and so, dear reader, do you), but a funny thing happened. Feeling at first that if anything could make me hate art, this tedious stroke-by-stroke analysis would, I found that Bourdon became progressively more interesting; partly because he began to run late and had to condense his explications, partly because the diversity of the art selected and his obviously dedicated, even ardent, study of it, were engaging, even irresistible, and partly, I suppose, because I adjusted to the inevitable. Bourdon also included a number of slides of the artists' earlier work, giving a perspective not usually available in the gallery.

Frank Stella: French scrolls and architectural drafting tools blown up in aluminum. "No form is exhausted as long as there's a good artist who can do something with it. . . . But there's also politics – you make a grand entrance with a cannon bolt across the bow. Then, when you're established, you can do what you like."

Willem de Kooning: "I'm pretty impressed by anyone who gets better with age . . . *Woman #1* shocked the art world, both as an abandonment of abstraction and a seemingly savage portrait of woman. But I see as much humor as corrosiveness They're women, as you can tell from their very prominent *boosems.*"

Alex Katz: " . . . influenced by pop . . . very attentive to hair . . ."

Audrey Flack: "What turns me off about most Photo-Realists is I don't think the paintings are very well done. If you get up close they dissolve into indifferent airbrushing. And the images – roadside Americana – are not all that enthralling. They're popular in Europe because Europeans take them as a social commentary on American society. They *are* documents, but as for art, if I had to choose one Photo-Realist, it would be Audrey Flack. She is an uncanny realist . . . contributes more information than a photograph. The highlights remind me of the kind of detached highlights you see in Vermeer."

Jennifer Bartlett: "One of the most extraordinary shows of the year, *Rhapsody* is 160 feet wide . . . cuts across many different styles: primitive, gestural, cartoon . . . references to Delaunay, Klee, Kandinsky, cartoon panels, medieval fresco, Jasper Johns, Sol Lewitt A knockout show, getting a lot of attention, and deserves it."

Robert Stackhouse: "*Running Animals Reindeer Way* is a corridor work, a kind of magical interior . . . anthropology and myth making. A promising New York debut for a younger artist."

Barry Le Va: " . . . Anti-object . . . believes in having a show and getting reviewed in the art press, but not in a lasting object that the viewer can pick up and take home. He's dealing with lines of vision. Wooden dowels show a theoretical line

which has entered the gallery from a space below . . . fascinating."

Daniel Buren: "A French conceptualist . . . very provocative use of vertical stripes, a classical image. . . . His theory is that a lot of contemporary art depends for much of its meaning on the setting and how the audience perceives it . . . very imaginative."

Christo: "*Running Fence* is the most spectacular thing I saw all year. . . . It redefined the existing landscape . . . turned pink in the morning . . . extraordinary seen from an automobile . . . cost two million dollars, a lot of it in lawyers' fees. . . . Since most of it came from European collectors, the money did a lot for the American economy."

"Any year you can see all these things, you can't say art is in the doldrums!"

Bourdon cannily does not attempt a grand unifying theory. He takes us on a connoisseur's tour, elucidating, educating. My own generosity with the term "art" is less than his, but still, his enthusiasm, his obvious love of the subject, illuminate the work. Yet, something, a trivial item really, stays in mind. Bourdon, writing in the *Voice* about Miriam Schapiro's recent show, said the "composition" of a particular painting failed because it was "essentially dull," while almost every artist I know who saw the painting found it especially fine. This "trifle" illuminates our consideration of art criticism, for it shows that a critic may study intentions and convey ideas with exquisite precision and authority, yet still miss in sensibility.

– Judy Seigel

Women Artists News, February 1977 [Vol. 2, No. 8]

'76 / #47

Free-Lance Feminist Art Critic

Lucy Lippard: Response and Responsibility In Art Criticism

New York University Art-Critics-in-Residence Series, NYC; December 1976

Lucy R. Lippard steps onto the stage in jeans and a comfortable jacket. It seems there has been some problem in deciding just how to introduce her. "Free-lance feminist art critic," we are told, and I suspect "feminist" is the word that's troublesome, being a recent addition.

Her opening remarks are important, but delivered in an offhand manner. Criticism "ideally is provocation and would fill the visual-verbal gap." She amplifies: criticism has changed its point of view, from making judgements to mak-

ing the reader/viewer *think*. "Criticism has been accustomed to making rules. . . .

[now] is not telling people what to like, but to think for themselves." Adjusting finally to Lippard's brusque style, I find myself agreeing with most of what she says, but begin to feel a lurking dissatisfaction I can't pin down.

Because she has found the question and answer part of her talks the most stimulating and productive, Lippard explains that she keeps her opening remarks minimal, then shows a series of slides lasting about 45 minutes. Some two-thirds of the way through the slides she says, "I'm getting to the feminist section, brace yourselves." No need to brace: these are the most interesting, the most stimulating, the most provocative of the group. As before, however, the commentary is restricted – a very few remarks about the artist and her intentions. I want to hear more.

During the question and answer period, Lippard is very warm and sympathetic when dealing with women who query her on her own professional history and on feminist art. At one point a well-meaning, but clearly unartworldly, gentleman asks what she thinks could possibly redeem the art of Brice Marden. The response of the critic was, to my mind, inadequate: the gentleman must find something to feel about the work; only then could he respond and understand.

In a larger sense, I feel the issue of response and responsibility of the critic is at the heart of the present art-critical malaise. Lippard is the only critic in the current NYU series who has attempted to address critical issues directly. But, is the responsibility of criticism, as she says, only to be provocative and bring work to light so the viewer can decide for himself? Is criticism's province only the small art-knowledgeable clique which can understand what Marden, for instance, is doing?

I, for one, feel criticism should encompass far more than provocation. Baudelaire said the critic must be "partial, passionate and political." I agree. But I want more, and I feel the responsive critic is responsible for more. More enlightenment about the exquisitely complex problems of art today; more unmuddied, unsloppy thinking about the work, about relations between the work, the critic and the society it reflects. And I want some more understandable, honest prose, please.

Lippard admittedly questions herself constantly about the critical role and responsibility, and I think it is this ambivalence and irresolution about the critical function that caused her talk to be rather meager. My feelings of dissatisfaction came from wanting more from art criticism in general, and more from Lippard in particular, because I think she has more than most to give.

– Alexandra Penney

Women Artists News, February 1977 [Vol. 2, No. 8]

'76 / #48

The Non-Mainstream Mainstream

Stephen Prokopoff on "Art Today and the Role of the Critic"

New York University Art-Critics-in-Residence Series, NYC; December 16, 1976

With Stephen Prokopoff, Director of the Chicago Museum of Contemporary Art,* NYU's five-year-old Art-Critics-in-Residence series came to an undramatic but interesting close.

To a scattered audience, Prokopoff depicted a rosy view of art today, finding especially positive the current condition of "pluralism" and the absence of a "mainstream." This confirms, he said, that at any moment there is not one train of development, one course of evolution dominating the arts, but a number of evolutions and specific personalities.

He then blithely proceeded to define '70s art as compared to '60s art: Sixties art was public in scale and intent. Abrasive, large in scale, it shocked people and challenged ideas of art. Seventies art is more private, smaller in scale, much more intimate. The tone is personal, at times hermetic. Thus in one breath he denied the notion of a trend or mainstream, and in the next identified the new mainstream as compared to the old.

Pluralism in museum exhibitions was the next topic. Museums in the '60s had been out to discover new talent and new directions in art. Now, Prokopoff said, they are searching for overlooked artists and artistic phenomena in the past, for the parallel streams, so to speak. Shows of Louis Lozowick at the National Collection of Fine Arts in Washington, D.C., of John Storrs and Manièrre Dawson at Prokopoff's museum (Dawson now seen as painting abstractions in the Midwest at the same time as Kandinsky and Kupka in Europe), "The Natural Paradise" show and the Beaux Arts exhibition at the Museum of Modern Art, were cited as examples of this new attitude. The Beaux Arts show, Prokopoff said, undermined the notion that modern architecture is so much better than previous styles because it is clean and modular and wall-to-wall carpeting is easier to care for.

To me, the coincidence of what Prokopoff called "a retrospective vision" in these shows suggests that mainstream thinking has *changed,* rather than disappeared, and that, along with the demystification of certain kinds of art, has come a questionable neo-mystification of other kinds. Behind the new attitude of museums is a practical factor, the need for box office receipts, which Prokopoff admitted is an element in current planning. "New art is less visible and consequently of less interest to the public," he claimed.

Prokopoff was more convincing when he touched on today's new and imaginative scholarship, not so much because fresh scholarship gives today's climber of art's foothills as spectacular a view as yesterday's climber of mountains (to paraphrase his quote from the late André Malraux), as because the view is worth looking at from many vantages.

Next Prokopoff turned to art criticism, listing the attributes that he, as museum director, would like in an ideal critic: He should be a connoisseur and an explicator, a historian and a sociologist. He should be capable of revising his positions. He should be lucid, selective, objective, perceptive. To Mr. Prokopoff's demands, I'd like to add my own: That "he" be thought of as "she" as well, and that she or he be paid what such a rare bird rightly deserves.

Prokopoff concluded by prophesying a continuation of what he called the personal, fanciful, romantic '70s, in contrast to the aloof, removed, classical '60s.

The question period fastened on why the art critic should stay away from politics: Clearly the public did not understand Prokopoff's emphasis on that point. His remark that *Guernica* survived as art, not because of its historical allusions, but because of its formal qualities, did not endear him to some of his audience.

Asked by this writer how art by women fitted into his discussion (not a single woman artist was mentioned), Prokopoff replied that though it is true that art by women does not exactly answer his description of '70s art, the issue of women's art and art by blacks is waning as more and more women and blacks become accepted simply as artists.

The program ended short of the allotted two hours.

— Michele Cone

Women Artists News, March 1977 [Volume 2, No. 9]

*Prokopoff subsequently became director of the Boston Institute of Contemporary Art, where he remained until 1981

'76 / #49

Artists Say Novelty is Passé

Another move of artists taking advantage of the "collapse of modernism" was the reclamation of figurative painting. The problem was to roll back 20 years without being considered a "throwback."

"Artists' Choice: Figurative Art in New York"

Moderator: **Bill Sullivan**; Panelists: **John Button, Rackstraw Downes, Jane Freilicher, Catherine Murphy, Philip Pearlstein**

Soho Center for Visual Arts, NYC; December 1976

Despite the ambitious title, "Artists' Choice: Figurative Art in New York"* didn't pretend to be a real survey of the best figurative art in this city. Although there was a strong push

by many in the galleries involved to have a more comprehensive show, what evolved was a hastily put-together exhibition with emphasis on the painters already showing in those galleries and the better-known painters who influenced them.

Each panelist was asked to bring a question, but much of the discussion was in response to Hilton Kramer's review, which had said the show was a throwback to another era, a great deal of it amateurish. (It should be noted that Kramer reviewed the show the week before it opened, with most of the paintings stacked in the back room at Green Mountain and larger works by his favorites not yet arrived.)

Catherine Murphy, whose question was, "What has influenced your work more, the recent past or the distant past, and has it been a positive or negative influence?" answered for herself by saying her work came equally from both – Rousseau as well as Laderman. She disagreed with the "implication that figurative art is a retrogressive movement. . . . The line isn't as broken as it was thought to be."

Philip Pearlstein replied that it depends on your age. "If you are in your 50s, the line has been broken. [I]t is a progressive movement because there was nothing to go back to except the American scene painters." In the early '60s it was a whole new problem, so that, he claimed, he and Al Leslie "had to invent a new kind of realism which could compete with Abstract Expressionism."

Rackstraw Downes asked how it felt from a "lonely isolated position" to be painting figuratively in the '60s. John Button said he came to New York from California, "feeling good" about the Abstract Expressionism he had learned there, but was disillusioned when he saw the actual paintings. Finding the artists centered around Tibor de Nagy Gallery, he "realized there were other possibilities." Pearlstein pointed out, "There were always painters who painted figuratively, using techniques that had a great deal to do with abstract painting. . . . What happened in the '60s was the degree of illusionism, an attempt to put measurable space into a painting. The radical difference is in setting up a coherent look of reality."

Jane Freilicher seemed puzzled by most of Pearlstein's comments. She asked, "Why necessarily a new problem? . . . What is a 'coherent look of reality?' Why is being 'measurable' so much better than not being measurable? That isn't the essence of painting."

Pearlstein replied that a "coherent look of reality" is "when everything holds together, and is done from a single point of view so you could make a floor plan of the space in the picture." Being "measurable," he said, "is a declaration of intent . . . to produce a sharper kind of realism."

Asked by the moderator about emotional content, the panelists agreed that you can't legislate emotions in a painting. Freilicher pointed out that although one can't intend emotion, there still must be a *focus*. What's wrong with most realist painting today, she said, is like Truman Capote's remark about Jack Kerouac: "That's not writing. That's typing!" It isn't enough to want to paint all the buildings in

New York, filling up the canvas with whatever you're looking at. "There has to be some other intention which has to do with making a painting."

Button asked the panelists how much they were aware that their imagery related to childhood memory or an interior landscape.

Freilicher: All art has to do with the subconscious, but we really don't know in what way. Once you do know it becomes a kind of phony thing Everything we do is subconsciously motivated, including why we became painters, but all that is really beside the point.

Button: I assume I'm choosing my subject matter all the time, but I've just come to realize that perhaps I'm not, that maybe it's choosing me. I made a picture of an ugly white '50s apartment house which enthralled me. Later I realized how much it looked like the Sierra Nevada Mountains in California.

Murphy: I have a desperate need to go back home and paint my house, the house I grew up in. I've painted it many times and I'll paint it many times again. . . . Gabriel Laderman was once asked why he painted realistically, and answered, "because my mother likes it!" Maybe it's as simple as that!

Freilicher wanted the panel to address early 20th-century painting, particularly the Impressionists. "Are we throwing them out with the bathwater?" Pearlstein said he feels "no connection whatsoever with French painters and French culture . . . as far removed from me as the Renaissance," but does connect with "archeological material in museums."

Downes: You mean that's what you *intend* to connect with, what you *want* to connect with.

Murphy: Cézanne taught us about structure and things like that, but one of the great influences of my life, when I was still in school, was Laderman's paintings. After seeing so much Op and Pop art, I realized this was a direction I could go in.

Button admitted he had never cared for Cézanne because of "all those earthquakes taking place on tabletops." He could see the excellence in Cézanne, but felt himself more a part of the previous century.

Pearlstein mentioned his interest in the photographer Muybridge, and his influence on 20th-century art. "A lot of my interest in realism comes from the look of early photography."

Asked by the audience to respond to Kramer's review, Murphy said she resents being called reactionary, as her painting is a combination of what she learned from recent abstract and realistic art. Downes, who had said a number of times that "what is novel about this kind of painting is that it doesn't try to be novel," added, "to be post-modernist is a highly radical position. . . . It's a paradox. To not have to be novel is novel."

Pearlstein saw a parallel in this show to the Stable Gallery shows of the '50s. There had been affinities and temporary

alliances among Rothko, Reinhardt, and others, but basic differences, also. "To the outside world it all looks like one thing." Murphy said, "When the academy was abolished, everyone had to learn to do it all over again."

Downes said he needed diversity to learn to "put the whole world on a postcard," and spoke of his love of details and wish to have them feel real without destroying the whole. Freilicher asked, "What is this appearance of reality? At what point is it real? Who is to say that delineation of detail is more real than if you kept it at the first impression, which is sometimes *more real*, because it will last you a lifetime."

Asked to address the unbroken tradition of representational painting preceding Abstract Expressionism, most panel members were reluctant or unable to deal with that or with "modern" painting before Abstract Expressionism either. A woman pointed out that there was a continuing figurative movement in Europe which included Balthus, Morandi and Kokoschka, who could have been used as role models. (In fact they were.)

After the panel someone remarked to Downes that a number of American painters had always painted figuratively, and it was peculiar that someone like Edward Hopper hadn't been mentioned. "Hopper!" Downes snorted. "Hopper was a terrible painter!"

– Mimi Weisbord

*The show, organized by the Green Mountain, Bowery, Prince Street and First Street Galleries, ran from December 17, 1976, to January 6, 1977, in those galleries and at Soho Center for the Visual Arts.

Women Artists News, March 1977 [Vol. 2, No. 9]

1977

'77 / #50

New Power Sources

The 1977 annual College Art Conference in Los Angeles, as usual, drew accolytes and honchos from all over, happy to mix business, pleasure and art. It's tempting to stress the transcontinental nature of the event, especially in view of the then-new appreciation of women's networking, but the facts are complex. For instance, Miriam Schapiro, a once-and-present New Yorker, had at an earlier time been based in California, a central figure in the beginnings of the women's movement there. Arlene Raven, a founding member of the Los Angeles Woman's Building, has since been claimed by New York. So let's take all that as a given and agree with the writer, Avis Lang (now moved from Canada to New York, where she is editor of the *Heresies* Collective), that the greatest impact of this all-star panel was simply the panel, "those eleven people in the same room at the same time."

"Feminist Art Criticism: What Are the Crucial Issues?"

Panelists: **June Blum, Arlene Raven, Alessandra Comini, Joanna Frueh, Ruth Iskin, Ann Sutherland Harris, Lucy Lippard, Linda Nochlin, Cindy Nemser, June Wayne, Miriam Schapiro**

Women's Caucus for Art, College Art Conference, Los Angeles; February 2, 1977

The 11 panelists ran the gamut from established women connected with venerable institutions to founders of alternate, feminist or collective places, but alternate or not, everybody is of course pretty much making things work out, or who would have invited them to speak?

Ruth Iskin and Arlene Raven are co-directors of the Woman's Building in L.A.; Alessandra Comini, Ann Sutherland Harris and Linda Nochlin are academic art historians; Joanna Frueh is ex-coordinator of Artemisia Gallery in Chicago; June Wayne IS; Cindy Nemser is editor of the *Feminist Art Journal*; Miriam Schapiro and June Blum are artists.

Actually the panel was less a panel than a series of formal autonomous papers and presentations without discussion, until Wayne, having heard everyone but Schapiro speak, informed the assembled company that

> The language of the papers here [is frequently] operational, medical, sadistic, often aggressive. It's a language of punishment and reward . . . I don't know how other artists hear it, but the word "criticism" is far less tolerable than is the language of art history. . . And because I've been around so long, I hear patterns that emerge out of the best and most loving of motives, but which simply fall upon my back with the same familiar sting with which I

experienced those words all these years with relation to the sexist male.

Was Wayne addressing the necessity of being Critical as opposed to legitimating – encouraging everything and everybody? Actually she was saying how offensive it is that not only critics, but art historians too, exercise selection in the natural course of their work.

Frueh: Even though one of criticism's responsibilities has been to determine greatness, feminist criticism as I see it makes the critic's first loyalty to art itself. Otherwise, good art, let alone great art, cannot be judged.

Extracting a definition from this: Feminist art criticism is that writing about art which is primarily loyal to the cause of Art and which moves beyond issues arising from gender to the field of Human Relations. Seriously fragmented thinking; we need to try again.

Nochlin: What feminist art criticism can do is make us *not* accept what *is*, art-historically, as natural, to see that it indeed has certain powers, certain positions, certain convenient ways of thinking about things, and to stir them up and question them. . . . We have to, on the one hand, abandon mystificatory essentialist theories about feminist style as something which just lasts all through history untouched by specific situations, and yet we must not deny that being a woman counts for something and often counts for a good deal. . . .

The "certain powers" and "certain positions" cited in this extremely circumspect statement were named more precisely by a few of the other panelists:

Iskin: There have been essentially two positions: One that women's art should become as accepted, prestigious, and monetarily valuable as any other art in the market system, and another which focuses on challenging the entire system. . . .

And even more pointed on the domain of feminist critical practice being within Feminism rather than within Art, were the following:

Raven: Today, as in every other day, women's oppression is the most crucial issue. Without acknowledging the ongoing evaluation of women as *the* issue, we would create a false sense of free intellectual discourse inappropriate to the real situation of the women's movement in art and of women generally.

Nemser: The basic premise that separates a feminist art critic from one who is not is the understanding that, since the advent of the patriarchy, women's accomplishments have been rated inferior to those of men. . . . Feminist criticism must see feminism as a world view, affecting every aspect of human society.

The complete title of this panel was "Feminist Art Criticism: What Are the Crucial Issues? Some of these issues are the need for definitions versus the need to withstand the art-world pressure to define and be defined; the role of theory; the dangers of naming styles or of naming Women as a category (read lesser, less "universal" category); to find what (if anything) can properly be called "the women's art movement"; to find whether the frame of reference is primarily feminism, or criticism, or art or class (or life) or the generally deplorable, elitist and doctrinaire state of the trade of criticism in recent times. . . .

Iskin: The women's art movement has a vital need for feminist criticism based on a shared and sympathetic point of view rather than adverseness. That of course does not mean uncritical acceptance or praise of women's art by feminist critics, but rather criticism that comes from a position of sharing and accepting feminist concerns.

Lippard: I'd like to see feminist criticism be realistic, as positively hard as well as soft on women artists as we've been on men, but hard in a supportive manner . . . a very difficult thing. Also a very feminist thing, in the spirit of consciousness-raising and the group criticisms, self-criticisms, evaluations, self-evaluations that go on at meetings.

Nemser: The issue of derogatory images of women brings us to the question of whether or not it is permissible for feminist critics to make judgements of women's art – negative judgements. [I]t is not only permissible, but it is absolutely essential. It is condescending to excuse or even endorse in a woman's work that which we would condemn in a man's. The feminist critic . . . must also be ready to evaluate women's art in terms of its technical achievement with the same stringent criteria that have been used for the art of men. . . . If it is iconographically confused, it will barely make an impact, and if it slavishly emulates sexist male art, it deserves to be denounced. The right to be judged honestly is also part of the struggle for equal rights.

Raven: In a feminist creative community . . . criticism and mutual support form the backbone of our social relations. . . . Statistics demonstrate that women are so sensitive to criticism they are more likely to be personally devastated than to learn from it. Without the ability to give and receive constructive criticism and self-criticism, how can we formulate work that goes beyond idiosyncratic or narcissistic concerns? . . . Criticism is an essential aspect of support, and without criticism, support can become an opiate. Criticism in the feminist community is an important aspect of the creative process and not an afterthought.

Schapiro: When I'm in the studio, and depressed, and call up a woman friend and ask her to come over . . . and show her the painting, I don't really want criticism. What I want is a good friend . . . somebody who will support me and give me that next shove or push. . . . The most important criticism for me and, I judge, for most artists, is self-criticism, that place in the studio where you develop your own kind of rigor and your own standards. . . . Self-criticism is that space between your last painting and your next painting.

On another issue – the pitfalls of dealing with women separately from men – two panelists gave warnings, extremely different in tone:

Frueh: Exclusivity also risks continuing a history of critical writing founded on favoritism and the promotion of particular aesthetics. . . . Feminist criticism cannot be separatist. While we know that male writers have ostracized women artists, this treatment does not require punishment in the manner of Hammurabi's Code, an eye for an eye. . . . Exclusivity would reinforce rather than overcome the oppressiveness in the art world . . . playing party politics.

Raven: The use of "women" as a new critical category acts much the same as any ethnic or minority circumscription, a sign that the art under discussion is not the same kind of art as ART, is inferior, and if considered at all should be studied anthropologically, biographically, psychologically, but not critically or art-historically, and *never* valued in the same coin as ART.

For me, not living in the Eastern third of North America or in California, the impact of this event was enormous – seeing these eleven people in the same room of the Hilton at the same time, while downstairs the medievalists and classics scholars milled around the bar, and chairmen of departments flexed their power ever so beneficently.

– Avis Lang

Women Artists News, April 1977, [Vol. 2, No. 10]

'77 / #51

Art into Topography

"Women and Large-Scale Sculpture: Feminist, Macho or Androgynist?"

Moderator: **Lila Katzen**; Panelists: **Lin Emery, Claire Falkenstein, Josefa Filkosky, Ann Healy, Beverly Pepper, Athena Tacha**
Women's Caucus for Art, College Art Conference, Los Angeles February 1977

This wide-ranging panel attracted an audience of some 400 people, perhaps 20% men, and, unlike other sessions where traffic in and out made it hard to listen, most stayed until the end. It would have been interesting to poll the audience to see how many were working artists; from the question period it seemed that most were not, and were somewhat in awe of women making large-scale sculptures. And large-scale they were – it was impressive and exciting to see the slides of each artist's work.

Beverly Pepper's 300-foot-long Cor-Ten and grass piece designed to be seen from automobiles, the work altering with time and movement (tape and slides sent from Rome); Ann Healy's large-scale recycling – six colored fabric strips each 56 feet long, installed vertically on a building, horizontally in

a mall; Athena Tacha's 30-foot-wide by 20-foot-deep construction inspired by a boulder-strewn stream; Claire Falkenstein's 130-foot-high church windows of metal and glass, which withstood an L.A. earthquake; Josefa Filkosky's massive fabrications of aluminum elbows and straight pipes, engineered and welded in a power plant; Lin Emery's kinetic forms of heavy-gauge bronze or expanded polyurethane and fiberglas, made in her own foundry and fabricating shop, a recent three-story-high piece activated by magnets in floor and ceiling; Lila Katzen's two- and three-ton undulating curves of mild steel or fused stainless steel and Cor-Ten, fabricated by industrial bending and rolling machinery.

There is a vast difference between "large-scale" and merely "big" sculptures, both in execution and placement. Historically, sculptors have been dependent on other people and their skills, and not always happily – Cellini was constantly complaining about his foundrymen. Added to this were feelings of being hassled because they were women. Emery, who runs her own shop, endures it from suppliers; Healy, who sews her own pieces, said installations are "a constant battle"; Katzen, who is completely dependent on fabricators, said, "When I first walk in they run into the office." Nevertheless, I had a strong image of women managing to work successfully in a variety of complex techniques.

Katzen tried to focus the discussion on philosophical implications of "Women and Large-Scale Sculpture." Are there specific feminine art images, she asked. Are women aping men? Does the choice of hard or soft materials indicate a macho or feminist outlook? But the artists in their answers and the audience in their questions were not as interested in such issues as in personal experiences.

Aside from one or two technical questions, the audience wanted to know how the artists support themselves (most teach), how they got the courage as women to work with large machines (most were surprised to discover that others thought it courageous), and about their family histories. (All were only or youngest children!)

Interestingly, Katzen was the only one who raised her hand when asked, "How many would make a large-scale sculpture without getting a commission?" Asked, "How do you get from one large piece to another?" she replied, "the Loan Company." (Successful male sculptors have told me that early in their careers they went into hock, begged, did anything to get a big piece built.) Tacha, however, said she must make "at least 10% profit, or it isn't worth my time."

There was a lot of sharing personal experience and strong feminist sentiment from panelists, yet when they were asked how does one hear about competitions (many of the pieces shown had been competition winners), there was a lot of silence. Sisters, we still have a long way to go.

– Ann Sperry

Women Artists News, April 1977 [Vol. 2, No. 10]

'77 / #52

Escape from Oregon (but Not to New York)

As Lynda Benglis points out here, much of the women artists' movement started on the west coast – "politically," she says, but probably aesthetically as well. This panel included already-famous west-coast women and others just being introduced to a national audience. Yes, they did talk about not being in New York, but they also had many more things on their minds – mixing women's new awareness of gender, region, and the L.A. "scene" with the collapse of formalism. (We hear, by the way, that lately they're going back to Oregon, though we haven't got the figures on that either.)

"Los Angeles, Women, Art and the Future"

Moderator: **Ruth Iskin**; Panelists: **June Wayne, Lynda Benglis, Alexis Smith, Karen Carson, Eleanor Antin**
Women's Caucus for Art, College Art Conference, Los Angeles; February 1977

"Los Angeles, Women, Art and the Future" turned out to be one of the better panels of WCA/CAA week. The following excerpts are from a two-hour discussion:

Eleanor Antin: The women's art movement helped give the death thrust to the stranglehold of formalism. . . .

Alexis Smith: The movement hasn't affected the content of my work, but it has affected my personal life and attitudes [and] focused attention on the kinds of work women are doing.

June Wayne: In the very beginning, when they were looking around for token women to show, I had been there for 40 years, so I was ready. . . . Now attention must be paid. Before you were simply looked right through. What you might toss into the conversation would be picked up and replied to among the men, as though you had, like some incompetent waitress, simply happened to drop the rolls on the table.

Antin [asked bout her background]: I majored in writing and minored in art. I was a professional actress for about 4 years. I was lousy at everything until I pulled it together a couple of years ago and started using it all as part of my work.

Karen Carson: I had literally been copying Cézanne until I stepped off the bus from Oregon seven years ago. An urban center allows you to think of breaking tradition. Good artists, whether female or male, are constantly breaking tradition. A funny thing happened to me in the last couple of years, though. I've re-embraced the academic notions I learned in Oregon . . . now parodying and making fun of them.

Audience: Is there a female sensibility or unique category of women's art?

Lynda Benglis: I think there is, both stylistically (in iconography) and in just the fact that there are so many women doing art and labeled women artists.

Ruth Iskin: An enormous variety and diversity of women's art has blossomed. The fact that there isn't one particular style doesn't invalidate the category.

Smith: I disagree with everybody. Good art should address itself to the human experience and not women's experience or men's experience.

Antin: I don't think women's experience *is* the human experience. . . . A big concern with human interaction, which will include female *and* male experience, hasn't fit into the art world until very recently.

Iskin: How has the L.A. art scene affected your work?

Wayne: Living in L.A. has always been better for me. I dislike being terrorized by any community. In New York there is no such thing as privacy. Whatever you do, people are talking about it. Whatever you are developing, somebody drops in and then, in no time at all, everybody is aware of it. The isolation here, seeing people when I want and not when I don't, is very important to me.

As for the male scene . . . I wouldn't have been admitted to it in any case. . . . The [New York] warfare, the cliques and planned wars, the gossip and anxiety about who sold what, everybody lying to everybody else, the sheer terror of losing face, the stake-outs on some aesthetic nuance by which careers were built or lost, it horrified me. But maybe if you're inside it, you feel pretty good.

Carson: When I first came to L.A., the artists I encountered were all male. The thing that struck me was the incredible stylization of maleness in Los Angeles – the heavy boots and motorcycle racing gear and all that real macho stuff. . . . You had to parade a male sensibility to get anywhere. My first notion was maybe I can be like them, or maybe I can date them. [Now I am] doing very private work for myself on the one hand, and on the other, dealing with the crass stylization of sexuality, consumer sexuality.

Smith: I think all those macho motorcycle guys went the way of Abstract Expressionism, a bygone era. The scene in L.A. right now is not particularly sexist.

Antin: I don't know much about the L.A. art scene, except for the Woman's Building. . . . I seem to do much better with the New York establishment than the L.A. establishment, whoever they are, I don't think they like me.

Smith: If you can't identify the establishment, then the system is pretty open.

Benglis: I think the essential difference between New York and L.A. is a stylistic one, and has to do with the weather . . . They exist like two medieval cities, each denying the other. . . . The women's movement really did begin here politically. I know Lucy Lippard and I were very taken with the ideas.

Smith: There's an amazing legacy for women about to become artists. There are models they can look to. The attention to women and the visibility of women artists has radically changed the structure of the art world.

Wayne: Recently a young artist told me about several jobs she got very easily – they had fallen into her lap. I thought to myself that, even four years before, this simply would not have been possible. She understood what I was thinking and

said, "I'm taking it for granted, because I really didn't work very hard for it." And I said, "Yes, and it is by no means secure." Unless you defend the territory, it can be very tough four years from now. . . . The freedom we fought for is chancy, we could lose it. The L.A. Institute of Contemporary Art . . . could close. The Woman's Building could close.* Not from lack of devotion or need, but because these are all young institutions, young movements. . . . If someone steps on them when they're too young, they die. I am not worried about artists aesthetically . . . the tremendous diversity and excitement are exhilarating, much different than during Abstract Expressionism and the '60s, when the styles were so oppressive to those who happened not to be in fashion. . . . Maybe we can consolidate this freedom and expand it.

– Ruth Askey

Women Artists News, May 1977 [Vol. 3. No. 1]

*The Woman's Building did close in 1991.

'77 / #53

Open Omissions

"Women and the Art Journals: Widening the Mainstream"

Moderator: **Norma Broude**, American University; Panelists: **Roberta Loach**, *Visual Dialog*; **Richard Martin**, *ARTS* Magazine; **Cindy Nemser**, *Feminist Art Journal*; **Catherine Stimpson**, *Signs*

Women's Caucus for Art, College Art Conference, Los Angeles; February 2, 1977

Moderator Broude led off with an over-long story of the rejection and eventual acceptance some eight months later by the prestigious CAA *Art Journal* of her article on Dégas's misogyny, from the initial, "sounds like a women's lib tract rather than an article," to the final, "excellent and suitable," a complete reversal. She used her experience to illustrate the power journals have in deciding, through omission, what is and is not art, and, therefore, in keeping women from the mainstream.

Each journal was described by its editor. Catherine Stimpson said *Signs* has two paid staff members and receives some 1000 manuscripts a year, which it sends anonymously to readers. Decisions are made "collaboratively," but not "collectively." There are seven thousand subscribers, including six in the USSR.

Richard Martin read a serious and thoughtful paper rewarding the audience with confirmation of its suspicions that women have been ill-served by the art magazines. And, since cover photographs are the decision of the editors (not the biggest advertiser as some of us may previously have thought), he understandably wanted credit for the February,

March and April covers of *ARTS*, which all featured women artists.

Visual Dialog was started by Roberta Loach out of her own need, as an artist, to have a magazine she could relate to, and to include west coast artists not getting coverage in eastern-based media. Each issue has a theme: March will be "Women in the Visual Arts." *Visual Dialog,* which does not follow the mainstream, emphasizes clear, understandable language, and selects artists who are original and expert in their media. Writers frequently choose their own artist-subjects for interviews or reviews.

Cindy Nemser said *Feminist Art Journal's* best articles come in unsolicited, many from women who feel they have no other place to publish. It also honors requests for interviews and reviews, and will read any feminist, interdisciplinary or inter-art material. *FAJ* tries to expose prejudice and discrimination in other publications and to challenge traditional concepts of great art, universality, etc. New policy is to include more reviews, but finding feminist critics has been difficult. *FAJ* has 2500 subscribers and a circulation of 8000. The editor is now receiving a salary; writers and staff are paid – slowly. Advertising is a problem, Nemser says, because there's no promise of a review as pay-off.

– **Cynthia Navaretta**

Women Artists News, April 1977 [Vol. 2, No. 10]

'77 / #54

Not at Your Corner Newsstand

The discussion of women and art publishing was continued in New York, with, except for Cindy Nemser, a different cast and a decidedly different flavor.

"Women's Art Publications"

Panelists: **Cindy Nemser**, *Feminist Art Journal*; **Ellen Lubell**, *womanart*; **Marty Pottenger**, *Heresies*; **Judy Seigel**, *Women Artists News*

A.I.R. Gallery, NYC; February 14, 1977

About 50 women and a couple of men turned up to hear and question speakers on the topic of women's art publications.

Asked her publication's aims, Cindy Nemser said any statement about the *Feminist Art Journal* would be redundant. After five years, she felt its stance should be perfectly clear. What did interest her was getting her husband and co-editor up on the panel with her. "Men," she said, "can be feminists too." Chuck Nemser never made it to the front of the room, but this might have been because 1) chairs were scarce there, 2) he was acknowledged from his position on the floor, and

3) each of the other panelists saw themselves as but one representative of their respective journals: *Women Artists News's* Judy Seigel is feature editor; Ellen Lubell of *womanart* shares the work with art director Gyorgy Beke, and Marty Pottenger is one member of the 17-woman collective that recently began *Heresies.*

As it happened, who does what and how much money and power are involved surfaced as an issue everybody cared about. But first, the women had this to say about their respective journals: Judy Seigel described *Women Artists News,* the only monthly of the group, as a voice for artists, an information exchange and a "document of record." She sees it as a free press, without a political or art line, striving to be lively, as well as alert to the humor in things. Ellen Lubell said *womanart* is a contrast to the standard art press that "supresses women artists," a vehicle for talking about women's art, and a means of self-strengthening. Marty Pottenger saw *Heresies* as an open forum for the discussion of art and politics within a feminist context. Not interested in creating markets for individual artists, it rejects personal monographs, critiques of shows, etc., as "bad politics." The collective feminist commitment, she said, is to "free all women."

At this point, differing politics occasioned some intra-panel discussion, reflecting the usual political approaches of the hour. Seigel said *Women Artists News's* primary focus is visual arts, not politics. Nemser said the two cannot be separated, but it is "criminal" not to promote the individual artist. Their differences, which appeared to be fairly basic, were not seriously explored. Instead, discussion meandered. The usual issues came up, but as usual, were not pinned down.

Seigel did read a statement indicting much feminist criticism as "pure drivel," saying in part: "Feminist literature in particular tends to be grandiose, sanctimonious, self-indulgent, self-congratulatory, mawkish, banal, long-winded and disorganized. It is riddled with rabid half-truths and personal prejudices stated as universal law and with fuzzy thinking disguised by great gobs of passionate sincerity. . . . If the label 'Feminist' must protect or excuse the second-rate, it will eventually become synonymous with it. If Feminism is to be attended like a pep rally, the group loyalty that has heretofore been a source of great strength will become our undoing."

This stirred everybody up a bit. Nemser wanted Seigel to "name names," others simply disagreed, and still others felt it wasn't necessary to focus on the poor stuff.

It's true that most art criticism is a bore, but this didn't really answer Seigel's objections and soon the entire panel was vaguely in accord about the virtues of self-criticism. Marty Pottenger remarked that she too was against "babbling feminism" and that part of *Heresies's* commitment was to break through stale rhetoric. "Feminism," she said, "desperately needs self-criticism now." Ellen Lubell said editors, like their audience, are undergoing a continuous education, and that the '70s need "positive collective endeavor, not the emotionalism of the '60s," while Nemser kept asking that the "bab-

blers" be named. "We can't keep the personal and political separate. There's a world out there trying to kill us."

Despite this agreement about self-criticism and the virtues of pluralistic dissent, nobody got very far when it came to replacing, "patriarchy," "sexism" and "oppression." It seemed easier to accuse these villains than to be really clear about what, finally, feminist criticism might be. At this point the subject of dollars surfaced – all the publications operate on a shoestring, and all are concerned about the implications of "volunteerism." Editor Lubell is unpaid. *Women Artists News*'s editors are unpaid and its writers only recently paid (a small grant makes token payments temporarily possible). Nemser, too, has only recently begun to draw a salary of $100 a week. Members of *Heresies*, Pottenger said, are not paid, although those who need it are partially reimbursed for expenses, and the intent is to pay for articles.

Talk about money led to the question of would success spoil these publications. Does one want *Feminist Art Journal, Women Artists News, womanart* or *Heresies* at the corner drugstore? This line of inquiry, like others that surfaced, seemed to me a bit inflated. The four journals are not on the corner newsstand because distribution would be very difficult and the audience very limited. But their minority status should not be confused with their putative radicalism. The term "feminist criticism," like "radical" in the '60s, is becoming an undefined, yet autocratic, standard of personal merit. The game is to be the best feminist of all, but there are no rules. Seigel remarked – rightly, I thought – that judgment of work on the basis of feminism is useless. "Am I," she asked, "going to make feminist scrambled eggs?"

Re the subject of Feminism and Art, the audience had, if not the last word, perhaps the most enlightened. One woman suggested that feminism isn't a litmus paper, but perhaps a way to explore what it means to be a woman who makes abstract art. Another remarked, "when you make your art you generate values." As she implied, maybe it's time to look at the values that are generated, not the ones that feminism sanctions. And maybe more attention to how women artists work – the process itself and their thinking about it – would help differentiate women's art publications from the standard press.

– Susan Manso

Women Artists News, May 1977 [Vol. 3, No. 1]

Postscript: *The Feminist Art Journal* ceased publishing later in 1977, *womanart* shortly thereafter, *Women Artists News* died in 1990, *Heresies* is still publishing.

I would like also to add to my comments at this panel that I have subsequently encountered feminist criticism that is riveting, rigorous, insightful, and gratifyingly on the mark.

Drawing on No Side of the Brain

"Drawing in the '70s"

Moderator: **Willard Midgette**; Panelists: **Pat Lasch, Kent Floeter, Steve s'Soreff, Agnes Denes**

Artist Talk on Art, NYC; February 25, 1977

The panelists began with slides of their work.

Pat Lasch's canvas pieces sewn with colored threads had a personal iconography for each color, eg., silver for male, gold for female.

Kent Floeter showed large pieces of paper painted red with cuts forming lines, and delivered a long, basically incomprehensible statement about his sources.

Steve s'Soreff's format derives from engineering drawings, with words and references to his prior kinetic sculpture. His slides were all backwards in the carousel, however, so reading the pieces was impossible.

Agenes Denes showed her map and graph-like formations, plus a chart based on human evolution. She said another work, six years in progress, analyzes "all the world's religions."

Discussion opened with Lasch's declaration that she hates reading works of art in a gallery (specifically s'Soreff's) and her denial of any identification with this conceptually-oriented group. The panel then, with little else to say, opened to questions from the floor.

The audience was hostile and unruly, reacting not only to the panelists' emphasis on conceptual work, but to their lack of thought and preparation for discussion. Agnes Denes began to talk about drawing as a private process, but soon digressed.

In the chaos, an audience comment rang true: "'Different strokes for different folks' doesn't make a panel!" Corinne Robins commented from the floor that the panel complied with her definition of drawing: "works on the wall not using paint." The change in the '70s, she said, is that drawings can be seen and accepted as an independent medium, not just studies for "higher" work.

This point *might* have opened an interesting discussion – whether or not drawing has historically been the stepchild of art – but it didn't. I kept thinking of alternate sets of artists to discuss drawing – Dottie Attie, Larry Blizard, Janet Culbertson, Sonia Gechtoff, Paul Spina, Stephenie Brodie Lederman, Michelle Stuart – a large and growing number of artists solely concerned with images on paper. Last year several major and minor exhibitions attempted to address *what is drawing*. I hope some future panels will do the same.

– Susan Schwalb

Women Artists News, May 1977 [Vol. 3, No. 1]

'77 / #56

Definitely Better Than Paris

It was the time of panel fever. As I noted in the original introduction to this report,

> Friday, March 4, an art-talkaholic could start at 7:30 PM at Phoenix School of Art for an aperitif of Max Kozloff talking about "Art Criticism, What Is To Be Done?" to an overflow crowd until 9, then grab a cab to the Figurative Artists Alliance to hear Richard Miller, but no lingering, because at Soho Center Cynthia Navaretta was moderating "Women Artists of the '50s," she and panel blending for yet another full house a leisurely mix of slides, commentary, and reminiscence, shared and savored with the audience until after 11, when, well-fortified, an addict might make it through the weekend with only a pick-me-up at a Saturday opening or two until the Women's Salon Monday night at A.I.R.
>
> Mimi Weisbord, who had been on the scene herself as "a young innocent in the late '50s," covered the '50s panel. Her suggestion that it be done over with "truth serum" and "no husbands" was provocative, but perhaps already too late, as she herself would be the first to acknowledge – embroidery mixed with nostalgia sets quickly.

Weisbord's report is followed by a selection from Moderator Navaretta's introduction, a telling synopsis of how women of the period were omitted from one of its written histories. With this happening more or less in our own time, Navaretta asks, "Why pick on Janson?"

"Women Artists of the '50s"

Moderator: **Cynthia Navaretta**; Panelists: **Ann Arnold**, **Louise Bourgeois**, **Gretna Campbell**, **Marisol**, **Marcia Marcus**, **Pat Passlof**

Artists Talk on Art, NYC; March 4, 1977

Moderator Navaretta set the mood for the evening, describing the ambience of the '50s in New York.

"It was a very exciting period. . . . There was a new kind of art criticism, a new language being created in the magazines – a kind of psycho-aesthetic for a new art public. . . . It was such a small art community that one knew everybody, which seems incredible now; there was a sense of community no longer possible. Everybody lived in the same area – Tenth Street was the center – and you saw everyone almost every day walking around in the streets. And then of course there was that great social center known as the Club . . . where you found out what was going on, the feuds, the gossip, who was showing where. . . . It was all very male-dominininated. Women were there to be danced with and to listen and be full of admiration and adulation." Women were also "more willing to do a lot of the chores, sit in the galleries, clean up, do the jobs that needed to be done."

Ann Arnold added that "the Tanager Gallery couldn't have functioned without Lois Dodd and Sally Hazlett. I don't remember people like Alex Katz ever sitting in the gallery." She said she herself was "pretty naive" as a young artist coming down from New England, having gotten the impression in school that all the artists were dead.

"I thought of myself as a struggling young artist – I never felt persecuted. I thought that when I had a body of work together, somebody would look at it. And it did more or less happen that way. Now with all the changes between the '50s and the '70s, it's O.K. to be a *woman* artist, and that's kind of a nice feeling, too. . . . But an artist has so many problems besides those of being a woman. . . . It would be nice to think that anything that goes wrong is because you're a woman and being discriminated against. . . . You have to do the best you can, and have patience and be tough and persevere and stab those men in the back whenever you can, but not worry about it too much."

Pat Passlof said the '50s were "marvelous," but, "out of ignorance, innocence, or stupidity" she didn't understand the slights for what they were. At the Club she helped out, but wasn't invited to be a charter member, although her boyfriend was. "During the WPA, women were included, and in the '40s women were needed during the war." On Tenth Street in the '50s, women were allowed in because the galleries needed the money and the members. Discrimination wasn't so clear. "If you're a young artist whose work is just developing and someone looks down on you, it isn't clear it's because you are a woman. You could just as easily think the person doesn't like your work."

Gretna Campbell said that although the '50s were pleasant, the thought of being a woman then made her very depressed. "We were young, full of energy and pretty, so we could pass. . . . We tried to live for the moment, just play the part and get along. Since no one was making it in the early '50s, artists in general wished each other well, and men could sometimes forget they were talking to a woman (for a little bit). At the Club, I'd be put down for saying something foolish, then several weeks later a man would say the same thing and it would be great . . . profound. But now we realize that what happened, happened to us because we are women.

"I've seen young women students come into a group with something new in their painting . . . but it never looks good; in order to develop an individual, you have to say, 'that's good, this new thing in your painting. I've not seen it before, and I've not seen it in your work.' The men are always encouraged, but if it's a woman, all sorts of little movements start going on – people get restless, they rub their hands together. You start feeling, 'I wish that kid would get her work out of here. I'm tired of looking at it – something's wrong with it.' And then you realize it's not the work. It's that the people looking at the work are annoyed. And that's because it's female work."

Louise Bourgeois: Yes, it's very difficult, but I happen to like a good fight. You have to be patient and also willing to be disagreeable; I work in a climate of hostility . . . but what is important is whether you make your point, whether you do what you want to do.

Here Navaretta suggested that Bourgeois had always had a great deal of acceptance and recognition. But Bourgeois responded, "Not at all. I was tolerated because they had to. Otherwise I would have gotten angry. . . . In fact, my work is

concerned with the injustice that women suffer, because a lot of men artists are just stupid. The men today don't consider women as artists. They consider them as sex objects or as nothing. If a woman artist has something to say, they know it, but they are not going to say so. They are not going to recognize you officially, as an artist. I think Marisol at the Tanager Gallery was recognized, though."

Marisol: I never felt discriminated against in the '50s for being a woman artist. But I don't think I did my good work until the '60s. I considered myself a student in the '50s. If there was any prejudice, I got confused and thought it was because I was a foreigner.

Marcia Marcus: I had the feeling that, for whatever reason, I had every right to be there. . . . As far as I was concerned. the people who had the most influence on my work and were my best friends in the art world were men. I know certain men thought women should be tied to the bed with a rope long enough to get to the kitchen – but they weren't my best friends. And it was only because of men that I did get involved in galleries or rather large shows or things like that.

Marcus said she could see in retrospect that there had been discrimination, but then again, "some of the worst experiences I had in terms of galleries were with women."

Campbell asked Bourgeois about the '40s, when no one had any money and there were fewer artists. Bourgeois said coming here was definitely better than being in Paris. "There were simply no women around Breton, Ernst, and that group. There were a few wives – the wife of Dali, the second wife of André Breton – but they functioned as clothes horses. . . . The famous games that Breton played included women only if they invented or related sexually interesting stories."At this point everyone showed slides of work done in the '50s, which looked terrific and also reflected a rawness and vitality that came out of Abstract Expressionism, in contrast to the refinement of work today.

My own recollection of coming to New York as a young innocent in the late '50s is that one was a blight on the landscape if one wasn't connected to a man (and everyone seemed to be). One late afternoon Landes Lewitan spotted me with my nose pressed against the window of the Cedar Bar and silently beckoned me to join him at a table. There I received a lecture on how much more "freedom" I would enjoy as a married woman. Twenty years later I realize that was a *Victorian* idea that had *nothing* to do with 1957.

And, Cynthia, I have a fantasy about the panel: Do it all over again, adding a few elements like Audrey Flack and Mimi Schapiro and Mary Frank and Jackie Ferrara and truth serum (or at least strong booze) and no husbands or men of any kind in the audience. Then maybe we could add another chapter to "Women Artists of the '50s"!

– Mimi Weisbord

Women Artists News, June 1977 [Vol. 3, No. 2]

"Why Pick on Janson?"

Opening statement by **Cynthia Navaretta** from "Women Artists of the Fifties"
Artists Talk on Art, NYC; March 4, 1977

The women artists' movement has often cited the fact that Janson's famous art history text has no women artists in it. Preparing for tonight's panel, I picked up Dore Ashton's *The New York School: A Cultural Reckoning*, and did some counting.

Of 420 names listed in the index, only 33 are women. Of the 33, only 12 are artists. Of the 12, four are mentioned only once (Georgia O'Keeffe, I. Rice Pereira, Hedda Sterne, and Perle Fine), and then only in a list of artists' shows.

Seven of these 12 women are referred to, not as artists but as writers (Dorothy Dehner, Elaine de Kooning, Lee Krasner, Jeanne Reynal, Ethel Schwabacher, Lyn Ward, and Charmion von Wiegand), or briefly quoted from letters, mostly about male artists. Only Lee Krasner is quoted with any indication of her real involvement and familiarity with the period. Betty Parsons, who was also an artist, is referred to only as gallery owner.

The other women Ashton mentions are writers (9), collectors (2), museum and gallery directors (5), a publisher (1), and women in theatre or dance (4).

Of course none of the women on tonight's panel are mentioned in the book, nor are Joan Mitchell, Helen Frankenthaler, Grace Hartigan, Louise Nevelson, Miriam Schapiro, Jane Freilicher, Jane Wilson, Lois Dodd, Nell Blaine, Biala, or some dozen others. In her opening note, Ashton says her book is not about art or artists, but "about artists in American society." Her book was published in *1973*. Why pick on Janson?

Women Artists News, June 1977 [Vol. 3, No. 2]

'77 / #57

Epigraph

Jerilyn Jurineck's response to the '50s panel could have had a page to itself at the beginning of this book as a kind of epigraph for artists' talk of the '70s and '80s. But then it seemed more effective to let it just arrive, as it did originally, in the flow of events. Her ironic resignation in the face of the complexities of a "mature" art world and clear-eyed assessment of what was lost and what gained by being "clubless" are a perfect expression of the time and place.

"When Will I Get What I Expect, or, When Will I Stop Expecting and Get About It?"

Reflection after "Women Artists of the '50s," March 4, 1977

The Friday night panel, "Women Artists of the '50s," completed a circle for me, and released me from an old fantasy.

I am one of those MFA'ers weaned on stories of New York Artists from the Depression to the '50s, mostly from the Club and the Cedar Bar; stories that filled me with romantic dreams of coming to New York and being part of the artist-community.

"The Club and Its Members" was a large portion of my graduate seminar on Contemporary Issues (as if nothing had happened after the late '50s). The Old Boys all travelled the College Lecture Circuit – safe and popular. Faculty might feel threatened by their better-known peers, younger artists, or women. But grateful students of the Club could safely pay homage by having the Old Boys speak, which they did, with great regularity.

Now, in a clubless and diffused artists' community in New York, I find I am annoyed and tired of the Club. Again the Club is the subject of a panel discussion, and again I am told with sadness and longing that these days in no way measure up to the old days. But I don't care any more. I'm sick of the subject.

The '70s have a substitute for the Club: the panel discussions. Six or so people attempting to relate something of their ideas and feelings, with really very little rhetoric. It's *hors d'oeuvres*, not a main course, but I think I prefer it. I'm relieved not to feel I need to belong or be in opposition to one group, not to be judged in relation to one dominating school. And the panels let me see diverse styles and work.

I'd like more contact with other artists and a more intense dialog. I feel a need to participate. The dream of community sustained me in my student years of isolation in the Midwest and sent me in search of women's groups, critique groups, and panel sessions in New York, L.A., and Chicago. But now is the time to let go of the fantasy, to stop expecting: real dialog at a panel discussion, a magically cohesive community, to know everyone in the art world, to have my rent paid this month by a rent party.

– Jerilyn Jurinek

Women Artists News, June 1977 [Vol. 3, No. 2]

'77 / #58

But Keep a Sharp Eye Out at Flea Markets

This panel brings together a range of contemporary sculptors with the proposition that they have a common root in folk art. The claim is three-quarters dismissed by the reviewer, who nevertheless inserts some engaging reflections of his own on the issue at hand – and a few others.

"American Sculpture: Folk and Modern"

Moderator: **Pat Mainardi**; Panelists: **Ann Arnold**, **Sidney Geist**, **Chaim Gross**, **Hans Hokanson**

Artists Talk on Art, NYC, March 11, 1977

Moderator Pat Mainardi opened this rather uninteresting and surprisingly well-attended panel on the "interrelationship between folk art and modern American sculpture" by showing slides of some terrific 19th-century American folk sculpture, followed by a few splendid examples of Elie Nadelman's folk-inspired wooden sculptures. In fact, the ghost of this very fine artist hovered over the panel all evening long.

Next we looked at slides of the work of the four panelists. Ann Arnold showed black-and-white slides of her sculptures from the '60s, when she was still making people. I especially liked her hand-carved wooden busts of some of her friends and the three-dimensional portrait of her aging father shrinking into his rocking chair. Arnold, who spoke well, went on to tell a little about her background and the influence folk art had on her work. As the evening progressed it became clear to me that she was the only one there who really belonged on a panel comparing folk art and modern American sculpture.

Hans Hokanson decided to show some unclear slides of his outdoor studio, with a lot of works-in-progress strewn about among the trees and rocks. His choice of visual material would have been OK if this had been a panel on, say, artists' life styles. At this point I knew I wouldn't be getting any new or interesting information from his part of the table.

Chaim Gross began by telling Ann Arnold's right shoulder a story about Nadelman. That ghost again. Besides Arnold's shoulder, I would guess maybe four people heard and understood him, which brings up a criticism I have about these panels. I'll leave the subject of the general discomfort for

some other time, and just ask if the people who run the series would please take the bucks they collect at the door and buy some sort of decent sound system so an audience could hear and perhaps understand what is said. Judging by the constant "Speak Up"s from the audience that night, I'm not alone in my annoyance.

Gross presented slides from 1928 to the '40s, but my interest ebbed drastically with his 1928 Nadelman-inspired sculpture of a woman. The last panelist was Sidney Geist, the Brancusi scholar, who thought the panel was next week, but did have a few slides from the late '50s to show. Naturally someone from the audience brought up Brancusi (whose work I love). Somehow panelists and audience got into a discussion trying to connect or disconnect Brancusi to or from folk art, Roumanian folk art at that – one of the most ridiculous discussions I have ever tried to listen to, but for me the highlight of the evening.

The audience started to moan and groan when Hokanson commented that "folk art doesn't exist any more," and a slight stench of elitism started to descend over the proceedings. Panelists and audience suggested some reasons for the loss. Too much media (information), too much education (art schools), and too many collectors, dealers and curators. All fairly good guesses if one agrees with the assumption. I don't.

Last fall, in North Carolina for two weeks of teaching, I went to one of those huge country flea markets. For a small sum I bought a basket from a young boy that his grandmother had made, an object of intricate design made from light and dark brown popsicle sticks, amber marbles and small pebbles – wildly beautiful, especially when light shines through the marbles. A person making such a thing would not or could not stop at just one. I see a roomful of popsicle sticks somewhere in the back woods of North Carolina. The flea-market finds of today will be the classic folk art of tomorrow.

My friend, the painter Cynthia Carlson, travels to various parts of the country photographing contemporary folk art for her lecture on that subject. When I told her about the notion that folk art is dead, she said, "I find it flourishing in abundance and of first-rate quality." She added that it has changed from primarily objects of use to primarily objects to look at. I left the panel after 90 minutes because I was pretty bored, and also a little depressed by meeting a man at Fanelli's Bar before the panel who had just been released from prison after 11 years for murdering two men with his bare hands. His motives sounded fully reasonable in a Fritz Langian way, although I knew he was soundly wrong. Also, it was a beautiful spring night and I felt a little ridiculous taking notes in the dark.

– Ira Joel Haber

Women Artists News, June 1977 [Vol. 3, No. 2]

'77 / #59

Post-Whitney Modernism

The anger of artists who had failed to make it to the Whitney Biennial with their "early work" shows the drastic change in expectations from the 1950s, when, as we have been told and told, artists expected little recognition in their lives, or at least until they were old, maybe 45 or so.

Artists responded in 1977 with the "First Whitney Counterweight," described here in a straight report, a panel report and revelations of a Counterweight juror. Whether any of the artists ultimately made it to the Establishment is not on record, but developments of the '80s suggest that the optimism of the Counterweight was – optimistic.

"Whitney Counterweight"

March, 1977

A counterweight, according to Webster, is an equivalent weight, a counterbalance. Below Houston Street in New York last month [March, 1977], counterweight meant the Whitney Counterweight – three weeks of rawly installed and hung art work, complemented by evening musical offerings and performances.

"The invention of the name 'Counterweight' was important to us," explained Barnaby Ruhe, who, along with Bill Rabinovitch and Elizabeth Converse, organized the exhibition. "We were going to call it 'Up Against the Whitney' [but] the word counterweight gives more the idea we wanted – weight for weight with the Whitney: the same number of artists, the same amount of space. We actually ended up with more art than the museum."

The idea for the artist-run exhibition, which was spread through five Soho galleries – Auction 393, James Yu, Cayman, Aames and Rabinovich-Guerra – jelled in January, when the Whitney announced its choices for the Biennial. According to Ruhe, who arrived in SoHo after a stint at the United States Naval Academy (first as student, then as art history instructor), the exhibition was a political and aesthetic statement.

"The Biennial is part of a commercial cabal," claims Ruhe. "How many galleries are we talking about in the Biennial? Castelli, Sonnabend, Paula Cooper, Sperrone. . . . It's a closed system, one that only wants a few artists who can be super-hyped."

The Counterweight selected 93 artists from the 1,000 who sent over 4,000 slides of work. The executive committee, expanded to six from the three artist-initiators to allow minority-group representation, chose seven artist-judges. The judges saw slides from a carousel, without any identification of the artists. Four of the seven had to vote yes for an artist to be included. Virtually none of the artists had a gallery affiliation.

"We came up with a much different aesthetic than the Whitney," Rabinovitch said. "The Biennial was a heavy minimal-conceptual thing."

The Whitney Biennial, which concluded last month, focused on artists who have made their initial impact or had their greatest influence in the 1970s. Sectors of the artist community claimed it was lopsidedly white, male, minimal, elitist, conceptual and/or commercial.

Not that the Counterweight was itself free of controversy and dispute.

"There were dozens of nights of rampage and rancor," admitted Rabinovitch. "There were valid disagreements but mostly a lot of frustration among artists."

He explained that some Hispanic groups had joined the project more intent on demanding than cooperating. The most publicized rift occurred when Arthur Guerra, Rabinovitch's partner in a gallery on Grand Street, disassociated himself from the exhibition and gallery for "social" and "aesthetic" reasons. Rabinovitch interpreted the situation differently.

"The real issue was ego," he said during an interview at James Yu. "He was very disturbed that members of the executive committee wanted some decision-making power. But we did most of the work while he was busy with his own concerns."

Guerra could not be reached for comment. But, personal problems aside, the biggest hassle for the organizers was finding space for their show.

"We knew we had to have professional space," explained Rabinovitch. "We couldn't be off on some side street and expect to draw attention."

The organizers rented space from the Yu's, and the three other galleries participated gratis. Money, so far, has come out of the Counterweight community's pockets, while a promised $3,000 grant from the National Endowment for the Arts has yet to arrive. The exhibition, according to Ruhe, drew roughly 15,000 viewers who contributed over $1,000 at the door.

Can we then expect a second Counterweight two years from now?

"Maybe at the Customs House with 300 artists," Ruhe speculates. "It would probably be easier. Now we know where the dead ends are."

— Gerald Marzorati

Artworkers News, April 1977 [Vol 6, No. 1]

Update: Contacted in 1991, Barnaby Ruhe recalled subsequent events: The National Endowment for the Arts did come through with a $1500 matching grant, meaning the Counterweight had to raise an equal amount. This was easily done, Ruhe explained, with an opening "Waltzing Ball" and a $1 admission to the show, which, he said, had 5,000 visitors the first day. (Please do not try to make all these figures match. It was a long time ago.) Artists Space also provided $350 for each of the three shows.

A mini-Counterweight was held two years later, in 1979, at "an artist's studio" at 76 Grand Street. In 1981 approximately 60 artists were shown in four galleries, on or near Grand Street. A mail art show in 1983 was evidently the last Counterweight. Each of 100 artists contributed 100 postcard-sized works. One work from each artist went into each of 100 boxes distributed to museums, collectors and critics around the world. These were declared "awards" for deserving persons. Ruhe recalled Barbara Gladstone, Richard Bellamy and Peter Schjeldahl among awardees.

Ruhe said several artists achieved gallery affiliation through the Counterweight; he also described the jurying process: Some 4000 sets of slides in all (three or four slides per set) were submitted. Juries, which included four women, two blacks and two Hispanics, changed with each Counterweight. Blind jurying produced a show that was 50% women, but "ethnic" jurors objected; they wanted to see names, so they could select artists identifiably "theirs."

"Whitney Counterweight Symposium"

Moderator: **Barnaby Ruhe**; Panelists: **Bill Rabinovitch, Vernita Nemec, Greg Reeve, Nitza Tufino de Breitman**

Artists Talk on Art, NYC; March 18, 1977

The Artists-Talk-on-Art announcement had "Patterson Sims, Whitney Curator" added in large black letters. *The New York Times* featured the event and Sims's name in its Weekender Guide. The Whitney Counterweight Symposium was indeed held, but Sims never showed. The rest of the panel, Counterweight organizers and moderator Ruhe faced a crowd of 200, many of them discontented artists.

The evening began with a show of slides, perhaps inappropriate to the occasion, of the work of three panelists. They, seemingly embarassed by their own efforts, offered such excuses as, "This is an early work: I did it last year," and, "I guess I'm still trying to find myself." Next came complaints from the floor, ranging from the fact that many hadn't heard about the show until it was a *fait accompli*, to criticism of jury selection, to the inevitable, "Why wasn't my work accepted?"

One irate artist demanded the names of the selection committee, shouting, "I paid a dollar to find out! "* The panelists obliged, and then spent most of the evening apologizing for organizational problems and defending decisions, particularly the questionable one to include their own work. Intending to clarify it all, committee-member Elizabeth Converse slowly and dramatically read an unintelligible "Statement of Purpose" from the floor.

Eventually the general griping subsided so that members of the audience and the panel were able to make a number of valuable proposals for future artist-run events. The sponsors anticipate an annual show, hoping next year to concentrate more on aesthetics than on the politics of jury selection and to solve the organizational problems which plagued this year's Counterweight. Artists, encouraged to volunteer their services, did sign up at the end of the evening. As one panelist noted, the need for artist-run shows is deeply felt. Despite its shortcomings, the Counterweight is a substantial beginning.

As for Patterson Sims's absence, it exemplifies the art establishment's arrogance toward artists. His acceptance of the invitation was surprising and pleasing, his subsequent refusal to appear, "for personal reasons," announced five days before the Symposium, after all the publicity had gone out, was more characteristic.

Perhaps he was suffering from Post-Minimal Drip.

– Judy Negron

Women Artists News, May 1977 [Vol. 3, No. 1]

*Price of admission to the panel was a dollar.

Tucked away in parentheses in the juror's tale excerpted here is the information that "only about 60% of the work chosen went through the jury process." Nor is that all to suggest hanky panky. . . .

"More Dope on the Counterweight: or, *Another* Story for Women"

Much has been said on the Whitney Counterweight. What I have to add is one of those stories that likes to be told and is not without significance. I had the questionable privilege of being one of seven jurors for some of the show (some, because only about 60% of the work chosen went through the jury process). . . .

Toward the end of the jurying, the moderator announced that over 60% of the finalists were women. One man blanched visibly. Another said, "Well, I had hoped it would be at least 50-50."

I had to leave town at this point. When I returned, this unique imbalance had been redressed. The final selection was 46% women.

I think without a cultural bias by male jurors the show would have been more than 60% female. Certainly it was evident during jurying that most of the strong work was by women. In the actual show, women, blacks, and Third World people still dominated with many of the stronger pieces.

Despite its problems, the Counterweight was a significant and much-needed event. But for me its greatest failure was that it played it safe, insisting on the status quo.

– Betsy Damon

Women Artists News, Summer 1977 [Vol. 3, No. 3]

'77 / #60

Unlimited Editions

Although artists have always made books, "artists' books" suddenly evolved into a new form. The possibilities for conceptual, visual and psychological exploration drew artists from all media. Some were so taken with the new "voice" that they made books their sole medium.

"Artists' Books"

Moderator: **Pat Steir**; Panelists: **Leandro Katz, Eve Sonneman, Robert Barry**

Artists Talk on Art, NYC; March 25, 1977

Moderator Pat Steir is an artist and member of Printed Matter, which publishes and distributes artists' books. The panelists are all artists who make books. They reviewed what is being done in the field and its potential value and relevance.

Steir began by commenting that the genre has become increasingly attractive to artists as a vehicle, allowing them through both form and context to cover areas that traditional painting and sculpture do not. She noted the difference between experiencing an artist's book in the privacy of one's own space and public viewing in a gallery or museum.

Books are unobtrusive, easy to transport, trade, or dispose of, and do not demand much space, she said. For the artist they can be relatively inexpensive to make, easily distributed, and affordable to the general public.

An astonishing number of artists are making books now, Steir pointed out. For an unknown artist, or one not living in a major urban area, it's a way to have one's work seen and, also, to curb the authority of galleries and museums in defining taste and shaping culture.

Leandro Katz has made some 14 books, printing at first with collectives, producing limited editions on small presses, then larger editions as new techniques became available. The artist can take over the milieu of books, a powerful medium for propagating ideas, Katz said, and should try to save the "idea" of a book from commercial trade. *Self-Hypnosis,* his most recent work, contains an image and numeral system interpreted by a continuing text. The reader becomes actively involved in the construction of the book, thrust out of the customary role of passive consumer or spectator.

Photographer Eve Sonneman has just finished her first book, *Real Time,* a collection of her favorite photographs. The "passing of time, moment to moment" is conveyed through double-image photographs side by side. Sonneman chose the book format for its concision and availability. She supervised the making of the book and reproduction of her photographs.

Robert Barry, who saw "the book as book" rather than as a carrier of information, had initially been invited by a dealer to make a book, *Zero to 1,* with Vito Acconci. Now Barry's books usually have no title, no beginning, and no end, but

each page has an isolated descriptive phrase, "adding up" to nothing, defying classical narrative structure.

Steir asked, "When does something become a book? Is 'sequentialness' in form necessary?" Katz replied that his books are not objects that reveal themselves, but reveal instead the didactic process of language. At this point the audience brought up the question of the economics of producing books, asking whether financial considerations limit creativity. The speakers outlined ways of making books cheaply, saying that with offset printing and xerography anyone can afford to make a book – cost being related to the degree of elaboration. Also, grants for making books are now available.

Again the audience asked whether the artist's book will *remain* democratic, "devaluing the 'art object.'" Would not hand-signed, limited-edition works eventually become like other precious art, increasing in price and in the hands of a few wealthy collectors?

The panelists said this would certainly happen with limited editions, but their own books are in unlimited editions. Steir's company will not accept any other kind.

Is it possible to make money from books? All said returns are slim – definitely not a money-making venture.

Katz said again that for him the form is a search for a language outside the general language of books. Able to reach all those persons not usually reached by art, the artist can gain some idea of potential audience and the general culture.

Do any national book chains take artists' books? Not many, Katz said, but advocated keeping the distinction between artists' books and general trade books, with a special section for these technical and didactic investigations.

– Medrie Macphee

Women Artists News, Summer 1977 [Vol. 3, No. 3]

'77 / #61

Ex-Whitney Curator

Marcia Tucker

Interviewed by **Gerald Marzorati**

NYC, Spring, 1977

Marcia Tucker – curator, writer, art historian, teacher – says she simply likes to look at art, bits and hints of which surround the desk in the Fine Arts Building on Hudson Street which currently serves as home base for her fledgling New Museum. The following is edited from a two-hour talk:

Gerald Marzorati: Gertrude Stein is said to have written about the Museum of Modern Art, when it opened almost 40 years ago, "A museum can either be a museum or it can be modern, but it cannot be both." Do you agree?

Marcia Tucker: What is now the avant-garde – the unacceptable – is the art history of the generation that follows. I don't see why, say, you can't have a museum concerned with art from 1970 on, which documents this work and collects in this very high-risk area.

Marzorati: The Museum of Modern Art – the American model – is, many say, no longer taking such risks.

Tucker: Yes, but the collections were always the key thing. The Whitney Studio Club, on the other hand, was interested in supporting the living artist. It is only in the last few years that the Whitney has started moving slowly but surely towards an emphasis on its permanent collection. The collection was originally used to give an historical framework to the exhibitions, and I believe that to be the proper formula for showing contemporary art.

Marzorati: Is the Whitney's growing interest in the permanent collection the reason you are no longer working there?

Tucker: Well, to find out the reason I am no longer there, you would have to ask the person who fired me.

Marzorati: Armstrong* gave you no reasons?

Tucker: He said that the way I worked would be better utilized elsewhere. Yes, he did mention the permanent collection. It's funny, but I'm so distanced from it now that it's difficult to recall the conversation.

Marzorati: Are you still tying up loose ends there?

Tucker: No, my work at the Whitney is completed. I made the selections for the Biennial with the two other curators [Barbara Haskell and Patterson Sims] but I had nothing to do with the installations or the catalogs.

Marzorati: Are you satisfied with the show?

Tucker: No, I can't say I'm satisfied. I think the artists are really good, really interesting. I have absolutely no quarrels with the work. But I don't think the show as a whole is justified, accurate, representative, nor is it a Biennial. The exhibition would be just fine if it were billed as 40 artists. But it's pretentious to say what the art of the '70s are in 1976. A Biennial has always been adventurous, controversial, a show in which well-known and unknown artists got mixed up together. This year's exhibition has only a handful of women and not a single non-white.

Marzorati: How did you perceive your role as a Whitney curator?

Tucker: My energies are always channelled towards the living artist and the work he or she makes. This means putting myself face-to-face with works I know less rather than more about, in hopes of bringing art which hasn't had adequate exposure into the public eye. That means a minimum of two years with the artist and his or her work, trying to get inside someone's head, trying to establish a really intimate relationship with the work over a very long period of time.

Marzorati: Where does this exposure usually take place?

Tucker: In the artist's studio, though, of course, I go to the galleries and museums.

Marzorati: What about galleries and museums, their relationship?

Tucker: Museums and galleries function in a complementary fashion. They do different things. The museum has no need to show work that is commercially viable.

Marzorati: But doesn't the museum still have to draw a public?

Tucker: Yes, but it can learn to cross audiences. When you have a show you know is going to draw a large audience, you mount a small, less popular show next to it.

Marzorati: But what of outside sources of funding, such as foundations and corporations. Since they are putting up money for public relations, they want a large public. Large publics don't turn out for contemporary art.

Tucker: Well, that is exactly what happened to me at the Whitney. Not one show I ever did was ever funded by an outside source. That is one of the reasons why my being at the Whitney is no longer expedient.

Marzorati: Does a museum showing contemporary art function as a tastemaker?

Tucker: I suppose museums often are tastemakers, but I tend to think that my shows seldom made taste. To make taste would mean you skirted a line somewhere that represented already-acceptable taste. That usually doesn't happen when you show, as I do, the work of contemporary living artists. Without exception, my shows at the Whitney were badly received. But historically, the contemporary artist has been badly received, with acceptance only many years later.

Marzorati: Should artists have a place in the museum structure?

Tucker: Were museums to do their job right, I suspect artists would be more than happy to go back to their studios and work. In a good museum situation, the roles of the artist and the curator are cooperative and symbiotic. The curator's function is to do the best he or she can for the artist's work. . . . It's like going to a really great movie; when you come out of the theatre, for hours afterward, the world looks different, the light is different, the way people move . . . With works I have spent a long time with, I find that my visual world has expanded as a result. When that happens, everything, even the very quality of your life, is changed.

Artworkers News, April, 1977 [Vol. 6, No. 9]

*Tom Armstrong, then director of the Whitney Museum, was himself fired in 1990.

See '80/#142 for another interview with Marcia Tucker, and '90/#222 for Tucker's update on the New Museum.

'77 / #62

Westward Ho

They were delighted to finally get some "gender dialog" out west – and we were delighted to send it to them.

"Gender in Art"

Moderator: **Anita Fiske**, artist; Panelists: **June Blum**, artist; **Dolores Tarzan**, *Seattle Times* art critic; **Isabel Sim-Hamilton**, artist; **Carol Orlock** poet, critic

and/or Gallery, Seattle; Spring 1977

For the first time in Seattle, a formal panel was held on "Gender in Art." New York artist June Blum, visiting here for her show, was joined by area artists and critics. Blum traced her own growth as a feminist artist from her 1969 play, "The Female President," which featured a pregnant female president.

"It used to be a compliment to women's art to say, 'I thought that was done by a man,'" Blum pointed out. "Women used to try consciously to paint like men." But today, neither men nor women need "fall into clichés that lead to dead ends, like Minimal art and Neuter art." Blum ended her introduction with, "I would feel complimented if someone thought my work was 'done by a woman.'"

Taking off from there, Dolores Tarzan spoke of her own experience viewing a great deal of art every week. Approximately 80% can be identified by the sex of the artist, she said. Men and women both tend to do the female figure, but men are more likely to idealize it, women to be more accurate, especially in the matter of breasts and dignity. She rarely finds a canvas by a woman on the order of Munch's "The Scream." Carol Orlock commented that when a woman paints a female figure, it looks like it *works*.

Moderator Fiske asked why there weren't any male panel members. Tarzan called it "marvelous poetic justice." Isabel Sim-Hamilton chuckled, "Ha, ha, ha." But Blum said it had simply been a communications problem before her arrival. . . .

To my surprise, Orlock questioned the professional behavior of some women artists. Recalling her experiences as a dealer, she told of visiting a woman's studio and breaking for tea when the artist's mother arrived. On another occasion, a woman walked into the gallery with a converted baby stroller loaded with slides and paraphernalia. Orlock found both episodes distasteful.

To me, they seemed charming and original. Why shouldn't women incorporate a part of their lives into their presentations? Why should traditional "professional" standards be universal? Blum described similar experiences of her own, which she had found refreshing. In women's studios, usually in kitchens or bedrooms, she said, she has often been offered tea. "Men never do this." Blum said she "really responded to the difference."

A number of tangential comments failed to throw light on this relatively new, but popular subject . . . I hope in the future we will proceed with more than gut reactions.

– Lyla Foggia

Women Artists News, September 1977 [Vol. 3, No. 4]

'77 / #63

Practical Advice

The co-op was a logical vehicle for artists in mutiny and 1977 was perhaps the apogee of the co-op. Before long some of those energies began to go into the East Village, where a number of artists became dealers, and some blocks, like east East 10th Street, became a string of galleries. When the East Village faded, the vertical art malls of Soho were proliferating, again increasing artists' options and again draining energy from co-ops. (Even after the art "bust" of 1990, there may remain more galleries in one converted 19th-century cast-iron building on the corner of Prince Street and Broadway than, who knows?, maybe all Paris in the '40s.)

As it happens, many of the co-ops from this period and earlier are still up and running, longer-lived than all but the hardiest dealerships. In fact, there has recently been speculation that with so many galleries closing, the co-op moment, or some form of it, will return.

"First Experiences of Organizing a Co-operative Gallery"

Moderator: **Sylvia Sleigh**; Panelists: **Marilyn Fein, Ann Sperry, Mary Ann Gillies, Emily Fuller, Bibi Lencek, Cora Cohen, Ann Stubbs, Blythe Bohnen**

A.I.R., NYC; April 1, 1977

Some of the panelists spoke at length from notes, and others were invited to speak informally from the audience. Except for Blythe Bohnen (A.I.R.), Ann Gillies (Soho 20), and Bibi Lencek (owner of available gallery space), each had at one time wanted to help set up a woman's cooperative gallery, but had so far not accomplished that goal. Some, especially Marilyn Fein and Emily Fuller, expressed a degree of frustration in the attempt.

Fein, with Bona Wygodzinsky, had envisioned a sculpture gallery in which the membership would be mutually encouraging, kind, democratic, and not elitist. She wondered aloud if their ideals had been too high, but Sylvia Sleigh thought the difficulty was that the organizers spent only half the time necessary to build a co-op. She said it takes a year. Fuller described being unable to attract a sufficient number of artists, while the interest of the six-member core group waned before the gallery could materialize. (She is now a member of Soho 20.) According to Ann Stubbs's description, her group was not sufficiently cooperative, too competitive. Ann Sperry said hers did not have enough people or time to work.

The following advice and suggestions were offered:

Remain frank and open with each other (Sleigh); share workload (Sleigh); seek grants (Sperry); align with other co-operatives elsewhere (Sperry); limit membership to 20 (Gillies); put about $200 each in the pot before you start (Gillies); xerox labels for a mailing list (Bohnen); produce a book instead (Cohen); hire a woman architect and a woman lawyer (Stubbs); include a demographic mix in membership (Stubbs); and meet periodically even though not much may be happening at the moment (Sleigh).

Gillies described the beginnings of Soho 20, the difficulties in finding and then renovating space, the arguments among members over costs. The inception of A.I.R. in 1972 was equally arduous, according to Bohnen. Each member contributed 80 hours to the renovation project; it now costs each artist $400 to $500 per show.

– Phyllis Floyd

Women Artists News, Summer 1977 [Vol. 3, No. 3]

'77 / #64

Area, Brata, Camino, Hansa, James, Jane Street, March, Nonagon, Peridot, Phoenix, Pyramid, & Tanager

The '50s co-op scene, which centered on Tenth Street, was fondly recollected a few weeks after the A.I.R.co-op workshop. The Phoenix Gallery is still in business, now on lower Broadway.

"The Downtown Art Scene a Quarter Century Ago"

Moderator: **Bruce Barton**; Panelists: **Nell Blaine**, Jane Street Gallery; **Louise Bourgeois**, Peridot Gallery; **Gretna Campbell**, Pyramid Gallery; **Angelo Ippolito** and **Lois Dodd**, Tanager Gallery; **Richard Stankiewiez**, Hansa Gallery; **Don David**, Camino Gallery; **Ed Clark**, Brata Gallery; **Pat Passlof**, March Gallery; **Bob Henry**, James Gallery; **Ruth Fortrel** (and **Charles Duback** from the floor), Area Gallery; **Bruno Palmer-Poroner**, Phoenix and Nonagon Galleries

Artists Talk on Art, NYC; April 29, 1977

This was a panel! The largest, the most interminable! Despite its broader title, which led me to expect talk about the work, the issues, the "Club," artists' publications (Sidney Geist was in the audience), and, incidentally, artists' galleries, the panel limited itself to the last-mentioned, which was, for me, only one expression of that expansionist period.

The Artists-Talk-on-Art Committee deserves a tribute, and a grant from somewhere, for sponsoring this series. My only

complaint is that there is no continuity, nor the flexibility which would allow such an unwieldy panel to be carried over to the following week. The old "Club" had an advantage in a smaller, more coherent art world, in which one man (Philip Pavia) could keep his ear to the ground and play it accordingly. Weekly post-card mailings, which could be changed at the last minute, helped too.

As it turned out, each panelist was there as historian for the gallery with which he or she had been affiliated, and thus burdened with the kind of documentation (founding dates, founding members, rents and rulings, old addresses, dues, budgets, lists and constitutions) which more properly belong in archives.

Bruce Barton had researched the subject conscientiously, one of the results being an increase of the originally announced panel of seven to the final dozen. Nell Blaine was represented on tape by an excellent interview with Bruce, too long to hear more than halfway through, but which stirred up flurries of memories. We panelists were just warming up when our exhausted audience deserted us.

– Pat Passlof

Women Artists News, Summer 1977 [Vol. 3, No. 3]

'77 / #65

Life After Art School

Mimi Smith reflects that when she entered graduate school in the early '60s, art "careers were looked on with disdain." She then helpfully reports advice from the experts.

"Myths and Realities of Art Careers"

Moderator: **Blythe Bohnen**; Panelists: **Deborah Remington, Joan Snyder, Jackie Winsor**

A.I.R. Monday Night Program, NYC; May 9, 1977

What is an *art career*? Is it different from being an artist? I have been an artist for 14 years, but until five years ago I never realized such a thing as an art career existed. I thought careers were for doctors and movie stars.

The artists I know and have known, even the ones who have managed to find careers, became involved in art for very different reasons. They liked to work in a private manner, with their ideas, and their eyes, and their hands. They may even have wanted to communicate ideas through their work, but would never have conceived of themselves as sales people, or public relations people. In fact, in the early '60s, when I entered graduate school, such careers were looked on with disdain.

For a woman artist, the notion of an art career seemed especially foreign and difficult, even ludicrous. Most women were never taught to expect any kind of career at all. In fact,

many middle-class girls were allowed to study art, while their equally talented brothers were discouraged, because art was so unsuited to any kind of occupation or respectability. Art school was the ultimate liberal arts education – it left you wholly incapable of anything but your own pursuits. Times change, however. Today, as soon as a woman artist becomes conscious of the words "career" and "ambition," she feels she must try to achieve both.

With some of these thoughts in mind, I attended a panel discussion on "Myths and Realities of Art Careers." For a rainy, cold Monday night, A.I.R. was exceptionally crowded. A roomful of women and a sprinkling of men had come to hear about art careers – not art ideas, but art *careers*. I myself had an extra curiosity: I went to graduate school with Joan Snyder and Deborah Remington at Rutgers in the '60s.

Questions and answers covered a range of issues, beginning with Business.

Contracts: Remington uses a purchaser's agreement about the piece, restoration, etc.– nothing about resale. Jackie Winsor uses her own simplified version of the Artists' Rights Contract. At first buyers objected; now they know that if they want a Winsor, they also get a contract.

Lawyers: Remington said a good lawyer is indispensable. She suggested Volunteer Lawyers for the Arts for artists of limited means.

Dealers: Remington said she gladly gives a dealer a cut to keep people away from her. She also said she had never approached a dealer. Snyder has no dealer now, had been with Paley and Lowe. She keeps her own records and enjoys meeting collectors, most of whom buy her work, not as an investment, but because they like it. She has never approached a dealer, either. Winsor likes having a dealer (Paula Cooper), because her "privacy is very important." She *had* approached dealers, she said.

Money: Remington said that although she makes money now from her art, she fantasizes about someday having to go back to work in the post office or as a waitress, if necessary to preserve her artistic freedom. Winsor observed that art is lucrative for only a few, and that some artists make money for a short time only. Those who last are committed to the work, not the money.

Other questions were more personal:

Who helped you? How did you get started? Remington said that at first other artists and friends helped her. Writers and critics came later. Her first show was a group show; she sold a print for $10. She felt that her success came from hard work, not luck. Snyder mentioned the importance of finding one or two people really interested in your work – Marcia Tucker and Klaus Kertess in her case. Kertess had followed her work, put one piece in a group show, and recommended her to Paley and Lowe and Marcia Tucker. She also mentioned help from the women's movement and from her husband (who urged her to show work when she felt uncertain). Winsor said a number of women had helped her, naming Marcia Tucker, Lucy Lippard, Liza Bear, and Ellen Johnson.

71

She had worked to make herself visible (done her "foot-work"), then was "in the right place at the right time" when the women's art movement began here in 1969-70. (Snyder and Winsor had come to New York together in 1967.)

All agreed on the importance of being articulate. Remington mentioned the media as the main reason to be in New York. Winsor said one of her first exposures as an artist was in an interview with Liza Bear (*Avalanche*). No one knows more about the work than the person who makes it, she added. It's important to speak well about it.

Men, kids: Snyder said a woman can have children and still be an artist if the man is very supportive. Winsor said a non-supportive man is "too draining," and kids "a luxury I can't afford." Remington had no comment. The audience asked how many panelists, how many A.I.R. members, have children. (None of the panelists,* about half the A.I.R. members.)

Hours and output: Remington stressed again that she works hard, saying she is "very focused," and, as she gets older, has less time for "nonsense." She works seven days a week, 10 a.m. to 7 p.m., and turns out about a dozen paintings a year. Snyder also produces some dozen paintings a year, Winsor, four to seven pieces.

And finally, **The System** and **Other Women:** Snyder has conflicts with "the system," but has "other priorities": making her work, her life, and feminism. She noted that art itself is an elitist activity, and the art world part of the capitalist system. She is more concerned, she said, with what happens to women in general than just women in the art world. She finds the art world "completely open" for women now, but women can be "just as greedy and resentful" as men. Remington said women who become part of the male system tend to want to keep other women out. Winsor agreed that things have "opened up tremendously" since she came here; also, it's "obvious" that you support "what is coming up behind you. That's your power."

Remington concluded with, "A career is a product of the work . . . hustling is distasteful. . . . Anyone spending the first ten years on anything but work is wasting their time." She seemed the toughest of the three, perhaps because she is older and has been around longer. Early in the evening Snyder said she'd had a "blessed career, a Cinderella story." However, by the end of the evening, she said none of her friends had helped her to get into their galleries in the last three years. Winsor seemed aware of the pitfalls and her own good luck. She said she "rode the wave of the women's movement," and "it's pretty tough to get a puffed-up ego, knowing that."

The fact is, these women themselves are the myths. Snyder, Winsor, and Remington, along with older women now receiving recognition, have become role models. But they achieved their fame in a different time. Although things are more open now, and small opportunities more readily available, the art establishment is no longer so able to create stars.

The economy has changed. The competition is greater. Three quarters of all undergraduate art students are female. Half of all graduate art students are female. And these women are no longer dropping out. The gallery system as it stands is unable to accommodate so many artists. The reality is that the mythical art career is, in practice, still a myth.

– Mimi Smith

Women Artists News, November, 1977 [Vol. 3, No. 5]

*Snyder had a baby a few years later.

'77 / #66

Backlash

This panel was intended to protest the oppression many women felt, not from "patriarchy," but from the onslaught of gender-related art and pressure to do same. Speaking as an artist rather than an editor, I titled my own remarks, "The Uplift Gap, Writers' Disease and Fear of Pluralism" (my explanations for the pressures to do "women's art"). Artist Lucy Sallick offered a parallel, personal reflection, which we excerpted in lieu of a report on the event:

"Gender in Art: Pluralism, Feminism, Politics and Art"

Speakers: **Ann Healy, Lila Katzen, Cynthia Mailman, Lucy Sallick, Judy Seigel**

Artists Talk on Art, NYC; May 13, 1977

Opening statement by **Lucy Sallick:**

The women's movement has given me the confidence to produce a kind of work that perhaps is not, or was not, acceptable, or related to by feminists. I don't know if it fits into a female sensibility scheme, but I can't think about that or I won't be able to work.

I care about the survival of the Women's Movement in Art, because it has given me the courage to do what I want. [But] right now I sense less interest in mutual support between women and more emphasis on whether or not work fits certain categories.

[If] an inherent female sensibility exists in women's art, how is it to be differentiated from "feminist art," which has been consciously produced as a result of the feminist movement? The phrase "female sensibility" is fraught with subtle and complex allusions to politics and feminism, and the very meaning of the term is subjective and unclear. . . . Do we want female sensibility to become a catch-all category for a school of art defined and made by "true" feminists? What happens to the women whose politics are not so apparent in their work, or whose sources are completely different? It used to be "paint like a man." Will it now be "paint like a woman"?

If a woman's art is not clearly feminist and does not happen to have characteristics attributable to female sensibility, is her consciousness not sufficiently raised? Is she operating under male-dominated ideas? These questions create an atmosphere of unease and resentment among women, have the ring of "I'm a better feminist than you," or "My art is better than your art."

Sociologists say that all movements run a certain course and then start to split into factions and become weakened. I hope the women's movement in art can be different – can continue to build support systems, fighting the narrow and cut-throat art world to produce the art that exists in our wildest dreams – whatever that art might be.

Women Artists News, September 1977 [Vol. 3, No. 4]

'77 / #67

Mixed Doubles on 57th Street

If you were around in 1977, one consolation for being a decade and a half older today is that no curator would dare explain the near-absence of women in an exhibition by saying "we wanted quality." And if the curators of such a near-womanless exhibition *were* women or included women, as was so often the case, that fact would not be considered exculpatory. (One hopes.)

"Feminist Art: Divergent Viewpoints"

Moderator: **Barbara Cesery**; Panelists: **Will Barnett**, **Audrey Flack**, **Nina Yankowitz**, artists; **Cindy Nemser**, editor; **Patterson Sims**, curator

Viridian Gallery, NYC; May 16, 1977

The Second Story Spring Street Society moved to 57th Street, changed its name to Viridian Gallery, and had a panel discussion. Artist Barbara Cesery, who moderated, said later she'd gotten some flak for including men, but was looking for "divergence."

Unfortunately, divergence was not visible to the naked eye, or diversity either, for that matter. First-timers in the large audience, attracted by ads in the *Village Voice* and *Soho Weekly News*, seemed satisfied, even happy. But to a veteran of the talk-show circuit, a seeming consensus that "Feminism is tapping into your roots" evoked Alex Haley more than current issues. Except for a poignant memoir of boyhood from Will Barnett and an unwitting revelation from Patterson Sims, the rest was familiar territory.

Nina Yankowitz: Feminism is the way a woman lives her life . . . I am not interested in feminist ideology for art-making . . . I demand the right to extrapolate from whatever area I want.

Cindy Nemser: Women's personal experience has been put down as unimportant or trivial. . . . Now women express

their experience in their artwork . . . and are beginning to seek their mythological roots. Their sexual roots also. Men have been flaunting their sexuality since time immemorial.

Patterson Sims: Specifically "feminist" art is made very self-consciously. Such notions as "from the center," or pink are sexist stereotypes.

Flack reiterated the fact that her style, Photo-Realism, is associated with male imagery, but her images are both feminine and feminist. Using lipstick and jewelry as subjects for *Jolie Madame* in 1971, "I had made a feminist still life without knowing it."

Will Barnett pointed out that "for a young male growing up in a small town, when to be an artist was to be a sissy, there were also frustrations . . . I used to carry a watercolor box in my pocket, and after a game of baseball – not telling anyone – I'd go out to the quarry to paint. My school advisor told me I'd starve to death as an artist. I said, 'But that's the only thing I want to be.' What I had to face was a lot like what women had to face."

Other panelists insisted, however, that Barnett had at least had a history full of male artists as role models. After noting that he and other men have painted domesticity, "many of the things women now paint as feminism," Barnett spoke of art-school classmate Jackson Pollock, and a time when "drinking and machismo were the two basic things, and I was neither, which made it very difficult for me to go to the Cedar Bar."

"But you're a Realist," Flack said. "If you drink, your hand shakes and you can't do it."

Then: "They were drinking because of capitalist society" [Yankowitz]. "They drink plenty in Russia" [Barnett]. "That's capitalist, too" [Yankowitz].

Finally the other shoe dropped. Sims himself brought up the subject of the male-female imbalance in the recent Whitney Biennial (31 to 9). This happened, he said, because, "We wanted the show to be what we thought of as quality. . . . We had to show what we believed in. . . . [Moreover] two of the three curators were women." Audience and panelists then expressed disfavor toward museums.

On the topic of feminist art, a young woman in the audience – Scribners' editor, Patricia Cristol, as it turned out – made an interesting comment, and after the panel obligingly dashed off a reprise for publication:

"In terms of subject matter and materials, feminism generally gets described in two exactly contradictory ways. On the one hand, subject matter that satisfies expectations of what are considered traditional women's roles and areas (e.g., the domestic environment) is seen as feminist. On the other hand, subject matter that *surprises* our expectations (e.g., cowgirls, motorcyclists, lumberjills) is seen as feminist. Similarly, from one point of view (the satisfactoral), methods and materials like collage, tapestry, and weaving are seen as feminist, while, from the other (the surprising), monumental sculpture, Cor-Ten steel, and Photo-Realism become feminist.

73

"For me, this contradiction disappears as soon as we simply allow feminism to be the fullest release of all our potential energies and fancies."

I'm not sure the contradiction does disappear – or that it needs to. But "What's Going On in Our Museums?" might be the more urgent question.

– Judy Seigel

Women Artists News, September 1977 [Vol. 3, No. 4]

'77 / #68

Dress for Duress

The intensely sexualized image of women in advertising, movies and fashion today makes 1977 look like Candy Land – but protest is rare. Whatever happened to Women Against Violence Against Women?

"Women Against Violence Against Women"

Speakers: **Harmony Hammond** and **Su Friedrich**

A.I.R. Gallery, NYC; May 23, 1977

Critic Gene Thornton attributes the "delicate undertone of torture" in fashion photography to the suffering of creatures "more beautiful and better dressed" and "sensitive" than the rest of us, who mope "around like catatonic idiots in shower rooms" because they see "how awful the world really is" [*New York Times,* May 29, 1977].

Women Against Violence Against Women (WAVAW) takes a less lighthearted view. At an A.I.R. presentation, Harmony Hammond showed, not an undertone, but an "epidemic of physical and sexual violence" against women on record-album covers and in advertising. WAVAW asks a consumer boycott, particularly of Warner, Elektra, and Atlantic records, and in-person complaints to store managers, against images that "contribute to a social climate that condones violent behavior towards women."

Su Friedrich presented slide images from high-fashion photography, primarily *Vogue* magazine. Images of prostitution, signs of violence and victimization were subtler here, but the women were, at best, passive.

After the slide show, audience and panelists discussed whether "fashion" itself is oppressive, because "you're no good if you don't look like that," or whether clothes and high style are just fun, perhaps even creative (as one high-style member of the audience rather courageously insisted).

What could not be questioned is that "glamorous" images of abused women are repulsive, and that "as rape becomes common in the mass media, rapists cease to see themselves as abnormal."

– Judy Seigel

Women Artists News, Summer, 1977 [Vol. 3, No. 3]

'77 / #69

Loneliness of Yesterday

The ambivalence and dilemma of those who wanted to be feminists but not "feminist artists" was at its height. Asked to put together a panel for Jacqueline Moss's "Art by Contemporary Women Artists" series at the Aldrich Museum, I found many women leery of the topic. They had a keen appreciation of permissions given and the end of isolation, but feared a new "imperative."

Therese Schwartz's closing statement on why the women artists' movement was so welcome to women who had no interest in doing "women's art" was eloquent. But the final exchange between panel and audience suggests that those who had not lived the dilemma, who had perhaps been safely familied, in a small town, could not understand.

"Women's Art 1977: Momentum and Response"

Moderator: **Judy Seigel**; Panelists: **Donna Byars, Carol Kreeger-Davidson, Patsy Norvell, Therese Schwartz, Phyllis Thompson**

Aldrich Museum, Ridgefield, CT; August 11, 1977

Judy Seigel: When I sent panelists preliminary questions I found them reluctant to talk about "feminism." They seemed to think they wouldn't give the "right" answers. I assured them, "I'm not traveling to Connecticut to pledge allegiance to some official dogma." I also noted that Phyllis, who said she isn't sure she's a "real feminist," is spending her time and energy to develop a feminist art school, which I hope she'll explain later. . . . First: What is feminism, and what, if anything, does it have to do with art?

Therese Schwartz: Feminism has nothing to do with art, any more than any political movement, whether you agree with it or not, has ever anything to do with art. A political movement does not further the cause of art. At best it stops it for a while; at worst, it rules it out of existence, as in totalitarian countries. Political force needs strength, and strength comes from numbers. Art is made alone, by one sole human, the synthesis of the experience of one human – who may or may not be aware of feminism – put into a tangible form. Do I think a feminist will be a better artist? Yes, but only because she will be more aware.

Phyllis Thompson: Initially I was very ambivalent about calling myself a feminist, even though I shared a feminist point of view. At Cornell, Betsy Damon invited me to her feminist workshop, but I backed off . . . I didn't identify with those women – I kept thinking of myself as a black woman. I thought if sexual oppression were erased there would still be racism, and those women couldn't identify with that aspect of my problem. . . . In the meantime, I was just doing my work. I wanted to use the sewing machine, but I'd been taught that crafts were a lesser art, not high art. Finally I did start to work with the machine, creating lines, tapestry kinds of things, but I was afraid to show them to anybody. When I came to New York, I met a lot of women drawn by similar subject matter. The majority were white, but they offered an

awful lot of support. . . . There are class differences and race differences, but I was attracted to the [New York Feminist Art Institute] because it seemed to be for all women.

Patsy Norvell: Liberation is attaining equality, but feminism is changing things – changing structures and developing support systems. I think that when women have had their consciousness raised, it will influence the work. . . . In college I was taught by an all-male faculty. I learned *welding* in sculpture. Then I started a women's group. In the first year I started sewing and pleating and using vinyl shelving (from kitchen cupboards) and quilted material. I was terrified to show the work. [At A.I.R.] I was sure people were going to say, "yecch, get that out of here, that's not art!" I'd never allowed myself to learn to sew, because that was being too much of a lady, and I was a *sculptor*. So for me feminism opened up processes and materials I would never have used. And eventually it got into subject matter. My work began to be, first, about women's history, then more and more my own history. I never would have done any of that without the women's movement.

Donna Byars: I've also felt the expansion of materials. I started as a painter. It never occurred to me you could use chamois or an ironing board. There were so many taboos. . . . And there weren't any women who were great artists. . . . My favorite painting teacher said, "Donna, if you really love art, marry a painter."

Carol Kreeger-Davidson: The movement and feminism have given women the confidence to work at a completely different scale. As soon as I felt women were moving out in the art world, my scale changed – got larger – and that changed my work.

Seigel: I remember an A.I.R. panel in 1975 – Blythe Bohnen was trying to pin down some male critics who didn't think women's art and the women's movement had much to do with art, when Max Kozloff finally allowed, "Well, I see work on these walls which in prior times would have been considered miniscule and now is respected." So it works both ways, and in this sense we mustn't underestimate what the women's movement has contributed in opening up art. . . . But how do feel about *deliberate* feminism in the art? Is it an extra dimension or a disturbing intrusion?

Schwartz: If it's unconscious, you can't call it feminist. To make political art you must know what you are doing and why. . . . But fabrics, rags, or sewing don't belong to women alone. There were men in the '40s and '50s working with fabric. And there are women like myself who have absolutely no interest in household things and never did. I never played with dolls or did any of those things. . . . When I see a collage made with aprons and doilies labeled feminism, it doesn't mean a thing to me.

Thompson: But I'm drawing from what I identified with as a child. I saw my mother sewing and darning. My father didn't do those things. I put that in my work, but I don't think it means the work is feminist. There's also a stigma on using those materials, and I'm reacting to *that*. . . .

Seigel: Discussion of "female sensibility in art" may have become an art form in itself. What about that topic – and the discussion?

Norvell: When the women's movement began there was great excitement. Everyone was looking for female sensibility. But the art world works so quickly, absorbs so quickly. As soon as something is halfway out it's grabbed and spread. You can see the effects of it, but you have a hard time finding it. I mean you could get your throat slit.

Byars: I'd been working in the closet for a long time when I started to hear about things like "central image" and so on. I already had a body of work I could look at and say, oh wow, central image! I do love a lot of the things they say, so, I don't know . . . it could be.

Norvell: I use circles, but I also came from a strong background in mathematics, loving the abstraction of math.

Seigel: It's been said that the women's movement has become a slightly idealized version of careerism and that the women's art movement puts pressure on women to produce a career. Do you see a danger in this?

Schwartz: The star system, if you want to call it that, is implicit in all the arts. Otherwise, how would you know about anybody? In every art there are stars and big names.

Davidson: When I had my first New York show at Parson-Truman, Jock Truman said my name was too long. I dropped my first name because my middle name is my maiden name and I'm the last "boy" in the family. So I was Kreeger-Davidson, but Lucy Lippard left me a note that said, "very good show – I understand you're going to be George Sand." When I had my show this spring, the dealer insisted that I use my three names, because now there's a women's movement and it's wonderful to show a woman!

In New York I found women who felt a certain resentment because I'm protected, have a husband, live out of the city. So I think there's a backlash, either because the movement is changing, or because I'm having a bit of success.

Audience: It seems to me that women being accepted and accepting each other is a New York phenomenon. [But] what about quality? How do you differentiate *women's* art and *good* art? Now that you're accepted, wouldn't you prefer to be known as people, as artists, rather than women artists?

Audience: At this point wouldn't it be refreshing for women's galleries to open themselves to men?

Byars: Maybe when the numbers balance, when there are as many women as men in the museums and teaching. . . .

Seigel: I've enjoyed the companionship of women and I'm not ready to give that up.

Audience: You wouldn't like men taking that attitude.

Seigel: But they *do*. I understand your point, but, aside from the gratifying bonds among women, we are still so far from equal [that] as long as men aren't suing me for discrimination . . .

Audience: But the gesture could be made, which I think would be terribly important.

Panel: We're not strong enough yet – we're mere children.

Schwartz: One of the reasons women found each other in the art world (and I don't think the work has much to do with it) was to overcome the terrible, terrible loneliness. So few women had arrived at the point where they were willing to deal with galleries, and relationships with male colleagues

were very limited. Of course some of them married male art-
ists, and that was unfortunate, and some had intimate rela-
tionships with them, and that was equally unfortunate, but
working relationships were limited. You were never told any-
thing real or important. When there were good bull sessions,
you were never invited. If you went to have a beer with the
boys, one of the boys would have to invite you, and you
would be his girl for the evening, and who wanted that?

The loneliness inhibited your work, because loneliness
diminishes your personality. When we found each other,
whether [women] supported you on a particular opportunity
or not, they were there, and you talked to them about your
work, your hopes, your disappointments, in a way you'd
never talk to any man. Women getting out of art school now
know they can go places to talk to other women. To break
into that for a "gesture" would be kind of self-destructive.

[Edited from tape]

Women Artists News, September 1977 [Vol 3, No. 4]

'77 / #70

Male Critics Change
Their Tune

Either the work improved remarkably in two years, or the
critics, like the Supreme Court, had learned to read the
election returns.

In 1975 Harold Rosenberg said the women's move-
ment was one of the most powerful currents in art ['75/
#2], but the panel of male critics that dismissed "women's
art" as a political ploy or self-fulfilling prophecy was prob-
ably closer to the consensus of the time. Even Carter
Ratcliff, fresh from exposing the "fiction" of "mainstream
formalism" ['75/#9], was skeptical about women's art on
aesthetic grounds.

At this event, scarcely more than two years later, when
Ratcliff casually mentions "the horrible old art-world rules,"
we understand that the death of formalism is a *fait
accompli.* The really dramatic change, however, is his rec-
ognition – and celebration – of women's art as "vanguard."

Footnote: You'd have to be more in the know than I
was to explain why Lawrence Alloway had it in for Har-
mony Hammond, but clearly she turned the tables on him.

"Contemporary Women: Consciousness and Content"

Moderator: **Blythe Bohnen**; Panelists: **Carter Ratcliff, Harmony
Hammond, Joan Semmel, May Stevens, Joyce Kozloff, Lawrence
Alloway**

Brooklyn Museum, Brooklyn, NY; October 23, 1977

I find it impossible to write even a simple summary of this
panel, held in conjunction with the "Contemporary
Women: Consciousness and Content" show at the Brooklyn
Museum, without referring to another panel, "Male Critics

Look at Women's Work" – can it be, only 29 months ear-
lier? ['75/#13] Carter Ratcliff and Lawrence Alloway were on
that one, too, and Blythe Bohnen moderated.

May Stevens had asked, "Why is there so little critical re-
sponse to women's art? This is a movement with tremendous
energy and thrust. . . . How do you justify remaining aside
from this issue?" And Carter Ratcliff had replied, "If women
come along with a theory of what significance in women's
art is, it will be in order to get accepted, to get prestige. So
far, the definitions don't stand up. [T]hey may gain support
and become self-fulfilling prophecies. . . . But I can't think
of one woman who presents herself as a 'woman artist' who
presents work that would seem to be of quality to a hardline
formalist critic."

Within 29 months, the "hardline formalist critic" had be-
come an object of ridicule. Here is Ratcliff again, October
23, 1977:

"I know the rules for good art, slick art. They're terribly bor-
ing. . . . The next level [of development] is to break away
from that notion of art as rule-making. . . . Women seem to
be in a better position to do that, or at least they *are* doing
it. . . . I'm not so concerned with feminism, as with the idea
of asserting that art does come out of personal experi-
ence. . . . To be a vanguard feminist at this point puts you in
a very good position to be a vanguard artist. . . . I don't really
believe that *all* women who present themselves as feminist
artists have broken really free of the horrible old art-world
rules, but most of the people doing that seem to be women
and they seem to be going in a good direction, not just com-
peting for a front-running spot."

But intellectual exchange was not primary at the Brooklyn
event, either. This was a ritual of celebration, with podium,
spotlights, video recorder, sound system, and paying audi-
ence nearly filling the vast lecture hall. Now clearly "devel-
oped as full artistic personalities," the women savored a
moment of triumph. They hadn't done it *entirely* by them-
selves, but the question of what male critics would do for
them now seemed unnecessary. The men appeared subdued;
not necessarily captive chieftains led before the high priestess
in chains, but the metaphor did somehow come to mind.
Still, in her opening remarks, Semmel was herself on the de-
fensive:

Joan Semmel: It fell my lot to curate the show as one of my
duties teaching at the Brooklyn Museum Art School, which I
chose to do at the time of the "Women Artists: 1550-1950"
show. It was not intended to be an extension of "Women
Artists: 1550-1950," which I would not have presumed to
do. It was not intended to be "the best" women artists
working, which I also would not have presumed to do. I
tried to get a balance of the different kinds of work done by
women today. . . . Some of the work is a personal statement,
not in a feminist context. But . . . personal art put into the
public arena can become political or, in this case, feminist.
Harmony Hammond: Ten years ago I was in the Twin Cities making
art . . . but my art had nothing to do with me. I did what I
had to do to compete with the boys, and I did it very well,

[but] at a certain point I realized I was going to be making some kind of art work for the rest of my life and it better have something to do with me.

[In New York] I met with a group of women; we talked about the things you weren't allowed to talk about, things connected to feelings about being a woman and being an artist. These things came out . . . had permission to come out. It's the women's institutions that have allowed the personal to be the political. . . . With no visibility and support, my work wouldn't have gone the direction it's gone. [But] I still don't think the personal is out there as public . . . The difficulties about this show are proof. Also, it may be just an oversight, but the women on this panel didn't have their credentials listed [in the Museum announcement]; the male critics did. There's a tendency to say it's all O.K. now, but it's not.

Carter Ratcliff: It's true that the rules of modernism are male rules and history is a history of heroes making and remaking rules. The feminist distrust of those rules and that history is central to the ideals of feminism [although perhaps also] for all artists. . . . But being in the feminist vanguard puts an artist in the vanguard [of those solving] the post-modernist crisis, of artists who want to not just follow modernist rules, [but to find] the possibilities for art in the present.

Stevens: This show is different from earlier attempts to define women's art. . . Another woman would have given us a different show. I would have wanted the drawings of Dottie Attie, among others, and work that deals with issues, such as Nancy Spero's *Torture of Women*, my own tribute to Rosa Luxembourg, or works by Martha Rossler and Adrian Piper.

[Women are making art] that ignores traditional media categories, a transformation of private pain.

Joyce Kozloff: I was surprised at how rich and colorful and beautiful the show was. I'm used to seeing so much grey art in New York. And I think Joan had a lot of guts to do it – being an artist in the community. She was bound to make enemies. . . . But I was disturbed about the makeup of the panel: two male critics and four women artists – an implied authority hierarchy.

I've been reading manuscripts about women's art in traditional cultures. Art by women is usually in the domestic sphere – utilitarian. Men's art is usually for ritual or public use, usually carving, stone or wood, and is called "art." The women's work is often not seen or talked about as art, although it may be very beautiful. [The question is] what is art and what is creativity? So much of women's art has been defined as personal, not necessarily by the women, but by the culture.

Anyway, I don't think just because something is personal, it's political. The context determines it.

Lawrence Alloway: I asked Joan what "the personal and the public in women's art" meant. She said personal feelings become a public statement in the political sense. . . . In this show you see a continuity between the personal and the public domains now forming [and] I see a non-stylistic unity. . . . Other facts than style can bind people together. In this exhibition it's a socio-political compatibility, explicitly anti-formalist, since style is deliberately downgraded as a value.

Ratcliff: Yes, the show is diverse stylistically and the artists are all compatible, but . . . I see a danger of making a feminist formalism. [Many] artists set out to solve formal problems and get critical recognition for doing that. . . . You could do feminist art that way, too.

Semmel: The work didn't exist as a public statement as long as it was just seen as a personal statement.

Stevens: But public and political are not the same. The work has personal qualities and is being made public, but that is not yet political. You have to make many connections in the work and in your activities to make the personal become the political.

Alloway: One has to define with some care what "political" expectations it's reasonable to have of art. [However] just because you can't demonstrate social utility doesn't mean it's apolitical. . . . Feminist art in the '70s does communicate changing attitudes, does have a political function. Art has a strong educative and moral function. . . . The informal and sophisticated distribution . . . doesn't mean it's politically helpless – it does change ideas.

Semmel: The fact that the show was organized in a public institution with a certain kind of political intent gives it a content it didn't have before. . . . And now we start to assert it. But [*in ringing tones*] I as an artist feel I have a lot more cachet and power and importance and interest than any male critic or institution and I hope all women artists feel that way! [*Applause*]

Hammond: I find more and more I don't care about that art world and that kind of approval. . . . Women will come here who'll never come to Soho. . . . Downstairs, at "Women Artists: 1550-1950," it's the noisiest show I've been to! There's discussion going on; everybody is whispering things. There's an actual hum in the room!

The audience had few questions.

Hannah Wilke [in audience]: Carter refers to us as "women artists." That doesn't help us as artists. Denying us as individuals wipes us out as artists.

Man [in audience]: The "Consciousness and Content" exhibition didn't show the outrage of women at being violated, left out.

Anita Steckel [in audience]: The phallic imagery definitely shows the outrage of women. The entire show expresses outrage. If you can't see it – that's a problem.

Woman [to Alloway]: Why did you find it interesting or important to note that Harmony Hammond's work in the show consists of old pieces?

Alloway: I thought she was having it both ways. Artists keep something old around the studio to show on these occasions. Showing old work shows she accepts the museum as a form of distribution.

Hammond: I *am* having it both ways. I see the show as a tool for getting the work out, and advise all women to do the same. Unfortunately, I have a lot of old work around – not just for these occasions.

Afterwards, sherry was served by white-jacketed waiters, and chitchat ranged from whether Carter Ratcliff had indeed called Jennifer Bartlett a barracuda in print, to the odds on Hilton Kramer's one day stumbling over, i.e, discovering, women's art. On the way out, I reminded May Stevens of that other, 1975, panel. She smiled.

— Judy Seigel

Women Artists News, January 1978 [Vol. 3, No. 7]

'77 / #71

When Men Were Men and Paintings Were Painterly

Pat Passlof recalls that Landes Lewitan accused her of probably not owning a tube of Venetian red, which today's young painter wouldn't even know was once considered crucial for flesh tones. Leland Bell describes the *zeitgeist* another way: "If you were hip," you had "a sort of pictorial literacy." We can certainly relate to that. But Tom Hess says the art world was "powerless" and *"ARTnews* didn't influence anybody." That calls for the White Queen, who could believe six impossible things before breakfast.

Mimi Weisbord reports the evening, another chapter in the ongoing replay of the '50s, with a perfect balance of skepticism and nostalgia.

"Tales of Tenth Street: The Early '50s"

Moderator: **Tom Hess**; Panelists: **Leland Bell, Charles Cajori, Sidney Geist, Pat Passlof, Wolf Kahn, Jane Wilson**

Auspices not recorded; December 22, 1977

No one talked about power in those days . . . the art world was the most powerless, beautiful, open, intellectual thing, where people had fun – they made jokes, they ate and they drank and they talked about art, and this whole idea of power, especially *ARTnews* having power, is the laugh. *ARTnews* didn't influence anybody.
 — *Tom Hess, "Tales of Tenth Street"*

Nobody likes to sit around listening to charming, attractive, nattily dressed, pipe-smoking men of a certain age talk, argue, and reminisce more than I do. I become so enchanted, I forget that in my real world I have to turn to Charlotte Bronte or Adrienne Rich at least once a week, the way women of another era turned to the Bible or smelling salts. Listening to this intriguing discussion of Tenth Street Days and the European (Picasso, Balthus, Giacometti) and Immigrant and American (Hofmann, de Kooning, Kline, Pollock) forefathers of the Tenth Street artists, I forget to wonder where the women were. And the presence of two articulate women on this panel did not in any way detract from the overwhelmingly masculine aura of the evening, with its allusions to the Club and the Cedar.

Moderator Hess, formerly editor of *ARTnews*, now art critic of *New York* Magazine, tried to direct the discourse of the evening into channels he deemed worthy. He was bored with artists' complaints about being overlooked by galleries, not being reviewed, and not making sales, and he was bored by talk of power in the art world. ("There's no such thing. I.T.T. has power. If you think the art world has power, you're paranoid.") However, he did think it was O.K. to talk about how other (more powerful?) critics and styles forced Abstract Expressionism out of "the commercial marketplace" in the '60s.

But let us now suspend consideration of issues of the present and return for a while to the simpler days of yesteryear.

Wolf Kahn [a founder of Hansa Gallery]: Everyone I knew had to overcome a great reluctance to start a gallery . . . feeling you'd lose your innocence being involved in commerce. The Hansa hired a director who would panic if someone wanted to buy a painting and if the buyer lost interest, we would all breathe a sigh of relief. . . . If you were a student in the '40s, your teachers were not making any sales. Hofmann, although he lived comfortably, wasn't a big shot, and always used to talk against the "commercial establishment." We would walk down the street [8th Street] to the Whitney and double over with laughter because there were Kuniyoshi and Speicher and Reginald Marsh and all sorts of people we thought were strictly for the birds. Hofmann was way off in the back room somewhere and nobody cared about him. And we ourselves really didn't know if he was a good painter or not – we knew he was a good teacher. And then we knew that Mondrian hadn't had a show until he was 60; we were perfectly willing to wait 40 years.

But when the Tanager [Gallery] started, we all lost our virginity. As soon as you walked in and saw how nice paintings looked on those white walls, you figured, gee, maybe my paintings would look as good as that, if I got them the hell out of the studio. Then the vague urge came on that you might conceivably have a show . . . But not to become famous or make money; you had a show to see your own paintings in less grungy circumstances. Another great hope was that the older guys would come and see your work. (That was definitely in everybody's mind.) But you never expected *uptown* to take an interest. And yet they did. Like Tom here, to his eternal credit.

Leland Bell [a founder of Jane Street Gallery, defunct by the '50s]: I really don't have much nostalgia for the '50s, and I don't think it was a golden time or anything of that sort. There is always a gap in recognizing the structure of pictorial elements, and during the '50s the gap was filled by the attitude that if you knew enough of what was going on, if you were hip, that was actually having a sort of pictorial literacy. There was also the mystique of "less is more," even from the example of some great painters like Mondrian (whom I admired very much, and would visit like a bobby-soxer when he had apartments here in New York). . . . Another influence was the attitude toward size, that a 5-foot painting is not as powerful or important as a 10-foot painting. . . .

I was never particularly interested in whether [de Kooning, Rothko, etc.] would come to any show of mine. My heroes were in Europe – Hélion, Giacometti, Balthus, Matisse, and Derain. I respected de Kooning, but to me he was someone who received his inspiration from Gorky and Graham and he was just like me, only older. . . . I don't know what Tenth Street painting is . . . I don't like the whole idea of the brushstroke, the surface. There was an entire issue of *ARTnews Annual* about painterly painting. But when I look at a Corinth, even if there's paint vomiting all over it, and then I look at a Dürer with its smooth surface, I find the Dürer more painterly. . . . So this talk of painterly painting turns me off.

Charles Cajori [Tanager Gallery]: I can't believe that, Leland, because you exhibited in those galleries and were very much a part of that scene!

There was a proximity, first of all, to the elder fellows – de Kooning, Kline, Pollock, and so on; you met them in the Bar and on the street; and sometimes they came to your show and had comments to make. There was a kind of camaraderie. They, in turn, had a closer proximity than the present group of that age to Europe – Matisse, Picasso, and Giacometti were still alive. There were these very big figures, still producing. After the war there was a great interest in Picasso. [Sam] Kootz brought the paintings back and everybody roared up there to look at them*. . . . The situation now feels more closed, less tolerant. But maybe things are opening up again, with all the co-ops and nobody being so sure any more.

Sidney Geist [a founder of Tanager]: Paul Brach and I wrote for *Arts* and the associate editor, Hubert Crehan, was a painter. Hess had a policy of hiring as many artists as possible – Elaine de Kooning, Fairfield Porter, Larry Campbell, Robert Goodnough. It was probably a sign of our sense of mission at Tanager that we decided to do a book on what we thought of as the New York School. . . . mostly the younger artists – the older generation was consigned to a chronology. We made an immense chart at the end of Ippolito's studio and with great difficulty selected 90 artists from hundreds of names, fighting over them week after week – our contribution to What Was What in second-generation painting and sculpture.

We paid five critics to write articles and got a contract from a publisher, but the book never saw the light of day because someone important was left out. [Geist declined to say who.] Then, with printer's ink in my blood, I got involved with Anita Ventura in a little newspaper called *Scrap*. I started by writing a lot of it, but the point was that it was to be an *artists'* paper. The first [of 8 issues] came out in December 1960. I had a long article on sculpture, and mentioned myself. The idea was that if the artists could talk about themselves, they wouldn't have to wait for the critics to say everything that might want to be said about art. But even today, artists are very loath to get themselves down in print, as if it could be held against them. [We hoped] somebody would pick up the idea of the paper and do it on a more regular basis, but nobody did.

Tom Hess: Sidney makes it sound so mellow and sweet – it was a lively little paper with rocks in both fists; not at all as mellow and crinkly as it looks now.

Pat Passlof [March Gallery]: To me that time is like any other elephant – it depends on which part you have hold of. I think I saw it differently because I was a student of de Kooning's and met the older generation, rather than my peers. . . . Many of them had gone through the Depression, the Project [WPA], the War. The lives they led, the political ideas forming the times, and the peculiar kind of optimism and utopianism that came out of the Depression years had something to do with the art. . . . Even though everyone refers to Abstract Expressionism as "Expressionism," and thereby painterly, in my mind it was a Florentine period in which drawing was the crucial thing. I remember all the talk about the *edge*, about Ingres. . . . I thought of it as the most learned and rigorous kind of thinking – from which we've fallen very far!

We weren't even sure what abstract art was; we weren't sure it was a really viable thing. When I was studying with Bill [de Kooning], a lot of people told me I was getting an improper education. Landes Lewitan said I probably didn't own a tube of Venetian Red – the implication being that I wouldn't know how to mix flesh tone, because if you were an abstract painter, you only used primaries. Now we take abstraction for granted (unless you're figurative and take a position against it).

Hess: Critics like Clement Greenberg invented the phrase "Tenth Street stroke," meaning bad painting. Barbara Rose said it was slavish, self-indulgent, bad copying of the existing masters. A lot of the kind of art we're seeing here today was crushed between the millstones of Pop Art on the one side and Realism and Color Field painting on the other.

Kahn: The leaders themselves had very ambiguous attitudes [about abstract vs. realistic art]. Hofmann used to say that the problem with modern art was that it lacked human content. After my first show, I met de Kooning on the street and he said, "You're a lucky guy because you know how to paint everyday life." Tworkov drew like an angel, drew constantly. . . . So these people were painting abstractly, but in the back of their heads they were doing something else. And maybe the younger people later on did it in a way the older people didn't like.

Jane Wilson: I remember at a certain point deciding that subject matter was very important to me, and somehow it was a great relief. I had felt it would be safer in some ways to paint abstractly, but [I also felt less secure about] a direction where I couldn't foresee what the painting would look like.

Passlof: [In the '60s and '70s] I think the center of the art world moved from among the artists, where it clearly was in the '50s, into some kind of P.R. world, where we were the outsiders and the dealers, or whoever, were the insiders – and that's where it still is.

Hess: In the late '40s, the artists Wolf Kahn was dying laughing at said exactly the same thing about the Abstract Expressionists: "It's just a P.R. thing – they've got a bunch of writers and a bunch of galleries!"

Passlof: Well, they did!

Kahn: But we felt something no one can feel today, that we were doing *mainstream painting* . . . following the important thread that started with Courbet.

Geist: We had some sense of history and tradition, and even if it didn't go back in a long continuous line, we did know who our immediate fathers were. . . . You might revolt against your father, but you had some idea of where you came from.

Although Jane Wilson had been the first to speak, her statement was never part of the discussion, and I have saved it for last in this account. She had been asked to address being a woman artist in the '50s:

Jane Wilson: I arrived in New York in 1949 fresh from the provinces, where there were very limited possibilities for artists, male or female. New York was a much freer and more open place than any I had ever been in. People were very supportive; if you were serious about [painting] they would help you with it, in the sense of being interested in your work. One of the most impressive things was the incredible amount of energy and activity and stamina of the women artists, the variety of their work, the range in ages. . . . That set an example that made it possible for me to proceed in a kind of intuitive way. In retrospect, I really feel there was a minimum of prejudice against women or resistance to accepting them, especially in the art world itself.

Well, O.K., that's how she experienced it. But what some women seemed to feel was interested concern on the part of their colleagues, I think could also be paternalism. There were important artists in the late '50s and '60s of every aesthetic persuasion who were delighted to have followers of any sex – thinking it a validation of their own work, which they were none too sure of themselves. (But heaven help you if you took a few tiny steps in your own direction!)

I don't know whether the *au courant* male artists of the '70s have the same need for forefathers. And although I would be the last to knock tradition and a sense of history (and *herstory*, please – I need both!), I suspect that those men who have been able to break with their own artistic forefathers are more able to give up paternalism. Women, on the other hand, having been written out of history, have had to re-create themselves from scratch every generation; they are left with the choice of working like the forefathers or looking into themselves. (The fact that male conceptual artists have co-opted the personal content that came out of the women's movement is a story too complicated to go into here.) Self-exploration, not particularly acceptable in '50s art, is what many women are doing in the '70s, and they are getting validation from each other. Which is why the excitement, the ferment of the art world *today* is where the women are.

— Mimi Weisbord

Women Artists News, February 1978 [Vol. 3 No. 8]

*Sam Kootz is known for having given exhibitions to New York avant-garde painters while supporting his (Madison Avenue) gallery through sales of major Europeans "from the back room." The story is that Kootz got his Picasso's by bringing Picasso a Cadillac right after World War II when new cars were not available in Europe and that Picasso was entranced with his new toy. (Another story has MoMA curator Bill Rubin supplying Picasso with a Cadillac some years later. Maybe it was a tradition.)

1978

'78 / #72

Sidney Janis Reads
the Future

The sense speakers conveyed at both this panel and the previous one that but for the machinations of "tightly knit forces" the beloved style would have prevailed for longer than its five (or ten?) years, does bespeak another time. Today it is assumed that tightly or even loosely-knit forces will bring replacements within the Warholian 15 minutes.

"More about Tenth Street Days – and Beyond"

Moderator: **Joellen Bard**; Panelists: **Alice Baber**, **Joann Gedney**, artists; **Helen Thomas**, director Phoenix Gallery; **Dore Ashton**, historian, critic; **Bruno Palmer-Poroner**, historian, novelist

Pleiades Gallery, NYC; January 5, 1978

This second symposium on the '50s presented another vivid replay of the period as well as sincere concern for the lot of artists today. "Love of the act of painting" and happy memories prevailed. The panel was reminded from the floor about the Friday evening openings, an "open air occasion," with a camaraderie very unlike the atmosphere today.

Joann Gedney recalled that co-ops were formed as alternate spaces by younger artists who needed to show and could not feed into the limited number of commercial galleries. Rents were as low as $25 a month – about $2.50 per member – a far cry from today's costs, which can be more than $1,000 a year per member. Joann described the artists' despair during the years immediately following the decline of Tenth Street, when critic Clement Greenberg, locking horns with critic Harold Rosenberg, declared Abstract Expressionism dead. "We artists were expected to fade away. We did not oblige, but our evolution has been an underground movement for more than ten years."

Dore Ashton spoke of the larger picture – the artists' dissatisfaction with the world at war in Korea, their pride in being a group apart. "A sense of solidarity meant something . . . mutual aid became an ethical necessity."

Joellen Bard noted that co-ops are again important in New York, but she urged that they be confined to "our own – no foreigners, no outside membership." Amending Mayor Koch's plan about living here in order to work here to include *exhibiting* here, Bard said, "we have paid heavy dues for living in this city and there is little enough to go around."

(One is tempted to agree, but there are other considerations. Vital art is a process of cross-semination. Many of the "New

York School," for instance, were foreigners, not all of whom lived or stayed here.)

Alice Baber, on the other hand, expressed concern for foreigners, saying there should be a way to clue them in! Her lively and extensive list of suggestions for "Beyond" noted the vacuum that exists for black artists, particularly in the museums. And what of artists coming back from war? She suggested more community museums and improved funding. Art is a "growth industry," she said – everybody gains. Alice recalled also that women in the '50s were expected to queue up behind the older (male) artists for recognition.

More recollections of "then" from Helen Thomas – an odd choice for panelist since, not having been there, she spoke from hearsay. Still, she had some delightful anecdotes. One was of Red Grooms, who, having been made Publicity Chairman of the Phoenix Gallery, designed an announcement and posted it everywhere. This upset the membership, which deemed his blurb unprofessional – "childlike." Grooms was demoted to scrubbing floors. Today of course, this announcement is a valuable artifact. (The Phoenix, longest-surviving Tenth Street co-op, is now uptown.)

Next, Bruno Palmer-Poroner, one-time director of the Camino Gallery, told us that the James and Hansa Galleries consisted mostly of ex-Hans Hofmann students, the James in particular carrying the "Hofmann look." (The look of Kline and de Kooning predominated at other galleries.) In the early '60s, there were more than 20 co-ops, as well as the publicly-funded Museum. An all-woman gallery opened in 1958 in the East 50s, but the name was not recalled.[1]

We learn that Claes Oldenburg, Jules Olitski, and Jasper Johns were, as unknowns, turned down by Tenth Street. Palmer-Poroner had considerably more information at his fingertips, but a restless crowd began to comment from the floor: We need more artist-run galleries and more corporate and government funding. One quarter of a million dollars in dues paid to co-ops is now fed into the city each year.[2] Artists today run galleries professionally, but get little critical coverage, none from the *New York Times*. The situation is far better in Canada.

These symposia have posed two questions: Why did Tenth Street end? What about the artists' predicament today?

Doubtless there was and is a concerted effort by "the establishment" to thwart and bypass the power of artists as a group. Artists might know – and *tell* – who is doing the work that counts, thus interfering with commercial propaganda. Tightly knit forces pulled the rug out from under artists. For instance, the innocuously titled book, *The Collage*, by Sidney Janis and Rudi Blesh, was purportedly history, but actually propaganda of the taste-makers; it "predicted" the

death of Abstract Expressionism. The then-newly-appointed *New York Times* critic, John Canaday, was a reactionary who bludgeoned Tenth Street regularly – and with a vengeance. Dore Ashton, also on the *Times*, had supported the younger artists, but was forced to resign.

Meanwhile, the artists themselves had in ten years graduated into expanding commercial galleries. New applicants, fresh out of school, did not look "professional" enough. Without important coverage and without new artists, how could Tenth Street continue?

— Jean Cohen

Women Artists News, March 1978 [Vol. 3, No. 9]

1. Gallery 15, the all-woman co-op, was founded at 59 West 54 Street in 1958.

2. Twenty co-op galleries with an average of 20 members, each paying an average of $1000 in annual dues, would equal $400,000.

'78 / #73

No More "Nice Girls"

Convening at College Art, women acknowledged some some signs of progress – but considered the rest of the loaf.

Women View the New York Art Scene

Moderator: **Paula Hays Harper**, Hunter College; Panelists: **Harmony Hammond** and **Howardena Pindell**, founders and former members of A.I.R. Gallery; **Eunice Lipton**, art historian; **Paula Cooper**, dealer; **Diane Kelder**, editor, *Art Journal*; **Marcia Tucker**, director of the New Museum

Women's Caucus for Art, College Art Conference, NYC; January 24, 1978

Eunice Lipton spoke feelingly of why women art historians must be vocal and make their presence known within the still very much male-defined art world, both as support for one another and as role models for younger women. "My colleagues at Ivy League schools still call women 'girls' [and] use the pronoun 'he.'" Lipton said women art historians should "stop being nice girls . . . *insist* on correcting them, and *insist* on having women on panels. . . . The reluctance of women to be assertive is part of the conservatism of our field."

Marcia Tucker addressed the issue of women in museums, which she called "old boys' clubs."

Howardena Pindell again mentioned "the buddy system" as one of the problems women artists, black women especially, face in showing their art within established art-world do-mains, e.g., museums and most galleries. "The private sector reflects the extended family. Dealers don't generally take on new artists by looking at slides. They hear about you over cocktails." Tucker and Pindell, respectively founder of an

alternative museum and founding member of an alternative gallery, had first-hand experience of bucking the art-world establishment, and both described how little effect such al-ternative structures have had on the establishment thus far. Pindell also made connections between who the buyers of art are (white men) and which artists get shown in establishment spaces.

Harmony Hammond spoke about "alternative options for women artists," namely artist-run (cooperative) galleries and public media (via performance or publishing in the feminist press). It is important, she said, that these alternatives be considered legitimate vehicles in themselves, not just testing-grounds for establishment spaces. Hammond also cited femi-nist art as influencing artists in general toward use of "personal boundaries, inner and outer space, and craft mate-rials" in their work.

Paula Cooper, who has run her gallery in Soho since 1964, and whose ten-person stable includes four women (Jennifer Bartlett, Lynda Benglis, Elizabeth Murray, and Jacqueline Winsor), spoke briefly about the dealer's role in the artist-to-public process. Since it has always been considered "proper" for women to be cultured, she said, monied women could become art dealers. She herself worked for years in other gal-leries before acquiring the means to open her own. Cooper said she doesn't identify with the women's movement in par-ticular, which placed her at a disadvantage in a conference of this sort, but grew up believing she could be anything she wanted. Still, she admitted, "Women have to work twice as hard."

The final speaker was Diane Kelder, editor of the scholarly *Art Journal*. Kelder described the *Art Journal's* evolution from the heavily male-dominated staff she'd found initially to the more open, contemporary magazine it has become since her editorship. Needless to say, *Art Journal* now accepts many more female-authored articles than before.

— Janet Heit

Women Artists News, April 1978 [Volume 3, No. 10]

'78 / #74

Slicing Steam

"Contemporary Women's Art: Iconography & Sensibility"

Moderator: **Frima Fox Hofrichter**; Panelists: **Barbara Aubin, Isabel Borgatta, Oriole Farb, Frances Kuehn, Ann Sperry**; Discussants: **Dorothy Dehner, Judith Stein, Vivienne Thaul Wechter**

Women's Caucus for Art, College Art Conference, NYC; January 25, 1978

Iconography and *sensibility*, words that combine euphoniously in a title, proved less than harmonious as twin themes for a discussion of contemporary women's art. Iconography, after

all, can be described, traced, labeled, and subjected to all the probings and dissections that art historians (myself included) favor. Analyzing sensibility, on the other hand, is like slicing steam. Thus, interesting as the talks were individually, the overall discussion was diffuse, because the themes were irreconcilable.

There were other problems. Addressing "the sexual role in artistic sensibility," Isabel Case Borgatta asserted that "the human spirit transcends gender." (Amen!) However, she then cited women dealing with "female shapes, colors, and symbols on an unconscious level" without presenting evidence to support her definitions of "female" imagery.

Barbara Aubin gave a kind of commercial for Chicago women artists, with attractive slides of work we seldom have a chance to see. Anne Sperry's presentation of six sculptors working in "hard materials and human scale" was also pleasant viewing, but lacked a strong central thesis. Frances Kuehn added yet another survey without a definite focus.

I do like to look at art, especially contemporary women's art and there was plenty of that for "live" viewing during the C.A.A. convention, but I expect a panel to give me some stimulus for the brain, not merely the eye. The only presentation with an exciting idea at its core was Oriole Farb's talk on "how a concern with time and motion results in new forms." Concentrating on several women artists who use photography in diverse ways to explore time and movement, she kept her well-reasoned and organized material within a careful framework. The talk was both thought-provoking and visually interesting, the very model of an art-historical lecture.

Frima Fox Hofrichter ably chaired the panel, while Judith Stein and Dorothy Dehner provided a few afterthoughts. My own afterthoughts concerned Frances Kuehn's statement that women artists are by nature feminist, since they are dedicated to achievement. Those of us who have been fighting for women artists' rights will be most grateful if all those natural feminists join us in the political arena as soon as possible.

— Sylvia Moore

Women Artists News, March 1978 [Vol. 3, No. 9]

'78 / #75

And the Word Was God

Despite the beginnings and "modest effect" of feminism on art history, the writer finds the panel fails to escape the authority of "the word" and the "haloed sources," which continue to override "visual evidence." Apparently, Gillies points out, those trained in the litany find it hard to abandon.

"Questioning the Litany: Feminist Views of Art History"

Moderator: **Mary Garrard**; Panelists: **Nancy Luomala, Claire Richter Sherman, Svetlana Alpers, Alan Garfield**; Discussants: **Eleanor Dodge Barton, Ann Sutherland Harris**
Women's Caucus, College Art Conference, NYC; January 25, 1978

Mary Garrard's introductory remarks acknowledged what most of us already know: Art history reflects a male bias, a solipsistic view based on patriarchal myths expressed in "idealist values of heroic art." After citing the makers and shapers of the discipline, Garrard noted that feminists have been having a "modest effect" as they discover lost women artists or question male interpretations of art. Feminism, she said, has a potential for greater influence on art history, for it raises other questions – the kinds of material deemed appropriate for examination and study, the methods whereby this material has been categorized and the ways in which it has been understood, what these choices reveal about the attitudes of the selectors and commentators themselves, and the functioning of art at all levels.

These are questions of methodology; they address the *discipline* of art history – its sources, implementation, justification for being. They ask for revisionism of the most basic sort: a redefining of the prevailing notions of art and a redirection of art history itself. That all the panelists and discussants understood this fact was not apparent, for, as a group, the panelists did not directly question the litany, and the discussants seemed oblivious to the fact that they were supporting its ritualistic forms.

Nancy Luomala's paper, "Matrilineal Interpretation of Some Egyptian Sacred Cows," was an attempt to demonstrate that images of a sacred cow goddess, traceable to a Neolithic, matrilineal culture, were associated with Egyptian queens until Roman times. Her thesis was that art historians have ignored the importance of the Great Wife's cow identification as evidence of matrilinearity in Egypt, and have misunderstood as incestuous her relationship with her brother-regent, to whom she transferred political authority. Luomala's visuals gave no new evidence of the cow-queen identification, which weakened her thesis. But more important, she did not justify her methodology to the satisfaction of discussants Eleanor Dodge Barton and Ann Sutherland Harris. One faulted her sources and the other questioned her knowledge of Egyptology and hieroglyphics, thereby diminishing any insights she might have contributed.

Claire Richter Sherman's "Taking a Second Look: Observations of the Iconography of a French Queen (Jeanne de Bourbon, 1338-1378)" and one other paper escaped marked negative comment from the discussants. Both she and Alan Garfield, who spoke on "The Founding Mothers of the Royal Academy," followed the traditional form of the litany with careful attention, each dealing with "acceptable" material and using established methodology.

Sherman illustrated the fact that male historians have ignored representations of women in art, thereby dismissing them from history, by showing a cycle on Jeanne de Bour-

bon, which has received little attention compared with that given the cycle on King Charles V in the same manuscript. She explained that the cycle was motivated by a concern for the queen's fertility, but that the queen lacked political authority. (The notion of woman as vessel through whom royal power is transmitted to men corresponds so closely to Luomala's thesis that one wishes to see images of other royal women examined for similar content.)

Alan Garfield suggested that gossip about the alleged sexual liaisons of Angelica Kauffman and Mary Moser, two founding members of the Royal Academy, was perpetrated by 19th-century men to discredit those artists' accomplishments. Although not wholly convincing, he, too, tried to show how chauvinistic attitudes, or "masculine pride," have distorted historical fact.

None of these three presentations really broadened our notions of what kinds of material might be included within art history, nor did they exemplify different ways to approach traditional material, presumably the point of the session. On the other hand, it is still useful to re-examine women's images, to study women artists, and to expose the bias permeating art-historical interpretations and judgments. So, when Barton asserted in her critique, "It is not true that traditional art history says, 'Don't look at women,'" she ignored the fact that this was what Luomala, Sherman, and Garfield were indeed proving. Then, moreover, she declared her concern about "manipulation of facts"!

Of the four speakers, only Svetlana Alpers identified some of the limitations of established art-historical methodology. In her paper "Art History and Its Exclusions," she said that treating women's art in the same way as men's or looking for differences in women's art is inadequate, and called for "the demystification of the very notion of art-historical methods." Unfortunately, her contention that art-historical rhetoric is based on the kind of art associated with the Italian Renaissance, and her assertion that such art is "masculine" because it asks one to "experience meaning," while Northern art may be considered "feminine" because it asks one to "experience presence," were mystifying in themselves. If she intended to suggest that Italianate characteristics have become the measure against which all art is judged either "good" or "bad," that was not clear. And, having been asked by some critics to see the "feminine" in women's art (which Alpers implied is an inadequate approach), are we really being asked to see the "feminine" in men's art because it is descriptive and features domestic scenes of women?

Alpers came closest to pinpointing a major problem that must be confronted by feminist art historians when she noted that the accepted procedure requires one to look for meaning in verbal terms. This suggests that the written word has been given primacy over the visual evidence as a source for meaning in and significance of art. That this is so was demonstrated by the discussants, both of whom urged the presenters to reread their sources. Ann Sutherland Harris affirmed what we have heard before: one must not study the art of a culture if one cannot read its language. So deeply

ingrained is this attitude as a *sine qua non* of art-historical methodology that one hesitates to challenge it, but such reliance on the Word places feminists in an awkward position. We know that the haloed sources have been written, more often than not, by and for men, and that they, like the interpretations and exclusions found in the discourse of art historians, reflect a male bias. Perhaps we must consult the written word, but as feminists we also have to be wary of the authority of the *Logos* and suspicious of its control over the visual evidence.

There was an evasiveness about this session, as though no one could openly address the constrictions of traditional methodology. Ironically, even the traditional format of reading formal papers was retained, and surely it must serve the purpose of the litany. Perhaps we need to question that before we can find new methods of inquiry. But certainly the major difficulty facing feminists was identified at this session: traditionalists do not doubt the efficacy of the litany. So firmly established is its recitation that questioning its form is not easily understood and deviation is inevitably censured.

— Jean Gillies

Women Artists News, April 1978 [Volume 3, No. 10]

The Medium is Still the Message

This panel could, in many respects, have been held yesterday – minus the concluding optimism, perhaps. However, the author found "the distinction between 'art' and 'crafts' is blurring"; in this respect we may have gone backwards. Today, "craft" media rarely appear in "art" galleries, while even the most acclaimed "craft" artists lack the recognition – and prices – of their "art" artist peers.

"The Art in Crafts"

Moderator: **Sigrid Weltge**; Panelists: **Joyce Aiken, Noma Copley, Martin Eidelberg, Wayne Higby, Lois Moran, Elizabeth Osborne**
Women's Caucus for Art, College Art Conference, NYC; January 25, 1978

There are so many issues vital to the crafts today that choosing as a topic "The Art in Crafts" seems tired, defensive and unproductive, especially since the audience of artist-craftspeople was well aware of the art component in good craft. Rather, the issue should have been how to eliminate the old prejudices that categorically belittle fiber, clay, and precious metal as "mere" craft.

Lois Moran, Director of Research and Education of the American Crafts Council, and Wayne Higby, an artist from Alfred University, were the only panelists to address this more vital issue, albeit from opposite points of view. Moran

advocated greater visibility within museums and galleries for contemporary crafts and more space for sound crafts criticism in journals. "How unfortunate that critics and historians talk only about the dead in crafts; they ought rather to address themselves to contemporary artists."

Higby focused on the evils of the art world – money, collectors, investments – and made an almost fearful plea for crafts people to avoid these legendary traps of the "art" world. (Yet artistic expression needs economic support. Are galleries to be charitable organizations? Do publications not exist for profit? Are artists and dealers not to be paid?)

Martin Eidelberg of Rutgers University traced the historical development of women's role in the crafts movement. He showed that, starting with the early 19th century, the role sprang from the so-called "domestic arts." Women, known for their "nimble fingers," were assigned largely decorative tasks. Either sewing in sweatshops or decorating china in the factories, women were the cheap labor pool, a situation that today no longer holds in the crafts, but still does elsewhere.

Elizabeth Osborne of the Pennsylvania Academy of Fine Arts presented a rather unique approach to the craft-art question. She uses craft objects as subject matter for her painting, her themes ranging from bottles, to pottery, to weavings in still-life arrangements. She is concerned with translucence and transparency and their interaction with light.

Christina Moore, reading Noma Copley's paper on "Women Goldsmiths," traced women's history in jewelry. Recent trends suggest that women are now the majority of those in training for the burgeoning field of goldsmithing.

Joyce Aiken from California State University, Fresno, in an excellent slide presentation, illustrated the wide range of materials now within the craft domain. She also discussed the re-education of students who have the notion that crafts constitute only those items serving a functional purpose.

Some comments about "The Art in Crafts" seem to be in order. More and more galleries are giving space to objects traditionally called crafts, and the distinction between "art" and "crafts" is blurring. An artist must never be limited to historically "correct" media, of which painting and sculpture are surely not the only forms. It is the artist's prerogative to express a concept in fabric, clay, plastic, gold, or epoxy. The *art* is judged by the degree to which the artist succeeds, not the medium through which expression is rendered.

– **Judy S. Schwartz**

Women Artists News, April 1978 [Vol. 3, No. 10]

'78 / #77

Exterior Visions

"Women / Nature"

Moderator: **Michelle Stuart**; Panelists: **Nancy Holt, Mary Miss, Pat Steir, Lauren Ewing**; Discussant: **Barbara Novak**

College Art Association, NYC; January 26, 1978

The idea that major concerns and ideas in art are consistent in a culture from one century to the next, and find expression in wildly disparate ways, is an intriguing one, and one that excited Barbara Novak, discussant on this panel. Currently working on a book, *Nature in American 19th-Century Painting*, Novak was amazed that so many of the panelists' ideas were related to ideas of 19th-century painters, "in terms of attitudes to nature, space, and time, a concern with the 'pure horizontal,' with geology and geologic time." This concern with time (often geologic time) and space (often in terms of the universe) was the consistent element in a panel of strong artists.

Even though many of the works shown were well known to the audience, there were still surprises and delights in hearing the artists themselves talk about them. This was most evident when Nancy Holt, the first to speak, showed slides documenting the movement of light – hourly, from 6:30 a.m. to 9:30 p.m.– across, through, and between the 9-foot-high concrete pipes of her *Sun Tunnels*, set with astronomic precision in the vast desert of northwestern Utah like a series of updated Monet *Haystacks*. Holt said, "I'm not interested in making megalithic monuments. My art is to make things of human scale that are perceptually available to the viewer." The feeling of "being in touch with prehistory" is also clear in her work, as it was for most of the other artists, who commented as follows:

Michelle Stuart: My work has an ephemeral life – it flows through time. I want to continue the flow of the universe in some sensible way. . . . At Martin's Creek, I chose a site because it was archetypal; I used the feathers of a bird found there to express past time and present time. *Niagara Gorge Path Relocated* incorporates all possible strata as material.

Mary Miss: I want to make people aware of space. *Marks in the Landscape* must be walked through. Sometimes I tie water and land together, as in the Ward's Island work. [In a filmed work] one comes up out of the center of the earth, as the landscape is slowly revealed by a construction, or "set."

Pat Steir: I'm in giddy awe of the universe. I worked and lived in the city my whole life, and did things related to internal space – then I took a trip out west, and began relating to outdoor space. [Now I use] the landscape to reflect thoughts, marking and marking time, taking things away, yet leaving their marks.

Lauren Ewing: I spent a lot of time walking up and down a hill, aware of the horizontal above my head. [Then I built]

25 Columns of Equal Height, on the hillside. The verticals make you aware of your efforts to walk on a hill. . . . In a video piece, lying on my back in the water, I'm watching grass, clouds, sky, earth, all moving. I imagined my body as the one constant in the stream.

I found it fascinating to hear these feminist artists discuss their work, with no mention of being women or of feminine imagery. However, some members of the audience were obviously not satisfied. They asked, "What is specifically feminine about your work?" and objected, "It's hard to see in what way the work is feminine." Reflecting on the dynamics of panels and audiences, while attending many of the CAA and WCA programs (some were illuminating and exciting, others fell apart at the seams), I concluded that these days, when a panel is composed only of women, with "Women" in the title, both men and women in the audience expect strong feminist discussion on a high professional and intellectual level. Times have changed.

– Ann Sperry

Women Artists News, March 1978 [Vol. 3, No. 9]

'78 / #78

Not Mainstream, Not Dada, Not a Pipe

Our reporter notes that panelists "seemed uncomfortable with the term 'surrealism.'" Nevertheless, just the word in the title was a sign that the mainstream was broadening – or braiding. The 1978 College Art conference also had panels on pluralism, post-modernism, realism, photography and art in nature, among others – a nearly surreal mix.

"Surrealism Now"

Moderator: **Ellen Lanyon**; Panelists: **Susan Hall, James McGarrell, Julien Levy, Irving Petlin** (**Llyn Foulkes** and **Duane Michals** unable to attend)

College Art Association, NYC; January 26, 1978

Ellen Lanyon opened the discussion with a brief history of Surrealism (despite a sign on the door reading "Sir Ealism Gnow"). Coined by Apollinaire, the term was adopted by Breton as a "sur-name" for the movement. Although the name has not been applied to contemporary American work, a strong undercurrent of that "very special mystique" is recognizable in many divergent styles. Lanyon quoted from Lucy Lippard: "Traces of these tenets have filtered into the most unexpected areas . . . modernist abstraction . . . Pop Art, Funk Art, anti-form happenings . . . primary structure, conceptual, technological . . . intermedia environment."

Lanyon was careful not to label any of the panelists Surrealist, but found the evidence of inheritance strong. She showed

a group of slides by artists not on the panel: Gertrude Abercrombie, Vera Burdick, Christine Ramburg, Stephanie Sanchez, Phyllis Ramsen, Brenda Goodman, Eve Sonneman, Jim Nutt, Ed Paschke, William Wiley, Cliff Westermann, etc., all of whom she described as "non-mainstream" artists.

James McGarrell described his work self-deprecatingly as stodgy and conservative, and his attitude toward subject matter as enigmatic, complicated, mysterious, with a base in sensuality. "The issue is not the rendering of objects as symbols (things meant to stand for things they are not), but the presentation of phenomena for what they are." He suggested that current non-mainstream art is in fact mainstream high art!

Susan Hall made a witty, brilliant, totally surreal presentation with a selected group of mini-stories, a few of which follow, quoted in full:

• The sculptor Ludwig von Schwanklauder intended to earn some extra money by smuggling cigars through customs, hiding them inside the hollow bronze statues that he made. However, he died before the cigars could be removed and the statues were erected in 1844 with the cigars still inside.

• Around the turn of the century, boll weevils devastated the cotton crop and virtually destroyed the economy of Alabama. As a result, farmers began diversifying their crops and planting peanuts, a much more stable and profitable crop. The farmers of Alabama rapidly reached new heights of prosperity and in appreciation erected a statue to the boll weevil.

• The world's most famous animal actor, Trigger, co-starred with Roy Rogers in 88 motion pictures and 100 TV shows. An unusually intelligent horse, Trigger was able to untie knots with his teeth and count to 20. Upon his death in 1965 at the age of 33, Trigger was stuffed. He is now on display at the Roy Rogers Museum in Victorville, California, as is Dale Evans's horse, Buttermilk.

• The conception of Minute Rice occurred in 1931. Eighteen years later, in 1949, it was realized.

• Last week I saw a lady in pink curlers driving a white car, which had a bumper sticker that said, "Beware of the Dog."

• In August 1887, two children with bright green skin and slanted eyes came out of a Spanish cave. They wore clothes of a strange material and spoke a language that experts from Barcelona were unable to identify. The boy died. The girl learned to speak Spanish and said she had been transported to the cave by a whirlwind, which had carried her off from a country that was always in twilight.

Julien Levy talked about the confusion between Dada and Surrealism. Dada was nihilism, the destruction of all values in "a great volcanic laugh or a great belch." Surrealism was more serious. It took the *tabula rasa* (devastated land) created by the Dadaists, and set out to build on it. Using Freud's concept of free association, the surrealists attempted to "systematically explore the unconscious" as a new approach to the center of "man's intuitive nature."

Irving Petlin read Duane Michals's statement: "I am sitting in the palace at 4 A.M., sipping my tea from a fur-lined tea-

cup, and I find myself writing, 'This is not a pencil,' but enigmatically I am in Egypt."

Petlin said, "A whole generation of art criticism had made Surrealism an unmentionable ingredient in the postwar art soup, but the ordinary American reality is too crazy to be wallpapered over by a color field or an index card. Even that fine Surrealist gesture by that master Nixon was missed by our press, when he showed up all spectral and pious for the funeral of good old Hubert Humphrey . . . It's endless."

With the exception of Susan Hall and Julien Levy (as historian), the panel seemed uncomfortable with the term "Surrealism." McGarrell preferred "metaphysical realist." Despite the present great interest in nonconformist personal art (Balthus, Magritte, etc.), panelists were somewhat defensive about not being part of the major currents.

There was no passionate concern with broader concepts of what might be common to all these artists working outside "the mainstream." The use of the word "man" to refer to artists was redundantly prominent, and the sexual or sado-masochistic content in much of the work went unnoticed or undiscussed. After a tepid floor discussion, the panel closed with the projection of a macho (but funny) serial photo essay by Duane Michals about a peyote dream of Mount Fujiyama.

One final comment: Petlin's description of Nixon as a Surrealist is inaccurate. Nixon is a Dadaist, and, like many Dadaists, is getting very rich by being very naughty.

– Martha Edelheit

Women Artists News, April 1978 [Vol. 3, No. 10]

'78 / #79

Post-Abstract Expressions

"Conceptualization of Realism"

Moderator: **Philip Pearlstein**; Panelists: **George Segal, Ben Schonzeit, Rackstraw Downes, Chuck Close, Sylvia Mangold**

College Art Association Conference, NYC; January 26, 1978

By the close of the panel, moderator Pearlstein had moved that the title be changed to "The Abstraction of Realism." The other panelists agreed, all holding that their involvement with realism happened as a reaction to their educational foundation in abstract art.

Pearlstein, defining a realist as "an artist who records the visual aspects of the world," concluded that "the realist has a kind of freedom from the necessity of interpreting nature in the ideological, sociological, or philosophical modes attuned to abstraction." He also noted that "the revival of realism has not been prompted by writers or education." The realist

works "in spite of art history pressing toward abstraction." Abstraction, Pearlstein said, was born out of the existential movement of the '40s and '50s. The realists turned from existentialism and began showing a more positive side of things. "The realists, like the poor, are always with us."

George Segal, realist sculptor, pointed out that the realists are also the children of modern painting. They are not "fighting with the abstractionist." About his own sculpture, Segal said he works from a preconceived idea, making decisions as problems occur. For him the spirit of the work is married to the matter of it; he aims to "get close to the texture and quality of experience." Segal also remarked that he believes everyone on the panel is a "closet abstract painter."

Ben Schonzeit, on the other hand, considers himself a "closet Expressionist." A Photo-Realist, he works with airbrush on canvas. In the past, he felt "something missing, going into the studio every morning painting abstract paintings." His work now concentrates on the way things are, but "when you paint things like photographs, you turn your back on a lot of stuff."

Rackstraw Downes also takes a technical approach to painting. His panoramic views have a format smaller than the usual aggressive realist work, because he paints on-site, outdoors. "When I see a landscape I have to get it on a flat surface." Downes also says that "drawing is like the first meeting of a friend. Each successive visit I learn more." People tell him that his work looks "better than the real thing," which leads him to conclude that "what we think is real may be convention."

Chuck Close seemed very removed from his work, and also concerned with the artificiality of painting. His large portraits use photographs and color separations for source and technique. He chooses color separation over palette painting to get away from "virtuoso" brushwork. He also chooses a way of working that is neat, precise, and controlled in contrast to his nature, which is "quick, sloppy, and nervous." He claimed "functional illiteracy" when questioned about his views on phenomenology, existentialism, and spiritualism.

In Sylvia Mangold's "corner paintings," process is content. Contradictions, juxtapositions, the dualities of nature and geometry, spontaneity and calculation are preeminent, as seen in a wood floor grid with a pile of laundry in the middle of it. She is interested in "relationships that do not exist in space" until she paints them. Though her paintings are very precise, she says the precision is arbitrary.

The panelists agreed that an "exact rule" is arbitrary, which of course it is, but "exact rule" struck me as the core of their conceptualization of realism. Realism creates an illusion of measured precision. However, it is in fact about an immeasurable place in the vision of the perceiver.

– Maurie Kerrigan

Women Artists News, April 1978 [Vol. 3, No. 10]

'78 / #80

Art, Lies and History

Perhaps to atone for topics like "Architectural Apotropaia and the Sinai Hoodguards," or "African Borderland Sculpture: Liminal Space in the Study of Style," College Art Conference programs usually feature at least one panel on the cusp of the coming moment. In 1978, "pluralism" played that role.

Besides being timely, "The Perils of Pluralism" panel was educational. It showed clearly how those in authority resist change not of their making. It also showed two approaches to art theory: Robert Pincus-Witten saw art theory as a rhetorical *tour de force*, a system for judgement controlled by the critic. Pat Mainardi expected art theory to grow out of actual fact and history, explicating art, rather than directing it. Her impatience with "system" criticism was palpable.

"Perils of Pluralism"

Moderator: **Richard Martin**; Panelists: **Pat Mainardi, Joseph Masheck, Robert Pincus-Witten, Jeanne Siegel**

College Art Association, January 27, 1978

It was delightful to see sparks of real feeling at a discussion of art. This one, which drew stragglers from all over, turned out to be a joust between Pat Mainardi and Robert Pincus-Witten. Pat, the only artist on the panel – wearing our colors, as it were – was magnificent. But that Pincus-Witten!

Art criticism today is complex, and conscientious critics can seem rather plodding. When one comes on, like Pincus-Witten, with an air of razzle-dazzle, he can get away with murder – or at least criminal sleight-of-mouth. No matter that beneath the hocus pocus and fancy talk he is hawking an array of semantic gibberish, false premises, gross distortions, and rapid-fire 180-degree shifts. The populace eats it up.

Richard Martin opened discussion with the suggestion that pluralism means "the acceptance of concomitant modes within the visual arts." Pincus-Witten immediately countered by declaring pluralism a "thing" and "the style of bad art."

Pincus-Witten: My talk will pretend there is a thing called pluralism and its greatest peril has befallen it – it died. Who is imperiled? What is imperiled? The formalist academy, i.e., the White Race of art. Pluralism is the White Race of art. Pluralism is the bad art of post-modernism.

Six or seven years ago the art world was not open, democratic, "Californian." There was a withering sense of exclusion, of single-minded purpose. . . . Each M.F.A. candidate was a subspecies of Frank Stella. Then conceptual, eccentric, naive, personal, constructivist propositions of all kinds came in. Pluralism was the banner for all types to once more raise their bloody heads. But the status of art for pluralism came, not necessarily because of its forms, but because of external activities. . . . Pluralism means open-enrollment art.

In the dreary academicism of pluralist art today, many figurative painters [are] annexed to or tried to annex the women's movement. But a genital image . . . can't vivify a painting which itself is dead. . . . The art content was revealed to be thin and decorative [with] familiarized, banal, and dated images . . . bad art, primitive, illustrative art and narcissistic self-indulgence called art. "You recognize my therapy as art and I'll recognize yours." The critical issues were able to warm the painting for a short time. . . . For several years pluralist art was art, but now that tautology no longer holds.

Next, Joseph Masheck read some Nietzsche in a rapid monotone. Whenever I began to catch a thread of meaning, he interrupted himself to "explain." I got six words, "crystal palace," and "cafeteria of cultural alternatives." Mainardi's response to Pincus-Witten followed.

Pat Mainardi: The question is not social concerns. . . . It's style, because Pincus-Witten is attacking representational painting. [But] as soon as you say something can no longer be done, you don't even give yourself the opportunity to do it in order to get to something else. Historically, great art has often come out of something very different.

Masheck: The artist who does only what he pleases only intersects with history by accident.

Mainardi: Artists don't intersect with history, they make history . . . unless you've written the history before the artists have made the paintings.

Masheck: If it's only what you please, by definition it doesn't have any value to the culture or the society outside of it, or only accidentally.

Mainardi: The artist is doing what he or she firmly believes will change . . .

Masheck: That's what Robert meant by therapy.

Mainardi: Would you say Courbet was therapy? They said he couldn't paint and his social concerns were repulsive.

Pincus-Witten: Courbet was not without support. Who cares if some trivial figure didn't understand him?

Mainardi: You're wrong, historically wrong. I've just finished writing an essay on the criticism of Courbet's paintings – the issue is the critical establishment of the time. People understood him accidentally, in pieces.

Pincus-Witten: In art itself, the quiddity, the essential notion, is not understood. No one knows what art is.

Mainardi: But in the 19th-century establishment, critics also thought they had the right to tell the artist what to do.

Pincus-Witten: Do you think the artists sit around waiting for the critic to tell them what to do?

Mainardi: You do it – that's how you live.

Jeanne Siegel: Pincus-Witten is talking about what is good and bad art. At some point he should say what he thinks is good art. . . . And he should clarify what pluralism really means. Chuck Close and Philip Pearlstein say they are really concerned with surfaces . . . essentially the concerns of abstraction – not the kind of thing you might talk about when you talk about realism.

Pincus-Witten: You've seen through some of the smokescreen of my position! Much of my diatribe is directed against what

I consider an obsolescent style. . . . In the last decade a tremendous sense of being throttled, violated, led to a complete retrenchment of a system of judgment. . . . What emerged from the style of no judgment is called pluralism – all kinds of fetishistic, constructivistic, naive, political art. [But now] we have a resurgence of dealing with art as if there were judgments. . . .

Mainardi: Pluralism is whatever you don't like and what you like is called history. Historical determinism is very attractive to a critic, because if only one style is valid and you are the critic [touting that style], then you are riding the horse of history.

Masheck: A great master of pluralism is a contradiction in terms.

Mainardi: Pluralism is many artists each doing one thing, not one artist doing many styles.

Siegel: If one examines the intention of the artist, [one can] lift work out of old "mainstream" categories and come to some kind of judgment.

Pincus-Witten: But intentionality is historically determined. I am going to hold in abeyance the attribution of intentions to works of art.

Siegel: I believe in staying close to the artist's intention as a starting point.

Pincus-Witten: There are dumb artists and smart artists and you don't listen to what the dumb artists are saying. I know a lot of dumb artists.

Mainardi: I think anyone who says artists are dumb shouldn't be a critic.

Pincus-Witten: It's very nice and very sentimental – anyone who says artists are terrific wins. [But] to articulate intentionality is not to make art. . . . The only way I can say this art is good is by comparing it to something that preceded it. Otherwise it's just a squeal of pleasure.

Mainardi: Art and art criticism are not mathematics, not that certain.

Siegel: Carter Ratcliff tries to write about art as if he were not making judgments, by putting art in a category in which it shares certain characteristics.

Masheck: But there are already two judgments – one, that they share characteristics; two, that the category is worth writing about.

Martin: What would you tell a young artist starting out?

Pincus-Witten: You have to have some system beyond the sheer moan of pleasure.

Mainardi: You should read the criticism of the past – how Michelangelo thought Flemish art was a waste of time, how Baldessari thought the old Titian had passed his prime.

Masheck: You ought to be aware of the role of art in general, which changes from time to time.

Pincus-Witten: There is only one convincing mechanism for judgment historically . . . which we call formalism. [Because it seemed] ruthless, people looked for another system, but they chose a system germane, not to art, but to politics, social justice, ethical or sociological principles. The essential poverty of [black art, Chicano art, etc.] hasn't been pointed to because the art has been very fortunate in the transposed value systems applied to it.

Nicolas Calas [from floor]: Social problems are not important in art, the cultural elements are important – the metaphor, the reversal from reality, what Baudelaire called a "liberation from experience."

Therese Schwartz [from floor]: Since artists are real people in history, what about political and economic influences on art?

Pincus-Witten: A political or economic scaffolding is not essential to the premises of art. Art is a dialog by one person of one moment in his or her life against another moment in his or her life. We've always had pluralism . . . but I think we are now at the end of pluralism. . . . The style is dead.

In all, a lively event, but more solecisms than Mainardi can address, even with a mild assist from Siegel. From the outset, Pincus-Witten clouds minds by contradicting his own metaphor at the speed of light. Pluralism is the White Race of art, then pluralism is open-enrollment, that is, minority, art. The formalist academy is the White Race, then pluralism, the antithesis of formalism, is the White Race. Etc.

Throughout, both he and Masheck deliver a series of rhetorical claims with an air of stating great truisms. For instance, Masheck's, "If it's only what you please, by definition it doesn't have any value to the culture or the society." By *definition*? Whose definition? When Mainardi catches Pincus-Witten flat-footed in a goof about Courbet, he simply changes the subject. Now, suddenly, "no one knows what art is." (If he believed that, he'd stop telling us.)

Pincus-Witten's disgust with flaccid daubs presented as art is fair enough, but calling them "pluralism" is not. Much Conceptual, Minimal, Environmental, and other art, which by virtue of having had certain critical certification is presumably not "pluralist," but "mainstream," is equally tired, trivial, and inane.

As Mainardi noted, critics get more power validating styles than by sticking their necks out on individual works. Jeanne Siegel invited Pincus-Witten to "say what he thinks is good art," but he failed to do so. Thus judgment was broached, but omitted, perhaps still in atonement for Greenbergian excess. Meanwhile, what Pincus-Witten called his "smokescreen" and "diatribe" kept everybody off balance. His dismissal of "political or economic scaffolding" might otherwise have been disputed, perhaps by Masheck. In any event, his version of art as "a dialog by one person of one moment in his or her life against another moment in his or her life" is outrageously sentimental for such a tough guy, especially one who has just accused Mainardi of being sentimental. In fact, it sounds almost like pluralism.

– Judy Seigel

Women Artists News, March 1978 [Vol. 3, No. 9]

'78 / #81

In Search of a Usable Future

This is not necessarily the first "post-modernism" panel in the history of the world, but it's the first we have on record. And very cogent, at least by this account.

"Towards Post-Modernist Form"

Moderator: **Douglas Davis**; Panelists: **Vito Acconci, Eleanor Antin, Roy Ascott, James Collins, Richard Foreman, Peter Frank, Newton and Helen Harrison**

College Art Association, NYC; January, 1978

What is "post-modernism"? The vast majority of artists and critics do not yet recognize a particular movement by that title. Neither is it clear exactly what the name means or will mean. ("We know what 'post' means and what 'modernism' means, but. . . .") On the other hand, most of the artists and critics who made up this panel do consider themselves "post-modernists." Consequently, their main thrust was toward defining and defending the movement as they see it.

The most common issue was the perception of rules and boundaries. Eleanor Antin, for example, likened the situation of the "post-modernist" to that of a kid in junior high school who suddenly realizes she can ignore the rules – or better yet, use them to her advantage.

Newton and Helen Harrison talked about the expansion and elimination of boundaries, especially those that limit artists' subject matter, and the kinds of methodologies and presentations they can use. Peter Frank gave a concise, radio-commercial-like reading considering "post-modernism," but concluded essentially that conflicting views are "both right."

Other participants presented a miscellany. Richard Foreman discussed the use of "garbage" in his art – that is, the conscious use of things he doesn't do well or ideas that don't seem particularly significant or relevant. Roy Ascott likened the continual revisionism of the art-world (the succession of dominant "movements") to the constant weapons-replacement mentality of the defense establishment. Jim Collins talked about personal aspects of the artist's relations with an audience – about the problem of having a relatively forgettable name, for example. Vito Acconci discussed changes in his work, such as removal of his actual physical presence, which made it less confrontational and more reflective.

Not unexpectedly, no grand synthesis occurred. There was a general consensus, however, about when the artists felt their work changed into "post-modernism": the last two or three years of the '60s. Though unstated, the change seems to have been from "anything goes" being the *point* of art to simply being its means.

– Blaise Tobias

Artworkers News, February/March 1978 [Volume 7 No. 5]

'78 / #82

Searching the Premises

"Art and Ideology"

Moderators: **Josephine Gear** and **Alan Wallach**; Panelists: **Peter Klein**, "Art and Revolution in the Spanish Civil War (1936-39)"; **Ursula Meyer**, "The Political Implications of Dürer's Knight, Death and Devil"; **Donald B. Kuspit**, "Meyer Schapiro's Marxism"; **Carol Duncan** and **Alan Wallach**, "The Museum as Ritual Structure"

Caucus for Marxism and Art, College Art Conference, NYC; January, 1978

Peter Klein's presentation on the Spanish Civil War demonstrated that works utilizing realist, and especially photographic, methods were far and away more effective political tools than those using either romantically exaggerated or contemporarily-abstract approaches.

Ursula Meyer's classic art-historical analysis of a famous Dürer print which has traditionally been interpreted as a "Christian Knight" triumphing over the devil, demonstrated convincingly that the work actually depicts a German robber-knight (a low-level member of the nobility) plundering the countryside with the devil as his ally.

Donald Kuspit attempted to clarify and reinforce art historian Meyer Schapiro's Marxist underpinnings. He demonstrated, with many direct quotes, that Schapiro believed Marxist analysis the only means of incorporating the social and political into a largely hermetic art history.

Carol Duncan and Allan Wallach showed, using the Museum of Modern Art as example, how museum architecture, specifically gallery design, mimics the traditional single-path theory of the evolution of art endorsed by those very museums. Patrons are led through selected works in an approximation of historical sequence, with occasional tangential movements in tangential galleries. Duncan and Wallach thus convincingly demonstrated how art institutions control art history and maintain the power to judge the importance and validity of a given work.

– Blaise Tobias

Artworkers News, February/March 1978 [Vol. 7, No. 5]

'78 / #83

Welcome to the 20th Century

"The Impact of Photography on the Visual Arts of the '70s"

Moderator: **Rosalind Krauss**; Panelists: **Thièry de Duve, Craig Owens, Nan Rosenthal, Allan Sekula, Sam Varnedoe**

College Art Association, NYC; January 1978

Despite its title, the primary activity of this panel turned out to be a general, and often quite abstract, discussion of photography and photographic theory. The two presentations which stayed closest to the stated topic were those of Nan Rosenthal and moderator Rosalind Krauss.

Rosenthal spoke about the use of photographs by Surrealists who worked primarily in other media. Her major example was Yves Klein, who made several outlandish photographic statements during his career, the most famous of them the photograph of himself "flying" out of a second-story window. Rosenthal thus demonstrated the value of photography as a medium with which to construct fiction.

Krauss spoke about photography's effect on abstract painting. Her major point seemed to be that many painters had moved towards "real" edges, discontinuities and other surface changes, rather than drawn or illusionistic ones, as a concession to both the "real" logic of photography and changes in the appearance of an art work when photographed.

Craig Owens did talk some about an artist's use of photography – Robert Smithson's – but his presentation addressed mostly the semiotics of photographic representation. His central issue seemed to be the photograph's ability to generate meanings internally. In considering a Brassai photograph, he spoke about the effect of mirror reflections and the photograph's similarities to such reflections.

Thièry de Duve, a Belgian theoretician, gave the most abstract presentation, a long derivation of a model linking the snapshot, or instantaneous photograph, which freezes time "and therefore reveals its passing," with the psychological concept of "mourning," and the time-exposure, or still-life photograph, which separates a subject from its context, with the concept of "trauma".

Allan Sekula said the most interesting and significant effects of photography are found in the media, which comprises a mass art, rather than in high art. He called the photograph a mute piece of evidence which attains all its meaning from its context and perceivers.

Finally, Sam Varnedoe, the only practicing photographer on the panel, gave a concise statement defending the photograph as art object and the photographer as artist, claiming that most attempts to analyze photography ignore the variety of current practice and possibility.

– Blaise Tobias

Artworkers News, February/March 1978 [Vol. 7, No. 5]

'78 / #84

Not a Style, But a Passion

Famous painting at the moment was likely to be still largely Minimal, Hard-Edge, Pop or Photo-Realism: *painterly* painting seemed new and exotic, even perhaps risqué.

"Painterly Painting Today"

Moderator: **Susan Crile**; Panelists: **Lois Dodd, Howard Hodgkin, Frank Roth, Joan Snyder, Frank Stella**

College Art Association, NYC; January 27, 1978

"Painterly Painting Today" started off on an uneasy note. While the audience (including many painters) came with an understandable preconception of what the term "painterly" means (i.e., tactile surface texture involving active, visible brushwork, what in the days of Abstract Expressionism would be called "gestural"), panel members took pains, each in turn, to redefine or totally reject the term:

Frank Roth: All painting is "painterly," in its awareness of craft and surface.

Frank Stella: The word "today" [in the panel title] catches my attention. I want to hear the phrase reversed to read, "Today I am painting in a painterly way."

Stella was physically located center stage, and proceeded to take on a center-stage aura, as he enjoyed his own linguistic playfulness.

Joan Snyder: When I think of this phrase, the only way I can see it absolutely is when I think of children's art. When we become sophisticated painters, the term "'painterly" becomes academic.

For Snyder what is "painterly" is not a style (in this all panel members appeared to agree), but what is "passionate," as in the difference between cold and hot, between not feeling and feeling.

Howard Hodgkin: Any mark that any artist makes on the canvas is in the end "painterly." Even what turns out to be representational was originally painted marks.

For Hodgkin, who takes the long view, painterly painting today is, in concept, no different from any other period.

In pointing out that "there is no *group*" today doing so-called "painterly painting," Lois Dodd made an interesting point. The difficulty in settling on a definition of painterly may stem from this, more perhaps than with a term like "minimal" or "realist." And, as Stella put it, "The term 'painterly' provokes a discussion on 'non-painterly,' and who wants to admit he is non-painterly?"

After this, talk became rather diffuse, including some statements about where to begin education for an understanding of modernism in art and a few declarations that the state of the art world today is basically healthy.

Roth: There is no dominant school, no dominant critic.

Stella: Let's call painterly painting today a looser situation in the art world today.

Then discussion was opened to the floor, and from the questions that followed it became evident that the audience was hungry – for particulars. They wanted to know more about the working processes of the artists on the panel and, seemingly frustrated in this, became increasingly hostile.

Man in Audience: Mr. Stella, in your painting now do you feel differently in your approach than you did in your past paintings?
Answer: Evasive.
Another Man in Audience: Mr. Roth, earlier you made the distinction between working from theory and working intuitively. Could you elaborate?

Roth, who in his own words works intuitively by "making mistakes," said, "I really would love to get it right the first time."

Joan Thorne, in the audience, asked how the panel felt about paint ("How do you relate to it in a personal way?"), which almost led into the kind of discussion the audience craved – personal comments on process:

Lois Dodd: It is the appearance of the external world that gets me going.
Hodgkin: It is a constant series of readjustments, a dialog in an endless process of addition and subtraction. It is the accumulation of reactions between oneself and the painting that produces the physical object in the end.

We were finally on our way to somewhere, but never quite made it. Explaining that working process was *not* the topic –

Susan Crile: We really are here to discuss issues. What is confusing . . . is that "painterly painting" as a term is difficult and incomplete and speaks only to part of the issues of being a painter.

True, certainly, but one would have hoped to come away from the panel with a larger sense of what these issues are, or certainly with a feeling for the individual approaches of these painters. (For this, slides would have been enormously helpful. Also, unfortunately, too many of the questions were addressed to Stella, probably because his work is the most widely known of the panelists.) The most basic audience question, "Why did you agree to associate yourself with this topic as opposed to any others?," was never answered.

Nevertheless, if a panel's success can be judged by audience involvement and the reaction it engenders, we could call this panel a kind of success. But, on the way out, a friend suggested that panel members ought at least to get to know each other once over dinner before they face an audience together.

– Barbara Rothenberg

Author's postscript: I have since heard that the panelists at this event complained bitterly of the "terrible audience."

Women Artists News. April 1978 [Vol. 3, No. 10]

'78 / #85

Carl Andre Calls for Marxist TV

This panel of the Marxist Caucus could presumably not be held in the '90s, or not in these terms.

"Radical Art: Theory and Practice"

Moderator: **Rudolph Baranik**; Panelists: **Carl Andre, Alan Sondheim, May Stevens, Gulsen Calic, Eva Cockcroft, Cliff Joseph, Martha Rosler, Leon Golub, Joan Braderman, Joseph Kosuth**
Caucus for Marxism and Art, College Art Association, NYC; January 28, 1978

The Caucus for Marxism and Art held three panels at this year's CAA convention. Two were titled simply "Art and Ideology," and consisted of several papers on art and art institutions in various historical contexts. I attended the opening panel. "Radical Art: Theory and Practice," chaired by Rudolf Baranik.

Carl Andre spoke, or rather performed, a short piece, the essence of which was that until America had Marxist TV, we could not have socialism. On a more verbal level, Alan Sondheim presented a complex paper critiquing the positive aspects of "art for art's sake," finding art one of the few humane choices left in this society.

May Stevens called attention to lessons to be learned from women, who are socialized to deal aptly with emotion and can therefore see the underlying emotions behind ideology more clearly than many men. Gulsen Calic argued in favor of placing art in the realm of life – "where the experience of art and aesthetics are no longer isolated from one another." Eva Cockcroft spoke on behalf of the flourishing community mural movement, in which artists and community members design and execute large-scale works with content directly relevant to community and site.

Baranik opened his portion of the panel with the statement, "Radical art theory is easy; practice is another thing," and addressed just that. Cliff Joseph spoke of the necessity for art to "hold up a mirror to the brutality of society." He also stressed connections between the personal and political, saying that knowledge of one's inner needs better equips one to deal with external political reality.

Martha Rosler argued for art directed toward areas beyond the art world. Leon Golub traced historical connections among art, technology, and power in terms of the U.S.'s emergence both as a world power and as the center of the art world after World War II. Joan Braderman addressed the question of how Marxist artists, historians, and theoreticians can assist in the proliferation of a Marxist culture. And Joseph Kosuth began a discourse on the relationship between modern-day science, which presents an illusion of being devoid of human contact, and modernism in the visual arts.

– Janet Heit

Women Artists News. April 1978 [Volume 3, No. 10]

'78 / #86

Janson Unrepentant

Horst W. Janson's classic all-time best-seller text, *The History of Art,* was by now notorious for its total omission of women. Sylvia Moore's interview with Janson, addressing this very point, raised a stir, as subsequent letters to the editor showed.

Horst Waldemar Janson

Interviewed by **Sylvia Moore**

NYC; February 1978

The History of Art, a five-pound, two-inch-thick text by Horst Waldemar Janson, is well known to art students. But its author, a distinguished art historian and teacher at NYU, has been the object of considerable criticism by feminists for his omission of women from this tome. In fact, the term "Jansonism" has been used to denote the act of ignoring women's contributions! Wondering if recent developments had led Janson to some second thoughts on the subject, I requested an interview with him for *Women Artists News.* He replied promptly that he was "willing – in fact eager – to be interviewed."

Welcoming me to his Washington Square, Greenwich Village, apartment on a chilly February afternoon, Dr. Janson was charming, almost courtly in manner. I came away with the impression that he would be a delightful teacher, mentor, or friend. Yet I could only conclude that he shares the cultural and intellectual biases of the white, male elite governing the art world.

He appeared determined to show that he himself is impartial toward contemporary artists, male and female. When I cited statistics from a 1975 WCA survey of doctoral programs, indicating that women have indeed been shortchanged in academia, he insisted that he had seen "no evidence of discrimination against women," either as students or faculty. But, asked whether he felt that opportunities in the field are now *improving* for women, he replied in the affirmative, suggesting that he understands there is room for improvement.

What follows is edited from our conversation:

Sylvia Moore: The one question our readers, and I myself, are most anxious to have answered is why, in your survey of art history, so widely used as a text (I used it myself), did you not name a single woman artist?

H. W. Janson: Well, the answer to that was supplied by Linda Nochlin, who is a friend and former student and an outstanding woman art historian. She wrote a piece entitled "Why Have There Been No Great Women Artists?" And there it is.

Moore: You feel, then, that there *have* been no great women artists.

Janson: Let us say not great enough to make the grade in a one-volume history of art. In a two-volume history of art there would undoubtedly be a number of women artists. I

mean, there are many women artists whom I greatly admire, past and present, but not a single one has changed the history of art sufficiently by her work to fit into a series of illustrations [covering] the *entire* history of art from the old Stone Age to the present in less than 1,000 entries.

Moore: And you were concentrating on those artists who had made significant changes in the progress of art history?

Janson: Yes, I picked those artists and those monuments that had the greatest discernible impact, and if there had been women among them, I would not have had the slightest objection to having them in there. But there happened not to be, at least not so far as I know; now, there are an awful lot of anonymous works in the book, and some, of course, might have been done by women.

Moore: The Bayeux tapestries, for instance?

Janson: Well, they certainly were embroidered by women, but whether women also designed them is another question.

Moore: In an interview with Milton Esterow, you said, "The degree of value imputed to a work of art never stands still." Do you think there may be a general re-evaluation of the work of some women artists now that there is more knowledge of them?

Janson: I cannot quite imagine . . . a very radical re-evaluation in terms of the historic importance, let us say, of any women artists of the past because well, you probably have seen the exhibition ["Women Artists: 1550-1950"] at the Brooklyn Museum. It was as excellent an exhibition as one could make; they did a fine job. But I could not look at any one of those pictures without being reminded of other works from which they derived and other works that they led to.

Moore: Have recent studies, such as the catalog for "Women Artists: 1550-1950," altered your evaluation of the role of women in art?

Janson: No, because the women in this exhibition came as no surprise to me.

Moore: You told Mr. Esterow, "If I had written my history of art 100 years ago, how different it would have been . . . in terms of the people I would have felt I must include whom I have not included and vice versa." Thinking ahead 100 years, are there are changes you would want to make regarding women in a 2078 edition?

Janson: I would hesitate to make any predictions . . . however, the next edition of my book may include some women.

Moore: Is it premature to specify who they might be?

Janson: Yes, it would be premature at this time.

Moore: Drawing upon your extensive studies, would you have any comment about images of women in art in relation to the reality of women's lives?

Janson: It depends very much on the subject. I mean, woman is a many-splendored thing, as somebody once remarked, and I would think, if anything, the range of images of women in art is greater than that of men. That is about the only generalization I dare to make. The range of male images in art rarely extends into the pure seductiveness that is such an important part of the image of women. . . .

As Dr. Janson says, "There you have it." The professor's rational tone conveys his exemplary scholarship, but his language reveals more. He speaks of "making the grade" and

"having the greatest discernible impact." But who sets the standards and who does the discerning? Although Janson *personally* would not have "the slightest objection" to including women artists, he was convinced that women just could not measure up.

Dr. Janson justifies his 1,000 pictures with one word, "great." Yet what is this quality of greatness? His criteria are vaguely defined, at best. I would not omit Rembrandt to make room for Köllwitz and Cassatt, but I cannot agree that every artist he chose is more worthy than they. However well-informed, the choices are still the decisions of one individual, and he himself has admitted that the list is subject to alteration.

The charge that women's art is derivative is no more convincing. One of the pleasures of Dr. Janson's book is the comparisons he makes. Tracing the continuity of art, he names teachers, sources, precedents, and influences. He is well aware that no artist, male or female, stands alone.

Dr. Janson sounds like a populist when speaking of "future patrons," advocating the education of everyone "to the extent of their ability." But, regarding art history, he is elitist to the core. He has contributed to what Adrienne Rich called "The Great Silence" about women's role in history. And, having omitted women artists from his book, he blames them for not being "great" enough to qualify.

— Sylvia Moore

Women Artists News, May 1978 [Vol. 4, No. 1]

Post Script: The third edition of the famous *History of Art*, edited by Janson's son, Anthony Janson, appeared in 1986. (Janson senior died in 1982.) As Sylvia Moore said, reviewing the new edition, "something very interesting has happened: 21 women have made the grade." Women of the contemporary art world thus recognized were Lee Krasner, Helen Frankenthaler, Audrey Flack and Judy Pfaff (the latter two with color plates). That the manner of presentation was not yet fully equitable goes without saying. It's interesting, however, that complaints to the publisher about "sexist language" led to some changes in the next printing (which followed almost immediately): remarks about the "beauty" of Vigée-Lebrun and a few comparable irritants were excised. [See *Women Artists News*, June 1986 (Vol. 11, No. 3) for Moore's review.]

Postscript to "Janson Interview"

Subsequent issues carried a gamut of responses to the Janson inteverview, which we summarized as follows:

Reaction to Sylvia Moore's "Interview with That Man Janson!" ranged from criticism for having let Janson into the pages of *Women Artists News*, to commendation of Moore for a neat exposé. But such is the power of the man that we had trouble getting quotes for attribution. We did learn, however, that Janson is *said* to have said, "Modern art – ugh! Monkeys make it"; that he remains all-powerful among those resisting change at the CAA; and that he retains, still, a "strangle-hold" on the art-history textbook field.

Another response that bears mention was from photographer Elsa Dorfman. She said she took a joint photo of Janson and his wife in 1965, but "when it was published, she had been

cut out of the image by [the publisher]. And they didn't credit me for my photo either."

We also quoted Miriam Schapiro: "Janson is culturally blind . . . and his blindness infuriates me. I sit on the board of the College Art Association in a room with Janson and other men like him. I watch these wise old owls, so impervious to women's lives and art . . . so armored against experience and change." [*Working it Out*, Pantheon Books]

Women Artists News, Summer 1978 [Vol. 4, No. 3]

And then there was a disapproving letter in response to the responses, championing Janson:

Letter to the editor:

Through my wife, who is a subscriber to *Women Artists News*, I have been able to read your interview with Professor H.P. Janson, and also the comments on that interview published in Volume 4, No. 3. It is not surprising that there should be criticism of Janson, but even allowing for the heat of polemic, I found it disappointing that the reaction of your readers should range "from criticism of WAN for having let Janson into its pages, to commendation of Moore for a neat exposé." Janson expressed himself in mild and measured terms, and I would like to think that his remarks, as well as his *History of Art*, would deserve serious discussion. Even more disappointing were the observations of some of your readers. They are so unfair in tone and in substance as to be unworthy of your publication's apparently approving reaction. I would make the following comments in detail:

1. With respect to Ms. Moore's observation on Janson's reputed dislike of modern art, no source or context is given, and it sounds very unlike the man. But in any case, does dislike of modern art make someone morally or ethically despicable? Is it your argument that a positive disposition toward modern art makes one more sensitive to the rights and aspirations of women?

2. Ms. Dorfman seems to imply that Janson had something to do with having his wife eliminated from a joint photographic portrait and that he should be blamed for having failed to give her credit for her work. Has it been considered whther this is necessarily a correct representation of the facts? Could the crime have been committed by others? Was it perhaps the work of an editor? Might his (or her) intentions have been innocent? I note in passing that a fair number of the photographs printed in WAN have no credits either. Could there be an evil male chauvinist in your office?

3. Ms. Schapiro suggests that it is a painful experience to sit on the board of the College Art Association with men like Janson. The CAA is a professional organization which represents all sorts of people, from "wise old owls" to feminists like Ms. Schapiro. One gets nominated and elected to the board by the membership of the organization, and no one is positively compelled to serve if they are impatient to the point of physical discomfort with the others. It is possible

that Ms. Schapiro would be happier in a room full of women, as she asserts. But if this is so, could she be in the wrong organization?

Walter Cahn, Professor, Department of History of Art, Yale University

We were happy to provide a reply:

Editors' Reply: While we appreciate Professor Cahn's serious exposition of some interesting points, he has missed the intent of our follow-up to the Janson interview and made some other errors.

1. Sylvia Moore didn't mention "Janson's reputed dislike of modern art"; we did.

Moore's aim was indeed "serious discussion" of important issues, and the fact that her story has been attacked from all sides seems to show she achieved it. One reader found her questions so penetrating and Janson's replies so revealing as to call the interview an "exposé." Others assuredly did not: We were scourged for allowing our "little paper" to be "taken in" by Janson. As for naming the "source" of a particular remark – never, as we said, have we found it so difficult to get quotes for attribution. But journalism is not a court of law: Hearsay evidence is acceptable. In fact, fair coverage of a complex situation often requires it.

The question, though, is not whether liking modern art "makes one more sensitive to the rights and aspirations of women." The question is whether a scholar who does not like modern art should judge its significant figures, or, for that matter, interpret the *history* of art for today's students.

2. Unattributed photos in WAN are either taken by one of our editors, with credit omitted to minimize use of our own names, or publicity pictures, submitted by an artist or institution without attribution.

A spot check of our bookshelf shows that the first six books with jacket photos give photo credits. We don't of course know the production history of Janson's book jacket, but the omission of both wife and photo credit could be considered – to continue the legal metaphor – circumstantial evidence. (We never blamed him for everything, anyway; we just liked the anecdote.)

3. Women artists are trying to save the College Art Association from itself. We think Miriam Schapiro is heroic to sit on the board.

Finally, we're not sure wherein lay our "apparently approving reaction" to criticism of Janson, but it should be obvious that if we had no beef at all with Janson, we wouldn't be doing this.

Miriam Schapiro's reply: Since the advent of the women's movement, people have come to see the world from another point of view. Mr. Cahn does not understand this. For him, Janson is a symbol of patriarchal faith to be revered and defended. But for some of us artists (notably women), such a symbol does not work. And what we are doing is simply describing from our experience how he does not work for us.

Women Artists News, November, 1978 [Vol. 4, No. 5]

Codes and Sagas

Meanwhile, back on Prince Street, ATOA continued its multiple themes and variations, but not, in this case, to the satisfaction of the reporter.

"Narrative Art: Hand and Camera"

Moderator: **Corinne Robins**; Panelists: **Mac Adams, Dotty Attie, Bill Beckley, Ralph Gibson, Stephanie Brody Lederman, Nancy Spero**

Artists Talk on Art, NYC; Feb 10, 1978

In spite of a variety of efforts, this panel did not live up to its full potential. The artists focused on characteristics of their own work, failing to respond abstractly to the designated topic. Moderator Corinne Robins tried to get panelists and audience involved with some thought-provoking questions, but responses were short and polite – questions answered economically, then promptly dismissed.

Each artist showed his or her work in slide form, the narrative aspects of the work (in words or implied stories) adding interest and diversity to the presentation.

Bill Beckley read his own short stories before his work was projected onto the waiting wall. For him the writing and the photographs were of equal importance. For me the two elements were intriguing separately, but confusing together.

Nancy Spero, who spoke of the randomized and fractured quality of time in her work, was one of the few who attempted to make connections between their art and the evening's topic. The non-sequentiality of her images reminds one of religious literature, where all components stand on their own, readable in any order.

Mac Adams sets up equivalent environments in different cultures, using mystery as a vehicle to involve the viewer. The mystery occurs *between* the photographs, events being implied with a minimum of visual material. Like most of the other artists, Adams works in groups, usually three or fewer. Codes and cross-references construct meanings of photographic "jigsaw puzzles." Comparisons of the results are fascinating.

Stephanie Brody Lederman takes real-life experiences and tries to transpose them into something else – fantasies. For instance, a series of childlike drawings describes a "shoe store saga." Unfortunately, I had trouble reading the work as anything other than accounts of mundane happenings.

Ralph Gibson reached no conclusions, but attempted to better define his problems. He has given up a wonderful style of narrative photography to do more experimental work, such as photographs of bricks in the wall of a building. Gibson says he is interested in edges. (Isn't everyone?)

Dotty Attie uses cropped portions of old master drawings, interjecting a narrative in the form of written words. Ironi-

cally, the implications of her Victorianesque stories remain titillating to the contemporary mind.

The audience was also at fault for the lack of group discussion. Panelists showed excellent examples of narrative art; both hand and camera were well represented as tools of communication. But any further conclusions about the narrative art form would have to be synthesized by each listener from the material presented. The entire affair was rather tiring; maybe it was the weather.

— Susan Harris

Women Artists News, June 1978 [Vol. 4, No. 2]

'78 / #88

Good Art, Bad Talk

The next week brought the first panel (good or bad) about "bad" art being good. The writer says the talk was "a letdown," but the appreciation of kitsch, camp and dimestore rugs was yet another little jig on the grave of formalism.

"'Bad' Painting"

Moderator **Irving Sandler**; Panelists: **Shari Urquhart, Joseph Hilton, Jeff Way, Marcia Tucker**

Artists Talk on Art, NYC; February 17, 1978

This "bad" painting grows on you. My mind has gradually accommodated Earl Stanley's flying purple mermaid, Judith Linhare's fabulously huge turkey framed with pink ribbon, Joan Brown's ghastly, vulnerable standing nude woman with purple cat mask, William Wegman's lovable, comical puns on paper. The humor, the irreverence, the throw-away quality of this so-called bad painting eventually charm you. Give these works a chance and they'll let you right in. But for that you had to go to the show [January-February, 1978] at the New Museum, and read Marcia Tucker's impressive, if overly comprehensive, catalog.

The "Bad Painting" panel was bad, without quotes. I attended the panel before seeing the show and came away feeling dreary and hoaxed. Panelists Shari Urquhart and Joseph Hilton were in the show; Jeff Way, was a guest artist and Marcia Tucker is founder of the New Museum. The artists showed slides of their work, but did little more than rather simplistically describe it.

One obvious question was whether the concept of "bad" painting was a valid link among the three artists, or was forced to justify a panel. At least at this presentation, they seemed to have little in common except that, as Tucker put it, "they distort the figure." But what artist has not? In fact, the term "bad painting" itself was never adequately defined.

Shari Urquhart did stand out as intriguing. She described herself as an artist attracted to "low culture" and captivated by dime-store rugs. Her own work is done as tapestry, with a complex weave incorporating gold and silver thread to dazzling effect. However, even this was hard to appreciate when seen only through slides presented in a somewhat careless manner.

Irving Sandler's questions did not bring us to any higher level of understanding. Marcia Tucker was articulate, but too general, saying that each artist has discarded convention in creating the figure, each is outside "the mainstream," and each makes what the public might call "bad art." That all are highly skilled, she took absolutely for granted, although several vocal members of the audience did not.

Even with Tucker as spokesperson, the lack of definition of the idea and the reluctance of the artists to do more than describe the work was a real letdown. The mostly irritated, nearly hostile audience seemed to feel let down as well. And so this good art, this whimsical, exuberant, cunning art, was lost in a panel of mediocre, if not downright careless, talk.

— Leanne Domash

Women Artists News, June 1978 [Vol. 4, No. 2]

'78 / #89

What Do You Mean, What Do I Mean?

Let the record show that "intentionality" *is* in the dictionary. Webster defines it as "the characteristic of being conscious of an object," which might explain why panelists had trouble defining it. We see also that "the painter" in this saga was still "he."

However, our reporter speaks of the "magic of the evening" she has "come to expect in one of the better ATOA discussions." At the risk of sounding hopelessly nostalgic: it *was* magic.

"Intentionality"

Moderator: **Pat Passlof**; Panelists: **Lennart Anderson, Howard Buchwald, David Dorfman, Geoffrey Dorfman**

Artists Talk on Art, NYC; March 3, 1978

Intentionality was the subject, and the evening was rife with abstruse philosophical digressions and turgid quotes, while panelists accused each other of being esoteric. Moderator Pat Passlof, laid back, enjoying the egotism and idealism, seemed to know that the real quest lay elsewhere. Or perhaps she understood that some battles have to be fought again and again by every adventurer.

The panelists, antagonistic to each other from the beginning, spent a lot of time trying to define intentionality to everyone's satisfaction. Howard Buchwald, from Princeton (a fact he frequently pointed out), pursued eloquently and at great length every nuance of the art-making process. He adamantly disagreed with the brothers Geoffrey Dorfman and David Dorfman, who contended that the first stroke is the painter's first confrontation with intentionality – all that he intends and all that he gets. Buchwald listed a whole complex of decisions to be dealt with *before* the initial stroke. But Geoffrey remained all innocence, insisting that everything before the stroke is of "manifest indifference."

David was determined to draw parallels between the "intentional experience" of the writer and that of the visual artist. "How does a painter, or in my case a writer, approach a blank page or a blank canvas?" he asked, claiming that artists and writers share this groping with intention. Premature interruptions from the audience were met with, "Shut up, schmuck!"

Lennart Anderson was content to describe his experience in painting and his feelings when faced with the disparity between what you want and what you get. "With every mark I make I'm always prejudiced in my favor." But the audience would not be silenced. "Are you addressing us or your own personal concerns?" And the answer, again from the audience, "It's all we have to work from." Finally, David Dorfman offered the mystical notion of Epiphany, an experience of revealed truth transcending the personal or the self, with the implication that intentionality remains mysterious, a process beyond our ability to understand.

But the real magic of the evening, as I have come to expect in the better ATOA discussions, was in the vulnerability of the panel and audience, unsuspectingly seduced by the subject into a fervent dialog, not just because they confront these issues daily, but because they really care enough to treat each confrontation with commitment.

– Germaine Keller

Women Artists News, June, 1978 [Vol. 4, No. 2]

'78 / #90

Spirited Discussion

Chicago had never been gripped by formalism as tightly as New York: With the Chicago Imagists, and later the "Hairy Who," figurative and narrative art had flourished from the '50s on. In other words, this discussion of critical issues had none of the sense of waking up after the fact, scapegoating, finger pointing, and disorientation, that soon led New York critics to declare a "crisis in criticism." Rather, talk centered on reality issues: varieties of art criticism and the demise of the daily paper that had been its best vehicle in Chicago.

"The Critic & His/Her Role in Chicago"

Moderator: **Jane Allen**, Editor *New Art Examiner*; Panelists: **Jack Burnham, Joanna Frueh, Franz Schulze**, critics.

N.A.M.E. Gallery, Chicago, March 16, 1978

The overflow audience of two to three hundred area artists sparked a mild temporary paranoia in at least two of the three panelists. Jane Allen, tending to forget the theoretically limited and neutral role of moderator, leapt into the spirited discussion. The event became the liveliest of the recent N.A.M.E. series and one of the most interesting panels in recent Chicago history.

Allen opened by pointing out that the critics present exemplified different aspects of criticism. Jack Burnham declared that communication in art is his main concern. Joanna Frueh said she doesn't care whether there is an art object *per se*, but what the work stands for, judging it on an intellectual, sensual, or emotional level. Franz Schulze declared himself more interested in the object than Burnham and more interested in making judgments than Frueh.

Burnham said that working as a sculptor he had felt "lost," but writing helped him clarify his work. He described an experience at the Sidney Janis Gallery, when he found himself more interested in photographs of the artists than the actual art. Frueh said she finds some art autobiographical and personal beyond a merely social or person-to-person level.

Schulze lamented the recent demise of the *Chicago Daily News,* for which he had written about art in the weekend Panorama section. He said Panorama had been a real vehicle for culture in Chicago, and the 1200-1400 words of his column there were a marked contrast to the 800 words now allotted his Friday column in the *Sun-Times.* He observed regretfully that the metropolitan press does not see art criticism as a means of selling papers in the way sports and comics are.

Burnham said he found the mass press limiting, while Allen considers long reviews to be an aspect of formalism, which supposedly died in the '50s. Frueh, describing her distress at having to limit coverage with so much going on in art, spoke of the "tyranny" of the art world and what "getting the work out" can do to an artist. Schulze, although he finds the present not a rich time for art, said he is happy to see pluralism replacing the apparent tyranny of the '50s and '60s.

From the audience, Barbara Housekeeper asked, "What is the function of art criticism?" Burnham replied that everyone damns the critic, but there would be a vacuum without criticism. Frueh said she would like her criticism to be considered as writing, too. Schulze listed types of critics – philosophers and aestheticians, as well as "daily" critics who report and make topical statements but are unwilling to make judgments.

Allen wondered if a good critic has to be a good writer and also have "a good eye." Schulze said some critics seem able to relate art to larger phenomena, such as literature, but a good eye is important in a formal context. Burnham claimed that

if the message of art is strong enough, the prose about it is relatively unimportant.

Allen said the *New Art Examiner* tries all types of criticism, but she herself is tired of the purely informational or reportorial. Burnham declared that the issue is really publicity, because that's what puts artists in museums. From the audience, Michele Fire pointed out the dilemma when the critic replaces the artist as communicator. Schulze said the difference is that the critic articulates his or her response in print, adding that critics really like art, like to talk about it, and feel a deep responsibility to the field.

Speakers then returned to discussion of the art object *per se*, and, after nearly three hours of verbal give-and-take, weary panelists and audience filed out into the night.

– Barbara Aubin

Women Artists News, Summer 1978 [Vol. 4, No. 3]

'78 / #91

It's *All* Three Inches High in *Artforum*

"Questions of Size and Scale"

Moderator: **Irving Sandler**; Panelists: **Ruth Abrams, Natvar Bhavsar, Judith Bernstein, Suzanne Harris, Pat Lasch, Judy Seigel**

Artists Talk on Art, NYC; March 31, 1978

Increasingly, the ceremony of the ATOA panels has lent itself to a kind of mini- or secondary exhibition, as slides with verbal accompaniment and a view of the artist in the flesh – an occasion for individual presentations of individual artists. The old idea of the series as a forum for finding and exploring issues fails through no fault of its organizers.* Exchanges between panelists are rare, each talking separately at the audience – probably not the people or the topics, but a condition of the times. There ought to be a common ground in this "do your own thing" world.

Moderator Sandler introduced the panelists, whose work implied a range of concerns with size and/or scale. Distinguishing between size as "the dimensions of the work" and scale as "internal relationships that may contribute to making the work seem larger or not," he went on to characterize each panelist's relation to the question:

Size and Vastness: Ruth Abrams found that the more cosmic the scale attempted, the more the size of her paintings diminished. (They measure one to five inches.) She uses a "finder" to frame or mat out details on large formats of paint strokes, spatters, and pools, formats that are presumably not in themselves coherent. While Abrams is probably the first to carry this problem to its ultimate conclusion on the reductive

end, it has always confronted painters, coming into focus when gestural painting attempted work in sizes greater than arms can gesture. Recent solutions have included the use of larger tools: sticks, squeegees, and finally the spray gun, which seems to have eliminated the problem – but may have done away with the solution as well, by amputating one of art's crucial metaphors.

Size and Power: Judith Bernstein sees her charcoal-on-paper screw/phalluses as power symbols, but thinks the work is "more about energy than power . . . I was very interested in making the largest drawings I could for the space I had in order to get the most impact."

Size and Endlessness: I wondered whether it was coincidence that Natvar Bhavsar was the only man on the panel, or whether the issue was expected to be more feminist than general. Bhavsar was also the only one to speak entirely of his work's effect on himself, never of what he was trying to say or its impact on others: painting as a dialog, "just trying to be with the color and trying to grow. Painting has its own rhythm, like walking in nature . . . the saturation of color in my eyes, in my being . . . Small works do not induce in me the states of ecstasy and agony." Though the work relates to Bhavsar's Indian background, as in Indian music, which "begins but does not end," his emphasis on the artist's experience and growth in the making harks back to the discredited existential stance of the Abstract Expressionists and underlines current insistence on forcing art into an objective mold: art as solution to problem.

Size in Harmony with Site: Suzanne Harris, the only sculptor on the panel, is "involved in a holistic way of trying to find non-amorphous form through sets of relativities." Isn't that what we all do? But I liked her sureness, the fact that she doesn't make models even for monumental works, and her direct, unpretentious use of material.

Size and Feminism: The heritage of the long line of anonymous women or "closet painters" is a reference easily, but mistakenly, inferred from Pat Lasch's iconic collages of oil-paint wedding cakes and family photos. As it turned out, her craft was learned at her father's, not mother's knee. (He was a professional baker.) Having worked large in the past, Lasch feels that the small size of her current work is a matter of appropriateness, not, in any case, a feminist point.

Here generations make the difference. Judy Seigel made clear that these options were not always available, that the "permission" to do small work and to be taken seriously doing it is a recent victory of feminism, liberating men as well as women. I understood her statement, of which the following is an excerpt, to be an attack on large work: "I find I increasingly dislike large cars, large dogs, and large art. Where no real function except size is served, they have a lot in common morally, philosophically, and practically." Bernstein and Harris clearly understood what I did, looked at Sandler, then each other, as if hesitating to break the unspoken taboo against panelist exchanges. Just as Bernstein took up the glove, Seigel saved the situation with a "present company excepted." I wish she hadn't.

Turnabout: Both Seigel and Lasch bridled at what they mistook for an attack on smallness. Unknown speaker in audience: "I find that in the case of certain artists their large paintings are usually better than their small ones." He mentioned Pollock, Still, Poons, Leslie. "If this is so, there may be something in contemporary imagery or syntax . . . "

A serious question, for which the historical and formal reasons have apparently been lost or forgotten, leaving size to stand as a mere signal of ambition in a competitive and theatrical arena.

– Pat Passlof

Women Artists News, Summer, 1978 [Vol. 4 , No. 3]

*However, the ATOA format stipulates that artists show slides.

'78 / #92

Modern Romance

Not even the moderator claimed the discussion was a success, but the evening did provide a once-over-lightly of a fascinating topic: whether modern artists' vaunted non-conformity is contrived, authentic, inevitable, or simply a romantic myth.

"Art Movements and the Non-Conformist"

Moderator: **Solomon Ethe**; Panelists: **Chryssa, Patterson Sims, Irwin Touster, Virginia Zabriskie, Jeff Perrone** (replacing **Peter Frank**)

Artists Talk on Art, NYC; April 7, 1978

As Patterson Sims summed up the evening, the subject of the panel was "heroically undiscussed" by panelists and moderator.

The conformist/non-conformist construct might have been illuminated if the "non-conformist" of the panel title had been considered in two parts: life and work. Such a division would at least yield the distinct definitions that this romantic topic needed for clear discussion. However, so much of the reading of a work of art today includes the romantic myths of the artist's life and context (as well as the reader's) that the separation of life and work seems increasingly difficult. A less romantic title or a less romantic panel might have fared better.

During the evening, questions arose about whether Joseph Cornell and Cézanne were non-conformists (Solomon Ethe and Virginia Zabriskie said Cornell was, Irwin Touster said Cézanne was, Jeff Perrone said neither was); whether folk artists are not the true non-conformists; and about the Synchromists, who were non-conformists in America, while at their source in Europe they were conformists. But it was impossible to consider these problems adequately, since no definition of terms and categories had been presented. The same difficulty arose in an argument about art movements –

whether there actually *are* art movements, whether they are a modernist invention, and when the phenomena began to be defined as such.

Zabriskie, logically suggesting a definition of "non-conformist" in terms of behavior, stated that all contemporary artists must conform to the gallery system in order to exhibit their work; on the other hand, the work itself can remain non-conformist, or, as she put it, unique. But later, almost contradicting herself, she added that the gallery system is no longer viable for artists, that its spaces are old-fashioned and unable to contain the new art forms that work better in museum spaces than in galleries. (And yet exposure of new art in museums has been shrinking since the early '70s, while revivals have surged and box office has become a major concern.)

It is probably inevitable that a gathering of interested peers such as this one would throw off some sparks to illuminate aspects of fleeting concerns. If panels warmed up before the actual event, both to the topic and each other, perhaps more sparks would fly.

– Margia Kramer

Women Artists News, Summer 1978 [Vol. 4, No. 3]

'78 / #93

Maybe Punk Just Isn't Panel Material

In which we see that elitism/anti-elitism can be a matter of context, that there are definitely differences between punk rock and art, and that a new form is evolving.

"Artists/Punk Rockers: The Search for a New Audience"

Moderator: **Edit deAk**; Panelists: **David Ebony, Jane Fire, Dan Graham, Judy Nylon, Robert Christgau, Pat Place, Susan Springfield, Alan Suicide, Ruth Marquand**

Artists Talk on Art, NYC; April 21, 1978

This punk forum ran true to form: it followed no rules. Topics were flung around, batted a bit, then dropped; hecklers ruled the discussion for most of the evening, and a stereo intermittently blared snatches of the latest punk singles throughout the proceedings. There was no microphone, and the panelists, most of whom are used to getting their messages across with the aid of high-decibel amplification, couldn't – or wouldn't – make themselves heard. A woman in black, whom I recognized as an habituée of CBGB's (the punk rocker's palace at Bowery and Bleecker), kept yelling things like, "I'd rather be dead than an artist," and "Rock and roll does not need the art world, the art world needs rock and roll."

So it was a circus, and some panelists took themselves seriously, others were simply clowning. Still, several interesting thoughts on the relationship between punk rock and the art community emerged.

First and foremost, there seems to be a real antagonism between punk rockers and the art establishment, even though many of the original punk rock bands (Television, Talking Heads) were formed by artists and art students. What the punkers seem to be against is the elitism of art circles. David Ebony, a musician and artist, found that the very idea of a panel discussion represented an aspect of the art world that is, to punk rockers, obnoxious. Other panel members vented their contempt for this form of discussion by making inane, anti-intellectual remarks. Judy Nylon, a conceptual artist who has worked with the avant-garde British composer Eno: "I'm not an artist, I'm just in this for money and a good time." Pat Place, lead singer of the Contortions, an up-and-coming punk band: "I got into this because I thought the guys were cuter in rock and roll."

Susan Springfield, lead singer of the Erasers, former art student from Ohio, was one of the panelists who tried seriously to explain her reasons for turning to rock and roll as a means of expression. "I wanted to get away from the elitism of the Soho art community. And I found I could get closer to the kind of expression I wanted in rock. In rock, musicians working together respect *that moment.* Artists try to destroy that moment."

It's strange that the concept of anti-elitism got harped on so frequently. The punk-rock community is, paradoxically, as insular a community as Soho – perhaps even more so. As Robert Christgau noted, punk and new wave are not exactly mass movements of the people. "Being anti-elite, it has a certain vitality, but it is also dying, because it's just as much of a self-contained community." Christgau noted that even the most successful punk rock bands reach an audience of no more than 100,000. (The biggest-selling record by Talking Heads, a group of former Rhode Island art students, sold that many copies – most New York punk bands have not been recorded.)

Christgau also reflected that the rise of punk rock bands performing exclusively in artists' spaces (as opposed to public spaces such as CBGB's bar) indicated that the punkers were seeking a smaller, more elite audience.

The punk rockers' case for their art and their community came across confused. The most lasting impression of this forum was of a roomful of people who knew each other, bantering and heckling. Perhaps the moderator should have prepared several specific topics for discussion. And perhaps the panel might have been chosen a little more carefully; ten was an unwieldy number and several panel members said nothing the entire evening.

Later that night I followed Susan Springfield, the woman in black, and Judy Nylon to CBGB's, meeting-ground of the punk rock community. Safe on their turf, the women seemed as at home as a conceptualist on West Broadway. There was no need for explanations or anti-intellectual posturing. Punk rock, like most "baby" movements just toddling to life, has yet to find its own vocabulary – the panel discussion revealed that clearly. But there *is* something going on here: new artists and a new audience. Maybe by the time they get around to discussing the relationship between punk and art again, the punkers will be secure enough about their work and their community to say something meaningful about both.

– Daisann McLane

Women Artists News, September/October 1978 [Vol. 4, No. 4]

'78 / #94

It's Everywhere and Worse Than You Think

Two weeks later, elitism was the *official* topic, and tries at defining it ranged from, "one group bitching about another," to rigging prices at auction. Other definitions do turn up from time to time, but few defenses – at least in public. In fact, the art-world-as-we-know-it would collapse instantly into a hill of ashes without elitism. But in our time "elite" is officially a bad thing to be. The term is used as a generic derogation: this, that or the other that we don't like is "elitist." To declare oneself an elitist would be tantamount to declaring oneself a child molester. (Maybe that's what stymied discussion.)

"Is Elitism an Issue in Art Today?"

Moderator: **Richard Martin**; Panelists: **Bruce Boice, Solomon Ethe, Janet Fish, Les Levine**

Artists Talk on Art, NYC; May 5, 1978

Moderator Richard Martin tossed this out as an opener: "The broad question of elitism implies social systems, democratic values – values that may or may not be involved in criticism or in the relationship between art and criticism and the way in which we lead our lives."

Speakers, with the notable exception of Les Levine, then proceeded to drop the ball and run away from it. They seemed not to be prepared or not to have very passionate views on the subject – which I find surprising, since most of the artists I know are in a permanent rage over the arrogance of the art world. (But then we are women.)

Indeed, Bruce Boice said he doesn't find elitism an issue at all today. "Artists worry about being elitist, but they have to worry every month about paying the rent. They are doing what they want to do, usually without infringing on anyone else." Boice suggested that elitism may be suspected in art because rich people buy art work. "But then, they buy everything."

Solomon Ethe said elitism is an issue of communication. "I've failed in communication when a person responds on a level I did not intend at all . . . Viewers are elitists too. If art does not fit into what they expect, forget it."

Janet Fish admitted not having considered the question until being invited to the panel, and had little to say. To her, elitism is simply "One group bitching about another, New York groups against other New York groups, New York versus the outside."

But when Les Levine began to speak, the room crackled. Panelists had been invited to show slides of their work before discussion opened. Levine, with a nice sense of theatre, showed slides of stuffed animals – a mouse, frog, pig, and rooster – and read a dialog of what they are saying. The mouse represents the artist; the others are badgering him to produce his best, *the* best. Mouse insists this *is* his best, but they do not let him alone. "We want the best of the best."

When it was time to make his statement, Levine said, "Elitism is everywhere, and it's worse than you think." The problem is not that "everyone is elite in one way or another," but that "elitists are a group of people who have gathered a certain privilege to use to their own advantage." They do this "in clandestine fashion," for their own aggrandizement, and "at the cost of the entire community."

Such abuses as rigging prices at auctions are accepted in the art world, Levine said. In the rock-and-roll business this would be a scandal. "We make the rules for our world, they make the rules for theirs. Any society that runs itself that way is going to generate elitism." He suggested that realism versus abstraction is not really the issue of elitism. "The notion of elitism on an aesthetic level is a red herring. 'We want the best' is a red herring. Best is too personal. A group will decide what's best and they'll be wrong . . . Until they agree that their taste is an exclusive attitude, there will always be elitism."

The audience was alert and involved, perhaps more so than the panel, and after some more fuzzy statements from the panel (Boice: "Economics does not imply elitism"; Ethe: "Elitism is not necessarily a matter that touches on social issues"), demanded a definition of elitism. They never really got one. Fish said elitists are the *crème de la crème*, but did not define or give criteria for the term.

Audience: In the past, elitists supported the arts. In democracy, has art found its place?

Ethe replied that in the past art was religious, a part of life. "Now it's a bauble."

Audience: Is there an alternative to elitism?
Levine: Make more baubles. If we don't keep people out on the basis of quality or economics, there is hope.
Audience: That's the red herring. There must be some standards.
Levine: Nobody needs to worry about standards . . . Elitism is when you gather others around you to reinforce your own power. Saying something is good is not elitism.

Responding to an audience pollster, the panel finally agreed that elitism is a negative force. (Will the force be always with us?)

All in all, pretty cool treatment of a hot subject. The relevant economic, political, social, and psychological aspects of elitism were hardly touched on. I was surprised that museums, dealers, and critics were barely mentioned and stunned that the issue of the *male elite* was not even brought up. Stimulating art panels always have an element of improvisational theatre, but participants should be – if not prepared – at least deeply interested in the subject.

– Donna Marxer

Women Artists News, Summer 1978 [Vol. 4, No. 3]

'78 / #95

Panel Incest, Cronyism, and Other Unoriginal Sins

In a sense this vivid testimony of corruption, arrogance and myopia in arts funding brought Soho's theoretical talk of elitism uptown and made it concrete. The subject was the New York State Council for the Arts, but could also have been art funding at the federal level (at least as I have observed it over the years) and no doubt other arts councils across the land as well.

By now, public protests about "panel incest" seem to have died out. A faint echo was heard at the height of Jessie Helms's attack on the National Endowment for the Arts, in the wan hope that if the Endowment cleaned up its act it would be less vulnerable to right-wing bullying. Since then, silence. Meanwhile, cronyism remains so pervasive as to be the norm. "Guidelines," which have always been manipulated to serve the purpose at hand, bend like pretzels. And, as Bill Stephens eloquently described at this hearing, well-connected groups still get big bucks, often for miniscule achievements, and panel selection is still the private prerogative of the powers that be.

However, there are a couple of differences. Today, the deference New York State legislators showed these minority artists seems as old-timey as bottled milk. Now government sees artists more as scapegoats than important constituents, and it's doubtful that any artist, of whatever ethnicity, could command such solicitude. Still, I would venture to guess that, at least in New York State, "minority artists" get a significantly bigger slice of the arts pie than they did at the time of this hearing. It's even possible that the hearing did some good.

The following is slightly cut from the original report:

Minority Artists Blast State Arts Council

New York State Special Committee on the Culture Industry, Harlem State Office Building. May 12, 1978.

You couldn't say that in seven hours of testimony there wasn't one kind word for the New York State Council on the Arts. Bruce Dowling of the America the Beautiful Fund said, "They do a good job with relatively little money."

But the criticism of NYSCA lacking at the New York Senate Special Committee on the Culture Industry hearing [3/3/78, Lincoln Center] was expressed at the committee's hearing on Minority and Community Arts at the Harlem State Office Building. In fact, at one point Chairman William Conklin was moved to say, "I would like the record to show that the group sitting up here is not the Council on the Arts."

Black, Asian, Native American, Hispanic and white ethnic groups of artists, performers, writers, and musicians were heard. Some simply asked for a taste of the pie. Others presented proposals. But the fact that Harlem, "titular capital of the black community in America," is being short-changed was expressed a dozen times in as many ways. Hazel Bryant

(Richard Allen Center for Culture and Art) said "corporate giants who made fortunes on the inspiration of black artists" gave back a "pitiful pittance." Carl McCall, State Senator representing the Harlem district and member of the committee, declared minority artists' "growing outrage" at "uneven treatment."

"When it looked as if Radio City could close . . . public outcry was spontaneous and widespread," he said. Harlem's Apollo Theatre, another landmark institution, was allowed to close. When it reopened three years later, "the State of New York had no part in it."

But the *passion* of the hearing was directed at the New York State Council on the Arts. NYSCA, this year disbursing some $30 million of public money, was declared guilty of discrimination, of cronyism, of irrelevant, or "Anglo" aesthetics, of dictating community priorities and flouting community values.

Assemblyman George Miller (Harlem, 71st A.D.) said, "For a multi-ethnic city, the current lily-whiteness of cultural decision-making bodies is a disgrace. These taxpayers' servants tell us, 'Oh, you people think this is a poverty program,' [but they use] lying, rationalization, and humiliation to deny funds." They also use guidelines.

Guidelines can be flexed at will, Miller said. On paper the Council can't fund therapy or recreation, but Bronx senior-citizen women got funding to do a *water ballet*. "Someone had some political influence. OK, that's what public officials are for, but don't talk about the Council not being involved in politics." Miller said that as a politician he had watched the legislature in Albany increase the NYSCA appropriation over the years to tens of millions of dollars. "That's when I got interested in art."

Bill Stephens of People's Communication Network charged that "Blacks and minorities are systematically eliminated from access to public TV . . . Only 1.5% of programming staff is minority – less even than at commercial networks. Most programming for minorities is by white independent producers . . . Channel 13/TV Lab has never given a grant to a black artist with NYSCA funds."

Later, Stephens described the State Arts Council as "a kind of club. [T]hey all know each other and you can't get in." This year, "All but one of the panelists had applications in themselves. They just left the room when their names came up!"

Stephens had been on video location in Africa, but couldn't get post-production funds for material that was "100 times hotter" than other projects that did get Council funding.

"Euro-American media artists can get monies across the board to do programs on minority situations – about police, housing, day care, even about black artists. But minority artists aren't allowed to interpret or reflect their own interests. John Alpert got funding to do a program on Chinatown. If a Chinese did the same job, word for word, shot for shot, he wouldn't get the money.*

102

"Our proposal included a documentary, but Lydia Silman told us, 'We'd rather you do something related to the cultural arts.' When I got my contract they had actually put on it, 'A new production related to the cultural arts.'"

Council favorites not only get funds for political and social commentary, Stephens said, they tend to get funding every year and to get "full support." His group "gets partial support for one particular project." PCN has been together and earning its own way since 1971, he pointed out, yet has had only $1000 from NYSCA to date. "Other groups, just organized, got 15 or 20 thousand dollars on their first application and went out of business the next year."

Chief among villains, Stephens named Lydia Silman, head of the Media Program at NYSCA. Formerly secretary to Director Russell Conner, when Conner left (to form his own organization – with substantial Council funding) she was "the only one who knew procedures" and was herself appointed to the position.

Now, as head of the Program, Silman "holds the reins." She not only chooses the panels, she decides which applications they will see – and when. (Those going first get the most money. By the end of hearings, little or nothing is left.) She decides which programs on each application will be funded, and recommends how much each should get. At the supposed "hearing," Stephens said, panelists "just raise their hands."

And, he points out, if for some reason the panel should oppose Silman's recommendations, she can still override them at the committee or full Council meeting where final decisions are made.

Andrew Gill, Executive Director of the New Muse Community Museum in Brooklyn, named a different villain at NYSCA: Executive Director Robert Mayer. He distributed copies of a letter from Mayer.

Refusing to reconsider denial of additional funds, the letter cited "a superficial level of instruction" at New Muse and "lack of evidence" of "interpretive programs . . . lectures, specialized tours, schedules of school groups, attendance figures per event" to signal "impact" on the community. The letter said "lack of faith" in New Muse was "entirely justified by audit reports and the freely expressed opinions of visual arts professionals that are members of the panel and/or the black arts community . . . The request was poorly articulated, the track record was minimal."

Gill called these "slanderous allegations without substance. . . . An example of the methods used to keep Third World artistic organizations subjugated." But now that minorities represent "the margin of victory in the Democratic party," he vowed to "make the Council an issue in the next election . . . to tear them limb from limb." Unless they "give us a sign," Gill said. "A very clear sign would be to tell us that Bob Mayer is fired."

Senator Conklin noted at this point that New Muse had gotten $196,000 in government funds last year, $93,000 of it from the New York State Council. "We're going to get

plenty of money," Gill told him, "but if they think we're going to let this insult to our people pass, they're crazy. I'll be after them when we have five million dollars."

"The utter lack of comprehension" at NYSCA has made arts funding the "most inequitable" in the state and "steadily getting worse." That was from Robert Shuster, director of the Downtown Ballet Company. If his group, with a prominent board of directors including noted Hispanics, a program rated "extraordinary," a choreographer praised by experts, and a "school that is a focal point in our community," can't get NYSCA funding, Shuster said, it is truly impossible for others. Moreover, the Council should "represent all the people, not just the famous and established."

Aside from these condemnations of NYSCA and "minority" representation, speaker after speaker revealed the partisan's love for an art form, a community, or a heritage. The City Island Cultural Center and Nautical Museum, in "a grand old lady of a schoolhouse," was described feelingly by Virginia Gallagher as "something within the Bronx so wonderful it *has* to be preserved." To date, the center has not had public money, but Gallagher said she would appreciate learning how to apply. The five-month-old International Jazz Federation is also "without any kind of government funds." Director Frank Weston says it will put on its first jazz festival this summer.

Rick Hill and fellow Native Americans came to New York, "because we thought this was a place for art things to happen . . . but the major museums had a stereotype of the kind of art they wanted to show. They thought we belonged in Santa Fe or Albuquerque." The group went back to Niagara Falls, "got major funding – $6 million this year," and built its own center. The Native American Center for the Living Arts is scheduled to open in June, 1979. "We believe the world is created on the turtle's back, so we designed a building in the shape of the turtle . . . Eventually, you'll come knocking at our door to find out how to keep North America alive. And we'll be there waiting for you."

What is now called "Special Projects" used to be "Ghetto Arts" ("ethnics" have been added although funds remain the same) and is, according to Emery Taylor, who was interviewed later by telephone, the most "dictatorial" of NYSCA programs. "What *we* want is unimportant. They say, 'We'd rather you do so and so.' Panel selection is done privately, without announcing names under consideration or soliciting outside suggestions."

Taylor says some of the Harlem Arts Council's problems with NYSCA are probably because "we don't publicize ourselves . . . and we don't butter them up." Most of the other 78 local arts councils in the state have a newsletter. "They talk more about middle arts management than about the arts, but [NYSCA staff] like to see their names in print. They tell us, 'You're not disseminating information.' That means we're not talking about them!"

What about New Muse? "The State Council is very lenient with people it likes," Taylor said. "If you don't toe the line

they rip into you. New Muse is very commendable as a community organization. There's a lot of good teaching going on."

— Judy Seigel

Women Artists News, Summer 1978 [Vol. 3, No. 4]

*This has changed, perhaps even reversed in the interim; "ethnic" topics may be off-limits, or taboo to non-"ethnics."

'78 / #96

Serious Talk About What's Funny

"Critic Donald Kuspit on 'Comic Modern'"

AIR Monday Night Program, September 25, 1978

At A.I.R.'s first Monday night program of the season, Donald Kuspit, critic and professor of art history at the State University at Stony Brook, read an essay on the theme "Comic Modern" to a small audience.

The essay, delivered with lightning speed, is to be published shortly in a new Boston cultural journal. Kuspit called it a "mind piece," an "antidote" to formalist art criticism, which "fetishizes the art object" and takes art too seriously. Instead, he said, he was offering observations on the development of humor in modern art. Stylistic analysis, the essence of formalism, is of limited interest to Kuspit. By finding humor in the *content* as well as the form of art, he shows that a whole range of disparate styles, from Cubism to Pop, can partake of the same comic modes.

But this was not a humorous paper. Reading in deadly earnest, Kuspit quoted at length from such venerable 20th-century critics as Adorno, Eliot, Huizinga, Freud and Bergson, and buttressed every point with a quote. The paper had, ultimately, the same pedantic tone as much other criticism.

Still, Kuspit had a lot of interesting ideas. He said that the formal structure of comedy consists of repetition, ambivalence, excess, eccentricity, incongruity, discontinuity, chance, exaggeration, superiority, surprise, and economy. These categories, taken mainly from Bergson and Freud, apply to both form and subject. He found comic themes threading through Cubism, Dada, Surrealism, Pop, Minimalism and some art of the '70s. Comedy, he said, has been a vitalizing element in modern art and, at times, a revolutionary force.

Prior to World War II, humor went hand-in-hand with the ubiquitous image of the machine in art, intended to subvert the mechanization and dehumanization of our world in subtle and ironic ways. Kuspit considered Duchamp, Ernst, and Leger (Klee, not mentioned, was implied) and their por-

trayals of "robot-man" as buffoon, fostering a tension between the mechanical appearance of art and its mocking intention. He discussed particularly the comic ambivalences of Cubism, its repetition, surprise, and wit; Cubist paintings, he said, are games in which the viewer is called on "to guess the gestalt."

Getting to recent art, Kuspit became less clear about what is comic. Eccentricity, chance, and repetition are funny only in certain contexts. Kuspit found humor in presumably serious art. He said that the repetition (seriality) in Minimalism is funny; Conceptualism is funny; attitude, pretense, or failed intentions are funny. Walking on a sculpture by Carl Andre is funny. Vito Acconci is funny. Paul Klee is funny because he claimed to be poor. Carl Andre is funny because he wears overalls and calls himself a Marxist. In other words, what Kuspit doesn't like is funny. (He had little sympathy for contemporary art in general, saying that artists now "are claiming more and offering less.")

There was some response from the audience. Rudolf Baranik questioned certain vague and contradictory comments about Minimalism. May Stevens asked how to differentiate between the comic which is immanent in an artwork and that which results from so-called "failed intention." Kuspit, very articulate, answered each question artfully, but there was a feeling in the audience that this was sophistry, or an elaborate rationale in the service of personal taste (taste being the *sine qua non* of art criticism anyway).

And Kuspit would probably agree. The audience warmed up to him toward the end of the evening, during the few light moments when everyone, including Kuspit himself, sensed the absurdity of such serious talk about humor. Some of his best points were in response to questions. He said that contemporary art, with certain notable exceptions, is abandoning humor and returning to ritual and Dionysian involvement with nature. This remark alone could have sustained an evening's discussion.

— Lenore Malen

Women Artists News, December 1978 [Vol. 4, No. 6]

'78 / #97

Queen-For-A-Day Syndrome

"Third World Women Artists"

Moderator: **Lula Mae Blocton**; Panelists: **Camille Billops, Selena Whitefeather, Vivian Browne, Howardena Pindell, Faith Ringgold, Tomei Arai**

Soho 20 Gallery, NYC; October 13, 1978

As artists, non-white women have had not only to defy expectations in role patterns, but to overcome the stunted creativity of colonized peoples whose indigenous culture has been disparaged and denied for 500 years. While white, Anglo-European women have had some access to art training and advancement (through family relationships: fathers, brothers), and some expansion of opportunity in a highly technological society, non-white women have had to confront residual "traditional" roles.

These and similar issues were discussed in the talk, "Third World Women Artists," held in conjunction with an invitational exhibit by eight Third World women: Camille Billops, Lula Mae Blocton, Evelyn Lopez de Guzman, Yoko Nii, Howardena Pindell, Faith Ringgold, Selena Whitefeather and Zarina.

Moderator Lula Mae Blocton pointed out that women from different cultural backgrounds are struggling to find the commonality of their experience, broaching the question, "What is 'Third World?'"

Tomei Arai began the session by describing her work with City Arts. She had gone there as a disillusioned artist looking for a way to make art relevant to her anti-war sympathies, her feminism, and her concern with lower-class communities throughout the city. She showed slides of mural projects of the last four years. Her approach included a demystification of the art process and solicitation of community members' perceptions about themselves and their world, which were then incorporated into the murals. She noted, incidentally, that nearly 50% of mural artists in the nation are women.

The second speaker, Howardena Pindell, began by showing slides of her art as it has evolved over the last eight years. The audience was fascinated by the presentation, particularly with technical aspects of the work. Then Pindell chronicled 11 years in, out of, and around the art world: finding a studio, a job, a gallery. She characterized the art world as an extended family which excludes artists who are not members. Her witty account of the politics and polemics of a black woman facing chauvinism and the double standard included a description of the "Queen for a Day" syndrome: Interest in black artists' work waxes and wanes according to the climate of the time and out of political – rarely, if ever, aesthetic – considerations.

Faith Ringgold declared at the outset that she would not dwell on her problems because "people don't sympathize with black women." For her the key issue was survival as an artist. If that could not be accomplished through conventional avenues, then alternatives would have to be found. She hired an agent to book the lecture/performances she organized with her soft sculptures, finding her own audience, albeit largely outside New York City. The tactic allowed her to continue doing art and at the same time to support herself. The itinerant activity required a more "portable and personable" art form than painting. Ringgold described her transition from painting to soft sculpture, recalling family resistance when she retreated alone to her studio to paint. To preserve her home life, she turned to a medium that was not only portable, but could be worked on sporadically in a social situation. This illuminated just one of the dilemmas faced by non-white women, whose group values may, as in this instance, militate against individualistic (i.e., artistic) expression, particularly by women.

Vivian Browne faced a similar reproach from family and friends who could not understand why her art demanded so much time. She reminisced about the days when she and Ringgold were in the New York City school system, frustrated at being relegated to administration, denied an opportunity for creativity. Browne said she is now "coming out" after three years of administrative responsibilities, although the assignments that interfered with her art did initiate her into the workings of the power structure.

For Selena Whitefeather, initiation into the frustrations of hassling with the power structure came through involvement with the Feminist Art Institute, as she and co-workers struggled to negotiate a site. Whitefeather mentioned her work with video and drawing and, for the last eight years, a preoccupation with plants, an interest first sparked by her grandfather. As a young woman she was, typically, not interested, but she rediscovered the enthusiasm as an adult.

The nuances of interaction with men and male-dominated institutions – from schools to galleries and museums – were also discussed. The consensus was that black women had not benefited as much from the black movement as white women had from the women's movement. Indeed, the speakers seemed more conscious of their identities as nonwhites than of their political situation as women. For them, individual encounters with the feminist movement had been keenly disappointing. Most of them had found white feminists incapable of comprehending the peculiar plight of non-white women – either because they were partners to the oppression or because they were too preoccupied with their own immediate priorities to deal meaningfully with those of others.

Third World women in this country exist on the lowest economic level; that condition has been reinforced by a deliberate stereotyping of each group. Even when individual women manage to enter a higher economic class, stereotypes persist and affect social interaction.

Selena Whitefeather described a case in point. She has been embroiled in a conflict over basic policy with white members of the Feminist Art Institute. The planned fee structure and time schedule of the Institute's workshop would place these courses beyond the reach of poor "minority" women financially and practically – a lack of empathy at the most basic level.

It is always up to the last speaker to suggest alternatives, and Camille Billops rose to the occasion. She enumerated her activities as sculptor, ceramist, teacher, author, and archivist and reiterated Ringgold's theme of self-help and determination for minority women. To illustrate, she noted the Hatch-Billops Collection, born out of her realization that only blacks could take responsibility for documentation of their presence in the country's cultural life. She warned against the wasteful preoccupation with the white male power structure and proposed that women infiltrate the establishment and exploit it to their advantage. (She also warned that power, once attained, entails loss of the idealistic innocence that fires revolutions.) Billops envisioned a new society, with information flowing freely, without distinctions or restrictions, to all members, a healthy society based on human references.

The evening held surprisingly little discussion of the political role of the art. Only Tomei Arai dealt with this, although Faith Ringgold asserted the political purpose of her art, without elaborating. In view of the rhetorical marathons about art and politics in which black Americans have participated over the last decade, one may assume that such issues have been talked out and assimilated and now are taken for granted or bypassed. Unfortunately, Blocton's initial mandate for a definition of "Third World women" was not fulfilled. Zarina pointed out that black American women, inhabitants of the affluent technological society of the "First World," could not be considered part of the "Third World" confederation of underdeveloped countries. The dilemma is that, although black American women may have relatively greater access to material resources, they share the political reality of other non-white women.

But this divergence vividly illustrated how multiple levels of enfranchisement within the socioeconomic and political context of the American capitalist system obscure the actuality of power. As a white woman in the audience pointed out, the greatest problem facing disenfranchised groups in this country is that the oppressor is not clearly defined. Until we gain a clear perception of the situation, the condition of non-whites and women will not change.

– Lowery Sims

Women Artists News. December 1978 [Vol. 4, No. 6]

'78 / #98

Three Briefs from the Mid-America Conference

That our correspondent's choice of three events to cover at this Mid-America Conference all featured New Yorkers was clearly not due to New York Chauvinism – she was from Chicago.

"The Artist and the Marketplace"

A talk by **Gene Baro**

College Art Association, Detroit; October 25-26, 1978

A curator at the Brooklyn Museum, Gene Baro also writes for *Vogue*, but it was obvious that his chief concern is artists and their work. He urged artists to organize more, citing the Detroit Plaza Hotel, where the conference was held, as an example of their victimization. Commendable support for Michigan artists is shown in a large collection of their work throughout the hotel, but the artists had no hand in the installation; work is often shown incorrectly, badly lit, without attribution, etc.

In the marketplace, Baro said, collectors are confused by lack of a prevailing standard. Despite lots of activity in the print world, museum money is drying up – new work often comes from bequests. Some corporations bought art speculatively in the '60s, but now stockholders want dividends. "Corporations do buy a lot of art, but often at a discount."

Moreover, visual artists face stiff competition on several fronts. Photography, often cheaper, competes for the same market as painting. Museums are "in the business of selling print reproductions at good prices," which contracts the market rather than expanding it for live artists. Ditto for sales of slides, replicas, presentations. "People are not stimulated to buy art by reproductions."

As Baro points out, "A hardware tycoon can buy paintings and take a tax write-off. Artists can't. The art community must instruct government."

"Women's Perspectives in Performance Art": Video Performance following a panel

Speakers: **Diane Spodarek**, **Marcia Tucker**, others

Women's Caucus for Art, Detroit; October 25-26, 1978

I found the Video/Performance at the Detroit Institute of Arts difficult to cover: Two hours on a marble floor, packed like sardines, with my closest neighbor, male gender, smoking pot, made my eyes water and my mind foggy. However, the women's pieces were good. Working with electronics myself – electronic sculpture, laser, light, and sound – I appreciated some of the visual and audio work. Women seem in the past to have steered away from this field; it was good to see the many dimensions they're working in now.

This was the first major video and performance show at the Institute. Included in the two hours were some area artists as well. A wide variety of styles and materials; standing-room-only audience – a lively follow-up to the morning panel.

"Responsibility and Effects of Publications"
A talk by **Milton Esterow**, publisher of *ARTnews*

Esterow made the not-surprising observations that critics have just as much ego as artists, and "matters of taste can be disputed until the end of time." His other points included: Critics have to show partiality; it's necessary for richness of mind and emotion. It is no longer so important for an artist to show in New York: "Art is more decentralized." There are more gifted artists than ever before, but fewer critics to write about them, in part because newspapers fail to train critics. Esterow suggested a program for art critics similar to one in which the Ford Foundation provided fellowships in music criticism for University of Chicago writers.

– Doryce Maher

Women Artists News, January 1979 [Vol. 4, No. 7]

'78 / #99

The Aesthetical Is the Political

"What Constitutes a Work of Art? Or, How is Fine Art Different from Crafts?"

Moderator: **Janice Glander-Bandyk**, calligrapher, makes collages with words; Panelists: **Dolores Lombardi**, fabric artist; **Richard Rutner**, painter (calls himself Abstract Surrealist); **Richard Nicksic**, painter, makes impressions of objects; **Ann Loeb**, Museum of Contemporary Crafts; **Stanley Lindwasser**, sculptor

Artists Talk on Art, NYC; November 3, 1978

It was hard to believe that after ten years of the New Feminism and Feminist Art, no one at this panel on "How Is Fine Art Different from Crafts" mentioned feminism in any context. Speakers complained and complained about discrimination against crafts, which are considered "low," while "art" is "high," but no connection between these attitudes and any issue of feminism was made. Had no one seen *Heresies* 4, "Women's Traditional Arts/The Politics of Aesthetics"? Maybe some of the frustration and defensiveness I felt in the room was related to this complicated issue, but it never surfaced in explicit terms.

Each artist showed slides of his/her work; Ann Loeb showed slides from an all-woman craft show at the Bronx Museum.

Speakers made individual statements and then quickly opened discussion with the audience.

Dolores Lombardi: "We ask what end does art serve and we examine the process, the viewed manner." She quoted Plato on what art is, but her removed-from-context reading did not mention Plato's caution toward mimetic art, particularly painting.

Stanley Lindwasser: "All artists are craftsmen." (Already I was offended, particularly after so much talk about *words*. Many "crafts*men*" are women.) According to Lindwasser, crafts have to do with materials, and people judge work, whether art or craft, by its material. "If it's useless, that makes it art."

Richard Rutner referred to the Fairtree Gallery as a place that showed what to his eyes was art. (Are craft objects useless in his eyes when they become art in a gallery?) He said that skill or craft are more necessary to crafts than to art.

Janice Glander-Bandyk: "Crafts have an obligation to a particular form or function . . . to marketability . . . Art creates markets for itself." (Collective groans from the audience.)

Richard Nicksic: "Fine art's definition is constantly changing. Jackson Pollock in the second century BC would not have been considered an artist . . . Art reflects society." (These Time Travel games are amusing but meaningless – sort of, "What would James Joyce have been like on a talk show?") Nicksic talked of the transcendent quality of art, giving as example Rembrandt's *Mother and Child*. The work is "valuable as a statement," he said. "The idea of this love is still true today." (Didn't many artists make paintings about maternal love that are not valued today? Is the theme all that confers this so-called transcendent quality?)

Loeb: "Art changes its meaning in time – art/craft crosses over."

Loeb stressed that the slides she had shown were all of one-of-a-kind works (and she also used the term "craftsman"). She is annoyed that crafts and fine arts galleries are separate and that CAPS* does not recognize crafts. "In order for potters to apply they must call themselves sculptors."

Lindwasser said he had gotten an NEA grant, and someone shouted from the audience, "That makes him an artist." He talked about materials – he uses clothesline. (Clothesline, I recall, was once an exclusively "feminine" material. And speaking of materials, I remember hearing Chuck Close talk about the time when everyone in Soho was searching Canal Street for an unused-in-art material. Does this mean that if the material is new, the work is new, and new is "art"?)

During the evening, I thought of the following Fine Arts/Crafts Differences: structure/design; painting/hanging; clay sculpture/pots; aesthetic/functional; high/low; smart/dumb; good/bad; hard/soft; big/small; useless/useful; transcends time/of its time; sacred/profane; elite/common; male/female.

– Melissa Meyer

Women Artists News, February, 1979 [Vol. 4, No. 8]

*Creative Artists Public Service, former division of New York State Council on the Arts that gave grants to individual artists.

'78 / #100

No More "X Over Y Equals Fog"

"What Artists Want from Critics / What Critics Expect from Criticism and from Artists"

Moderator: **Irving Sandler**; Panelists: **Leon Golub, Philip Pearlstein, Jeff Perrone, Deborah Remington, Corinne Robins, Barbara Zucker**

Artists Talk on Art, NYC; November 17, 1978

What do artists want from critics? Barbara Zucker answered for us all: "I want them to be my fairy godmother, champion my career, say I'm a genius, and stand behind me unequivocally."

Although she and others went on to discuss the importance of dialog and the wonderful insights that artists might derive from criticism of their work, nothing rang as true as these opening remarks. Criticism may be literature, may even be "an art form," as Jeff Perrone insisted, but for artists, criticism is chiefly survival. Good reviews mean sales, jobs, grants, and more shows. Bad reviews or no reviews mean oblivion.

This was the conflict that ran through the entire evening, artists trying to build some safeguards into the practice of criticism, critics insisting on their right to self-expression.

Philip Pearlstein and Leon Golub were the most outspoken about the unequal power relationship between artists and critics. Pearlstein has been crusading on the subject for some time now, and opened the discussion by reading his guidelines for art criticism, published in *Art Journal*, Winter 77/78. An established artist, Pearlstein did not need to take such a controversial stand, and deserves the respect of all artists for doing so. (In a conversation after the panel, he noted that, although he didn't want to seem paranoid, his exhibition shortly after the article was published was the least written-about he'd had.)

Pearlstein's principal point is that an artist's career is vulnerable to a critic's power. Golub added that critics present ideas, but artists have no way of responding to or offsetting those ideas. Critics have access to the public; artists can only gain that access through pleasing critics, or curators and dealers. "The main problem the artist faces is how to get to the public," said Golub.

So, willy-nilly, the critic presents the artist to the public. Although most artists, on and off the panel, were of the opinion that critics with nothing good to say should just say nothing, Corinne Robins pointed out that this is not always possible. She differentiated between the short journalistic review, usually done on assignment, and the long critical article, which is more often the critic's choice. "What are we supposed to do when we have to write about a show we

don't like?" she asked. "Differentiate carefully between opinion and fact and present the facts as fairly as possible," said Pearlstein. The short review was disdained by all critics on the panel, but Pearlstein pointed out that it frequently is the only historical record of a show, particularly for a young artist.

How *does* the artist get to the critic? Don't call or send slides, said one and all. And don't expect us to come to your studio unless we already know and like your work. "Critics see lots of shows," said Sandler. "We hear about interesting things and then we go to see them." ("Critics see with their ears," mumbled a cynic near me.) Like love, these things are just supposed to happen. But as we women-who-are-artists and artists-who-are-women know, there's a lot of behind-the-scenes action to falling in love.

Was there anything the panel could agree on? Everyone was down on nasty writing, on dense impenetrable prose (Remington called this "x over y = fog") and everyone agreed on the necessity for a personal encounter with the work, rather than with photographs and press releases. But that was it. Critics discounted any feeling of power they might enjoy and claimed they were at the mercy of editors. Artists insisted they are at the mercy of critics. The artists wanted critics to listen to their ideas about their work. Jeff Perrone, who said he didn't know any artists, any art history, or what happened in the '50s, said, "There's no need to talk, or listen, or go to artists' studios." Unfortunately, artists cannot so easily discount the work and ideas of critics.

Some years ago, June Wayne made a succinct analysis of power relationships in the art world. "The artist is a woman," she said, and detailed the ways in which artists, like women, must act through others, be devious and use flattery and other "feminine" wiles to survive. Although no such brilliant feminist analysis emerged from this panel, it was a good solid attempt to deal with the issues on at least the first of the three questions of the title, "What Artists Want from Critics." The other two questions got lost in the shuffle and were never really answered.

– Pat Mainardi

Women Artists News, January 1979 [Vol. 4, No. 7]

The following letter arrived in response to the report above:

Letter to the Editor

The positions I stated on "What Artists Want/What Critics Expect" are not even remotely recognizable in Patricia Mainardi's writeup.

Her review of the panel appears to make me a supporter of Philip Pearlstein's "crusading" on the subject of art criticism. I do not subscribe to his position and made comments in precise opposition to it . . . I tried to point out that the making of art and the criticism of art face (obviously) similar problems of definition and context in relation to how information today (which includes the look of art) is picked out and distributed. Mainardi missed (or ignored) all that.

Pearlstein made a big point of accusing critics of blanketing out realist painting. This [is] far off the mark and an incorrect perception, particularly in his case . . .

The crux or irony of the situation is this: Mainardi quotes Pearlstein as asking critics to "Differentiate carefully between opinion and fact and present the facts as fairly as possible." But she is as irresponsible in reporting on the panel as the critics (unnamed) she and Pearlstein find wanting.

– **Leon Golub**, *Manhattan*

Women Artists News, February 1979 [Vol. 4, No. 8]

'78 / #101

Readings and Ms-Readings

One may perhaps be forgiven for answering the title question, "What are the Issues Affecting Communication Between Artists and Writers on Art?" with "Title writing perhaps?" But more practical problems were reported at the time, as follows:

The topic, widely advertised as "What Are the Issues that Affect Communication Between Artists and Writers on Art?," had been changed unannounced by chapter president Ora Lerman to "Examples of Misreadings of Art." Yet another item was that the "contribution" had been raised without notice, from $1 on the flyer to $2 at the door. . . . Still, for some, the unkindest cut was that speakers' readings of the misreadings tended to address only *male* artists.

"What Are the Issues Affecting Communication Between Artists and Writers on Art?" Changed to "Examples of Misreadings of Art"

Moderator: **Ora Lerman**; Panelists: **Isabel Bishop, Alessandra Comini, Carol Duncan, Corinne Robins, Harriet Schorr, Jane Wilson**

NY Chapter, Women's Caucus for Art, Metropolitan Museum; November 18, 1978

In the calm sanctity of the Junior Museum at the Metropolitan, moderator Ora Lerman began: "In order to validate the symbiotic relationship between those of us who make art and those who validate art . . . we must establish the issues that connect us."

As the first of these "issues," the panel (split down the middle between artists and writers) had been assigned by Lerman to seek out works of art that had been "misread." Some very scholarly stuff followed, delivered in a series of prepared papers. As you might guess from the format, this made for a long evening, alternately fascinating and dull.

Harriet Schorr showed how slides can lie by altering the scale of works. She compared a Piero Della Francesca to a Barnett Newman – both the same size in projection, but in reality the Piero only inches high, the Newman nine feet high.

A large Franz Kline appeared deceptively similar to a fragment of Chinese calligraphy, but the calligraphy was only 12 inches wide. "Slide presentation calls attention away from context, intention and meaning," Schorr said.

Isabel Bishop showed slides from a wide span of art history to illustrate how critics and historians have missed similarities of movement or "continuity," regardless of subject matter, within the work of such diverse painters as Delacroix and Braque.

Corinne Robins pointed out that Monet's waterlilies had been misread as "devoid of space." But those critics and historians, Robins said, simply saw with the eyes of their era. We value the Impressionists today, "because our expectations have changed in 100 years. *Because* this new art was optical and perceptual, it took a long time to see."

Addressing today's pluralism, Robins said critics have trouble when there is no single predominating movement. "Women's art came out of a political movement and did not therefore have a set of rules. Critics don't know how to deal with no rules." To prove her point, she showed slides of a dozen diverse women artists, defying the audience to find a unifying thread. "One of the strengths of women's art today is that it is very much a matter of individual vision."

Alessandra Comini, combining a razzledazzle delivery with sound scholarship, used confusion about titles for her discourse on misreadings. The title of Larry Rivers' *America's Number 1 Problem* (the length of a man's penis) leaves no doubt of the artist's intent, she said. But in two of Gustav Klimt's paintings the titles were ignored: In two versions of *Judith and Holofernes* a sexy, underclothed, and rather lascivious Judith snuggles the severed head of her would-be lover. Contemporary critics refused to accept these as Judith, although the titles were clearly inscribed on the frame, insisting that the lady was Salome, who, however odd her taste in souvenirs, was not a murderer. At that time, no lustful vengeance was accepted from womanhood; Judith was made Salome, despite the artist's protests. Contrarily, Klimt's *The Kiss* was accepted as just that, the kiss of a handsome couple. Critics ignored the patterning of sexual symbolism in the garments, although they dominate the painting.

Jane Wilson used the entire career of an artist – Bonnard – as an example of misreading. For the second time in an evening dominated by slide presentations, the use of slides to illustrate art was attacked. Wilson referred to the "jellybean school" of photography (pumped-up color), particularly damaging to Bonnard.

"He is hard to write about because he did not take a stand against things that developed in the course of art history, but was rather a user and absorber of art history that was channeled through him."

Bonnard is misread also through the plethora of superficial imitations in Madison Avenue art shops, Wilson said, showing that imitation is not always flattering.

Coming closest to what the discussion of the evening should have been, she said that Bonnard takes us into a realm of intimacy that is "claustrophobic [and] very difficult to discuss, an area where there is very little vocabulary . . . like Alice

Neel's portraits, where you confront a psyche. Is there indeed a language for this kind of art?"

What Lerman described as a "mop-up" operation was the most controversial speech of the evening – Carol Duncan's apologia for today's criticism. "Artists make works but they do not make art in a social sense," Duncan said. "Criticism is the alchemy, the invisible power that converts potential art into the real thing . . . Artists may or may not have insight about their own work, but in any case cannot validate it."

Duncan called "high art," the tower of which is the Museum, a "culture of negation" that "needs mass culture in order to deny it." She suggested that artists who *wish* to reach a larger audience should question whether their art could indeed be appreciated by a larger audience.

Duncan doesn't see artists as "poor victims, mythic folk heroes," while critics are "all-powerful cops or parasites." The present system of criticism (including dealers and curators) channels art into a thin trickle, she said, which "works pretty well." Surprisingly, no one groaned at that, or when she said flatly there is no conspiracy in the art world. (I assume immense fatigue had overtaken the audience.)

One of Duncan's points was that any kind of art can be shown in a museum if it first goes through the process of "critical validation." On leaving the Metropolitan I noticed an Arman wall piece consisting of a large glass frame filled with discarded Metropolitan Museum buttons. It happens that the donor, dealer-collector Andrew Crispo, has his very own tax-shelter syndicate.* (But of course I don't believe in a conspiracy, either.)

Finally, a word about the structure of panels: I have suggested before in these pages that good panel discussions have a touch of theatre. This one didn't. Seven people reading prepared statements for nearly two hours with five minutes of group discussion cannot hold the attention of even a dedicated audience. Especially in an area as loaded as the conflict between artists and art writers, more participation would be fitting. However worthy the material of this seminar, so thick was the erudition and scholarship of the papers, that until I replayed them on tape I missed the main point; I had misread the intent of the panel.

– **Donna Marxer**

Women Artists News, January 1979 [Vol. 4, No. 7]

*Dealer Crispo subsequently went to jail for tax evasion.

'78 / #102

Selfish, Elitist Monsters Vs. Custodians

"Art Education: Is It Either?"

Moderator: **Yale Epstein**, Brooklyn College; Panelists: **Linda Bastian**, School of Visual Arts; **Rosemarie Beck**, Queens College; **Andrew Forge**, Yale School of Art; **George Hershkowitz**, Supervisor of Art, NYC Board of Education; **Mercedes Matter**, New York Studio School; **George McNeil**, Pratt Institute and New York Studio School

Artists Talk on Art, NYC; December 15, 1978

One potential panelist, a painter of considerable reputation and a very effective teacher in a major art school in the city, told me that he refused to participate because to talk about art education was not to talk about art and he would be on the panel only to talk about art. Someone else insisted that the inclusion of this topic in the Artists Talk on Art series was a kind of misrepresentation of the intent of the series. – *from Yale Epstein's opening remarks*

Moderator Yale Epstein sat in the middle. The artist-educators (McNeil, Beck, Matter) sat on his left. The art educators (Bastian, Hershkowitz) sat on his right. Andrew Forge, attempting a conciliatory position, sat with the art educators. Like a marriage counselor, Epstein tried to get the estranged parties to speak to each other. Verbal darts flew across the table. The reconciliation was a failure, the evening was a success. The clear statement of charges and counter-charges revealed the contradictions within the situation.

Art education for whom? Although Epstein was eloquent in asserting that artists have a stake in an enlightened public, the artists' primary concern was getting their own work done. This they were willing to interrupt grudgingly – only for the education of other professional artists. "Few artists are involved in teaching voluntarily. It is forced on them because they can't think of anything else to do to make a living," said Andrew Forge.

The art educators considered this elitist. George McNeil described the contradictions within art education: "There is art as personality development, principally concerned with process." (George Hershkowitz put this succinctly as "Art helps children grow.") Then, continued McNeil, "There is professional education, which is overwhelmingly concerned with the product. The artist can go to hell, if in the process he does something worthwhile." The only conclusion to be drawn was that a little art is a civilizing experience, but in large doses it becomes what Rosemarie Beck ironically called "a selfish elitist possessed monster thing."

Andrew Forge traced the genesis of the problem: "From the early 1900s people began looking at children's art and began to see the possibility of encouraging children to make art as a way of uncovering their innate creativity. 'Creativity' and 'self-expression' became catch-words – students were allowed

to be creative in art, but God help them if they were creative anywhere else. But what right does art have to claim all of human creativity? Art is a specialized form of creativity."

To illustrate his point, he told the story of the man who, asked if he could play the violin, replied, "I don't know; I've never tried." This is funny because everyone acknowledges that music requires a high degree of knowledge and skill; visual art is assumed to be mostly inspiration and "creativity." Forge's main point all evening was that art education consists of both the imparting of information and the imparting of attitudes and values.

Art education where? Rosemarie Beck defined a hierarchy that begins with "aloneness" and descends through "apprenticeship, atelier, professional art school, liberal arts college," the last of which she characterized as "a series of interruptions to the artist's aloneness." Mercedes Matter described the New York Studio School as a place "for people who already know what they want to do and do not want to spend four years not doing it." George McNeil praised "the atelier system of art from nine on Monday to five on Friday with the school open on Saturdays and Sundays for the maniacs."

These were the artist-educators. George Hershkowitz spoke up for the art educators: "I'm interested in appetite at the point where it can first be noted. It should be fostered so it can grow. I like to ensure that when students get to the university their appetites can flourish and grow."

Art education by whom? According to Rosemarie Beck, the difference between artists and educators is that for an artist "prejudice is a joy." Matter also came out for prejudice: "Even the most prejudiced artists can be wonderful teachers. Even if they have no tolerance outside their own point of view and are dictatorial and imposing. Students can find themselves by pushing against it." Linda Bastian disagreed: "It is reprehensible when a teacher sets up a problem that can only be answered by making something that looks like the teacher's own work."

Forge described two kinds of strong teachers: "One presents the students with an objective problem and then sits on them until they come through with their own solutions. The other never allows any commitment to the objectivity of the problem and renders students disciples of the most craven kind." His conclusion: "A good strong teacher is impassioned with something worth knowing."

On the practical side, Hershkowitz pointed out that when artists say "art cannot be taught" they are playing into the prejudices of the general public, which also believes that art education is mainly custodial and, as a result, when budgets are tight, art education is the first area to be eliminated.

Among the many issues that were considered in a short time, the differences between art teachers and artist-teachers manifested themselves quickly and consistently. Although one might hope for agreement on some common ground, in such a brief evening it was barely possible to survey the terrain.

– Pat Mainardi

Women Artists News, February 1979 [Vol. 4. No. 8]

"The Hazards of Art Education" *(Thoughts After a Panel)*

A friend of mine in the audience at the "Art Education: Is It Either?" panel said it was a pleasure to listen to such articulate people after spending so much time among art educators. My own, admittedly cranky, response was, dammit, how in this day and year can they do 45 minutes non-stop about the artist and teacher as *he*?! (Asking that question from the floor, I was received by both panel and audience like The Bad Fairy At The Christening.)

As for Art Education, it's probably safe to say that once an art mode has become so thoroughly formulated as to be transmittable through the devices of academe, it is more or less finished as art currency. Or, as Harold Rosenberg once put it, by the time there's a bandwagon, it's too late to jump on it. Certainly what is going to be taught in art school in the year 1979 won't in *itself* be much use to the next generation, although it brings the salary, perquisites, and satisfactions of teaching to *this* generation. But the benefit of art school, its real function for the future artist, is not so much educational as social.

Art Education is the initiation into a looseknit, far-flung mystical coterie, or family, of artists. Even those who reject the milieu tend to make it the screen against which they play their future development. No matter how private the work, how maverick or isolated the artist, a life devoted to "high" art has little meaning apart from the world of art. (Art has lost its myriad former functions, and has no other independent value like, say, a truckload of apples; the artist has only an oeuvre that, one way or another, requires the validation, context, marketplace, and communication system of the art world.)

Beyond this initiation or indoctrination into the fellowship – or enemyship – of art, Art Education is just one boobytrap after another. Here's an item from my own education: I'd entered Cooper Union with some advanced standing and so was put into second-year two-dimensional design instead of first. In this class Miss Henrietta Schutz taught a flat, decorative technique (sort of midway between Picasso and "The Wiz"), that we called "Cooper Style." It looked adorable and I longed to do it, but, try as I might, I couldn't get the hang of it. On the verge of dropping out of school in despair, I went instead to Miss Schutz's *first*-year design class. There, at about the third session, it clicked. So *that's* how you do it, I said, and spent the next two years happily doing Cooper Style musical instruments, boats, churches, people, trains. Then I finished school and after a while decided to paint seriously. It took me ten years to get Cooper Style out of my hand, and on a damp day I can *still* feel it.

After telling this story I usually present my own prescription for Art Education: only art history (museums) and art techniques (drawing, preservation, chemistry, and machines, e.g., camera, video, computer, copier, welder, power tools). At Cooper we had one required course in Painting Techniques, which we scorned in that heyday of Abstract Expressionism. We thought artists were too exalted to study the properties of binders. (Later I pored in vain over those few sketchy notes.)

There is yet another hazard, in addition to the dangers of learning art, for the student being Art Educated: He or she will be held in thrall during the time when his or her less artistic cohorts are learning such marketable skills as titration of fluids, accounting, library science, or syntax. The art student, after four years at the shrine of creativity, may well emerge unemployable in any manner except in the teaching of art, a captive – willing or unwilling – for life.

Postscript: As I was completing these thoughts, Pat Mainardi arrived to deliver her manuscript, all excited because she was off to the country that night for some weeks of painting in the snow. (It was 18 degrees Fahrenheit.) It occurred to me then that all our explanations and arguments are irrelevant, that we should only ask what combination of art and personality will give that joy and dedication, and whether Art Education makes it more or less likely.

– Judy Seigel

Women Artists News, February 1979 [Vol. 4, No. 8]

'78 / #103

Unimaginable Destructurations

"The Question of Post-Modernism"

Speakers: **Ihab Hassan, David Antin, Julia Kristeva,** others

Modern Language Association, NYC; December 1978

Unable to be in more than one place at a time, I opted for the forum, "The Question of Post-Modernism," an event held in two contiguous ballrooms filled to capacity, with luminaries from this country and abroad participating.

In the art world, post-modernism is a relatively familiar concept: it refers to an art scene that is pluralistic, eclectic, and interdisciplinary; to art that eschews the immodest statement or the overstated ambition. The fare offered at P.S. 1 in Queens qualifies as post-modernist. Although attempts have been made to show together works of art that share this tendency, everyone is aware of the fragmentation and incompleteness of post-modernist conditions. There is an atmosphere of wait-and-see in the air of post-modernism, yet the art crowd continues to go its rounds, agreeing on the talent evinced in individual works, disagreeing on what they mean.

For the professorial elite gathered at the Americana and Hilton to discuss modern languages and literatures, the question of post-modernism was terribly complicated. It produced hours of text, some of it beautiful, but, perhaps because of the form (post-modernist?) of the papers, the content, read by authors or translators, came through incompletely, by spurts.

Ihab Hassan, the authority on post-modernism in literature, professor at the University of Wisconsin, and author of *Para-Criticism,* introduced the subject. The essential difficulty with post-modernism, he said, is due to its fuzzy distinction from modernism, semantically (modernism and post-modernism are not contradictory terms), historically (there is no set date when the one died and the other was born), conceptually (each is difficult to define). Yet, to Hassan, this consciousness of lack of clear demarcation is itself post-modernist, as is the realization that in one epoch there is modernist and post–modernist writing going on at the same time, or that Joyce was both a modernist and post-modernist writer by turns.

Hassan then ventured a definition: "As an artistic and philosophic, erotic and social phenomenon, post-modernism veers toward open, playful, optative, disjunctive, displaced, indeterminate forms, a discourse of fragments, an ideology of fracture, the will to unmaking, an invocation to silences, and yet it implies their very opposite!" It is, he added, "as if *Waiting for Godot* found an echo, an answer, in *Superman.*" Hassan suggested in conclusion that some mutation involving art and science, low and high culture, fracture and totalities, "male" and "female" principles, might possibly be on the way.

Each of the speakers following this broad discourse represented the view of a different country: David Antin for the U.S., Julia Kristeva for France, Christine Brooke-Rose from England, and Heiner Muller (through his translator – he was not allowed out of his country!) from East Germany. Because of space limitations, I review here the positions of only Antin and Kristeva. Very different in approach, and even opposite in their judgment of the part language plays in post-modernism, both were fundamentally humanistic in their warnings. Antin is a poet, art critic, and teacher (University of California at San Diego), married to performer Eleanor Antin; Julia Kristeva is a linguist and teacher married to French poet Philippe Sollers.

Antin, with a vaguely surreal, hairless, egglike head, massive in his red parka, regaled us with irony when he began, "One of the salient characteristics of post-modernism is its cheerful use of bad faith," bad faith to explain the Vietnam war, bad faith of the Nixon government during the Watergate hearings, "to the point that there was no way of knowing whether what was happening was what was happening, was declared or rumored to have happened, or simply was staged for the benefit of spectators." Bad faith led to a new image of reality, or rather "irreality," he said, and that was the beginning of post-modernism.

In an aside, Antin suggested that before Watergate, only poets knew how well language could lie. Connecting post-modernism and the ambiguities of Watergate, he could also have mentioned a recent ambiguity – the sale of reproductions as works of art.

Antin declared himself hostile to definitions of post-modernism based on the limitations of language, because "that was already a modernist preoccupation." As a "baby poet," he

dealt with "discovery and invention in language, with the limits of grammar and its mode of representation." What once made such expression "modernist" was a sense that poetic or "sensate discourse" was a "second-rate citizen," a "cognitive slum," merely a "thought-like thing" (said in irony, of course), compared to "rationalist discourse." Such discourse was assumed to tell things straight, the way they were, and grammatically at that. Or, in the background of what was called modernism stood a belief in the existence of something solid, be it called science, technology, or "the Academy."

What has changed and brought about post-modernism, according to Antin, is the background against which all art activity takes place. "Before, there was a necessity . . . for running around conventional language," or that's what he and others believed. This produced some fascinating works, including Minimal art and concrete and imagist poetry. Now all rationalist systems are acknowledged to be in shreds and that necessity has ended. (Indeed, it seems to me that now the context in which we live is understood to be as fraught with irrationality as modernist poetry itself. Moreover, the traditions against which modernism rebelled – giving modernism the polemical character Harold Rosenberg always read into it – have collapsed. Thus Rimbaud's famous admonition, "It is necessary to be absolutely modern," is now irrelevant.)

In conclusion Antin said, "The major issue of post-modernism is the shifting of background against which works . . . sometimes similar to modernist works and sometimes divergent, are produced side by side." Or, post-modernism is like modernism minus the "necessity to be modern."

Julia Kristeva, young, a refugee from Eastern Europe now living in Paris, was introduced as "one of the most brilliant minds at work today." She read her text in English and her accented diction did not facilitate understanding of the French view of post-modernism. Here is a try:

She began by asking, "In what way can anything be written in the 20th century?" In Kristeva's view, all disciplines dealing with "symbolic capabilities" – linguistics, psychoanalysis, anthropology, and even biological science – have "clearly demonstrated the determinant but fragile position of language within the human experience." Determinant, because all social phenomena are symbolic; fragile, because at times language no longer functions or makes sense ("It no longer inscribes itself in its own space within the sign, hence no longer inscribes itself at all, but rather cries out and supplicates"); and because, at times, language as a speaking vehicle stops communicating. "It reveals itself to being capable of unimaginable destructurations." (I suspect that Piaget is an important reference of this discourse.)

Despite the fragility of language, in writing, "a formidable attempt to extend the limits of the signifiable is going on." Post-modernism, Kristeva says, is that literature "written with the more or less conscious intention of expanding the signifiable and thus expanding human will." She calls this an "experience of limits" in deference to Georges Bataille's for-

mulation: limits of language as a communicative vehicle, limits of sociability, limits of the subjective and of sexual identity. ("How can I know who I truly am?") "Writing as an experience of limits is the most fascinating and bizarre rival of psychoanalysis in its liberation of primary narcissism."

Since the 18th century, society has evolved toward the current technocratic centralism in politics, while on the level of morality, "a gap has opened up, due not only to the flagrant lack of institutions (religious or otherwise), but to the lack of languages with which to speak of that possibility." Today in totalitarian societies, there is total uniformity of language, and language is controlled by the state; in liberal societies, there is singularity and proliferation of languages, but they are ignored by the state.

Literature used to have a dialog with the state, "to play the role of social counselor or critic" (think of Diderot, Balzac, and Zola). In the 20th century, the state is impermeable to all discourse save its own. (Let us not forget that this is the view of one raised behind the Iron Curtain.)

In what way can one write today and be heard? Kristeva's answer, based on such diverse examples as Celine, Mayakovsky, Pound, Artaud, Burroughs, John Cage, and Robert Wilson, is as follows: through more and more frequent use of "pre-symbolic" or "asymbolic" language, through screams, incantations, rhythms, and alliterations that "either stand up against meaning or shape it; through the emptying and circumventing of language, through the theatricalization of gesture; through sounds and through silence" (through the kind of body language, I might add, that a young and frustrated child uses in its relations with Mother). Kristeva said that women must also resort at times to "pre-symbolic" language in order to be heard.

But, she warns, with all this post-modernist speech of their own invention, with no audience but themselves, writers become asocial, "ideolects, proliferating uncontrollably," and risk becoming "sunken monuments, gigantic but invisible, within a society whose general tendency is, on the contrary, toward uniformity." Never before in history has exploration of limits of meaning been so "unprotected," that is, "without religious, mystical, or any other justification."

I was hesitant to describe these two messages as "humanist warnings," but on reflection find warnings in both: Antin warns us to be wary of bad faith; Kristeva warns us to be aware of the moral impact of the word.

– Michele Cone

Women Artists News, February 1979 [Vol. 4. No. 8]

1979

'79 / #104

Decoration Day in Soho

From Julia Kristeva's talk of "destructuration" at the Modern Language Association to artists' talk of decoration in Soho was just a month in time, but to the other side of the rainbow in sensibility. Both of course are "post-modern."

"Interior (and Exterior) Decoration"

Moderator: **Robert Jensen**; Panelists: **Valerie Jaudon, Ned Smyth, Robert Kushner, Joyce Kozloff, Scott Burton, Miriam Schapiro, Arlene Slavin**

Artists Talk on Art, NYC; January 26, 1979

> If there's anything I'm certain of at this moment, it's that ornament and decoration have become dead arts in the west. — Clement Greenberg, *Art International*, January 1975

That quotation, ripening in my files these four years, came to mind on the auspicious occasion of "Decoration Day" in Soho last month. Whether Greenberg meant primarily the kind of squiggles a factory might stamp onto, say, a refrigerator door as "decoration" or had the fine arts sector in mind is not clear. Either way, he should have read his Wölfflin: "The history of art is not secondarily, but absolutely primarily a history of decoration" [*Principles of Art History*, 1932].

Two recent panels about contemporary art that declares itself, first and foremost, *decoration*, suggest the movement's great energy at this moment. Here, for Greenberg and whoever else may have missed it, is a report on the first of them.

From the outset, there was an air of celebration — and old home week — in the gallery. When a man in the audience called out to Joyce Kozloff, "Louder we can't hear you !," everyone laughed, because they knew it was her husband, Max. Miriam Schapiro's husband, Paul Brach, also made some fine points from the sidelines, including the fact that in ancient Greece the artist who carved the capital of a column received exactly the same wage as the one who "sculpted" the figures in the pediment.

The program opened with slides: each panelist whipped through a set of wonders that ranged from the Piazza Italia in New Orleans, designed by Charles Moore, and New York's Dag Hammarskjold Plaza fantasy in concrete, "Five Arcades," by panelist Ned Smyth, to Miriam Schapiro's collages-of-kimono shown side by side with the antique kimonos that inspired them. (Schapiro noted later that artists have always used resources — "their studios are filled with reference materials" — but in the recent past have been skittish about owning up to them.) Scott Burton, an anomaly in this

context, earned his place with a concise review of aspects of the history of furniture as decoration and a place in my heart by calling the pink, light blue and yellow paint on his children's furniture "babied-out" versions of the primaries.

Discussion after the slides was desultory, picking up only mildly when one would-be Young Turk declared from the floor that decoration lacks "confrontation." (His own work, he allowed, is based on the sundial.) Joyce Kozloff ended this confrontation by sweetly but firmly explaining that the premise of these artists is decoration *for its own sake.* The absence of further confrontation may have been due to current general acceptance — even ascendance — of this work. In fact, pattern painting, a major form of the new decoration, has recently been declared by the popular press to be, not only "the rage of Europe," but "the most vital current style."

Among other non-confronters in the audience was a phalanx of *Heresies* women, including many from the Women's Traditional Arts issue on which both Schapiro and Kozloff had worked, a flock of panel regulars, and probably other decoration fans like myself — some of whom may also have been at the first panel on pattern painting moderated by Peter Frank at the Open Mind, February 7, 1975.[2] As far as I know, that was the first "public" appearance of the topic, up from underground. I note that the date was just one month after Greenberg's "certainty."

– Judy Seigel

Women Artists News, March 1979 [Vol 4, No. 9]

1. This is the first of two back-to-back ATOA panels on themes of decoration. The second, February 2, 1979, was "Source of Patterning and Decoration," with moderator Carrie Rickey, panelists Brad Davis, Richard Kalina, Robin Lehrer, Tony Robbin and Barbara Zucker.

2. The pioneer 1975 panel was "The Pattern in Painting," with moderator Frank, panelists Martin Bressler, Rosalind Hodgkins, Valerie Jaudon, Tony Robbin, Sandford Wormfeld and Mario Yrissary.

See also '76/#37, "Is Painting One of the Decorative Arts?"

'79 / #105

Sublime Leftovers

The topic of Folk Art appears on a College Art panel, apparently for the first time. Original research provides a scholarly framework for talk that also pieces in craft, feminism, history, decoration, and – "femmage."

"Folk Art and Neo-Folk Art"

Moderator: **Judith Stein**, University of Pennsylvania; Panelists: **Betty MacDowell**, Michigan State University; **Rachel Maines**, Center for the History of American Needlework, Pittsburgh; **Pat Ferraro**, San Francisco State University; **Miriam Schapiro**, Amherst College; **Melissa Meyer**, NYC

Women's Caucus for Art, College Art Conference, Washington, DC; January 30, 1979

"Folk Art and Neo-Folk Art" was both exhilarating and illuminating. Panelists touched on important points of original research, while much new territory was explored. However, a cloud of doubt may still linger as to where and when folk art and naiveté give way to professionalism. Betty MacDowell and Rachel Maines asserted that *training* is the key, but their fellow panelists freely interspersed untrained artists' work without distinctions. One was left to make one's own deductions.

In her introduction, Judith Stein said Folk Art was "discovered" in the 1920s, but that this panel was the first on the topic for either College Art or the Women's Caucus. She suggested this might be because art historians have trouble dealing with Folk Art as *art*. Now feminism makes us aware that women have long studied, collected, and documented (primarily for themselves and their families) artifacts and objects of folk art by other women. Then again, much of this art is made with relatively cheap materials and/or discards, so perhaps art historians really had difficulty understanding and appraising it. Now there appears to be a growing revolution in taste allowing us to begin, at last, to evaluate and document the work.

MacDowell, whose new book is *Artists and Aprons*, pointed out that 18th and 19th-century women's folk art was shaped by American culture. Rigid roles in marriage and parenthood meant that women's lives were filled with domestic responsibility. Their education stressed needlework, penmanship and watercolor, along with the "social graces." Entering the "fine" arts was discouraged for women, who were not allowed to study the live male nude, so they channeled their creativity into the domestic scene. Portraiture was popular, because familiar and available faces of family and friends could be done quickly in pastels or watercolors, between chores. Women also took the scissors of domesticity to cut paper profiles. MacDowell said repeatedly that the art had to fit into accepted patterns of a woman's life; it rarely even approached a full-time activity.

By the mid-1800s, with the advent of the camera, demand for portraits by self-taught artists lessened. People preferred the likeness of photographs for recording friends and family, and the naive artist began to disappear.

Rachel Maines, author of *The Designer and Artisan: The Ancient Contract*, traced these professional relationships. Little has been written about the division of labor between the creator of an idea and the maker-constructor, a division that in Europe and America may be made according to class and sex, with the designer reigning over the technician. Mechanization of textile-making reduced the artisan's role to mere machine tender, and began the producer-consumer division.

In early times, embroiderers often had a higher status. In wealthy households, the designer was part of the staff and devised patterns for linens, curtains, rugs, and furniture, besides intricate details of clothing. Folk embroidery, however, borrowed and combined motifs freely from many sources. Samplers, the work of students learning stitchery, held even more incongruities.

The earliest commercial needlepoint used handpainted charts. Later they were printed, when thread and yarn manufacturers hired women to draft patterns derived from popular magazines and pamphlets. After 1870, charts were available for beadwork, filet lace, crochet and counted cross-stitch. Various forms of these are still available in the hobby or home craft. market, but needleworkers and textile artisans often want concept and design wed together.

Pat Ferrero, author of *Quilts in Our Lives*, traced the life transitions of women folk artists through their quilts. Baby quilts could be utilitarian or elaborate or both. Quilting skills were passed from generation to generation, women teaching young children. The engagement party was often the occasion for quilting, while the "masterpiece" was usually the wedding quilt – carefully conceived and painstakingly rendered during the engagement. The widow's quilt drew on a rich store of memories. Ferrero showed a quilt made from a Victorian mourning coat which had been opened up to become ground for both quilting and embroidery. A coffin in the center was surrounded by vignettes of the quilter's life.

Several of Ferrero's slides showed Grace Earl, a transplanted Chicagoan now working in San Francisco, with an incredible array of patterned fabrics which she pieces into intricate coverlets of exquisite skill and conception in her crowded one-room apartment. (Ferrero has also made a film on Earl.)

Mimi Schapiro and Melissa Meyer distributed a document to the audience with their definitions of collage, assemblage, découpage and photomontage as background for their jointly coined phrase, "femmage." Their premise is that "leftovers" are essential to a woman's experience. Schapiro pointed out that most of the classic written works on collage refer to male artists. She and Meyer developed "femmage" to mean the form made solely by women.

Meyer and Schapiro listed several criteria for "femmage," but were careful to state that not every one need appear in each object. But for the work to be "appreciated" as "femmage" at least half the criteria must be met. These include being made by a woman, recycling of scraps, saving and collecting,

themes related to life contexts, covert imagery, diaristic nature, celebration of private or public events, expectation of an intimate audience, drawing or handwriting "sewn" in, silhouetted images fixed on other material, inclusion of photographs or printed matter, recognizable images in narrative sequence, abstract pattern elements, and the possibility of a functional, as well as an aesthetic, life for the work.

– Barbara Aubin

Women Artists News, March, 1979 [Vol. 4, No. 9]

To the disappointment of the audience, there was no discussion among the artists about the nature of landscape imagery, their use of American landscape tradition, or the future of landscape painting. No one addressed the ambivalence expressed by those trained in abstract art toward working in landscape or why landscape painters belittle their own subject matter.

– Patt Likos

Women Artists News, May, 1979 [Vol. 5, No. 1]

'79 / #106

Personal Outer Space

"Landscape Transformed"

Moderator: **Lenore Malen**; Panelists: **Diane Burko, Jane Freilicher, Yvonne Jacquette, Ann McCoy**

College Art Association, Washington, DC; January 30, 1979

Moderator Lenore Malen structured a parenthesis for "Landscape Transformed," introducing discussion with an excerpt from Annie Dillard's *Pilgrim at Tinker Creek* and concluding with slides of landscape-related works and statements by the artists.

Diane Burko, the first panelist, described her evolution from abstraction to realism. She now feels fully committed to the tradition of landscape painting, particularly that of Church and Bierstadt. Working from photographs and color slides, she creates panoramic views of mountains and, lately, the Grand Canyon, as seen from an airplane.

Yvonne Jacquette also works with aerial views from planes, sketching New York City or the New England countryside. She dramatized her method by donning a flyer's cap, and, with a drawing board on her knee, quickly sketching the patterns of light and colors "below" her. Like Burko, she feels an affinity with early American landscape painters, George Catlin in particular.

Jane Freilicher began her presentation with an apologetic statement about landscape as subject. Trained in the abstract tradition, she is reluctant to call her works landscapes. Like the first two speakers, she works quite large, painting broad planes of land, sea, and sky. Her loose, wet style reveals an attachment to the principles of Abstract Expressionism as taught by Hans Hofmann and a concern with surface treatment, as well as "a romantic feeling" about place."

Ann McCoy gave a long, stream-of-consciousness account of herself and the inspirations for her large Prismacolor drawings of undersea life. As she brought no slides, it was impossible to place her statements in a visual context. She said her approach concerns "Nature with a capital N" and that her images are influenced by inner worlds of dream and myth.

'79 / #107

Social Meanings of Art

"Marxist Approaches to Art History"

Moderators: **Eunice Lipton** and **Carol Duncan**; Panelists: **David Kunzle, Ken Lawrence, Gary Tartakov, Josephine Gear, Adrian Rifkin**

Caucus for Marxism and Art, College Art Conference, Washington DC; February 1, 1979

David Kunzle discussed art in Chile during the Allende regime and under the current military dictatorship, seeing art as part of, not a response to, social change. Since the 1973 coup and the concurrent attempts at destruction of popular political art, new forms of underground art have appeared, such as *arpilleras*, fabric wall hangings made by Chilean women. Many of the *arpilleras* contain explicitly political messages; some are less overt and some are simply beautiful. Women earn money selling this work, frequently supporting families splintered by the junta. Pinochet's government finds such art threatening, and has tried, unsuccessfully, to co-opt the *arpillera* movement.

Ken Lawrence provided a refreshing break from the recent deluge of Tutmania. Showing how the African-ness, the Egyptian-ness, of the Boy King has been distorted and the conflicts of that period of history de-emphasized, he discussed the way art is used by imperialism as "not political."

Gary Tartakov defined exotica as what is "incomprehensible and irrational to us." The title of his talk was "Exoticism and the Imperialist Vision of 19th-Century European Photography of India." Showing some of these photographs in slides, he demonstrated the way viewing out-of-context can give an entirely false view. For example, the familiar image of a man lying on a bed of nails conjures up visions of asceticism, pain, and strangeness. Actually, this is a painless, safe religious act done for money by the very poor – at the bottom of the photo, generally cropped, is the receptacle for coins.

Josephine Gear's topic was "The Cult of the Baby in 19th-Century Art." Using extraordinary slides of British art, all containing the two figures of mother and child, she spoke about baby worship and its relation to conditions of the

time. The new primacy of nuclear families had brought up-heavals in male-female relationships amounting to "the hus-band producing labor, the wife producing love." Along with this came an idealization of motherhood, and hence of ba-bies. The repressed sexuality of the time was also expressed in the strong eroticism of some works (this relationship appar-ently being the only acceptable place for women's sexuality). Other paintings reflected moods ranging from adulation to fun.

Adrian Rifkin, speaking about the cultural context of the Paris Commune, showed another collection of beautiful slides, most of them of cartoons showing formation of class alliances within the political struggle. A great deal of physical violence was depicted – on both sides. The women's move-ment was seen as the most socialist of the time.

In the question and answer period there was some discussion about the Caucus and its relation to the College Art Associa-tion. In a brief exchange, Carol Duncan politely refused to agree with CAA representative Beatrice Farwell that the CAA is a democratic organization.

– Leslie Satin

Women Artists News, March 1979 [Vol. 4, No. 9]

'79 / #108

Real People as Art

"Artists and Community in the Context of Social Change"

Moderators: **Martha Rosler** and **Alan Sekula**; Panelists: **Mel Rosenthal, Suzanne Lacy, Fred Lonidier**

Caucus for Marxism and Art, College Art Conference; February 2, 1979

Because the Caucus had been granted a very brief time slot, only three artists were scheduled to speak, each to discuss her/his work in the context of social change. Martha Rosler noted in her introduction that each of them dealt with vio-lence – physical or social. Later she addressed the need of political artists to gain control of language, to move away from the media definition of "violence."

Photographer Mel Rosenthal described his discomfort when audiences skim over the political content of his photographs, responding only to the form of the work. In his photographs of the South Bronx he has insisted, not only on political meanings of the subject, but on the relationship between the art and the subject – the people of the area. His original idea was to make portraits of everyone living on the street where he works at a health center. It became apparent that many of these people, with whom Rosenthal became very involved over the course of a year, had never seen accurate photos of themselves. The photographs show them as real people in

real poverty – not just another burned-out South-Bronx scene from media.

Suzanne Lacy presented material she'd covered in a previous panel on performance and environmental art from a some-what different perspective. She and Leslie Labowitz co-founded Ariadne* to work against violence against women. Discussing several projects on rape, murder and violence in the record industry, Lacy explained their approach, which involves, not just getting the personal cooperation of local government officials and journalists, but actually setting up performances and exhibits for media. This follows Ariadne's analysis of the role played by media in preventing or allow-ing political change.

Fred Lonidier spoke about reaching a labor-union audience. Believing that the structure of the workplace must be changed to affect occupational health problems in a major way, he created an exhibit of photographs showing results of work-related diseases and added a text giving the historical context. The exhibit did attract many union members. At the panel, he spoke of the difficulties of reaching such "non-art" audiences.

When our time in the Lincoln Room ran out, we were in mid-discussion, but discovered another spot available unoffi-cially. Perhaps 40 of us sat in a circle there and continued to talk and talk about the role media play for the political artist, the difference between performance art and political activism (is Phyllis Schlafly a performance artist?), political art as a process of self-identification, definitions of "cultural worker," the exhibit of shoppingbag ladies' art at the Met organized by Anne Marie Rousseau.

– Leslie Satin

Women Artists News, March 1979 [Vol. 4, No. 9]

*Ariadne, a California woman's network, produced public art on political issues from 1977 to 1980.

'79 / #109

Framing Stories

"Narrative Content in the '70s: On the Issue of Storytelling"

Panelists: **Eleanor Antin, Newton Harrison, Helen Harrison, Douglas Huebler, Nathan Lyons, Roland Reiss, Jehanne Teilhet**

College Art Association, Washington, DC; February 1, 1979

The California crowd grumbled about jet lag as they got into gear for their biennial panel.

Newton Harrison began, "Narrative is an account and a story. . . . Everyone knows when they are telling a story, but do we know what a story is?" He went on to share the find-

ings of a class project. When assigned to write their personal stories, students readily disclosed their sad stories, but were reluctant to share their stories of well-being. Discussion revealed that they were anxious about jealousy and the possibility that their good fortune would vanish if exposed. Harrison asked, "What does it mean if your friendship circle will listen to your sad story, but not your story of well-being? How does this affect the ways we relate to one another?"

Eleanor Antin said storytelling needs delicate handling now, but perhaps as time goes by it will be possible to relax. "Storytelling is a basic human need." After reciting her four images/selves (king, ballerina, black movie star and nurse), she said we need to "kick the modernist out" in order to get back to human concerns.

Roland Reiss seemed to feel that narrative art as it exists now is "just the tip of the iceberg." Explaining his own category of what he calls "narrative tableaux," small constructions of rooms or spaces, he said he gives the audience "a didactic start," with certain clues and then works "toward accessibility" (a term he says we use now instead of "communication"). Reiss credited the women's movement with help in making certain connections and giving license to be personal. In his "transitional strategy coming out of a linear mode," the rooms or tableaux are spread out to allow "comparisons." There is also a literal rendition of ideas and puns. "You have seen it before," Reiss said.

Douglas Huebler explained his strategy, which refers back to painting. He found that the picture plane behind his earlier paintings could be replaced by language as an integral part of the picture, with words written on the surface of the work. "The words are boring . . . presenting a fiction, but a truth. The reader puts it together. These kinds of notations bury the point." The burial becomes an "archeological dig."

Huebler then described several of his well-known conceptual pieces: making a drawing of a guy who has left the room; making a fiction out of 80 cliché personality types (both assignments he gives students); finding a person in existing objects, such as clouds or trees. He closed with the cheering proclamation that nothing in art has been used up. He also let drop a term I loved – "spooky formalism."

Nathan Lyons gave a thoughtful presentation of issues in photography, which he said "framed" his own intentions of using images primarily in book form. He suggested that the situation is now reversed from "the original notion that narrative photography must tell a story." Today it seems that "there are many *ways* to tell a story." Lyons said "a symbolist system of signals" tells that a message is being given. By breaking expectations it is possible to introduce "new symbolist code systems." It's not just a question of "how the stories are told," but of "what the expectations of storytelling can be." As for the book arts, they "are a physical extension of the photographer's frame, extended, layered, with descriptive roles dislodged."

Helen Harrison finds that in these new contexts "what a story means, what has been clear and intuitively known, be-

comes blurred, fuzzy." However, "we create empathy." Recounting the story of a piece she and Newton had done, "The Spanish Conquest and the Indians," she said their intuition about a certain site led them to do research on the Indians who had lived there. The results were included in the artwork. Questioned about the length of time it takes to get through one of their exhibitions, she said this reflects the process. "The research does not give up its information rapidly. . . . It takes time and so does the exhibition. You are not meant to be able to run through it." Asked by Linda Cunningham, from the audience, why narrative art is developing *today*, Harrison offered that it was only in the '60s that we veered away from it. "What modernism dug itself into, some, like Rothko, filled with spiritualism." Now we are *returning* to narration, "a human need." (This is a need for her especially, she said, because she doesn't dream.)

Narration departs from "masturbatory art and self-interest," according to Harrison, but all this understanding takes time. "We get an overload," and there is "so much that we don't know." We need to "trust our own gestalt processes. . . . Our value as artists is that we can come up with another visualization."

Newton Harrison added, à propos of the gestalt/research synthesis, "When you come up for air, an internal message says enough . . . you can't stay in that state very long."

Irving Sandler, in the audience, had two things on his mind. First, "Is there an *abstract* division of narrative art?" He named a few artists who might be included in such a list, but Eleanor Antin shouted *"No!* They have no right to the term!"

Clearly the question of trust and the liberty of the critic was in the air. This wasn't simply the response of a group who, having painstakingly molded their theories over the years, wished to defend their turf, but the understandable frustration of artists who hope the critic will take their cues. And indeed the critic does, but may apply them to someone else, someone else perhaps more *marketable*.

Sandler's second question, "Is narrative a wave of the future, a main line?" was answered by Huebler, who said the genre derived, not from an abstract or figurative tradition, but from "humanism."

The session ended with a note about the way the story is actually told. "The *voice* is important." Using the written word must be done well or the story doesn't come across. Panelists agreed that, "Artists need to think about how they use language as much as they think about how they use pictures."

– Mary Beth Edelson

Women Artists News, April 1979 [Vol. 4, No. 10]

'79 / #110

New Realism at Museums

"Museums and Present-Day Art"

Moderator: **Hilton Kramer**, art critic, *New York Times*; Panelists: **William Lieberman**, MoMA; **Martin Friedman**, Director, Walker Art Center

College Art Association, Washington, DC; February 2, 1979

Since the original title of this panel was "Museums and the Reality Principle," the artist-listener might have expected an adrenalin-rousing discourse on exhibition politics, how artists are chosen or ignored, the manipulations of trustees, the perfidy of curators and their lovers, etc. Instead, the Reality Principle at issue quite reasonably concerned the costs of running a museum, the problems of attracting a broad public, and how, having done so, not to go broke being popular.

Hilton Kramer described the task of a museum over the past 30 years as changed, from an agency showing classics of modern art to an institution whose function is also to introduce new and emerging artists and movements.

Martin Friedman said the total exhibition program must be constructed to build a pattern of shows that are "ongoing reportages of art." A museum must never schedule a series of one-artist shows, he maintained, but alternate single artists with classical modernism and diverse media. He sees "crucial examples" from the past as essential to intelligent shows of classical modernism (such as Cubism, Futurism, or the Cézanne show); these examples are then reinterpreted in the light of today's taste.

Friedman noted that there are several museum audiences; first, the continuing audience in the habit of museum-going; second, the specialized audience drawn to certain media such as photography, design, or architecture; and third, the first-time audience, brought by the publicity for a special show, such as King Tut. Even though museums plan shows they think have ongoing significance, he said, the Reality Principle does not allow them to ignore the fact of these separate audiences.

Kramer asked the others how seriously "box-office" considerations affect choice of museum shows.

William Lieberman (the most soigné, detached, and ironic of the three) said box office has become more important, "because more corporations are funding the shows and they see popularity as the yardstick of success." MoMA doesn't have the money today to do shows without large-audience appeal. And, "titles are important for shows."

Friedman, who was conscious of speaking to an audience of, after all, CAA members, insisted, "We cannot limit programming to the popular."

A member of the audience, referring to Kramer's article about art museums run as businesses, asked him, "What about the businessman as top director, over the curator?"

Kramer responded by paraphrasing Alan Shestack of Yale's statement that every decision made in a museum, including the collection of garbage, is an aesthetic decision.

Lieberman thought the divided leadership running the Metropolitan Museum seemed to be working, but Friedman objected, declaring that the chief officer of a museum must absolutely be a scholar and art historian, and that the core of a museum must be "artistic." Artists and art historians, he said, "are not necessarily financial morons." However, Friedman conceded that very large museums involved in big investment funds and city politics would be exceptions to the rule of scholars.

Kramer finds museum trustees failing in their responsibilities today. They ought to worry *more*, not less, he said. He also suggested that trustees prefer financial types at the helm because it's less work for them when the administration belongs to the "world of money" rather than scholarship. He pointed out drily that we should view with alarm the fact that America's leading universities, publishing houses, and newspapers are now run by "administrators," not scholars, men of letters [sic], or journalists. We should not let museums go the same way, he said.

The panel then took up the question of corporate support, and what that means to new artists. Lieberman conceded that it's very hard to raise funds to show contemporary work. Most corporations prefer art of the past. It's safer, attracts a larger audience, and causes less controversy. The British Council, he pointed out, gives MoMA funds to show , not just any artists, but British artists, and the few private donors left are nervous about the new and unknown.

All three panelists pointed out several times that art is a commodity, vying for the leisure time of audiences in competition with movies, theatre, and sports, and that the need to attract mass audiences brings unending new problems.

To a question from the floor about the profitability of MoMA's Cézanne show, Lieberman said MoMA *loses* $2 for each person who walks in and buys a ticket. The extra attendance at a show like Cézanne is offset by the expense of extra guards and other personnel. In fact, MoMA closes one day a week to save money. He agreed that boards of trustees today still view themselves as a "club" of art sponsors, but that museums get public money and must justify their activities to the community at large.

Kramer asked to what extent this affects aesthetic decisions. Or, as one audience member put it, "Isn't this concern for the mass audience making the art museum a media event, rather than an art event?"

Friedman conceded that this was largely so, but said he hoped to find ways to solve the problem. One answer might be to schedule a "younger artist" show at the same time as a Cézanne blockbuster to catch the larger audience.

The panel also addressed questions of catalog expenses, the trend toward elaborate labeling, extended graphics, and long cassettes; and acknowledged the difficulty of looking at art along with so many other people at the popular hours – in

119

short, educational "overkill." Popularity of the museum experience could carry the seeds of its own destruction, and newer artists might one day have no place to show. Friedman saw university museums and alternative spaces as a possible answer for lesser-known artists.

The panel ended all too briskly just as this last topic ripened for discussion, participants having to catch their planes to continue their appointed rounds. One thing is certain: artists may rise and fall and rise again, but the institutionalization of art is here to stay.

— **Abby Goell**

Women Artists News, April 1979 [Vol. 4, No. 10]

'79 / #111

Lunch-Hour Litany

"Questioning the Litany, Part II:
Feminist Views of Art History"

Moderator: **Christine M. Havelock**; Panelists: **Adele M. Holcomb,
Renée Y. Sandell, Sandra Kraskin, Norma Broude**; Discussants:
Eugene Carroll, H. Diane Russell

Women's Caucus, College Art Conference, Washington DC; February 2, 1979

On the premise that a good question is worth asking twice, the Women's Caucus resumed a panel topic initiated in 1978, "Feminist Views of Art History." But, as Christine Havelock reminded us, it is easier to expose bias than to supplant it.

Sandra Kraskin's history of the American Abstract Artists group questioned the litany of American critics who ignored home-grown abstraction until the massive hype of Abstract Expressionism got under way. Her well-researched talk documented the New York City-based association, which was most active just prior to World War II. Kraskin insisted that the women members were taken seriously; in fact they seem not to have been any more neglected than the males. (However, there were only six women among 28 charter members.)

Adele Holcomb's lecture addressed some early women art historians, including Anna Jameson, author of a number of widely-read books on art. These women were influential in areas such as the rediscovery of the Italian "primitives." Holcomb's feminist query: why are Jameson, Elizabeth Eastlake, and others so little known, when Ruskin's bibliography "proliferates on toward infinity"?

Renée Sandell's talk on Marie Laurencin was calculated to show that the artist was far more than a "muse" to Apollinaire and the Cubist clique. Laurencin worked hard, exhibited frequently, and established her own credentials. Cubism held the limelight, yet Laurencin followed her own

vision, finally closer in spirit to Renoir and the Impressionists than to Picasso and Braque. She was not just Apollinaire's lover, or a Cubist manqué; her rich and full career in art merits attention on its own terms.

Norma Broude's gem of a talk on the decorative versus the abstract in 20th-century art went beyond cases of neglected individuals to probe attitudes about modes of expression. Deploring critical contempt toward "mere" decoration and the handicraft tradition, she cited the deliberate use of decorative forms and craft techniques in Miriam Schapiro's work. Seeing Schapiro's "femmage" as "artifacts of women's will to create," Broude illuminated Schapiro's genuine questioning of the litany of "high" and "low" art in her own work.

I came away with a few questions of my own. Why did C.A.A. assign only one and a half hours to an important (and well-attended) feminist discussion, when most panels, however trivial, have two and a half hours? There was little time for discussants and no time for questions from the floor. Why did a C.A.A. staff member charge in like the U.S. Cavalry to hustle us out? She might have been gracious enough to invite us to stay for the next session, since most of us were dues-paying members. Finally, how long are we going to put up with this?

— **Sylvia Moore**

Women Artists News, May 1979 [Vol. 5, No. 1]

'79 / #112

Good Ol' Boys of the Appalachian Connection

"Recurring Regionalism: The Southern Rim"

Moderator: **William R. Dunlap**; Panelists: **John Canaday, William
Christenberry, Larry Edwards, Jim Roche, James Surls, John
Alexander**

College Art Association, Washington, DC, February 2, 1979

John Canaday, for those of you too young to remember, used to be senior art critic on *The New York Times,* and hence, some felt, the most powerful art critic in the country. I remember a Sunday column of his about a woman in the art department of Appalachian University who had put together an exhibition so fine that he praised it unstintingly. This was particularly impressive to a New Yorker because at the time the very name of the university conjured up an isolated pocket of insularity where it was hardly expected art would be taught, let alone exhibited, and abstract art at that. Canaday's Appalachian connection appeared again at College Art, as we saw him on the panel, "Recurring Regionalism: The Southern Rim." (The title came from an earlier conference of the same name.)

Moderator William R. Dunlap of Appalachian University acted like a suave cosmopolitan – that is, until he exhibited all the worst characteristics the rest of the country might attribute to New Yorkers. He was rude, egotistical, insulting, arrogant, uncaring, and crude. He also made a great show of swilling bourbon from a prominently displayed bottle. Typical of this Southern gentleman's behavior was his reply to Elsa Fine's question from the floor about the absence of women, or even one good ol' girl, on the panel with the good ol' boys. It was OK, Dunlap said, because there were two homosexuals on the panel.

Having arrived late, I missed the opening presentation of slides, but I was in time to hear John Alexander entertain the audience with anecdotes from the past year which he had spent traveling the country in the role of famous artist, accepting recognition and success. He declared himself on the side of minority artists (Chicanos), but definitely against New York lady art critics with briefcases. (One had spent no more than three minutes scanning his show before writing a several-page magazine article.) He was bemused by Lions Club audiences who, in Lions Club tradition, roared approval of his witticisms rather than applauding. His other adventures ranged the country both sociologically and geographically. Alexander enchanted the CAA audience in general, the women less so.

James Surls, apparently the only member of the panel concerned with human values, was generous in crediting the Dallas Women's Co-op with opening up the art scene there. They did all the work, he said – politicking, letter-writing and the rest – that made it possible to exhibit art in Dallas outside the museum. He said he himself "rode in on the coat tails."

Discussion continued as, by and large, a series of rambling non sequiturs. Members of the audience seemed to feel compelled to make statements themselves, like at a revival meeting, and their random statements, usually irrelevant to the discussion, prompted other remotely connected observations. One item surfacing in this manner was the moderator's statement that New York had "closed down for young artists." He attributed that to Marcia Tucker's departure from the Whitney. (Maybe it was the bourbon.)

This profundity was followed by an editor of *Art Voices South* – an expensively glossy magazine dedicated to praise of Southern artists – who got to his feet in the audience to say that the magazine covers 22 southern states and is trying to attract an audience not accustomed to going to galleries. The panel responded very warmly to this and the subject of regional art came up – whether the South was producing any, whether any Southern state had ever produced any. Washington, DC, got some credit here, specifically the Washington Color School, but that was quickly dismissed by a panelist – Canaday perhaps – as a "suburban" expression of New York Abstract Expressionism.

Well, things just moved along. Soon John Alexander spoke in recognition of the people of Iran – he felt they should be honored for "standing up and getting rid of a cancerous ty-

rant." (This was the week of street riots in Iran.) Dunlap even managed an insulting joke on the subject. Then Margaret Gorove, chairperson of the art department at the University of Mississippi, former teacher of moderator Dunlap, got to her feet to say, first, that a proper grad of Ol' Miss would have kept the bottle in a paper bag, and second, to describe the very real problems of women artists in the South. She pointed out that, as is well known, women do well in blind-juried shows, but aren't included in invitationals, not having had the exposure or experience.

Moderator Dunlap's response to this serious and impassioned statement was, "Let me say, I love your hair, and the color of your dress."

Gorove, resigned, even gentle, replied, "You haven't changed a bit." Dunlap then felt it necessary to go on record with, "I make no apology for the sexual make-up of this panel."

John Alexander added quickly that he himself is concerned with the problems of women artists and is aware of prejudice against them and minorities. But, he claimed, the previous night's panel, "Modern Art and Economics," had been "all big names, all men, and no one brought the issue up there." Aggrieved at what he saw as discrimination against the Southern panel, Alexander wanted to pursue the topic. "I recommend we continue and go for the throat" (which throat he didn't say).

Surls mentioned that, having found the Contemporary Art Museum in Houston without a director, curator or scheduled exhibition, he had grabbed the free slot to do a show of 100 Texas artists ("Fire"). He may have intended to say women as well as men were included, but never got to it, because next came Robert Pincus-Witten from the audience.

Bitingly sarcastic about *Art Voices South*'s self-congratulatory tone and self-serving ways, Pincus-Witten said that "without a critical voice for the Southern Rim you'll be back on this panel continuing this conversation for the rest of your lives." Only the development of a critical voice can bring Southern artists recognition from the rest of the country, he said.

John Canaday didn't see it that way. "American art would have been better off without all the known critics," said the former known critic. He quoted from an essay by Harold Rosenberg: "Artists are faced with a wall of opinion – a formulated taste dictating the direction of art." Canaday advised us that "what is really needed is a buying public for the arts." (An exemplary opinion, certainly.)

Next it was Irving Sandler's turn. Sandler said from the audience that there was "more energy, more wit in this panel" than any he had heard in New York. That seemed like a good time to leave.

– Cynthia Navaretta

Women Artists News, May 1979 [Vol. 5, No.1]

'79 / #113

Fighting Words

When Artists Space titled an exhibition by a white male artist, "The Nigger Drawings," it surely did not anticipate the storm that followed. Years later, hearing speakers at the "Bad-Girl Art" panel talking casually about "Cunt Art" ['86/#186], I recalled this episode. My thought was, men using that term better be *awfully* careful to put it in *very* heavy quotation marks. The word "queer" may be similarly privileged. A recently formed advocacy group for homosexuals calls itself "Queer Nation," but "queer" will have to enter the language much more fully in this sense before it can be used casually by others.

Lawrence Alloway once noted that the lobby gallery in the Whitney Museum had been called "The Nigger Room" by artists,* and that the name had been bestowed by blacks. Richard Pryor's "That Nigger's Crazy" (1974) and "Bicentennial Nigger" (1976) are other instances of black usage. But permissions in language are no less binding for being tacit. What Artists Space presumably intended as provocative, proved, in the complex, ever-changing etiquette of language, to be over the edge – or was declared over the edge in 1979.

In any event, this account also shows that the cry "public accountability for public funds," lately the refrain of Jesse Helms and company in their attack on the NEA, once came from *the arts community* – or a sector of it.

*May, 1975 *Artforum*

The "Nigger Drawing" Commentaries

Arts people respond to the title of an exhibit at New York's Artists Space – "The Nigger Drawings"

Douglas Crimp, *Critic*:
[A] small group called the Emergency Coalition takes Donald Newman's title "The Nigger Drawings" as a clear-cut, unambiguous instance of racism. They seem to be telling us that we must suspend everything we know about how art and language function, and accept as simply *true* that any use of the word "nigger" is categorically racist.

It may well be true that some people have been offended by Newman's work. It is also true that avant-garde art has a long history of such offenses, a history inseparable from art's political radicalism and vitality. And it is also true that there have been many attempts to restrict the freedom of art to embrace controversial issues. These attempts at censorship have, however, rarely come from those pretending to defend a liberal cause.

[T]he protest in response to Newman's title was directed for the most part, not to the artist or the alternative space showing his work, but to Artists Space's principal funding agency, The New York State Council on the Arts. Even when the dangers of making a government agency the instrument of censorship had been pointed out, the protestors persisted in this insidious direction.

A particularly telling example of the kind of activity involved was the work of Museum of Modern Art curator Howardena Pindell, who has kept the New York State Council on the Arts, the National Endowment for the Arts, the Press, and various individuals apprised of the minutest details of the controversy. When an article expressing concern about this means of protest appeared in *Skyline*, Ms. Pindell, presumably thinking the article a self-evident display of racism, circled the author's name and the statement "*Skyline* is published with partial support from The New York State Council on the Arts" and sent it to her ad hoc mailing list, including, of course, the Council.

The potential dangers of directing protest to government funding agencies is illustrated by the response of NYSCA. Rather than simply informing the protestors that their letters were misdirected, they felt compelled to issue apologies and reprimands. NYSCA knows that the legislators in Albany would be only too happy to use this kind of incident to oppose appropriations [for art] neither they nor many of their constituents value.

Public support for the arts will always be politically precarious in a capitalist economy, with the result that only those aspects of culture which fully participate in the capitalist structure are invulnerable to this kind of censorship. If one follows the logic of this situation, one realizes the members of the Emergency Coalition – notable among them a few "Marxist" art historians – work indirectly in support of a philistine society where only the crassest commercialism in the arts is assured a safe existence. [But] one might ask them, which artists are most vulnerable to the threat of censorship? Are they not those who are most disenfranchised? Are they not those with the most to say through their art about the inequities and injustices of our society?

It remains to be seen how Artists Space will fare in the upcoming funding sessions at NYSCA. This is, of course, of deepest concern to that large community that Artist Space is chartered and funded to serve – and has for the past few years served so effectively – those younger artists who are not participating in that sector of the art world structure directly dominated by a capitalist economy.

Haffiz Mohamed, *Arts Administrator*
The ethnic insensitivity demonstrated by Artists Space through their "Nigger Drawing" exhibition, and its callous reaction to subsequent events, raises another important issue with regard to this "alternative space" – the issue of public accountability for public funds.

If Artists Space is funded through public monies (National Endowment for the Arts and the New York State Council on the Arts) based on its claim to be an alternative to the large, established exhibition spaces, why are we hearing the same familiar song regarding minorities and the selection process for showing artists? As I understand it, artists are not selected through a panel process, nor is there adequate minority representation on the gallery's board, and absolutely no minority staff members.

Once understanding this, it is clear how a "Nigger Drawing" incident is possible, why minority artists are discouraged from exhibiting there, as well as the reason minority views are considered invalid by heavy-handed (and, perhaps, single-handed) policy-makers at Artists Space. Historically, the facts point to a well-known trend rather than an alternative.

The issue is, as I see it, a question: Why should our public tax dollars be supporting an organization which ignores public accountability for those specific funds?

In Fiscal Year 1978-79, Artists Space received approximately $74,000 from NYSCA, as opposed to a total of approximately $18,000 awarded to three comparable minority organizations combined.

After the events surrounding the "Nigger Drawing" show, which pointed out the lack of democratic process and minority representation at Artists Space, it will be important to monitor reactions and follow-up by our distributors of public funds [and] the level of funding to this "alternative space" during the next funding cycle of our public agencies. . . .

Dr. Lawn Mower [Gregory Battcock, *Critic*]
The recent exhibition at Artists Space, called "The Nigger Drawings," has provoked considerable argument in artistic circles. Many people question the propriety of a publicly supported gallery sponsoring the controversial exhibition. And most agree with Dr. [Lowery] Sims: "Greater . . . consideration should have been given to the title [of the exhibition]," she claims.

Are Dr. Sims's and Ms. [Helen] Winer's* views shared by the art community at large? At the request of the editors, in order to seek out various viewpoints, we conducted a brief survey of several prominent artists, critics and museum officials.

Edit deAk, editor of *Art Rite* magazine, well known art theorist and a founding member of the New York Art Critics Circle, was appalled, and rightly so.

"Racism is terrible," explained Ms. deAk. "But inflation, is worse. 99¢ for broccoli. $1.49 for a pack of razor blades. 79¢ for a lousy. . . ." We hated to interrupt Ms. deAk, but asked her to stick to the exhibition. "What exhibition? Those drawings? I didn't see it. But 79¢ for a lousy. . . ."

Thanking Ms. deAk for her frank opinion, we rushed to catch the subway downtown. Boarding the No. 3 train, we almost didn't recognize Dr. Stephen Varble, the well-known performance and costume artist, who was dressed to resemble a sliding door.

We asked the sliding door what he thought of the exhibition of "Nigger Drawings."

"Terrible, terrible," whispered Dr. Varble. "Sliding doors aren't supposed to talk, but that show is nothing but plagiarism. I did a show called 'Nigger Nonsense' in '73. That harlot stole the title and I'm suing Artists Space and the New York State Council and – *Oh, Canal Street? Let me out!*"

Changing for the Hudson Tubes, then transferring to the Jersey Shore Line at Elizabeth, we arrived, a scant four hours later, at Lindcroft, N.J., for our appointment with Dr. Judith Van Baron, Director of the Monmouth County Museum.

"I don't believe in segregated exhibitions," explained Dr. Van Baron. "Now if they'd let some whites into the show, they'd have to change the title, wouldn't they?"

We explained to Dr. Van Baron that the show was not an exhibition of black art. "The Nigger Drawings" were done by a white boy.

"Oh really?" asked Dr. Van Baron. "Isn't that misrepresentation? Come see our new exhibition of broken phonograph records, as long as you're here . . . You can [also] browse in our specialized and personalized gift shop and. . . ."

We bid Dr. Van Baron and the gift shop a warm goodbye, caught the Jersey Shore Line to Newark, where we changed to the Tubes, then the uptown BMT at 34th. Waiting for the train, we couldn't help but overhear a squabble at the newsstand.

"This ain't no library," growled the news dealer. "If ya wanna read it you can buy it." The man being yelled at was Mr. Ronnie Caran, the well-known art dealer and associate of Crispo Galleries. . . .

"Oh! Mr. Caran, Mr. Caran," we shouted, trying to make ourself heard above the screech of an incoming train. "Can we ride with you? We want to ask you about 'The Nigger Drawings.'"

"Lower your voice, you idiot," he said.

"Why? Everybody's talking about 'The Nigger Drawings,'" we shouted. "Just want to ask. . . ."

He pushed us into the uptown train. "You could get us killed!" he said. "Those people might have lynched us!"

A crowd of angry looking blacks glared at us from the platform that, blessedly, was moving away with increasing rapidity.

"Well, what about 'The Nigger Drawings?'" we asked.

"If you don't shut up I'm going to call the police," explained Mr. Caran. "There's some things we don't talk about on the subway." And he stormed out of the car onto the 57th Street platform, along with everybody else. We decided to take the bus to our consultation with Dr. Chuck Hovland, a floorwalker for the Guggenheim Museum.

Dr. Hovland, gracious to a fault, met us at the door and, taking our coat and gloves, volunteered his thoughts about the controversial exhibition and blatant racial insult:

"Something like that would never happen at the Goo Goo," he explained. "Firstly, we don't do black art, and secondly, we don't do drawings, and thirdly, we certainly don't have anything to do with the New York State Council, and fourthly . . . if I don't clean out the gold-fish pond by five o'clock, they threatened to put me on the switchboard. . . ."

Next stop: The Metropolitan Museum of Art!

We asked at the main information desk if we might speak to a museum official, other than Dr. Sims, about the controversial exhibition and blatant racial insult.

"That will be $7," replied the clerk.

"$7 for what?" we asked.

"That's our minimum consultation fee," she explained. "Unless, of course, you want to speak to a curatorial person. That's $25."

We thanked the information lady. We had, perhaps, quite enough information on racism for one day.

Alan Wallach, *Political Scientist*
The controversy over the exhibition of the "Nigger Drawings" has been going on for over three months and despite repeated protests and demonstrations Artists Space has so far given little indication that it comprehends the full significance of its actions. While admitting to "insensitivity," it has not disguised the fact that its main concern has been the possibility that the protests might undermine its funding, and it has responded to the demonstrations with charges of "censorship" and "publicity-seeking." It is perhaps understandable that Artists Space and its defenders have seen the protests in careerist terms; however all the arguments raised in bad faith against the protests should not obscure the fact that the central issue is not "censorship" but racism.

For at this late date, it should not come as news to anyone that we live in a profoundly racist society and that in recent years racism has been on the increase. Perhaps it is too much to expect mainstream artworld institutions like Artists Space to mount a conscientious struggle against racism, but at least for sake of appearances, if nothing else, we could have hoped to have been spared the "Nigger Drawings." That we were not testifies to a mood that is becoming very ugly indeed.

To many participants in the controversy on the side of Artists Space, the artist who created the "Nigger Drawings" was simply exercising his artistic freedom, a prerogative that galleries – those bastions of *laissez faire* – have no right to tamper with. But it requires little imagination to see the situation from the viewpoint of those who look upon the artworld as an exclusive and privileged realm. From that viewpoint – and it is the viewpoint of the majority in our society – an exhibition at public expense of a white artist's "Nigger Drawings" can only appear as a racist gesture, an arrogant slap in the face of the powerless and, at this historical moment, a portent of worse things yet to come.

Such a gesture, besides a direct insult to blacks, makes explicit what is already implicit in a situation in which black and other minority artists are everywhere under-represented and minority cultural institutions are neglected by public funding agencies. The "Nigger Drawings" incident only underscores the desperate need for action. . . .

Artworkers News, June 1979 [Volume 8, No.10]

*Lowery Sims is a curator at the Metropolitan Museum of Art. Helen Winer was Director of Artists Space.

The Only 'Ism' Left Is Criticism:

Suddenly the panels were about criticism itself. In retrospect, the dawning recognition that criticism no longer commanded the course of art as it had, or had *seemed* to, was a central theme. Apparently the advent of pluralism rattled critics. Or perhaps they were simply spread too thin, as art-talk events proliferated. Whichever, at a number of these all-star evenings, critics failed to talk as cogently as they wrote.

Summer '79 *Women Artists News* covered three blockbuster panels sponsored by School of Visual Arts, Cooper Union and the New Museum within a two-month period, all of them addressing criticism.

"Artist and Critic: The Nature of the Relationship"

Moderator: **Donald Kuspit**; Panelists: **Alice Aycock, Alex Katz, Hilton Kramer, Lucio Pozzi, Irving Sandler** (replacing Lawrence Alloway, who was sick)

School of Visual Arts, NYC; March 10, 1979

When I asked Jeanne Siegel, chairperson of the School of Visual Arts fine-arts/art-history department, why the panel had only one woman, she snapped, "Somebody's always complaining about something," and turned on her heel. Nor was the rest of the evening much more enlightening. Well, Alex Katz was more interesting than his paintings, showing signs of the wit that critics who, it seems, know him, find in his art. It's not surprising, therefore, that Katz defended criticism: "In the '60s critics were doing criticism and the painters were illustrating it. [But] you build your art through criticism. . . . You couldn't make art without criticism." However, "When your style changes, you have to change a lot of friends or change your style back."

Alice Aycock was *less* interesting than her art. Someone said they thought she was intimidated, but I prefer to think that, seeing no point of entry into what was essentially an Old Boys' Triviality and Stock-Sentiment Exchange, Aycock stayed wisely out of it. She did note that "as artists get approved of more and more, their relevance seems to diminish." Her solution was to "court disapproval – to keep the cutting edge."

Hilton Kramer, informed by a member of the audience that "conceptual art is a creative investigation," said, "Conceptual art, like the Virgin Birth, is complete in itself. It doesn't call for criticism; it calls for worship." Kramer also said, "I protest the idea that it's the primary function of criticism to transform society," and, "anyone who writes about painting and thinks he has explained it fully is kidding himself." To this, Donald Kuspit replied, "I could explain Mel Bochner's art fully," but failed to make clear whether he meant bad for Bochner or good for Kuspit.

Kramer speaks as he writes, cleverly, but, like all *New York Times* critics, is sadly lacking in sensibility. He does at times recognize fribble, but only in its literary, seldom in its plastic form.

Lucio Pozzi proved to be a rapid mumbler. He got off what sounded like some pungent comments, but I caught only: "Our art at this moment seems always to need a caption to be understood. You can't have a show without having to write out a goddam statement."

Irving Sandler said he was willing to take "the risk of being friends with artists," in part because he upholds "the artist as critic – perhaps the primary critic." His fellow critics doubted that, leading Sandler to ask, "Do you at least grant that artists create the context in which their art is discussed?" They did not, but Sandler insisted: "Critics probably listen more closely to artists than they realize or admit."

That was the substance of two hours' discussion; the audience went away hungry. As for "the nature of the relationship" between artist and critic, we learned somewhat more in the next panel.*

*"The State of Formalism," following.

– **Judy Seigel**

Women Artists News, June/Summer 1979 [Vol. 5, No. 2-3]

'79 / #115

Not with a Bang but a Mumble

What had not that long before been simply "criticism," was now being called "formalism," and having its "state" looked into. That is, the belief that visual form, or art's *appearance*, is the only proper concern of the critic was now called "formalism"; it had previously been, not a *belief*, but *the nature of art*.

Although Inevitable Progression and company were being drummed into oblivion, "formalism" could still be defended. As Rudolf Baranik put it, Greenberg's formalism was never all formalism, just his own twisted version of it. Others on the panel made similar points. Nevertheless, it wasn't long before the very term "formalism" was an execration.

Greenberg of course was declared chief formalist and perpetrator of Minimalism, blamed for his "incredible power" by legions who had been mum while he had that power – or even eager collaborators. Not just at this event, but ever since, Greenberg has been castigated for the whole grinding folly – the tyrannies he was responsible for and those he wasn't – as if he had sprinkled fairy dust into everyone's eyes. (See '87/#195 for his disclaimers.)

"The State of Formalism"

Moderator: Kate Linker; Panelists: Dore Ashton, Rudolf Baranik, Douglas Davis, Donald Kuspit, Brian O'Doherty, Miriam Schapiro

Cooper Union, NYC; March 21, 1979

The first speaker on "The State of Formalism," Brian O'Doherty, surprised me by being, for all his eminence, another mumbler (or a mumbler on this occasion). Otherwise he had only the news that in the early '70s, formalism "became the 'fall guy' for deficiencies in art."

Miriam Schapiro contributed, "Formal values in themselves are not evil." In fact, "I find them useful," but "they have been used against women." Almost alone among the season's greats in speaking slowly and distinctly, Schapiro may have gone to the opposite extreme, speaking *too* slowly and distinctly as she quoted Clive Bell's paean to "the thrilling raptures of . . . the cold white peaks of art," which she termed "a metaphor for patriarchal attitudes." She prefers "the warm red circle of art," where form is "a vessel into which I can pour my content."

From Donald Kuspit, whose ultra-rapid delivery would have defeated material as familiar as "Jingle Bells," I could glean only that formalism is "extremely viable still," that it is "thinking about what art is," and that "Schapiro missed the point."

Douglas Davis declared himself "surprised and flattered" at being invited, because "I spent all my life at war with formalism." Listing his interests as performance, film, video, earthworks, and related media, he asked, "Can we speak of the formal qualities of nature?" Assuming we cannot, he urged, "Let us promise tonight that this be the last panel on the state of formalism." Davis, too, was difficult to understand because, yes, he talked too fast.

But then Rudolf Baranik read a complexly aphoristic paper too fast, too low, *and* in accented English from behind two pillars – which was too bad because his points were well taken. From a copy of the paper obligingly lent by Baranik, I note the following apt observations:

Clement Greenberg's formalism was the application of "theories of societal determinism to superficial or minor innovations in painting." He used this *supposed* formalist criticism as "a banner for one style" of art, thus locking himself in "with the Bannards, the Boxers and the Bushes, the academy of provincial museums of today." *True* formalism is a tool "for serious analysis of the relationship between art and all discourse on art."

At present, Baranik says, art is assaulted from many quarters, including "the pro-populists to whom all high art is disposable and who see 420 West Broadway* as the Pentagon . . . the dogmatic conceptual artists who confuse the conceptual with the intelligent," and the "vandals" of the left. Baranik envisions a "socialist formalism" which would value art "as one of the most intense forces in life."

The last presentation was by Dore Ashton, who said, "art cures itself periodically with homeopathic doses," but didn't

say of what and with what, then followed with the wisdom of Mies van der Rohe: "Form as a goal always ends in formalism." She also said, "Real form pre-supposes real life." These remarks, which strike me still as devoid of meaning, were not elaborated or related to any other point; Ashton seemed simply to hope we would find them profound.

Then, for the remainder of the evening, panelists sat in a circle, crying, as it were, "Clement Greenberg, ptui! ptui! Ptui on Clement Greenberg!" That is, these noted contemporary art advocates laid every iota of the mistakes, misjudgments, dead ends and fatuities of a generation on the absent, but presumably debunked, discredited, and dethroned Greenberg and his "incredible power."

In other words, except for Douglas Davis, who was probably in high school at the time, everyone was wonderfully free-thinking after the fact. Where were they when 12 MFA candidates and *Artforum* actually believed in Greenberg? In fact, now they seemed to be agreeing on yet another fiction, as simplistic in its way as "inevitable progression" had been – that during Greenberg's reign everyone thought as he thought and did as he said. There were, in fact, nearly as many different kinds of art being done then (if not shown) as today, and nobody *I* knew believed those rules.

By now, of course, critics routinely kiss every art frog that comes down the pike in hopes that it will turn into a prince, which tends to make them even less discerning, less independent and less coherent than their predecessors. As for artists, much of the energy they once put into such aesthetic issues now goes into feminism – feminism as focus, arena, and vehicle for art. That leaves a vacuum of intelligence and concern in discussions such as these, even among the men. And speaking of the men (and "the nature of the relationship" between artists and critics, topic of the previous forum), Kuspit didn't help matters when, after a brief tug of the forelock to the virtues of feminism, he attacked Schapiro in the tone of a taunting eight-year old for the "Freudian imagery" of her "cold white pillar." He seemed to imagine she was unaware of the symbolism she had so carefully devised. (Whereupon Schapiro sank to the occasion.)

Early in the evening, Davis listed among the blows, losses and dilemmas of formalism today the fact that "Max Kozloff has deserted art for photography." Judging by this panel, Kozloff knows something.

– Judy Seigel

Women Artists News, June/Summer, 1979 [Vol.5, #2-3]

*420 West Broadway, the first Soho multiple gallery building, was best known for the Leo Castelli Gallery, also the Ileanna Sonnabend Gallery and a changing roster of others.

"Crisis" in Criticism

I forget now why two of us covered the same panel, although it sometimes happened when an event was particularly provocative, or just from lack of planning. Clearly, Pat and I had very different takes on this one (making me hope I don't seem too ill-tempered). In any event, twelve years later, many of the issues at this third of three block-busters on criticism are still current.

"Art Writing and Criticism" *(Report #1)*

Moderator: **Irving Sandler**; Panelists: **Nicolas Calas, Douglas Davis, Joseph Masheck, Carter Ratcliff, Barbara Rose**

New Museum, NYC; May 9, 1979

The New School auditorium is an antiseptic affair after the historic Great Hall at Cooper Union and the raunchy amphitheater at the School of Visual Arts, but its acoustics are much kinder to amateur speakers. If that suggests I'm reviewing these programs as entertainment, I am. Douglas Davis remarked that the panel is itself now "a generic form." It's also a form of entertainment with aspects of performance, social arena, soap box, forum and lately, gathering of lost lambs. This time, though, Barbara Rose came down like the wolf on the fold: "If you publish in an art magazine . . . you are writing ad copy," she said, "and if you don't know that, you're stupid."

It was refreshing to hear such truth from one who was there, but, as a survivor of alternative publishing, I must add that the artists themselves demand, beseech, *slaver after*, that kind of "copy" and the "reviews" they pay for with their exhibition ads. (*ARTS* Magazine used to give a "review" if you took an ad, but I understand that's no longer the case. Now it has to be at least a half-page ad.)

This evening the first speaker was Douglas Davis, who again opened with a disclaimer: "I'm not sure I belong here; I don't practice art criticism any more." He listed the "critical issues raised by recent art" of interest to him as "personality or biography, time, nature, content, artifice and moral exhortation." Davis said he misses the "intensity" of Tom Hess, Clement Greenberg and Harold Rosenberg, seeing today "rhetorical and pedagogical finesse, but no passion." (Let us note in passing the difference between moral exhortation and morality. If, for all its moral *exhortation*, the art world had to be *moral* in its critical, curatorial and publishing ventures, it would grind to a halt instantly.)

Carter Ratcliff presented himself as a "journalist" whose subject is "ideology." This, he said, means simply "reporting – even in a theoretical piece – what's going on." In his role as journalist, he said, he shows "connections between the economic, fashion and style aspects of art," which prevents a "firm ideological position" of his own and is "what's under attack in my writing." (This is perhaps another disclaimer – of responsibility for the art he chooses to write about.)

Nicolas Calas began: "Politics and poetry are the two great passions of my life," adding that "there is poetry in painting and in words." Then, in almost the same breath: "Aesthetics are to artists as ornithology is to birds. . . . We must rid ourselves of such unnecessary terms as 'aesthetic,' 'art for art's sake' and the clichés of gestalt psychology. . . . Modern art must be vanguard art . . . polemical . . . experimental . . . and a continuous struggle, which is the only thing that is interesting. The things that are enigmatic create the greatest impression. . . . The only thing that should remain in the end is ambiguity."

Calas seemed unaware or unconcerned that many of his avant-garde catch phrases are mutually contradictory, that poetry *is* aesthetic, that ambiguous polemics are not possible (while ambiguity itself is one of the least attractive mannerisms of modernism – the refuge of lazy minds), that "continuous struggle" is a bore, and that at this moment art presented as "vanguard" is banal to the point of asphyxiation.

Barbara Rose's critique of the first three speakers was, "I can see I'm going to be the creep on this panel." Art is not about "fashion, journalism or culture," she said, but about "quality and values . . . things that are very profound and obsessional." As for biography, time, nature and the rest of Davis's concerns, "I already have those in my life [and] my own stories are more interesting than other people's." Rose is now doing the study of an artist who died in 1936 but will have his first one-man show this year at MoMA. "I stopped writing criticism when I saw it might upset the value of the art market. How could you hurt your friend's career?"

Speaking of criticism, she continued, "How many people in this room read art criticism? . . . I only look at the pictures. . . . The quality of art critics today is very poor and critical judgments are made by dealers, not critics. Economic factors attract a certain brilliance to the marketplace; the dealers I know are smarter than the critics and have begun to curate their own shows, better than the shows in the museums." Clement Greenberg's "excesses made people lose faith in criticism," but he at least "talked about the visual experience of looking at a work of art. Today criticism is redundant and irrelevant and no writer with the talent of a Rosenberg would waste that talent on criticism."

Joseph Masheck vowed that there is "a *scrupulous* separation between editorial and advertising departments" at *Artforum*, and that he is "really sharpening up the blue pencils" to correct that magazine's famous unreadability. Really, I thought, they should take sharp pencils away from a man who writes the sentences he writes and says "irregardless." Then I realized that Masheck is actually Steve Martin, "Saturday Night Live" art critic. I stopped trying to make his subjects and verbs come out even, and just enjoyed the parts I understood – two points both true and terrible: "It's easier today to get grants for a videotape of an orange rolling across the table than for serious painting," and, "There are only eight months left of the '70s" (fewer of course by now).

Ray Parker, in the audience, called out to Masheck, "Why don't you make *Artforum* more interesting to look at?" Calas

replied, "I find it very interesting to look at – even, sometimes, to read."

Irving Sandler asked Rose to define quality, which she did in terms of "the intuition one has in the presence of a great work of art." Today connoisseurship is deprecated as "elitist," she said, but "some people have spent a lifetime making value judgments in the museums. Like doing pushups, that's something you get better at."

And if that isn't every intelligent remark from three nights of all-star culture mumble, it's close to it. If Alex Katz's building-art-through-criticism theory were true, we could say now why most art being dished up is so anemic. The only energy came from Rose, who in closing made another astute comment: "Today the society is avant-garde, experimental, all the things artists used to be. . . . It's almost impossible for the real artists to recognize each other." Meanwhile, I don't think art *is* built through critics' criticizing – fortunately.

– Judy Seigel

"Art Writing and Criticism" (Report #2)

Moderator: **Irving Sandler**; Panelists: **Nicholas Calas, Douglas Davis, Joseph Masheck, Carter Ratcliff, Barbara Rose**
New Museum, NYC; May 9, 1979

Anticipating yet another version of the standard critic's disclaimer, "We have no power and no one reads us, anyway," I found the New School's auditorium overflowing with an expectant audience, which, as Barbara Rose put it, did not look "as if they were about to ask the usual 1960s question, 'How do I make it?'" Did this imply that the audience looked successful? Secure? Sophisticated? Shrewd? Savvy? I did see a lot of familiar faces.

The expected disclaimer was indeed made, but with a difference. My friend Jim Muehleman reminded me that painful honesty is in fashion these days.

Carter Ratcliff said, "I am not an idealist," and supported Barbara Rose's contention that the real critical and curatorial functions of the art world are now performed by dealers. In his opinion, "Most dealers are smarter than most critics and . . . they're smarter than a lot of artists, too." Moreover, "If you're going to set up critical values absolutely opposed to Leo Castelli's, you're going to have to set up [pause] very detached ones." Is detachment the new word for failure? Banishment? Sleep? A whole art world winnowed, beaten, sifted, by one such man?

Incidentally, this accolade elicited only one pained protest from the audience: "Everybody knows dealers are assholes, jerks, incompetents, and . . . eunuchs!" (A giggle from the rest who had apparently achieved the requisite "detachment.")

Douglas Davis found a crisis in American art criticism characterized by "rhetorical and pedagogical finesse with no passion at the core." His own concerns are "personality, time, nature, content and artifice."

"What's wrong with what Doug wants in art is that I already have those things in my own life," said Rose, who added that she finds her life "intoxicating." What she wants from art is "something I can't think of myself." On the other hand, "If only you, your cousin, and three friends understand your work, you're just engaging in a form of belly-button-lint gazing." Irving Sandler protested: "Even [Barnett] Newman's peers didn't understand him!" (I wonder if Sandler has considered that maybe Newman's peers simply disagreed with him.)

As for criticism, Nicolas Calas elucidated the nature and satisfactions of understanding modern art with great eloquence. The task of the critic, as he sees it, is to "explore and follow the thinking of the artist in order to form a dense image." For Calas, criticism is a continuous struggle and constant learning. It means reaching directly for the intellectual and poetic core of art – what is most resistant to discussion and analysis. His description made criticism seem, not a job, or a compromise, but a calling worthy of his own extraordinary abilities.

Carter Ratcliff, on the other hand, said that on those days when he's "doing art criticism," he sees himself primarily as a journalist. "The subject matter I report on is art, ideology and art writing itself as manifestations of style." By extension, there is "an attempt to question the curious, circular ideology of the art world, which is that being in the art world is better than being somewhere else." Ratcliff intends also to "show connections between art and things outside the art world – money or the uses to which art is put by the larger economic system."

Tom Wolfe's *The Painted Word* was ridiculed by art worlders because it was the kind of flattened parody a curious and energetic outsider would derive from surface evidence. But, hearing the same kind of uninflected views from those knowledgable about more than the exterior of the art world, we may doubt their "intuitions" – and some of their other powers as well.

When Barbara Rose said, "I believe that art is about quality and value," she was thunderously applauded. But the rest of her discourse on the "crisis," suggested that she finds quality, taste, value and price interchangeable, as she finds all these determinations are made in the marketplace. Pressed to define quality, she offered, "Quality is an intuition one has in the presence of a work of art." That sounds good and is hard to argue with because it escapes through the loophole of intuition, without actually revealing what the intuition is about. Thus it can suggest other considerations ("What I can't think of myself," for example) without eliminating taste.

As for her colleagues, Rose announced, "If you publish in art magazines . . . where editorial space and advertising space are in no way differentiated, you are writing advertising copy. If you don't know that, you are very stupid. If you practice as a profession something at which you can't make a living, you're very stupid. Therefore the quality of the people who, at this point, purport to be art critics, is not high. . . . No-

body reads art criticism. . . . I don't. I look at the pictures like everybody else."

Joseph Masheck disagreed: "If we really take seriously what we're doing, we'd be willing to drive a taxi for a few years." Unfortunately, he did not articulate this position well. One senses that he is following an unformed certainty, the dimensions and character of which he has not yet determined. Still, his sincerity and urgency engage our interest. We want to know more.

Rose again: "If we're going to be honest as critics, we have to admit we don't know everything at the time."

– Pat Passlof

Women Artists News, June/Summer 1979 [Vol. 5, No. 2-3]

'79 / #117

Stars Come Out for NYFAI

The message, or messages, and the "update" make any further comment gratuitous.

New York Feminist Art Institute Benefit

Speakers: **Miriam Schapiro, Linda Nochlin, Gloria Steinem, Carol Bellamy, Louise Nevelson, Kate Millett**, others
Mezzanine of One World Trade Center, NYC; March 30, 1979

After egg rolls and rum (donated in huge quantities), Miriam Schapiro introduced the five other members, besides herself, of the New York Feminist Art Institute Board of Directors: Nancy Azara, Lucy Lessane, Irene Peslikis, Carol Stronghilos and Selena Whitefeather. Outlining plans for the education of "women-artists-makers" in the new school, Schapiro said it would be "a repository of women's wisdom," where students would learn "to make art in their own image." Education, she said, will include consciousness-raising, collective projects and traditional women's art forms such as journal writing.

Linda Nochlin spoke of the historic oppression of women students in male art schools – their exclusion from life-drawing classes in the 19th century and their separate, but *not* equal, facilities and opportunities.

Gloria Steinem said that, although she is a verbal rather than a visual person, she has been educated by women artists, and that there can be "no revolution, no justice without art."

Carol Bellamy, after voicing support for the school and the goals of the women artists' movement, introduced Louise Nevelson as the woman she always tries to look like. Nevelson made a brief statement, impressive because of her deep voice and dramatic appearance.

The last speaker, Kate Millett, said our society still has no respect for women artists, and it is time for New York to

have a feminist art school. Then she spoke at length about her recent experiences in Iran. For me at least, this was a particularly exciting and immediate talk. She described the bravery and audacity of the Iranian women who led the revolution against the Shah, adding that Americans have a special burden and responsibility to support the women of Iran.

Gloria Steinem ended the festivities with a strong pitch for contributions, declaring that she was "turning a trick for the movement." She implied that the men in the audience might "survive the revolution" if they would pay reparations.

– Joyce Kozloff

Women Artists News, May 1979 [Vol. 5, No. 1]

Update: The New York Feminist Art Institute closed in 1990.

'79 / #118

Lies of New York #4: "I Always Look at Slides"

"Artists versus Dealers"

Moderator: **Arnold Glimcher** [Pace Gallery]; Panelists: **Leo Castelli, Betty Parsons, Holly Solomon, Jock Truman**

New Museum, NYC; May 23, 1979

In a glutted art market, it would be surprising if there were not animosity between art dealers and artists. In this discussion at the New Museum, dealers and artists ostensibly set aside their animosity in order to understand each other better – and failed abysmally. The big mistake was in the choice of panelists, all primarily known as art dealers. The audience was made up of artists and a few collectors. Panelists spoke first, from the dais. Sides were clearly drawn.

In a somewhat embarrassed, but self-congratulatory manner, panelists entertained each other with stories of how they began their careers and rose to success with the help of more experienced dealers.

Arnold Glimcher then opened the session to questions from the audience. The thrust was parried with a slow, formal question about the position and marketability of photography in galleries. Because their collectors are not in the market for photography, most of these dealers said they find photographs difficult to sell.

The questions that followed were more vehement, and fed a steadily mounting tension and anger:

How do you make decisions on unknown artists? Does the press influence you? How much does the dealer try to influence the artist? What is the best way to approach galleries? Do you think that rich artists and dealers should be taxed and the money given to poor artists? Do you counsel for in-

vestment? How do you build an artist's career? Are there enough collectors? What do you think of artists' contracts? What do you think of critics? Don't you think you might divest yourselves of some of your authority and return it to the curators?

After a number of testimonials from the audience on the impossibility of getting these dealers to look at their work – and after some flippant and some exasperated answers from panelists on the impossibility of seeing it all, one collector asked, "How can you have such a patronizing attitude toward all these artists – not looking at their work, not wanting new art?"

My own experience with these dealers is that those who swore and testified so sincerely that they do everything to help young artists, and always look at their slides, in fact do not. It was in part this blatant denial of fact that roused the audience to anger.

In summary, young hopefuls can try the following: obtain an instruction sheet from Alan Frumkin on how, where, and when to show slides; attempt to get past the secretary to the dealer (as one panelist put it, "it's the artist's job to get to you and your job to hide"); or know someone who knows someone.

Once past these preliminaries, meet the following criteria (for Holly Solomon): your work is good; it will remain good; you are ambitious – you want to be a great artist; you are recognized (not necessarily appreciated) by your peers; you can work with the dealer in question.

How do galleries sell art? Dealers say they nurture a group of collectors who become the nucleus of their market. These people are often educated by the dealer and called when a work of possible interest to them arrives. Dealers also keep slides of their artists' works on hand, publish catalogs, advertise, pray.

Other dealer wisdom: Critics rarely matter. Except for Clement Greenberg, they rarely affect the market. Artists' contracts are not popular with collectors, who want a feeling of ownership, not of caretaking. And from Glimcher, "We find the artists for the media and for the museums. Part of our role is curatorial – after all, who knows the artists' work better?"

Some information passed from dealer to dealt in these few hours, though no exchange worth recounting. But the final outcome was anger, frustration, and bitterness, artists and their sympathizers standing up and shouting at the dealers, Holly Solomon in tears.

– Nancy Ungar

Women Artists News, September/October, 1979 [Vol. 5, No. 4]

'79 / #119

They Know What They Like

"Collectors and the Private Patronage System"

Moderator: **Gene Schwartz**; Panelists: **Barbara Schwartz**, **Sondra Gilman**, **Richard Brown Baker**, **Dorothy Vogel**, **Herbert Vogel**

New Museum, NYC; May 30, 1979

Hungry artists arrived in droves to hear collectors tell whom they buy and why.

Affable moderator Gene Schwartz posed simple, direct questions to his panel. Asked what their criteria in selecting art are, all the collectors said their attraction to the work is the important thing.

Sondra Gilman: I get a feeling in my stomach, an actual physical reaction.

Gene Schwartz: I research, learn everything I can about the artist and his work, then throw it all away and react emotionally.

Dorothy Vogel: I buy whatever will fit into the apartment.

Richard Baker: I want to buy the best in the show, regardless of size.

Questioned about being artists' patrons, none of the panelists said they were. Although the Vogels keep files on artists and follow their careers closely, they don't patronize any in particular. Baker, while he has never supported one particular artist, likes to have several works from each. Gilman wants no artist friends, a separation she thinks is necessary. In contrast, Barbara Schwartz maintains serious friendships with artists, although not all are in her collection, because she feels that collectors, whether or not they buy, "can help artists by having dialogs with them."

At one point in the discussion, Herbert Vogel exploded, saying that today's young artists are forced to exhibit in alternative spaces where they are seen once and disappear because they can't get into a gallery. "Young artists are just being thrown away." Later, from the floor, Lila Katzen observed that some older artists are equally ignored. Vogel responded that a "young" artist is one of any age who hasn't received due recognition.

None of the collectors would admit that they consider investment when buying art. Indeed, the Schwartzes were the only ones of the group who sell work. They explained that they often spend every available cent on art and, finding themselves broke, are forced to sell. They also want to make room for new works, as well as "trade up."

Gilman and Baker both observed that current works by some artists in their collections have escalated so much that they are "priced out of the market" for new ones. But they "can't bear to part with" any they own. Baker quoted the late Martha Jackson's philosophy on collecting for profit: "Al-

ways buy two works from an artist, later selling the lesser work for a profit and keeping the better one."

The moderator asked panelists to name their latest acquisitions. Most often mentioned were recent works – the New York School, Frank Stella, Photo-Realism. Yet, asked about their "dream purchase," Baker and Dorothy Vogel responded with Cézanne and Monet respectively.

What is the impulse to collect art, anyway? These collectors were proud of their achievements, certain that they bring to collecting an aesthetic mirroring that of the artist. Indeed, Gene Schwartz said, "Buying requires the same clarity [of vision] the artist has." Artists may find it galling that the collector is a kind of celebrity, but this is not new. In the art world, it has always been a buyer's market.

Barbara Schwartz found "the collecting impulse gathers a momentum that becomes a madness." The walls get filled and still more and more works are bought. She expressed some guilt about the private collector owning works denied the general public, but described how hard it is to lend work without having it damaged.

Participants were lucid and passionate about their love for art. Even a few barbed questions from a very informed audience failed to raise the temperature. For example, "You haven't mentioned collecting the art of the '70s: gay art, women's art, black art." The unanimous response: "We buy good art, no matter who does it." However, most of them purchased work from galleries where minority artists are seldom represented. The Schwartzes and Vogels buy from artists' studios as well; Barbara Schwartz spoke of using her "network" of artists and friends.

Future prospects for collectors like these, described by Baker as having "very individual tastes, which is good for artists," are faint. Herbert Vogel calls the private collector "almost extinct." As for the current phenomenon of corporations buying art, opinion varied, from Barbara Schwartz's approval because it exposes art to people who wouldn't ordinarily see it, to the Vogels' observation that the art thus selected tends to be rather pallid and second-rate.

I approached this panel with my usual cynicism toward any member of the art establishment. But I was charmed. In particular, Dorothy Vogel seems to be a direct, modest woman, dripping in neither mink nor camp. Her husband, Herbert, drew applause. A small, kindly man who had little to say at first, his voice boomed with eloquence when he took the part of artists, "who are treated as disposables." My young artist friend (I mean really young – 25) approached him, heart in mouth, to ask if he would look at her work. He agreed to see her that week.

– **Donna Marxer**

Women Artists News, November 1978 [Vol. 5, No. 5]

'79 / #120

Eleanor of Aquitaine to Holly Solomon

"'Matronage' from Medieval to Modern Times"

Speakers: Christine Bernstein, Holly Solomon, others

Women's Caucus for Art, NY Chapter, at Naomi Teppich's loft; October 12, 1979

This program on "matronage," support of the arts by women, discussed examples in the Middle Ages and women's role as collectors today. Christine Bernstein, associate professor at the University of Michigan, gave a slide talk about her research on medieval women who supported the arts with their money and prestige. Some notable names were Eleanor of Aquitaine, Blanche of Castile, and Matilda of Canossa. Many less famous noblewomen and heads of religious orders also promoted the arts, from cathedral sculpture to illustrated breviaries. Bernstein closed with examples of "consumer" art commissioned by the emerging upper-middle-class woman of the 14th century – personal luxury items, such as carved ivory combs.

Sidestepping matronage in the intervening six centuries, when women from Marie de Medici to Mrs. Potter Palmer supported artists, the program moved to the contemporary scene. Leading the discussion was gallery owner Holly Solomon, herself a collector. Two years ago, she estimated her collection at around 400 works, 40% of them by women. Solomon's major complaint was that there are so few women collectors today, a refrain she has repeated on numerous occasions. One of her more cogent points was directed at universities that "churn out art students, but not one collector." Why, indeed, don't universities teach "cultural responsiblity"?

Discussion, heated at times, touched on collecting as hedonistic activity and investment, the tendency of museum board members to push their favorite artists and art styles, public versus private support of the arts, and corporate collections, among other topics. Aside from Bernstein's beguiling reminder of historical precedents in matronage, the major value of the evening was discussion of support of the arts today.

A special effort had been made to invite women collectors, to encourage dialog among artists and collectors. Perhaps a half dozen came, but they were not readily identifiable in the crowd, and few spoke. However, those who did comment were unanimous in enthusiasm for the "excitement" of collecting. As Ursula Parke said, "It's great fun to buy art."

– Sylvia Moore

Women Artists News, December 1979/January 1980 [Vol. 5, No. 6-7]

'79 / #121

I Have a Feeling We're Not in Kansas Any More.

It was 1979. They thought New York was "impossible," but they were clear about why they made art here – or why not. Today, of course, New York is beyond impossible. But much of what they said about making art (and "it") in the city is still true.

"Why Make Art in New York?"

Moderator: Lori Antonacci, filmmaker; Panelists: Jack Sonenberg, sculptor; Martha Wilson, performance artist; Diane Burko, painter; Loren Madsen, sculptor; Ted Thirlby, sculptor

Artists Talk on Art, NYC; October 26, 1979

Panelists showed slides: Diano Burko paints places like the Grand Canyon and Colorado using photographs shot from an airplane. Ted Thirlby's constructions incorporate found objects, "like a pipe left over from installing my toilet." Jack Sonenberg said his large outdoor sculptures, extending as much as 200 feet across a field, are "geometric constructs in nature." Loren Madsen's sculpture of bricks suspended on wires could include 2000 bricks, "real tedious" to make. Martha Wilson showed slides of her performances and sang songs from the repertoire of her band, Disband. Lori Antonacci showed excerpts from her documentary film, "Freedom to Know," but said she planned to do shorter works in future: This one cost $30,000 to make.

Introducing panelists, Antonacci noted that Ted arrived in 1974 from Travers City, Michigan, Loren in 1977 from Los Angeles, Jack right after World War II from Toronto, Martha from Canada in 1974. Diane is a native New Yorker who lives in Philadelphia.

Lori Antonacci: What were the myths that got you here – or the realities?

Ted Thirlby: I was drawn to New York because of the art galleries and the other artists. Even more, I was drawn by the mystique of the big city and the real life. So, here I am. I found it.

Loren Madsen: I came for about 50 very obvious reasons, and 50 less obvious ones, the obvious being that in L.A. there are 40 galleries and in New York there are 400. And the museums, and the publications, and the fact that it's the financial capital and direct link to Europe. There are more artists here, too. . . . I was starting to do fairly well in L.A. It was a question of becoming comfortable or putting a little salt in the wounds. I wanted to put some salt in the wounds. New York is the perfect place to do that.

Also, if I was going to play at all, I wanted to play with the big kids. This is where the big kids are. Not just at 420 [West Broadway]. I'm talking about going up to the Met and the Modern, and the Guggenheim and the Whitney, and contrasting my work – or your work, or whoever's work – with what's hanging there. And in this town, you have that

opportunity as in no other town in the United States. This is where the energy is, and the excitement. And the rents are lower than in L.A., if you can believe that.

Antonacci: You say, "pouring salt on the wounds." Martha, you've said New York is purgatory for artists. . . .

Martha Wilson: I started by saying New York is Mecca. For a long time, I wasn't an artist and New York didn't mean anything. I was an English Lit major, so I could live in Montreal, or any place. Then, when I decided I was an artist, suddenly, I had to go to New York . . .

But my notion of New York was of a terribly bitter, horrible place, where other artists hate you and try to make you feel like shit. When I got here, I found that artists, especially women, were very supportive and thought I was great. It's not purgatory, after all, except for the rents, the crime, and all that stuff. In terms of art, it remains a mecca.

Jack Sonenberg: When I came here, there just wasn't any place else to go. I was living in Toronto and had no one to talk to. So I really came here to escape having to talk to my own family. My major concern was escape.

If you realize that in Toronto, Canada, when I left, there was one art gallery, and it paid its rent by having wedding receptions on Sundays, you understand the appeal of New York.

Antonacci: What keeps you here?

Sonenberg: I've stayed, but it's both attraction and repulsion at this point. I think all of us . . . hate the place as well as love it. But when I came to New York, you could rent a loft for $15 or $20 a month, and you could rent an apartment for $40 or $50.

Antonacci: Jack says it's love-hate. Diane, are you *not* here because you hate it?

Diane Burko: I don't hate New York. I love it. It's ironic that on this panel about why we make art in New York, no one's a New Yorker but me. I was born in Brooklyn, raised in Brooklyn, and you can tell by the way I speak I'm from Brooklyn; certainly everyone in Philadelphia can tell. What got me to Philly was graduate school. I made a conscious choice to stay and I've been there 13 years. I still consider myself a New Yorker – it's only an hour and 40 minutes by train. And I appreciate what Loren said about the museums. I feel they're mine, too. But being away from New York has allowed me to turn it on and off in terms of pressure and hustle.

I'm supposedly frenetic and full of energy – much too fast for Philadelphia in speaking or walking. I literally used to trip over people when I got off the trolley. When I taught the first year, I found out later there was a rumor I was on speed. My personality is so much the typical New York kind of hype personality, that Philadelphia sort of balanced out my karma and made me much saner. And as far as rents go, they're fantastic in Philadelphia. I've been very spoiled.

Antonacci: We should all move to Philadelphia?

Burko: Well, basically, it's real estate value. I'm somewhat middle class and I have a family, and I teach. I can have a lot of comfortable things – a good studio assistant, a good day-care facility. I couldn't afford to live in New York. My nice

11-room townhouse on 64th Street would cost more than half a million dollars.

Antonacci: I came here from Chicago in 1975, but I'm originally from a very small town in Illinois. I came basically to have an adventure. I was between jobs and doing nothing in particular in my life. I had majored in art history and film-making at college, but they didn't teach anything beyond the beginning of contemporary art. Nothing about Soho. Not even about the New York art community of the '50s. When I got here, I started reading about that and felt a bit nostalgic at having missed it. But there was still an artists' support system. I began doing art again after a pause of several years.

Almost everyone on the panel has said something about the hustle of New York. The things that are prized in the midwest, a very straight way of doing business, don't operate here, but there's a particular energy that I've never found anywhere else. And it calls to parts of me I never used anywhere else.

Martha Wilson: New York looks like a very big, ominous place that can't be cracked when you're outside it. And then you get inside, and you live here for a year or two. And what I discovered was that there's so much going on . . . it's possible to carve out a job and a little place for yourself and not be noticed too much by the larger world.

Consequently, a few years into my life in New York, I had a teaching job at Brooklyn College. And then the city nearly defaulted and all the teachers were fired, and I was fired. I thought, I can go back up there to work in a corporation, or I can start my own business. I chose, of course, to try to start my own business . . . a non-profit arts organization.

New York offers a large enough community that a little rickety place like mine can survive, because there are 5,000 people on the mailing list and a real community that supports the particular corner of art we care for, which is published works, artists' books and pamphlets and magazines, cassettes, records and material like that. Many artists either live here or send their stuff here when they find out Franklin Furnace is down there to take care of it.

And the grapevine that [reaches] out of New York is much more efficient than the grapevine out of any other place. So, the importance of New York is as a distribution center, not only for goods, but also for art ideas. When I came down here to live, my art changed radically. Everything about you changes just because of the influx of information and the life style that's so different.

I think the sense of community is different, too: It's actually very strong. If I had continued to live in New Town, Pennsylvania; Wilmington, Ohio; or Halifax, Nova Scotia, I couldn't have started an arts organization. And I couldn't have done the kind of art I do with other people.

Loren Madsen: I think there are basically two kinds of people in New York. People who were born or raised here and don't know enough to get out. And people with ambition and aggression who came here. And that goes for wave after wave of immigrants, certainly for all the artists who have moved here. Because it's not the kind of place you move into if you're looking for a comfortable place to bring up the kids. I mean,

you have to have something that you want to be doing for yourself and your life. That's the reason to move here.

Sonenberg: What we're talking about is opportunities in New York for being an artist. But a lot of artists who have succeeded, then move out. They still continue to be important artists, but prefer to do their work outside.

I don't think I'd do that, if I had the option, because here there's a sense of *time* that's lacking anywhere else. . . . The moment I go to the country I lose that sense of the immediacy of the moment and everything just seems to disappear in terms of confronting issues. So it's absolutely necessary for me as an artist to be here.

Thirlby: About your idea of time and New York's particular time frame: I often feel, because I'm so busy and there are so many things I want to do or have to do, that I'm actually living a week or two ahead of right now . . . focused way ahead of where I am and that has a strong effect on the way I work.

Another thing is the sort of entrepreneurial hustler scene. I came here without apparent skills, and have fashioned a money-making career to support myself. I made it all up as I went along, and convinced people I could do it, along with convincing myself. I think the town encourages that kind of thing.

Burko: I don't think it's the town. I think it's the person. If New York is in your blood, you just have that energy. I don't think it leaves you because you leave the place.

Antonacci: I didn't have it before I came here. It was in me [but it] didn't function in the midwest. Here you feel a sense of the people producing around you.

Wilson: New York offers something different from a place like, say, Aspen, Colorado. That's the stamp of approval. There's something about living in New York so strenuous that even if you've lived here just one year, you can get a teaching job in Ohio. You just say, "I lived in New York."

Madsen: I agree. Simply living here lends a certain cachet. Since I moved out of L.A., my reputation there really skyrocketed – and I haven't done a thing in L.A. If you live in New York, you're automatically considered (1) very adventurous and (2) a survivor.

Wilson: The people who live in New York are willing to uphold that myth. We're always patting each other on the back and saying, "Well, did you get a victory today?"

Sonenberg: But when you talk to most people, they don't sound that way. Everybody's pretty sour about New York. It's becoming more and more impossible. It's still the urban center that Paris was and maybe Berlin at one time. But there's no guarantee that will continue.

I think when people talk about being driven out of Soho or this place or that place, they're really talking anxiously about the possibility of the demise of New York as an art center – an obvious possibility. I almost feel the hustle and bustle will finally be what destroys the place. Now we see so many artists hustling to be real estate operators, or dealers involved in real estate, not art. . . .

Burko: Do you want to move to Philadelphia?

Sonenberg: I think it would be healthy for artists to have an option. I don't have an option.

Antonacci: OK. We've got problems. What are the big problems?

Madsen: I wonder if the problems Jack raised aren't endemic to all large metropolitan centers. Certainly in L.A. a lot of artists have become real estate entrepreneurs. And in Chicago. It's a great misfortune that we don't have other centers. Wherever you go, any large city – Washington or Houston or L.A. or Chicago – tries to represent itself as the coming center, until you start talking to the artists. Then they all say, "Well, I'm going to move to New York as soon as I can get out of this damn place."

Antonacci: We're talking about where the artists are and the art is, but doesn't that [itself] bring pressures?

Thirlby: Well, the pressures are different. I'm talking about the internal pressures of working. I worked in the midwest for a month this summer. I see myself here as a rather conservative artist, rather conventional, and I feel a lot of pressure to try to innovate, as a way of perhaps drawing more attention to my work and myself. Back there, I was doing my same "conservative" work and showing it to people who were artists or who thought about art. And their response was, "It's interesting, but it's not sculpture."

So the pressure of New York's more refined, more esoteric art scene may keep me moving forward. But it could be, if I were [in the midwest] and relaxed, other things would come out that would be better. Who knows?

Sonenberg: I just take it for granted that this place is such a focus for energy that people do their best work here. But everybody's becoming very middle class, and the only kind of success that matters is commercial success. . . .

If artists 10 years ago had faced the kind of situation developing in Soho right now [influx of non-artists; city's attempt to grandfather in non-artists, rising rents, etc.], there probably would have been an enormous outburst. But now everybody's just sitting around and taking it.

Madsen: I don't mean to bad-mouth L.A. L.A. was very good to me in the sense that when I was a student and a younger artist, there was a very flourishing art scene. *Artforum* was there, and the L.A. County Museum, and the Pasadena Museum of Modern Art. The material was there you needed to look at.

At the same time, there was very little pressure. I was allowed to develop along my own lines without anybody saying, "Hey, let's see the work. When are you going to show it?" You could be fairly reclusive in the studio and still have the emotional support you needed from your friends.

My experience here, particularly amongst younger artists, is that they get enormous pressure: "When are you going to show?" "When will you have it together?" "Can I come and see your stuff?" And this in their early 20s, when they're still trying to sort things out and find their way through styles and ideas.

Wilson: That kind of pressure is preferable to attitudes in, say, Halifax, Nova Scotia, when I was trying to invade men's rooms. My teachers were telling me, "What you're doing is

not art. . . . You're a terrible person for thinking up this kind of art." It took somebody from New York who came to Halifax and said, "You're doing good work. Send me your stuff," to tell me there was another world out there with different rules. And the rules here are very flexible. You can walk down Fifth Avenue smoking a joint. Nobody cares. You go down Fifth Avenue in New Brunswick smoking a joint and you're arrested.

So, I think the pressure is one of absence. There isn't any limit to art when you get here. You discover there's so much going on that you *have* to create. You're throwing things into a vacuum.

Antonacci: That's part of New York in general – anything goes. Whatever you can hustle is yours.

Wilson: That doesn't exist any other place. I can't think of a burg in which there are no limits, except maybe L.A.

Burko: New York is the mecca and the marketplace, but being away from it and making it in that little pond [Philly], was very easy to do. . . . One of the reasons I stayed in Philly after I finished school [was I could] keep working and developing. I was lucky enough to find a good dealer who was interested in me even before she was ready to sell me. If you're from New York and you go to any small town, if you have talent you could be *the* artist. Then you can come back to New York, and have a bit more of an edge.

A friend of mine went to see a New York dealer, who will remain nameless, and she [the dealer] said, "I don't care what your art looks like, if you don't have a few collectors and a following, I can't take you on." So if you develop in one of those burgs, you can come here and have a bit more going for you – except if you're going into men's rooms.

Antonacci: But there's a difference between "little burgs" and L.A. or Philadelphia.

Burko: Anything's little compared to New York.

Antonacci: Loren, you said earlier this is the one place in our society you feel respected as an artist.

Madsen: New York has a history, and New York is attached to and an extension of European history. All that European history came over on the boats with everybody else. And I have a sense here that art history continues – as well as other political and social histories. I feel part of a continuum here that I never felt part of in L.A. or any place on the west coast.

In L.A., history was last month's *Artforum*. Here you can go up to the Met and be very close to El Greco or Velasquez or whoever you happen to like – and feel part of that history. People brought up in this context have a respect for it I don't find any place else.

When I first did a show in a museum here, I couldn't believe how well they treated me. They thanked me for coming and doing this piece. Instead of, they're doing me a favor, I was doing *them* a favor. I thought, "Give me a ticket to town."

Antonacci: Jack, when you moved here, there was a very small, close art community. Has it changed?

Sonenberg: While Martha was talking about charging into men's bathrooms and getting away with that better here, I

was thinking of years ago, going to St. Louis to study. It was the height of the McCarthy era, and we were put through an incredible inquisition at the university. At that time, just being an artist was pretty close to subversive. I always have the feeling that redneck America is out to get us, and at least New York offers some sort of refuge. I remember coming back to New York with an incredible sense of relief that I was safe home again.

Burko: I think there's a sense of community in New York that you can't find anywhere else. I know artists from Philly but I don't feel as close to them.

Wilson: I think that's critical mass. There are more artists here, so you can pick better. There are how many in Philadelphia?

Burko: Well, there are four art schools and about 40 galleries. There are a lot of artists, but they're not as good as New York artists.

Audience: Was it easier to be an artist in New York in the '50s and to be successful?

Sonenberg: New York is about the only place you can expect to receive [major success]. People then did not deliberately take vows of poverty. They wanted some sort of material success. . . .

Audience: What about needing to keep your art pure but needing commercial success so you have more time to make art? Is that more difficult in New York than redneck America?

Thirlby: I'm able to make my living another way, independent of my art, and I like doing it. I don't make money, or very little, from my art, although I devote most of my real energy to it. And that's a conflict.

On the one hand, I feel like I'm beginning to understand what I'm doing and project it. On the other hand, I can't resolve my lack of commercial success, and more importantly, my obscurity as an artist. If New York does exert a pressure, at least it offers the *possibility* of wider recognition – and money. If you don't have that, it's hard to keep those tensions out of the work. The tensions are in *my* work – and in me too, a kind of anger.

Audience: You feel pressured?

Thirlby: I feel a pressure – and a confusion, because, although I feel I am successful as an artist in my work, I don't have the trappings of recognition or money.

You always wonder, "Is this work really communicating? Am I really projecting myself?" Apparently other people do that and get money and recognition. And *apparently* I'm doing it, but not getting those things. So, maybe I'm *not* doing it. It's an insecurity – and difficult to resolve. You feel successful as an artist, but you don't get the trappings.

Wilson: You make this work, but you don't make it for money. You make it for art. And yet you want to sell this work when you're done making it. And one way I got myself out of this problem was to make a kind of art that's not commercially viable at all. It's non-saleable. Poof! It disappears. So I escape the need to produce a product which is then sold after I've done it for art.

Burko: A lot of my friends, who went to the same schools I did, are doing really shitty things with their lives and making a lot of money. I think I'm doing a fantastic thing with my life, and I see nothing wrong with getting paid for it, godammit. If you make so much money it stops you from making art, you're that kind of person.

Sonnenberg: Ted commented about knowing you're successful on certain terms but not getting the rewards you think you deserve. I think all of us have been snowed by the notion that being an artist can be something like being a movie star. And that really was begun by the dealers, who created these great artists through an incredible manipulation. So every time Jackson Pollock sells for two million dollars, that makes him terrific, wherever he is, but it diminishes us.

We're trying to reach a very small audience, and if we can do that successfully, that should be gratifying. But we're all confused about this other thing – being like a movie star.

Audience [woman]: On the one hand, New York has an art community large enough to stimulate your art. On the other, is New York still the center from which art emanates, the center for art ideas? Are art ideas being *processed* here or *emanating* from here? Martha says she gets stuff from all over the country and she does whatever with it and it looks for a while like it's *coming* from New York.

As I see it, the schools, the innovations, the people doing definitive new work are absolutely not in New York.

Audience [man]: I just got off the plane yesterday from San Francisco. This is my first experience here. [To woman] What you're saying about geography is not true, except for Ansel Adams.

Madsen: I can't see that great art is happening on the west coast.

Audience [man]: Let me give you an example about things back there. I was sitting in a French restaurant in San Francisco a couple of weeks ago with a group of about 12 artists. We were talking about portraits and I brought up something about space and the comment was – and everybody agreed – "let's not get heavy." That's the antithesis of New York. This is the intellectual cutting-edge of culture. [It's an] atmosphere that does require a certain amount of pressure. And it's where I'm going.

Audience: But the impetus for art could in some circumstances be from a more isolated situation or environment . . . A certain kind of discovery and powerful art can happen outside New York.

Antonacci: But another reason I think we came to this city is how making art in New York affects the art.

Madsen: [Before the panel] I asked Diane, given what you're painting – mountains and canyons – why aren't you in Arizona?

Burko: And I said, or should have said, "If I were in Arizona, I'd be painting New York skyscrapers." *Going out there*, not being *from* there, is what I need as stimulation.

Madsen: I would say art has less to do with materials or styles or forms or nature or geometry than [being] simply a cultural activity. And cultural activities happen in large metropolitan areas, no matter what they're about.

Audience: I find too much emphasis on this man-made, "cultural" activity in New York. To me, it's almost masturbation. When I finally got out of New York on a grant and looked at the earth, and the sky and those simple things, I couldn't believe it. I had become a part of a world of careerist concerns and people talking, which is great, but this natural element was left out. I had seen only what was man-made.

Audience: You talk about New York as if it were empty, a place [just for] people to come who want to be aggressors.

Wilson: If you live in Wilmington, Ohio, you have to live with the mayor and the police chief and all of them. I think it's great not to have to live with those people stabbing me in the back. I can choose the people I want to live with. There are lots of different kinds of people in New York.

Edited from tape.

'79 / #122

Morality Play: "Big Bad Businessman"

"Corporate Support: Positive or Negative Influence on the Arts?"

Moderator: **Mary Lanier**; Panelists: **Jack Boulton, Gideon Chagy, Christo, Barbara Gladstone, Hans Haacke, Robin Winters**

The New Museum, NYC; November 3, 1979

If the artists on this panel had written the whole script, it would have indeed been the medieval morality play panelist Gideon Chagy called it, with Chagy himself cast as the personification of evil. Erudition notwithstanding, as vice president of the national Business Committee for the Arts, hence the "Voice of Business" on this panel, he took the rap for all the misguided and self-serving forays of business into art. He managed, nevertheless, to play a valiant, if rather defensive role in the face of artist-critics Hans Haacke, Christo, and Robin Winters. (Other panelists and moderator Lanier treated him more kindly.)

In fact, Chagy's talk was more believable than the stereotyped angry-artist-hates-business routine of Robin Winters, who seemed to have gotten his lines from a '60s underground newspaper. Fortunately for the artists' side, Haacke and Christo gave more credible performances. Christo can always talk about the huge business enterprises his art projects involve, and Haacke came armed with quotes from business and cultural leaders reflecting questionable interests of business in funding arts – quotes Chagy dismissed as out of context or dated.

With all the rhetoric flying between Artists (the Good) and Business (the Bad), the remaining two panelists seemed con-

135

signed to minor roles when they did not join the fray. Jack Boulton, formerly with the Cincinnati Contemporary Art Center, currently works for Chase Manhattan Bank, and Barbara Gladstone sells art to corporations.

Chagy insisted that corporations are as idiosyncratic as individuals in giving money to the arts or buying art, and have many motives besides narrow self-interest. The broadest view, he said, is that it is simply good business to support a vigorous art and cultural life: it stimulates employees' innovative and creative tendencies, helps foster a rich cultural milieu or "matrix" that may in fact inspire or improve the commercial arts that business itself uses, and may help attract good people to the company. He admitted that some businesses do support art to help improve their image in the community, but denied that business always supports "safe" art, citing support for some controversial projects. (One assumes, however, that the balance is still strongly on the side of safe projects that help the corporate image or the bottom line.)

Hans Haacke said he sees the main message of corporate largesse to the arts going to liberals, who need to be continually reassured that the free-enterprise system is a good thing, and whose influence in Washington could be beneficial to business or harmful if they're not persuaded by such good deeds. Chagy took exception to this, accusing Haacke of being contemptuous of liberals.

Chagy also accused Haacke of being contemptuous of the "ordinary people" who attend the well-publicized, corporate-supported blockbuster museum shows. Responding to Haacke's claim that corporate support has reduced the number of difficult art shows and those by younger artists in favor of safe art, he noted that museums don't have to take corporate money. They could cut expenses by slowing growth and reducing ancillary services.

This argument seemed to place the onus on museum curators and boards rather than business. However, the fact remains that what gets funded flourishes. As Haacke pointed out, "Alternative views are seen as crank positions," a clear reference to critical positions such as his own.

Marcia Tucker, founder and director of the New Museum, where the panel was held, came to the defense of business, saying there have been no strings attached to corporate funding of the New Museum, which purports to show art not accepted by more established institutions.

Barbara Gladstone pointed out that corporate attitudes toward purchasing art for office decoration are very different from those involved in building corporate collections. There are always fewer buyers for "difficult," ephemeral or controversial art, or art with specific political content, she said. Still, she cited some notable cases where avant-garde work has been chosen. In her experience, most corporations spend $1,000 to $5,000 for paintings and sculpture by younger artists and under $1,000 for prints. (However, another seller of art to corporations recently told me that most of them want the art, frame and all, for $100!) Gladstone suggested

trying to increase the number of corporate buyers in order to spread or dilute the impact of their power.

While the panel provided a lively discussion of the issues, most of the pros and cons of corporate arts support are more thoroughly and coherently discussed by Alvin Reiss in his 1972 book, *Culture and Company: A Critical Study of an Improbable Alliance.* Reiss outlined the development of substantial corporate support over the previous 15 years and foresaw the dilemmas and dangers of the present.

What neither the panel nor Reiss adequately explored is the relationship of business funding and government funding to each other – how they exert "leverage" on each other in a kind of alliance of power that artists and arts administrators have to contend with. The issue would seem to be to secure a balance of power. *Whatever* these behemoths do, it will change the game and its rules, and affect all other players, even lesser entities of their own kind, like local arts councils and small businesses, who tend to play follow-the-leader. Faye Levine perceptively outlines this process in the "Battle for Control of Lincoln Center," a section of her book, *The Culture Barons.* Rockefellers, Mellons, Kennedys and the NEA set the pace.

– Jacqueline Skiles

Women Artists News, December 1979/January 1980 [Vol. 5, No. 6-7]

'79 / #123

Fighting the Last War

"Who Creates Art Movements: Artists or Critics?"

Moderator: **Joan Marter**, art historian; Panelists: **Grace Glueck**, *New York Times* art critic; **Nancy Holt** and **Idelle Weber**, artists; **Jill Kornblee**, dealer; **Alanna Heiss**, executive director, Institute for Art and Urban Resources

Marymount Manhattan College and NY Chapter Women's Caucus for Art, co-sponsors; November 16, 1979

The topic, "Who Creates Art Movements," distant cousin of last year's "What Are the Issues Affecting Communication Between Artists and Writers on Art?" ['78/#101] did not appear to light any fires, although it did stir up some smoldering coals. Jill Kornblee astutely remarked that art movements are best seen in retrospect, like a train pulling out of the station. So, for quite a while, panelists looked back at receding Abstract Expressionism and the role of critics Greenberg and Rosenberg in creation thereof.

After a perceptive opening statement by Idelle Weber, who had obviously done some thinking about the significance of the topic to artists, Grace Glueck's informed comments kept discussion moving, while Nancy Holt hammered away at the

myopia of critics who seldom step beyond their own thresholds in search of the new. Alanna Heiss left early.

Quite a few members of the large audience participated enthusiastically when invited to comment. Some criticism of the choice of topic emerged. It should be noted that the Women's Caucus attempts to reach a wider audience in these annual symposia. Themes that are somewhat speculative are therefore chosen purposely. And, clearly, there was something attractive in the topic to bring out all those people.

What the discussion lacked was historical perspective on the ebb and flow of movements in other times and places. A topic as large as this one need not have become stuck in a rehash of Abstract Expressionism; it should have moved forward, backward and outward from the narrow focus of the last 30 years.

– Sylvia Moore

Women Artists News, November 16, 1979 [Vol. 5, No. 8]

1980

'80 / #124

"History" Is Politics by Other Means

Many women who wouldn't go to New Orleans for the 1980 College Art Conference because Louisiana hadn't ratified the ERA attended a "National Alternative Conference" in Washington, DC. The "Great Women Artists" panel was a "spirited reappraisal" of some basic issues that set tone and theme for the '80s.

"The Great Women Artists Issue: A Reappraisal, Eight Years Later"

Moderator: **Josephine Withers**; Panelists: **Diane Burko, Audrey Flack, Thalia Gouma-Peterson, Grace Hartigan, Frima Fox Hofrichter, Diane Russell, May Stevens**

Women's Caucus for Art and Coalition of Women's Art Organizations, National Alternative Conference, Washington, DC; January 12, 1980

The event was a spirited reappraisal of Linda Nochlin's essay, "Why Have There Been No Great Women Artists?" and a survey of changes since its 1971 publication. The consensus was that, despite progress, "our history in large part remains unwritten." Verdicts to date on who and what are "great" and why are going to be seriously re-examined.

There were the war stories, the Janson anecdotes, the irritating, if humorous, reminders of how impervious to change, to research of feminist art historians, and to exhibits of women artists, mainstream art history has been. The Great Women Artists question could at this point be summed up as, "There have been no great women artists because there have been no great women artists." Despite similar experiences, however, panelists had very different priorities.

Moderator Josephine Withers reviewed pivotal insights: how women have for centuries been barred from opportunities to become *successful* artists, nearly always a prerequisite to becoming "great" artists; how the "golden nugget" theory of genius has masked the fact that only white, Western, males of the post-Italian-Renaissance "heroic" tradition of painting and sculpture have been eligible for the Great Artists Club; and how totally misunderstood Nochlin's article was by Elaine de Kooning and Roslyn Drexler – as well as by Janson.

Thalia Gouma-Peterson said there has been too little progress in feminist art history since 1976, when *Women Artists: 1550-1950* opened with its catalog by Linda Nochlin and Ann Sutherland Harris. She pointed out the absurdity of expecting Janson and company to unearth our heritage and

restore it. Urging new research, she challenged her colleagues:

> Unless we commit ourselves to the task of constant and diligent recording of the lives, actions, and work of women, we are not going to change the image of the past and transform the present. We have as women in all creative fields been robbed of our history. History does not exist until it has been recorded. And our history continues to remain in large part unwritten.

Gouma-Peterson reminded us once again of the ways mainstream art history has operated to exclude women – for example, by downgrading narrative painting and relegating the decorative arts to the category of "low" art:

> There are no absolute or objective standards to determine quality or greatness in art. Great art is finally established by a series of cumulative and subjective judgments, which have thus far been made primarily by men or by women trained in living within a male-defined context and who have adopted its standards.

Frima Fox Hofrichter finds the problem with "Why have there been no great women artists?" in the question itself, "one of self-flagellation, as if we are asking ourselves, 'What did we do wrong?'"

The tone of discussion changed abruptly when Grace Hartigan spoke. She announced that, for her, great art is not in the museums. In fact, she did not "shiver, hear bells, want to cry," and think she would faint until she stood atop the Pyramid of the Sun near Mexico City, visited the cathedral of Chartres, and sat amidst the paintings in the Lascaux caves in France:

> There it became human. I knew that women had done this. The men were out there hunting and fighting for territory. The women invented art; men invented the idea of great artists, just like men invented the idea that God is a man. Men found fire; women found charcoal. Men invented the ego, the individual consciousness. There is nothing more wonderful in a civilization than the dynamics of flow of expression without that ego. It's lost to us now. We women have fallen into this trap. Anonymous was a woman . . . well, bless her. She was standing up for it till the last minute, and then she finally succumbed.

Diane Burko also claimed detachment from visions of "greatness," which she called "a word made up by men to give them credibility and to link the making of art with power." She characterized women's power as "power to control your own destiny," saying she herself had arrived at a sense of wholeness, that lets her "feel good" about going to the studio to do "only" drawings.

For art historian Diane Russell, the problem with "greatness" lies in its definition, which, with the term "genius . . . deadens our experience of works of art by programming us." Calling for a broader definition of art, or its "de-parlorization,"

she urged that the line between "fine" and utilitarian or decorative arts be abandoned. She and Hofrichter both suggested more attention to themes of work by women in art.

Audrey Flack, on the other hand, would retain the term "greatness," bending it to her own uses. "Of course there are great women artists!" she proclaimed, listing Rachel Ruysch and Luisa Roldan among her top choices. Agreeing with Hartigan that great art conveys a physical charge, Flack suggested it reflects the archetypal collective unconscious.

Finally, May Stevens noted that for the past eight years the feminist art movement has not worked in a directed way to develop a group consciousness. However, she praised its "endlessly inventive way of dealing with the 'trialectic' of the women's world, the art world, and the real world." Stevens sees a sort of "horizontality," in which art is not ranked in categories, but offers a sense of "being one with your environment" and blending boundaries.

The time is ripe to reach for a broadened framework of art history and a transformed concept of "greatness." These women show that changes, on a small scale at least, have begun.

– Ann Bruce Stoddard

Women Artists News, March 1980 [Volume 5, No. 9]

'80 / #125

Critics' Rights?

In New Orleans, other issues of the '80s came up. Robert Pincus-Witten describes himself as "the gender anomaly" at this panel. Gylbert Coker observes that a lot of isms "and many more artists" have bit the dust (an observation that is apparently timeless), then predicts a "slower pace" and "refining of concepts."

"Critics as Curators"

Moderator: **Lucy Lippard**; Panelists: **Gylbert Coker, Ruth Iskin, Jayne Merkel, Robert Pincus-Witten, Shelley Rice**

College Art Association, New Orleans; January 31, 1980

Invited to describe an ideal exhibition that they would curate, given the opportunity, critic-panelists reflected their varied sensibilities and interests.

Lucy Lippard commented that nowadays it's taken for granted that critics may also curate; in 1966, when she first curated a show, it was breaking the rules. Only scholars and curators were supposed to curate. For her, organizing a show is an opportunity to deal concretely with art and to avoid the editing usual in books and magazines. It also gives the critic a chance to deal with real space and objects, although fewer people will see an exhibition than would generally see a work in print.

Robert Pincus-Witten read selections from exhibition catalogs he has written and pointed out that, inevitably, a critic-curator expresses a particular point of view and has a right to exercise this control over a show. It's naive for an artist not to expect that, he said.

Ruth Iskin prefers socially and politically oriented art, that is, art meant to raise social consciousness and effect social change. She showed slides of performance art and installations in non-gallery spaces, much of addressing the condition of workers. For example, Fred Lonidier's 1976, "The Health and Safety Game," is exhibited in union halls, "to educate the general public on issues important to workers and unions and to facilitate social change." Martha Rosler's "Postcard Novel Series" is the "autobiography" of a worker in a fast-food chain. She describes "the social isolation of both worker and customer, the frustrations of individual action, and the more positive results of group action." Other works were intended to create new images of women.

Gylbert Coker of New York's *Amsterdam News* and *Art in America* is drawn to mixed-media artists who reflect the numerous trends of the 1980s. She surveyed recent developments as follows:

> By the end of the 1960s, formalist abstraction had been challenged by a new set of formal and moral values. Visual expression had been tempered by a despair over American polities . . . Emotions ran similar to those of the Depression. There was a new sense of regional nationalism. [D]oors opened to all kinds of ethnic imagery. In 1964, when Don Judd wrote that the conventional media and the canvas rectangle were no longer adequate for contemporary expression . . . he was in effect laying the foundation for the 1980s. This new wave of artists is about as eclectic a group as we are a nation . . . These artists prefer the freedom of using unconventional materials such as string, wire, hair, leftover recycled materials. [There's also a] tendency to submerge oneself in a ritual or religious experience [in] performance pieces and again in outdoor works. [But] for the last two decades we've been turning out new "isms" as fast as the young artist can get out of school, sometimes even before they're finished. The result is that many isms, and many more artists, have bit the dust. With a slower pace we are going to see a refining of concepts.

Jayne Merkel spoke from her experience as an architectural critic for the *Cincinnati Enquirer*. She said "the public job of the critic is to call attention to, and come to terms with, the best and most ambitious and most problematic work." She sees much of that work being done today on paper, a kind of "rite of passage."

Shelley Rice talked about photography and sexual stereotyping in visual imagery. She sees her responsibilities as photo critic as an extension of teaching. "Most of us are socialized primarily on images. I am a photo critic because I can play up the ways in which images function in our society – their various forms, functions, and messages. This attitude puts me in a position of straddling art criticism and social criticism. As a feminist, I've learned how images are used to cre-

ate and maintain an ideology, and I'm interested in issues of censorship in terms of how images do *not* get seen."

Rice's concern with censorship led to an interest in the male nude and its conspicuous absence from art history books and exhibits. She feels that greater exposure of the male nude in art could redefine our attitude toward nudity and sexuality, reshape power relationships, and point the way toward a more complex and humane visual understanding of maleness. Meanwhile, although it's been observed lately that a goodly percentage of curators are women, Rice pointed out that whatever the percentages in curatorial – and critical – positions today, men still maintain *hegemony*.

Later, noting that he had been the sole male speaker, Robert Pincus-Witten said he found it curious to be the "gender anomaly," particularly since he had originally suggested the topic.

– Anne Stanner

Women Artists News, April 1980 [Vol. 5, No. 10]

'80 / #126

More Coast-to-Coast Ferment

Women who went to New Orleans reviewed the story so far, beginning with WAR.

"Protest and Politics in the Feminist Art Movement of the 1970s"

Moderator: **Lucy Lippard**; Panelists: **Martha Rosler, Jacqueline Skiles, Faith Wilding, Judith Barry, Leslie Labowitz, Mary Beth Edelson**

Women's Caucus for Art, College Art Conference, New Orleans; January 31, 1980

My own presentation was scheduled first, because my assignment had been to review the women artists' movement on the East Coast since its 1969 beginning. New York was the cauldron of early feminist-artist ferment, beginning with Women Artists in Revolution (WAR), a response to sexism in the radical Art Workers Coalition and the art world in general, and Redstocking Artists, an adjunct of the radical-feminist Redstockings group.

Women artists owe much to historical antecedents of protest in the '60s, the civil rights movement, suffragists, and earlier models of dissent. I outlined the major groups and their actions, then discussed the problems, from personal conflicts to the lack of access to art-world recognition and rewards. The women artists' movement is based largely on women's demand for inclusion in the existing opportunity structure, for showing and selling work and serious criticism. Can alternative galleries and shows, usually forged out of women's scarce financial resources, provide the rewards they seek? And what about the time these take from art-making?

If a new, alternative gateway to Eden is constructed, will it lead to the center of the garden or will there still be a great forest to conquer on the other side? Will this path lead to the material rewards and honors that validate an artist in society's eyes? If not, we must keep up pressure on existing institutions.

The second speaker, Faith Wilding, showed slides to illustrate the unique contribution of West Coast feminist performance artists doing collaborative work. Most of these groups emerged from the workshops and processes of the Los Angeles Woman's Building, where opportunities to make "new public art" combined "aspects of traditional social-protest art with feminist themes and forms such as street theatre, art performance, and ritual."

"All aspects of women's lives and experience are subjects," Wilding noted, including violence against women (rape, incest, assault), negative media images of women, women's health and survival, and utopian visions. However, not satisfied to merely depict problems, these artists want to *involve audiences in seeking solutions*. Moreover, performed in the context of specific communities, the pieces tap new sources of public patronage, such as churches and social agencies.

Wilding described the Feminist Art Workers, founded in 1976, who make supportive but anonymous phone calls to unknown women, organize bus trips to women's events in other cities, and distributed "dollar bills" carrying feminist economic messages at New Orleans. The most visible of these groups, Ariadne, is a social art network led by Suzanne Lacy and Leslie Labowitz, bringing together women in the arts, media, politics, and professions in events designed to raise consciousness about feminist issues.

Leslie Labowitz described some of Ariadne's performance pieces: "Three Weeks in May" focused on rape; "In Mourning and In Rage" was a public ritual commemorating murdered women and responding with rage (as opposed to fear, usually emphasized by the media). Ariadne also participated in the San Francisco march against pornography during the 1979 "Take Back the Night" conference. Such work, Wilding said, challenges traditional definitions of art and strives "to create a new vision of human community and a new world."

The next two panelists focused on their own work. Mary Beth Edelson spoke about images and rituals she has created to project new, strong, positive images of women. Books, she said, are a natural format for political statements as well as aesthetic challenges. Many of her books involve audience participation.

Martha Rosler said her own work is "about everyday life, but from the point of view of ideology . . . art that illumines social life [and] promotes critical consciousness about everyday things." She wants to create "art that unfreezes our experiences and penetrates the frozen block of the present moment – with an understanding of [the way] society is responsible for how we live our lives." She prefers ideological material to traditional aesthetics, and says, "the fundamental insight of

this stage of the women's movement" is how the personal and the political combine.

Rosler's topics include how women have become depersonalized and fragmented by ads for food and food-preparation equipment. Her "Know Your Servants" series focuses on illegal Mexican servants in Southern California. She has also contrasted *anorexia nervosa* – the "fashionable" disorder of excessive and uncontrollable weight loss – with starvation in poor countries.

San Francisco performance artist Judith Barry, who designs conventions for a living, talked about the ideological role of big business conventions, with their Disneyland paraphernalia, suspension of real time, and emphasis on fantasy, which nevertheless fail to achieve their goal of a kind of artificial sense of "community" among participants. Conventions in Las Vegas, part of the corporate reward system, and now big business themselves, fail as genuine spectacles in Barry's eyes, because they do not elicit the communal emotional response of a good Fourth-of-July fireworks display.

– Jacqueline Skiles

Women Artists News, March 1980 [Vol. 5, No. 9]

'80 / #127

Why You're Not Smiling

As noted, the 1980 College Art Association Conference had already been set for New Orleans when Louisiana failed to ratify the ERA. Some Women's Caucus members boycotted (going to an alternative meeting in Washington, DC) and some went to New Orleans, but made an effort to stay in private homes and bring food with them, that is, to spend as little money as possible in the state. The Caucus for Marxism and Art had planned to "act in solidarity with the Women's Caucus," but in the event did go to New Orleans. It announced, however, that the focus of its panels would be feminism and "the politics of sexuality," and all speakers would be women.

"Women at Work: Artmaking and Organizing"

Moderators: **Josephine Gear** and **Joan Braderman**; Panelists: **Pearl Bowser, Martha Rosler, May Stevens**

Caucus for Marxism and Art, College Art Association, New Orleans; January 31, 1980

Joan Braderman explained that traditional Marxist theory has not dealt with the subject of sexuality, nor has Marxism resolved capitalism's "false dichotomies" between theory and practice, production and reproduction of daily life, the community and the individual, the personal and the private. A socialist-feminist approach (with that important hyphen linking the two ideologies) is necessary to break down those false dichotomies, she said.

May Stevens began the first session with her work, *Ordinary Extraordinary: Rosa Luxemburg, Alice Stevens.* She showed slides of her black-and-white collages, largely of portraits of Rosa Luxemburg in various times of her life. She also read passages from Luxemburg's political essays, such as "The Russian Revolution," "The Role of Organization in Revolutionary Activity," and articles in *Die Rote Fahne*, personal letters to her friend Sonya Liebknecht, her lover Leo Jogiches, and comrades.

Luxemburg, one of the most profound political thinkers and revolutionaries of her time, criticized authoritarian tendencies within Lenin's party organization. The goal of the revolution, she argued, was not to erect a new dictatorship over the masses, but to release their freedom and creativity. Writing from prison (she was imprisoned from 1916 to 1918), she exhorted and cajoled Sonya, whose husband was also imprisoned, to remain courageous. She made the most of her little prison comforts and was sustained by her faith in the imminence of a German revolution.

Stevens evoked a sense of Luxemburg's personality, humor, and seriousness through these readings and the collages, while from time to time the image of Luxemburg's decomposed head appeared on screen. A few months after her release from prison, Luxemburg was murdered by the *Freikorps* and her body thrown into a river. In some collages, Stevens had added images of her own mother, Alice Stevens, to celebrate also the unknown heroism of her mother's life and signify that both women – indeed all women – are "ordinary, extraordinary."

Pearl Bowser, of Third World Newsreel, talked about African film, particularly films of the leading Senegalese filmmaker, Ousmane Sembene. Bowser said that, in showing social conditions of African society in transition, African film tends more to overt political commentary than neutral entertainment. The films criticized the corruption of government, the persistence of racism and neocolonialism, and the erosion of communal values. African films are also beginning to question the traditional position of women in African society, Bowser said, and women directors, though few, are emerging.

"Why Aren't You Smiling?," a slide show with a synchronized sound track by Lorna Rasmussen (who was unable to attend), was about unionizing clerical workers. After the Civil War, women replaced men as clerical workers, and, with the development of technology, clerical work was deskilled and degraded. The show, which is used as a union organizing tool, was skillfully done, but at times predictable.

Next, Martha Rosler presented her work, "The Body in Pieces," exploring alienation and fragmentation in pornography and advertising imagery. As the lonely consumer has replaced community and the patriarchy of the family has shifted to the patriarchy of the corporation, pornography and advertising have worked to rationalize the experience culturally and sexually. Rosler showed a series of collages and juxtapositions of advertising and pornographic images, both of which presented the woman's body in pieces as a series of

sexual parts thus conditioning women to see themselves as the patriarchy sees them – fragmented, compartmentalized, alienated. However, members of the audience argued later that all art deals with fragmented subject matter.

– Janet Koenig

Women Artists News, March 1980 [Vol. 5, No. 9]

'80 / #128

Social Studies

"Art and Sexuality: Socialist-Feminist Perspectives"

Moderators: **Josephine Gear** and **Joan Braderman**; Panelists: **Hollis Clayson**, **Joan Semmel**, **Maureen Turim**

Caucus for Marxism and Art, College Art Association, New Orleans; February 2, 1980

In this session on "Art and Sexuality," Hollis Clayson spoke on a "A New Breed of Unofficial Prostitute: Images by Manet." Manet's paintings of the French beerhalls, *brasseries à femmes,* cannot be understood today, she argued, without knowledge of their history. Ostensibly, Manet painted the waitresses with their customers in a nonsexualized way. They wore pert black-and-white uniforms and looked alert and businesslike. In reality, at the time Manet painted them, the *brasseries à femmes* were replacing brothels. In addition to serving beer, these waitresses were also obliged to serve their customers as prostitutes on demand. Many women saw this, despite the long hours and sexual exploitation, as preferable to the incredible misery of factory work. Clayson argued that Manet worked as anthropologist, faithfully recording on canvas the social conditions he saw. Yet her paper raised a number of questions. What was Manet saying about these women? Where were his sympathies? What did these paintings mean to his contemporaries?

Maureen Turim, discussing "Lifting the Veil: Women, Desire, and the Visual Image," also dealt with pornography. Such images operate on the male viewer using a symbolic code, she said. There is a kind of "phallic gaze": women in the images are available and waiting for the male viewer to act on them. The act of looking is symbolic of male penetration. The male is the missing actor in every pornographic image, even in images of seemingly self-absorbed "lesbian" couples. Pornography, Turim concluded, is not about female sexuality, but male sexuality as conditioned by society.

Joan Semmel's talk, "From the Object's Eye: A New Eros," in some ways could have been a response to Turim, although it preceded her. Semmel presented a survey of women artists who have dealt with female sexuality, from Georgia O'Keeffe to young women artists of today. Women artists, Semmel said, have had to surmount the legacy of the "high art" tradi-

tion in which female sexuality was envisioned as women's submission to men.

Earlier women artists had difficulty expressing or admitting the sexual content of their work. Georgia O'Keeffe, for example, categorically denied sexual references in her painting. But the work of earlier artists, together with the development of feminism, encouraged later generations to explore female sexuality in abstractions, centered female imagery, figurative work and performance, and to express sexual content explicitly.

The session ended with two films. The first, from Third World Newsreel, dealt with racism and sexism in the black working class, a mixture of documentary and re-enactment. The second, "A Comedy in Six Unnatural Acts" by Jan Oxenberg, dealt with sexual ideologies, fears and misconceptions about lesbianism.

– Janet Koenig

Women Artists News, March 1980 [Vol. 5, No. 9]

'80 / #129

The Natural State of Woman is Nudity

More even than all the ferment of political-feminist-socialist-activist-revisionist panels of the caucuses, the choice of convocation speaker signalled change at College Art.

"Revisionism: Holy Cows & Pure Bull"

Convocation Address by **Alessandra Comini**

College Art Association, New Orleans; February 1980

The most striking evidence of the College Art Association's apparent new commitment to equality for women was the choice of Alessandra Comini, professor of art history at Southern Methodist University, to deliver this year's convocation address. Her talk proved to be the most entertaining event of the convention, as well as a major contribution to both feminist and art-historical literature, delivered with an impeccable blend of wit and conviction.

To illustrate her remarks and amuse her audience, Comini showed paired slides during her talk. The first juxtaposition presented Mae West grinning lasciviously at a row of musclemen and Bernard Berenson examining the statue of a reclining female nude. With the gravity and caution of a fastidious scholar, Comini explained, "Art history, or the history of art, may not be the world's oldest profession, but art appreciation, or the appreciation of art, is certainly a time-honored activity."

A series of works featuring cows and bulls then appeared, with running commentary: "Tradition and our own text

books have told us that mothers don't matter in the birth of art history, as long as a plurality of fathers can be identified. Some of these progenitors have become the venerated bellwethers of our field, but . . . what is sacred cow to one century can appear as pure bull to another."

Flashing the cover of Helen Gardner's *Art Through the Ages* on screen, Comini lamented the "modern pasteurization techniques" by which 20th-century art-history texts rid the field of "undesirable presences." This trend contrasts unfavorably, she contended, with the chronicling of art history in previous centuries. "A cow is a very good animal in the field, but we turn her out of the garden."

Of course every era revises what it asks of art, as shown by Dolores Bacon's *Pictures Every Child Should Know*, published in 1908. Comini pointed out that today's college students would be unfamiliar with some of "the holy cows these bullied children of 1908 were expected to know." Among artists turned out of the garden was Rosa Bonheur, now, Comini noted, enjoying a return to favor, as the "mighty quadrupeds" of her *Horse Fair* gallop across the pages of at least five revisionist books of the '70s.

The contributions of recent revisionists have yet to affect college art history, she said, because today's teachers were themselves educated before the new wave of historical analysis. To demonstrate conditions in the '50s and '60s, when many of today's art historians were in school, Comini traced the education of "little Ala Toya Khomini – a simple child from Middle America, raised as a Texas cowperson, and sent, as was her mother before her, to a Seven Sisters College in New York City in pursuit of that ultimate academic goal, an Eastern education." Snapshots from Ala Toya's family album documented the transformation of little cowgirl into collegian of modest demeanor.

Ala Toya worshiped her art history professor, a hero with a thick German accent, thus acquiring her first "holy cow" – the notion that real art historians have foreign accents, preferably German. Then, flashing slide after slide of Rubensian flesh, Comini told how a second holy cow took shape in her mind: the belief that "the natural, most desirable state of woman is nudity." Of course "phallic flora" were largely ignored in the classroom. Comini recalled the nervous professor who consulted his notes about a sarcophagus carving of Adam and Eve, then offered, "The figure on the left is, uh, male; notice the play of light and shade. And the figure on the right is, uh, female; notice the play of light and shade."

Ala Toya also found three "profane" cows or topics neglected in her undergraduate training: one, American art; two, "any serious rumination on the visionary power of artists to anticipate cataclysmic events in history"; and three, any encouragement for women to go to graduate school. Consequently, after graduation, Ala Toya packed up her guitar and headed for Vienna.

Several years later, back in school, earning her master's at Berkeley and her doctorate at Columbia, she realized something else that had been missing from her education. "Never once during those years of graduate school in California and New York did the name of a single female artist pass the lips of one of her instructors. The largest holy quadruped of them all was . . . that artists are male."

Ala Toya discovered that while even lesser male artists "qualified for mandatory inclusion" in her grad school art history program, and the histories of the most obscure of them had been carefully recorded for posterity, even the best women were excluded. She realized, however, that whether or not women artists were ignored, they have existed, "our hidden heritage."

Lest it be thought that art education was once better, Comini described how "woman students in Eakins' class drew, not from a live female or male model, but from a live cow." In fact, "for 5000 years . . . the male mode of seeing has been elevated to the status of universal principle. Male values, male concerns, have dictated not only the subject matter but the interpretation of art."

Still, Comini warned against separatism in art history. "Are we going to have two stories of art, or are we going to integrate them into a *whole* history of art?" Although "the educational tide is now turning," she cautioned against excesses that could result in "a feminist tail wagging the revisionist cow."

Before Comini's address, I had spied Horst Janson himself, author of the most influential art history text in America today, *The History of Art*. Although Comini never mentioned him or his book by name, each time she catalogued another instance of sexism in art history, one's thoughts could not but drift to the man who stubbornly resisted mentioning the name of even one woman artist in a volume covering 3000 works.*

Janson sat through the speech, smoking continuously, his face expressionless. At the conclusion, the crowd gave Comini a wildly enthusiastic standing ovation; he hesitated, then stood and, without registering his own reaction, exited.

– Cindy Lyle

Women Artists News, March 1980 [Vol. 5, No. 9]

*The 1986 third edition of Janson's *History of Art*, edited by his son, included 21 women [review by Sylvia Moore, *Women Artists News*, June 1986]. See also "Interview with Horst Janson," '78/ #86.

'80 / #130

Water Plus Earth Equals Form

Meanwhile, in a parallel universe, far from the highly politicized conferences of New Orleans and Washington, and real world issues like ERA, artists talk about form, medium and process. It sounds exotic, almost radical.

"Artists in Clay"

Moderator: **Ann Loeb**; Panelists: **Jan Axel, Raymon Elouza, Jacqueline Freedman, Chris Gustin**

Artists Talk on Art, NYC; February 1, 1980

"It breaks, it warps, it's a bitch, and yet I keep coming back to clay."

Panelists used phrases like squeezing, touching, and pushing. One built the decaying structures of his childhood, one created giant vessels that had gotten nearly too large to lift, one rolled out small wall pieces, and another fitted large modular standing works together. Four widely divergent philosophies and aesthetics had a common focus on clay as medium.

Jan Axel traced the path by which her early works, porcelain roses menaced by thorns and barbed wire, led to her present modular abstractions. This major shift happened last year when she was artist-in-residence at the Kohler plumbing-fixtures factory in Wisconsin and had the opportunity to create sculpture with the factory facilities.

"I was striving for a sense of intimacy, so I went to the factory," she said. "It was overwhelming! I spent days just wandering around looking at bathroom parts. I made a mold from part of a urinal and this became the basic form for a modular sculpture with an unglazed china body. Then I took the sculpture outdoors into the sun." Even limitations were beneficial. For safety reasons, no sharp edges were allowed in the factory, Axel explained. She became "interested in the curves."

Another panelist influenced by a residency was Jacqueline Freedman, who spent a few weeks at Clayworks in Manhattan. She was a painter whose canvases had become so thick with acrylic paint and paste that she realized she was moving toward clay. She found that the transition seemed natural, in both color and texture.

Freedman's level of involvement with the medium was less than that of the other panelists, her interest being largely in translating her paintings into the new vocabulary. Though the works are in porcelain and white clay, she considers them "paintings that happen to be in clay. I'm not really interested in the technical aspects of the medium." She added that she likes clay because of its directness compared to paint.

Chris Gustin, who makes stoneware, also spoke about the immediacy of working with clay, which he lets "act out what it wants to do." He spoke about working loosely and freely

so that each piece is a direct response to the material. But clay can also pose problems. "It's a struggle to keep those pots wet . . . to keep the life in them."

The pots are made by stacking geometric shape upon shape. Gustin explained that the ideas for his new works evolved from a series done directly from the figure. Moderator Ann Loeb, who is with the Museum of Contemporary Crafts, asked about his latest excursion into monumental one-ton vessels and he replied: "I want to make six-foot-tall pots you can't use. Sure I deal with function, but I don't want it to dominate over form."

Sculptor Raymon Elouza seemed the most concerned of the group with the unique qualities of clay, or, as he put it, "water plus earth." But, he said, time is also an important element. "Clay can mimic natural aging processes. Like a carpenter, I build structures brand new, and then act out the hand of time and the hand of man in breaking down these structures and creating ruins."

Panelists agreed that despite the problems and unpredictablity of clay, it has a feel and a plasticity that less breakable, synthetic materials lack. On my way out, I heard sculptor Marilyn Fox telling a friend, "When you touch clay, it responds in a warmer way than metal."

– Rochelle Wyner

Women Artists News, May 1980 [Vol. 6, No. 1]

'80 / #131

Mixed-Media Wizards Speak

It's 1980. Yet a third manifestion is at hand. Michele Cone has sampled the sound, light, and electro-vision of Intermedia and translated the experience into print. It is, she says, "wizards" seeking "the vertigo of total art."

"The Intermedia Art Form"

Speakers: **David Antin, Gregory Battcock, René Berger, Jack Burnham, Germano Celant, Gillo Dorfles, Jorge Glusberg, Allan Kaprow, Udo Kultermann, Abraham Moles, Lil Picard, Pierre Restany, Carlos Silva, Pierre Van Tieghe**

Intermedia Festival, Guggenheim Museum, NYC; February 5, 1980

The "Intermedia Festival," ten days of performances, workshops, and seminars was held in New York City (January 25 to February 3, 1980), but truly international in scope. Organized by Elaine Summers, an intermedia artist, and Anna Canepa, a video specialist and director of the Experimental Intermedia Foundation, the Festival honored the arrival of intermedia as an art form and paid tribute to its creators — who combine film, dance, music, sculpture, video, and sophisticated technology. Fund raising for the event took three years.

Michele Cone's report covers the culminating event of the festival – a five-hour symposium, "Theoretical Analysis of the Intermedia Art Form," which included 14 critics, artists, and educators from Switzerland, Italy, France, Venezuela, and the U.S.

For ten days, uptown and downtown, from the Kitchen to the Guggenheim, from NYU's Maison Française to the Donnell Library, an intermedia event of heroic size was in the works. There were performances by Elaine Summers, Joan Jonas, Nam June Paik, and Charlotte Moorman, among others; workshops on electronic music, kinetic theatre, dance, and sculpture; seminars; and a concluding event that gathered 14 luminaries (mostly male) from the international art scene for a theoretical confrontation on the meaning and future of intermedia.

As Pierre Restany had to admit toward the end of the marathon event, discussion was on the level of the intermedia products themselves – neither good nor bad, sort of in limbo somewhere. Once in a while, during those five hours of nearly incessant talk, half of it in heavily accented English, an insightful comment was made. The best were reported by Grace Glueck in her *New York Times* "Art People" column, February 8. These included intermedia's function in overcoming the one-way direction of the mass media from emitter to receiver (Dorfles); the idea of the TV screen as linking near and far in a new intuition of space (Berger); the notion of performance art as "liberating chaos" (Antin); intermedia as mass avant-garde (Celant). I will focus on two issues that came up.

The first, raised by Corinne Robbins and Ken Friedman from the floor, addressed critical approaches to intermedia events and complaints that no one person is competent to judge work that makes simultaneous use of art forms generally covered separately by specialists in dance, music, art, and TV and by aficionados of advanced technology in art. Works that combine these forms, as did those performed at the festival, risk being unfairly maligned by a reviewer who understands neither the media nor the mix.

I, for example, was unable fully to appreciate the technological nuances of Stan Vanderbeek's sci-fi, simulated dope-trip piece called *Vapors Screen*. During that performance, at least three or four moving images set at different angles to viewers (including overhead) were visible at any one time. Some images were photographic, such as that of a woman's mouth spewing out a trail of smoke; others were produced by computers, such as a pattern of open cubes linked in a self-perpetuating chain. A cloud of vapor rising from some fancy contraption on the floor occasionally distorted the projected images in a dreamlike way. Through all this, I could not help being distracted at times by the sound of movie projectors in action, or be unaware of technicians using flashlights and walkie-talkies to give and receive signals.

My response is, I am sure, not at all a proper one for the technological feat represented. But I think that a work in *any* medium that leans too heavily on technique for appeal is on

the wrong track as an aesthetic enterprise, be it *trompe-l'oeil* painting or an intermedia event.

If, out of the occasionally pleasing forms and sounds of *Vapors Screen*, I had been able to piece together some content, I might have felt that, besides being a salute to the technologically hyped-up and artifically happy '60s, the work had something to say about the emission of messages and the mystery of their travel through time and space, and I might have responded favorably to the idea, forgetting technology altogether. As Allan Kaprow said, "To see video as TV is not the same as to watch TV as art."

Jack Burnham acknowledged the difficulty of coping critically with intermedia events, citing as an example a recent intermedia performance by Laurie Anderson in Chicago. The artist so overwhelmed the viewer's senses that maintaining a critical distance became impossible. Yet, if I read Burnham correctly, he enjoyed himself at the performance and found it exuded "vitality."

Others on the panel seemed more concerned with the moral implications of intermedia. Pierre Restany brought up the failure of technology to serve other than technological ends. Abraham Moles distinguished between old forms of intermedia, such as opera, in which criteria are pretty direct, and new intermedia forms mediated by technology, in which, he said, "you can splice, cut, distort, change, manipulate." Kaprow lamented that "as long as the gallery and museum system persists, nothing will change and everything that gets into them will continue to be framed as art."

Several people had an overriding concern with the language of intermedia. For example, intermedia artist Dick Higgins spoke from the audience in metaphors comparing media to mediums, and the mixture of media to lovemaking by mediums who conceive a child that will turn out different from either parent.

Gillo Dorfles asked whether intermedia was a mixture of languages or of codes and predicted that a new language with its own linguistic code would probably arise from intermedia. Berger gave a hint as to what that language might be: It would have no center and no finality, because when "meanings" are given through several media images that are sometimes conflicting, sometimes distorted and sometimes amalgams, meaning in one medium cannot dominate meaning in another.

Abe Moles entertained us with his drawing of a "bi-media creativity matrix" in the form of a chart showing, along horizontal and vertical axes, multiple ways the senses can be stimulated (texture, odor, taste, smell, sound, light). Any two-way combination is a bi-media event. Imagine such a chart as multi-dimensional; that is, imagine a matrix based on the potential stimulation of all senses at once. The result would be, in Moles's words, "the vertigo of total art." Exactly what New Yorkers experience in their daily lives.

– Michele Cone

Women Artists News, March 1980 [Vol. 5, No. 9]

'80 / #132

Post-Modernists Just Wanna Have Fun

As we see here, post-modernism was not always the stern, moralistic post-modernism of Mary Kelly and company. It also becomes quickly clear that we're talking about something besides "pluralism," something that has, despite claims of no style, its own style. In other words, we are in yet another cave, with yet another crew, cultivating yet another attitude, and it has nothing to do with politics, "regular art" (that is, "face-value" art), or technology.

And yes, they did say, "artists want to have fun." Although frustrated by panelists' refusal to give definitions, name names, or cite particular works of art, the audience had fun too – if gales of laughter are an indication. The free exchange between audience and panel was, as it often is, productive: speakers grew more cogent and forthcoming as questions or concepts engaged them. It may not have been Edit deAk's finest hour, but the others were subtle, knowing, and very sharp about the mindset claiming – or being claimed by – "post-modernism."

The evening, one of my all-time favorites, was too laid-back to be called a celebration: Let's call it a progress report – on art and artists departing the pure, ardent certainties of modernism.

"Post-Modernism"

Moderator: **Peter "Blackhawk" von Brandenburg**; Panelists: **Edit deAk, Glenn O'Brien, David Salle, Tim Wright**

Artists Talk on Art, NYC; February 29, 1980

The moderator introduced himself and immediately set the tone of the evening:

Peter "Blackhawk" von Brandenburg: Post-Modernism is almost impossible to talk about and I must have been out of my mind when I suggested this panel. . . . The only hard and fast technical use of the word is in architecture, but post-modern architecture is about the farthest thing from what we're talking about.

Four or five years ago something happened, first in the music world and then starting to turn up in art. One term for it is New Wave, but not what you think of now for New Wave, not punk rock, or anything like that, but the sets of conditions that gave New Wave the style it has, had and will have three years from now. Sets of criteria, assumptions, attitudes, poses, stances, perspectives. These are part of a system, and accessible to an artist working in a variety of media – in art, painting, music, film – not New Image painting or polystylism, which are expressions of symptoms. . . .

Ever since World War II there have been youth movements in this country in which a group of people with an indigenous style or culture discover the media structure which informs them. And likewise the media structure discovers them. As soon as the media find out there is something going on, they appropriate it – a style, its attitudes, its

vocabulary – and so co-opt it, domesticate it. This happens time and time again, because the media doesn't invent anything itself.

Four or five years ago, there was a movement, or a set of conventions that allowed itself to be seen as a movement, but wasn't really a movement [that] planned for its own co-opting and commercialization. The process whereby it would be co-opted became part of its rhetoric, symbology, and mythology. . . . Think of punk rock, where it was four years ago. Now there's New Wave night one night a week at every bar in Long Island and New Jersey. . . .

What post-modernism is about, like I said, is the criteria for making the choices, for picking the styles, for figuring out what the rest of the world is going to pick up on, how to do it first, and when it does become appropriated, how the person who came up with it can maintain control. Having your language taken over, watered down, disseminated in the mass market, that becomes a vehicle for you to influence the whole culture – which is trying to influence you.

In post-modernism, or New Wave . . . you take an attitude about an art-making process. If you take an attitude that would be pertinent to conceptual art, and then apply that back to a very traditional, standard, formal art product – painting, sculpture, film or records – then you may be engaging in a post-modern activity. . . . You treat a formal art product as if it were conceptual art, the same way one takes a progressive rock-and-roll mentality and applies it to the most simple and traditional music forms. [But] if you do to art what punk rock did to music, that art will be anything but punk, because you're dealing with the structure of the art world, which is real different.

So I took people [for this panel] who are not post-modernists necessarily, but were involved in the avant-garde before this stuff happened. And when it happened they got into the forefront. Original thinkers. This is all a function of people saying, "There's nothing new, there can never be anything new."

Von Brandenburg introduced Glenn O'Brien as "probably the closest thing to a post-modernist columnist and one of our foremost television personalities."

Glenn O'Brien: I've no idea what post-modern means. I know they talk a lot about it in England; it might be better to say "post-art." Maybe this is all about what people do after there's no more art.

Artists started to get like doctors, they all became specialists and pretty soon instead of being a sculptor and a painter, an artist was spending all his time baling hay, or cutting down trees to put in galleries, or making paintings that were readily identifiable by anyone who had ever seen one of his other paintings. And art became not art, but this sort of gesture.

There's been a moratorium on painting anyway – there's enough paintings, just like there's enough buildings. We should have things that are disposable, like magazines and records. People just got so bored with Minimalism that they started getting interested in Maximalism . . . The post-artist life style is what people want, like being an arty businessman.

Who has the time to sit around and write a good book or do a really nice painting? I think the interest rates and the quality of painting are directly related.

Von Brandenburg: We're used to thinking style is impoRtant. Now you're supposed to treat style as cliché, as a set of instantly identifiable moves or references. When people start talking about what *style* [post-modern art] is, they're in trouble, because they're dealing with people who don't have style and don't believe in style.

Von Brandenburg introduced the next speaker as "everyone's favorite editor and writer, Edit de Ak."

Edit de Ak: I danced with Johnny Rotten three nights ago and I was writing supposedly about art magazines for *Artforum* about a month ago. Nobody had any opinions, and I finally was thinking of this beautiful picture of Mayakovsky smoking a cigarette and I kept writing stuff like, "I used to write, but now I just smoke cigarettes." . . . I thought post-modernism was something kind of before me, like a dirty word I could just wash my hands and skip over. I think it's kind of like a messy, polluted, saturation principle, maybe in terms of aesthetic attitude, related to cynicism, related to a self-protective principle, or self-managed, or hype, no longer about quality as long as you can be hot, even beyond style, because you can't be hot with the same necktie for half a year.

In terms of artists and culture, it's an Heisenbergian whodunit, in which you affect a substance by your experiment. There are these downtown creatures around the art world, around the Lower East Side. They've been working with immediately understandable genres of mass culture, so they have a desire to cop certain aspects of the general culture and assimilate it. The product is marginal and esoteric, cultish and campy and underground. At the same time, the art world, not these people's art world, but *the* art world, has become a gigantic and well-known machinery, such an incredible infra-structure that . . . artists would probably qualify in the top rank as top all-American middle-class high-ranking individuals, and that was all built up in the last 15 years. . . .

I finally found some function for the art world, which I was looking for for about 15 years – dishing up pedigrees. Artists are kind of hot in the culture at large, because they represent "quality," or a kind of "kinkiness." So artists try to use formats which have been familiar to the general culture, sort of slumming among the mediums of general culture, and the general culture reaches out to artists.

Next, Brandenburg introduced "a painter and writer, David Salle."

David Salle: We seem to have come to a point where the relationship between object and meaning is no longer as fixed as it was thought to be. Criticism [once proceeded] as if there were in fact determinable meanings and objects created the meanings. Despite all the talk about context and pluralism and self-referentiality and mutual contiguous meanings, my experience in the art world was that there was this object that had a more or less assigned meaning and it didn't really mat-

ter if it was a formalist painting or a work of so-called poetic, irrational juxtaposition, or a conceptual piece, or an autobiographical or narrative piece. The form became unimportant, in a sense a metonym for itself. That is, it ceased to mean anything except that it as a form existed.

On the one hand, [modernism is a] celebration of the irrational: *it's not what you think it is*, and on the other hand, of the empirical: *it's just what it is.* . . . After 20 or 30 or however many years of seeing successively encoded forms brought to attention, they become simply that – that thing which has that attention. Post-modernism proceeds from a very deeply internalized recognition of that as a trap. . . . The post-modern sensibility, if there's a sense of opposition to modernism, has to do with the fact that meaning is literally beyond the grasp of the viewer, rather than the modernist or high-modernist position that meaning is linguistically or contextually arrived at.

Just one more "radical" notion: basically, modernism is about an art that is beyond the comprehension, because that's what art is supposed to be and how it's supposed to function – beyond one's comprehension. Much of the post-modernist sensibility tends to manifest itself in the use of images, [but] different from the early use of images, like the Surrealists used or Pop Art used. Instead of the viewer understanding or decoding the images, the viewer is understood by the images. It is the audience which is understood and decoded, rather than the other way around.

The last panelist, Tim Wright, was introduced as "a social archeo-musicologist."

Tim Wright: I confess that I'm quite bored most of the time and what I find most boring is what David was talking about, the track in time that most people seem to fall into [about] modernism – because people like to decide what is modern and feel secure in identifying with it. And that sort of locks them into present standards of acceptablity and present standards of what's new. . . . As an archeologist I find the past exciting, but people who live in the past I find boring. People who live in the future all the time are *really* boring . . . Post-modernism seems to be implying movement, and that's kind of attractive. To be locked in any point of time tends to distort your point of view.

Audience: What do you do?

Wright: I'm a song writer. I'm in a band calLed DNA. I used to be in a band called Pere Ubu. I'm a free-lance archeologist. [*Laughter, which continues.*] A long time ago I became aware that time flies when you're having fun. I'm pretty bored by addiction to any frame of time, especially the present, which is more obvious than the past or the future, because you're getting hit with it every day. Like anything we constantly consume again and again, even if it was fun the first time, or the fifth time, after a while it's not fun any more. So, being a musician, for me to continue to have fun, I have to find adventurous new things. . . . Fun is the goal, at the same time that it's the source. Yes [answer to audience question], post-modernism is synonymous with fun.

Audience: That's the most sophomoric thing I ever heard.

Von Brandenburg: That's what being an American is about – Life, liberty and the pursuit of fun. Whatever anybody says now about post-modernism (if anyone has the faintest idea of what we're talking about), if it's post-modernism now, in 5 years, it's going to be modernism, period.

Salle: Maybe post-futurism is more interesting. "Planet of the Apes" is retro-futurism. And so is "Battle Star Galactica," where you have the tribes of Israel wandering around all the planets. Because what else do they have to model the future on but the past?

In art like Pop Art, artists reached the greatest degree of success. They started selling art at the greatest price it would ever reach. I think we're going to have an art market crash pretty soon. I don't know very many rich people.

de Ak: There's a bunch of things made which kind of don't have a vested interest in its material. [They could be a] product artists make or artist types make, not quite saleable, just a statement on 100 sheets of xerox paper, that looks like a piece of shit.

Audience: Will paintings ever become like the master race and communicate with each other directly?

Von Brandenburg: A painting can't give a sperm sample.

Audience: Will the people continue to have fun?

Von Brandenburg: The problem as I see it right now is that almost no one in the art world has fun. If you're having fun, you can't be serious.

Audience: The art world is like the stock market. . . .

Audience: If there's anyone who's blown up out of proportion, like the stock market, a total facade, it's Andy Warhol.

Von Brandenburg: I don't know – I'd vote for Joseph Beuys.

Audience [to David Salle]: You said earlier that whoever makes Abstract Expressionism or Pop Art has these personal targets, the way they judge the work and they want to make it "work out." That means they're caught up in just making more stuff. . . .

Salle: I don't think it has anything to do with whether one makes things or not. I don't make a distinction. I wouldn't say for myself that inventiveness is no longer possible. My point is that, given the model of meaning most people in the art context have internalized, for better or worse, consciously or unconsciously, what gets made is made, and things not getting made are still getting made, like, "I'm not going to do this." That's still doing it. The image of meaning in that activity is hopelessly simplistic and inevitably superceded by just the nature of attention. If I pay attention to something I'm going to change it. And any work [should] incorporate that into its methodology, whether its a 40-foot painting or a little piece of shit, whether it's *Art Rite* or *Artforum*.

Von Brandenburg: The idea was, there was this *incredible* meaning out there and it was locked into this thing and who were you, you weren't going to get it out. That meaning and the truth this thing represented were just going to go on and on and on and you would turn into dust and ashes and this could be under glass in a temperature-controlled museum, like the Thousand-Year Reich.

This is what art is supposed to be, this great meaning, that no one understands, that you have to have some prior information to get at, and the sick thing is that as far as the [general public] is concerned, it's true. In recognition of this, a lot of artists now, given the opportunity to do formalist art, to make a painting or a sculpture, instead of going back and trying to legitimately recreate whatever that true creative divine spark is, and put that in the painting, would find it more honest to generate or recreate the mythology surrounding the painting that they heard of way back when and create something that exists like the popular *myth* exists, not something like the real painting during that period.

Post-modernism is not anti-modernism; it *is* modernism in a way. The values tend to be inverse. In formalist art, all those areas of the artwork that the artist is supposed to take real *seriously* and make the vehicle or the arena for their own individual stamp, talent, activity, those places in post-modernist art are taken up with references, quotations, clichés – like I said before, the things that are automatically identifiable, that you don't have to think twice about: subtitles, almost captions, thought balloons. Then it is usually all those *other* things, things taken for granted, like the economic structure the work's going to go into, like gallery marketing schemes, like choice of a particular kind of material, all these things that are supposed to be taken seriously are the things the artist starts screwing around with. You simply invert the ironies. All the places where you're supposed to have ironies, and original creativity in formalist art, those are the places in post-modernist art where you have references and where you define your own perception of history, and in so doing, define who you are . . . You tell people where you are by telling them what you see.

Audience: Where does the meaning come from?

Salle: It's coming from a discourse which is simultaneously three things: It's internalized via culture; it's intuited via one's desires, hopes, dreams, etc., and it's worked out in some kind of moment-to-moment dialog. Like speaking to a person, in a conversation, there are several things going on, memories, unstated kinds of things that will never be stated, and then what is stated at that particular moment. . . .

de Ak: You make me blush.

Audience: It's more a stream of consciousness?

Salle: Let's say it's situational. . . .

de Ak: I think what we're talking about is some kind of meta-analytic Catch-22 which one has, a kind of circuitry which is infinite, because everything around us is so cluttered and saturated, and what he's talking about is an inversion. I mean an inversion is almost like no inversion. And meta-anything, it just makes my brain inside, I don't know, it almost tickles; I get nervous, I can't handle it. I'd say what is going on is a kind of para-production, not *meta*, but *para*, not inverted, but . . . All kinds of productions are just semi-productions; they intend to be like productions in real life, but what is real life? Meanwhile, you can have fun doing it, even though all you want to do is qualify.

That's what I heard from a bunch of people. I thought that was pretty good: "What do you want to do?" "I want to qualify." And that struck me as an incredible statement . . . Just merely qualify. If you think of it, it's not easy, but it's an

incredible attitude. They want to qualify as a musician, as a human being. . . . If you can handle qualifying in your own manner, you're O.K.

Audience: What are you guys doing, Dada?

de Ak: I wouldn't mind being a Dadaist. . . .

Salle: I'm a Mama-ist.

Audience: Could you name any artists we know as an example of post-modernism? . . . I don't have a visual idea of post-modernism.

Von Brandenburg: That's sort of a problem, because an artist who is a post-modernist, they'll almost never be known for that. They'll find a set of qualities and then get known for that thing. . . . But what allowed them to do that thing is a post-modernist style. Everybody's still looking for your style, they don't understand that you don't take that seriously.

Audience: Then you'd say post-modernism is the kind of art that recognizes that the particular thing called art at the moment is not in reality the fixed value of art, that no matter what kind of canvas it is, it's still something hanging by a nail. And the post-modernist hasn't got canvas, hasn't got the nail, but has the attitude that that canvas is already hanging on the wall.

de Ak: Not even the nail.

Von Brandenburg: The critical machinery, all the stuff surrounding that art, the words, the text, the shows, *that's not what made it work*, if it worked. Art is for all practical purposes *completely* subject to style, and stylistic mentality. That a post-modernist takes for granted. It's got to be relative, and if you recognize as relative what other people think is absolute then you might get some mileage out of really fucking with it. . . .

Wright: There's very little as self-conscious, or decadent, or self-aware as this art is. . . .

Audience: What are your paintings about?

de Ak: I can make two drawings – a scarecrow with a bird on it and . . .

Audience: I think what we might be saying is that people around the world who do art, or create things, are trying to fill in the gaps the military and the politicians are failing to do, for instance, in Europe in the environmentalist movement. We just had in Cooper Union a few weeks ago an artist from Germany; he said he's trying to do something to pull us out of the inevitable . . . massive destruction and mutual annihilation we're headed for.

Audience: Here in New York artists are meeting to do work related to a non-nuclear future. We're beginning to see artists emerging as leaders with a social conscience.

Wright: I'd say that was absolutely the *opposite* of post-modernism. The post-modernist artists' idea would be to hasten nuclear proliferation. . . . [But] that was a serious question, so I'll give you a serious answer. I think that if a problem in the world presents itself to an artist in terms other than art terms and they feel a personal responsibility to solve those problems, then they should solve those problems in the terms which they thought of them in. Which is to say, if they're worried about nuclear power, they should become an environmentalist or a politician or something else. The only

direct effect art has on culture is to inform the media [about] a set of ideas or images or concerns which in five years will get picked up on and form a kind of stew, or basis for all the other commercial messages going on.

Audience: I gather you're saying post-modernism says anything can be art. But I thought that was *modernism*. . . .

Wright: I think anybody who's really good now is making Magical Objects. . . . But most people would probably say that when they find an artwork that does for them what primitive art did for primitive man, the chances are it isn't a work of art. It's not fine art, not in a gallery, it's something they stumbled upon.

Salle: This isn't the first time people have said in serious or unserious company there's no more art, no more artists. It's a signal for something; perhaps it's intended literally, or perhaps intended to point to something else.

O'Brien: You said before, people used to make art; you'd go in and look at it and it would mean something. Now people go in and the art looks at them and it means something to the art, but not to the people. So therefore the artist has reversed his role.

Von Brandenburg: How does art become informed by its viewers and can artists change that, depending on where they put their art to be looked at?

O'Brien: I have no idea.

de Ak: I hope to completely agree with Glenn that there is no more artists and no more art, but at the same time I must admit I do get kicks here and there. I'm not necessarily calling those things or activity art, but they give me some kind of intense input, reaction, which could be some sort of art reaction.

Audience: You mean there are no artists and no art?

de Ak: No, I take [Glenn O'Brien's] position full-heartedly; at the same time I find very talented people and good things in the world. Call it what you want, I'd take his position from an art-world argument. From my personal experience, I have experiences which are great.

Audience: Inaudibile.

de Ak: I don't object to anything at all. I have no objections even to the art world. I don't have any objections to not being able to write about anything. There's no time to write in the first place. . . .

Von Brandenburg: When you say the word "art," you expect people to know what that means. What people really think art is is probably even more diverse than what they think post-modernism is. And in some ways, post-modernism is *just* a handy term to define a particular crop of avant-garde artists whose particular working styles have not been copped yet, so we're not all familiar with them and when we say avant-garde we don't naturally think of them.

Audience: You said in your opening talk that the central question of post-modernism is how to maintain control, how to use the fact that the media will co-opt whatever is created, how to incorporate into your art a knowledge of and resistance to that inevitabililty of being co-opted. That seems to me a political position.

Panel: It is.

Audience: We do have this lust for the example. If you can name some artists or talk about some strategy by which . . .

Von Brandenburg: One concrete example – this is a post-modernist tactic: A person identifies an attitude that would make certain choices among styles, a selector, an attitude which permeated a particular movement in formal modernism, in the '40s, in the '50s and in the '60s. You could do this with Expressionism, you could do this with Pop Art, you could do this with Hard-Edge painting. There will be a culturally induced stylistic criteria [sic] which is responsible for the aesthetic in the works of several artists working in these genres – which were *supposed* to be just the individual artist's vision or *métier*. . . . You take such an attitude, or such a perception of style [after] we've had 20 years of perspective, and what looked like it was just ingenuous at the time, now appears to be more the result of certain factors in *culture* which showed up in the art world before they turned up in the general culture.

That mentality in those genres is probably expressed in a metaphor, through the medium of paint, by making paint do a particular thing or through a type of edge, or through a shaped canvas. You take that metaphor and translate it into a literal actuality. If you're dealing with Hard-Edge painting and the idea of light carrying color, for instance, then if you're a post-modernist artist, you make art where literally light carries color, where the art is made up of light, not of painting. You might be doing a Kenneth Noland or a Frank Stella, exactly the same painting, except you'd be doing it literally, for real, you'd not be working with metaphor.

Audience: Will a time come when there's a post-post modernism, when artists re-interpret the attitudes coming out of post-modernism?

Von Brandenburg: Oh sure. That's when we're all innocent again.

O'Brien: There's something wrong when you place all the responsibility on the culture, all the blame for the draining away of meaning on the media.

Von Brandenburg: Now we say "the media" the way people used to say "the establishment."

Audience: Can a post-modernist co-opt the way he's going to be co-opted?

Wright: He can think that he can.

O'Brien: I think the people in control of the media are the same ones who patronize certain forms of art alienating to the general public – so when they have the news and the weather and the sports, then they can bring on the art report and show some ridiculous thing that someone's installed at great expense that means nothing. Then the people can say, "Yep, we're not missing anything. They call that art!" And they're right. The whole reason *that* art is there is just to make people think there's something wrong with art.

Audience: Would you comment on the relation between post-structuralism and post-modernism?

Von Brandenburg: I think that would be a generally good note to end on.

Edited from tape.

'80 / #133

Sincerity Rules

The absolutely final and complete overthrow of the "rules of modernism" had given fresh currency, even urgency, to questions of "quality." However, the criterion apparently accepted here – "sincerity" – hardly solves the problem: the worst art in the world is always the most utterly sincere. Last week's post-modernists would have trounced such a notion instantly. Kuspit probably agrees with them, saying, "there is no quality today." And Sandler, echoing Von Brandenburg, says, "you can't get to it."

Whichever, the topic is always with us, and presumably always will be. But the suggestion that the title drew the overflow audience leads to the reflection that well-known or important persons could announce a disquisition on cloud formations of 18th-century landscape painting and fill the hall. Still, a timely theme and apt title are like another 25 points of IQ all around. As our reporter says, "The evening was not disappointing."

"The Question of Quality"

Moderator: **Phoebe Helman**; Panelists: **Howard Buchwald, Donald Kuspit, Elizabeth Murray, Harvey Quaytman, Corinne Robins, Irving Sandler**

Artists Talk On Art, NYC; March 7, 1980

Many times I've been drawn to an event by a dramatic or provocative title that seemed somehow to promise special insights or profound wisdom I could never have thought of myself. The panel title, "The Question of Quality," held out such a promise. Apparently others felt the same way, because some 250 listeners crowded Landmark Gallery, while an overflow of 70 waited on the sidewalk outside, pressing their faces against the cold windows.

While I didn't come away instantly enlightened, the evening was not disappointing. Three painters (Howard Buchwald, Elizabeth Murray, Harvey Quaytman) and three critics (Donald Kuspit, Corinne Robins, Irving Sandler) discussed the topic, a very broad one. Quality emerged as undefinable and important, as well as nebulous, confusing, and deeply felt.

Elizabeth Murray: It's a fact of life, a reality. When you feel it, you can't talk about it.

Donald Kuspit: There is no concept of quality now. We have quantity, not quality, because anyone and everyone can make anything.

Irving Sandler: It's individual. You select work to write about because it gets to you and you want to deal with the quality of it and yet you can't get to it. You can describe your experience of it, but what about getting to the *quality*?

Harvey Quaytman: Quality moves you. I paint what my soul dictates . . . One's work is the truest thermometer of quality one can make.

Corinne Robins: Vision has to do with quality. I go into a gallery and I'm not sure. If something bothers me, I will go

back. It's something you want to think about, something that holds your attention.

Howard Buchwald: It's an issue that's important, but I don't know what it is . . . It has something to do with the inability to deal with all the art that's out there. I have to look at my value system, which may be open to question.

With one exception, panelists agreed that quality in art exists, but that it does so on an intuitive level, and that may change. The only panelist who questioned the existence of quality was Donald Kuspit, who presented an art-historian-as-scientist argument. He argued that quality in art exists only categorically within a rating system. Before 1855, art was ranked, based on universally recognizable ideals of perfection. But when art began to encompass more diverse forms of individual expression (pure art for art's sake), the ranking system broke down. And because there is no standard rating system today, Kuspit concluded there is no quality today.

He went so far as to say that our quest for individual expression only shows us the uselessness of art. Anyone can make anything, so we have an overabundance of art that is easily processed into journals, with little selectivity about what is processed. When Kuspit claimed further that there are no artists or critics any more, only art administrators, the others finally protested. Elizabeth Murray reminded him that making art is a creative human process, both difficult and risky. Sandler, gentleman-critic, said Kuspit's diagnosis had no relation to *his* experience of art.

Listening to Kuspit, I heard an academician at odds with the administrative chores and paperwork of a bureaucratic society. An art critic reviewing the Salon of 1844 similarly reflected his own position in the midst of the Industrial Revolution, when he declared that art was becoming a mere marketable product. "Where is art?," he asked. "Instead of art we find only industry." Art survived the traumas of the 19th century, however, and is still sustaining itself.

The "anything goes" atmosphere Kuspit sees may have been true a few years ago, but not, I think, today. The other panelists declared that they do have standards (although they could not or would not pinpoint those standards) and that they use them to make judgments. The discussion at times took on a quasi-moralistic tone. Both artists and critics expressed the belief that one's primary responsibility is to produce the most *sincere* work possible. The struggle to find the most sincere expression is, then, the struggle for "quality."

I suppose that if anyone had said quality is this or quality is that, no one else would have believed her or him. And so I left feeling satisfied, in some strange way. Even if the panelists were chosen for the high "quality" of their knowledge and experience, they verified that there can be no ultimate expert or final word on the issue.

– Ann Schoenfeld

Women Artists News, April 1980 [Vol. 5, No. 10]

'80 / #134

Fooling with Mother Nature

The reporter poses philosophical and ecological questions that the panelists do not address. They probably see theory as subsumed in the work, or maybe, as practitioners in the field, just leave it to the desk types back home.

"Sticks and Stones: A Dialog with the Earth"

Moderator: **Judith Tannenbaum**; Panelists: **Cathey Billian, Robert Lobe, George Trakas**

Artists Talk on Art, NYC; March 21, 1980

Environmental sculpture, site-specific sculpture, earthworks – a given project could fit one or all of these categories. These exciting new forms of contemporary art developed during the past ten years have styles and solutions as diverse as the artists who produce them.

Art in this vein can stretch our awareness of both natural and made environments, address new interests and bring up new issues. For instance, should the fragility of a given site be studied thoroughly before disturbing it? How much should an artist alter an environment? Are works that occupy an outdoor or public space really accessible to casual viewers and passersby, or do they too often become private events? Endless questions spring to mind, yet none were mentioned or considered at this panel. Like most environmental and site-specific artists, these artists use nature at one stage or another in shaping their work, and a relationship to the earth (physical or psychological) is an important factor in it. But discussion never really got off the ground, which is to say that each artist showed slides and gave an account of his/her personal approach, but little else. The evening was a combination Show-and-Tell and What I Did Last Summer.

Not that I was totally disappointed. It's always worth while to listen to artists explain their work. But the audience seemed bored, which says to me that the panel did not meet expectations, did not challenge, stimulate, or leave us with something to ponder.

Cathey Billian's choice of site begins with its autobiographical or spiritual significance. Then she roams her chosen land looking for interesting ground formations (her most recent project was in a volcanic desert in Hawaii); these she casts by embedding a mixture of porcelain, volcanic dust, and mica into the surface of the earth. Each "impression" is only about a foot and a half long so that it can be bent slightly to achieve a satisfying shape. Then the piece is fired, which counters the precious appearance of the porcelain with the ashiness of diffused dust and mica. For exhibition, Billian fastens the clay fragments in a line, one after another. The spectator perceives her/himself as part of a well-ordered human-made environment, intensified by irregular extrusions or "partings" from the natural world.

Since 1978, Robert Lobe has worked from the terrain of islands off the coast of Nova Scotia. He looks for "a combination of events in the landscape," or random formations of trees and boulders, or a cluster of natural elements that catches his eye. Then he hammers sheets of aluminum snugly to the found composition, at times digging underneath and around the "objects" in order to make the metal fit (arguably a drastic violation of the Nova Scotia coastal islands). What he brings back to the studio are these aluminum shells, which he terms "portraits" of the environment. They're fragmentary at this point, so he welds them to a support or closes the backs. Installed in a gallery, they are records of arrested moments in the life of an island.

While George Trakas's work, which occupies a region somewhere between sculpture and architecture, is usually site-specific, the particular raw environment or architectural setting is neither personally nor inherently meaningful to him. After choosing a site, he may consider its history, but he always looks for ways to change awareness of the place chosen – often through studied contrasts. One work, for instance, used wood beam and metal skeletal structures: a low steel bridge was fastened to a ledge of shale and dolomite; another bridge had wood and steel planks, some of them perpendicular to the ground. He also dynamited the ground below to bring a muddy pool to the surface (another violation?). Indoors, Trakas works with walls, columns, stairways, and light. The spectator may sense scale more acutely, follow tentative paths in and through the structure, and reconsider the regularity of ordinary existence in contrast to Trakas's irregular alternatives.

These are interesting artists, but their personal experiences did not suffice as an evening's content. We need to address larger meanings of such art in the environment: it can strongly affect the unpredictable world of nature, as well as the well-ordered world of architecture, and the volatile world of art.

– Ann Schoenfeld

Women Artists News, May 1980 [Vol. 6, No. 1]

Seven Critics Interviewed

The following seven interviews with critics appeared in April 1980 *Artworkers News*. Introducing them, *AWN* editor Elliott Barowitz reflected that critics, as well as artists, have proliferated since the days of Harold Rosenberg, Tom Hess and John Canaday. He also quoted a savage review by John Canaday to point out that the tone of criticism had changed as well.

Considering the vicious missives critics continue to write each other in letters columns, I suspect they haven't so much mellowed as adapted to the exigencies of advertiser-supported press. Nevertheless, these interviews show a group as pluralistic and multiplexed as today's art milieu itself.

Shelley Rice may be the first critic to admit for publication that the critic *is* in a "power position." (As Pat Passlof put it somewhere in these pages, the critic's perennial refrain is, "We have no power and no one reads us anyway.") Donald Kuspit hopes to encourage dialetical thinking. Dore Ashton would settle for more reviews. The art magazines "keep publishing these lengthy discourses," she says, "so they can't get in enough reviews." Hilton Kramer disdains the role of the critic as "artist-groupie." But Barbara Rose favors involvement. The reason John Canaday's criticism was so "completely ephemeral," she says, is that he was so completely "uninvolved with the issues." Lucy Lippard also says, "the critic should be as entangled in the art world as possible." She even shows monographs to the artist in case they've changed their minds about quotes! Well, read on. There are insights into personality and experience and many true, or at least provocative, statements.

'80 / #135

In the Old Sense of "Amateur"

Dore Ashton

Interviewed by **Amy Lubelski**

Amy Lubelski: How did you become a critic?
Dore Ashton: I was a gifted child. I studied painting all through my childhood years. I also loved literature and so I studied a lot of literature in college and took some art history and then did a year's graduate work at Harvard. But I always did want to write about art and to write journalism. Since I came from a bohemian milieu, being an art historian did not appeal to me. Besides, people I knew were artists and I was interested in art.
Lubelski: Are a lot of your friends artists? You don't feel any conflict being a critic?
Ashton: I was never that kind of critic. I always became interested in somebody's work and sooner or later would meet him or her and sometimes a friendship would develop.
Lubelski: How does one say, "I'm going to write criTicism"?
Ashton: I didn't start out writing criticism. I Started out to write about what interested me and I hope I've become a critic.
Lubelski: Do you feel that the kinds of things you write about have an influence on art movements?
Ashton: No, I was never ambitious in terms of shAping anything; I just wanted to find satisfaction in my own way. I'm interested in writing and hope to become a good writer – someday.
Lubelski: You see yourself more as a writer than as a critic?
Ashton: I really see myself as what they used to call an *amateur*, in the sense that I try to live in such a way that I'm in

touch with things that move me. [I]n that sense I don't think of myself as a power broker or a very important person in the art world. I had my chance, I could have . . . when I was a critic for the *Times*, but it wasn't in my temperament. Mind you, I'm not being modest, I'm quite arrogant.

Lubelski: Do you read the other critics?

Ashton: Not really . . . they're just as intolerable.

Lubelski: Do you see any real value in reviewing shows?

Ashton: Yes, I think everybody, including people my age and stature, has an obligation to do reviews and when I can I do.

Lubelski: Isn't art very subjective?

Ashton: In some contexts a work of art can be discussed relatively objectively. You can, in reviewing an exhibition, look at the genre and its historical and local context. If you're a good writer, you can describe it, which even in the age of photography has a certain value.

Lubelski: The aim of book reviewing is to alert the reader whether to spend the money. Do you feel art critics have that same kind of power. . . ?

Ashton: In the long run, the attention a respected critic can give an artist does count to a number of people interested in seeing work. Just a couple of weeks ago I was lecturing out of town and a man said, "I always looked forward to reading you because it made me want to go and see the show," which is a nice tribute.

Lubelski: Do people who are contemplating buying art ever ask you is this a good investment?

Ashton: Never! I'm not on that circuit. I don't know those people.

Lubelski: Do you do art yourself?

Ashton: I sometimes do water colors.

Lubelski: What kind of influence do you think that has?

Ashton: In my case I think it's very important. People may say particular critics don't know anything about art, not having made any [but] that's not really true. Some people have a real sense of the visual. In my case [painting] was very helpful in terms of learning the idioms and trying to draw. There are any number of modes you could draw in and just the choice of mode and striving for perfection within that mode enter into the way I perceive art.

Lubelski: Who do you feel are the major artists of the last 30 years, or since the war?

Ashton: I hate to make those judgments. I don't even do it when I write. I can tell you the names of some artists who move me. I certainly think that Rothko would remain a great figure for me . . . I take Pollock very seriously, including the late work, which everybody puts down – I think the last drawings are superb. [And] I would have to mention Guston, about whom I wrote a book.

Lubelski: In terms of your students, do you try to give them your view?

Ashton: Inevitably it's my view. When I'm teaching them history, it's still my view because my enthusiasms are certainly going to be communicated.

Lubelski: Where do they go?

Ashton: After they leave? The most tenacious get part-time jobs and try to keep painting and sculpting; some of the oth-

ers just get drowned. . . . It's rather hard circumstances right now. Wherever possible I try to get them into graduate school so they have two more years.

Lubelski: Do you ever encourage them to be critics?

Ashton: No. Remember my students are all art students. On rare occasions I've had people who were gifted, who could write very well, and where they showed interest, I encouraged them.

Lubelski: What kind of influence do you think someone like the critic for the *New York Times* has?

Ashton: I'm told that the critics for the *New York Times* are very influential. The *Village Voice*, I don't read . . . I prefer a kind of dispassionate, simple, straightforward review to an editorial.

Lubelski: When you talk about reviews in terms of bringing a particular artist's work. . . .

Ashton: The review has a double function. It is a record and can be an advocacy; probably there should be more reviews. The *Times* can't cover everything. The complaint is that they don't cover very much, but I think they cover about as much as you can decently cover, given their space limitation.

Lubelski: What kind of influence do you think a poor review, or a negative review, has on an artist?

Ashton: Finally, I don't think it really matters much. But then again, there certainly are, let's say, conjunctions, of writers . . . museums and so on, where, I suppose, it would matter. If a certain critic says "X is a comer," it might matter in certain areas. I think outside of the big metropolises they tend to look to a couple of art magazines and the *New York Times* to find out what is going on. To that degree, it probably affects artists trying to sell work. But as far as reputation is concerned, it shouldn't matter in the least.

Lubelski: What about the art magazines?

Ashton: The art magazines, as far as I'm concerned, have far too much interest in articles. They keep publishing these lengthy discourses which take a lot of space and they can't get in enough reviews.

Artworkers News, April 1980 [Vol. 9, No 8]

'80 / #136

Critic of the Times

Hilton Kramer

Interviewed by **Elliott Barowitz**

Elliott Barowitz: You wrote in your book, *The Age of Avant-Garde*, that Clement Greenberg's criticism grew out of a "crucible of a Marxian dialectic." How would you characterize the ideological base of your criticism?

Hilton Kramer: The influence that has most decisively shaped my outlook as a critic is not primarily political. It comes

from the critical writing of Henry James. I think James, quite apart from his accomplishments as a novelist, is one of the greatest American critics. It was his criticism that prompted my own initial interest. The particularly marvelous thing about James as a critic is his gift for making connections between aesthetic issues and what you might call the cultural context surrounding the aesthetic issues, the political and social and moral context. He is always looking for that kind of equation. For James, an aesthetic issue is always a human issue. There is always an element of human experience being addressed in the aesthetic problem. That is where I come from as a critic.

The more explicit political elements in my writing have changed a good deal over the years, I suppose, like everything else of my generation. I was tremendously influenced, both negatively and positively, by Marx and the whole Marxist tradition in criticism, and I have also been greatly influenced by the New Criticism in literature, which had a very different kind of ideological basis. It was much more conservative. But it was primarily the aesthetic issues, rather than the political side of the New Criticism, which interested me.

Unlike Greenberg, I was never actively involved as a Marxist.

Barowitz: You wouldn't suggest that your politics are unknown?

Kramer: Oh, no, not at all.

Barowitz: You found that Harold Rosenberg embellished his criticism with ideas outside those related to pictorial content or element in paintings. It seems to me that you do that yourself – maybe every critic does – particularly when a moment ago you talked about the cultural elements of the aesthetic.

Kramer: I think it is one of the tasks of criticism to deal with the cultural context. The question I raise in relation to Harold Rosenberg's writing as a critic is how it's done. Because for me, Rosenberg's writing on art is able to deal brilliantly with everything but the art. There is no eye functioning in that criticism. He had no way of dealing with what the artist is actually doing on the canvas or in a work of sculpture or whatever. It's all context and no text.

Barowitz: Let me say parenthetically that every critic I've known has accused every other critic of not having an eye.

Kramer: But, of course. Just as artists are harsher about other artists than most critics are, critics are much harsher on critics than most other people are.

Barowitz: A lot of artists and other critics call you a journalist. How do you respond to that?

Kramer: I don't mind being called a journalist. I work on a newspaper. I've spent my whole professional life writing for and/or editing magazines and newspapers. If Edmund Wilson didn't mind being called a journalist, I certainly don't.

Barowitz: In your review of the "Originals" show . . .

Kramer: Oh yes, the women's show.

Barowitz: It seems to me that was a piece of journalism even without getting into the controversy of the criticism, inasmuch as you looked for a story and the story you looked for was feminism.

Kramer: It certainly was an issue that I felt needed to be addressed, and I wanted to make one large point, which I felt has not been made elsewhere, about the whole relation of feminism to questions of quality. [That's] a question all the other writers on the subject seem to have agreed to let drop.

Barowitz: Didn't Rosenberg address himself to That subject in the August 2nd, 1977, issue of the *New Yorker*?

Kramer: In relation to feminism?

Barowitz: In relation to feminism, when he revIewed a show at the Brooklyn Museum a few years back.

Kramer: I don't remember that. I know he wrote about 200 years of black art at the Brooklyn Museum and kind of sidled up to the question of quality.

Barowitz: What upset people over your review of "Originals" is that you seem to refuse to acknowledge that some sort of compensation is due to women and minorities who have not had the same access as others.

Kramer: I am not a believer in the principle of compensation.

Barowitz: You like artists like Pearlstein, Leslie, Welliver andBeal and, apparently . . .

Kramer: Well, I have critical things to say about most of those people. For me, writing about artists is not a question of writing endorsements. I've written very critical things about Al Leslie's paintings, and very critical things about Jack Beal's paintings, but at the same time I am very eager to acknowledge an accomplishment that I feel is there.

As I see it, criticism isn't choosing up sides on artists' work – it's trying to deal with something concrete in their work.

Barowitz: But you seem to like these particular painters and you appear to dislike the so-called Super-Realists and (stop me if I am wrong) I have the feeling you dislike the Super-Realists because they're not painting from nature.

Kramer: Well, I'm not really concerned, as a matter of principle, about whether or not a painter is dealing directly with nature. I'm concerned only about the results. My experience with these different approaches to realism is that the results tend to be artistically stronger in painters who are working from nature than in those who work from advertisements and photographs or whatever.

There is some kind of stimulus there that, I feel, results in much stronger artistic work. But I realize that an artist can work from anything if he gets a strong result. There are plenty of marvelous pictures done from photographs. I suppose what bothers me about Super-Realism is its abject dependence on something that is already an aesthetic statement in its own right.

Barowitz: You basically *don't* differ very much from Rosenberg.

Kramer: But Rosenberg's criticism was pretty much limited to an artistic universe in which de Kooning and Hans Hofmann were the center. The major exhibitions Rosenberg did *not* write about during his tenure at the *New Yorker* would make a long and impressive list, even people like David Smith. There were many other big figures he never wrote about because they weren't de Kooning or Hofmann or Guston or Newman, and that was a great limitation. No, I don't think our outlook is the same at all.

Barowitz: Well, you raise the issue, and I agree with you that Rosenberg didn't look at very many things, but neither do you.

Kramer: I certainly have looked at an awful lot. I would guess that in the course of a year, I review the work of a greater number of living artists than any other writer on art living at this moment with the possible exception of my colleague, John Russell.

Barowitz: Nonetheless, you are not consistently seen on the streets of Soho and on 57th Street. . . .

Kramer: That simply is not true. Whether one is seen or not is something else, but I spend three days every week doing nothing but going to exhibitions. I'm sure I see many more exhibitions than the people who say I never come to their exhibitions. No, that's Ivan Karp's particular line, because I'm not usually very favorably inclined toward the artists he shows. However, he is showing a very marvelous artist right now, Kolibal, whose work I saw in Prague in 1969 and wrote about in the *Times* at that time. There is a reproduction of his work in my book, *The Age of Avant-Garde.*

Anyway, it's not true. I go to Soho about every second week, I guess. It's not my favorite scene because I find the level usually leaves a lot to be desired.

Barowitz: Do you ever write about people whose names are not already known?

Kramer: I've done it very often. The one rule I always observe is that I never write about the first solo exhibition of an artist if I dislike the work very much; I don't think there is any point is saying that this artist is having a show and it stinks.

I reviewed the first show of an artist at Parsons-Dreyfus the other day. I never heard of him before, but the work had some qualities I admired, and I was glad to say so.

Barowitz: A lot of artists believe that you . . . go out of your way not to associate with artists. [And they] feel estranged from you as a result of your criticism.

Kramer: I'm not sure it's the role of a critic to be a kind of artist groupie. Whom I see in my non-working life is really my business. As it happens, neither my wife nor I are people who go very much to parties or openings. We live a much quieter life. I spend so much of my time working that the very small amount I have left over is particularly precious. On the other hand, I know lots and lots of artists. . . . I don't meet many who are a great deal younger than myself – say, 25 years younger – because my life simply does not take me into their neck of the woods. But that's not totally true either. Anyway, the important thing is I see their work. What is not entirely appreciated by people leveling that kind of criticism is the logistics of my job, the number of exhibitions and events that have to be dealt with, the number of deadlines. Then there's a whole news side to the operation that I'm involved in. To handle all that, and write about art with a certain seriousness [is] more than a full-time job.

Artworkers News. April 1980 [Vol. 9, No. 8]

'80 / #137

Doctor of Dialectics

Donald Kuspit

Interviewed by **Rupert Ravens**

Rupert Ravens: You originally studied philosophy. What prompted the move to art criticism?

Donald Kuspit: It was essentially by way of art history and more or less a natural drift. [But] I still regard what I'm doing as a kind of philosophical work, generated, essentially, from my connection with the Frankfurt School. I studied in Germany and took my doctorate in philosophy there with Theodore Adorno – his school of thought is called the Critical School. For Adorno, art is a social, as well as an aesthetic, phenomenon. The idea of the general significance of criticism in life became very important to me.

When I returned to the United States, I felt the sterility and irrelevance of academic philosophy – a kind of pseudo-Wittgensteinean linguistic analysis. Also, I had a "natural" interest in art . . . Art and art criticism seemed to offer greater concreteness than professional philosophy, as well as a critical spirit. Last, but not least, I do take pleasure in art, as a quasi-relief from reality.

Ravens: In *Artforum* [September 1977], you said "the critic must know more than both the artist and the scholar." Do you feel the critic must be "above" the artist and scholar?

Kuspit: I wouldn't use the term "above." What I would say is that to be a proper critic you have to have a general knowledge or vision of culture, which neither the conventional artist nor scholar has. You have to be a cultural historian and an intellectual historian, and, more pointedly, a visionary. You have to have a horizon on which the art can be located, rather than simply take the art as given or occuring, as both the artist and the scholar tend to. Only by locating the art on this broader horizon is it possible to understand its value and not simply to report it, to give information about it. The issue of values strikes me as crucial in criticism. Artists assume naively that their work automatically has value. They need that belief to function.

Ravens: What kind of education give artists a broader "general intellect"?

Kuspit: The artist needs a broad humanistic and social scientific education, not simply a strict art education. I regard the visual arts as very much a kind of liberal arts. Both artists and critics in general have insufficient education, in the best sense of the term. Both artists and critics tend to be good in certain "crafts" skills, but lack a sense of what one might call "the larger vision of Western art." I know that sounds terribly corny, but there must be a sense of operating within a larger meaning to make art.

Ravens: In *Artforum* again [December 1977], you said it's time criticism stopped "serving" art and challenge it, that "there's altogether too much sycophancy in criticism."

Would this kind of challenge be directed to the work or the artist's intention of the work?

Kuspit: The challenge is directed to the work itself. It's also directed to the artist's intention, provided we understand the word "intention" in terms of intentionality, that is, in terms of the general structure of consciousness involved in the work. The art object, whatever it might be . . . is itself a mediation, a communication of ideas, a "symptom" of attitudes of various kinds, involving both sentiment and spontaneous consciousness. I think the kind of consciousness in the work of art, or the nature of the objecthood, is too much taken for granted. One must really ask whether the claims it makes for itself are valid, what effect it wants to have, who it claims to reach and what it is made for.

[But] most criticism today . . . simply locates the art in conventional art historical terms. It doesn't ask the art any difficult questions. It simply regards the art as self-serving and, therefore, becomes a servant or flatterer of the art. It helps the art's own vanity. What I want to do is to break the idea of criticism as a kind of narcissistic reflection of the work of art. . . . I want criticism to offer an alternate reflection, to set up, as it were, its own parameters and see how the art fits into that.

Ravens: Today, is the artist really challenging the critic, or working for the critic, where he used to challenge the public?

Kuspit: It's hard to speak of the artist in general, but a lot of artists are working for critics. There are certain people, like some of the new decorative artists, who claim not to be working for critics. But I think we have what T.S. Eliot talks about in *Tradition and the Individual Talent.* He says the artist must be his own critic to make significant work. In some sense he is appealing to the critical consciousness in his audience. . . . However, there are artists who have a love-me-or-leave-me attitude, which allows no kind of critical questioning at all, no kind of inquisitive doubt.

Ravens: Do you think criticism and art can exist outside the commerce and "culture" of a capitalistic society?

Kuspit: I don't know if they *can*, but they don't right now. We're in a capitalist society and capitalism is very interested in art at the moment. The artist takes part in this society as much as anybody else; he sells his work, obtains commissions through capitalistic resources. At the moment, I don't see any alternate structure of support for artists. How an artist would function in a socialistic society is moot. I don't see that the Russian model is the necessary model and, of course, there is some question as to what kind of socialist society Russian society is. But, right now, there is no way of functioning outside of capitalism – it simply is a means of elementary, if shaky, support.

Ravens: What do you have in common with Greenberg's thoughts about philosophy and criticism?

Kuspit: I accept Greenberg's idea that one must not be just a working critic, but a philosopher of art, that there has to be some fusion. I accept the idea that you must know your own principles as a critic – know exactly where you stand – as much as possible. You must always justify yourself; and, the only way you can justify yourself is philosophically. Also, I accept Greenberg's conception of dialectical conversion and what I value as the general dialectical orientation of his way of thinking, although it becomes more and more muted as he goes along.

Ravens: In what areas outside art is a new type of dialectic criticism emerging?

Kuspit: Two areas strike me as important, sociology and psychology. There is a school of dialectic thinking slowly developing in psychology – originally connected with certain figures at the University of Michigan. And in sociology I think the major dialectic thought is the Critical School in Frankfurt, with which I was once, in a limited way, associated. I don't think the dialectic criticism in art is emerging – I think I'm the only critic who has a dialectical attitude.

Ravens: So there is no school of dialectic critics?

Kuspit: No, just myself banging my head against the wall.

Ravens: The true vulnerability necessary for criticism is to be unprepared, to be caught off guard by an art, to have to find the methods and resources for dealing with it on the spot. Today, with art so pluralistic, is it possible for critics to be "caught off guard" by something new and authentic?

Kuspit: Greenberg once remarked that a work of art was intention dealing with material, and the more resistant the material, the more interesting the art was likely to be. Today we don't find too many things that seem to resist our critical awareness – presuming one has such a critical awareness. So one has to manufacture one's own spontaneity, which may not sound like spontaneity, but I think we are caught up in – not simply having to generate – "artificial existence," to use Baudelaire's term. Within that, one sets up one's own surprises; certainly the surprises aren't as automatic as Apollinaire once regarded them.

Ravens: Do you think art is utilitarian to the public today?

Kuspit: Not particularly, except as an economic investment – if you know how to buy it. In the general sense of "practical," I don't think much art is. I regard art as an effort to deal with consciousness, to change consciousness as well as to mediate a certain kind of sensation, and if that's useful, fine! Today, art appeals more to the pleasure principle of the public than the reality principle; certainly a lot of *abstract art* does.

Ravens: Are you saying art is entertainment for the elite?

Kuspit: Not necessarily, although perhaps there is an aristocratic implication in the idea that one has to be at a certain level of comprehension and sensibility to grasp the art.

Ravens: Are there a sufficient number of critics to handle the "productivity and diffusion of artists" Alloway mentions?

Kuspit: Not the kind of critics I want.

Ravens: Do you think there is some way to train critics to be more dialectic or does that come only from interested individuals?

Kuspit: I think it comes from "interested individuals." It would emerge from a total educational complex, but it's one approach among many, and comes, I think, only after you've exhausted the other approaches. You have to know the more positivistic approaches and go through them to realize their inadequacy.

Ravens: What prompted you to publish the magazine *Art Criticism*, and what results do you expect?

Kuspit: *Art Criticism* is [an alternative] to the market-oriented magazines, which are most of the other magazines. It is an effort to give a little more space to writers to pursue their own interests . . . to take a step back from immediate concerns . . . to permit a longer and more complicated look at art, and to raise the status of art criticism in general. There will be analytical pieces on art critics. [T]o make art critics self-conscious is perhaps our ultimate aim.

Ravens: Do you think your book will generate enough interest and energy to make other critics follow suit?

Kuspit: No, I think it's a very individualistic world, maybe almost decadently individualistic, and nobody's likely to follow anybody. Also, there's too much journalistic pressure to simply be a reporter. Nobody's likely to take the dialectic gambit, which, from a journalistic point of view, is not the best reporting.

Ravens: What are your criteria for selecting an artist to critique?

Kuspit: There is no single rule. Some people interest me for a specific exhibition. Others' long-range development interests me. Sometimes certain artists seem symptomatic of certain ideas or attitudes that interest me. Sometimes the art is a challenge to write about and I'm interested in what I think about it. But I have no single method for deciding to deal with this artist rather than that artist.

Ravens: Irving Sandler feels "an artist can provide relevant insights about his/her aims and work" through an interview. Do you agree?

Kuspit: I would say, yes, but I think everything said about a work of art, including what the artist says, has to be taken with a grain of salt, with a question mark. Again one has to avoid the positivistic fallacy of assuming that simply because something is said about the art [it] is the case.

Ravens: What do you think the artist's responsibility to society will be in the 1980s?

Kuspit: I keep expecting some kind of change in the art world, very much like the kind of change Caravaggio represents in the Baroque period. That is, I feel we are in a kind of mannerist-historicist period – there is a certain sense of *déja vu*, of looking backwards, of having experienced things already. I would like to see a looking forward, which, to me, would come only, as it did in the case of Caravaggio, from an extra-artistic source, which would then lead to a new kind of artistic formulation. I keep expecting this development, which may be my own shortcoming and naiveté, or my own prejudice or desires.

My own feeling is that artistic developments take place by changing the terms of art's responsibility. That may be moralistic, and I have been accused of that, but it's also my sense of art's responsibility to itself. I don't think pluralism is going to solve some of the demands that can be put on art and that art ought to put on itself. Pluralism is an evasive as well as a descriptive term.

Artworkers News, April 1980 [Vol. 9, No. 8]

'80 / #138

First Feminist Art Critic

Lucy Lippard

Interviewed by **David Troy**

David Troy: What past critics do you admire?

Lucy Lippard: I haven't ever liked criticism much – I'm more interested in artists' writings. I suppose I would say Ad Reinhardt, Bob Morris, Bob Smithson, Sol LeWitt, Judy Chicago, Martha Rosler, Suzanne Lacy. . . .

Troy: Do you think a critic should write from a position of objectivity or advocacy?

Lippard: I don't think there is such a thing as objectivity, which is probably something every critic should at least keep in mind. You're working in a terrific gap between what you're looking at and what you're able to express in words. Certainly anybody under the illusion they are not being subjective is full of shit. You bring all your own associations and knowledge to everything you see.

Troy: Why are you a critic?

Lippard: Well, that gets into the advocacy thing, though basically I guess I'm a critic because I could never figure out how to make a living writing without being an art critic, and I love to write. I'm a critic because I advocate art as something society needs.

Troy: Does criticism serve any useful purpose?

Lippard: Yes, though I go through periods where I don't think it does, and periods where I think art itself serves no useful function. Over the years, I've come around to the fact that criticism doesn't just exist for those of us who live on it. Artists love it – I mean they hate it and love it; there is this terrific ambivalence. Obviously it's about feedback; where else do you get feedback? You never know what anyone thinks of your work – and you may not when you finish reading the review either. It does at least provide a middle ground that's a forum, a place where the tension between the audience and the work itself meets. At one point, I wanted to call a moratorium on criticism for a decade and see what happened to art, because there are times when the artists are reading too much criticism.

[But] critics are kind of forced into using what is called our "power." In a sense we manipulate the artists; the editors manipulate the critics. The editors, in turn, are manipulated by the advertisers and by the people who own the magazines and the boards of trustees of museums – who are then manipulated by (or *are*) the people who run the country. Artists and critics are at the very bottom.

I write criticism because I really like the gap, knowing that you never actually get to what you're looking at. You're working in a totally different medium, which is words. Of course, it came together at one point in the late '60s, when there was so much art that was just words. Literary criticism leaves me cold. I'm not the least bit interested in writing

about words. I like writing about experience. I see no reason why a critic shouldn't be an advocate, because, after all, the art world wouldn't be there if it weren't for the artists.

I don't think you have to be a sucker, I mean, you don't have to fall for everything the artist tells you. I always quote artists if I have gotten hold of the artist him or herself, or if I can find a statement or anything to tell me what the artist thinks he or she is doing, because it illuminates the whole thing . . . especially when so much criticism, including my own is, I'm sure, full of baloney.

Troy: What do you think of the recent involvement among some critics in curating shows, exhibitions and other activities?

Lippard: Well, I've always done that, so I'm very much for it. I did my first show in 1966 and at that point critics weren't doing much curating. I had only been writing for about a year. The press griped about the fact that a critic dared to put on a show at a gallery. It was a thing called "Eccentric Abstraction." I've done about 30 shows since then.

I love doing shows because it gives you a chance to deal with the art itself. I love hanging shows and making a whole out of the ideas I have about the parts. In magazine articles, you never get to reproduce much work and in shows you really get to express your opinions visually. I think a critic should be as entangled in the art world as possible. I don't mean that in the social sense; I don't think we should be selling art or any such thing, but I think we should *be there*, as advocates, or devil's advocates, or catalysts. (Maybe the devil is the artist?)

Troy: The other part of the question was, does the critic's involvement in the exhibition expand the role of criticism?

Lippard: It's all criticism. I've done some things that look like art, so people say, "Oh, Lucy wants to be an artist." I'm a writer and I love writing and I have absolutely no urge to be anything else. But I like to use words in different ways – if the art suggests different ways to deal with it, then I'm happy to go with that. But it's really all criticism in a sense – or fiction; since I write fiction too, sometimes the two of them get meshed together. I'm doing something at Franklin Furnace this month called "Progaganda Fictions" – things that are not supposed to be seen in print – they're verbal things, and some of it is criticism. I don't know whether it's a lecture on art or a complete fiction; it's both, a sort of collage. Inevitably I'm going to get, "Lucy wants to be a performance artist now." But it's still criticism. I make a living off lecturing, so it's not a foreign place for me – behind a slide projector.

Troy: How do you select the shows you review?

Lippard: It entirely depends. I haven't written actual reviews for 15 years or so. How I select what I write articles about is a combination of issues I'm passionately interested in at the moment, and things that I like to look at, and things I have meant to write about for years and never got around to.

Sometimes I'll do a catalog preface, or a magazine will ask me what I want to write on. I'll give them a list and they will pick one or two, but I don't do any commissioned work per se. If somebody calls up and says, "Do you want to do a piece on so-and-so," it's usually *not* someone I want to write

on. My choices aren't about individual artists, even those I wholeheartedly support. [They're] about a network of interests and what would be effective on certain levels at a certain time.

I think that some artists are more exemplary at certain times than at others, which doesn't mean that they're better artists, but that they bring up issues that need to be thought about at the moment. I try to be sensitive to that.

Troy: How do you feel about reviewing shows of artists who are close friends of yours? Do you think that knowing the artist improves or harms criticism?

Lippard Well, again, I don't do reviews, and I've certainly written on people I don't know. But even if I've never met them before, a lot of artists I write on end up as friends by the time the article is out. I then get accused of writing about my friends – sort of a vicious circle. But if the artist is at all available, I want to talk to the person. Actually, when I do a monograph article, I always show the whole manuscript to the artist and ask them to check it for accuracy and quotes that they may have changed their minds about. So literally every monograph I've ever published has gone through the artist, if he or she is alive, which I think is important. It improves what I write and it sets up a dialog within the piece.

Troy: Do you think art critics are too powerful in the art world?

Lippard: I don't think so. I would rather have critics powerful than some other people; if it can't be artists, it might as well be critics, who are the next closest thing. We have the same economic situation – we're mostly freelance. Although I know a lot of critics teach, I never have. I'm a working critic – I make my living off writing and talking. If artists are listening to critics too much, I'm not happy about that. Not that I don't want to be read. [But] it would be nice if everything I wrote were taken as part of a dialog, rather than as an imposition – being told what to do. A lot of artists read criticism with this kind of chip on their shoulder: "So-and-so doesn't like my work – or does." Some of the primary aesthetic issues disappear in the midst of the social anxiety and paranoia.

. . . Lawrence Alloway is not somebody I always agree with, to say the least, but over the years he has brought up real issues; he's done good articles that make artists think, and that's important.

Troy: You were at *Artforum* and you left. Were you officially with them?

Lippard: The first writing job I had was with *Artforum*, through Max Kozloff, in 1964; they fired me after two months. I wasn't really aware that they had fired me – I got another job and then I heard that Phil Leider didn't want me to write for *Artforum* any more anyway. Then I worked for *Art International*, which I guess is as official as I've ever been. I did the whole New York Letter, which was like 35 shows a month. Everybody else had quit just as I came on, so I ended up doing the entire New York scene, 1965 to 1967. I became the senior critic immediately, which was great, because I got to choose more or less exactly what I wanted to write

about, and I could put reviews together into an article instead of just bits and pieces.

I haven't written for *Artforum* in years. But now the new editor is a friend of mine whom I much admire, and I'm writing for it again. In the meantime, I've been a contributing editor at *Art in America* for years.

Troy: What about the *Heresies* magazine piece?

Lippard: You haven't seen it? I'm very proud of that. It's by a collective of 10 women, a board game about making it in the art world – or not making it in the art world. People either love it or hate it. Working collectively has been a huge influence on my criticism. I find many of the ideas I've been writing about in the last couple of years have come up through dialogs and discussions in *Heresies.*

Writing for the art magazines, even if you think of yourself as a dissident, you're "the dissident" for that issue. It doesn't leave you room to write that freely, even though the editors aren't telling you that you can't. It's like something happens in your head and you don't blow off quite as strongly. With *Heresies*, I find writing within a fabric of shared values very important. I feel like I'm increasingly able to get this kind of political directness into the art writing, which I had never been able to do before.

Troy: This comes out of the experience of working collectively. . . .

Lippard: I love trying to collaborate with dozens of people on different projects. I've been working nonstop in relative isolation for 20 years, and it's fun to work with other people. It doesn't ever get boring, though it sure as hell can be infuriating. Actually, I've been working with people for the last 11 years, first with the Artworkers' Coalition and then [on feminist issues]. A lot of younger artists really seem to be into collaboration now. The germ has been there since the 1960s, when people sort of muttered about collaboration, but didn't do much about it, except for the Guerrilla Art Action Group and a few others. I think now its time has come. It's the good old principle of organization, of unions – united we stand, divided we fall. Artists have got to break out of the imposed isolation from their audiences and each other, if art isn't going to be suffocated by lack of any real social risk-taking.

Troy: People have said that a review by you would really "make" them as an artist.

Lippard: Tell that to the people who didn't get made! It might go for certain critics with better connections. I don't have a single friend who collects. I never go to openings. I don't see any dealers socially. Whatever power I have is useless, because I'm not using it except in print and in my own shows. I can write on someone until I'm blue in the face and it's not going to make them into Clement Greenberg's favorite artist or get them a show at the Museum of Modern Art – especially since my reputation is that I'm too political, too feminist, that I like "bad art." So it's an illusion.

I get pestered by artists who think their reputation will be made if I would only come to their studios. That just isn't so. And I don't have time to go to the studio of every artist in the world. I've gotten very belligerent about it in the last

few years. I'm simply not interested in everything anyone does. I'm working on things I care about all the time and I don't think I'm neglecting art and artists. I just don't have the time to get to everybody any more. On the other hand, where would I be without the artist? Everything I've done is completely dependent on art and artists.

Troy: What about dealers and that whole process?

Lippard: I usually tell people if I love their work and I know the dealer (which is rare) that they can use my name. But I will not call the dealers and say so-and-so is showing up with some wonderful art, because I don't see that as my role. Although sometimes there are certain people from out of town I'd like to help. Then, also, I say don't use my name unless you ask me who you're using it to, because it's the kiss of death in certain quarters. Any critic gets calls every day asking for suggestions of dealers to go to. I keep saying, "I'm not an agent and I can't do anything." Anyway, the dealers are so whimsical. I mean, who knows who is going to like what? I just tell people that I know it's a humiliating, horrible process. I don't approve of it at all, the way artists have to trundle around with their wares. I hate being in a gallery when an artist is in there showing slides. It makes me sick to my stomach – I mean, whoever the artist is. But the fact remains, that's how it works, and I can't change it single–handedly. If artists get upset about it, maybe they will do something about it.

Troy: What about art politics? How would you place yourself in that aspect of the art scene?

Lippard: Well, I'm a populist and that's very unpopular in the hard core of the art world. I keep realizing how much I'm sort of soft core, on the periphery in the last 10 years (voluntarily, of course), because I really don't know what goes on in the apolitical areas. I forget it's there, but I realize the mainstream still flows happily along. . . .

Yet more and more I want to function as a vehicle for the political ideas I'm interested in: how the art gets out, encouraging artists to do outreach work that will get to different audiences and all that. It's immensely time-consuming, all the organizational stuff – Printed Matter and *Heresies* and so forth.

At the same time, I feel like I ought to see all these things. The two afternoons a week I go to galleries, I often wish I could be proofreading *Heresies* instead, because I feel more effective there. A critic who doesn't see things is not very effective and has no right to be pontificating. I used to go to any studio anyone asked me to go to and prided myself that I was always accessible. I am no longer – the numbers have gotten incredible and I'm not interested in seeing things I'm not interested in any more. I think that's something that happens to you with age. Years ago it used to be fun to go to any artist's studio, whatever the art was like, and look at it and think about it and talk to the artist about it. It's just not that way for me any more.

I'm pretty clear about what interests I have – it's a broad span. If somebody sends me slides, I can tell whether I want to go to the studio or not. Recently, I just haven't had time to do much of it. I know it's hard for artists to understand –

I've always lived with artists and so I've seen it from both sides. I don't know how to solve the problem. I think maybe it's the younger critics who should be rushing in and out of the studios. A younger critic who doesn't get around to the studios is really in trouble.

At some point, you get jaded; there are so many damn things in the galleries. I could do nothing but look at art, and I'd never write anything and never do shows or any other works. Then nobody would ever get anything out of me! I always feel like shouting that over the telephone when people start pressing me to come see something I know it's a waste of time for me to see. I hope I'm reincarnated as at least five people – then I might be able to accomplish what I'd like, and be more useful on all these levels.

Artworkers News, April 1980 [Vol. 9, No. 8]

'80 / #139

Poet Into Critic

John Perreault

Interviewed by **Walter Weissman**

Walter Weissman: How did you become an art critic?

John Perreault: I always had an interest in writing and the visual arts, but I began by concentrating on poetry. There is a tradition of poets writing about artists that goes back at least to Baudelaire. That tradition was revived in the '50s, mainly by Tom Hess. John Ashbery was assistant editor of *ARTnews*; he was familiar with my poetry and knew I was an artist. He asked me to do some reviews.

Then I met Tom Hess. On my first assignment I went around to various lofts, handing in about a half dozen reviews, for which I was paid $4 apiece. He was happy with my work and then I got to do full length articles. In 1965 there was an opening at the *Village Voice* for a regular weekly art critic and I got that job, writing pretty much every week for seven years. Then, when Clay Felker came to the *Voice* . . . I was one of the casualties.

There was a short hiatus at that point until I began to get calls from Michael Goldstein of the *Soho Weekly News* of which I am now senior art critic.

Weissman: Should there be academic and formalized training or some specific schooling for art critics?

Perreault: At present there isn't except for a few sporadic courses in the history of art criticism and a few workshops here and there. As far as I know, only one university gives a degree in art criticism – the University of California at San Diego and La Jolla. And even there it's difficult to receive a Masters in art criticism. The first and still maybe the only person to receive such a degree is a colleague of mine, now interestingly enough, the critic for the *Village Voice*, Carrie Rickey

I feel a critic should have some studio experience because it's really necessary to develop an empathy with the creative process. [It's important] to try to make a painting, to try to make a sculpture, to see in that process how difficult it really is, and how one should never take the creative act lightly.

Weissman: Do you find that your writing comes out of a tradition different from that of Tom Hess and perhaps others like Harold Rosenberg?

Perreault: More out of Rosenberg than Greenberg, though I admire Greenberg's writing style immensely, certainly his earlier criticism. . . . I have been influenced by any number of critics. When the tradition is so loose you take whatever input you can get, whatever is helpful. A very strong influence on my work, oddly enough, is a dance critic, Edwin Denby.

Weissman: Do you think art critics should hang out together and do they hang out at any particular bars?

Perreault: More and more of them are hanging out together, which may be disturbing to artists, galleries, museum people and art magazines [but] we have been pitted against each other, so there has not been any opportunity to share grievances. Paranoia and intense competition have been encouraged. In other words, if you keep art critics apart, they won't learn that critic X makes more money than Y or that Y has the right to approve all editorial changes or that Z can do such and such.

I don't think we are hanging out together, but there is more communication amongst critics and hopefully more communication [in part] through the American Section of the International Association of Art Critics, of which I am president. It's quite amazing to have 30 art critics in a room talking in a civilized fashion about art issues, but from my point of view, even more importantly, about problems we have in common as members of a much-maligned profession. I.A.A.C. has 80 to 100 national sections [and] almost 90 members in the American Section; half are from New York City, but many are from across the country, and membership keeps growing.

Weissman: Does the American Section have any platform?

Perreault: We have our own goals, [which] include encouragement of younger critics, regional critics and general problems, such as being so woefully underpaid, plus issues of copyright and kill fees. [These are] prime concerns of mine. . . .

As I mentioned, critics are shockingly underpaid. At the last meeting of the American Section, we passed a resolution toward a ten-cents-a-word fee across the board.* Some of the national art magazines pay much less. For instance, one of them pays $35 for a 1,500-word article. And we have had it; we're sick of it. Now a number of well-established critics are willing to go to bat for younger critics, demanding fair payment for professional work.

Weissman: Is there any art magazine you would not write for?

Perreault: Yes, as a matter of fact, I won't write for *ARTS* Magazine because the relation between ads and copy is direct and all too clear. Secondly, they exploit writers by paying them an infinitesimal amount, particularly younger writers, an insulting amount.

Weissman: Do you think there's a conflict of interest when a critic either curates a gallery exhibition, writes a catalog for a gallery exhibition, or is consultant to a gallery or museum?

Perreault: Critics are sometimes asked to write catalogs for gallery shows and I usually jump at the chance if the art interests me.

There is a way out of [any conflict of interest], a very clear and logical way, in that it's generally considered wrong to be paid twice for the same work. If you are a paid advisor to a gallery, which has happened in the past, telling them what shows to put on [and you also write] a magazine article praising that show, then in a sense you are collecting two fees, which I don't think is right. I don't act in an advisory capacity to any gallery. Some critics have [done that] in a *sub rosa* way. [But] if it is open and above board I don't see anything wrong with it.

Weissman: How do you feel about critics creating exhibitions at museums?

Perreault: I think it's sorely needed. In New York City at present, museum curators – fine, sweet, intelligent people – are not doing a very good job. Critics coming in from the outside can give a fresh, vital approach that someone enmeshed in museum politics might find impossible even to think about. For example, the "Afro-American Abstraction" show at P.S. 1 should have been at MoMA or the Whitney. Why wasn't it?

Weissman: I have noticed an undercurrent of social consciousness in your writings.

Perreault: Well, I try to have a social consciousness. . . . These are issues I am quite passionate about [that are] important to art now and to the future of art.

Weissman: Do you see the critic as effecting change in the art world or the world at large?

Perreault: One hopes [to] be a force for positive change. I do not believe you can separate art from a social-political context, so in my writing those things are bound to come up.

Weissman: You recently stated that content has been coming back into abstract art.

Perreault: I hope so! A number of people besides myself are rethinking the whole question of content in art. If you're suddenly confronted by art works that do refer to the world, either in a subtle or direct way, then as a critic you have to think about that whole issue.

Weissman: In writing, do you mold art you see to a set of already-established ideas, or do you let the art help you formulate ideas about art?

Perreault: I start with the art. One source of interest now is the pattern and decoration movement. Beyond that, the feminist movement in art has made me re-examine my own premises about social content in art, abstract or not. . . . The art itself set this chain of thoughts off.

Weissman: Where in feminist art and the decorative in painting do you find the political or other content?

Perreault: What I'm about to say isn't true of all artists in this category, but of the women in a strong, creative, innovative leadership position within the patterning/decorative movement. A great deal of the impulse for the work [comes out of] their own experience in feminism. They have tried to translate that kind of knowledge, that kind of understanding, into a visual language – for instance, acknowledging the anonymous work of artists of the past, calling attention to so-called women's work in general, sewing and home activities, the home crafts, weaving, pottery, etc., that women have been limited to. [These media] have been looked down on for sexist reasons: they can't be any good because women do them. *High* art is men's art – and white men's art at that.

Weissman: How do you describe feminist art?

Perreault: First of all, we have to realize the variety of women's art. There is no universal agreement as to what is or is not feminist art. To me, it's art that [makes] a conscious decision to draw inspiration from and refer to the decorative tradition, which has usually been looked down on as low-class art and women's stuff.

Weissman: What about sexual imagery in feminist art?

Perreault: In the case of women painting male nudes, the reversal of roles is a political statement. In the case of women artists concentrating on a sexual, centered imagery, that obviously is a political statement. Some women artists insist that a centralized vaginal imagery is characteristic of women's art *per se* on a deep universal level, [but] I think women are just beginning to develop a language to express feminism. Many men have central images of female sexual organs. Are Kenneth Noland's targets or Lowell Nesbitt's irises feminist statements?

Weissman: Do you know of any other minority or group of artists whose work has either been suppressed or needs to be given proper attention?

Perreault: Yes. Gay people. There have been shows of lesbian art and now, male gay art. Several galleries show homo-erotic art. A number of famous gay male artists are still in the closet, for whatever reasons, and one has to respect that – a symptom of the repression in our society. They fear they would lose their market if it were known that they're gay and perhaps they're right.

Just exhibiting gay male art would be a political gesture. And certainly the kind of issues that accompanied women's art would come up. Could you tell whether or not the art was made by a gay man? Is there something specifically gay about this abstract painting?

Weissman: How do you feel about reviewing the work of close friends and do you think that knowing the artist improves or harms the criticism?

Perreault: Most of my friends are artists. I don't know why they should suffer just because they happen to know me. I like to think that the artists who are my friends are very good artists. Perhaps a more difficult one is: I had a lover for seven years who is an artist – I think an extremely talented artist – and we agreed that I would not write about him. Now in

some ways he has suffered from that, but we both felt better about resolving the conflict that way. Perhaps we were being too puritanical. I think it is possible to write about a husband, wife, lover if one is honest about it.

Weissman: If one is up front and straightforward about it.

Perreault: [I would say] I know as much about this person's art as probably anyone else on the face of the earth, this is what I think about it, these are insights I have about it. That's very difficult to do and is usually not done. From my point of view, the more information I have about the art and the artist, the better. Many times I have gotten invaluable insights by talking to the artist. Sometimes the reverse happens – it's not always advantageous for the artist to talk to the critic.

Weissman: Do you think critics affect an artist's sales?

Perreault: When I give a favorable review, more people go to see the show, sometimes by as much as three times, I have heard. How that translates into actual sales or increase in prices, I have no way of knowing.

Weissman: In what ways are artists affected by reviews?

Perreault: A review lets the public know what art is interesting to see. It's also a kind of feedback to the artists, which I think can be helpful. Artists in general will do almost anything to get a review.

I have had artists tell me, please write about my show. I don't care if you hate it, but write something. It's very important for artists to have that show documented, in print In fact, one of the things we do as art critics is provide sources for future art history. So there is a basis for artists having that feeling, beyond the mere ego trip of seeing their name in print.

Weissman: So it's legitimate the way artists pursue critics?

Perreault: And it's legitimate the way critics elude artists. There are so many artists and exhibitions in this city it's difficult to see them all.

We now have . . . a pluralism of art criticism, which I would like to see increased. We have very individual, strong points of view that are often in disagreement. That's better than a dogmatic situation where only one point of view is expressed. If you as an artist do not fit into that one view, forget it.

Weissman: You don't think then that the mainstream of contemporary art will continue to exist?

Perreault: We have made the mistake in the past of considering the "mainstream" as this very narrow trickle that leads from Cézanne, Picasso, Mondrian, Pollock down to the latest artist the critic would like to promote.

If there is any use for the word mainstream we should begin to see it as a more complicated phenomenon. I am interested in all kinds of art, not only art that directly relates to one particular tradition of modernism. . . . I tend not to use the word "mainstream" because it has connotations of an extremely narrow view of modernism and art in general.

Weissman: Do you think post-modernism is dying?

Perreault: Post-modernism is a rhetorical term. Post-modernism only has meaning if we define modernism in that very narrow, formalist way. If, however, we see modernism, and this is a revisionist view, as broader and a more complicated tradition, then there is no use for the term "post-modernism," except as a sales gimmick . . .

I used the word [post-modernism] in the '60s and have lived to regret it. People need catch phrases to hold onto, but I think [the term] rises from a misunderstanding of what modernism really is. If it is just formalism, then I am all for using the word or abandoning it. But I don't think post-modernism is just formalism. We can't throw out the rest of the art because it doesn't fit neatly into those categories.

To me, modernism in some sense means the tradition of the new, which is Harold Rosenberg's phrase. It includes a tradition of, not just the inevitable march toward the black canvas, but more importantly and essentially, the constant questioning of art – the high value we put on originality more than any one strain of modernism. To me, modernism means art that has something to do with contemporary life, that in some ways questions received notions about art and searches for and puts a premium on originality, the unique vision.

Weissman: Is that why you attacked Hilton Kramer for his castigation of Eleanor Munro's exhibition, "Originals: American Women Artists"?

Perreault: One wants to respect another person's point of view. But what Hilton Kramer was saying was so off-the-wall and so dangerous I felt it had to be answered in some way.

Weissman: What do you think was so dangerous?

Perreault: I read him as saying that this particular exhibition, "Originals: American Women Artists," was bad because it expressed a feminist point of view. Eleanor Munro just [curated] a boring, not too-exciting exhibition, but he blamed it on feminism. I think it was a misinterpretation of the exhibition and of feminism. The *New York Times* has a very large readership, and people, unfortunately, tend to believe what they read from critics. He just made me mad and I had to write something.

Weissman: Do you think rivalries between critics like Harold Rosenberg and Clement Greenberg and now you and Hilton Kramer are healthy?

Perreault: Oh, absolutely. I wish during the Greenberg/ Rosenberg period more rivalry existed, that other critics had gotten into the fray, instead of having the whole thing between two people. One would hope that critics could disagree without being too dogmatic and without rancour [but] we are a very volatile and passionate lot.

Weissman: Do you think critics have any responsibility to each other?

Perreault: I think they do in terms of the profession. We're trying to provide an arena for them in the American Section, although we may disagree violently about aesthetic issues, even political issues. We are working toward making the profession more professional.

Weissman: How has the function of art criticism changed over the past 25 years?

Perreault: I think it's moving now to a *practice*, not just something done by rich people who can afford to indulge in writ-

ing about art, which has often been the case in the past. And it has moved toward pluralism, which of course reflects the art itself.

Artworkers News, April 1980 [Vol. 9, No. 8]

*As of 1991, the ten-cents-a-word goal had not yet been achieved.

'80 / #140

First Feminist Photo Critic

Shelley Rice

Interviewed by **Mary Beth Edelson**

Mary Beth Edelson: When did you begin to weave feminist attitudes into your criticism?
Shelley Rice: Around 1977. I'd been working as a regular reviewer in New York since 1975, at the *Village Voice* and elsewhere, when suddenly I realized that 90% of the work I'd covered was by men. One day someone asked me to name some women photographers and I realized how few I knew. I knew there were women artists out there. As long as I wasn't aware of them – and wasn't making my readers aware of them – I was inadvertently propagating the sexism of the New York art world. So Sandi Fellman, a photographer who teaches at Rutgers now, and I decided to research women's photography. We presented our findings at the Society for Photographic Education meeting in California in 1978.
Edelson: Before that, had anybody challenged you about the lack of women in your reviews?
Rice: No, because I was working so much within the mainstream, and, needless to say, that suited the establishment just fine. There's very little feminist consciousness in the photo field, since photography didn't become a recognized part of the art world until after the women's movement had passed its initial protest stage. So no one really noticed.
Edelson: Then you began this project?
Rice: Sandi and I sent letters to about 100 people all over the country: critics, curators, artists, etc., asking them to tell women photographers to send us work. We got slides from about 100 people the first go-around, and these, along with many others collected since, are now in an archive in my apartment.* Then we had all this work and almost no critical . . . framework within which to place it. The process of putting the work together led to a revamping of all my critical attitudes.
Edelson: So you had to re-think the way you had been analyzing and perceiving images. Was there a specific different approach?
Rice: There had to be. Most of the work I'd written about until that time was what I consider "classic" art photography: formalist work, street photography, urban and suburban landscapes, a few portraits, the type of work that's prevalent

– actually, almost universal – within the established New York photo community. There was incredibly little of this – and percentage-wise, very little straight photography – in the slides I received. So here I was, looking at a lot of non-straight photography, a lot of still lifes and pattern work and images dealing with family issues and emotional problems. Creating a new set of critical standards by which to analyze and judge these photographs was probably the most challenging critical problem I've faced. And I'm still working on it; I've been giving variations on this talk for two years now, and it keeps changing and growing, teaching me a lot of things about myself, other women, and artistic expression in general.
Edelson: What about audience response?
Rice: I've met a lot of wonderful women – and some wonderful men – who've been very supportive. Their comments have contributed a great deal to the talk, and made it a wonderful exierence for me personally. But there have been negative experiences, and negative responses. There's usually one man in each audience who objects to my "anger." I ignore that comment; yes, I do have anger; I don't like seeing women fucked over. But I also occasionally get negative comments from women, and when I do they're much more vicious. Every time that happens it really throws me. Sometimes it's from women who feel I haven't promoted their work enough; other times it's from women who don't like some of the work I show – maybe five or six slides out of 160 – and who therefore don't want it to represent all women, including them.
Edelson: Where do you think that's coming from?
Rice: Well, let's face it, women have been socialized to a great deal of self-hatred. And when I give this talk I seem to become the messenger with what they perceive as the "bad" news and the self-hatred gets laid on me. If they see any work they don't like, they think I'm giving them concrete proof that all women just aren't good enough.
Edelson: I've been guilty of that. I get very defensive if I see women's work I feel isn't as professional as it should be, because I identify so strongly with it I feel it's a reflection on me.
Rice: The expectations being laid on women – and that women are laying on each other – are really unreasonable. This is still the first blush of feminist activity within the art world. [T]he work I present is work-in-progress, and part of a much larger, very exciting process. There are, of course, women artists who are really fabulous, and there are others, not so extraordinary, who are laying the groundwork for those to come later. . . .

Most of all, though, there are very few cut-and-dried answers. Women's work is anything women do, and it can't be boxed. Those who can't accept this get terribly angry with me.
Edelson: Meanwhile, the women who are a generation ahead and who appear to have an enormous amount of power and recognition really don't have enough to pass down to those coming up, and that's a frustration on both sides. Another

problem is [that] a lot of women have unrealistic expectations. . . .

Rice: And that brings us to the way they treat feminist critics. I know Lucy Lippard and I have similar problems on this score. Women know I'm sympathetic, they know I write about women's work and issues, and they sort of project their needs to get their work out onto me and expect me to do it for them. [But] being aggressive is not just my responsibility. It's something they have to learn for themselves.

Edelson: Women artists who have some recognition also get asked for help, and most of the women I know try to extend that help. . . . Then you get crazy, because you don't have enough time to do your own work. [Unfortunately] there are still very few women who address feminist issues in writing.

Rice: The first thing you have to understand about anyone who chooses to be a critic is that they are choosing to have a power position. . . .

Edelson: Obviously . . . and that's the only reward, because you don't get any money.

Rice: And people hate you for it . . . Anyway, one of the ways to gain a power position is to gain the respect of the establishment and let its power float you. When I first started writing criticism, I was writing establishment criticism . . . I didn't rock the boat much, even if I did have a tendency to pan institutional shows. My decision to start dealing with feminist issues changed all that and had a lot of repercussions. It was very unpopular.

When you become a feminist critic you become as vulnerable – almost as low on the totem pole – as feminist artists. Many editors will not publish feminist criticism – a lot of pieces I've written have had feminist parts cut out, ostensibly because of space problems. I have had several arguments with editors and in fact left the *SoHo Weekly News* in 1979 basically over feminist issues, even though they were *sub rosa* rather than up front. You'll notice there are no longer any women, let alone feminists, writing art criticism in that newspaper. So any critic deciding to deal with feminist issues is putting her (or him) self in a position of extreme vulnerability – and, needless to say, most people interested in power are not willing to jeopardize it for a cause.

Edelson: So if you want power, you don't pick a powerless segment of society to write about. . . .

Rice: Right. But what most people don't understand is that you can ignore the flack you get as the result of an unpopular stand or position [and] eventually it works to your advantage. At this point, even though I still get into hassles, my position has helped a lot of people, and they, entering the art world, help me by just being there and accomplishing. Now every step forward for women reflects well on the work I've done. People don't question that about me anymore.

Edelson: Have you gotten support from the feminist art world?

Rice: Yes, a lot, and I'm very pleased and grateful for it. But in 1978, when I started my "Image-Making" column in the *Soho Weekly News,* which was overtly feminist much of the time, I was still considered part of the photo community, where there's little support for feminist ideas. As a result, my

audience shifted. I started getting support from the art-world feminist community, and also – since I was dealing with multi-media work that the photo community wouldn't accept, but that other artists accepted easily – from the Soho art community at large. And I like this audience much better than my original one, because the feedback is more thoughtful. People will sit down and talk to me sometimes for an hour about a piece of writing, what they liked and what they didn't like. That feedback helps me a great deal.

Edelson: I've heard you talk a lot about photo theory and some very interesting concepts. Would you elaborate?

Rice: One of the reasons I came into photography was because I felt that a high percentage of our socialization takes place through photographic images [but] that very few people – in the art world or society at large – understand the ways photographic images have affected them.

Edelson: Photography as a social tool is potentially very powerful.

Rice: It *already* is very powerful.

Edelson: If people taking the photographs had a higher consciousness about the theories and philosophies behind what they present, the images could have even more power.

Rice: That's why I keep trying to get photographers – and other people – to see their images within this broader social and ethical context. As far as I'm concerned, art photography is simply one tradition out of many within the field. Popular images, scientific images, surveillance images, photojournalism, etc., have at least as much impact, if not more, on society as the most beautiful artistic creation. [I see] these uses of the medium within a cross-cultural continuum, rather than as mutually exclusive.

The photographic medium was invented during the 19th century and adopted for a lot of different uses in a very short time. It was also adopted as an artistic medium. Unfortunately, most of the serious literature written about photography sees the medium from this perspective only, which has seriously distorted our understanding of the enormous range and influence of photography. [Moreover] the "art" history of the medium is in many ways defensive, based on photographers' desire to prove that they are as good as other artists. . . .

Those of us looking at photography now should stop aping other peoples' forms and ideas and start shaping our own – and start trying to understand the history and criticism of the medium [and] its role in all facets of society and daily life.

Artworkers News, April 1980 [Vol. 9, No. 8]

*The Archive is now housed permanently at the International Center for Photography in NYC.

'80 / #141

Champion of Quality

Barbara Rose

Interviewed by **Eva Cockcroft**

Eva Cockcroft: Why did you become an art critic?
Barbara Rose: I became an art critic because I couldn't get a job. I was pregnant with my first child, and, although I had all the credentials, nobody was going to hire a pregnant art historian. I was married to an artist [Frank Stella] whose paintings didn't sell at that time, so I needed money. I didn't know what to do with myself, so I just started typing. I sent in an article – it was called "Dada, Then and Now" – to *Art International*. I knew nobody, but Fitzsimmon published it. Then he said, "Do you want to write the New York Letter? I pay $300 a month." I said, "You better believe it," and it was great.
Cockcroft: What is your single most important criterion for criticism?
Rose: My subjective perception of quality in a work as measured against the standards of past art, with which I am very well acquainted. That is not to say that new art is going to look like old art, but the feeling I get is similar – although I analyse it after the fact. I would say I have no *a priori* criteria – just my experience of looking at a great deal of art all my life.
Cockcroft: A lot has been written about the influence of art critics in promoting and even creating art movements, as well as having the power to determine what is seen in galleries and museums. Do you feel critics have this kind of power?
Rose: I think they once did. The power of the art critic is very diminished at present. The only critic who has any real power in terms of getting people to look at art or buy art is Hilton Kramer. That [comes from] the podium of the *New York Times*, as well as the fact that he has a tone of authority and is much more intelligent in general than most people who write art criticism.

As for inventing art movements, I think that comes after the fact. A lot of people have accused me of inventing Minimal art. I wrote an article in 1965 called "ABC Art." It was not even my idea to write the article. Jean Lipman, who was editor of *Art in America*, said, "You know a lot of young artists. Why don't you write an article about them?" I said, "Well, I want to try something new in criticism, sort of a field approach, trying to relate phenomena from dance, music, literature, and visual arts to get a gestalt [of] what I feel is a new spirit." I didn't have a title. "ABC Art" was her title. But I started with discussion of an essay by the philosopher Richard Waldheim on Minimalism. He had clearly invented the word to discuss Reinhardt.

I had no intention of starting an art movement. The thing gathered steam in a way that was utterly mysterious to me and began to have a life of its own. People look for labels, for journalistic categories, because they want some way of organizing things and don't want to think too hard about individuals.

I did this show (and I really hate the title), "American Painting: The Eighties." The reason I used that title was because I didn't want to invent an art movement, to call it "New Image Painting" or something like that, although everybody in the show did use images, either abstract or representational. So I gave it this very general and neuter title.
Cockcroft: In the catalog to the show you say you stopped writing about contemporary art in the '70s and only returned to it after . . .
Rose: About ten years. I wrote historical articles: I wrote about Hofmann, about Krasner, about historical issues, but I didn't write contemporary art criticism after I quit *New York* Magazine.
Cockcroft: Why?
Rose: I became aware that as a critic I had power, and that my opinion did in some ways influence the art market. It made me not want to write, particularly not negative criticism – and if you can't write negatively, then you're not being critical. But, the thought that if I said something negative I was harming the artist's livelihood would paralyse me. So, I had this paralysis on the one hand, and on the other hand, I really loathed almost everything I saw.

The '70s were a decade when a lot of interesting art was being done, but not by the people in the forefront of the media. The decade is older people. When history looks back on the '70s, I think what they'll see is terrific paintings by de Kooning, Motherwell, Krasner, Tworkov, Guston, Goodnough and Diebenkorn.

I also became extremely disenchanted with the art magazines. After the original *Artforum* group broke up, I no longer felt a sense of community with any group of writers. I did publish some – very little – about contemporary artists, almost all of it about Jasper Johns, the one artist I could feel a continued interest in at that time. Then, when conceptual and performance art were passed off as the avant-garde, I felt there was literally nothing to say.

Conceptual art, as far as I'm concerned, is closet criticism. It's people who aren't brave enough to make something, or respectful enough of other artists' work to deal with it as a critic. They don't want to be an audience, they want to be a performer, but they basically don't want to put themselves on the line and make an object that can be judged. As far as performance art is concerned, I think the audience for that kind of thing, if they weren't relatives of the performers, were emotionally bankrupt. The idea that somehow someone else's neuroses are interesting! If you have time to sit around and watch other people's psychodramas, it means you have no life of your own – you're not alive yourself.

Also, I realized that the role of criticism had changed and if you wanted to have any kind of communication it had to be more powerful. One of the artists with whose work I was profoundly involved in the '70s was Mark Di Suvero. And I chose at the time, although eventually I intend to

write a book, to make a film about Di Suvero – which took years.

Cockroft: Now that contemporary art is frankly discussed as investment property – Citibank, for example, buying art for people's portfolios – some people draw direct links between positive criticism and monetary value. Do you think this kind of economic linkage distorts the critic's role?

Rose: It's exactly the role criticism had in the 19th century. In other words, art is again a part of the society – for better or worse.

On the other hand, it's probably more difficult today to choose a critic to listen to than it is to find art you are interested in. The classical example is always Greenberg. There is the Greenberg myth, which is that because he was right about Pollock, he's going to be right about everything. Well, if you really look at what Greenberg came out for, and you start to have a little historical distance on that, after Pollock what did he come out for? Louis, Noland, Frankenthaler, Olitski, Bannard, Poons. How much of that is going to stand up? I really feel for those Texas millionaires who have 40 million dollars invested in Jules Olitski. I feel for them.

Cockroft: Often critics are directly identified as spokespersons for the particular art movements they write about and are friends of the artists about whom they write. Others disavow this approach and claim impartial objectivity. Do you think criticism should be partisan or objective?

Rose: First of all, I think anyone who maintains that criticism is objective is unconscious, or a liar, or both. You respond to things . . . because you are a certain kind of person emotionally, or have had certain kinds of experiences. Critical judgment is a subjective judgment, an intuition of quality, and whether you are right about that is something that can only be seen in hindsight. We are very interested in the criticism of Baudelaire and Pater and Ruskin because of the quality of their writing, but in fact, for the most part their critical judgments were totally off. Those very few critics who had anything good to say about the Impressionists and Post–Impressionists were not very good writers.

I think all important art critics historically have been allied with a specific kind of art toward which they felt a certain affinity and for which they were to a degree propagandist. Even someone like Henry McBride, who was not a particularly outstanding critic, but was the house propagandist for the Stieglitz school, played a very important role for that reason.

The idea that you don't have to know artists and you can be absolutely detached and live in some superior zone where you only go to dinner parties with your peers is nonsense. First of all, if you're really attracted to art you usually like the person who makes it. The idea that you write favorably about your friends is unavoidable. I often meet the person through the art. For example, I didn't know Susan Rothenberg, but I was very interested in her art and later I got to know her because I liked her art. That's been the main reason I have gotten to know artists.

There are myths which are nonsense. It was John Canaday who said the critic shouldn't know any artists, that you have to be totally objective and can't be swayed by your relationships with artists, and I think that Canaday's criticism has that quality. It won't stand up to any kind of scrutiny. It's completely ephemeral; nobody cares about it anymore – he was absolutely uninvolved with the issues. I think if you're not involved and don't care that much about the issues, you're not a very good critic.

Cockroft: In putting together "American Painting: The Eighties," you functioned as a curator rather than as a critic. This has become commonplace; however, don't you think there is a conflict?

Rose: Not at all. In fact, judgment and taste are formed in exhibitions. The art magazines are really superfluous. They're publicity brochures for the galleries, sort of words around the ads, with a total confusion between editorial and advertising. The only way you can really get your statement, your vision, out there to the public is to put it up on the wall. And to be willing to be judged.

That exhibition was my vision of a kind of painting I am particularly interested in, which is a continuation of the modernist tradition. I think critics generally are more qualified than curators to do exhibitions. People who become critics are generally mavericks, people who don't fit well into institutional structures. I would much rather be a curator, but because of my personality, I can't get a job in a museum. I offered to be the curator at the Whitney – and I can't think of anybody who is more qualified than I am to be curator of 20th-century American Art. The Whitney Museum doesn't want me because I am too strong a personality and I'm not a person who people trust to function within an institutional framework. That's been true of teaching also. I think people who don't fit into institutions are more interesting than those who do.

Cockroft: There is a rumor circulating in the art world that a single corporation or person bought the entire collection of your "American Painting: The Eighties" show. Is that true?

Rose: The idea for that exhibition took shape in a very fuzzy way in my mind. I was bored and disenchanted with museum shows. I suggested to the Whitney that the most radical exhibition they could have would be mainstream modernist painting and sculpture today. That was not looked upon with great favor.

I wanted to do this exhibition and nobody wanted me to do it. I wanted to do it, to see it, to put it up and look at it. And I wanted the artists to see each other's work and to be able to identify other people who perhaps had similar objectives in the mob scene which is the art world. I was in Paris talking to a friend of mine, Paul Hain, a private dealer who does not sell American art at all. He is a dealer in School-of-Paris pre-World-War-II masters. I said, "I really want to do this." And he said, "You pick this show and my foundation will pay for it and tour it and pay for the catalog." He has a non-profit foundation, and those paintings belong to that foundation, which is paying to have them shipped and stored and catalogued. His foundation is called "Fine Art of This Century," which is a sort of evocation of Peggy Guggenheim's Art of This Century – and I think his motiva-

tions are very much like hers. He felt he had made money out of art and wanted to put something back in, to stimulate younger people whose work he doesn't handle and has nothing to do with.

It was a terrific thing to do because the artists got money immediately, which permitted them to buy more materials. The work is being taken care of, being exhibited, and a catalog was published. I am fascinated by the reaction that somehow there's something wrong in this man giving money to artists for their work.

Cockroft: Do you think women and minority artists who have faced massive discrimination in the art world should receive compensatory treatment of any kind?

Rose: That's a difficult question. No, I don't. Personally, I am involved in standards and quality, and I think that compensatory behavior or actions don't necessarily lead to maintaining levels of quality or standards in art. However, I think they should have a greater percentage of grant money because they have a greater economic disadvantage.

Artworkers News, April 1980 [Vol. 9, No. 8]

'80 / #142

Museum Person

Upon departing a curatorship at the Whitney Museum in the late '70s, Marcia Tucker set about fund-raising and planning for a museum closer to her own vision. By the time of this interview, she had become Director of the newly-founded New Museum. (For a report on the New Museum a decade later, see '90/#222.)

Marcia Tucker

Interviewed by **David Troy**

David Troy: It seems any hole in the wall can now call itself a museum. Just what is a museum?

Marcia Tucker: I'd rather not begin with a polemic, but I think traditionally a museum is a collecting institution that preserves the art and artifacts of present and former civilizations against time. I probably should look up the word "museum" and find its Greek root; but at least it was traditionally a place for the care and preservation of those artifacts, as well as for the public viewing of them. In recent years, the idea of the museum has changed considerably and it's actually possible now to have a museum that isn't a collecting institution. But in that case it's more like a *Kunsthalle* – an exhibition space.

I think most contemporary art museums fall between the Kunsthalles and traditional museums in that, although they don't collect, they do provide the kind of scholarly context in which to see those objects and artifacts. It used to be said that a museum of contemporary art was a contradiction

in terms. I don't think that's so any more. But one of the things that separates a museum from an alternative space, for example, is the idea of scholarship. Most people who run alternative spaces – though not all – are artists, people who are dissatisfied by the way the system works, and rightly so. Alternative spaces function for the artist first and foremost. A museum functions for the art first and foremost. Alternative spaces are run by people who aren't necessarily art historians, and their concerns are not museological. They're not concerned with climate control or insurance or alarm systems or handling procedures. For the most part, they just let the artist come in and do what he or she needs and wants to do.

Now, in saying that, I want to make very clear my absolute belief in those alternative spaces and my commitment to them. It's just that I'm a museum person, an art historian . . . Although I hate art history, in one sense, I really believe it is valuable. I think the art of the present sometimes is not so much inherently valuable in terms of objects, but may be valuable as repositories for ideas [which] interest me as much as the objects. That means we don't do a show unless it has a catalog with a lengthy critical essay (not just an introduction), biographies, bibliographies and documentation that's as thorough as our funds will allow. Actually, our funds don't even allow for the kind of documentation we do. . . .

Troy: What about the question of where the money comes from and the influence that may come with it?

Tucker: This is a complicated issue: I remember years ago when I did a Robert Morris show at the Whitney. It was during the anti-war movement, and he withdrew the show, which cost the museum thousands of dollars. I asked if he couldn't drape it in black instead, but he said no, he couldn't do that – he had to withdraw it. He talked, I remember, about "dirty" money, and I really thought about the phrase and I realized that, in one sense, all money is "dirty" money. It's not where the money comes from, but what you do with it. I don't care if our money comes from a large corporation, if we can use it in a way that will benefit artists and minorities, or advance new ideas.

Thus far [there have been few] restrictions on money. Mostly, they give it and say, "Continue the work you're doing." I have never had a corporation or private individual tell me what to do with the money.

Corporate contributions officers can be pretty terrific people. Whatever the corporate mentality is, they don't have it – they wouldn't be contributions officers if they did. I've only encountered one corporate contributions officer who wasn't like that. . . . He didn't like modern art. Other people, however, are happy to see you and want to do what they can. I don't want to be a Pollyanna, but our experience has been good. In fact [The New Museum] is basically a socialist model. There is no hierarchy of job title, position, or salary.

Troy: You did not get any salary when you started here.

Tucker: I'm on salary for the first time this year – the same amount as everyone else.

Troy: How about decision-making; is that done in a collective way?

Tucker: People make decisons according to their area of knowledge or expertise. Mostly, we enjoy talking with each other, but certainly I am not the sole decision-maker, nor do I have the last word on everything. The core of our work is, and will remain, collaborative. . . .

Troy: What about relationships with the artists you show?

Tucker: We're the only museum that pays artists honoraria. Most museums don't do it because they know they're opening up a can of worms. They'd have to decide whom to pay and how much. Most alternative spaces do it because they're concerned with artists. We also never ask the artists to pay for anything – no shipping, no framing, no publicity or postage – the artist never has to finance anything. If an artist needs to come from California, for example, we pay transportation and expenses.

Hundreds of artists come in to show slides, and we have only two people on the curatorial staff to handle them. If you're coming from outside New York, they will always try to give you priority. We have a very active travel program, so our curatorial staff travels all the time. We also try to subvert our own taste in the exhibitions we do.

For instance, people have been saying for years, "Why don't you just give your space to us?" – and we've been saying that museums need to exercise curatorial control. Then we sat down and thought about it, and said, "Why do we need to exercise control?" So, for the next show coming up, "Events," we are giving up our space to three independent artist collaborative groups – Fashion Moda, Taller Boricua from the Museo del Barrio, and CoLab. We're paying them and giving them a budget for materials . . . with the agreement that they will turn it back over to us in the same condition that they got it in. [But] one of the groups went ahead and didn't tell us that they were showing with a highly commercial gallery beforehand, and that's upsetting.

Troy: What about your relationship with galleries?

Tucker: I'm sure every museum has relationships with galleries. You know most of the dealers, and you try to keep up. Dealers come and look at the work and you exchange as much information as possible, but we're under no pressure to show certain people.

I would like to come back to your original question about spaces suddenly calling themselves museums. One space, for instance, decided to add "museum" to its name. I asked why and they said it gives them a little more prestige. I thought that was opportunistic. There wasn't a single art historian on their staff. It isn't the only place that's done that. Which is not to say anything about the quality of the work shown, but I do believe there's a museological function that has to do with scholarship and professionalism.

We don't have any artists on our staff working in curatorial positions and we won't have any. I think that's a conflict of interest.

Artists do want to have museum shows. It's one thing to have an alternative space that can show 50 or 100 people a month, but I also think there has to be a place that provides a context for the lesser-known artist, which will allow that artist's work to be seen against some more established work

or in a fairly clear, critical light. That means fewer shows, and more work on each show – especially the writing, which is important. It also means establishing a very broad base from which to choose work.

I think the idea of what a museum is is changing, and I hope The New Museum can [change] and meet the needs of the art.

Artworkers News, December 1980 [Vol. 10, No. 4] Excerpted.

'80 / #143

The Abstract and the Particular

It was a time of great expansion for artists, as well as critics – and also for art talk. Here is perhaps the first of a series of almost miraculous artists' panels in the early '80s – relaxed, intelligent discussion by artists of their ways of working and thinking and the devices that helped them. This one was further abetted by the moderator, who came prepared with questions (not always the case) to give structure and encourage wider reflection.

It might also be said that artists talking about their art are themselves a "personal abstraction," that is, wonderfully peculiar and disarmingly candid, at least on their working methods. The artist who here describes working without his glasses by one small light bulb to avoid visual "overload" may well be *sui generis*. Other feelings and ideas of the evening are equally personal, although Stuart Diamond reminds us that for a number of years, "if you were working in a personal vein, the work had no public arena." One other very strong flavor of the evening was Max Gimblett's British voice and Virginia Cuppaige's remnants of Australian, now relegated to the reader's imagination.

"Personal Abstraction, Four Painters' Views"

Moderator: **Corinne Robins**; Panelists: **Ross Bleckner, Virginia Cuppaige, Stuart Diamond, Maxwell Gimblett**
Artists Talk on Art, NYC; May 9, 1980

Slides and commentary began with Stuart Diamond describing the evolution of his thickly-painted pictures of 1973 into art using "physically found elements" as "skeletons" of works weighing as much as 80 or 90 pounds.

Stuart Diamond: Here I'm still working on the floor, with most of the activity around the perimeter, and a darkened graphite center. Now I'm starting to throw in some wood, fabric, other materials, for a kind of resistance, something to bounce off. These are done very fast, usually in 14 or 15 hours. I started to introduce boundaries and materials to slow down and define some of the drawing, so it wasn't just created by the paint. . . .

I was working at the Soho library, doing a lot of reading, reading Leo Steinberg on Picasso's obsession with flipping

his figures front and back. It was sort of an absurd pursuit, but Picasso spent many years doing that. *Reversal* became the same kind of play off a reversal.

Table for To With Three started with a transfer type upside-down "To" in the center. . . . After thinking about it for a year, this encouraged me to move away from canvas. [But] something changed when I began to work with wood. As the pieces got denser and denser, the energy went from front to back, not side to side, like it does with canvas. Then almost by instinct I started to punch holes, and use the negative space, to read the wall as an active element. . . .

My source material was everything I could pick up in this neighborhood [Soho] as it's been transformed, remnants with many echoes attached. I wanted them to look like another time, not to have a contemporary veneer or finish, to tie into something older. The basic structures are packing crates and materials other artists or factories throw out – creating a kind of encrusted, fossilized surface.

This is titled *Thick Painting*, a term Jasper Johns used in an interview. If you're not working directly on canvas, the issue of definition comes up. Are they paintings? sculpture? a hybrid? So they're "thick paintings."

I don't like to build the way a carpenter would build. I had to find a process that would let me build the way I paint, very fast and direct.

Enmeshed has a sort of screening in the background, so I could use the wall for negative space. . . . *Painting with Shelf* is a play on the dilemma of painting, its needing some kind of support.

Ross Bleckner: It's very hard to talk outside a bar or a studio. I'm at a loss for words. I forget my titles. So I wrote some notes:

> You're a language that I speak in but do not know /
> You're always hiding under the surface / My paint is your
> skin / In your world I seek dispensation from the struc-
> tures and values of mine/ You believe in things that I
> question / You question things that I believe in / . . . You
> respond, you point, you desire, you mediate / and are
> critical of being in the world / You mock our dual expec-
> tations and this we call discourse / . . . Painting places us
> at the edge of articulate being / It expresses us by making
> us what it expresses.

That's excerpts from notes I write down occasionally.

Now I remember the name of this painting: It's *Party for the Real Murderer.*
Audience: How important are the titles?
Bleckner: Not very.

Having read his "notes" by the light of the Party for the Real Murderer *slide, Bleckner showed other slides of paintings rang- ing from 12 by 18 inches to about 6 by 5 feet. Then Virginia Cuppaige showed slides of her acrylic paintings of the last two years, from six by four feet to as much as 20 feet long.*

Virginia Cuppaige: I'd been painting abstractly. Now I bring the surface into a light and airy space, using many, many, thin layers of color. It's a very soft surface, with a kind of powdery, floating effect, a change from my earlier bright, intense color. The recent work is about open space and shapes working in it . . . The shapes are chosen so they won't

be symbolic or represent anything . . . I consider myself a totally abstract artist . . . I choose simple semi-geometric shapes to play against one another. [They have] their own dialog on the canvas, rather than talking about something else outside the painting . . . I try to keep the shapes specific, simple and few. . . .

Max Gimblett: The reason I don't have slides is I just learned I was on the panel. (I know I should always carry slides with me.) But you can have a look-alike in the sense that Len Lye once did a few slide pieces. He put up two slides at once – one was an artist's finger, or their nose, or their foot, or their bum, and the other was a piece of their work. And the char- acteristics were invariably recognizable. Eames's finger, Eames's chair. The side of Corbusier's ear; a Corbusier part of the building. So you're getting a little of the look-alike of a Max Gimblett.

My work has color and structure, geometry, and an im- age. I'm a non-objective painter. I have the notion of creat- ing a language from year to year. My year is made up of four seasons. I paint through the seasons, year after year. I have the sense of creating a language. I believe in this language and its ability to articulate. . . . A few of my current titles are, *In a Pure Regard, White*, which has a twin painting, *In a Pure Regard, Black.* A lot of titles are simply colors, like *Blue Red, Black Red, White Blue.* Sometimes titles recognize heroes of mine. There's a *Blue Red to Len Lye*, a *Black Red to Barnett Newman*, a painting to Rilke, and one to Valéry.
Robins: I have a two-part question about where panelists think they're coming from, what has influenced them, and what the sources of the work are.
Diamond: Sixteen or 18 years ago I'd see someone's work like Léger and not like it and two weeks later I was painting something like Léger. When I got introduced to Max Beckman, I had to work my way out of that and then I dis- covered someone else sitting a few yards down the road. This using the past went back to the 16th, 17th, 18th century.

Then, for a great number of years, I found that the na- ture of my work was not public. My dialog was with myself, my experiences, information I picked up, and with my friends, whose work I saw in their studios and shows. Infor- mation from the public art world was a little synthetic: too controlled, not open to many options. That seems to be changing in the last few years. For a number of years, if you were working in a personal vein, the work had no public arena. It wasn't considered part of the dynamic dialog being presented outside. So the relation of the artist to the public was always five to seven years after the fact. . . . Essentially mine has been a relationship to other artists, some known, some not known.

I slowly started finding things, like an Indian myth, or literature, as a way of connecting to the work. It may have come from a sentence in my reading, a moment I experi- enced or saw. I set out when I was about 18 or 19 to digest a lot of information. The problem was to find a merger for the visual information, to put it all together. The found materi- als introduced a neutrality, a pause, that let me find new

meanings, new connections. So I like to keep the work open-ended, not to know where it's going.

Ross Bleckner: There's always a ghost with you in the studio – they come with tremendous velocity. There's always a dialog with these people who sit with you in the studio, but it's difficult to [cite] a particular influence.

Virginia Cuppaige: I've been influenced by many, many artists, but Mondrian immediately comes to mind. When I first came to America, I saw a huge exhibit of Mondrian. I'd only seen him in reproduction and I realized I'd totally misunderstood him. In fact I hadn't liked the paintings in reproduction. They looked cold, architectural, removed. When I saw them close enough to touch, they were so exquisite and so delicate and so fine; it was a great revelation.

That stayed with me, that revelation about surface and delicacy, how something can be so strong, fine and subtle. But as far as influence in the last few moments, it's come from living in America – the popular culture. For example the music produced in America is fun and delightful, at the same time very strong and driving. That in the last few years has influenced my painting.

[A]bout 6 years ago I decided I wanted my paintings to communicate much more directly, even though they were acceptable in aesthetic terms. I wanted to be influenced by everything around me, to visually translate that, so it could speak out to the world again.

Gimblett: I have one dominant interest – in values. I'm trying to open myself up and learn more and have more experiences. Everything affects me, absolutely everything that I can sense. [So] my dominant source is our collective values.

Robins: It's interesting how very, very different all the "personal abstraction" on the panel is. Three-dimensional painting, large color-field, a kind of black and white, and single image dealing with color. I'll ask each panelist to talk briefly about the main elements of their vocabulary.

Diamond: The word "personal" keeps sliding away, a very ambiguous term, because it's a code word. *All* work is personal. It may produce a look that *says* it's about negating certain personal information and setting up a system that's very clearcut or it may be more visually connected to subjective personal information.

Here's a quote from Harold Rosenberg: "Choices having to do with method in art become in practice attitudes regarding the future of man.". . . The sense of collapsing systems can be interpeted through a filter that is only an art filter, or it can be a psychological filter or a social filter. I found recently that things going on internationally were raising my anxiety level, also personal issues, and I couldn't separate them, so I began to do a lot or research on World Wars I and II, finding images from tank battles and a lot of the more violent objects produced in our society and then finding a way to assimilate or digest them. . . .

Robins: By the use of things you find currently?

Diamond: The findings have driven me out of my studio. I did a show in three months with one light bulb so I wouldn't have to look at all this chaos around me. I went from a 100-foot space to maybe a 12 by 12-foot work area. I was able to do the paintings half in the dark, half without a conscious seeing. I had a connection to the work that allowed me to make it in a very uncomfortable working situation.

Since then, I tried to shove a lot of the stuff back out into the street, to drop them all back where I'd received them over six years, but I was getting summonses and violations from the Sanitation Department. . . . Still, part of my education was in this odd collecting thing that took over and started to drive me out of my own place. Now I'm sort of working my way out of that overload.

I intentionally would not wear my glasses when I paint so it's slightly out of focus. I intentionally created a vocabulary of images and shapes that engulfed me, that was constantly feeding me information. Very common objects seen in the street from 20 feet away start to take on some interesting configurations. Up close, they're just a chair and a table. So the street and this area have been my landscape, a starting point.

Robins: Ross, your work is a completely different approach. I'm interested in the black and white, and the linear quality.

Bleckner: The fact that I start my paintings with color leads me to believe one of three things: The first is, color for me is too arbitrary; the second is, I don't know how to work with it; third, is that I see the world in black and white.

Robins: How many layers of color do you use before you get to the black and white?

Bleckner: Usually I start painting and just choose a color and then I can't figure out why I chose it so I always end up painting it black.

Robins: What about the linear aspect – a couple of geometric lines that inform almost all the paintings?

Bleckner: I build up a surface, then go back into it. The painting emerges from the drawing, so they are drawn paintings, in the sense that the shape-making inside the painting is how I establish a relationship.

Robins: I assume everyone on this panel works directly on the canvas.

Bleckner: Yes. I don't make drawings. I used to write a lot in a journal. I stopped writing, so it's almost like the writing became the drawing in the painting, the language of inscribing shapes into painting.

Cuppaige: As opposed to Stuart's way of working, I think I paint *in spite of* what's going on in the world . . . The paintings are sort of like their own universe. The shapes can set up a dialog among themselves. The painting is about what's going on on that canvas. I feel they're revealing of myself as a person, but in other terms. So whilst I say they're not of this world in one sense, I feel they are very much about the kind of person I am.

Robins: Of everybody's, Max's work is the most honed down – a single aspect of a single shape on a ground.

Gimblett: I do one-color paintings, two-color paintings, and three-color paintings [in] a fairly straightforward, simplistic geometry, like a child's geometry. I've got a very old traditional idea at the center of it, on the duality, or the polarity, of color and form. Most of the time I feel divided and I enjoy the times I don't feel divided. The way I attempt to be whole is in a dialog of color and structure. I want my color, finally, to be a feeling cluster – I don't want it to be genuine.

Robins: You all work on a rather large scale. Would you talk about the kind of space you're interested in?

Diamond: I used to do a lot of drawing, but now I feel free to "draw" with these random elements laid out on the floor, or built up around me. So my actual space is the floor and these actual elements draw themselves in relief above the floor.

Bleckner: What I consider the space of my painting has to do with the articulation of the relationship inside the painting. . . . I try to make it as complex as I can.

Cuppaige: When I think of space, I think of infinite space. But when I'm working, the forms I use are very specific. I think of them as a "something" of few words. I myself like to talk and move around fast. But the paintings are kind of slow-moving and quiet and soft-spoken. I try to show space is precious, can't be wasted, and must be very, very clear. I deliberate for months about how few or how many and the placement of elements on the canvas.

Gimblett: Concave and convex; see-touch, touch-see; the space in my original house; the space in my body; inner-outer. . . . I think I paint a different space all the time. Sometimes I have notions of painting across space, of aerial space, gravity space, a very, very deep space, infinite space, a space like in de Kooning's *Doors to the River*.

[Gaston] Bachelard's book, *The Poetics of Space*, has always meant a lot to me. . . .

Audience [To Bleckner]: You talked about how words or language inform your art and how a word may be a trigger. Can you give an example?

Bleckner: Jail.

Audience: How so?

Bleckner: It's like a reconstitution of psychological elements that are basically pre-verbal. . . . Painting is really the only art that doesn't negotiate itself in the world by dealing with language. One of the ways of getting into painting, for me, is thinking of a word, almost the incantation of a word.

Audience: You seem to enjoy loaded words.

Bleckner: Well, words are loaded.

Audience: You mentioned a title . . .

Bleckner: *Party for a Real Murderer*. . . . There's an extended narrative I think painters work with, a way of entering into the space of the empty thing in front of you. Like Max thinks about all this harmony, I think of the work as very disjunctive, schizophrenic . . . Some things occur to you – a nuance, an inflection; you're trying to capture something, or free yourself from something. That painting just had to do with a friend who got murdered.

Audience: I wonder if Stuart would talk about working on the floor versus working on the wall . . .

Diamond: I never saw the work up until it got to the gallery. And I never saw the work very clearly, because it was surrounded by other work. I realized I was unconsciously setting up interference and resistances between me and the work – as if it wasn't difficult enough. I worked by one bulb at night and then in the morning I'd have a more conscious, clarified look. I'd build a few pieces a night and leave them, and if my cats hadn't destroyed them the next morning, I'd presume they were structurally sound and immediately glue

them down. I learned more about carpentry, but I wanted something that could be made very directly and quickly, without second-guessing.

There was a night-consciousness versus a day-consciousness, [with] a kind of trusting – allowing something to happen and not to worry about things not happening. I found I never had to take the work down from the wall and reorganize anything.

Irving Sandler [from audience]: The panel title is "Personal Abstraction." Is there a notion of an *impersonal* abstraction, that you think you don't want?

Diamond: When I was woken up and asked to be on this panel, the title had to do with subject and content . . . At times I'm not sure I'm a completely abstract painter because I'm willing to use a real object, although possibly transform it, make it difficult to see . . . The word "personal" seems to be a codified word [as opposed to] "impersonal" visual systems. But even that doesn't deny personal psychology and information, although some people make a point of denying it.

Cuppaige: I thought the title mainly meant "personal" in the sense of translating into personal terms I take it for granted that my personal self will reveal itself through the paintings. But it's nver been a particular issue for me to get a "personal" message across. If a painting isn't revealing of your inner self or your personality, that's a tremendous block to placing it on a universal level.

Robins: I took it for granted, having inherited the title, that what everyone had in mind was non-formal painting, rather loose abstraction that did not belong to a particular school of the moment, a kind of idiosyncratic painting that wouldn't fit into the definition of decorative or realistic or hard-edge geometry.

Gimblett: If Sol LeWitt says that he's working on a logic of grammar that isn't logical, and Jung says when we're the most personal we're the most collective, then I don't really like the notion of the idiosyncratic. I don't feel located in the "personal," but I do feel located in the history of non-objective painting. . . . So the question goes back to you, Irving.

Sandler: Recognizing the diversity of the people on the panel, I wondered if there could be any common denominator.

Diamond: It feels like, after a number of years, abstraction is seeking to refuel itself . . . not just a systematic progress of art events, where someone makes the next little move, which has developed a heightened, overloaded way of working. "Personal" reintroduces, besides a way of working, the possibility of a personal psychology or set of references parallel to the art-language information. So in that respect the use of the word "personal" made some sense for me.

Gimblett: For me, abstraction is not abstract. At this point, in fourth or fifth generation non-objective language, it's totally real – a language. So, as for "abstracting" from something, I'm not abstracting from anything. The thing has this language. It's real. It is what it is.

Edited from tape.

'80 / #144

Cluing in the Unclued

Now we consider the artist, not in relation to art, but in relation to the "business of art," a concept that had clearly gotten its nose well into the tent by 1980. There were a number of conferences on the subject, all sharing one major characteristic: the relatively poor and obscure have paid the relatively rich and celebrated to torment them. But Georgia Kornbluth turns her personal chagrin into a public service by succinctly recording selected pronouncements on "how to make it in the art world." She even draws blood from stone by coming to some sensible conclusions. (I well remember the helpful advice from one such tutorial, circa 1975 – "Get someone to write about your work" – although that affair was at least free.)
By the 1990s, of course, we have a clearer understanding that the *really* best way to make it in the art world is to go to school with the well-connected, seek out such a person or persons and sleep with him, her, or them, and/or join their punk rock group.

"The Business of Art and the Artist"

Speakers: **Kitty Carlisle Hart, Tad Crawford, James Rosenquist, Deborah Remington, Terry Dintenfass, Andrew Konstandt, Monona Rossol, Philip Pearlstein, Joan Snyder, Kate Keller, Nancy Holt, Linda Bryant, Geno Rodriguez, Ivan Karp**

Jointly sponsored by National Endowment for the Arts, the US Small Business Administration and New York's Foundation for the Community of Artists. Museum of Natural History, New York; 1st Conference: January 24 - 25; 2nd: May 15-16, 1980

The first conference had been devastating. I went home with a headache and had trouble painting for days. I had been treated like a nonentity, and resented it. But when notice of a second "Business of Art and the Artist" conference arrived a few months later, I immediately mailed a check. "Why go to another one?" my husband asked. "Unfinished business," I replied.

I am an artist – the strongest fact of my identity. I am happy in my studio on the Hudson, painting the river, the sky, the buildings, the trees. But I want more. I want the world to know me as an artist. I want people to look at my work. The world rarely sees my paintings, and I know if I want them to be seen I have to leave my studio and take them out into the world. But where to start? Whom to approach? I thought the conference on the business of art might help.

The Museum of Natural History is a wonderful place. Primitive gods line the halls leading to the auditorium. I don't know the rituals to appease them so they won't come down off the walls to tear me limb from limb; but the presence of uniformed guards is a deterrent, and on the day of the conference thousands of artists passed through the halls safely to find cushioned seats in the auditorium. The first row was reserved for panelists and deaf artists and their interpreters.

The conference was a microcosm of the art world. The underlying message was, "We don't need you, but we know you need us." We were many, the panelists were few. They sat on the high, bright stage; we sat below, in twilight and obscurity. They did not allow us to speak to them, only to write questions, which were read aloud if they were of "general interest."

They had names. We knew who they were; they had no way of knowing who we were. We were anonymous, even to each other. Getting anything out of the conference meant two days of hard listening. A river of information and opinions flowed off the stage, muddled and clear, inaccurate and accurate, some of it intimidating, humiliating, or otherwise infuriating. For example:

•Several successful artists claimed they had never gone out looking for galleries because dealers had always sought them out. These statements were disheartening. I could paint in my studio for another 50 years and no dealer would even know I existed, much less seek me out. My written questions to these artists about how the dealers knew they existed went unanswered.
•Several panelists implied that most artists who have not yet achieved success (however that elusive quality may be measured) will never achieve it. Their attitudes about this likelihood ranged from mostly smug indifference to occasional compassion and regret.
•Several members of minority groups said there is still discrimination against minorities at all levels of the art world, if only because minority group members often cannot socialize comfortably with the establishment.
•Several women panelists said there is no longer discrimination against women in the galleries – to the great astonishment of many in the audience.
•Some panelists said, "Price your work high, because you can always go down," but others said, "Price low, because you can't go down but you can always go up." My written request for a discussion of these discrepant viewpoints was ignored.

Along with these confusing and discouraging opinions was much practical and useful advice. For example:

•Find out about the health hazards of your materials. Learn and follow the safest working methods.
•Visit a gallery several times before you approach the dealer, in order to decide whether this particular gallery would be a suitable place for your work. Ask how they prefer you to submit work, and follow their preferences.
•Don't present a sampling of all the kinds of work you can do. Instead, choose what you feel is your best.
•Prepare a professional slide presentation. Get a good 35mm camera and lenses, tripod, film, and lights. Learn to use them professionally. Give careful attention not only to background, exposure, focusing, color, and lighting, but also to the aesthetic qualities of the slides and to the interpretation of your work.
•When you approach dealers, foundation representatives, architects, curators, collectors, or anyone else to show your work, let them know you are proud of it.
•Present yourself well. Show that you value yourself as well as your work. Develop your socializing skills.

After two enervating days had eroded our socializing skills and self-confidence to their least impressive level, we unknown artists had our only chance to speak to panelists and lecturers. A wine and cheese reception took place in another awe-inspiring, dimly lit hall of the museum with a huge white whale hovering overhead. I got some valuable information on safe methods of working with pastels from Monona Rossol, director of the Art Hazards Project of the Center for Occupational Hazards. But my attempts to strike up a conversation with Geno Rodriguez of the Alternative Museum were unsuccessful, although during the panel he had declared his openness and welcome to unknown artists. I was unable to spot any other panelists among the hordes. I quickly drank my wine, ate my cheese, and hurried home.

Were the conferences useful? Yes, I learned and relearned things of value. I learned that it takes *chutzpah* as well as talent and hard work to be a successful artist. I learned that Image counts, although – the more idealistic panelists insisted – the quality of the work is the deciding factor. I learned I must make a beautiful presentation if I want dealers and buyers to be impressed by my work.

I learned that there is no one art world, but various alternative and splinter art worlds, each oriented toward a different vision of what art is and who artists are or ought to be.

I learned that I must continue to expand my knowledge by frequent visits to galleries, museums, and alternative spaces and through magazines and newsletters. I learned that to get where I want to be will take money, time, hardheaded planning, and hard work on all fronts – all while continuing to earn a living in another field.

But, most of all, I learned that I must be my own authority on my work and how to get it out into the world.

– Georgia Kornbluth

Women Artists News, November 1980 [Vol. 6, No. 5]

'80 / #145

Art and Soul

Despite the "art biz" craze, or possibly because of it, many artists nurtured an intense focus on the spiritual. In fact, one could imagine an artist exiting the conference described above and going directly to Tibet. (I note in passing that the spirituality-of-art event reported here and the business-of-art event were held the same day.)

"Feminism, Spirituality and the Arts"

Moderator: **Linda Hill**; Panelists: **Nancy Azara, Bambi Brown, Catti, Donna Henes, Ana Mendieta, Merlin Stone**
New York Feminist Art Institute, NYC, May 16, 1980

"Spiritual values" in art have traditionally meant individual freedom, intuitive, nonrational processes, and an emphasis on subjective experience. This understanding of spirituality, which has its roots in 19th-century Romanticism, has been extremely influential in shaping modern art movements, especially Symbolism and early abstraction. Recently artists have revived the attempt to express a "spiritual" view of reality, as the effects of 1960s formalism fade farther into the past.

This panel associated spirituality in art with feminism. Earlier concepts of spirituality in art have been formulated by men, as is reflected in its predominantly negative view of women. Gauguin's obsession with the image of Eve, Munch's personification of Sin as a woman, and, more recently, de Kooning's ironically satanic "Woman as Landscape" series, are a few notable examples. It is not surprising, then, that all seven of the women on this panel share a sense of struggling against male ideas and values to express their own experience and subjectivity.

As summed up by Linda Hill, shared concerns included belief that creating art is a way of "centering" the self and giving meaning to life, an interest in the cycles of nature and time, a faith that the meditative quality of art can have a healing effect on individuals and society, and a preference for intuitive rather than rational processes. Much of the art discussed also dealt with autobiography and the "peeling away of masks." Finally, several of the panelists have incorporated ancient (and often non-Western) myths and rituals portraying women in new and personal art forms.

Nancy Azara is a woodcarver who uses old wood, such as oak, for its strength, and allows traces of the carving, transforming process to remain. In fact, much of her work deals with the theme of transformation as life process. Her sculpture of the goddess Kali personifies creation and destruction in the Hindu religion. Parts have been oiled, others bleached white to resemble bone or death.

Process is also important in the work of Bambi Brown and Linda Hill. Both artists mentioned relaxing rational control while working, thinking about significance afterwards. Like the Surrealists, they believe they can thus tap the collective

unconscious. Hill's art is predicated on a belief in astrology. (She attributes the contemporary interest in ritual to the dawning of the Age of Aquarius.) Brown's work is based on Eastern mysticism. In both cases there are barriers for non-believers and the uninitiated.

By contrast, Catti's art is rooted in an understanding of the history of African and European art and the roles of women in each. A black woman, Catti rejects the traditional image of women in Western art as sexual objects, turning instead to African art as model for the celebration of power, sexuality, and pride – of African women and potentially all women. To focus on what she calls "essential reality," and to heighten emotional impact, she uses clear, simple, abstract forms. (The tendency toward abstraction is of course also characteristic of African art.)

Ana Mendieta's earth/body art is more personal and poetic, but no less strong. Having been separated from her parents and culture in Cuba at a young age, she uses her work as a means of establishing "a sense of being," of healing the "wound" of separation. Mendieta's art is a quiet dialog with nature, which represents the land she didn't have. Her images are ephemeral traces of her existence, sometimes merely footprints or handprints on hillsides. Perhaps their meditative power derives from the longing to connect with nature and home that pervades our fragmented culture.

Donna Henes's art also deals with healing, although she sees herself in the more active role of *shaman*. A recent project, which resembles some of Beuys's actions, called "Dressing Our Wounds in Warm Clothes," involved collecting special clothing and bringing it to the Wards Island psychiatric shelter. There Henes ripped up the clothes to make bandages and tied a knot for each patient on one of the trees in the area, a practice inspired by healing rituals of many cultures. Henes believes that during this ritual the special energy captured in the weave of the clothing was transmitted to the patients, with healing effect. This is art that attempts to *be* magic rather than simply refer to magic, and another indication of the perceived need for healing and regeneration in our time.

The last panelist to speak, which she did with great wit and humor, was Merlin Stone, artist and author of *When God Was a Woman* and *Mirrors of Womanhood*. Stone's two books are intelligent, illuminating accounts of ancient goddess religions and other female mythologies. Her studies, which began as a hobby, became a fascinating chronicle of a history we rarely hear. More important, they shatter many conventional "archetypal" notions of the "masculine" and "feminine," and delineate an alternative world where women are powerful and creative.

Making art explicitly based on spiritual values, these artists also advance a new image of woman, as subject rather than object, powerful, free, and connected to her own history.

– Christine Poggi

Women Artists News, Summer 1980 [Vol. 6, No. 2-3]

'80 / #146

A Worthy "Yes" – or a Worthy "No"

Last month's NYFAI panel talked about "art explicitly based on spiritual values." Many artists would find that a tautology, because, for them, "art" is spiritual *by definition* . But for a growing number of others, spiritual value in art requires some kind of "political" meaning or advocacy (although they may differ about whether aesthetics can, must, or don't enter the picture). This cross-section of opinion at this "art and politics" panel includes several succinct expressions of the political artist's dilemma (which, needless to say, is not yet resolved).

"Art and Politics: Do We Have to Choose Between the Two?"

Panelists: **Joan Braderman, Betsy Hess, Candace Hill-Montgomery, Lucy Lippard, Beverly Naidus**

New York Feminist Art Institute, NYC; June 5, 1980

That the question, "Do We have to Choose Between Art and Politics?," exists at all tells us the feminist artist's relationship to art and politics is not easily reconciled. At one end of the spectrum, some women have a hard time integrating the two aspects of their lives; others don't have to make a choice because they believe their art activities and political activities are essentially the same. Still others feel that their art and politics exist autonomously and separately from each other.

Lucy Lippard, who opened discussion, said she believes the goals of political art have not been realized, although she has seen successful feminist art. A tremendous collective work like *The Dinner Party* may move people to tears, she said, but has not received support from elite museum echelons. They educate the public to like only what they like and see *The Dinner Party* as "bad art," or "sociology, not art." Lippard argued that the power structure of the art world must be changed if feminist art is to be appreciated by the widest possible audience. At the same time, feminist artists must organize to bring their aesthetic and political message to society.

Beverly Naidus spoke about her socially concerned art and the impetus behind it – frustration and anger at the arbitrary middle-class values she grew up with. For instance, she confronted menstruation taboos in "The Wrong Day to Wear White Pants" and conspicuous consumption in "Markdown." Her work has evolved from the two-dimensional to installations or sets, recently with a major role for sound, in recorded messages.

Betsy Hess, self-proclaimed propagandist, creates abstract paintings when she has the time, an aesthetic activity she separates from her political work. She did not show slides of her paintings or talk about them. Committed artists, she said, must demonstrate that they understand the crisis in this

country by involving themselves with all aspects of the women's movement. Hess thinks feminist art can take any form or style as long as it doesn't fuel the traditional sexist corporate hierarchy. Creating art that is "angry, passionate, optimistic, forward-thinking, and defying common stereotypes," she says, is the feminist artist's best service to the public.

Candace Hill-Montgomery uses the painter's vocabulary to address minority peoples' struggles in America. She wants the viewer to make a visual connection between the unfortunate cultural reality and her aesthetic expression of it. She is not a "feminist artist," she said, but rather a "feminine" artist.

Joan Braderman said she doesn't have to choose between art and politics, because "the aesthetic permeates the political at every level." With so much work to be done, she feels "creative solutions are essential." Filmmaker and political organizer, she finds each step of the work includes creativity and challenges. She also noted that every feminist she knows is an artist, because each does something to keep her mind alive.

In her recent article, "Horseblinders" [*Heresies* 9], Harmony Hammond said "feminism is not an aesthetic. It is the political analysis of the experience of being a woman in patriarchal culture." It follows, however, that there can be no feminist art without politics or at least some political stance.

– Ann Schoenfeld

Women Artists News, Summer 1980 [Vol. 6, No. 2-3]

'80 / #147

What Every Artist Wants to Know

More practical information from *Artworkers News.*

"Whitney Museum Acquisition Policies"

Linda Gordon, Public Relations, and **Patterson Sims**, Associate Curator
Interviewed by **Ellen Baum**

NYC; November 4, 1980

Linda Gordon said that while the museum holds one or two big historical shows per year, it is interested in new directions, with a special commitment to independent film and video, among contemporary forms. She admitted there is no special photography curator. The Biennial will include photography in 1981, but photography shows have been few and restricted to historical surveys.

Patterson Sims's response was that the Whitney was really not for established artists, but for those whom the curatorial staff felt strongly about. . . .

Every day three or four artists call the museum directly and request information about slide viewings or invite curators to their studios. The mails bring the slides, biographies, and résumés of hundreds of artists from around the country. Calls from friends, collectors and gallery owners about an artist are another means of introduction. Exhibition invitations pour into the museum. On the basis of slides and exhibition notices, curators call for appointments with individual artists for studio visits. Conversations with artists, art writers and museum personnel also bring an artist's name to a curator's attention. On a studio visit, Sims said he may see the work of another artist on a friend's wall and ask about him or her. Trustees of the museum do not decide on inclusion of specific artists in museum shows, nor are they encouraged to do so.

As for selection of exhibitions and acquisitions, Sims said decisions are made at curatorial staff meetings. It's up to individual curators to promote the work of an artist they feel has a fresh style and a provocative outlook. If a curator can convince the others that an artist's work has strength and aesthetic quality, the group will invite the artist to participate in exhibitions. Sims noted that many times he had a favorite, but his choice was not accepted.

Acquisitions are made by curatorial decison. Sims reviews all gifts, but rarely finds works that interest the museum. Three or four times a year a purchase committee meets to decide on paintings, sculpture and drawings. Sims recommends works that interest the staff and solicits money to purchase specific works, which will be labeled "Gift of." Eighty-five percent of the artists receive direct payment for their work from the museum.

Two painters described their experiences with the Whitney. A landscape painter joined a Madison Avenue gallery in 1960. Shortly afterwards he was invited to exhibit in a Whitney show called "Young Americans." In 1961 he was invited to exhibit in the Annual. A committee selected his work for purchase through a Ford Foundation grant. In 1962 his painting traveled throughout museums in New York state in a show entitled "40 Artists under 40." The museum acquired another of his works through a bequest. Since that time he has had no interaction with the museum, although one of his works was exhibited this year in a show of selections from the permanent collection.

Another artist, an abstract painter without a permanent gallery but with an impressive list of group shows, sent slides to the museum three years ago. Within ten days she received a call from Sims's office and a studio visit was set up. She said Sims was bewildered by her work and it was immediately clear that he did not care for her style. She wondered why he came, as her slides represented the work accurately. In any case, he made several recommendations of galleries, one of which took her on. The gallery sent show announcements to the museum and last year Barbara Haskell called for a studio visit. She was very enthusiastic about the work, praising it lavishly, but nothing came of the visit.

Over his years at the museum, Sims has viewed work by hundreds of contemporary artists. He says he really likes studio and gallery visits. His attitudes towards artists and their careers has changed over time. Now he believes exclusion is necessary, that the museum does not have to be responsive to everything contemporary. Mixing judgment of a work with personal consideratons is wrong, he said. Aesthetic consideration must be the only priority.

Twelve years ago, when he first arrived at the Whitney, Sims recommended that artists be included as trustees. (The Tate Gallery in London has artists on its board.) The Whitney was not interested, but Sims still feels that having people like Johns, Motherwell and Dine on the board would give a marvelous perspective.

The Whitney Studio and Art Criticism program is run by the Whitney's Education Department. Sims said interaction between the uptown museum and the downtown program is not encouraged. Gordon believes visual artists are neither helped nor hindered by their connection with the museum. Teachers in the program may not exhibit at the museum while on the staff, which would be a conflict of interest. Students of art criticism, however, are likely to be considered for museum positions when they open up. . . .

– Ellen Baum

Artworkers News, December 1980 [Vol. 10, No. 4]

'80 / #148

Varieties of Expressionist Experience

Ana Mendieta's talk of her "death wish," her need to "become one with the earth," is chilling in retrospect.* Phillip Wofford's paean to "pure painting" is as intellectual and expressive as lost youth. But the major revelation of this panel lies in something *not* mentioned – the fact that in 1980 a wide-ranging discussion of "Expressionism" could run its two-hour course without the "Neo" word (or the "Schnabel" word either).

The moderator explained that the panel had been inspired by his sense of "currents" of Expressionism in the air. Discussion ranged from the Times Square Show to Expressionism's roots in Europe – but the Europe of Kandinsky and *die Brucke*. The present-day Europeans credited with originating "Neo-Expressionism" – Clemente, Kiefer, Immendorf and company – were not mentioned.

According to one authoritative source, Neo-Expressionism began in 1978. [*Artspeak*, Atkins, Abbeville Press, 1990]. The term Neo-Expressionism was in wide use by 1982, a cliché within a year or two, and virtually dead by, say, 1985 (although obviously Expressionism continues). The lesson, then, as if we didn't know, is *how quickly media-derived or media-propagated ideas highjack emerging phenomena of art!*

*Ana Mendieta died September 10, 1985, when she fell, jumped or was thrown from the window of the Greenwich Village apartment she shared with her husband, Carl Andre.

"Expressionism 1980"

Moderator: **Jesse Murry**; Panelists: **Natalie Edgar, Joe Lewis, Masami Masuda, Ana Mendieta, Peter Passuntino, Nancy Spero, Phillip Wofford**

Artists Talk on Art, NYC; November 7, 1980

The moderator showed five slides from each panelist, but Joe Lewis, a late addition, showed his own slides, including some shots of the Times Square Show, and his own Shangri-la, which he said was 46 feet by 90 feet by 23 feet.*

Panelist: How'd you do it?
Joe Lewis: I don't want to say. [*Laughter, continuing*] This one is titled, *They Come for Rent*. The rat is about 8 inches by 4 inches, the hundred-dollar bill is real. It was shown at the "Animals Living in the City" show at Fashion Moda last year. [*Applause*]

Then the topic of the evening:

Jesse Murry: I wanted to have a panel because I was having a critical crisis, trying to understand a few currents in contemporary art I thought were Expressionist – that's an old term for an old movement. . . .

When Expressionism began in Germany in 1910, or 1911, it was from a desire to depict human situations with a focus on the world, and against art-for-art's-sake art, against the formalism of Delaunay and Matisse. Its central issues were the individual against the world. Kirschner said his work sprang from a violent need to make an *anti-realism*, a *counter-image* of the world. He said, "The world is there, it makes no sense to reproduce it."

So Expressionism to me is a destruction of reality to create a counter-image. This original Expressionism was primarily representational, but it blurred abstraction and representation, creating a kind of hybrid. Kirschner and Franz Marc, for instance, showed man's isolation, alienation, spiritual crisis. I see a similar situation today, a reaction against Conceptualist, Minimalist, reductivist art.
Phillip Wofford: My concerns in painting are essentially apolitical and asocial, but other kinds of realities can converge and affect the work. . . .

Painting includes the classical and the primitive, pure optics, narrative, invisibility, symbols of things, symbols of symbols, nothing but itself or everything else. Painting, besides being painting, is a balancing act, ritual, habit, experience, fantasy, the real thing or its substitute. Painting is an illusion of movement, energy, stasis, light, space, form.

In great painting, one forgets the illusion and communes with *painting* as reality. Painting as reality is not religion or sex or literature, nature or philosophy, but can be an expression of these other realities – and everything Ad Reinhardt said painting is not. It is in this spirit that I consider myself an Expressionist. I would like to do a painting that includes everything I just said.

FEMINISTS ARE SELF-CENTERED, SELF-PROMOTING INDIVIDUALS WHO WANT A LARGER SLICE OF THE PIE.

Nancy Spero: These expressionist times are a perfect time for an explosion of Expressionism, which *has* happened in New York. I've been doing it myself with my partner, Leon Golub, for many, many years. . . .

I am a woman artist in what is essentially a male-dominated – not that all art movements aren't male-dominated – but Expressionism is particularly male, because it is so aggressive, so at odds. Society is ready to accept, to embrace this nastiness, and maybe some of this punk art, which is very lively and aggressive, even titillating. But I think it's in the classic male mode. The female voice has hardly been allowed to emerge, except maybe in the traditional mode. Women sit in the corner knitting, making pretty pictures and designs. That's great, but a woman can't participate to the full extent in the very macho, punk New-Wave attitude.

In 1966 I suddenly became aggressive. The Vietnam War was entering my consciousness. I was tired of painting the way I had been painting, and I fused sexual imagery with the symbols of power, with the symbol of the bomb and a helicopter in Vietnam, to produce an agonizing, very, very angry attack on power abuse and the symbol of war. But I can't tell you how much trouble I had with this work. I have never shown it as a whole, I have hardly shown it at all. [What does get shown is] a kind of Minimalism which is in total contradiction to what I've been doing. So I speak as a woman artist and a loner, in conjunction of course with Golub, but we have been doing this stuff for I can't tell you how many years.

Natalie Edgar: I studied with Ad Reinhardt and Rothko, artists [associated with] the Abstract Expressionist group. Later I went to Columbia University and studied with Meyer Schapiro and heard about another kind of Expressionism, the Munch type. So I learned there are two kinds of Expressionism, one more circumscribed within the personality, the other more involved with the world.

Here's an example of the second type, the worldly type – from a book my husband, Philip Pavia, is preparing on the Club – the *old* Club. They had an Expressionist Night in that Club also, and someone quoted Vlaminck. Vlaminck said he could tell if you were an Expressionist by the way you painted a telephone wire. If you were imitating nature, you'd paint a nice thin line, it would have a sag and it would be parabolic and that was that. But if you were an *Expressionist*, you'd have to think about all the things that go on on the line – the pain, the emergencies, the conniving, the anguish, the arguments, the love stories, all these terrible things . . . So that's how those Expressionists paint the telephone line. You don't paint a straight thin line. You paint it *thick and thin*. You paint it with a lot of color, a lot of weight – your reaction to the world.

Ana Mendieta: My work is very emotional; I like to connect Expressionism to emotionalism. . . . I'm an artist because I really had no choice. Earlier in my life I decided I would be either a criminal or an artist, because to me, making art is an anti-social activity.

I was very angry to be put into this American culture, and I needed to express this anger, which has taken on other

qualities along the way. But in the art world today, in the galleries, women's art using autobiographical material is not necessarily Expressionist. It's more looking at the self, not really humanistic in the way I think Expressionism is.

Joe Lewis: One of the reasons I'm in art is to remain sweet. In about 1976, going through a rigorous academic tradition and being involved with academic commercial-type artists really started to turn my stomach. I was doing nice landscapes. [Then] I found myself veering out into esoterica. I had fun, but I became very bitter about being lumped into a non-existent group of artists – performance artists. Performance art has never been taken seriously. What's taken seriously is not really performance art, but what reflects attitudes of theatre and technical communication arts, like video. . . .

So I started trying to do indirect social commentary [and] found myself thriving on that fringe where your life is actually involved with your work, where you can be seriously reprimanded for doing what you're doing. [*Laughter*] Just putting paint on the wall, that can be great, but I don't see it any more. The people who put up the wall, those are the people art should talk to, not the academic self-serving types.

Masami Masuda: I don't know why I'm here to talk about Expressionism. I can talk about art, but I don't like to talk about art in a gallery. . . . I have no assistant, no sharp teeth, just me.

Peter Passuntino: I don't think my relation to Expressionism is as intense as some of the other panelists. In the '70s I did anti-war, anti-draft paintings, and paintings to show the Mardi Gras atmosphere of New York When the war was over, I continued to paint, but I had to use a more subtle meaning. I feel I'm still an Expressionist, but it's part of my palette now. A real Expressionist can't be 100% constant.

Murry: Another aspect of Expressionism is the relation to nature and primitivism, as a mythology.

Mendieta: The figure in my work represents me. When I started working this way, I was in the actual work physically; my body was there. Now it's just my size, the mark of my body . . . I was taken from my homeland; I have no land, so I was drawn to the earth. I think my work has very much the death instinct in it, the death wish. That is based on a part of my wish. I want to become one with the earth and go into it. . . . My work really comes from a need of placing myself on the earth, literally placing myself within the natural environment.

Murry: Is that really a death wish? The way I see it in your work, the body extends to nature and nature extends to the body. It seems to me that's a life-affirmative kind of thing, because it becomes a part of the actual space, in a reciprocal relationship – a body sends to nature and nature sends back into it.

Mendieta: What you're saying is right, but I don't see the death wish as a medical thing at all. I mean life is death and death is life. It's a cycle. [I can't] throw out the fact that whether we want to deal with it or not, we have the death wish in us.

Edgar: The Joseph Beuys show was a very clear idea of German Expressionism brought up-to-date in the 20th century.

He had two rows of sleds in double file. Each sled had a flashlight and some fat. Every one of these was a sign. . . . With these signs you sort of delineate a drama, which is why a lot of American performance artists think they are central to Expressionism.

Wofford: I find it very difficult to deal with the political implications of a lot of the comments tonight [including] the socio-political aspects of performance work . . . I believe in the power of painting. The history I come out of is all about the primacy of painting.

I say powerful painting is the glorious last black series of the Witch's Sabbath, or other incredibly powerful energies of spirits floating over non-specific landscapes, a kind of resonance which transcends politics, society, conflicts; transcends subjective, Expressionistic, poetic; transcends metaphorical indulgences, needs, desires, urges, and finally becomes reality itself.

I feel, contrary to what Greenberg says, that there is a narrative relationship between public, street, everyday discovered, revealed, devastated art and formalism, and the best aspects of a spirituality that derives from as far back as Giotto and Piero, and goes through Impressionism and Abstract Expressionism and so forth. [But] I'm here as a representative of painting, a kind of spokesman for the validity of painting in an age when everyone asks if painting is dead.

Believe me, when I go into my studio and I'm faced with the problems of recreating the world from scratch and I come out with something that excites me and that other people respond to, I'm convinced painting is alive.

Mendieta: You mention things that transcend politics, but they were done out of a political consciousness. You mention Goya and German Expressionists. They came out of a time when political repression was at an extreme – which is going to happen in this country very shortly. But art *is* a reality . . . and very particularly Expressionistic art. It's not an intellectual exercise, it's not theory, it's a specific kind of absorbing and throwing back to the work something that is in you, that you have been the medium to act on.

Wofford: Would you equate Expressionistic art with political art?

Mendieta: Some is and some isn't. I think Nancy's work is particularly Expressionist and very political, feminist-political, as well as political-political. We're not talking about painting being dead, or not being dead or any of that romantic conflict. The same thing with Expressionism. It's not whether it's going to come back or not come back. We're not sitting around waiting for something to be *in*. You do what you have to do.

Spero: I think Expressionism is human responses and attitudes in direct contrast to painting *per se*, the old modernist axioms – which I have been fighting against . . . Political art is a way of establishing a sense of myself as an artist and as a woman artist in society, and trying to establish some kind of dialog with the art world, with fine art, low art, street art. I'd like to talk about street art, because I find that very exciting and dangerous.

Murry: Expressionist art has, I think, a very loaded content, not always visual content or formal content, but often political, autobiographical or in the case of the Times Square Show, cultural.

Lewis: As I see Joseph Beuys, he has not really made [his ideas] accessible to other people.

Edgar: I want to defend Beuys. He's a really good artist. Anyone can take a piano and put a few things together; you can read it like a story, but it won't have impact unless you know how to organize space. Beuys had an ominous form, a lot of volume. What he did with some of those rooms gave such a feeling of compression and fear. It wasn't only the signs that were working, he had real sensibility. And that's what a good Expressionist is . . . By the way, I'm an abstract painter, but I have a hidden sign in it.

Spero: I think of the passion and enthusiasm and authenticity of the Times Square show as a breaking out after a long span of modernism, sort of like the early Christian period, in which quite primitive art was done with passion. Now the passion of Expressionism returns.

Wofford: I recall Masumi's comment. I think his phrase was "no sharp teeth."

Masuda: Yeah, can't bite! . . . I'm not talking about people, I'm talking about art.

Wofford: I figure on an abrasiveness, an acuity of visual impact, a psychological and emotional impact. If it doesn't have sharp teeth, it's not Expressionistic.

Passuntino: Do we have two kinds of Expressionism on this panel? An inner expressionism of feelings and an expression of something out there?

Murry: I think we're groping for something alive with contradiction. It won't settle into easy resolution, but keeps itself in agitated tension, balancing intellect and instinct – a constant juggling act. The dynamism that results bespeaks the ethos of Expressionism.

Audience: The sharp teeth comment was a very powerful one. I see the most sharp-teeth Expressionism in American art today at the visceral, gut level, in the American modern motion picture. We watch stabbings, sex slayings, shower destruction and I think everybody in the United States is viscerally grabbed, for at least a moment.

But I haven't heard anybody here talk about the possiblity of social change through art. I think that's because artists (and other people) have been so castrated for a number of years.

I'd like people to address what they want in Expressionist art – a visceral grabbing or a movement toward . . .

Edgar: You see a lot of things you don't remember for five minutes. It takes a sensibility to make you remember it. You can't remember anything from the newspapers. If it's just some horrible thing, no one's going to remember it. It has to be like Van Gogh, who did terrific color, or like Joe Lewis, who does some ominous mass . . .

Lewis: What you're seeing now, especially with my contemporaries, is this kind of artiness [where] they shoot dogs, then do comparative anatomy drawings of the gun and the penis.

Audience: But the artist has to go out there and prove that shooting the dog means something.

Edgar: Shakespeare used 10,000 words and you never forget them. But the *New York Times* you could burn up every day. If something doesn't have sensibility, you're going to forget it in 24 hours. All this verbiage, if it isn't couched in aesthetic language, you're going to forget it. I don't care about dogs; I'm not going to talk about moral issues. Certain things are journalistic and certain things are not. Certain things last and certain things don't.

Murry: We're talking about art, not moral issues. The newspaper is visceral and direct. Art is a medium transformed. All of the artists here use this medium to interpret the world and their relationship to it.

Audience: I wasn't talking about *news stories.* I was talking about the artistry that's visually impactful in our society today – that's motion pictures, video and types of things that will soon be pouring into people's homes and influencing them, some of it from new artists. That's an Expressionistic direction.

Wofford: All of us are affected and moved by circumstances, occasions, incidents that arise every day. My god, the recent election is enough to make a lot of us vomit. But how do you express that or *transform* it into a contained, succinct form, convey something that transcends an emotional wallowing in despair and sickness?

Audience: Expressionism has been used to describe someone fighting, whether in a social situation, like feminism, or a political situation – Joe mentioned workers as opposed to people who go to Madison Avenue art galleries. But why isn't the art of someone like Robert Motherwell Expressionism? He was born with a silver spoon in his mouth maybe, but if he honestly expresses his situation, which was having everything, and if his heart is complacent, which I don't think it is, if it doesn't have sharp teeth because he never had the need to develop sharp teeth, isn't that an honest and powerful expression of that part of our culture? . . . The panel is describing Expressionism as something that's fighting upwards, not something that comes straight out from wherever an artist is.

Spero: I don't necessarily see it as an upward motion, but a reaction to your own reality.

Audience: The German artists were not political. We're discussing an altogether different Expressionism tonight.

Audience: Isn't Expressionism a deeply romantic attitude? Isn't Goya the father of romanticism? Isn't romanticism the father, as it were, of Expressionism? Didn't Expressionism lead to Kandinsky [or] the painterly quality of Van Gogh? There's an enormous area we haven't touched.

Murry: The German Expressionism was also celebratory, it had an exuberance. You see that in the Blue Rider, and Kandinsky's early forays into Expressionism.

Audience: Van Gogh was a religious fanatic and Kandinsky was a religious fanatic and so was Mondrian; they had a common root.

Murry: The freedom of Franz Marc was to paint a sensibility alive to nature. *Die Sturm* was more political. There's a

range. But the unifying core seems to be the emphasis on self and the relationship to medium. Expressionism does not ignore the formal problems of making a work of art. It just shifts the emphasis to another place, which is more *urgent.* . . . The emphasis is always on the interpreting sensibility.

Edited from tape.

*The Times Square show was held in the summer of 1980, when some 100 artists, sponsored by CoLab and "a few foundations," took over a building on 41st Street and 7th Avenue to exhibit art.

'80 / #149

Putting the Pieces Together Again

These artists were neither "modernists," claiming art history is over, nor "post-modernists," in the vein of the "Post-Modernism" panel the previous February ['80/#132]. They saw Hopper largely as an American artist of "a different epoch," and were interested in how their own work related to his – or didn't. The underlying issue, as Eric Fischl put it, was "how to put together the last 20 years of mainstream art with a tradition of representation that was broken."

"Hopper and Realism Today"

Moderator: **Robert Berlind**; Panelists: **Eric Fischl, April Gornik, Paul Georges, Michael Mazur, Harriet Shorr**

Artists Talk on Art, NYC; November 14, 1980

The evening began as usual with panelists' slides. Harriet Shorr showed recent paintings, "directly observed . . . with actual colors," but Michael Mazur had shown only a few scenes painted from his Massachussetts studio window when the carousel jammed. During the unjamming, Moderator Berlind explained that the artists' own work was shown "to clue you in to any biases we might have," then addressed the current Whitney Museum Hopper show, which had inspired the panel:

Robert Berlind: I begin with Hopper's popularity. It seems that everyone, journalists, or my first year students, or people off the street, everybody "gets Hopper," which might suggest his work is in some way too facile or too accessible. I have a feeling this has worked against serious consideration of Hopper.

Two words always come up about Hopper's work: One is light. Everyone recognizes it plays a crucial role in his paintings. And the other is something they call solitude, or loneliness, or alienation. Everyone sees that, whether they're sophisticated about art or not.

Hopper's position as a public figure is a little like Robert Frost's. For a long time, Frost was taken to be a cozy New England poet who wrote about familiar themes and shouldn't be taken as seriously as some of the more difficult

poets. In fact, Frost's central themes, it seems to me, are mortality and solitude. Those are not very easy themes [but] they are congenial to Hopper. We also know Hopper had an interest in Frost . . . A 1935 painting by Jo Hopper [the artist's wife] is titled, *Edward Hopper Reading Robert Frost.*

My own sense is that Hopper is *not* an easy painter. People have the feeling that when they've said "loneliness" they've finished the conversation, rather than taking that as a point of departure, or considering what that means in formal issues, the kinds of subjects he chooses. . . .

The current show in certain respects serves Hopper very badly. . . . In some ways, because of my affection for Hopper, I would prefer a show about a quarter of the size, which would represent him as a stronger artist. There's a certain sense of a museum celebrating a bequest, a kind of laudatory tone in everything written, not much delving into his difficulties. The catalog by Gail Levin and most of the writing I've seen on Hopper don't really attempt to deal with the work critically. . . . I think with a more tough-minded critical attitude we could get to his failings, better estimate what he's about [and] his real strengths.

The carousel was now clear and slides continued. Paul Georges showed Portrait of Lenny Bocour, *saying Bocour was "very bitter because I wasn't using his paint," also* The Gods Meeting the Satellites, *an 11 by 20 foot painting.*

April Gornik said she painted only landscapes, observing nature "very carefully," but not using photographs. "I paint mostly from dreams. . . . I'm not going for realism per se [but] something more metaphysical . . . intimations of immortality from nature. . . ."

Berlind's slides included works painted on plexiglass, in a "split focus," with part "back-painted" on the plexi, the rest on the front.

Eric Fischl showed oil paintings on 6x11-foot glassine paper, also on canvas. Of a painting titled Bathroom Scene, *he admitted "some violence has taken place." Other titles included* Woman Surrounded by Dogs, *and* Boys at Bat, *which Fischl said was about "sexual intimidation."*

Then Berlind showed slides of Hopper's work, including Chop Suey, Railroad at Sunset, Early Sunday Morning *and* Cape Cod Evening.

Michael Mazur: The French paintings [show] Hopper established his basic structure early . . . a low stage with a diagonal line, with guiding lines about two-thirds down the canvas Almost all the figures come from his life, due to his reluctance to use models other than himself. Hence you see the relationship between two people, himself and his wife: They were alone in their lives. . . . Hopper is happy in his solitude.

His figures glance, not at the viewer, but toward what may be the light source. You get the figure looking at the thing he may want us to look at. I find almost all the sailing pictures failures. He tries a kind of healthy, robust approach to life which isn't his own relationship with nature. He was *taken* sailing, he wasn't a sailor.

April Gornik: The figures seem less glancing into the light than staring, absorbed. As for aloneness, it almost seems as if the figures are subordinated to the stage they're set into; the surrounding aloneness is really the subject, what he was seeing privately. [But] I wasn't looking at the figures and saying how sad that person is alone; rather I myself was absorbed into the contemplation of the aloneness.

Audience: Would you say Hopper was consciously painting these things?

Gornik: I think they must have occurred to him, it must have been a part of his psyche.

Berlind: I think he recognized fairly early [in France] that light was going to be the subject of his paintings. [After a traditional] sort of "tobacco"-colored painting, he's taken with Impressionism and rushes into that blonde tonality. I think they're very bad paintings, but what strikes me is the incredible exuberance. In 1920, his first major show here (aged 38) he showed a lot of paintings he'd made in France in the flush of youth. In maturity, he finds out how to make the kind of shadow space he needs and play it off against the slab of light . . . His choice of subject and perspective is absolutely crucial and when it's off the painting seems to go awry. Something prior to the painting had to be thoroughly felt. . . . He worked very slowly in his later years, making only one or two paintings a year.

Harriet Shorr: For as long as I've been looking at pictures, Hopper has been a fixture, part of the American imagination. For someone my age, it's very hard to see him fresh . . . My experience of New York as a girl seemed to be confirmed by Hopper. I could see people leaning out of tenement windows as I went by on the elevated I didn't understand when I was 16 that those paintings were synthetic, that he wasn't painting directly from observation. I didn't like Reginald Marsh, or Thomas Hart Benton. I didn't understand that Hopper was in some way as synthetic. . . . It seems to me that at some point Fairfield Porter started to make the paintings I thought Hopper was making.

Audience: You attach some significance to the difference between direct and synthetic. . . .

Shorr: I don't attach a value, but I identify different attitudes toward representation. Hopper's response looked so authentic, I assumed it was direct. He looked more authentic then than he does now. [Later he seemed] relevant to Pop Art, because you saw the gas pumps and the ordinary images you hadn't seen at all for a very long time. Pop at that moment suddenly looked like a new response to the American scene. [But] Hopper had been dealing with that kind of subject for a long time. . . . Now I respond to the terrific images [and his drama], almost like images of the cinema.

Audience: Is there a future for Realism?

Paul Georges: I saw the Hopper show today. I fought my way uptown, that's America today, and I fought my way through all these hot breaths [*laughter*], and then I got to all this loneliness and I realized Notre Dame is still the same. In all those years, France hasn't changed. The pictures he did there weren't like America at all America is the Whitney Museum: hype, stupidity, good suits, fancy dresses, suburban

ladies, black kids running around like crazy in the museum, they don't know what the hell they're doing there, screaming bloody murder. That doesn't have anything to do with Hopper. Hopper's gone. He was some other epic, some other world, some other time. . . . But France is still there. Go there tomorrow and it's there.

Gornik: I disagree with you, on the basis that I like my grandmother and I like Edward Hopper too, pretty much in the same way. They're both from different epochs, but both mean something to me. It's precisely Edward Hopper's private attitude to his own world that I respect. I don't think he was an all-around great painter, but he produced some marvelous paintings. . . . Our attitude today is the new, the new, the new. . . .

George: What worries me is that Ronald Reagan thinks the world looks like Hopper. [*Applause*]

Eric Fischl: Notre Dame looks the same as it's always looked. What Ronald Reagan means is that America can be the same as it's always been . . . In the last room of the Hopper show there's a couple of paintings that seem poignant and timeless and a couple that reveal their time and fail because of it.

Georges: Guy Pène du Bois, who I think was also a very great painter, painted in a manner very much of his time, the '20s. When we get far enough away, that becomes an epoch and the work a whole statement, almost more treasure than timelessness.

Mazur: But if Guy Pène Dubois was painting now using the same kind of figuration to express daily life, it would be absurd, it would be nostalgia, sentimental. . . .

Georges: But Jack Armstrong the all-American boy is up there and he thinks its the same . . . He's showing us Hopper like it's us . . . Well, his name is Tom,* but he's the all-American boy and he eats Wheaties. . .And he's trying to show us who we are through this show and that's what I resent about the museum.

Berlind: We [shouldn't be] talking about paintings in terms of the museums they're in and not in terms of the paintings themselves. [*Applause*] We've gotten so hung up on other issues, we're not talking about what Hopper tried to do. We don't talk about Breughels and say they're dated because the people are running around in codpieces . . . or Degas and say they're dated because they have high hats. These artists dealt with relationships, not only in painting, but between images . . . which have lasted to our day. I think Hopper did too, and the way he did it was interesting, complicated and gutsy.

Shorr: But we talked earlier about whether some of the Hopper paintings didn't in fact look dated, whether they hadn't stopped speaking . . . I went with a group of people who were 18, and I wondered whether they would be as enthused about Hopper as I am, whether he would speak to them, and I have to report that he didn't. And many of them are painters or want to be painters. There was something they no longer responded to, or that wasn't authentic to their sense of what painting is about, or what the American experience is about. I have experienced Hopper over another period of time, but if some people are out to look at painting it isn't going to be Hopper.

Gornik: As the youngest person on this panel, I disagree. When I first saw Hopper paintings, I was very, very moved by them . . . When I began doing landscapes I found a lot of inspirational material.

Georges: The "datedness" might be an advantage . . . Dated art as opposed to eternal art might be more important, like Guy Pène du Bois, whose art is really dated and now slowly becoming this thing from that date. If you look at a movie from the '20s or '30s, the treasure of it is that it's dated.

Shorr: I don't think "dated" and "of its time" are the same thing. Something does have to be of its time to keep talking to other times.

Audience: Didn't Hopper do something with the paint that kept you from looking *into* the painting?

Shorr: Looking into a painting has partly to do with certain conventions about making pictures. If you're using a perspective system . . . you look into the picture. Paintings which come out of an all-over light, after 1870 or so, [are] expanding, or coming toward you. That's part of modern or contemporary painting – you're not looking *in*, you're looking *at*, the field of vision. That's a different way of constructing than constructing a perspective . . . I like the idea of having a painting *expand*, the way a Matisse, or a Rothko expand. You don't look *into* a Rothko, it comes out to you. That has to do with using color to make a structure, as opposed to using drawing.

Georges: In Breughel [there's usually] a person in front who faces into the picture and puts his back to you. Hopper is very much like that . . . If someone's back is to you, does that pull you in or repel you? It's *not* confrontational and it's *not* welcoming. And it's not like a photograph today where [everybody] is looking into the camera. It's quite the opposite and very dramatic. . . . There's a Breughel painting of St. John getting a revelation. You can hardly find the guy. All you can see is a horse's ass. Does that draw you in?

Audience: But the dramatist always refers to the audience looking at the stage . . . You know Hopper was taking into account the viewer. The other point of view is that you're the viewer-voyeur, sharing that glance into the lit window as you go by in your car.

Berlind: In Hopper, where there's often one person in the painting, [you're] not a voyeur; you *share* the experience. . . . The person in the painting becomes the viewer in a sense. Or you imagine yourself to be the painter. That's not necessarily confrontational.

Audience: But there's a *spiritual* space.

Berlind. It's maudlin sentimentality. People confuse Hopper with Wyeth. . . . The space, while it's very quiet, is also very charged.

Audience: Violent!

Berlind: You can't experience the space in the kind of meditational way some of us might want . . . There's a curious dichotomy in Hopper. In many of the most successful pictures there's a sense that you're seeing it perhaps from a moving vehicle, or a train. At the same time, there's a peculiar desire to remain in that space. That tension to me is rather magical. It isn't done with charm, or the sensuality

that this is a beautiful passage, so I should linger over it. It's done with a knowledge of the rightness of that combination of narrative or form and anecdote. Great pictures can't be explained beyond that.

Audience: I attribute that to the fact that Hopper paints objects very well, or paints a wonderful person, but at the same time he'll give you foliage, sky – not painting much detail.

Mazur: Pine trees in my neck of the woods have a very funny effect. From certain distances they're absolutely out of focus. For years I looked at Hopper's pine trees and saw them codified, [with] a dumbness, a sameness . . . Then I realized – nature for Hopper is not a comfortable placeLook at Winslow Homer: Man-and-nature is very comfortable in Homer, there's an equivalence. The trees are painted with the same kind of confidence and joy and knowledge as the figures. Hopper paints a kind of man-madeness, a solidity that nature doesn't provide for him. Very rarely does it give him the things to hold onto that have the structure man-made things have.

Audience: I saw the Hopper show today and I saw something I'd never seen before – his discomfort with women . . . You see the initial drawings of his wife, then an exaggeration of the breasts, and a pulling in of the waist. *The Girlie Show* is a perfect example. You said there wasn't a prurient interest in the paintings. And I think that's a basic fundamental tension.

Take the secretary and the man in the office – in the initial sketch, she's just turned away. In the final version, she's twisted her body around in an erotic fashion. They're alone. It's night . . . In the painting of the hotel room, the woman is too large for the room. There's an adjustment to give her more symbolic significance. You cannot avoid her sensuality. She's dominating that room.

Berlind: Maybe prurient is the right word. [In his 70s] he's still a very competent draftsman – he has that from his days at *Harpers* Magazine – but there's some kind of pressure, some sense of unresolved personal history, that makes it impossible to see the female figure in other than this curious archetypal, aggressive, attractive, conflicting way.

Georges: I lived through those epics. . . . *The Naked and the Dead* by Norman Mailer is a novel of a certain time; Herman Wouk's *Caine Mutiny*; Thomas Wolfe, *You Can't Go Home Again.* There's a whole idea of epic-ness, an attitude toward alienation, toward women, that was really from the '30s and '40s. And that is what Hopper was, and can be very well accounted for by being the fashion of its time. I came in 1939 to Wilkes Barre from Oregon and I went to all the burlesque houses in New York, and saw everything Hopper painted.

Norman Mailer is a perfect example of someone who can't go home again, because he can't write any more *Naked and the Dead*'s. He can write about the moon, and Marilyn Monroe, but he can't do that particular thing that he and Hopper could both do *at that time.* There's no replacing a time. There's no way to escape it and no way to join it. If somebody wanted to do Hopper now, and found an old gas pump, it would just be stupid.

Shorr: Hopper and his wife had entered into an agreement that she was, literally and metaphorically, to represent women to him. But [as she aged] she wasn't "Jo." I think there's a kind of ineptness you don't find in the drawings [that] I attribute partly to his no longer looking directly at the situation.

Georges: I find as I progress there are logical, clear, important reasons not to work from nature. It's binding, limiting. Art isn't nature. There are legions and legions of reasons that nature makes art impossible. If you look at the history of art, most artists didn't work from nature. . . . Hopper is too complex and diffuse to make why he did something overly clear.

Mazur: When I see a painting where the breasts are emphasized, distorted, I assume that was particular, meant to be, and I'm to make something out of that, whatever I can.

Audience: What has this to do with contemporary realism?

Fischl: I propose that one of the problems with contemporary realism [and] figurative painting is that people try for virtuosity. It becomes a technological problem. Hopper's lesson to us has something to do with fitting the painting into the mind *before* it comes onto the canvas. It's a very tough lesson. It's so much easier to learn how to copy something, to render it well.

If Hopper comes up again as a force for influencing younger painters, it may [be] this sense of allowing for something more complex – an awkwardness, reaching, refining through the head, a process that takes time and takes risks. In fact, all the crap we see that is so beautifully painted, that relies so much on reflections and seductive quality to convince us of its validity as art, is really perhaps an avoidance of what I think are the major issues for figurative painting today.

Shorr: I'd like to disagree. Bob began by questioning some aspects of Hopper's work, and whether all the paintings are as fine as we've been taught. But as the evening draws to a close we seem to be elevating Hopper to a position where I think the Whitney would like us to place him . . . To hear Michael say we should consider Hopper as a direction, I find that disheartening. There's a lot of representational painting which followed Hopper, say starting with Fairfield Porter and continuing, including some of the people in this room, that puts that kind of painting into question. I'm surprised that, perhaps in your enthusiasm. . . .

Gornik: But that is really disheartening, to imagine we're in a long, linear progression, that we're adding on. Why *not* Hopper?

Shorr: But we're being asked to consider Hopper by the Whitney.

Mazur: We're being asked to consider Hopper by Hopper.

Shorr: We're living in an era of orchestrated, very large exhibitions. The context you're responding to can be manipulated. . . . Contemporary realism would still exist without Hopper.

Audience: *No! No! I disagree!* Hopper's deliberate way of painting without working from nature has affected all of you on this panel, especially Fischl.

Shorr: I think you're ignoring a lot of painting we all saw after Hopper that was a lot more important to each of us in our development.

Mazur: It wasn't more important to me. I've been stuck with this man for years and years. Not to say I don't admire other artists, but I would have liked to talk about Hopper even if there weren't a show. There's something sad to me that we have to have panels only as a result of museums having shows . . . We're not all one kind of person. Sometimes I'm very interested in conceptual problems, or in studying nature . . . A part of me always rebels against the difficulty, the real difficulty, in inventing pictures. That's the hardest thing to do.

Georges: I don't *ever* think about Hopper. I don't use him as a model. I'm quite uninterested in him.

Audience: Why are you on the panel?

Georges: Don't ask me. I was asked. I got a right. But I'd like to say one thing further: The Whitney museum just bought a Jasper Johns for a million dollars. They never had a show of Fairfield Porter, they never had a show of Pearlstein, they never had a show of Katz. So what the hell is going on?

Audience: Perfection will never be attained. There are people who deserve to be in museums who aren't, and those who don't belong there who are.

Berlind: I didn't mean my opening remarks to be an attack on Hopper, but to say he was in a certain sense disserved by the show.

Fischl [Interrupts audience comment]: I'd like to say something, I'm on the panel! I come out of abstraction. My movement into representation is new. I think Johns has had more direct and immediate effect on art and culture than Pearlstein has, so I don't have any trouble choosing the one over the other. But Johns in relation to Hopper is interesting – the sense that you're observing in Hopper a certain kind of life and lifestyle, as Michael said, at a glance, as if you're whizzing by. Probably you are the one in the late 20th century moving by the Hopper painting. You are the people in the society that ultimately *is* Johns, and Rauschenberg, and on up through the last 20 years of art history. What's interesting to me is trying to figure out, in the face of the last 20 years, how can I use Hopper, what are the things in Hopper that are still pertinent.

I don't recognize but a few faces here tonight; I'm pretty sure the people here are not the same peer group I'm at in the art world of New York and I sense you come out of an entirely different tradition, or perspective, than I do, maybe having rejected certain things longer ago than I have or accepted certain things I have not accepted. But I think one of the compelling issues tonight is how to put together the last 20 years of mainstream art with a tradition of representation that was broken.

Audience: It seems to me that in a sense Hopper is the most reactionary kind of painting one could imagine. . . . all these forms are a means to an end, rather than an end in itself.

Fischl: I think Hopper is primarily an illustrator who at times transcends illustration.

Mazur: You can't see even *abstract* painting today without understanding a lot of Hopper in it. There's a spareness and a structuralism in Hopper that makes itself work. Look at the way he edges his paintings, the way he divides them, this incredible tightness and control and flat structure. This is not illustration, or materialist reaction to modernism, either. In fact, during the '50s, most painters who were abstract painters liked Hopper as much as they liked any figurative painter around for precisely those reasons.

Fischl: When I said illustrator, I'm thinking about a technique of advertising that seeks to reduce the distance between the buyer and the product and does it with very strong graphic imagery, usually eclectic, collaged. Hopper was an illustrator as well as a painter. You can see that some of his paintings failed because they are simply illustrative. He hasn't been able to internalize it.

Audience: We all have paintings that fail, but when you talk Hopper, and say he didn't have the structure, you're wrong. He's painting light. Light is there as a structure. That's the whole point about nature. You don't look to nature for detail, you look for the order that's in it. There must be a structure, you have to seek it out.

Gornik: To my mind, the thing Hopper painted best is architecture, sort of the place that man and nature meet. . .

Edited from tape.

*Thomas Armstrong was Director of the Whitney Museum.

'80 / #150

Art and Argument

Here's an exchange from "Figure/Space/Content":

Audience: It sounds like the majority of the panel are talking about "no style," the *impersonal*, as an idea of the work . . .

Panelist: I think the personal trip at this point in time is useless. Somebody trying to be sincere now is like bullshit.

Audience: Fuck you.

Panelist: Let me finish. . . . It's *very* personal in the way it's controlled, the *effort*. But at this point, for me to be "personal," I'd just assume I was being phony, that I didn't believe in my own action. But the tighter and the more complete the presentation of the work, the more I put into it, the more *personal* I feel about it.

Most panel formats won't tolerate a question, much less a statement, hollered out from the floor, certainly not before panelists have finished their set pieces – and understandably so. Important, even brilliant, papers are at the ready and if time and energy get sidetracked, they will be slighted. As a result, whether the audience is enraptured or comatose has little effect on meaning delivered; little or no time is left for questions; and if a sliver remains, the audience is too vast, intimidated, numb, or restless to respond.

In the intimacy, and laxer discipline, of ATOA, an early response from the audience is often the harbinger of an

183

excellent evening. Called-out questions, even during the slide-showing, mean the work is effective; people like it and want to know more. Besides, with everything so casual, panelists probably haven't prepared a statement and are glad to be cued.

Equally important, the live, participating audience tends to be a catalyst. The flow of energy wakes everyone up and new ideas are generated. In the exchange above, a subtle point, perhaps several, were made that would not otherwise have been articulated. In the best such moments, a group mind can at least be imagined, at least for a while. Which is to say, the sum may be greater than the parts.

"Figure / Space / Content"

Moderator: **Jeanne Siegel**; Panelists: **Robert Longo**, **Judy Pfaff**, **David Salle**, **Paul Waldman**

Artists Talk on Art, NYC; November 21, 1980

Jeanne Seigel: I want to try to undercut some so-called trends, to understand how these diverse artists have reintroduced and are using imagery. Three of them were originally called New Wave. All of them reached maturity after Abstract Expressionism had waned, and after Pop and Minimal Art had surfaced, if not peaked. They are, I feel, still acutely aware of modernist tenets – flat surface, or, if not flat surface, certainly an awareness of space, of field, a desire to keep the imagery to essences. But at the same time that there is this awareness of recent modernist abstraction, there is an interest in re-introducing the figure.

The question is, what does the figure mean? How is it used, how is it located in the space, what is the content?

Siegel showed a slide of an untitled New Image Painting by the absent Lois Lane and described it as follows:

A 96 by 96-inch image of a humming bird holding a snake in its beak in oil and graphite on canvas, monochrome black. The only differentiation of figure from space is glossy versus mat finish, which calls attention to itself as painting, and is a reference to modernist ideas . . . an extremely personal way of dealing with something archetypal, a reference to an unborn, or re-born, child, also perhaps to creativity. . . . It's symbolic, not real space, that *uses* the lack of illusion. . . .

Panelists then showed and commented on their own slides, but were soon joined by the audience:

Paul Waldman: I have a lot of set rules, a lot of do's and don'ts, but after a few years the do's and don'ts start to switch sides. What I'm sure of is I don't want anything to become specific. So there are always things left off, like body parts. Nothing is anatomically correct. I pervert them to suit my needs. These drawings were sort of a map for me to work from. I don't want a specific situation. "Specific" would be a portrait of your dog Charlie, or 14th Street. That wouldn't interest me at all. I would like *what I do* to be specific – as opposed to specific subject matter.

David Salle: Considering the meaning or metaphor being created, I have used the idea of the joke. [M]aybe you've heard

someone tell the same joke on several occasions. The joke exists as a structure for inflection or interaction which is much more complex than the meaning of the joke linguistically. So if you consider the difference between the *response* to the joke and the literal *meaning* of the joke, you have some idea of the kinds of things I think about with the use of imagery.

Audience: Could you talk more about jokes? I mean, jokes are jokes.

Salle: You could use the image of any dramatic exchange or an anonymous exchange, a telephone conversation . . . The meaning doesn't reside exclusively in the image, but in how the image is invoked – that's as much a factor in what it means as the literal meaning.

Audience: You have two things going on. Do you talk about them at different levels while they're going on?

Salle: The way you talk about something becomes a metaphor for what it could mean. There could be an imitation of some kind of roudaboutness.

Audience: Could you be more specific by talking about the painting we're looking at?

Salle: Just looking at it in a very literal way, you can't separate the figure behind from the figure on top. They're just two figures rendered very differently on the same canvas and the canvas is painted blue. There's a reclining female nude in extreme foreshortening, not unlike Mantegna's painting of Christ (that's not a reference, that's just something you notice) and there's a figure on top, the gender of which is not important, or not clear, rendered in a very different way, in a metallic paint, a very different surface quality. The nude is painted more as a stain, into the canvas, so there's a difference, not just in the image, but how the image is used spatially.

Audience: Why is that a complex relationship?

Salle: The complex relationship is like any three things which are neither totally unified nor able to be totally separated, like a condition one encounters in life. Some people see things as simultaneously several different things. Some people see things as one thing. Lots of things occur simultaneously. In terms of how I see interaction with the world, that's what makes it complex .

Audience: Is it anything like the way graffiti relates to the surface of a subway train?

Salle: That's kind of nicely poetic, but it's not an image I would use to describe my work. [Here are] two figures side-by-side, co-existing. They have something to do with each other, yet the relationship is not clear. It's not just ambiguity for ambiguity's sake. That would be a failed painting.

Judy Pfaff showed slides of 50 or 60 free-standing figures, ranging from about 8 to more than 14 feet high, from a show at the Neuberger Museum.

Judy Pfaff: I'm in a funny place in this panel, because I come out of abstraction. It's only for a year I've worked on the figure and this is the beginning of that work. They're real simple, like two hands, two feet, one head. I was horrified that I was really doing this. It was peculiar to have all these kinds of people around the studio. You set up relationships,

184

like two figures looking at each other, or one figure big and one small. There's not a whole lot of mucking around with the thing, they're plain and simply painted. I was a painter, but I hate being painterly. Everything is straight, sort of codified . . . There's a *lot* of history. If a thing made a reference to history, I'd think that was terrific – another language, another way to think about it. Some languages might "smoosh" together, like a historic reference and the gesture of a person I knew. There isn't one way to focus, or one medium. I set up different ways to see things. Maybe 30% of these things were made in the shop of the basement of the museum. . . .

Here are veils of images, stacks of images passing each other

Audience: Is the lighting a serious factor?

Pfaff: The lighting flashes across your head. I know what lighting I need in terms of imagery, but I can't do it. I just put red and blue in the ceiling and hope it works. But [unnamed lighting expert] really understands that. These are pin spots at an oblique angle, they really penetrate, the light really goes through, just slices that wall like crazy. He lights for the circus, and Red Grooms and people like that and he understands theatrical . . . The lighting is very important. Also the work is made up of stuff that does stuff with light, it's fluorescent and transparent.

These are works from a [Soho] show, titled "Deep Water." Very psychological, frightening, difficult to do. . . .

Robert Longo: My work basically take three forms: These are large-scale drawings, each 40 x 60 inches. Then I work in cast-aluminum relief. And this is a performance. . . . The drawings are derived from photographs. I employ a person who's a professional illustrator to do a great deal of the work on them. I work with an agenda very much like making movies [but] in the tradition of sculpture, because I want a certain scale. I do a lot of the work, and she does a lot of the work. . . . I'm more impressed with the person who prints the photograph than the person who can draw real well because drawing as a technique is basically a subversive kind of seduction.

I'm working on a series of drawings now about 10 feet tall by five feet wide to get on a scale like sculpture. . . . I'm concerned with a certain kind of modern gesture. The drawings are probably the most enigmatic, because drawings can't seem to hide anything. The reliefs are cast aluminum, painted at the factory with piano lacquer, then installed into the wall. They weigh about 200 pounds, fairly large. The activities in the reliefs are kind of like clichéd actions, a kind of resisted embrace, or one man punching another, some kind of violent action that has a duality, also an elegance, kind of like a dance step. . . . This figure has a vulnerability from a distance, like falling, but on closer inspection he's kind of screaming, and very aggressive, kind of like what happens when you cross Rodin with Russian Constructivism.

This is a 10-minute performance from 1978. Two men wrestle in slow motion on a revolving stage. The woman on the right sings in an operatic voice. . . . Here a man and

woman dance very slowly, kind of like the Grecian urn kind of thing. The idea that goes through the work has to do with a certain degree of, like, epic – I'm real interested in, kind of like, popular sculpture that no one quite knows what it is, also size, and most definitely gesture.

Siegel: I want to ask each of the artists why they use photographs, and what change in the photograph takes place in the painting.

Salle: Increasingly, I'm not working from photographs. I have for years, and it still seems to be a focus for the work, but increasingly I'm working also from drawings made from life. But the fact that the painting is from a photograph, or refers to a photographic image, makes it like no man's image in particular, even though it's mine. I choose it, I do paint it, I render it in a certain way; but it's not just a "photograph" in the sense of being reproduced mechanically. I reproduce it by a physical process, a *hand* process. The fact that it is a photograph makes it "from the public domain,"* and I think that's important for the work.

Siegel: In some cases it's recognizable as from a photograph, in others it's a kind of gestural drawing that isn't from a photograph.

Salle: Increasingly, it comes more from drawings than photography. The drawing also has the look of something that's been seen in another place, like a life-class drawing or a gestural drawing, somewhere between being completely private and completely public.

Audience: Does a grid figure in the work at all?

Salle: No. I think of the composition as quite the opposite, related to the classical French – like Poussin, kind of neoclassical composition, which also functions somewhat, although in a much more varied way, like the photograph.

Waldman: What I do and what a lot of people do and what we say are not the same thing. I like the idea that I probably lie to you. That makes it even richer. So I'm not too sure I'll say exactly what I might say tomorrow. . . . The photograph is a tool that works directly into what I want to do with my hand [and] I can change it at will, sort of like going into the supermarket and taking what you want. I can take the photograph and translate it, make it more and more ambiguous.

Longo: I'm not crazy about people either, so that's why I use photographs. But my work starts from using movie stills. I couldn't wait for the movies to send out stills, so I started taking my own pictures. I take people up to the roof of my house and shoot them against the sky. In the process of drawing them, they get altered, customized. I perfect them, take out the imperfections, if I don't like their nose, or something . . . The photograph helps the style of work, helps make the "no style." The style I use is the style that comes out and I guess the photograph has a lot to do with it. Also, like David says, I enjoy the journalistic photography, that you don't quite know who the person is who took the picture of the person falling off the building.

[But] I totally fantasize that I'm not long for this art world and that soon I'll be making movies. So I take my own photographs and I have no fear of what medium I use. In that sense, the photograph is kind of like home base; it

makes me feel that I'm operating in a modern world. I take the pictures, I make the drawings.

Audience: How do you do that?

Longo: I use a slide projector.

Audience: It sounds like the majority of the panel talk about "no style," the *impersonal* as an idea of the work. (Personally, I think Judy's work is very personal in comparison.) Could you talk about that?

Waldman: I think the personal trip at this point in time is useless. Somebody trying to be sincere now is like bullshit . . .

Audience: Fuck you.

Waldman: Let me finish. I have an affinity for a kind of coldness, a way of presenting the thing that gives you the option to like it or not like it, without attaching any personal thing to it. It's *very* personal in the way it's controlled, the effort — but at this point for me to be "personal," I'd just assume I was being phony, that I didn't believe in my own action. The tighter and the more complete the presentation of the work, the more I put into it, the more *personal* I feel about it.

Audience: The reason I ask is I find Judy's work, by comparison, really just neat to look at. You three gentleman, you just have a lot of talk behind your work. [*Laughter, applause*]

Audience: [To Pfaff] Judy, you say at a certain point in your work you didn't want to do what you felt was strange in the figurative. Did that come from feeling that two-by-fours are not human enough to express something? [To Waldman] Why do you make paintings that avoid sexual faces? Are you avoiding issues and just making a "modern" painting? [To Salle] When you finish a painting, do you feel fulfilled in finishing a painting, or fulfilled in some kind of fantasized image that will relieve you of something in yourself? [To Longo] When you're making figurative sculpture and put it on the wall, do you feel you're avoiding social issues, not confronting anything out in real space?

Salle: That's not a question.

Pfaff: As an undergraduate, I was simply an artist. In graduate school, I was the female abstract painter who studied with *that* person. I suddenly became responsible for being a woman and an abstract painter, and since I'm good at positioning myself and being belligerent, against things, it was real interesting to me that those push buttons on that figure, what's proper and not proper, what you can and can't do, was so operable. . . . I look for a way to have ideas, to put things together, that I can do objectively – and not get into my own stuff. I can't think when I get real close. . . .

I think of myself as a formalist, by the way.

Waldman: Everything that everybody does is personal. When I say I'm interested in the figure as an object, that doesn't make it impersonal. If I'm not interested in a specific face or hand, that doesn't make it impersonal. I never thought in terms of sexual faces, that's not the way my mind works. Faces interest me, but I don't choose to paint them. It wasn't an avoidance, it was a decision not to do.

Audience: But you said something about "perverted images."

Waldman: I don't mean perverted sexually, I mean alteration. Those are the things about painting that interest me.

Audience: What would be the difference between *altering* and *perverting*?

Waldman: The English language. . . . I'm not specific the way a writer would be specific with words, but I like to be specific with images.

Audience: The pictures obviously have a direct kind of sexual . . . at the same time they've very abstract and formal, [but] maybe "kinky."

Waldman: I'd reject that. I'd go back to altered. I don't think of what I do as kinky.

Audience: I think of a different kind of "perverted." It seems like you're forcing yourself into an "art" mold and that's the only thing you can express. Your *form* is your perversion.

Siegel: I think there are other meanings in the paintings that haven't been mentioned, aside from the sexual. One can see the figures, and the way they're clustered and bundled, symbolically meaning *activity*, not necessarily sexual activity . . .

Panel: It *is* rather voyeuristic.

Waldman: In my earlier work they were behind slits and you couldn't see any activity. . . .

As a kid, growing up on a farm in Pennsylvania, one of my hobbies was being a Peeping Tom, going from farm to farm. . . . I remember looking at Ingres's Turkish bath (of course people felt he was perverted), I felt I was looking *into* it . . . When I walk down the street, I love to look into windows to see what's going on. It's more fun for me looking from the outside in. Inside, it's sort of boring. Everything from the outside is better, except let's say sex, which I'm not that interested in . . . Like, Times Square is only good from the outside, where it says "Peep Shows." You think that's great. You go inside, you're going to get bored. Of course I've never been inside, but people inside told me that.

Siegel: The question of degrees of visibility, the hidden, is also involved in David's work.

Salle: There's a real confusion between things which are drawn or made in a way which has come to be known as expressive or Expressionistic – which equates that with the *personal*. You have to make room for everyone's personal. There's no way you can set up a scale in which one is personal and the other is not personal. . . . There *is* a relationship between looking at paintings and voyeurism. . . . I want to make an object that has a sense of itself, but I don't want to make something that is simply self-referential. [As for "personal" style], I wouldn't say this art is personal because it's decorated with flowers and that isn't personal because it's all white.

Audience: Your paintings are very dramatic; they look like incidents. Would you say they're melodramatic?

Salle: They're not a drama in the sense of something that resolves itself, that has a dénouement, but they have a sense of drama.

Question-and-answer with the audience, diffuse at times, continued until a final comment:

Longo: I find more fulfillment in *un*-knowing . . . I work from a sense of not knowing what I'm doing, [but] I pursue

it. I've gotten to a point of refinement now. I'm getting fairly bored; I look forward to what change will occur. But that kind of initial reaction to something being rendered graphically is just a basic apprehension over the end of an era of a certain kind of art. An artist can use anything he wants to use. At this point I want to use that kind of image because I find the references are real rich, and at the same time it's a game I play with the execution and the way it's looked at.

Edited from tape.

*Longo's characterization of a photograph as "from the public domain" is presumably a figure of speech, not a legal opinion. In any event, it was recently established that photographs are not all *in fact* in the public domain. Jeff Koons had hired artisans to copy a photograph, "String of Puppies," line for line in wood without permission of the photographer. The photographer sued Koons and won in the lower courts (story, photo and "sculpture" featured prominently in the news in 1991). An appeal is pending.

1981

'81 / #151

The Feely Bag Comes to Art Ed

The stigma of being an "art educator" is not a sometime thing in the art world ['78/#102]. However, at this 1981 College Art Week panel there's an override because, (1) most of the educators in question are distinguished for other accomplishments, (2) they're doing it at the college level (much more acceptable), and, (3) they're women, so what have they got to lose, anyway?

"Innovative Teaching in the Arts"

Moderator: **Helene Aylon**; Panelists: **Joyce Aiken, Nancy Azara, Alessandra Comini, Leila Daw, Betsy Damon, Sheila de Bretteville, Pat Ferrero, Gilah Hirsch, Susan Kleckner, Lyn Matthew**

Women's Caucus for Art, College Art Conference, San Francisco; February 25, 1981

The topic sounded dull and pedantic, but I went on the strength of panelists' reputations and the promise of "a favorite teaching project described by each." The event proved exciting and energetic, and the projects satisfyingly experimental.

Susan Kleckner's five-minute clip of her "Birth Film" (the birth of a baby in an urban home) startled everyone in its explicitness. The film is used in workshops given by Kleckner and Betsy Damon to encourage women's growth through meditation, ritual, and other group and individual activities.

Alessandra Comini's fiery delivery and whammo slide presentation prompted one artist in the audience to call her "the Joan Rivers of art history." Comini demonstrated how she "sneaks" women's art into art history survey courses at SMU. For instance, in a discussion of totalitarian art, she uses paired slides to contrast Hitler's youth propaganda with Käthe Kollwitz's World War II drawings of agonized women and children.

Leila Daw asks each of her design students to build a personalized shelter. The women's shelters tend to be enclosed, houselike places – cozy and attractive "huts" into which they can withdraw. As one woman said, "I want a safe place where I can be invisible and look out." The men's shelters are less enclosed and more conceptual, often requiring verbal explanations. For example, one man hung a swing from a tree branch with a seat "large enough so that I can always have a can of beer by me." Another made a shelter he could wear like a space suit.

Pat Ferrero discussed the form, content, and functions of quilts. Quilts were often made to commemorate important occasions, particularly births, deaths, and marriages. Girls might quilt for years in anticipation of marriage. Quiltmaking, Ferraro said, connects art and life.

Nancy Azara finds that women come away from art school disillusioned, unable to put their personal lives into their art. She has her students make "visual diaries" during consciousness-raising sessions, which they can hide or share, as they wish. Relieved of the need to do the "right" art, students can "discover what their personal forms are."

According to Lyn Matthew, schools teach students how to make art but not how to market it. Her students learn to prepare a portfolio, approach galleries, apply for grants, make contracts, and handle other business aspects of art.

Joyce Aiken taught art at Fresno State University, developing feminist art programs before and after the arrival of Judy Chicago. She tried consciousness-raising techniques for a while, but stopped when it became apparent that students felt uncomfortable sharing intimacies in an academic setting. Women students pooled their skills and contacts in making and selling work, and a cooperative gallery resulted.

Sheila de Bretteville's project, "Public Announcements and Private Conversations," is assigned to students at the Los Angeles Woman's Building Graphics Center. They design posters about their personal connection to a place in the city, post them in the community, and observe reactions. Because women and men inhabited separate spheres in the 19th century (men in the public, women in the private), working women in the 20th century still have a muffled presence, de Bretteville says. She helps them bridge the gap between their private and public selves.

Gilah Hirsch invented the "Feely Bag" for her beginning painting class. She asks each student to bring a bag filled with items of different colors, textures, and shapes, excluding the readily identifiable. They then trade bags and explore the objects with their hands, without looking, and finally record speculations about form and color in paint. They do intuit the colors of some objects, Hirsch said, and gain confidence in generating form and color.

– Ruth Askey

Women Artists News, April/May 1981 [Vol. 7, No. 1]

'81 / #152

Steel Wool Peignoir

"The Force of Habit: Artists' Clothes"

Moderator: **Judith Stein**; Panelists: **Maureen Connor, Martha Madigan, Judith Shea, Richard Shiff, Sigrid Weltge**

College Art Association, San Francisco; February 26, 1981

Judith Stein, describing how she came to organize a panel on clothing as an art form, said, "Garments carry with them the implication of use, a quality not as a rule associated with contemporary art. Nevertheless, this potential of clothing to convey the context of custom has attracted many recent artists to its literal substances or metaphoric appearance. Apparel expresses both individual and collective experience, a reference which may be used in an ironic, nostalgic, religious, or political fashion."

Artists have traditionally announced their calling through their clothing, Stein continued, citing poet Oscar Wilde and painter James McNeill Whistler, both of whom dressed in bohemian attire, the better to resemble geniuses. In the 20th century, artists' personas are often as important a factor in their recognition and success as their art. Some artists have taken their accoutrements as inspiration, using their pillows, sheets, quilts (Rauschenberg), bathrobes (Dine), and other articles of clothing (Oldenburg) as art objects. Lynda Benglis and Hannah Wilke have used their own bodies as medium. Jeff Way and Michael Berkowitz use handmade costumes of their own design in performance works. The performance provides the context, the actual use completes them as art, and afterward the garments exist as relics of the event.

Judith Shea's works are both fashion items and art objects. Her wall piece constructed of wire mesh, *Checked Pants* (1979), and another piece made of silk organza, display her versatility. They're not intended to be worn, although they could be. Fibre artist Claire Zeisler created a Spandex bathing-suit with designs based on tattoos, intended to be "wearable art."

Are changes in the visual arts reflected in fashion, and vice versa? Stein believes that clothing as an art form can reflect both individual and collective experience, as well as a specific era. Meret Oppenheim's Surrealist fur-lined teacup of 1936 presented materials in an unexpected context, as does Mimi Smith's 1966 *Peignoir*. This full-size robe, with steel wool sewn to resemble fur, is a barbed reference, in the artist's words, to the gap between "the reality of marriage and the romance of marriage." Smith's feminist sentiments are further demonstrated by her *Candy Bra* of 1971 (made of candy, thread, and elastic) and Tootsie Roll *Jockstrap* of 1972.

Miriam Schapiro's belief that the applied arts of needlework are part of her "feminine heritage" has radically affected her work as an artist. In her *Vestment* Series of 1978, the shape of the garment becomes a framework for dialog between fabric patterns and painted brushstrokes. Later Schapiro incorporated actual items of clothing, such as aprons and handkerchiefs, into her "Femmages."

Sigrid Weltge discussed artist Henri van de Velde's influence on fashion during his tenure at the School of Applied Arts in Weimar, Germany. In an era of heavy whalebone corsets and voluminous garments, van de Velde created, for his wife, clothes designed for the uncorseted female body. In 1900 he organized a clothing exhibit to express his conviction that clothing should rank with the other arts, which ultimately stimulated the formation of costume departments in art schools and museums.

Richard Shiff addressed the packaging of artists as performers. He asked such questions as, "Are artists born, or are they self-created? Do we know an artist when we see one? How should the modern artist appear to his or her public?" Citing van Gogh, O'Keeffe, and Duchamp as artists who created their own images, Shiff concluded that the public does not want its artists to act and dress like ordinary people, but to reveal themselves externally, and that artists, by artful eccentricity, blur the distinction between their authentic and created selves.

Judith Shea, addressing "Clothing and Context," described the designs of Vladimir Tatlin, the father of Constructivism. He used gray industrial felt to fashion clothing that was mass-produced in Russia after the 1917 revolution.

"Clothing as Subject Matter and Metaphor in Contemporary Photography" was Martha Madigan's topic. To illustrate the use of sex as sales device, she showed work by photographer Helmut Newton, with its intimations of soft porn, then a different approach to fashion by artist Linda Gerban, whose photography is concerned with the sensuousness of cloth alone, and Harry Bowers, whose photo, *Skirts I Have Known*, deals with the remnants of a relationship. Clothing as social mask, clothing as artifact, clothing as nostalgia, and discarded clothing are among ideas being explored by photographers today, Madigan said.

Panelist Maureen Connor, who says she uses her closet as palette in making art, emphasized that, although clothing functions as bodily protection, it has other layers of meaning, becoming social sign language.

Audience questions suggested the welter of meanings possible in a garment. Is it image? Bodily protection? Art? All this and more? Punk costume and cowboy gear may be clothing as movable art exhibition. But the "G.O.P. look," with its return to "basic black and pearls" and a conservative image for women, was cited as evidence that clothing and social history are cut from the same cloth.

– Nancy Cusick

Women Artists News, April/May 1981 [Vol. 7, No. 1]

'81 / #153

Mutiny on the Boundaries

This promising panel was apparently afflicted by a phe-
nomenon of the TV talk show – the moment an interesting
topic comes up, the moderator changes the subject. As
consolation, our reporter gives us an informed overview of
provocative issues that surfaced and a vivid description of
what went wrong.

"Sensibility of Sculpture:
Painters into Sculpture, Sculptors into Construction"

Moderator: **Lila Katzen**, sculptor; Panelists: **Wayne Anderson**, art
historian; **Carl Andre**, **Mark di Suvero**, **Fred Eversley** and **Claire
Falkenstein**, sculptors; **April Kingsley**, art critic, director
Sculpture Center, NYC; **Gail Levin**, art historian, curator
Whitney Museum, NYC; **Dorothy Mayhall**, director Aldrich
Museum of Contemporary Art; **Robert Pincus-Witten**, critic,
Associate Editor *ARTS* Magazine

Women's Caucus for Art, College Art Conference, San Francisco; February 27, 1981

Moderator Lila Katzen opened with the dramatic pro-
nouncement that "It is now apparent that sculpture has be-
come the major mode of artistic expression of our time."
This bold statement – her approach would soon be called
"pugnacious" – was greeted by surprised laughter and spon-
taneous applause throughout the large ballroom. Katzen
went on to note that contemporary sculpture embodies con-
tradictory values and is unaligned with truly formalist con-
tentions. She also claimed that past arguments about division
of "subject matter appropriate to painting and to sculpture
have been worked through," citing Picasso as an innovator in
blurring lines between sculpture and painting, as seen in the
recent MoMA show where his relief works were "three-di-
mensional planar counterparts of Cubist painting." Katzen
concluded that, "contrary to the views of formalist critics,
modernism resulted from this rejection of categories. Artists
brought to sculpture spatial attitudes that the formalists at-
tribute to painting."

After introducing the four sculptors, "each with distinctive
concerns," and the four art historian/critics as "unique
minds," she asked if any of the latter had something to ask
any of the former. April Kingsley plunged in by asking
Katzen what she felt were the advantages of blurring the
boundaries between painting and sculpture. Katzen replied
quickly and firmly, "I don't think we are here today to talk
about boundaries, but to explore relationships between the
two media and what primary difference in sensibility each
brings to the making of art."

It would seem, however, that the issue of boundaries must
impinge on the issue of relationships. With that refusal to
discuss a fundamental issue of definition, the dialog was hin-
dered from the start.

Next, Mark di Suvero refused to answer Gail Levin's ques-
tion about the importance of Abstract-Expressionist painting

(Franz Kline's in particular) to his sculpture, and called in-
stead for further discussion of what Kingsley had called
"blurring the boundaries." In response, Carl Andre discussed
his own sculpture, the importance to him of both Brancusi
and Turner, and how he intends his sculpture to "sever mass
from description." Di Suvero and Fred Eversley also spoke
briefly about their work, di Suvero noting that he had re-
cently begun painting.

Wayne Anderson made some suggestions about the disparate
artistic sensibilities involved in painting and sculpture. His-
torically, sculpture has held first rank in the hierarchy, he
said, because it is corporeal and thus does not have to deal
with illusion the same way painting does. He added that the
mental differences ascribed to the two kinds of artists go
back to the 19th-century German theory of the sculptor be-
ing more haptic and tactile and the painter eidetic and picto-
rial.

It appeared that a provocative subject for discussion had
been introduced, but it was immediately diverted by Katzen
asking Robert Pincus-Witten to ask a question. The discus-
sion suffered another abrupt shift when Pincus-Witten
warned sharply, "If we don't screw into something impor-
tant, the panel will rapidly dissipate." He then criticized
Katzen's opening statement as a "mishmash of non sequi-
turs" in which "it strikes me that the initial premise was
wrong." Painting has, in fact, been "the central mode of ex-
pression in Western bureaucratic circles," Pincus-Witten
said. "Sculpture has failed to grip the imagination, and
painting is the medium with the extraordinary power that
tells you it is the best of species." By way of example, he
cited "the resurgence in painting today of the extraordinary
use of allegory and figuration, qualities used to revive the
moribund condition of formalist sculpture as of the late
'70s." And he reiterated, "The resurgence of private allegory
and narrative painting gave to sculpture its present capacity
to revive itself."

As was typical of this panel, a forcefully worded statement
was not directly considered and responded to, but a tangen-
tial subject was introduced as answer and disagreement.
Katzen immediately shot back at Pincus-Witten, "Do you
consider yourself leading or following the artist?" Unfortu-
nately, she was attempting to undercut his authority, rather
than discuss the merits of his ideas about contemporary art.
He replied with unflappable confidence that analogous cre-
ative concerns underlie the endeavors of both artist and
critic.

Discussion returned to the relative viability of current paint-
ing and sculpture with di Suvero's comment that "the so-
called 'lyrical abstraction' of today looks just like overblown
'Ecole de Paris,'" and "painting really doesn't seem that
much alive." Pincus-Witten later observed that he didn't un-
derstand why the "lyrical abstraction" of around 1959 was
cited as current painting. At this point, less than half the
two-hour session had elapsed. The remaining time was spent
in brief references to provocative ideas previously introduced
and the quick deflection of their serious consideration by

self-justifications from panelists or abrupt changes of subject by the moderator.

Katzen seemed to take too seriously her responsibility to keep conversation rolling along, which led to many diversions from potentially interesting subjects and sharp demands for a question from a panelist or spectator who wanted to preface a question with a statement.

Other topics introduced but not pursued were the balance of public and corporate patronage for sculpture versus painting – Anderson noting that patronage for sculpture only appears greater because of the works' public and monumental visibility – and a statement by di Suvero that it was "superficial" to be discussing differences between painting and sculpture when we are entering a very dangerous political era. He hoped to inject some awareness of the imminent "death and destruction which the military-industrial complex seems intent to bring upon us."

Because it seemed to promise discussion of current issues by an all-star cast, this panel had been eagerly anticipated, drawing one of the largest audiences of the CAA session. In the event, it repeatedly frustrated those seeking active and thoughtful discussion. While individual panelists had evidently thought about the subject and came prepared with a statement or point of view, few of them could transcend their own myopia. The artists seemed chiefly interested in discussing their own work, while the more theoretical approaches of the historians were either ignored or obscured by bickering. Clearly, a genuine exchange of information and ideas was not desired by the moderator, who refused to consider points of view other than those in her introductory manifesto. The few expressions of informed analysis that reached the audience did so despite, rather than because of, her coordinating intervention. No one seemed able to direct this succession of opinions toward any real consideration of new relationships between sculpture, painting and construction.

– **Suzaan Boettger**

Women Artists News, April/May 1981 [Vol. 7, No. 1]

Footnote: See panel '81/#156 for an excellent sculpture discussion.

'81 / #154

Artist Strips to Protest Underexposure

"The Problem of Art Now" was illuminated, not so much by the panel, as by the stand-off between panel and interloper. Eleanor Dickinson thoughtfully examines this College Art happening from several perspectives.

"The Problem of Art Now"

Moderator: **Jonathan Fineberg**, Yale University; Panelists: **Joan Brown**, San Francisco; **Christo**, NYC; **Mark di Suvero**, NYC; **Richard Haas**, NYC; **Peter Plagens**, University of North Carolina; **Daniel Robbins**, Union College, Schenectady, NY; **William Wiley**, San Francisco

College Art Association, San Francisco; February 27, 1981

The distinguished panel had been making statements, mostly personal, about the present condition of art, and displaying the usual myopia. Vision past the canvas at hand seemed unlikely. Discussion was larded with comments about economics.

Moderator Fineberg: How do the times impinge on your art?
Peter Plagens: Think of it as entertainment.
Joan Brown*: In the 1960s I consciously dropped out. . . . Now I can show and sell what I want. . . . There's a good support system with teaching; the work accelerates. . . . Today is joyous, not grim. . . . The avant-garde for me isn't really there.
William Wiley: Five years out of school I was very unhappy. I got a grant from [the San Francisco Art Institute] and went to Europe . . . decided to surrender to feelings. Drawings are very important to me. Everyone has the right to practice in the privacy of their studio.
Christo [describing his *Gates* project, proposed for New York City's Central Park]: One hundred and seven pages and a 120-page appendix to the City of New York to get a permit! There is a great resistance to art outside of personal experience.
Richard Haas: When the president of a corporation declared that he wanted "art that represents the future," I asked him, "Who do you think represents the future?" He said, "Picasso and Leroy Neiman."
Plagens: Rothko and Gottlieb said, "There is no such thing as a good painting about nothing." Ad Reinhardt replied, "There is no such thing as a good painting about something."
Haas: Peter, did you ever seriously consider that an artist might not have to be suffering to do significant art?

The discussion was following these well-worn tracks of friendly bickering, *bons mots* for the press, the current art wisdom that "contemporary criticism is pretty dull" (unless it's your show being attacked), and universal complaints that nothing exciting is happening in art today. Half the large

audience seemed about to go to sleep, others were watching the celebrities on stage and planning their own questions.

For some time a man who appeared to be wearing Army fatigues and carrying a long gun-like object had been leaning against the left wall. The moderator began soliciting questions from the audience to enliven the panel, which by now had agreed that art today is in one of those long, dull stretches that must be endured. All had agreed there is no cutting edge; Plagens commented that "avant-garde is a term that ought to be returned to the French military, where its sense of utility will be appreciated."

The man against the wall was now in his underwear and seeking the moderator's recognition. When finally called upon, he was entirely stripped and eagerly seized the microphone, declaring, "He who holds the mike holds the history of America in his hands!" He announced that he was "the Statute of Liberty, which all artists should assume." The moderator demanded that he ask a question, not make a statement, so the nude artist, in apocalyptic tones, declared, "Why don't you know who and what I am and what I've been doing for the last 15 years?"

Panel and moderator seemed stunned, embarrassed, or comatose – it was hard to tell which – and the artist mounted the stage and climbed the platform behind the panel where, with his legs spread apart and the gun-like sculpture forming the crosspiece of the letter A, the invader assumed a certain symmetry and dignity. He pointed out that the flashing metal on his chest was a key to the city given him by George Neubert. He offered to show slides of his work and continued to ask loudly why his work was not known to the panel. No witticisms came from the experts; Christo failed to wrap the nude artist; Wiley had no puns. Plagens alone rose to the occasion, saying he would like to see the slides, but the moderator refused. Deciding to ignore the problem, he recognized another member of the audience. A series of dull questions and answers ensued, farcically upstaged by the dramatic nude hovering behind the panel.

Haas: It's not enough to simply present himself; the artist today must have something to say.
Plagens: Why is it that most people in art-biz feel good about post-modernism? Is it good to have no more cutting edge?
The artist has turned out to be Paul Cotton, a respected Bay Area artist, according to Plagens.
Christo: I'm very cautious about subversive art. All art is public art.
Artist leaves stage center.
Audience: A lot of art we see has had government support. With the NEA cuts, will art be affected?
Daniel Robbins: It's tough to be an artist in a revisionist age; only the best survive. It's either a log jam or a thousand flowers bloom. There's a pause in art today, the lack of a leading edge.
Artist puts clothes back on.
Audience: Do you feel the women's movement is playing a leading role today?

Plagens: No one in their right mind would say no to that. The interesting thing is the rising number of women in the art world. Is there such a thing as a female sensibility that has been ignored? I've mulled that over a lot. [In art criticism] there's a lot of flaccidity now, like press releases. It ought to attack, to stand for something.
Artist distributes biographies showing a very respectable academic record – two masters degrees – and exhibition background.
Brown: The support I give [the artists' rights movement] is not in money or getting shows. My role is in teaching and doing my own work,
Haas: These questions are for a trade union.
Plagens: Artists want the benefits of all this art legislation. They don't want to be scabs, but don't want to join either; that makes tension.
Haas: The repression is not all that real. It doesn't seem to affect what I'm going to do next year.
Artist distributes a letter from the National Endowment for the Arts' Jim Melchert regarding the importance and daring of his work.
Plagens: New patrons are the corporations.
Christo: International corporations buy lots of art; big patrons are still there.
Haas: The wife of the corporation president has a lot to say.
Artist appears to have given up or is sulking.
Moderator: Every major show is supported by corporations and the government.
Plagens: Who is a perfect, clean patron?

A question from a New Yorker to Christo – "Why do you want to take away my green space?" – rouses Christo to a lengthy description of his current project, indeed animates him for the first time, and the entire panel becomes embroiled in an interminable hassle over public versus art use of a park. The previously strict moderator seems relieved to have a controlled discussion going and allows the dissection of minutiae by Christo and others to continue until he can gracefully announce the windup of this more or less typical CAA panel.

But what was this artist's protest really about? Paul Cotton told me after the conference that he had been attending the CAA for several days and found himself despairing at the pervasive mood of impotence, the view of art as business and jobs.

"The CAA is riddled with illusion; tearing off clothes is tearing down the veil of illusion that separates our roles. That panel, in accepting their roles, was playing the part of the system, not of artists." He pointed out that they "would show a slide of a nude, but the real thing is viewed as an interruption of the polite order of the convention.

"The projection of myself in the nude into the panel posed a complex collage of questions," Cotton explained. "They were unwilling to consider any of them. I believe this focused on the archetypal split between mind and body that characterizes the bureaucratic order of illusions, which is always trying to use art. From my point of view, art is a system that isn't

about money. If an artist were worried about money, he wouldn't be making art."

Cotton told of going to the 1981 College Art orientation briefing for new MFA hopefuls about to interview for jobs. They were told, "forget all that bohemian stuff you heard in art school. This is business." He felt, "if people were concerned about art and poetry and integrity it would be hard to keep the jobs they are offered in the system. I enjoy teaching, but not what you must do if you want to keep your job. The fault line that runs between money and art is deep."

This artist should have been heard. Instead, someone sent for security guards, who came and almost arrested him. Within a week he had been fired from his teaching job at UC Davis because of his public display. Yet he had exhibited the commitment asked for by the panel; he put himself on the line in a very real way to make his point.

Would another type of panel – one that wasn't all white and almost entirely male – have so consistently talked about government subsidies, dwelt so constantly on the business of art, and dealt with content as technique alone, ignoring problems of pain, poverty, violence, and alienation? Christo says he is cautious about subversive art. Good art is always subversive. Good artists frequently are – and may show their bravery in becoming a Statute of Liberty.

– Eleanor Dickinson

Women Artists News, April/May 1981 [Vol. 7, No. 1]

*Joan Brown was killed in the summer of 1990 while working on a project in India.

In a letter dated January 19, 1991, Eleanor Dickinson updated the story of Paul Cotton, the artist fired for his nude protest: "He is still active in the Bay Area and has been nude in various other art exhibitions. One was the Annual at the San Francisco Art Institute, which he curated. I was at his studio on Hudson Street in the East Bay recently; he is doing very interesting work with small buildings and corridors with mirrors in the studio: sometimes you see a mirror and sometimes you see Paul sitting very still. They are about identity and I found them affecting."

'81 / #155

The Co-op Moment

The director of the National Endowment for the Arts said the prospects from Washington were "discouraging," but expressed confidence that it was just a "temporary setback." The fact that he and other VIPs came to Hartford, Connecticut, to talk about artists' co-ops is another clear proof of a different moment.

"The Future of Co-ops"

Speakers: **Lawrence Alloway, James Melchert, Rudy Nashan, Livingstone Biddle, Sylvia Sleigh, Alanna Heiss, Norma Fox, Cynthia Close,** others

Artists in Cooperation Conference, Asylum Hills Co-op, Hartford, CT, April 3-4, 1981

Most of the 150 participants at the *Artists in Cooperation Conference* had experienced what keynote speaker Lawrence Alloway called "the bottleneck" of exclusionist commercial galleries. In the spirit of self-help, they had expanded the scope of the art world by forming their own alternative galleries.

"Everyone is trying to make the art world smaller," Alloway told the audience, but artist-initiated actions allow "stylistic *expansion* for artists." He decried the lack of media interest in such efforts. "Because art magazines are shaped by [commercial] galleries, and cooperatives are excluded, maybe we need alternative critics and a magazine devoted exclusively to alternative spaces."

One Hartford mainstream critic had forecast a weak future for a local cooperative because of its emphasis on "flat surfaces and art on pedestals." Alloway countered this opinion in an interview by stressing expanded critical range. Limits should be drawn only when cooperatives assimilate the "practiced sell" of commercial galleries, he said.

While Alloway spoke of expansion through media coverage, James Melchert spoke of sustenance through funding. Himself a sculptor, Melchert supports artist-run spaces because they can contain "spontaneous forms that commercial galleries feel are not merchandisable." But rather than mere spaces, Melchert envisions "centers for new art" with "art-making facilities in which the testing of new ideas takes place, laboratories for aesthetic investigation."

Regional NEA coordinator Rudy Nashan introduced Livingstone Biddle, director of the NEA, who had, in Hashan's words, "a few unkind words from Washington." Though clearly in the midst of a discouraging prospect, Biddle relayed the sentiment that "the values of art are enough perceived to survive this temporary setback."

After this panoramic overview, and cutting neatly across the newspeak, Sylvia Sleigh of Soho 20 Gallery provided an intimate glimpse of her cooperative at work. She testified that, unlike the commercial space, "the cooperative gives the artist the chance to get the exhibition she really wants." In addi-

tion, "the amiable group gives sisterly advice, candid, but not unkind. That supportiveness makes it possible to take the advice." In an interview, Sleigh stressed the importance of caring about the co-op. "Love and affection for the co-op make us feel we have to give for it as well as ourselves," she said, in a combination of "autonomy and good faith."

In another form of alternative, Alanna Heiss, president and executive director of the Institute for Art and Urban Resources, adopts buildings between uses for art. "P.S. 1 is a monster alternative space with 30 to 40 shows every two months, plus a large studio program," but "still capable of the individual attention museums should give artists." Heiss warned that alternative spaces must be careful not to "deprive artists of revolutionary activity [by] draining them of energy."

The New York-based Association of Artist Run Galleries (AARG) and Boston Visual Artists Union (BVAU) came to the fore as activist artists' service organizations. BVAU past-president Norma Fox said the group "raises conscience as well as consciousness." Present director, Cynthia Close, called it "a voice for the artists from art school on." Run by artists, it has 13 committees to oversee 900 members. Services include a slide registry, gallery space, newsletter, artists' rights counseling, files on housing, studios, employment, cooperative buying of supplies, workshops and programs such as *Visual Artists: Learn to Mind Your Own Business*, to be held the following month at the Boston University Law School.

– Linda Blaker Hirsh

Women Artists News, May 1981 [Vol. 10, No. 9]

'81 / #156

Sculptors Talk on Art

The moderator wanted to talk about "bisecting planes," "the idea of the room as an environment," and "the controversial pedestal." Panelists wanted to talk about *Goya and the Origins of the Modern Temperament in Art*, Kandinsky's *Concerning the Spiritual in Art*, and how artists create their own heroics.

So, while it's hard to say this was *definitely* the most contentious panel of the year, it *was* a night of non-stop wrangling. Panelists corrected the moderator and each other, and a very sharp audience lent a hand. Indeed at one crucial point a woman in the audience called out to the moderator, "you're ruining the whole panel!" Along the way, art's new permissions were saluted, and a satisfying range of ideas and idiosyncracies was addressed. Although nothing was resolved, what is ever resolved?, and there were more than a few laughs.

However, the discussion itself raised another question. Panelists had bridled at the moderator's agenda, insisting that just because they were a "sculpture" panel, didn't mean they had to talk about materials and struc-

ture, "as though there's something different involved in making sculpture than in making painting." They wanted to address "just art issues, because sculpture is an art."

But in the talk that followed, examples, metaphors, and references were drawn almost entirely from painting. One can't help reflecting that when painters talk about painting, they don't illustrate by citing sculpture. Someone in the audience said that today sculpture "sits at the center of its time," a claim also made at another recent panel ['81/#153], but the terms of discussion seemed to undercut that argument.

Never mind. A panel that knows Veronese from Rubens and Perugino from Grunewald is a special pleasure. Talk was never less than compelling.

"Issues in Contemporary Sculpture"

Moderator: **Beth Urdang**; Panelists: **Jackie Ferarra, Wade Saunders, Martin Silverman, William Tucker, Richard Stankiewicz, Mia Westerlund**

Artists Talk on Art, NYC; April 24, 1981

The moderator said she was not a typographical error for dealer Bertha Urdang, but Beth Urdang, and had been with the Zabriskie Gallery "for many years." Introducing panelists, she remarked that although they worked in a variety of styles, all made "objects that could be placed into a room." Indeed Wade Saunders's objects had titles like Radio, Chair, Window, and Lamp, although made of cast bronze and steel. Mia Westerlund said she used pigmented concrete and lead. Others cited a range of materials, but all wished to address art-critical, not technical issues.

Each panelist showed five slides, after which discussion proceeded:

Beth Urdang: Many works of "sculpture" today incorporate "painterly motifs." They are in fact wall reliefs, and use a lot of composition, paint, surface, texture, and color, features traditionally associated with painting, but now seeming to run rampant in sculpture.

Wade Saunders: Minimalism is all light brown wood. There's no reason for sculpture to be so achromatic, but color is a permission of the last five years. Almost every sculptor of my generation is working with color, mostly applied. But one uses the color more for *dis*ociation than association. You know what you *don't* want it to look like. (I pay no attention to color when I'm working.)

Urdang: Why is so much sculpture hanging on the wall?

Richard Stankiewicz: I don't think that's anything new. People have always done things on walls and ceilings – with color and without color. I was drawing with metal on a relatively flat plane in the '50s. That's not ancient history in the *world*, but for me it goes back.

Urdang: But you do see architecture's influence on a lot of sculpture. There's a two-dimensionality, wrapping planes around space, bisecting planes in space, a definite trend toward flatness as opposed to tremendous volume. [To Ferarra] You show at the Max Protech Gallery, which is very much associated with architecture and art, and your work has a lot of influences which are architectural.

Jackie Ferrara: I never thought I was being influenced by architecture. As far as my gallery showing a lot of architects, that's just something he seems to be doing.
Mia Westerlund: I think she's talking about "house sculpture," making things that look like houses or buildings.
Ferrara: I started out thinking I was making stairways.
Urdang: That's definitely architectural.
Westerlund: You do think about sculpture in [architectural] terms. You say you're "building" a piece. You go to the hardware store or the lumber yard to buy your materials, instead of the art store. You're approaching it the way a builder might. . . .
Urdang: And someone like Bill Tucker, who's involved in wheel shapes, doesn't have an overall architectural look, but there's definitely a reference to something very ancient.
William Tucker: The problem is, you have a panel on sculpture, so you have to talk about something technical, as though there's something different involved in making sculpture than in making painting. There's the Sculptors Conference every two years, but you can't imagine having a painters' conference. It's not your fault, but the kind of questions you tend to ask are technical or stylistic. I think the sculptor's business is to make a really powerful image. I mean you wouldn't have a discussion about acrylic paint. I think the problems for sculpture are no different from the problems of painting and essentially no different to what they ever have been.
Urdang: We're not discussing just technical kinds of things.
Martin Silverman: We are sort of focussing, pinpointing things about technique. I agree with Bill that we should talk more about just art issues, because sculpture is an art, and not focus on the small groupings that come out of the '70s, that don't mean very much any more.
Urdang: But this is a panel on contemporary sculpture and there are certain areas that are seemingly very contemporary in the consciousness of quite a few artists who seem to fall into categories. Another area that I think you have to discuss are materials. . . .
Tucker: Why do we have to talk about materials if we're talking about sculpture? I think it's ridiculous! Every discussion about sculpture talks about materials, about structure . . . about everything that distinguishes sculpture from painting. Who is interested in that, really? [*Applause*] Looking at these slides just now – it's obvious that Martin's sculptures are completely different to what everyone else here is doing. The fact that he is making clear and recognizable images of human beings is something that could only have happened very recently. It has become *possible.*

When I started making sculpture, I was in reaction to a tired kind of Expressionist tradition. It's really interesting to me that someone like Martin, in his early 30s, could make this direct evocation of the figure, of everyday life, human emotions, with no inhibition at all.

The questions you're asking about architecture are stylistic issues of the last 10 years, but the fact that Martin can do these things makes a considerable difference. Nobody would have dared five years ago. Even three years ago his work

would not have been looked at. That he can do those things now, based on the direct observation of everyday life, without embarrassment, means a total change in our way of making art and looking at art that has nothing to do with the kind of categories you're attempting to set up.
Silverman: I expected that by now there would be *hundreds* of figurative sculptors. I imagined what things could look like in the late '80s. We could open up sculpture again to social issues. There could be a death image, or sculpture about something optimistic – about almost anything. But the academy doesn't understand that yet. They're stuck in an attitude that began maybe 30 years ago in America, that forces artists into this horrible category. . . . If you're always forced into this category, you can't grow.
Urdang: Isn't it true that the categories are so much more open now than 10 years ago? Then, if you didn't make sculpture that had a Minimal content or a Minimal look, you couldn't even show it. Now there's an entire range of work being shown.
Silverman: The brackets just went out a bit, but there's still the same structure. Like these soldiers are guarding this room and they're saying, you can't go out of here you motherfucker, we're going to shoot you! [*Laughter*] Not only *shoot* you, you'll be *out of the art world!* [*Wild laughter*]
Urdang: What about all these sculpture people who are looking at objects, not the figure, looking at tables and chairs, and lamps and things of the everyday world as an inspiration for their forms and their content? Is that a kind of democratizing art, making it accessible?
Silverman: That's nothing real new. Robert Morris did this chair-table piece in the '60s.
Urdang: And Brancusi . . .
Tucker: That's been part of the vocabulary of modern art since Cubism. But right now it's easier and more acceptable to make small things that are kind of cosy and easier to deal with. They're painted – thick painting. But the kind of permissiveness you're talking about is very cloying; it seems as if anything is allowed. Still, a direct confrontation with human emotions, with social issues, is in a sense excluded. There are still some unwritten rules.

Consider the amount of public sculpture commissioned and built in the last decade. Most of it is public only in the sense of being in public spaces. It's not public in the sense of a direct appeal [to the public], or in terms of message or content. It doesn't mean anything to anyone who sees it. It's just a badge for the hierarchy, an enlarged version of something the artist made in his studio.

The problem is a tremendous egotism. We assume that because we're making art in New York, it necessarily has a public, social and historical importance. That's completely untrue. People won't address issues outside what are supposed to be the important issues of 1980.
Urdang: How do you see Oldenburg's *Bat Column* and *Baseball Mitt?*
Tucker: They're a start. At least he's making an image out of something most people in the culture can recognize. But

they're self-indulgent in many ways. I don't think he's making any kind of comment.
Audience: What about Mark di Suvero's sculpture? That's totally abstract.
Urdang: We'll open it up to the floor soon, but not right now. [To Tucker] How do you see your own work in this context?

At this point a woman in the audience called out angrily to the moderator: "I think you're ruining the whole panel!" Whether she was protesting Urdang's approach to issues or her delay of audience participation wasn't clear. Perhaps both.

Urdang [Ignoring the interruption]: How do you see your own work in terms of that kind of discussion?
Tucker: In a way I envy Martin, because I think that if I were starting to make sculpture now, I would almost certainly be making sculpture much more directly based on the figure. But I can't. It would be very insincere. I came into sculpture at a time when to make abstract sculpture was the most progressive thing to do and I remain totally committed to making abstract sculpture. Nonetheless, I want it to carry more than a stylistic message. I want it, if possible, to have greater power than that.
Urdang: Mia, you once said you felt the challenge was to make work that had absolutely no references or associations, almost totally without content.
Westerlund: But to also convey a lot of emotion. I don't agree with Martin that we're all suffering from constipation if we're doing abstraction. I also don't agree with Bill saying you have to do public art that will necessarily appeal to the public.
Tucker: I didn't say that. I said that public sculpture should move people, address people. It shouldn't just be a celebration of the artist who made it.
Westerlund: Except you have to keep your art going. It would be wonderful if it did [address people], but if it doesn't . . .
Silverman: That's *modernist* thinking. It's *not* OK.
Urdang: It sounds like you're talking in terms of quality. What's successful and what's not successful can't be a *stylistic* decision.
Tucker: No, I'm not talking about that at all. I'm talking about why it isn't possible to make a crucifixion today. And if you can't make a crucifixion, why can't you make something that has that kind of universal power?
Westerlund: Well, obviously, Martin thinks he *can* make a crucifixion.
Tucker: *I* don't think he can. But Martin does not make representations of contemporary life. He makes representations of late '40s life. I think it's extremely interesting that, as liberated as he is, he has to cloak what he makes with a cover of irony or historical distance. Martin, why can't you make a completely contemporary figure?
Silverman: Because I think I do. But from 1950 or 1949. So I'm doing "20th-century figures."
Westerlund: What year were you born?
Silverman: 1950 . . . I'm doing figures that'll be looked back at as 20th-century figures. They don't worry about being hip 1980 or 1920. They're sort of just in the middle. But I think the question about Christ and things like that is very serious.

You have to take the role of almost a civic artist, create your own heroics, and give yourself out to culture, again. You can't be stuck in your own ego. The world's bigger than that. It's a really great opportunity for sculptors. Painters are doing it. (Most of my friends are painters.)
Urdang: Do you think the lamp is replacing the crucifixion? Your work has definite references to a utilitarian, everyday kind of world.
Tucker: But he's doing things from the 1930s. They're not straight, they're deliberate quotations. That's the problem. People can't make anything straight any more. Everything has to be in quotations.
Urdang: There's also a looking at history, definite references, to the Bauhaus, to de Stijl, all kinds of . . .
Saunders: The way I read the time of Martin's figures, I think about Anthony Burgess. In *Clockwork Orange,* he puts the slang into Russian, because Russian is never going to date, like English slang will, never going to be absorbed. . . . In Martin's work, the advantage of picking something that's not present is that five years from now it won't look out of fashion.
Westerlund: It's a classicism, or a universalism. Or maybe it's strategy.
Silverman: It's not strategy.
Saunders: I don't look enough or read enough to be quoting . . . We talked about what the art scene would accept – the art scene will accept more today simply because it's larger. The number of galleries seems to double every decade. With someone like, say, Chris Burden, or myself, we just work from newspapers, or magazines, from images of how things might appear, sort of a guess. I'll never move in the collectors' world of art nouveau, so you sort of generate it for yourself, create an ambience as you go along.
Urdang: There is definitely an enormous influence of the 1920s and '30s.
Tucker: It's a perennial problem for figurative sculpture in the European tradition – what clothes to put on your figure, or whether to represent the figure nude. Can you realistically represent George Washington, say, or Napoleon nude – or dressed in a toga? . . . Nudity has a wholly different connotation in the 1980s than it did in the Renaissance or classical times. Martin dresses his figures 1940s-style; he's putting an historical distance between his figures and today. And I think that's his problem. If he says he's making figures of today, he should be making figures of today, but they have a kind of dated look about them.
Urdang: Richard, you were making figures in the mid-'50s and early '60s, taking junk steel and welding it and making figures that were very satirical, very witty, at a time when many people were just making pure abstraction with welded steel. Did you have an idea about bringing back some kind of humanism, or just like making figures?
Stankiewicz: I wasn't thinking. I didn't have a message. I didn't have any money and that material was the cheapest thing at hand – I *found* it. And it suggested the images that came out. So between me and the material was a private connection. I'm not a theoretical operator as an artist. Later,

when I began using hard stock forms from the mill, the situation was similar. I was in Australia, committed to a show and given work facilities in a fabrication shop. Again, that was the only material at hand. I didn't have figurative, suggestive scrap. All I had was new milled steel. So what I did then evolved out of that kind of confrontation with the material at hand. I didn't make a decision to go suddenly, totally non-objective/abstract. I guess I don't really believe in imposing myself on the material. Communication is a two-way thing.

Silverman: But your work always has a certain humanism. You humanize metal. I'm thinking of this piece at the Hirschhorn of a frog leaping. It's quite beautiful. It communicates the narrative. So I don't think you have to do what I'm doing. You could communicate in abstract ways also. But the willingness to communicate is so important.

Stankiewicz: That's *The Sound of the Little Frog.*

Urdang: What about the idea of the room as an environment? The different use of floor and walls and ceiling, and the idea of gravity. The use of the pedestal always seems to be controversial. . . .

Audience: I'm reading a book called *Goya and the Origins of the Modern Temperament in Art.* The premise is that artists had been supported by dynasty and religion, money and kingships and that at a certain point the artist's ego had to replace that support system. Goya and David had to deal with revolution; they had to rely on their own ego and their own sense of what was important in art. When you were talking about public sculpture, it seemed to me that an art like Martin's and Stan's should be accessible to the public [but] it's also important not to condescend to what you think would be accessible.

Stankiewicz: It may be that political dynasties and powerful religions govern art. But a period like the present is different in that the support of art comes from much more diversified sources. This permits a variety of views about such things as crucifixions. One of the slides I showed was a face, called *The Suicide.* The other side shows an agonized face with dagger-like points, as a crown of thorns. This side uses the daggger-like thorns as fangs. I was thinking that the Christ story, the crucifixion and so on, is really the story of a suicide. Anybody who thinks about suicide will recognize that it's a vicious, aggressive, rotten thing to do to other people. This is the kind of view that could not be put forward in the time of a powerful Christian church. When the support of art is diversified, many unorthodox expressions can come out.

Audience: A lot of the prejudice about how to make art, and what art it's all right to make, comes from the critical world as much as anything else. Prejudices are developed and supported, and artists feel obliged to respond to that critical attitude.

Stankiewicz: My reaction to the critic who disapproves of what I'm doing is to wonder what he's worth.

Tucker: The religious themes, the crucifixions, the annunciations, were not in order to stereotype expression, but to allow artists to invent creatively in terms of form and interpretation of a universal story. Think of the difference between a crucifixion by Perugino and Grünewald. There's a tremendous difference in those two artists' ideas, not only about painting, but about death, and in a sense the existence of commonly accepted subject matter made that art accessible. I'm sure that the number of people who could appreciate the quality of the art was just the same as today, but those generally-accepted themes made it possible to say things directly in a way it's very hard to do now. Now the artist becomes very self-conscious, because he has to invent the theme and then illustrate it.

Stankiewicz: I wonder if that's true. Was it Rubens who did the marriage feast and got in trouble with the church because of the dogs?

Panel: Veronese.

Stankiewicz: It seems to me that when you have those powerful sponsors your expression is distinctly censored.

Tucker: But I think you'll find censorship related to emergence of the artist's ego. When the artist was projecting himself at the expense of the religious subject matter, censorship became a problem.

Audience: There seems to be a lot of discussion about abstraction versus image. Is that a central question today?

Silverman: Content is much more important.

Westerlund: Is it the story of a painting that gives you palpitations, to look at the difference between a Giotto and a Sassetta, or is it the way it's actually done? . . . I think you can get as much joy out of an abstraction as out of a figurative thing. It's crazy to think the only work you can understand has to have a lot of "human" content and story-telling – the neurotic stuff around now. I get very tired of all these neuroses hanging out all over the place. It's not interesting unless the painting is done really well. If the painting is done really well, it can be a painting of a square – *or* a neurotic.

Silverman: If you're neurotic, you do paintings about being neurotic.

Westerlund: I'm not saying the artist is necessarily neurotic, but that's what the paintings are about.

Urdang: Are you saying Abstract Expressionism was about neurosis?

Tucker: Victorian painting and sculpture was terrible and it was filled with the direct and simple illustration of everyday incident, human life, all that stuff. Artists of the modern group rejected that totally. They put the energy and feeling into an art that eventually became total abstraction and the kind of easy, anodyne, decorative work you see all around today, that's the majority of work being done. It's a pity artists can no longer address the kinds of problems directly that they could with an easily accessible subject matter, as in the Renaissance.

Audience: Go to the Art Students League.

Tucker: I teach at the Studio School, why do I have to go the Art Students League?

Audience: Talking about "abstraction" versus "image" is a fundamental confusion. I can't imagine what work of art would not in fact *be* an image. The problem with the kind of work you're describing is it's an image we don't like to see.

197

Tucker: The problem is, it's an image we *like* to see. It doesn't disturb you or confront you.

Urdang: In public art you have a tremendous audience. That's the nature of public art.

Westerlund: The nature of public art is that it's generally chosen by bureaucrats.

Tucker: It's usually chosen by other artists.

Ferrara: There are many instances where artists are advisors. I was just on a panel for the NEA. . . .

Westerlund: That's not "public art." Public art is chosen by the mayor of the town and officials.

Stankiewicz: I know of instances where local selections of art were overriden by the NEA. This is an ominous development. It casts the shadow of an official art, if local decisions are cancelled by the central authority.

Westerlund: But that's not where all the money is coming from.

Stankiewicz: If the local money isn't enough for a large commission and the project depends on the NEA for a supplement, then it falls through if the NEA doesn't approve. Therefore, to that degree, NEA controls.

Westerlund: That's bureaucrats.

Stankiewicz: I don't like the word bureaucrat; it's a bogeyman word.

Audience: On one hand, Bill is lamenting a public sculpture that's not in some way in the public interest. At the same time he's opposed to the kind of corporate art that I would say supports the public taste. . . . I see in Bill's work, in fact in a lot of work in town, a kind of nostalgia or yearning, references to other cultural, architectural configurations, skeletal remains of Biblical imagery – like the Ark, or wheels of fire – fragmentations of popular cultural things or '30s humanism, as in Martin's work.

Westerlund: When Beth introduced the panel, I thought she said we all have something in common. Maybe that's it – we're all living in the past.

Audience: I didn't mean that as an accusation. I'm trying to draw a thread . . . There's a tremendous sense of loss at the center that does not get assuaged.

Urdang: Isn't that always true? The desire to make art is to fill some kind of . . .

Audience: But with Abstract Expressionism, it was like a fullblown war. We were all agreed there was a void and an existential kind of problem. Nowadays that is not even agreed upon. In fact there's an awful lot of denial about the distance one has from cultural meaning, or cultural imagery. There's a tremendous over-saturation of images, artists *quoting* old art. . . .

Audience: Most of you ladies and gentlemen, are trying to find the new form, not to go back and quote, but to find a new form for new problems. I believe sculpture more than any other art sits at the center of its time. Minimal art, which I don't like – and you don't have to like art to understand it – Minimal art is the basis of a new form, an entirely new development. Tucker has put his finger pretty much on the problem: we have lost the past. Nobody can do a crucifixion today. Neither do we believe in it, nor do we have the form

for it. So the simplification of form, going back to pure design, is the basis for a new humanism, for an entirely new evolution in sculpture.

Audience: I have a question about materials. Sculptors are always very involved in materials. Martin's idea about an artist addressing himself to culture is important, but sculptors have to deal with the material at hand. Are you a metal sculptor? Are you into wood? A kind of return to craft is happening right now. I'd like the artists to talk about the relation of their image to their material.

Westerlund: Material is absolutely at the base of my images. I start out manipulating two materials together in my hand to figure out a form and I just hope that in that process some of my character, of the emotion I want to express, the magic, whatever you want to call it, comes through. But there's no way I can tell you how that happens or *if* it happens. . . . For me it doesn't matter if the form is real or abstract. In fact sometimes I think a recognizable form gets in the way of experiencing what else is in the piece.

Audience: What I was getting at was whether material has a hierarchy for the artist. . . .

Silverman: I'm very involved with earth and clay. I picked it as a basic material that was neutral and flexible, that could be manipulated.

Audience: Stankiewicz, I think you short-changed yourself. Your stuff is powerful and masculine and then some. You're much too near your own art to discuss it. But materials are only at the surface. You are educating us, and society. You create a new culture every day you make a new piece. What is your responsiblity toward the culture, in which you live [while you] constantly enlarge the culture?

Silverman: Optimism. I think sculpture itself is a very optimistic form, and a life-giving form. Traditionally, whatever you do with it, it tends to be optimistic.

Westerlund: When you say the responsibility is optimism, that sounds – irresponsible.

Tucker: I don't see how anyone who is culturally or politically aware can be optimistic. . . . If you get a commission from a corporation and your work is used to clean up the image of that corporation, that creates a conflict . . . A lot of public sculpture and public art of the last 10 years dresses up the people who commissioned it to seem benevolent.

Audience: We're talking around questions of social consciousness, and questions of making art for the rich.

Silverman: We're not making art for the rich, because the rich are corrupt. . . .

Audience: But who can afford to buy your sculpture? The rich.

Audience: I'd like to hear the panel address responsibility. Every one of you is showing your work. As long as you show your work to whatever audience, there is a responsibility implied.

Tucker: There is a real conflict between trying, on the one hand, to do good sculpture, and take the art of sculpture seriously, and, on the other hand, not to work within [the existing] structure. . . . What I meant about the Renaissance was that you could make a work of art that was simulta-

neously a wonderful work of art and a depiction of an annunciation or a crucifixion, or say something meaningful about important human situations. And I think artists want to say something beyond just making a good piece of sculpture. [They want] to go beyond an audience of connoisseurs.
Westerlund: In the Renaissance, an artist could do a religious subject and it immediately had acceptance. Now we can only do the best work we know how to do. Hopefully, in 50 years the cultural implications of the art we do now will be clear.
Audience: I wonder why in these discussions the onus is always on the artist. It's always the artist's reponsibility and never any mention about the public's responsibility. Maybe there's been a change in the public since the Renaissance, a failure of spirituality in the public at large that affects their relationship to a work of art. Why is the *artist* always supposed to change to suit the public and never a mention that maybe there's something lacking in the public?
Tucker: Kandinsky wrote a book, *Concerning the Spiritual in Art.* Early modernism had a real concern with idealism, philosophy and religious values that is now completely gone. Most of us are repeating the thoughts given to us, but without that kind of idealism. They were working against an academy. Now we're the academy.
Westerlund: I don't agree. You have to speak for yourself.
Audience: Because most of us are now intimately associated with something like an academy, we have a nostalgia for things that are academic, for an iconography, which may be one of the reasons people say today nobody can make a crucifixion. But there is a crucifixion over at Julian Schnabel's show.
Tucker: If you look at what used to be considered illustrative, 19th-century Victorian painting, it's now taken a lot more seriously by art historians, and given quite a decent place in the recent hanging at the Metropolitan Museum. It's obvious that there is a real longing for some kind of security. We take an attitude equidistant from that kind of stuff, which is really awful, and Kandinsky or Mondrian or Brancusi. I'm not talking about a nostalgia for iconography, but a nostalgia for the kind of idealism that informed Mondrian and Brancusi and Kandinsky.
Audience: But there seems to be a tremendous sense of loss and disability compared to the past, perhaps exaggerated by the fact that we all, or many of us, have a highly academic frame of reference, which the 19th century and earlier didn't. We all have MFA's and BFA's and art history courses, certain anticipations about what art ought to answer. . . .
Audience: Julian Schnabel's crucifixion just shows it *is* impossible to make a crucifixion.
Audience: But we still have this sense of loss.
Silverman: That's not so! Optimism!
Audience: Any piece of sculpture is by definition an optimistic statement.

Edited from tape.

'81 / #157

The Critic's Lot

"Art Criticism: The Ongoing Crisis"

Moderator: **John Perreault**; Panelists: **Ellen Lubell, Carrie Rickey, Michele Cone, Keith Morrison**

American Section of the International Association of Art Critics, American Writers Congress, NYC, October 11, 1981

In Roslyn Drexler's novel, *To Smithereens*, the heroine, a wrestler named Rosa, asks her lover, an art critic named Paul, "Isn't it a drag . . . to be dependent on what someone else does for what you do?. . . I mean, what if there were no artists?" Paul replies, "I help clarify. [M]y writing is the best writing of its kind that you'll read anywhere."

Paul's defense of his trade helps to explain a panel on art criticism at a weekend convocation of writers – major, minor, and aspiring. Art critics may teach, lecture, curate, edit, or even paint, but they also write. Some write very well indeed, others abominably; some clarify, others obfuscate. In any case, it is this dual focus on elucidation and prose quality that marks the serious critic.

Criticism was featured in another panel at the Writers Congress. Billed as "The Tastemakers: Critics as Cultural Czars," and starring John Simon, it drew a large audience. In contrast, only about 25 people gathered to consider the "ongoing crisis" in art criticism. Perhaps participants were surfeited with crises, having been harangued about them all weekend. In fact, the major business of the Congress was to form a writer's union to deal with sundry crises.

The question, "Are art critics free to write what they want?" had appeared in the program notes for this panel. "No," replied moderator John Perreault, describing the life of a critic as low in pay, if fairly gratifying to the ego, and distinctly lacking in control over choice of material. He reiterated Paul's justification, saying, "We are first and foremost writers" who try "to communicate and to educate."

Carrie Rickey cast an even colder eye on the system, claiming that art criticism has become an adjunct to the four-color ads in the art magazines. Analytic writing is neglected, she said, although sometimes a "think piece" can "create an art movement," giving a boost to sales. She, too, believes criticism should "explicate and amplify."

Keith Morrison of the *New Art Examiner*, who is also a painter, said he thinks of himself as an artist who writes. He considers the distinction between commercial and non-commercial art has "largely evaporated," causing art buyers and culture consumers to read reviews "more for information than analysis." Certainly "many people think art criticism has become mainly promotion."

Michele Cone talked about the need for a new kind of criticism to deal with the new art, which "seems to ask the critic,

'Am I really worth looking at?'" Her most incisive comment was, "Often the best writing hypes mediocre art." This is a dilemma for the careful writer who cannot select which artists or galleries to cover.

Feminism's representative on the panel, Ellen Lubell, presented a brief history of women's co-op galleries, which was not very heartening: She believes the women's art movement has "lost steam." For the benefit of those who hadn't noticed, she reported that women artists and women's galleries get comparatively little attention from art magazines, and cited examples from her own experience as reviewer for *ARTS* Magazine.

During the open discussion, the subject of pressure from advertisers was expanded. Perreault denied that there is any direct pressure, while Rickey said there is, but one can usually ignore it. There was general agreement, however, that editorial pressures make it difficult to be candid, since the magazine can always have the last word by eliminating material they find undesirable.

The group seemed to share the general enthusiasm for a union to establish standards and promote the rights of writers. We were told that the International Association of Art Critics has already recommended a 10-cent-a-word minimum payment for art writing.*

At the "Tastemakers" panel, novelist and critic Helen Yglesias had said she preferred to call herself a reviewer, since, "there are very few critics in the true sense." No one on the art panel expressed a similar view. When a member of the audience made a distinction between art criticism and art journalism, Carrie Rickey deplored the "false dichotomy." Journalism, she said, "is no more superficial and no less exacting a discipline" than criticism and "most critics today are also journalists." One can only suppose a critic in the "true" sense has an independent income and can exercise the critical faculties purely for the joy of it.

In closing, Perreault quoted Peter Schjeldahl, who said dealers are the real critics nowadays, while perhaps critics write only for other critics anyhow. And we all went off to pay our union dues.

– Sylvia Moore

Women Artists News, January/February 1982 [Vol. 7, No. 4]

*Not yet achieved, as of 1991.

A Hundred Prints to Get One Good One

"Berenice Abbott Speaks"

International Center for Photography, NYC, Dec. 1981

Berenice Abbott returned to the city she regards as the most photogenic and exciting in the world on the occasion of an exhibition of her work at the International Center of Photography. In a room crowded with photographers, she faced the lenses of those who had come, not only to listen, but to make their own documents of the event. She took it all in stride.

Now in her early 80s, Abbott had gone to Paris in the 1920s as an aspiring sculptor with no money. It was just as easy to starve there, she said, as in America, where "art was a dirty word and you were supposed to go out and get rich." In Paris after the war, when everyone was busy and full of hope and excitement, she lived on 15 francs a day, though she doesn't advise anyone to try that now.

A photo of her by Man Ray, whose assistant she became ("He wanted someone who didn't know anything"), shows a rather dreamy-eyed and beautiful young woman. But she envisioned photography as a means of recording reality "with an unblinking stare." Abbott is known today for her photos of New York of the '30s and for retrieving the work of Atget. She does not feel, however, that her admiration for Atget influenced her New York City documentaries. When she returned from Paris to New York, she was struck by its ever-changing quality and wanted to capture it before it was gone. She was never able to sell any of these photos.

The audience was very quiet as she described the utter collapse of everything, shortly after her return from Europe, in the crash of 1929. She managed to live on small commercial jobs that came her way, but eventually monetary problems put a stop to the documentation she felt was so important. There were other difficulties too. She had to overcome her own reluctance to work with the view camera in public places, to go where nice ladies didn't go and to conquer her fear of heights in holding a view camera over the side of a skyscraper. Asked if she wore a skirt, she replied that she always had, but now regards them as impractical and ugly.

Abbott deplored manufacturers' lack of concern for the serious photographer. "Everything is made for the amateur now." She added that the quality of printing paper today is terrible. When she hears people say they have taken a thousand shots she feels they are going backwards. Better, she said, to take one and spend four days in the dark room, drudging away until you get a perfect print. She quoted Steiglitz's standard: 100 prints to get one good one.

On the relation between painting and photography, she said she attended *croquis** class in Paris whenever she could afford it, but regarded painting as anathema to photography. "Most photographers today are still imitating painting. Even the great Cartier-Bresson sees like a painter. One must see like a photographer." When pressed to name one who does, she named Lisette Model, who was sitting in the audience.

On color: "Color adds another dimension, which crowds everything. I have rarely seen a subject improved with color. There are very few exceptions."

As for advice to the young, she said she really didn't have any. She commented that today everyone is interested in money, including herself. "Each time is different and demands different solutions. Desperate actions."

– Gladys Osterman

Croquis, meaning a rough or quick sketch, was art students' slang for an informal sketch class

Women Artists News, January/February, 1982 [Vol. 7, No. 4]

1982

'82 / #159

History is Whoever Gets to the Typewriter First

The occasion was ATOA's 150th Friday evening forum. The event was one of those recollections-through-nostalgia of the "Club." This extensive write-up *cum* memoir by Lenny Horowitz is followed by excerpts from a report by Diana Morris.

"The Artists' Club: A Rare Look Back at Friday Nights in the '50s"

Moderator: **Cynthia Navaretta**; Panelists: **George McNeil, Philip Pavia, Ray Parker, Nora Speyer, May Natalie Tabak**

Artists Talk on Art, NYC; January 29, 1982

It was a great evening of stories, reminiscences, confessions, asides, the New York art world, the origins of Abstract Expressionism, the hanging out, the good old days, and the 1950s, when the artists and their friends, husbands, wives and lovers had their own Club, their own bar and their own way of life.

Every artist on the panel had a version of what really happened and 30 years later it all sounded very authentic to me, since I know these people and was a member of that Club. As for the accuracy of each detail – history is whoever gets to the typewriter first. And speaking of that very subject, Philip Pavia is writing a book, May Taback[1] is writing one and William Barrett published a controversial 12-page article in January [1982] *Commentary*, titled "The Painters Club." Fred McDarrah's *The Artists' World in Pictures* [1961] was the first book about the scene. Irving Sandler has written *The New York School: Painters and Sculptors of the Fifties*, as well as *The Triumph of American Painting: A History of Abstract Expressionism*, and an article, "The Club," in September '65 *Artforum*. I, too, wrote a number of articles for the *Village Voice* in the early 1960s, including one called "Portrait of a Scene."

In her introduction, Moderator Cynthia Navaretta described the origins of the Club and its early operation:

> Philip Pavia says the artists' Club really started in the late 1930s in the lunchroom of the Art Students League, where the students, including Pavia and Jackson Pollock, gathered daily for discussion and to listen to Arshile Gorky and Stuart Davis. This informal lunch group eventually moved over to the Waldorf Cafeteria (on Eighth Street and Fourth Avenue), where nightly one could find a group of eight or 10 artists sitting around a table talking. By the late '40s, the group had grown so large that they were occupying several tables. (May Taback says the Waldorf asked them to either spend some money on food or leave and they left.)
>
> This was a period when the artists' community centered around Eighth Street, home of the Hans Hofmann school, and the Robert Motherwell school, which was called Subjects of the Artist, and Tenth Street [from Third to Fourth Avenues] where most of the artists lived and worked (except for George McNeil here, who always lived in Brooklyn) and where they eventually opened a number of co-op galleries. This downtown avant-garde artists' community consisted of some 200 painters and sculptors – isolated and alienated from the commercial mainstream and the uptown museum world. All this of course was soon to change.
>
> In the fall of 1949, some 20 artists, including Willem de Kooning, Franz Kline, Ibram Lassaw, Conrad Marca-Relli, Emmanuel Navaretta, Philip Pavia, Ad Reinhardt, Milton Resnick and Jack Tworkov organized the Club, sometimes called the Eighth Street Club or the Artists' Club. They rented a loft and established what was to become the focus of "New York School" activities for the next decade. At first, every member had a key and came around whenever he liked, pretty sure of finding someone else to talk to. However, the Club soon took a more formal character, presenting invited speakers, symposiums and occasional concerts on Friday evenings, with Wednesdays reserved for free-wheeling discussion and occasional organizational meetings. [During the years of the co-op galleries on Tenth Street, there were collective openings every three weeks, preceding the Club forums.]
>
> The Club continued to grow rapidly, with younger artists, like Robert Rauschenberg, Helen Frankenthaler, Larry Rivers and Joan Mitchell invited into membership; succeeding years brought in the second generation New York School artists. Poets, avant-garde theatre people, musicians, filmmakers and publishers mingled. It was an opportunity to meet the elders of the community, a forum for new ideas and esoteric subjects in all the arts and an informal support system.
>
> The character of the Club changed somewhat as leadership changed. Pavia pretty much ran things until 1955, then John Ferren took over for a year, followed by Irving Sandler from 1956 to 1962, when the Club was temporarily discontinued[2]. The membership lists read like a Who's Who of two generations of American painters, and the programs convey the breadth of concerns of the artists involved. It was an extraordinary phenomenon of the time when American art came of age.

I myself first attended the Club on Wednesday evenings, when a few artists would sit in a circle and talk to each other informally about whatever was on their minds. As I recall those evenings, artists who attended on a regular basis were Pat Pasloff, Milton Resnick, Paul Georges, Bill Littlefield, Sam Goodman, Landes Lewitin, George Spaventa, Ruth Vodicka, and, if I've forgotten anyone, please forgive me.

Pat Passlof recently told me she started those Wednesday evenings because the Friday evenings had become too formal, but even within the informal atmosphere of a handful of artists sitting around, intense personalities made for certain consistencies. Paul Georges would always complain that the prevailing attitude was unfair to his way of working (figurative) and Milton Resnick would always wind up telling him off. Lewitin would sit, silently, outside the circle, in the rear, and eventually try to expose us for not being intelligent about the way we were conducting the conversation. Littlefield would then take exception to Lewitin's tactics and accuse him of setting us up. I distinctly remember one bitter cold night when Resnick and Passlof went around the circle, asking each of us why we were there, and Milton, at the end, saying he was there because he was "scared."

Next, Nora Speyer delivered her version of the Club, which she "attended religiously every Friday night," in great style. She said the Club went through a number of changes, starting out with one set of values, then, after five years, winding up with an entirely different attitude:

> The people who went to the first Club were primarily painters and sculptors with a few poets, musicians and several serious art historians – Lionel Trilling, Rueven Todd, John Cage, Morty Feldman and Robert Goldwater. We were a very searching, introspective group.
>
> The motivation in the first Club was to get together, to express, encourage and reassure ourselves that what we were doing as painters and sculptors made sense. A favorite topic was, "Where are we going?" One could have said, "What are we doing?" and this idea was repeated over and over. . . . Paint materials were not discussed. . . . Art History was looked down on. Picasso and Matisse were rarely mentioned.
>
> We were exploring new ground and tried to avoid looking back. Almost all of the panels were on different aspects of creative thinking. Artists were an isolated group back then, without support from the museums. Because of this, no one was preoccupied with selling. Most artists had other jobs to survive.
>
> The people who went to the second Club were painters, sculptors, one or two serious art historians, poets, musicians, dealers, museum curators, critics, editors and collectors, large and small. Artists had become more interested in status and selling. Club panels now [featured] the new elite of the art world. The Club was crowded only if a museum curator, big dealer, critic or collector, preferably large, was on the panel. Topics at the second Club included: "The Role of the Art Critic" and "The Role of the Museum." Everyone was pleased. The new idea of the Club was that the outside world was going to help the artist and the artist would use this help to full advantage.
>
> The important part of the first years was that the artists were the total picture. They felt they were the only ones who had the ideas, and to hell with the outside – they would evaluate each other's talents. They thought they were in the driver's seat and calling the shots. In the beginning, they were, but slowly the power brokers took over and the artist found himself either sitting in the back seat, in the trunk, or under the wheel.

Speyer ended on a philosophical note by asking whether the first Club was an exception to the norm and whether artists today need a strong conceptual idea to unite.

Philip Pavia said the talk actually began in the lunchroom of the Art Students League on 57th Street. Later, during WW II, it moved to the Waldorf Cafeteria:

> [There was] a hard core of artists who were as tough as nails. They stayed together all during the war years, 1942, '43, '44 and met every night around 11 PM. Then there developed a terrible argument which centered around [Landes] Lewitin and [Aristedimes] Kaldis. Lewitin had lived in France for many years and loved French painting; Kaldis loved Greek art and accused his friends of being decadent and worse.
>
> By 1946, artists who had been in the service started coming to the Waldorf, too. They didn't all sit together as comrades, though, but rather as a fierce debating group. If anyone went home early, the others would pick him apart. The last two guys to leave were safe, but you were never sure. Kaldis would say, "Poor guy, poor brains, poor painter, doesn't have a rich wife," and on and on. Kaldis hated the Renaissance and accused the other artists of listening to de Kooning too much. De Kooning was talkative and argumentative. He loved the Renaissance and Lewitan loved French art and Kaldis hated French art. Franz Kline thought anyone who liked Picasso was out of his head. He couldn't see Picasso. He said: "Don't you like Kuniyoshi better?" You never saw such contrasting people.
>
> Kline would say how much he admired Albert Ryder and I would warn him not to cause trouble by bringing up those dead Americans again – they are all finished. Lewitin would then bring up the French and Kaldis would say we were all decadent and we needed a new kind of spirit.
>
> The original Club started around 1948-49. We would run into Gorky and Gorky would ask us why we painted abstract pictures and we were in such awe of him that we were afraid to ask him why *he* painted abstract pictures. Then Kaldis said we were not only decadent, but a bunch of cowards. Kaldis's insults were marvellous, like Greek wine, sweet but with the bite of resin. John Graham would tell about being in Siberia and washing his face in ice cold water, which he said makes the mind very clear. He said the younger artists seemed lost and should wash their faces in ice cold water.

Pavia suggested that perhaps the confluence of all these contrasting cultures gave the group its dynamism, creating a "very, very strong art movement that spread all over the world." He also said that in retrospect it was apparent Hans Hofmann had had a bigger influence on the movement than is generally acknowledged. As for the name "Abstract Expressionism," he said it originally meant there were two factions at the Club, one abstract and the other expressionist. Outsiders joined the two terms for convenience.

After a while, word spread, panels were talked about and Tom Hess wrote some essays. People came to the Club from all over and it became very crowded. The Continuing Education program of NYU had taken over Motherwell's school, and students Larry Rivers, Grace Hartigan, Bob De Niro and Robert Goodnough also began attending. "They amalgamated with us."

May Taback (Harold Rosenberg's wife), who is writing a history of American art in the 1930s, '40s and '50s, had a

slightly different version of some of the above, including who showed up when. She said it was unfair to characterize these artists as drunkards, since they really couldn't afford booze and some of them, like Pollock and de Kooning, only needed one or two drinks to get drunk. She told a story about climbing across rooftops on Tenth Street and into Pavia's studio to get a sculpture for an early exhibition. (Pavia evidently hadn't wanted to show at the time.)

Milton Resnick, from the audience, protested that mentioning particular names was misleading, because the main idea was that the Club was free for all ideas and you couldn't really keep anyone out.

All kinds of interesting people came to the Club and to the Cedar Tavern and eventually to the Chuck Wagon restaurant and bar diagonally opposite the original Cedar Bar at Eighth Street and University Place. Lewitin and I started sitting around the Chuck Wagon in 1958, since we both agreed that the Cedar was getting too popular, too crowded, too smoky and too noisy.

By 1959, the Cedar Bar had become everybody's club and was the most "in" place to go in all Greenwich Village. I asked Lewitin if we weren't going to isolate ourselves by sitting alone in the Chuck Wagon. Lewitin smiled his enigmatic smile and assured me that within two weeks everyone would be dying of curiosity and follow us. As usual, Lewitin (who was Dutch uncle, father confessor and grandfather to many of us) was right. The nightly meetings at the Chuck Wagon lasted about four years and ended when Lewitin died. His intelligence, wit, and provoking style made each evening memorable and it was Lewitin who kept us going from night to night.

The Club, in a more organized way, was forum for all kinds of new ideas, and I remember many terrific Friday nights listening to Eric Hawkins, Paul Goodman, Morty Feldman, Kaldis, and Louis Finkelstein, and seeing avant-garde films by Ilya Bolotowsky, Irving Kreisberg and Larry Rivers. John Cage came to the Club; Stefan Wolpe came and so did Leo Castelli. It became, besides an artists' support system, a power base, since many dealers (Castelli, Kootz, Egan and Janis, among others) and collectors relied on word-of-mouth from artists about who was good.

Ray Parker spoke about the passion in the New York art world during that period, contrasting it with attitudes today. He told how someone had recently written on the front door of a Soho gallery, "Art is what sells." Nevertheless, the idea of change appeals to him: "Change is the one thing we can be certain of." He described leaving a good teaching job at the University of Minnesota for New York in 1951, getting a loft on Wooster and Prince Streets for $32 a month, his furniture from the street and hanging out at the Cedar. Parker also made some interesting comments about aesthetics, describing how color alone can convey the content in art and, of course, he is right.

For George McNeil, 1950 was the turning point in American art. Artists had studied on the G.I. Bill in Paris after World War II (Resnick, Sugarman and Spaventa studied in Paris with Zadkine). And these influences began to be felt:

> 1950 marked a whole new generation of younger artists, around 30 years old, interested in modern art. Before that, "modern art" in America had been dominated by Gorky, Stuart Davis and John Graham. The younger artists were bursting with energy. The Cedar Bar was the real place to meet, but not for serious discussion. It was both the best and worst of times. Everyone was pretty much in the same boat, broke, and there was lots of fun, camaraderie, music, drinking and dancing.

Comparing the New York art world artists' Club/Cedar Bar with the great periods of Montparnasse and the Latin Quarter of Paris, McNeil wished there were a bar to fill the same role for artists today. In a sense, he said, "we went to school at the Cedar Bar and then at the Club."

It was friendly, belligerent and tough and also very stimulating. I wrote about that scene for the *Village Voice* from 1962 to 1965.

– Leonard Horowitz

Artworkers News. April 1982 [Vol. 11, No. 8]

1. May Tabak's book was never published. Philip Pavia's book is under way, seriously under way.

2. In 1964 some of the founding members resurrected the Club "uptown," in a loft on 23rd Street, where it lasted until 1967.

Report #2

"The Artists' Club: A Rare Look Back at Friday Nights in the '50s"

The panel spun a web of fond remembrance of Tenth Street: cheap lofts, furniture off the street, the round neon sign of the Cedar Bar seen from nearby studios like a beacon, and above all, a passion for art shared by artists who felt themselves outside the system.

"Just a place with a pot of coffee," was May Tabak's description of the club; "somewhere that anybody doing anything unacceptable in his or her field* could come and give a talk, whether a scientist, mathematician, avant-garde composer or oddball artist trying to do something new."

Pavia also commented on the artists' attitude toward galleries: "We wanted, not dealers, but entrepreneurs. They should believe in the artist as a star, and not think like merchants with merchandise to sell. Don't just sell my paintings, we told them, say I'm a genius."

Nora Speyer described how artists lost power to critics and dealers as the market enlarged. Still, she said, "Those first five years of the Club were a unique moment, like the time of the Impressionists and the Barbizon School, when artists found themselves isolated and turned to each other for support."

Ray Parker spoke nostalgically of the Club as a place where anything could happen. One might find a Zen monk in black robes or hear John Cage expounding his theories, or

even sit through Ad Reinhardt showing 400 slides of art-works he photographed on his travels. Parker felt there's a return of passion about art today, rather than mere interest in what's selling. "Where there's a waning, there's a waxing," he said.

George McNeil pointed out that in those days all American art was created within a half-mile of the corner of Eighth Street and University Place. "The Club was a place where artists could share, not only their ideas, but their frustrations and anxieties. We worked out a system of values which kept us going until the present." Deploring some of the changes in the New York art world, he summed up with the thought, "What is desperately needed is a bar everybody can afford."

– Diana Morris

Women Artists News, March/April 1982 [Vol. 7, No. 5]

*The phrase "his or her," whether Tabak's or the writer's, is probably more a reflection of the language of 1982 than the time under discussion. Other women have bitterly, or at least ruefully, pointed out how marginal "her" was. The only woman on record as having been invited to "give a talk" at the Club was Hannah Arendt, although women did at times participate in panel discussions. May Tabak was wife of critic Harold Rosenberg. Lee Krasner was married to Jackson Pollock. Helen Frankenthaler was, first companion of Clement Greenberg, later wife of Robert Motherwell. Cynthia Navaretta was married to Emmanuel Navaretta, who, with Philip Pavia and Harold Rosenberg was one of the club's founders and central forces. Mercedes Matter was the only woman who had a serious role in the Club's early years who wasn't there as wife or girl friend. In fact few of those who *were* wives or girlfriends played a serious role either, other than in support services.

'82 / #160

First-Day Look at the Behemoth

Now, back in 1982 (or one of many 1982's), women filmmakers are exploring identity – theirs, ours, yours, and the culture's.

"Film and Social Change"
Speakers: **Alida Walsh, Jane Lurie**, others
Women's Caucus for Art; College Art Conference, NYC; February , 1982

If a sample of first-day panels this year are any indication, women are still deeply involved in searching for identity, rooting around in the past of Africa, or Pre-Columbian America, and looking for connections in the trash of media.

Anthropologists, painters and filmmakers had their hand on a small part of the behemoth, which they presented to the rest of us in somewhat kaleidoscopic fashion in darkened auditoriums. Panels ranged from scholarly to haphazard. At the end of the day, I sensed a common thread running through

this welter of disparate material: retrieval and reconciliation with the past, even when the past has been totally obliterated. Listening to the applause through thin walls of the Hilton, it seemed like the good stuff was always going on elsewhere. One succumbed to the temptation to cover two panels at once. The contrast in styles was interesting. The filmmakers from the panel "Film and Social Change" had a sort of swashbuckling aura, as if they'd been struggling out on the streets, as indeed some of them had. They brought the message that economic difficulties make it almost impossible to continue. It's very hard to get your money back from a film on bag ladies. And if you're working with the actual bag lady, her money problems might become yours. Nevertheless, Alida Walsh's emphatic message was, go out there and get the precious material before it disappears forever. She is currently doing an oral history project with elderly women, an undertaking that seems to help these women recognize the value of their own lives and experience.

Walsh's film, made on the death of Marilyn Monroe, showed a beautiful and repulsive creature whose red lipstick leached into the chalky white crevices of her makeup. Close-up of mouth, teeth, alternating with crucifixion, dark pubic hair smeared with smashed egg – allure and agony. After that, the audience could cool off with Jane Lurie's documentary of Lower East Side mothers being dragged by the NYC police out of their cooperative community center in an abandoned school.

"Awakening Consciousness and the Female Principle of Art"
Speakers: **June Nash, Nancy Azara, Michele Cliff**, others
Women's Caucus for Art; College Art Conference, NYC; February, 1982

On the other side of the thin partition, "Awakening Consciousness and the Female Principle of Art" started with a scholarly presention of pre-Aztec goddesses and fertility symbols. June Nash of the City University of NY described a culture of equality and matriarchy, where rain, harvest, fertility and birth were religious concerns. The arrival of the warlike Aztecs brought monogamy, new goddesses of love, and discord – brothels and subjugation of wives. Nancy Azara showed slides of her many-breasted Kali in maplewood; myriad miniature books filled with private signs and symbols; and paintings of experiences with psychics.

The panel on black women artists pondered the African antecedents of black American hairstyles, hair combs and curling irons, and the woman entrepreneur who turned a formula for pomade into a Hudson River estate. There were also presentations on folk art, such as sculpture made of chewing gum. Michele Cliff, who did not have time for her entire paper, told the story of Abraham, Sarah and Hagar as a seeming explanation of bad black-Jewish relations.

"Images of Jewish Women at the Jewish Museum"

Moderator: **Fran Peyser**; Panelists: **Claudia Weill** and **Mira Bank**, filmmakers; **June Wayne** and **Dina Dar**, artists

Women's Caucus for Art; College Art Conference, NYC; February, 1982

At an evening panel, "Images of Jewish Women at the Jewish Museum," Fran Peyser said, "We suffer from stereotypes: the Jewish mother, prophetesses of the Bible. How can we be taken seriously? In the 18th century, Chasidic men were taught in separate rooms. Women were portrayed as silly, possessive, or dominating. This changes only recently as more women portray themselves and each other."

June Wayne: The *Dorothy* Series is not just a tribute to my mother, but a way of saying that one ought to be free as a creative person or as a woman to simply say straight out what one wants to say. I wanted to see if it was possible to let her tell her own story, to allow myself to be amanuensis. How far could I move away from my own subjectivity, putting my art at Dorothy's service? I didn't have a stormy relationship with Dorothy. I had a separate existence and the belief that any individual has a right to be what they are without stereotypes imposed by any milieu. I emphasized things most important to her – feeling-tone, not just that she was Jewish.

Mira Bank: My mother came from Russia and I had an assimilated upbringing. My work is about ordinary lives, an exploration of the sadness of loss of tradition. I did not learn Yiddish, but had a desire to move into areas not accessible to my mother. My film *Yudie* is about a relative, my aunt, brought up on the Lower East Side. Hers was a finite generation. Yiddish was the touchstone, gone forever unless retrieved. She was a rebel, but dutiful at the same time – a daughter, never a mother. She triumphed over old age through eccentricity. In *Anonymous Was A Woman*, I see creativity as a subversive form. Women any moment will be old, helplessly, hopelessly attached to the previous generation. Who remembers the Holocaust? Realists, romantics. People are always in conflict with love and obligation, conducting guerrilla warfare for personal freedom. Everything is a form of personal autobiography.

Dina Dar [Born in Poland, 1939, survived disguised as a non-Jewish child] A relative of mine had family albums. We had nothing . . . I had never seen my grandmother. For years I heard stories about my relatives, the aunts who committed suicide in Auschwitz. Suddenly I had these pictures, of the aunts, my grandmother. I created shrines (*Obraski* in Polish – small images). People from totally different backgrounds understood. This show is a healing show. I see the work as performances. I take ephemeral objects to the [copy] machine. Like cinema making, the outcome is surprising. You cannot lie with a xerox machine. It's like looking under a microscope. The photograph of the curved back of my mother, this part is most precious, this part she didn't want seen. During the war I slept next to her back.

Claudia Weill: I don't think of films as self-expression. I grew up with two different traditions. Spanish Orthodox and Scarsdale Reform. I was attached to the orthodox tradition. I wanted to be a rabbi. It seemed mystical, magical to me. It took me a while to understand how unincluded I was. Seeing my grandfather pray, talking to God, I wanted to, too. The women sat separately at the synagogue, a mixture of contempt and love, while the men talked seriously to God. At my Grandmother's funeral, daughters were not allowed at the grave. The women were in a separate room. In Scarsdale's suburban Judaism, women were more included; there was a woman rabbi. But the thin spirituality offended me. The reception was more important than the Bar Mitzvah. There was also the ambivalence of suburban Jewry; they felt themselves better than others, but changed their names and noses. I decided to become a WASP. I went to Harvard, and went out with WASPs, but their mothers always saw me as a Jew. My films (*Girlfriends, It's My Turn*) are about Jewish romantic heroines – a WASP is cast in the part. There is a comedic quality, but I try to avoid stereotypes. I resent films where people gorge themselves at Bar Mitzvahs. Being Jewish is detail. Now I'm proud – I feel close to sisters, to the Amazon tribe – a fierce and jubilant chauvinism.

– Gladys Osterman

Women Artists News, Summer 1982 [Vol. 7, No. 6]

'82 / #161

Camping Out in the "Neo" Zone

Meanwhile, back in the Art World, the Art World of the Grand Ballroom of the Hilton Hotel, that is, we find ourselves once again in theoretical mode. Personal material on the order of the women filmmakers' talk would be a gross breach of etiquette in this setting. Nevertheless, with two – no, make that three – masters of invective on the rostrum, the event is lively every minute and chock-full of ideas.

"Deliberately Good/Deliberately Bad"

Moderator: **Peter Plagens**; Panelists: **Hilton Kramer, Judith Linhares, Jeff Perrone, Peter Pinchbeck**

College Art Conference, NYC; February 26, 1982

"Deliberately Good/Deliberately Bad" was one of those panels that are actually more fun to be at than to be on.

Moderator Peter Plagens himself seemed ambivalent about the newly hot "deliberately bad" mode of art. His two invited critics, Hilton Kramer and Jeff Perrone, were articulately contemptuous of the style, and the two invited artists, Judith Linhares and Peter Pinchbeck, denied having any in-

tention to do bad work at all. In response to a question from the audience about this lack of enthusiasm, Plagens explained somewhat wanly that he'd thought, from a large favorable review Hilton Kramer had given Julian Schnabel in the *New York Times*, that Kramer at least liked the art, whereupon Kramer whipped out the review in question, read aloud his description of Schnabel's work as "the pictorial equivalent of a junk food binge," and exclaimed, "That was laudatory?!"[1]

Perrone, despite a penchant for childish gestures, such as turning his name plate around so the blank side faced the audience (whether meaning, "you should all know my name," or conversely, "what's in a name?," or something else entirely, was unclear), is a master of invective and conducted a running squabble/nitpick with Kramer, himself a world-class culture broker and word monger, thus introducing some real, albeit slightly sulky, feelings into the discussion, if not into the *art* under discussion. (Ironically, in the next panel that morning, whether or not an artwork is "felt" was suggested as one criterion for judging it.)

In his opening remarks, Plagens called current "deliberately bad" art "a strategy posing as an obsession." It is, he said, "*supposedly* 'Outsider art' done by *in* gallery people, while the real thing, by jail inmates, juveniles, black folk artists, exists outside." He characterized "good" painting as "major, ambitious, abstract, neat, square and polished." "Bad" painting, originally exemplified by folk and primitive art, he said, is now complicated by the elevation through promotion and manipulation of such *really* bad but *intended to be good* art as that done by Leroy Neiman, further complicated by the *intended* to be "bad" but considered by many to be just plain bad art of, for instance, the stable of dealer Mary Boone. In truth, Mary Boone turned out to be the *de facto* focus of this panel. (And her publicity juggernaut has continued apace since then, with a *New York* Magazine cover story in April, accompanied, no doubt, by more gnashing of teeth in studios and panels across the continent.)

Plagens showed slides of a carefully neat "good" painting and a "clumsy" primitive painting. He called Leroy Neiman the "penultimate hotel painter" (meaning, of course, the *ultimate* hotel painter), and described a recent California show of Neiman and Andy Warhol as "something to offend everyone," saying Warhol had achieved "yet another turn on putting cheap, degraded *New York Daily News*-type photos on canvas . . . a parody of fine art, the Mark IV model with brushwork."

Hilton Kramer: There are two conventions for bad or "stupid" art, and I haven't seen any that doesn't fit one or the other – either the Expressionist convention or the Dada-ist convention . . . In our culture, where everything is artistically permitted, the problem is how to sustain aesthetic vitality in art . . . The 20th century associates artistic quality with shock value, or a stunned response, but now the shock lasts only 15 seconds or so and you're left with the art.

You can't speak about "bad" art for long without dealing with camp, that is, the mode of being facetious about things normally taken solemnly. What happens today, however, is that the culture assimilates the facetiousness so rapidly that what begins as facetious almost instantly becomes solemnity. [However] no one ever bought a painting because it's facetious, but because they think it has some kind of cultural weight.

Kramer sees no way out of the dilemma because "our culture is so voracious it wants everything. We want good (clean, neat, visible) and bad (messy, emotional) and representational paintings, too. We want the facetious and the solemn, camp and straightforward. But basically we don't believe in anything – hence our anxiety."

Jeff Perrone: Deliberately good art is stupidity pretending to be smart; deliberately bad art is a naif spilling out his feelings. ["Bad" art is] a kind of cunning turned into dealer power . . . bad-boy thrashing about, fostered by dealers who claim they can't control the work, but who in fact are like the producers of teenage slasher films, pandering to an audience . . . grovelling disguised as Expressionism, a grab bag of Expressionist technique . . . huge drawings that high school students might find clever . . . the new Blood-and-Barf school of temporary insanity . . . Neo-Nitwit art. *How to Make It in the Art World* is the most crowded class in art school, and usually taught by a dealer. The lesson is, be original, but not too original, so they can say it's rooted in experience.

The so-called "new master," Julian Schnabel, Perrone added, imitates a kind of despair "in a self-congratulatory way," but in fact exemplifies a "revolting sentimentality. While deliberately good art is sentimental about art, deliberately bad art is sentimental about artists." And there's no help from critics. "Dress yourself up as a schoolgirl and take photographs of yourself and the *New York Times* will devote a page to you and *Artforum* will compare you to Caravaggio." (The reference is to a recent show by photographer Cindy Sherman and subsequent reviews.)[2]

Peter Pinchbeck showed slides of his paintings, very large canvases with a few shapes, which he described as "geometric, but not precise," that is, edges aren't neat and surface texture is visible. Pinchbeck said his work is a "combination of Abstract Expressionism and Constructivism, or concept art, and comes a little out of Suprematism but is not a Cubist space, which is an overlapping space." He is "trying to make the paintings as flat as possible but still have an illusion."

Judith Linhares, substituting for Hollis Sigler, said that Abstract Expressionism was on the wane when she was in art school in California, so she decided to work with subject matter. "But I wanted subject matter rooted in life experience, not just anything." She doesn't see her work as "bad," but rather as "narrative and loaded with meanings." Moreover, "I am concerned about things like composition." Linhares finds "a kind of resonance" in good painting that "somehow sticks with you." Showing several of her own paintings with water in them, she said, "Painting for me is a

form of communicating with my own unconscious. I think water is a pretty universal symbol for the unconscious."

In the discussion that followed, Plagens pointed out that in talking about his own work, Peter Pinchbeck spoke sincerely and unironically about color, form, and space. On the subject of art-world manipulation, Kramer said these "modes of accusation seem to occur at ten year intervals. A young and rapidly successful career raises questions of 'good' and 'bad' careers and other epiphenomena of the art world, just as it did with Johns, Stella and Rauschenberg." In a former time of innocence, Kramer reminisced, Sidney Janis was considered the worst person in the New York art world because he took Mark Rothko away from Betty Parsons and gave him a bigger show.

But it's not the same today, Perrone insisted: "The rhetoric may be the same, but in 1954 Johns sold work for $900. Schnabel sells for $100,000."

Again, Linhares and Pinchbeck denied intending irony or facetiousness in their work. According to Pinchbeck, "The whole thing about deliberately good or bad is a semantical game for critics." Linhares said, "My work is in no way naive. I certainly don't set out to do bad painting. My task is to avoid getting categorized, because when the category is over – you're finished. I do paint for an audience: other painters."

Kramer pointed out that for Marcia Tucker, evidently the first curator to use the term in this sense, "bad painting" meant what a sophisticated audience would soon embrace as the new *good* painting. He added that, in the 11th edition of the Encyclopedia Britannica, art is described as being distinguished from nature, but it's no longer that simple for us. Today, he said, we might think in such categories as work that is *failed* art, but still in some sense art, or *trivial* art.

Plagens paraphrased the old line about the continent being tilted to the west so that everything not nailed down ends up in California, with, "The continent of culture is tilted toward the visual, so that everything not nailed down ends up in the art world." As a tentative definition of "aesthetic," he proposed, "I think I know lousy and good, but I don't know it until I see it."

Hilton Kramer attempted to distinguish between *aesthetic* as referring to "impulse and mode of gratification" and *artistic* as referring to "the making of something," but these distinctions seemed to require more elaboration than was vouchsafed here. He closed with a quote from T.S. Eliot: "The function of the critic is to explicate works of art and to correct taste." The real issue at this panel seems to have been exactly that – taste.

– Judy Seigel

Post Script: An essay by Peter Plagens that fell into my hands shortly afterwards made me think he may after all have intended exactly what took place at this panel. In any event, for the greater public pleasure I quote a portion of his description of the current art scene:

> The art world welcomes an awful lot of bad philosophy too hermetic even for conferences in Ann Arbor, bad the-

atre too postabsurd and autobiographically self-indulgent even for Wednesday night in the rec room of the Unitarian church, bad mathematics too rote even for the remedial arithmetic class at Grover Cleveland School, bad poetry too yearning even for a Barry Manilow lyric, bad music too aleatory even for playing out the I Ching on a Cal Tech physics lab synthesizer, bad politics too sophomorically Utopian or adolescently enraged even for pamphlets in Sprout Plaza, bad architecture too rickety even for a tobacco barn in Guilford County, bad natural science too sloppy even for the cosmetics counter at K-Mart, bad sociology too half-baked even for an extension class at Franconia College, and bad prose too garbled even for a review in an art tabloid. Refugees from these fields, and artists whose educations leap from undergraduate study in them to an M. F. A. degree without even passing "Go," and without ever collecting any visual sensibility whatsoever, form an increasing percentage of the exhibiting population. [*New Art Examiner,* January 1982]

Women Artists News, Summer 1982 [Vol. 7, No. 6]

1. Nevertheless, Robert Hughes informs us that, "at the dizzy height of the '80s" something in Kramer's "sensibility. . . induced him to publish a long encomium on the prize turkey of the day, Julian Schnabel, in the vanity catalogue of Charles Saatchi's collection." Hughes made this point in a letter to the editor of the *New York Observer* [2/24-12/31, 1990], the ostensible occasion for which was displeasure at having been called "an honorary Brit" by Kramer, but the real provocation seems more likely to have been Kramer's disparagement of Hughes's admiration for British painter Frank Auerbach. All of which is of course small cheese in the loving literature of the art world, but interesting in this context.

2. When this report was originally published in 1982, it seemed necessary to identify Cindy Sherman. Today it probably wouldn't occur to me that some reader might not get the reference.

'82 / #162

Work-shopping Feminist Ideas

The leader of a workshop is introduced as "Barbara Kruger, an artist," another identification that would hardly be necessary today. But some things haven't changed, including the fact that it's still generally "taken for granted that the female is more photogenic than the male." The arguments of feminist theoreticians on this topic have apparently had zero impact on the culture at large. Forget girlie magazines, forget "porn." If it's a woman's magazine, it has a "sexy" female on the cover. And that's what *women* want. Not even chocolate cake, *not even kittens,* sell as well.

"The Scholar and the Feminist IX: Toward a Politics of Sexuality"

Barnard College Women's Center, NYC; April 24,1982

After 18 workshops and a summing up, readings by three poets, Hattie Gossett, Cherrie Moraga, and Sharon Olds, were warmly received by the overflow audience of almost a thousand women. But a Diary of the Conference planning process intended for distribution was withdrawn at the last minute by the Barnard College administration, a dramatic illustration of the threat perceived by the "establishment" when sex is publicized by women.

The one workshop directly relevant to visual arts was "Power, Sexuality, and the Organization of Vision." In a paper based on the work of Laura Mulvey, Mary Anne Doane of Brown University pointed out that pleasure in the classical film is organized around the idea of the female body as a pleasurable object. It is taken for granted that the female is more photogenic than the male. Men are "feminized" when they pose for the camera. Women are "natural subjects for the camera." This makes the woman a spectacle and reinforces the subject-object split.

Thus the spectator is "masculinized." Images of desire are for males. Since the female spectator is not considered, she must, in order to enjoy the film, take the masculine viewpoint, an accepted process in our society. The "tomboy" is OK, women commonly wear male clothing, the reverse is unacceptable. Male transvestitism is seen as either disgraceful or funny. Julie Andrews looks stunningly beautiful as a man in *Victor-Victoria;* Robert Preston is a farce in woman's get-up.

Classical cinema does not accommodate two fully conscious identities. Even where the female gaze is represented, it is most often negated by various devices: Joan Crawford in *Humoresque* is seen looking at John Garfield, her protegé. But the camera also sees her husband looking at her as she is looking. She is often seen looking into a mirror – she breaks a glass door which reflects her gaze. Thus her looking is effectively bracketed.

The second workshop leader was Barbara Kruger, an artist. Slides of her work showed graphic but straightforward photographic images combined with messages in boldface type. Both images and messages were provocative and harsh. "Your property is a rumor of power." "You destroy what you think is difference." "You construct intricate rituals which allow you to touch the skin of other men." Kruger explained that she wants to break down the art-world practice of praising the spectator by reasserting dominant myths. She directly challenges the spectator by using "you."

However, in the discussion that followed, members of the group commented that much of her work seemed directed at a male "you." It was curious that no one commented on the photographs used, some of them mysterious in their relationship to the text, some shocking, as in the image of three knives cutting diagonally down the plane of the photograph. We had spent the morning listening to words, so perhaps we were primed to react to more of same. In further discussion,

Doane emphasized that images are not automatically a universal language. We learn to read image systems. To assume that movies give us "reality" is a mistake.

– Rena Hansen

Women Artists News, Summer 1982 [Vol. 7, No. 6]

'82 / #163

Photo-Art Games

Art photography had not yet abandoned Point Lobos for high-gloss "appropriation." Photography itself could still be defined in terms of what everybody "knew." Discussion between audience and panelists ranged over What is "Reality" and What is Illusion, What is a "Real Photograph" and What Makes You Think So ! (Talk also touched on "The Difference Between Painting and Photography," but that's next year's panel ['83/#169].)

"Photo Start: Using the Photographic Image as an Initial Stimulus in Art"

Moderator: **Philip Verre**; Panelists: **Helen Block, Russell Drisch, Juan Sanchez, Judy Seigel, Lynton Wells**

Artists Talk on Art, NYC; November 5, 1982

The moderator began by describing "Photo Start," an exhibit he had curated at the Bronx Museum of the Arts, occasion for the panel.

Philip Verre: The common bond among the 19 artists, five of whom are here tonight, was use of the photographic image as initial stimulus, although techniques and expressions varied. Aside from the richness of altered or "manipulated" photography, there was an emphasis on figure and place, and evidence of the artist's hand, as opposed to purely laboratory processes. Themes ranged from private mythology to political issues, the urban environment and landscape, [as well as] the photographic medium itself. Some of the artists are photographers by training; some are painters or sculptors who shoot and print their own material; others use available or existing photographs.

Verre showed slides by other artists in the show, then panelists spoke about their own work:

Helen Block: In the '70s I experimented with photomontage made in the camera and chemically altered. These were standard photographic prints, joined into images five to 12 feet long. Then, after working so large, I decided to work small. Each photograph in the "Peepholes" series is 1/2 inch by 3/4 inch. They're black-and-white negatives printed on Cibachrome through color filters. . . . *Circumstantial Evidence* is a series of hand-painted and toned photographs, each 1/16th-inch by 1/4-inch. The idea was to make them as tiny as possible to see how much the viewer could get by studying them.

Russell Drisch: Any medium, whether it's photography or drawing and painting, is a tool to be manipulated. My concern is where the photographic image can take you . . . More important than whether it's drawing or photography or sculpture is making it work. I'm using photography as a tool and drawing as a tool. The last two slides are images on paper with airbrushing, pencil, china marker and acrylic. [Others] have pastel, oil paint, oil pencil, crayon . . . These were studies for a mural 8 feet high by 35 feet long.

Juan Sanchez: Sometimes I call myself a photographer, but at other times I call myself a painter. I used to go out and photograph two or three days a week and paint the rest of the time. Then I decided to experiment with how paint and canvas would work with photography. . . . We have this idea of the photographic image being "true," in spite of the fact that the photographer has the choice of selecting anything he or she wants to photograph and presenting it as a fact, as something that happened. Plus we can add a caption to further identify what this is all about.

My work is political. I want to make art identified with the Puerto Rican culture, the present colonial situation. I also combine words with the image . . . in Spanish or English. These could be anything from Latin American poetry to Puerto Rican revolutionary slang. Then I work with texture and color in hopes that each element will compliment the others. . . .

For a long time I was very respectful of the photographic image. It was difficult for me to do any kind of manipulation in terms of painting or marking on the surface. This slide is the first painting in which I was daring enough to start staining and adding color to a black and white image. Hopefully, I will be much more daring, as daring as some of the artists in this show . . . Some of the images I combine have a very strong cultural derivative, which many people don't know anything about. The drawings that surround this photograph are called petroglyphs, from the indigenous culture in the island before the Spaniards. . . . Now I'm combining other language, that's not mine, and other photographs.

This is a portrait of my mother, *Mi Madre*. In the middle is a drawing of my mother chasing a chicken for dinner. It's her drawing, she drew it. Underneath she wrote a little story about her adventure, about it taking her so long to catch the chicken and when she caught it feeling bad because the chicken had made such an all-out struggle for survival. So she let it live – until the next day. This is a portrait of a woman who was one of 11 Puerto Ricans captured in Chicago, accused of being a member of the FALN. Her name is Maria de Torres . . . I wrote [her statement] underneath: "I am a Puerto Rican prisoner of war. I am a product of a continuous struggle of my country. I am the consciousness of my country in art."

Considering that the New York papers have published so many photographs of her as "accused terrorist finally captured by the FBI so now we can all live safely," I had difficulty using her face one more time for the portrait. So I used a photograph that is symbolic of her history . . . feet, sandals, and the earth, to symbolize perserverance, growth, weariness and hard work. [Other slides showed works addressing repression, assassination and activism in Puerto Rico.]

Judy Seigel: My background is as a painter. I was always using a paint "process," in a sense at the other end of the spectrum from Juan, who is very *politically* oriented, although he uses process also – but my process *begins* my orientation. I'd been painting in acrylic, using techniques I'd devised to refer to various *effects* of photography, when I discovered I could actually do photography. It became this mad, passionate love affair — I grew more and more in love with the photo processes. Then it happened that I brought the photography and painting together, doing manipulative photography with painting on it.

These [slides] were photographed in 1981, painted in 1982. That's the birdbath in my New York City backyard. I had set the camera up in the window and snapped it over the year. All started as black-and-white photographs, printed by a method called solarization (or Sabattier effect), which gives what's called a "Mackie line" around the shapes. Then they're toned, usually with many baths. Here the silver in the "silver print" is plated out to look metallic. The iridescent blue on the bottom is another toner, but the bird is metallic paint. . . .

I thought that little outline from solarizing was like a 20th-century version of the exquisite outline around the figures in Persian miniatures, so I began to add motifs in paint, making them simultaneously Persian miniatures and modern paintings. For instance, these cloud shapes are taken from, or my version of, cloud shapes in Persian miniatures. *Dragon* is a chemically toned black and white photograph; the dragon in the corner is acrylic paint. This is another toned photograph, except Pope John, Martin Luther King and John Kennedy in the sky are paint. . . . This is *F-64 Man, Sa'di Observer*; the photographer with the view camera of course is painted, the little figure watching him is painted, copied directly out of a book of Persian miniatures, and the snow is also painted. I had a print I really liked and somehow put it down on a contaminated surface and got spots all over it. So I painted in snow. *At the Conservatory* has figures along the bottom in raised "underpainting"; the cartoony features are glazed over them, like fine-art Renaissance-style underpainting and glazing. . . .

Lynton Wells: I think most of you are photographically oriented and may be disappointed in what I have to say. I don't have very much interest in the photographic process. This work is from about 1971; at roughly eight by eight feet it's probably the smallest in the group. I was trying to address problems of painting, to get away from a very literal syntax that pretty much informs most painting styles today. I wanted to involve myself somehow in the problem of "illusion," always a dreaded and extremely discredited usage.

The work starts out using myself as a model, simply drawing over the photograph. The drawing is one part, the photograph another part. Photographing against the same wall, using different props [I'm] using space as a kind of substance to put the paintings together. The landscape tends to take different forms through the years, but essentially the

photograph acts as a scrim behind the painting that's done over the top.

By 1978 and '79 I went out and did a literal photographic landscape and then drew a tree, which was even more literal, over it, echoing an interest I had in Japanese screens and Oriental art in general. For a while I abandoned the photograph and simply painted what had been the photograph onto the canvas . . . The tree at this point became very frontal and built up with other substances, so it stood out from the flat canvas. This summer the tree metamorphized back into the lines, which had, I think, become more of a metaphor. . . . The lines have picked up a photographic quality, for me anyway, whether they reside in the photographic ambiance or the ambiance of painting.

Audience: How big are they? . . . How do you get the photograph on the canvas?

Wells: Now they're about 14 feet across. The photographic part is a standard bromide process on a material from Germany, what they call photo-sensitized linen, but it's essentially Egyptian cotton, a process developed in World War II. It's commercially available, used in Europe more than here to make "quality" photo murals. I start with a 4x5 inch Polaroid negative; the enlarger has a mirror that projects onto the wall. It's like standard photography, except the trays are four feet by five feet, and take ten gallons of solution each. Exposures are five to eight minutes.

Audience: Do you do test strips? [*Laughter*]

Wells: I've been doing it for a long time, but sometimes I make test strips.

Audience: How do you roll this huge canvas through the developer?

Wells: Notice that, except for the first one, the photographic parts are on panels, about 50 inches wide. And once it hits the developer it gets fairly soft so you can mush it around . . . Then I wash it for a couple of days and hang it on a clothesline to dry. It's a simple process, just bigger. When I first started, I asked a lot of photographers about it and everybody pooh-poohed the idea, saying I needed a lot of equipment. This was not true.

Audience: Then how did you learn how to do it?

Wells: I asked someone how they did regular photographs . . . I went and got an enlarger, and I found the film. Polaroid film doesn't give any grain and I don't have to develop it. And then I made the trays out of plywood, coated with Neoprene.

Verre: For someone not interested in process, thank you for the explanation.

Doug Sheer [in audience]: It seems to me "Photo Start" isn't a very accurate way of naming what you're all doing. There's a tradition of using photography as a starting-off place for painting [in the sense of a reference] or a maquette. But that's very different from the way [the panel] is using photography. I see the photograph as a much more integral part of their work – not in the tradition of photography as a jumping-off point for, but rather as part of the painting.

Verre: It's true most of the panelists use photography in a very integral way. But there are other examples in the show where existing photographs are used, some by artists not interested in photography at all, just as illustrative material for other, non-photographic reasons. . . .

I note that certain words used tonight by panelists reveal attitudes toward the photographic print. Someone said "respectful," someone said "disregard," someone said "extending the photograph." It seems to be a distancing from the photograph as we know it, or as it was presented to us.

My interest [in curating the show] was that point of interaction between photography and the second medium. Judy, for someone who is so interested in process, why did you add those painted elements? Was it because of your training and background as a painter, or your interest in the Persian miniature, or a need for that relief element, or . . . ?

Seigel: All those, plus. My feeling was that photography was wonderful, but had gotten to a place that was not so wonderful; also to not repeat the glories of the past. Photography is beautiful and thrilling, but you want to do your own thing to it. And, besides wanting to paint, and realizing I'd given up a certain freedom, when you do these manipulative processes, you can have a luscious, absolutely fantastic photograph and right in the middle of it there's a blob. I do 10 or 15 different baths sometimes, and a lot will be terrific, and I could work for 30 days and never get that again, but in this one spot it didn't happen – the silver all washed away or something. So you put paint over it.

Beyond that, I really had trouble, coming into photography and looking at photographs, with the fact that they are flat, under glass. You go into a photography gallery and what you see is basically metal frames and sheets of glass. Even a very flat painting has got some little edges or bits of raised paint. I very much missed that tactile surface – and I *love* being able to put it back on.

Sanchez: One of the arguments of photography from the very beginning, which was really the curse of the painters, was this whole idea of accuracy. And it put the painters into that delicate position of being told, you're not really documenting things the way they *are*, you're documenting things the way you feel. Also the painters would say we have surface, we have color, we have texture, we have body. That's why I decided to try to integrate the two. Both mediums complement each other.

Audience: In the past, the photograph has been the perfect art to facilitate illusion, which painters can't do the same way. But it seems to me that all of you are trying to destroy that quality, that you're uneasy with it.

Wells: I don't think you can say that illusion and realism are the same thing. True, you have this realistic space, which is also illusionistic space, but in a lot of art there's illusion *without* being realistic. Anyway, what was important to me was the fact of having space in the painting.

Audience: But you're negating the quality of the photograph. So why do you use photography? I liked the effect, I'm not challenging your doing it, but . . .

Seigel: It's a myth that the photograph is realistic. We have been conditioned to think of the photograph as realistic, but the camera lies like crazy, in all kinds of ways. Take blur –

there's no such thing as a blurred person, but you get a blurred image.

Audience: But it comes as close to normal vision as you can get. There's no reason to deny that.

Seigel: It's accepted that it does, but it doesn't – like the photograph of a lady in the street with a tree growing out of her head. And it's small, it's black and white . . . In medicine, when they want a really realistic picture of a germ, or a tool, or an operation, they probably call in an artist to paint it, because the photograph will not describe it as clearly as it needs to be described for a medical text book. So the whole business of which is more "real," the photograph or the drawing or the painting, is moot.

Audience: But yet you all deal with photography as if it were real.

Wells: With this particular exhibition, you have however many people who happen at a particular time to be using photography as a tool or a device for a personal expression. It doesn't mean any of them are necessarily wedded to photography. They are wedded to themselves and whatever means best express what they're about. And what an artist is really about is manipulating as many kinds of devices as they can possibly have at their command. So, in 1975, they're feeling and thinking a certain way and have at their command etching, painting, photography, drawing, theatre, music. In 1977 there's an incorporation of another combination of elements . . . not that you jump from one thing in 1975 and two years later to another thing totally, but that there is a kind of bleeding and feathering of mediums which better explain how you are feeling and thinking. So what we're looking at really with "Photo Start" is 15 or 20 people who, at a stopped moment in time, are making use of this medium, not necessarily wedded to it in total. It's a changing kind of thing.

Audience: But I'm looking for the relationship between the subject that you start with and what you finish up with.

Block: It also depends on the concept you're working with. I approach my photography as drawing. I try to draw my work, but I can't do it as fantastical as it would be if I shot randomly through the camera.

Verre: Are you asking about the difference between what a painted image implies and what a photographic image implies? When it's a more or less standard or decipherable photographic process, a photograph is a stopped moment in time. Whereas with painting, no matter how realistic it might be, there's always the element of the human hand.

Audience: No matter how "real" it is or isn't, we *think* about a photograph and a painting differently.

Wells: I agree. Even when the painter is absolutely, incredibly brilliant and makes you think it's a photograph, the very process of making you think it's a photograph draws attention to itself, so you think about it differently. A photograph, ultimately, cannot be deciphered any way other than being a photograph.

Audience: Or a reproduction of the truth.

Wells: Of something that actually was there, that was recorded by this mechanical device. We have a mental set

about recording a situation, whether it's video or motion picture or still film, it is practically impossible for any other medium to duplicate that sensation.

Audience: We drift in and out? We're in our time and then that other . . . ?

Verre: Absolutely. And one of the things Lynton does is play off the photographic reality against the painted reality. This is very exciting, because it jars your sense of reality. Painting has a kind of reality, as still photography, video, motion picture, each have a reality. And the kind of thing he does is a fascinating contrast of realities hitting together. . . .

Audience: But there are ways that paintings and photographs coincide. Historically, ever since the camera obscura there was this common reference.

Seigel: Exactly. I'm not so ready to buy this total split between what is a photograph and what is a painting. There is work that runs down the middle, such as photographers doing totally unmanipulated "straight" photographs using Rockland Emulsion on paper. No painting, no manipulation, just purely "photographic" straight projection, and it comes out looking like the most delicate silverpoint drawing.

Wells: Why does it look like drawing?

Seigel: Because that's what it looks like. Silver-bromide emulsion on Arches artists' paper comes out a soft gray, very *graphic*. Yes, there is a hit in the photographic effect, but that doesn't mean there is a complete dichotomy between a photograph and painting. When I was doing painting processes about photographic effects, it was pure painting, no photographic anything, and people would think it was a photograph. We *generally* deal with one or the other end of the spectrum, but not necessarily.

Audience: We can look at a manipulation done to a photograph as some kind of destructive process – destroying the actual, *real* image – and some people could have trouble with that. Painting is a totally *con*structive process, building something up on canvas . . . But compare what a sculptor does to get the image out of a piece of stone. In terms of process, like you, he is destroying it. On the other hand, what he's really doing, is releasing something already in the stone. That might be a way of looking at what you're doing with the photographs. You're not destroying the image that's there; you're getting people to look at it in another way.

Block: I don't see altering as destruction. We're using it as a tool to get to a further end.

Seigel: Art *is* a transformation. I liked what Helen said before, that she sees photography as a drawing medium. I agree – it's a drawing, or *art-making*, medium. There's nothing holy about it. The attitude that photography must be totally pure and straight [has] a certain religiosity. . . .

Audience: But that's really what a photograph *is*.

Seigel: A photograph is whatever we make it.

Audience: I consider [the panel's] works multi-media, and one of the processes you use is photography. For me, straight photographs would all be done in the chemicals, because that's the process.

Seigel: Where is it written what is "the" process? Even Ansel Adams manipulates. He does artificial things to get a long

grey scale, or intensifies his negatives, or bleaches his prints. . . .

Audience: All photographs are the victims of context anyway – where they're shown, how they're shown, where they're published . . .

Audience: What about content? Like Helen Block's little tiny picture. What is it a picture of? Does it have significance to you?

Block: You have to define content. Anything to me is content. How does the image relate to what you see? How do the colors alter that? How do you see the colors? How much can you see? How much do I want you to see?

Wells: I think most of the people on this panel regard the photograph as a fiction, a surreal object in itself, having absolutely nothing to do with reality, except a chemical process that somehow transposes it [onto a surface]. It has a certain veracity, but nobody up here really *believes* it, not like Berenice Abbott . . . who believed it was close to "truth."

Audience: I see Judy's work as playing with the concept of what is real and what is not real. She's playing with physical *and* psychological dimensions, denying the, quote, "veracity" of the sacrosanct photograph. Often the paint becomes more real than photographs ought to be. It's all games and magic.

Audience: But I see Juan's work very much believing in the content.

Drisch: That's different than believing in the photograph.

Edited from tape.

'82 / #164

Who's In, Who's Out

The title question here is probably one of the better unanswered questions of the series, not because there is an answer or we'd listen if there were (Is there a women's aesthetic? Sure, when we say there is), but because the discussion pulls in so many strands of culture, style, gender, feeling and aesthetics.

Part I: "Is There a Homosexual Aesthetic?"

Moderator: **Roger Litz**; Panelists: **Daniel Cameron, Harmony Hammond, John Perreault, Arlene Raven, Ingrid Sischy**

New School, NYC; November 15, 1982

A small, rather dour audience, mostly male, generally black-clad, awaited the panelists – people from the art world. At the front of the auditorium, a knot of disparate looking people finally separated themselves out and filed on stage. Their appearance forecast the unfocused nature of what was to follow. Titled, *Is there a Homosexual Aesthetic?,* this was the first of a two-part symposium in conjunction with the show, *Extended Sensibilities,* at the New Museum. It was not an auspicious beginning.

First was Roger Litz, director of the Roger Litz Gallery, a sallow man in a suit to match (mustard, double breasted); followed by Harmony Hammond, artist, black T-shirt and pants, buccaneer boots, DYKE in big black letters across her chest; Arlene Raven, straight from California, co-founder of *Chrysalis,* petite in grey suede heels, modified harem pants, nip-waisted jacket, locket, and dyed stripe of fuschia hair plunging back from the front of her dark head; John Perreault, writer and critic for the *Voice,* reassuring (at least to me) in a tweed jacket; Daniel Cameron, curator of the show, animated in red letter-jacket without the letter, newly washed hair atop baby face, wide mouth from which braces had surely only recently been removed; lastly, Ingrid Sischy, editor of *Artforum,* a little rumpled in skirt, blouse and glasses, reminiscent of those elite Ivy League schools where the suicide rate is high.

The question on the floor (Is there a homosexual aesthetic?) was given a desultory kick by Litz. He asked, what is homosexual and what is sensibility, seeming really not to know. Hammond followed with a correction and complaint that the catalog of the show had incorrectly claimed it as an historical "first" with a homosexual theme. She pointed out several shows on the west coast and in the midwest with a lesbian theme, preceding this one by several years. She continued, "No one ever asks if there is a heterosexual sensibility. If sensibility is content, perhaps there is, but if it's an aesthetic, there are many."

John Perreault appeared to have given the matter some thought. He said he assumed "an aesthetic equals art, equals practice, equals results, and must be held by viewers, critics, and artists. Their statements must be examined, but it is very difficult to get statements, since not enough artists and critics have 'come out' yet. It is still a stigma. 'Coming out' is a spiritual and political act not liked by corporations. On a deep level, we are male and female or both. We are examples of both-ness rather than either/or-ness. Art work is not form *or* content. It is both. Craft is craft *and* art at the same time. We must apply insight to other artificial binary models. The gay aesthetic should yield good art, be against the dull, the drab, and against the pretentious. It should be biographical, personal, universal, embarrassing; it should celebrate the arbitrary nature of gender, be against 'good taste.' If we are outsiders, act like it."

Cameron told how he chose the works for the show. Sischy's prepared statement was delivered in language with the texture of rocky-road ice cream. Perhaps the late hour made it indigestible. She seemed to give a warning that being homosexual is historic, not semantic, and that the relationship between aesthetics and politics is revolutionary.

Perreault: I'm not sure what "feminine-masculine" means. All suffer from rigid categories.

Hammond: There is male bonding in the art world. 90% of bonding is through gay men, not straights. There is more discrimination against lesbians, because they are not part of this bonding.

Litz: There are incredibly powerful women dealers who are showing men. Why? If I have to choose between a man and a woman, I will choose a man every time, because you can assume a man will get on with his career. But the question really should be asked, why more women aren't shown.

Raven: My interests do not fit with those of the art world, so I know I'm different.

Cameron: Sexual activity is used to keep gays down. They think we are as promiscuous as rabbits.

Perreault: We are more than what we do in bed, but society perceives us as playing a sexual role, along with stewardesses, divorcées, and prostitutes.

Hammond: Sexuality and art-making are frequently connected. The process of making work is related to one's sexuality; work begins to go well when artists "come out."

Raven: I'm appalled by the over-eroticism in the white male power structure.

Audience: Not having social and economic support does make it harder for women. Every part of myself and my work is perceived differently depending on whether or not I declare myself "lesbian." People don't mind if you're gay until you decide to use sexual material. Caravaggio's boys-with-fruit were made for homosexual patrons.

Raven: There are many minority sensibilities; there is a great hunger to see ourselves.

Audience: Sexual identity is not important. There is only good art and bad art. (Hisses from others in audience.)

Hammond: We are at the end of a formalist period. We must consider content as a radical issue. Everything we do in bed is political. I have been both a lesbian and a heterosexual. The world looks completely different as a lesbian.

Litz: You cannot define a homosexual sensibility.

Hammond: Labels are not necessarily bad, but walking into this show, I felt all have some homophobia. Being lesbian is being other than male or female.

Sischy: Labels are not necessarily bad, but borders are. All minorities would do well to be alert to the special threat to them in uncertain times, rather than cultivate borders.

Cameron: Clichés are not useful. Be as much an individual as possible . . . Authenticity . . .

– **Gladys Osterman**

Women Artists News, Spring 1983 [Vol. 8, No. 3]

'82 / #165

Mixed Gay Chorus

Part II: "The Homosexual Sensibility"

Panelists: **Arthur Bell, Jeff Weinstein,** *Village Voice* staff writers; **Jim Fouratt,** impresario and performer; **Bertha Harris, Vito Russo** and **Edmund White,** writers; **Kate Millett,** writer, artist

New School, NYC; November 29, 1982

This was the second of two symposia in conjunction with the show, "Extended Sensibilities," at the New Museum.

Edmund White: The particular point of view of some gays has nothing in common with the Greek homosexual past, with those in England in the last century, or with people like Quentin Crisp of the last generation. I deny any significance in a homosexual sensibility. It is a limiting term – racist and sexist. A more progressive way has to do with the characteristics of each group. The social consequences of coming out depend on whether you are black, etc.

There is an oblique angle of vision, an interest in the underdog, a love of ornamentation and decoration (for instance, Erté, Beardsley, Firbank, and Burroughs). In the novel, the dominant male heterosexual mode – Faulkner – is showing, not telling, understatement and control, the reinforcement of the status quo. It is conservative, capitalist – Hemingway. In Proust there is endless description, author's intervention, elaboration, a peculiar world view, as with Tony DuVer. But "gay" and "sensibility" are suspect. Fantasy and unreality are important.

Jim Fouratt: Before I start I want to announce my engagement to Miss Alice Stein who is sitting in the back with her mother. I am getting married, but I'm glad to be here and I think you have a right to live. All those friendships I had with men were just innocent boyish fun.

I was told all actors and actresses in New York are gay but I have yet to meet a famous actor who is gay. It is a very sad state for anyone who comes out in the commercial world. Many who come out suffer a penalty. Critics are predominantly gay, but have no power. Did Rock Hudson marry Jim Nabors? It's not important to name who is gay, but society doesn't allow this – so we have the gay sensibility: a sensitive, delicate way with style, fashion, and so forth. What is the contribution? To identify with the underdog? The capacity to hide? The potential to go beyond what society says we can explore? The ability to hide our passion? I don't know what a homosexual sensibility means. Is it the environment supporting people being who they are? Does it make great art? Warhol lives with his mother and goes to church; he can't be gay. Why doesn't Tomlin come out? 75% of punk at CBGB was gay.

We need to affect the culture – the artist is most dependent on the dominant culture. The new mask is hidden, not part of the regular gay culture; the breaking down of roles, women playing instruments. I did not know how to say,

"I'm gay," although it was post-Stonewall. I was victimized by the dominant culture.

Vito Russo: I don't think there is a gay sensibility. Famous stars can't and won't come out; they don't want to be a gay writer, a gay actor and so forth. We have to pretend it's not important to know whether a person is gay or not. We must hide in order to work. We cannot name the gay directors who are working today. Gays practice bricolage [Levi-Strauss's term] so film can reflect their own life.

True lesbianism, woman-defined, is never presented on film. I spend a lifetime giving a performance, pretending. Is that positive? There's a double vision: what you're told/what is true. You imagine all sorts of things in order to create a world in which you exist. In *Gilda*, Garbo is dressed as a man; one can feel nostalgia for a place one has never been. In *Maedchen in Uniform* the censors removed the lesbian scenes. Critics said it wasn't there, so people said the audience was queer.

Hiding is turned into an art form. We are forced to deny our existence and then to justify it by the art produced. Gay music has been cycled into the dominant culture – the Village People, for instance. We keep ourselves where we are because we don't want to be known as dyke actresses.

I don't think there is a gay sensibility.

Bertha Harris: I have always been enormously in favor of perversion. Sensibility is more than feelings. It is objective reality. All great art has some homosexual sensibility in it. Reality is interesting only when distorted. Reality lacks interest because it is controlled by the heterosexual need to be practical. Homosexuals are interested in not contributing to usefulness. Art reinforces the connection with history and friends to give the illusion that there is a future. Personally, I think *Jaws* is the perfect lesbian movie – *vagina dentata*.

Jeff Weinstein: Louis the 14th is an example of patterning and decoration in a patriarchal society – an oddity. *Severity* may have been considered gay at that time. Hemingway learned the manly simple style from Gertrude Stein.

Fouratt: These are dangerous old fashioned ideas – decoration – not generational peer group. I do not agree with this. The outsider has the capacity for communality, physicality, and celebration of outlawed love. The biggest "closets" are teachers and clergy. We took care of children and denied that we loved and cared for new generations. We must get away from the marketing idea that we are rich and have discretionary income.

Arthur Bell: Ornamentation in journalism is lousy journalism. In novels it's junk. I detest *Dancer from the Dance*. One hundred and seventy-six words followed by three; good readable writing does not have ornamentation. John Paul Hudson has too many words!

Kate Millet: Female economic independence from family and marriage is vital. Why has there been no history? Between Sappho and Stein is the longest blank in history.

There is a big difference in the history of male homosexuality [but] a dyke is a real threat. Homosexual sensibility doesn't quite include lesbians. This exhibit is about gay men. The sexual is very strong, it has a confrontive impact. It is about the forbidden, except in codified ways, not really permitted or explicit. Patriarchal culture is about heterosexual roles. The used and abused, dominant and submissive. The switching of roles is unknown. An idea, when permitted, changes much of this. Do we lose our romantic status? . . . The forbidden has become permissive sexual fantasy. It is interesting that this occurs under the "moral majority" and Reagan. Pleasure is part of the home aura, raffish and undone pariah to everyone else.

Harris: The fear is that gay art is a response to being the underdog – or a response to the need to hide or be secret. What we fear is losing our own history [which] we are trying to resurrect. Janson's *History of Art* does not have one woman. . . . We have learned the arbitrary nature of sexuality. We must utilize this, work with things that will work into the art. Coding, masking, mirrors, secrets, closets, reinterpretation, bricolage, costume as opposed to fashion. Publication of gay art will broaden culture. The gay chorus, a mix of classical music and Cole Porter, and culture itself can be manipulated – a general diffusion into art.

Millet: It's problematic. There's so little in Poughkeepsie. There are so many different Americas. The rest is very different, like country music. To rephrase the question, What is the impact of the lesbian sensibility? Zilch! The independence of the lesbian sensibility is very practical for the autonomy of lesbians. To earn your own living is vital. The homosexual sensibility is the desire for the unsafe, to risk relief from the tedium of cause and effect. We find real life is burdensome aesthetically, [hence] the desire for the morbid, the fantastic. We must get something queer in our lives: the instinct is to work *contra naturam*, to rearrange, pervert nature and be free to act and feel in ways that are useless. The heterosexual sensibility is interested in making things happen that are useful. The homosexual converts things into something fabulous.

Coming out is an act of sanity. Socially useful, correct, is heterosocialist realism – a contradiction. We must stop confusing ideas with homosexual practice. [There should be] freedom for homosexual art to use and abuse the heterosexual sensibility. This would free the hetero artist to create out of the homosexual sensibility [which] is axiomatically elitist, a perversion of the useful, and a revision to more and more uselessness: Lois Goulet, "Sea Change," La Presidenta, Janet Frame, James McCort, Angela Carter, Djuna Barnes, Flannery O'Connor. [It is] extremism frozen into elegant postures of hyperbole; everything else is straight.

Weinstein: The gay sensibility is difficult to define: Duberman, Salmagund, in the '40s and '50s. How much has changed? The post-liberation period is finished with coming out, with bringing experience to the rest of the culture. Post-industrial [means] connecting with the cutting edge. We are part of what is new, but only in the largest cities. If a sensibility exists, it has to exist in the mass culture. The clone sensibility, the style of wearing clothes (I left my outfit at home) with the tight shirt and pants costume so people know the person is gay, the coming out costume, bricolage – that's now two generations old. In New York, people dressed that

way may not be gay. [Elsewhere] the clone outfit is different and difference is differently interpreted.

Genet's prison-gay sensibility would not exist if gays were not oppressed, like starving artists. If we're not oppressed, what is left? What would the sensibility be? Would a zippered jacket be less important?

Russo: Homosexuals are a community of outsiders, people who are different and who come out and remain different. [But we] must be integrated into the mainstream majority. Acceptance of our difference means changing the world. How do you come out and remain different? We have Chinatown or Little Italy because people don't like being with people who are different from them. Is it a civil rights issue? We *will* change the world. Jerry Falwell is right.

Bell: Everybody is not like everybody else.

Russo: Homosexuals aways present themselves on TV as *not* different.

Audience: Cole Porter and Larry Hart were homosexuals. When you know this, it casts a different light on their lyrics: American musical theater is not funny anymore; there is despair.

Fouratt: Cole touched everybody who didn't know – could he have done this if he'd come out?

Weinstein: It's awfully nice to know the biography along with the painting or musical. You do not have to bricolage so much.

Audience: In advertising, Calvin Klein's overt homosexual tendencies are accepted.

Audience: Subversive religions use nonverbal communication so the majority world doesn't pick it up. The [gay] essence is cruising, and subversion. Gay sensibility has to be through homoerotic content.

Harris: The homosexual sensibility includes ornamentation, lack of productivity, fantasy, enrichment, and change of the environment. It doesn't produce families with children, people are not tied into vertical structures. Rather than thinking of producing things and handing them down, a horizontal network occurs making a beautiful life in the present. Does that contribute to gay sensibility?

White: Historically, dandyism (Sontag's "camp") constitutes part of coming out. Conventional ideas of virility say anything else is writing like a woman. Coming out releases the gay writer from this. The wide-spread interest in ornament is more child-like, allows one to be free to indulge.

Millet: There are possibilities for hedonism when released from the ongoing generations, possibilities of odious selfishness. Not having to feed children [allows] the urge to culture and fashion. American life is not dictated by the ruling class, which has no taste anyway. [Gay sensibility is] part ghetto, part closet, being a minority, having compassion. I don't like the term underdog. [We have been] always a mirror of what they think of us, the "us" they always have in their eyes. But we have always known the ridiculousness of gender roles – everybody in his little place. With the patriarchy crumbling and puritanism routed, we are faced with freedom and the fear of freedom. Opening up becomes a different sensibility. We are catalysts, but not clones.

Bell: I feel ravaged by all this intelligence. I have no business being here. I am and do have gay sensibility; I don't know what it is, it just is. Gay sensibility, generativity of spirit, the ability to cut through crap with a scalpel. A lot of straight people could pick up from, have picked up from this.

White: Most extreme images are permissible as long as homosexuality is not mentioned. Calvin Klein took his lover and put his ass on Times Square with his name on it. That's better than Emperor Hadrian did.

Audience: I feel a lesbian elitism in who I am. There is more freedom, imagination, and theatricality. I object to the fact that women fall into the same patterns as we do in straight society.

Harris: Elitism, the oppressed homosexual queer, started when I was ten, and feeling better than everybody else. No matter how poor, how oppressed, I was gifted in taste, in sexuality. The artist takes that to an extreme point.

Audience: Women's music is out of the closet – sellout concerts in Carnegie Hall. The movement gives courage. Women are willing to sacrifice money to come out. Why have women been able to do this more than men?

Millet: It's hardest to find a homosexual sensibility in Pop Art. Mass taste arbiters are careful to be heterosexual. We are dealing with a minority within a minority. Don't be an artist if you want to get anyplace. I am discouraged tonight by so many people talking about not being able to be successful if you come out.

Fouratt: Bringing our sensibility to other sensitive people, that's how we can affect mass culture. There is a hunger for identification, but most gay art, shows, movies, and concerts are terrible.

Bell: You don't know what you're talking about, James.

Audience: The ideal feminist relationship [is in terms of] subject to subject, rather than subject to object.

Millet: That subject is too complicated to be discussed here tonight.

– Gladys Osterman

Women Artists News. Spring 1983 [Vol. 8, No. 3]

'82 / #166

No More "Companions of Great Men"!

A panel on the influence of feminism addressed the *general* culture (rather than the *art* culture) covered well-covered ground less than rivetingly. The exception was Vivian Gornick, who vividly evoked changes any "woman anywhere of 50 or over" has lived through.

"How Feminism Has Influenced the Cultural Presentation of Sexuality"

Moderator: **Ann Snitow**; Panelists: **Kate Ellis**, **Vivian Gornick**, **Laurie Stone**, writers/critics

A.I.R. Gallery, NYC, December 18, 1982.

Excerpts from Vivian Gornick's remarks:

When I was in my mid-forties, I entered psychoanalysis – ten years ago. You can chart the changes since that time. Ten years ago (it was not uncommon), the therapist I went to originally asked why I was in resistance to being a natural woman. Don't laugh – I didn't laugh – the man I was involved with didn't laugh. It was a great problem with both of us. We both truly believed. . . .

There isn't a woman anywhere . . . of 50 or over who didn't go through this sort of analysis. (Forgive the gross generalization.) Every analysis revolved around this principle: Why do you feel competitive? Why do you feel ambitious? Why don't you accept your natural self, which is to be an intelligent companion to men? Plato said it. Bruno Bettleheim said it. In 1960, Bettleheim said, "As much as women wish to be scientists and engineers, they wish more to be wives and companions of great men." He said it and he believed it.

Later on, when I had become deeply touched by feminist ideas, and entered seriously into analysis, my analyst, who was good and decent and never sacrificed a human being in her office to theory, nevertheless believed I was possessed by penis envy and had the nerve to say to me, "You don't want to marry the great man, you want to *be* the great man."

She was shocked (this was in the early '70s) that I could turn and say to her, "That is an insupportable statement. That is not a thing we are going to address ourselves to here." And I had behind me a social movement that had given me the strength of mind, the clarity to say, "This is jargon, this is not anything that will help me get to the bottom of my experience so that I can become a human being," and we both agreed the purpose was for us to make a human being.

Seven years later, the same woman, not an intellectual, not at all literary, with a very bourgeois value system, who truly believed she wanted to see me married and safe, said,

"Your books will be your babies." I rather think she'd be disappointed if I got married. . . .

For me, that is revolution, to have watched the change in the most ordinary of competent analysts (who are the most ordinary people in every way). To have watched the change in their mindset and their realization that being a mother and wife does not define the human being, that a woman undergoes the psychoanalytic process to discover herself. That change has taken place massively. . . . Among young intellectuals . . . the idea of the self is beginning to replace the struggle for sexual identity. The formation of self, which is a new idea in psychoanalysis, has been appearing from many different places. To see it in the analytic process, where we learn who we are by telling them who we are, by having them tell us back in another key, another idiom, another vocabulary – I actually do credit feminism for that change. The idea that a woman is simply a sexual identity has changed. Feminism has had its impact.

– Gladys Osterman

Women Artists News, Spring 1983 [Vol. 8, No. 3]

1983

'83 / #167

Laughing and Crying at College Art

Recollections of Five Panels of the 1983 Conference

Women's Caucus for Art / College Art Conference, Philadelphia; February, 1983

Art worldings who went to Philadelphia this past February for the hot panel of the CAA conference, **Carrie Rickey**'s **"Pluralism of the Seventies and the Art of the Eighties,"** were disappointed. It was announced that four of the panelists "or their mothers" were sick, and the panel was cancelled at the last minute. Of course everybody knows already that the pluralism of the '70s hardened into the Neo-Expressionism of the '80s. But it would have been fun to hear **Kay Larson, Joe Lewis, Robert Pincus-Witten, Miriam Schapiro, Ingrid Sischy** and **Guy Trebay** mull over the details.

Meanwhile, much of the marooned audience drifted into the **"Changing My Mind"** panel, where **Irving Lavin**, speaking for the late Professor Janson, and his colleagues **Held, Holt, Horn, Hamilton, Kugler** and **Kitzinger** ground out some fairly fine strokes. I mean, speaking of *mind changes* in a panel evidently initiated by the late Horst W. Janson and now dedicated to his memory, I confess it *had* occurred to me that there might be something about women in the history of art. The revelations we were invited to share, however, were that the pre-Columbian mud fertility fetish was lefthanded, not righthanded (or the equivalent) and a few even less compelling second thoughts.

However, there were rewards. **Alessandra Comini**'s presentation at the Women's Caucus panel, **"The Hierarchy in Art and Art History: Has It Changed After a Decade of Ferment?,"** provided the most laughs while crying, and a reminder that it is not yet a woman's world. [See excerpt below.]

Among studio panels, **"Drawing: A Mainstream Activity of the Eighties,"** moderated by **Diane Burko**, was perhaps most satisfying. It was charming to hear **Chuck Close** note that if some world ayatollah destroyed every extant work of art, art historians could continue their "art in the dark" (i.e., slide lectures) without skipping a beat. Close described the range of his work and concluded by musing that his accountant says he makes more money per hour on an eight-month drawing than on a 14-month painting, but "I don't want to know that."

It was charming to see **Dotty Attie**'s jewel-like drawings projected up to the size of barn doors, and to see Burko's limpid

Pennsylvania waterways without having to approach the Schuykill, and Lanyons enough, flipped through at breakneck speed, to sustain a panel solo. And who could not smile when the angry young man in the audience arose to ask just how this work related to the "mainstream," making clear that he considered it all hopelessly antiquated and nothing to do with *his* mainstream. One might smile again when **Ellen Lanyon** explained, gently, what "mainstream" means and that drawing, formerly considered a minor expression, has entered it as a fully accredited form in its own right, which fact prompted the panel title.

The problem with the **"Problems of Regional Criticism"** panel, chaired by **Derek Guthrie** of the *New Art Examiner*, was that speakers seemed able to think of only one problem, i.e., the problem of not being in New York. The Philadelphia critic (whose name we would know if it had been listed in the catalog or on a name plate) illustrated the situation with an anecdote. Local critics had attended an important critics' panel in Philadelphia, where they were joined by New York's Peter Frank. The event was indeed covered by the Philadelphia papers. And whom did they feature? A large photograph of Mr. Frank accompanied the story – telling more clearly than words that the important person was the one from New York.

A writer in the audience described her experience when, relocating to New York from Chicago, she'd proceeded to proselytize at *Artforum* (or maybe it was *Art in America*) on the need for more reviews from "the regions." The editor told her she'd really like to run more, but couldn't find writers. The young woman said she'd then called numerous writer friends in Chicago, urging them to submit material, but "not one of them did." Murmurs from the audience were interrupted by panelist **Sandy Baletori**, who pointed out that the excuse of no writers was probably just an excuse. Baletori, editor of *Issues and Images*, an L.A.-based art glossy, said that if "the greatest artist in the world" lived in Des Moines, and the greatest writer in the world wanted to write about him [sic], she couldn't give them much space because she has only three subscribers and no advertisers in the entire state of Iowa.

Privately, another writer in the audience added, who wants to write for *Art in America*? They cut your copy, stick in whole sentences of their own ideas, things you never said and don't agree with, then print it over your name and pay you almost nothing for the privilege. Locally, "a writer has more clout and control."

Finally, another problem of regional criticism may be the criticism. A current issue of *Issues and Images* proved to be, again, obsessed with New York. One of the few major articles was a badly-edited transcription of a panel that had

taken place in New York, rendered even less comprehensible by insertion of numerous so-called "Commentaries" to "explain" – archly, sourly, or shrilly – why the speakers were wrong, bad, dumb, or otherwise in need of California correction. In fact, although there must have been, I can't at this point recall any material in the issue *not* concerned, directly or indirectly, with New York (although I do remember wincing at two grammatical errors in the lead editorial). However, the magazine was full of ads and is reported to be in the black, so Baletori must be doing something right.*

– Judy Seigel

*Wrong, it ceased publication shortly.

The following is excerpted from Alessandra Comini's paper at the "Hierarchy in Art and Art History" panel. Her basic message was that, after a decade of ferment in art academia, abuses were still legion, but some stirrings for change had appeared. Comini's final, ironic review of Vigée Le Brun-day at the Kimbell Museum provides another great opportunity for laughing while crying – and a perfect midterm marker for the 15-year period of this book.

"Decade of Ferment"

by Alessandra Comini

Women's Caucus for Art, College Art Conference, Philadelphia; February, 1983

Is *tokenism* all a decade of ferment can point to? If so, then no wonder there has been a change in tone over the past decade in the very titles of books on women artists.

Witness the genteel, inoffensive wording of Eleanor Tufts's offering of nine years ago, *Our Hidden Heritage: Five Centuries of Women Artists* – a title imposed on the author by her publisher, incidentally – and the no-holds barred, non-apologetic title selected by co-editors Norma Broude and Mary Garrard for their book of last year, *Feminism and Art History: Questioning the Litany.* If, as critics might say, an increased militancy in tone has begun to mark the woman-oriented art publications of the 1980s, perhaps it is because precious little correction of stereotypes marks the general art books of the 1970s: *The Artist and His Studio.* By males for males?

And why should publishing houses and male writers adjust, as long as women continue to permit themselves to be pictured and defined as adoring, nameless clones who catch "errors in spelling, construction, grammar and all those other things a wife intuitively sees." Consider the fact that for every woman who makes it as a museum director, there are 150 women who *service* museums as volunteers. Of course volunteers are needed, but the fact that it's always "the ladies, God bless 'em" who constitute this *unpaid* work force, sim-

ply reinforces a pervasive attitude in the art world that men work for money and women work for – free.

If feminist voices sound with a more aggressive resonance in the 1980s, the spokes*men* of conservative clans literally shriek with caustic reactionism. Here is University of Chicago sociologist Edward Shils in an article outlining the damage done to academia by our government's enforcement of equal opportunity laws: "Then the women entered the battle for the equality of women. The crippled came later."

We all know that the push for women's rights in this decade of ferment has been paralleled by greater audacity in presenting women as sex objects. But perhaps even more extensive in impact than ludicrous Madison Avenue *images* is the continued manipulation of women through *words* as this is so often done, not "against our wills," but with our *complicity,* since many women still see no reason to question or change tradition-condoned terms such as the supposedly generic "man."

I personally will go right on being ostentatiously confounded at how and when a woman can be a man. . . And I will continue vociferously to insist, along with George Orwell, that the *meaning choose the word,* and not the other way about – hence the suitability of the term "chairperson" for administrative personnel of either sex who serve as department or committee heads. If such linguistic nuances seemed too trivial for consistent application in the 1970s, then we shouldn't be surprised in the 1980s when traditionally male-associated trigger words are still understood as just that and as female-exclusive. A recent ad in my university's student newspaper reads, "Business for Sale. Established word processing business. Ideal for professor's wife who types."

The danger is that such interpretations reinforce and are re-inforced by – *reality.* Five years after the College Art Association published a survey of Ph.D-granting institutions, the hierarchy of art history at Princeton University remains unchanged: Out of 11 tenured art history professors, 11 are male, 0 are female. . . .

Evaluating my own undergraduate and graduate education of the '50s and '60s in the New Orleans Convocation address, I came face to face with the fact that, "Never once during those years of study in California or New York did the name of a single female artist pass the lips of any one of my instructors!" Well, month before last, the mail brought me this letter from one of my former teachers at Berkeley, Herschel Chipp: "I am trying, as penitence for past sins, to use some of these in my course (or at least to let their names pass my lips). Also in my revised *Theories of Modern Art.*" So, sometimes feminist ferment can attract converts!

[But] allow me to cite, in closing what can happen when unquestioned, conventional modes of thought rule the day . . . Recently the Kimbell Museum in Fort Worth organized a major Elisabeth Vigée Le Brun exhibition and hosted a much-touted international symposium on the subject. At least that's what the blurb on the program announced: *Vigée Le Brun Symposium.*

Let's not dwell on the reputations or affiliations or symposium panel members, but let's do run a quick gender check by glancing at the first names. Hmmmm. Robert, Joseph, David, Edgar, Malcolm and William. Guess what? Six out of six panel members are male. . . . Well, let's take a look at the content of this Vigée Le Brun Symposium, let's see what the individual talks are about. Speech Number One: "A Context for Vigée Le Brun." Speech Number Two: "The Imagery of Vigée Le Brun: Some Specific Sources. [I]t's interesting that when specific sources for male artists are ferreted out, we are asked to admire the *transforming* powers of the creative artist; but when specific sources for female artists are discovered, a lack of originality and dependence on precedent are confirmed.

Speech Number Three: "The Rise of the 'Artist-Initiated' Portrait." [W]e learn that this new phenomenon, from which Vigée benefited, was initiated by male artists. . . On to Speech Number Four: "Pompeo Batoni: 'The Best Portrait Artist in the World.'" Speech Number Five: "Sir Joshua Reynolds and the Grand Style.". . . At this point Vigée shares the stage with some half-dozen luminaries of the opposite sex, and we have found out a great deal about *them*, but not much about [her]. And now to the dénouement, the last lecture. [Surely] the pieces will form a whole, and our heroine will reappear on center stage front. Speech Number Six: "The Portraiture of Francisco de Goya: Tradition and Innovation"! . . .

Certainly the organizers of this Vigée Le Brun Symposium must be congratulated on having successfully *skirted* a woman artist. Elisabeth Vigée Le Brun has become the foil for an all-male review. The reluctance of the Kimbell Museum's all-male panel to come to grips with the announced artist, to shift gears, gain new perspectives, consider different hierarchies, is, I am afraid, typical of what the 1980s have to offer – unless we continue to agitate for change.

After a decade of ferment, can you change him? – meaning the hierarchy in art and art history. Only if you acknowledge that art history still needs feminism, and only if we all, both privately and publicly, go on, not only questioning, but changing the litany.

– Alessandra Comini

Women Artists News, May/June 1983 [Vol. 8, No. 4]

Color-Coded and Loaded

"Color: Can the Environment Nurture a Personal Vision?"

Moderator: **Ora Lerman**; Panelists: **Joyce Kozloff, Ellen Lanyon, Judy Pfaff, Sandra Skoglund**

Noho Gallery, NYC; April 14, 1983

Each of the four panelists had recently executed work of environmental scope – room-sized pieces that either penetrated three dimensional space or used non-traditional materials, or both.

Ora Lerman's own paintings show dolls, toys and other small objects penetrating the larger spaces of sky and sea, suggesting the space of dreams. She proposed an American desire to encompass a large field of vision, from the sweeping perspectives of Thomas Cole to Jackson Pollock's method of investing every part of the canvas with equal energy. Lerman contrasted this to the traditional association of women's painting with interior space and private meanings. Women artists of the '70s, she said, merged the two spheres by creating a larger stage on which to publicly feel the personal.

Joyce Kozloff showed slides of such architectural settings as the Alhambra and the pool room at San Simeon, both of which use interaction of light and architectural detail to create, as well as supplement, color. Her own tile wall works in progress for the Wilmington, Delaware, train station and the San Francisco airport include images the public might recognize and identify with, sometimes suggested by original details of the building. Kozloff's color and intimately scaled passages are intended to make people linger and enjoy places they might ordinarily rush through.

Ellen Lanyon began her presentation with slides of her studio shelves and the clutter of boxes, shells and animal specimens from which she has drawn both imagery and color. When she lived in city studios, there was no exterior world in her work. Summers spent outdoors in Michigan led her to use the landscape, and she began juxtaposing large and small objects, which became monumental art forms when she set them outdoors. On a trip to Florida in 1976 to execute a commission for the Department of the Interior, she discovered the tropical landscape. As she became more involved with nature, she added green to her summer colors of blue, red and lavender. To present Florida and the dangers to its environment, she expanded her scale, transcribing an accordion-folded 8 by 10 inch sketch book into panels 50 inches by 6 feet. She also replaced saturated color with colors emanating from "earth and the dawn sky."

Judy Pfaff described herself as a former Albers student who reacted to the purely optical exercises of his famous color course by conceiving of color differently – through emotional and word references, or as a code in which different parts of a piece are aspects of the same person in different

shapes. Having been accused of using trashy materials, Pfaff said she drew strength from a trip to the Yucatan, with its "tons" of color in "bad taste." Her crowded, highly colored environments now reflect the places in which they are installed. Suggestions of Niagara Falls and the Albright-Knox collection appeared in a work installed there, while memories of the Futurists influenced an Italian piece. These prior motifs originated more from images than from actual experience, Pfaff said. Movies might affect her more than travel. She refers to color as "raising the temperature of a room" or uses "layers of color and tactile things until they start compounding and become layers of noise," a "buzz" or "flicker," an all-out attack that commands attention.

Sandra Skoglund described construction of her 3-dimensional work, "Baby Babies," a rain of oversized babies witnessed by a man in a dark house in a landscape of twisted antennas. She said this represents outer space with humanoid, not human, characters. The babies are purple for visual effect and the unisex overtones. Skoglund explained that although her thoughts about the scene were color-oriented, the execution required working at length without color, building and casting the forms.

While Ora Lerman concluded that "the dybbuk of color" had not yet been tamed, some common ground was reached. None of the panelists thought of color in exclusively optical terms. All stressed the role of memory, emotion and meaning in their palettes. Their work has a generosity that seems to arise from the desire to share feelings and perceptions rather than solve problems of art history.

– Fran Hodes

Women Artists News, Summer 1983 [Vol. 8, No. 5-6]

'83 / #169

Repainting the Battle Lines

As I recall the moment, Photo-Realist painting had become so well accepted it was passé; painting on photographs was still tacky, or anyway naughty, at least in New York – in the West or Southwest it was a regular style. But "discourse between painting and photography" was not yet so obvious and popular a topic as it soon became. (I was amazed, *amazed*, the other day to see *Art and Photography*, Aaron Scharf's excellent book on the subject, in B. Dalton!)

Having myself recently switched from painting to photography, and being then on the Program Committee of Artists Talk on Art, I thought a "Difference Between Painting and Photography" panel would be timely, and began casting about for a brainy moderator. Someone suggested Craig Owens, who not only agreed cheerfully, but turned out to be a committee-person's dream, conjuring up an all-star cast *on time*, not just for the announcement, but for the event itself, without so much as a reminder.

The panel Owens conjured up became one of those special Soho events, measurably enhanced by the overflow gang on the sidewalk outside pounding on the plate glass window. These were reportedly motorcyclist friends of Robert Mapplethorpe, whose work, by the way, looked smashing in the evening's format of slides projected onto a portable screen. I suppose it hardly needs to be added that nobody defined anything, let alone the difference, though since then I have heard others make a stab at it. (Ben Lifson presented a two-part theory at a photo conference in 1990. The part I remember was that the photograph has an absolutely even surface.) Another difference occurred to me that night: photographs probably mutate less in slides than do paintings.

Carol Steinberg's report, which came in "over the transom," precisely and eloquently defined the ways discussants begged – or fogged – the issues.

"Painting and Photography: Defining the Difference"

Moderator: **Craig Owens**; Panelists: **Joseph Kosuth, Jack Goldstein, Sarah Charlesworth, Barbara Kruger, Mark Tansey, Robert Mapplethorpe**

Artists Talk on Art, NYC; April 29, 1983

Craig Owens, senior editor of *Art in America*, sat with the six panel members and spread his hands, butterflylike, cigarette dangling from the long fingers. We, seated on the floor of the crowded gallery, were, mercifully, not permitted to smoke, having squeezed in while others less fortunate clamored at the entrance and pressed against the window to see – an Artists Talk On Art panel!

True, it was, at $1, a cheap Friday night and an interesting topic: *Painting and Photography: Defining The Difference.* Owens's hands seemed to point to two points of view even while he hoped those who had come for the latest installment of the historical battle would be disappointed. They were there, he said, to "define difference," not define or create false oppositions.

Joseph Kosuth, in his perennial black outfit (is he making an unconscious statement about being in mourning, does black flatter his figure, or is it some kind of '60s minimalist, conceptualist, artist's statement?), read a tract about how the institutions of gallery, critic, market, etc., create what we think "art" means. He showed no slides, not to be arrogant, he said, but because those familiar with his work didn't need to see them and those not might fall into that tendency people have of thinking they understand something after they've seen slides. No one told the audience he is a conceptualist. I guess he wasn't on the side of painting *or* photography. Next, Jack Goldstein showed us a slide of his painting of a Bourke-White photograph of a Kremlin air raid. He jocularly read an interview and some comments on the dilemmas of quotation and authorship. He also said he was "not interested in Painting."

Sarah Charlesworth said she was "freaked out" that day about having to do the panel and that she would read to us from a letter she had written to a friend. She even began, "Dear Rudy," but I was not convinced her friend really

wanted to hear about the gap between the subjective/presence of oneself of painting and the objective/absence of self-presence of the other in photography, which I found difficult to hear and understand. She showed a slide of a photo of a photo of a photo which had been ripped up and some other manipulated photographs.

Barbara Kruger spoke about the potential for creating feelings of richness or poverty in the spectator face-to-face with the artist's image and the importance of understanding the politics of images, as well as her attempt to provide for a female art spectator. Her work consisted of photos with words collaged together, making political statements. I think one said, "You destroy what you perceive as different."

Mark Tansey showed his joke paintings. Each got a laugh from the audience, as with the *National Geographic* photo-boat crew on the edge of a waterfall, entitled, *Take One*, or a woman lying in bed pointing a gun at a man pointing a camera at her entitled, *Homage to Susan Sontag*.

Robert Mapplethorpe took off his dark glasses to tell us he really hadn't prepared anything to say, just brought slides of his photographs, which he related more to sculpture than painting. The photos included Lisa Lyons (the bodybuilder) in the nude with graphite powder covering her body to emphasize its statuesqueness, portraits, a black guy who we were told could achieve erection at a moment's notice, men embracing, children (whom he doesn't particularly like, he said), flowers.

The most wonderful commentary on the difference between painting and photography came unexpectedly from the audience when Cynthia Mailman, whose works adorned the walls of the Soho 20 Gallery, was moved to shout, "Don't Touch My Painting!" as another member of the audience on her self/unconscious way out was about to put her hand through one of the paintings to support herself. As the audience laughed at the serendipity of the moment, Mailman became a bit defensive and added, "mine are only one of a kind, you know."

I couldn't decide whether this was more fun than realizing that the woman across the room I'd been admiring all evening was probably Lisa Lyons, as she left in her sleeveless white mini-dress with her beautiful arm and leg muscles bulging out just a bit more than one is used to seeing on the average woman.

Someone in the audience asked about the power of painters to paint what isn't there. Mapplethorpe answered that, as a photographer, he feels his best work is that in which he sees what he hasn't seen before.

Another member of the audience began to explain his understanding that, in light of the panel, "aren't painting and photography the same thing except for content?" Sarah Charlesworth assured him that form was content and Craig Owens cautioned not to go from one extreme to the other, that is, from saying they're opposites to saying there's no difference.

Too late, I tremblingly raised my hand, shocked by this question, and burning with something to ask, if only I could figure out what it was, something, something about the *process* of painting – by its nature longer, with more potential for discovering relationships, meanings, ideas, feelings, images, subconscious meanderings, *the way we perceive*. Don't most of us feel we must study a painting for longer than a photograph? How long do we study photographs, and for what purpose? Isn't there some major difference between the act of painting and the act of photographing? And then, can we escape evaluating that difference, at least for ourselves?

I don't know. I don't know. I almost didn't dare to write this and I didn't dare to ask so I had to write. These ideas need deep questions and deep answers. Where were the painters, *process* painters, painters who discover ideas through their painting, not start with a pre-fixed idea or image and paint it? Where were the paintings, real paintings, not slides of photos of paintings, of paintings of photos, photos of photos. Slides *are* photos. Form is content. The panel was weighted, the sides were uneven, and the difference was never defined.

– Carol Steinberg

Women Artists News, Summer 1983 [Vol. 8, No. 5-6]

The event evoked another, allegorical commentary:

"Night of the Shamans"

Reflections on "Painting and Photography, Defining the Difference"

Once upon a time in a constantly collapsing and re-rising city, the inhabitants made buildings with large spaces where people sweated to make things for others to sell. But one day they painted the spaces white and displayed mysterious and precious objects there. At last, on a night in spring, 1983, many people gathered in such a space to hear messages from shamans who made the precious objects. They worried about a tool producing these objects quickly and easily, and wondered if the new objects would be precious in the old way. So they gathered to DEFINE THE DIFFERENCE. On the walls were canvases with scenes of the Far West painted by a person with a new kind of organ transplant – 50 mm lenses permanently in both eyes.

The shamans sat down on chairs on one side of a long skinny table with glasses of water on it and were lit by spotlights. The rest of the people sat on the floor on the other side of the table in the dark. A scribe who wrote important words about shamanism sat with the shamans and said the people on the floor were probably there to enjoy dissension between shamans who used brushes and those who used the new tool, but he was there to make peace and had personally picked these shamans to address the issues.

However, the first shaman, an acclaimed user of the brush, hadn't brought his magic objects with him, saying that, anyway, holy objects made with a brush were now meaningless,

and even worse, decorative, but unscrupulous folks attributed false values to them so people who had lots of money but inadequate wardrobes would buy them and feel like emperors.

The other shamans showed their precious objects and told of their powers, but no one could define the difference, because they had forgotten or never knew the old way of making something unique yet universal. Mostly they talked shaman shop talk and complained that there was too much of an abundance of their product and that they were saturated, alienated, repressed, politically "other" and lost in multiplicity, while yearning for singularity or maybe irregularity and had a headache that night.

Because of these feelings, they used images they just found lying around. They ripped off some and copied some onto canvas in a larger size. The one who did that was so demoralized he said he didn't trust his intuition any more, which may have been why he didn't make the copies himself, but hired others to do so. Learning that this fellow had helped himself to images, like fruit in the Garden of Eden (denying existence of originality and authorship), one hopeful questioner from the other side of the table asked if these were political acts. This might be a very brave and principled shaman who denied, not only authorship, but also ownership and the putting of price tags on holy objects. But that one was very silent about the authorship of his bank account.

It turned out that all the shamans had, in one way or another, been using the new tool or its products. One modest shaman in rumpled ivy league jacket and tie (although the evening was hot), who told in a low voice of changing photos into paintings and putting old shamans into new paintings of old paintings, had evidently seen Woody Allen frightening Susan Sontag. Another shaman harked back to the Russian Revolution. She advised that the propaganda of the culture should be turned against it and warned that in times of political repression people lose sight of the pleasures of multiplicity. She herself seemed to have suffered this loss because, although she uses the camera-tool and the printing-press-tool, her magical objects are nevertheless, one of a kind. She also stressed the importance of increasing the number of spectators with her kind of reproductive organs. The last shaman made no bones about it. He said he used the camera instead of a brush or a chisel. He thought he was good at helping his subjects show their fantasy or reality. And then he showed his work, which reflected his life: outrageous rock stars, men with magical erections, famous androgynous women, flower studies and male members of the races embracing. Even a few children, although he admitted to not liking them. It wasn't Rembrandt's Saskia as Susanah, but there was an echo of the same process. "For whom do you do your work?" someone asked. Robert Mapplethorpe replied, "For the people I love." And put his dark glasses back on.

Then everyone went out onto the sidewalk where a loud argument had earlier made it hard to hear the proceedings,

much of which had been mumbled, as if the shamans found it very hard to communicate.

– Gladys Osterman

Women Artists News, Summer 1983 [Vol. 8, No. 5-6]

'83 / #170

Welcome to Post-Modernism

This drop-dead blue-ribbon affair managed against the odds to have some dramatic moments, like John Simon's outraged denunciation of Michael Graves's architecture – right to Michael Graves's face! But mostly it was just infuriating. My report (originally signed "Art Lover") was intended to be humorously savage. It is, in any event, entirely true. OK, I was First Lady Questioner (somebody had to do it), but Hilton Kramer's reply and the rest were exactly as quoted.

"Post-Modernism in Art and Literature"

Speakers: **Michael Graves**, architect; **Hilton Kramer**, art critic; **John Simon**, theatre and literary critic.

New York University, NYC; November 3, 1983

I went to this really weird panel last night called "Post-Modernism in Art and Literature," only it was mostly John Simon, Michael Graves and Hilton Kramer in the same room, so the place was packed. To start off, they had a beautiful lady with long blond hair and a really great black dress who talked about something you couldn't understand because we were still trying to find a seat in the crowded room. She must have been a doctor, though, because when she finished the moderator said, thank you Doctor Soandso. Then she sat down and only the four guys with just OK suits and vests were there. The one who was the moderator gave a speech about how distinguished each of the others was, as if we didn't know, and then they all started to talk about George Bernard Shaw and Baudelaire and Picasso and Rimbaud and Mallarmé and Mies.

Hilton Kramer was first and he said post-modernism is an Agenda of Stylistic Options, but then he said how in post-modernism it doesn't matter what things look like because we don't have aesthetics any more. It was Michael Graves's turn next and *he* said the thing about post-modernism in architecture is it matters what things look like, because we can't have these big boring boxes any more or terrible-looking places like the Somebody Memorial Auditorium we were in that very minute in the Bobst Library. But, he said, it was probably designed by a committee, so what could you expect, and everyone laughed.

Then it was John Simon's turn, and *he* said he didn't know anything about *art*, but he gave a lot of quotes from literature and the French Symbolists. The thing was, he had this

awesome French accent and you could see that made Hilton Kramer and Michael Graves gnash their teeth because they didn't have a French accent. Then suddenly, just when his talk was supposed to be over, Simon unrolled a poster of a Michael Graves building and held it up, stabbing the paper with his finger while it flapped and curled in the air. He was so excited he was out of breath and almost spitting. "Look What Won All Those Prizes!," he sputtered (really). "It's So Terrible It Looks Like Three Pregnant Buildings, Each One Having A Baby Building That Will Be Out And Running Around In The Nineties!" People couldn't believe this was happening, that John Simon was saying these things with Michael Graves sitting right next to him, so when we had the question period a man just asked, "What Is Deconstruction?" But I thought, he had the poster with him. That was planned!!

I was starting to think something else, too. I was thinking maybe the pretty lady in the beginning was like the lady on the TV game show who comes out in the black leotard with the envelope, only she was for intellectuals. I mean I had the idea, Why isn't there a woman on the panel? There are some *very important* women critics. Then, suddenly, it flashed on me, how in the whole entire deal, with the French accent and the immortal lines and the end-to-end story of modern thought, *nobody mentioned a single woman,* unless you count John Simon saying Ayn-Rand-That-Miserable-Novelist because she had a terrible hero based on Frank Lloyd Wright, though I wondered at the time *how he knew,* because I, personally, could not *read* Ayn Rand. Anyway, nobody mentioned a single painter or writer or anyone who was a woman who wasn't their girl friend. I thought, are these guys doing Janson's *History of Art* all over again, only for *all* the arts and literature and poetry?

Of course you could tell they still *thought* about women, from little things they Let drop. Like Michael Graves said if there was a threshold in one of his buildings, "If I Ever Got Married, God Help Me, I could Carry My Bride Over It." So you gathered he didn't want to get married, which might be why his buildings have to have the children. That's OK with me, because they're pretty good-looking buildings, but maybe the roofs leak, because he said something about having a "27-bucket building" and everyone laughed. Then he kept saying that if he had to make a building this way or that way or another way he didn't *want* to, he'd rather be a lawyer. He said that a lot, so I figure he's probably being sued, which may be a post-modernist development in the arts everyone forgot to mention. Another thing that showed he thinks about women was, after the part about the Bride and the Threshold, he said, "Going into a building is like Penetrating a Membrane." You could tell he thought that was pretty daring.

John Simon thinks about women, too, or anyway about his girl friend, because he said she's a hostess on a talk show and told a story about her right there on the panel. He called her "my girl friend," so she's probably around 15 and she could grow up and get some good ideas about "Post-Modernism

and Art" herself some day. But, meanwhile, John is interested in *older* women, too. A lot of older men only go for the chicks, but he said something was like a Lovely Woman Of Indeterminate Age. (So you knew he thought it was better for an older woman not to tell her age.)

Then something amazing happened. Near the end, one of these men (maybe it was John, too) said all the artists in the world are like One Heroic Priesthood. Yes, he did. In 1983. So I was still worrying about whether I could be a member of a heroic priesthood when they had the question about Deconstruction. Then another person started her question, which was exactly what I was thinking, which was why in a zillion artists and writers they didn't mention *one woman,* but Hilton Kramer cut in real loud right away and said, That's Not A Question For Here! You Have A Place For These Things!, which was dumb, because *he* was the one who didn't mention women, but the moderator had another question real quick. He asked John Simon what he meant when he said Hilton Kramer had a Hidden Agenda, and they started trying to kill each other again, but smiling, so they would still look charming, and nobody said anything more about women.

Then another lady in the audience asked, What About The Sacred in Relation to Man And His World? And once more I couldn't believe my ears. *Man And His World!* So a lady near me said, Welcome To Post-Modernism, and I said I guess so! Then the ones who hadn't left yet got some kind of pink punch, but I was having a depressing thought. Maybe we shouldn't have any more women's panels, so they couldn't say, You Have A Place For That.

But looking on the *bright* side, Deconstruction is really getting out there. Deconstruction, I forgot to mention, is when you say what *you* think is going on, not what everybody else thinks is going on. The lady asking what about women artists was doing Deconstruction, but they weren't ready for it, or for post-modernism either, if you really want to know, except Michael Graves. You could call it that Middle Age Faces The Future panel, but for the audience it was The Being In The Same Room With Famous Men panel and that part was excellent. I mean I don't know a whole lot of famous men personally to find out about their girl friends and all.

Anyway, Michael Graves was best, because he's an artist and he has his *art* out there for people to make cracks about and it looks great. (I bet the roofs on *nasty*-looking buildings, like the Pan Am building, leak too.)

One other thing I almost forgot. At the end, another lady in the audience stood up and told Michael Graves that she visited her daughter at Yale and had tea in the Master's House and felt really comfortable there. But that must have been the wrong kind of post-modernism because Michael Graves looked pained and you could see he hated to tell her in front of all those people that she shouldn't have felt comfortable in the Master's House because Aero Saarinen wasn't the right Saarinen, although she *could* have felt comfortable with his *father.* But the lady said she knows comfortable because *her*

house is an 1840's house and the most perfect and comfortable of all. But if you want to know what *I* think, *I* think she felt comfortable because her daughter was at Yale, and who wouldn't feel comfortable if their daughter was at Yale? And who wouldn't want to get up after that evening and tell the whole room, Our Daughters Are at Yale?!

– Judy Seigel ("Art Lover")

Women Artists News, Winter 1983-1984 [Vol. 9, No. 2]

'83 / #171

Art Image as Consumer Product

Although they may seem like opposites to the casual observer, Carter Ratcliff has some things in common with Hilton Kramer: Both can talk and write marvelously about art-and-the-culture, and I'm probably not going to like the art either of them likes. This is of course not the Hilton Kramer of the post-modernism panel above, the one who arrogantly slaps down a serious question, but the Kramer who fulminates so engagingly against the "advanced" political thinkers in art's infrastructure that we applaud those shysters for inspiring him.

Carter Ratcliff, on the other hand, analyzes art's moves from a more detached, and, as a rule, more tolerant, position. He nearly always sharpens our view of what we have only sensed, or supplies an aspect we have entirely missed – in some cases the defining one. Here the focus is on "art image," always an issue in modern art, now, Ratcliff says, a "junkie addiction."

"Fads in Art"

Lecture by **Carter Ratcliff**

New Museum, NYC; November 1983

Carter Ratcliff, art critic, author and lecturer, spoke at the New Museum on "Fads in Art." His diagnosis, delivered in a dryly clinical manner, depicted a horrendous condition with tinges of sin, damnation and guilt. Art faddism is like a "junkie addiction" in which neurotic need meshes with the market forces of our consumer society, he said. Stressing neurosis as explanatory structure, he touched only briefly on the economics that encourage such phenomena.

"The endless need of the art faddist for a new style is like the need of a junkie for another high," he said. The faddist has the junkie's concentration on the next fix and functions in a shallow reductive way to this end. "Politics has turned into advertising and food marketing into image shopping . . . It was wrongly thought that the art world was different. But it has succumbed to the metaphysical trading of art images. They have become a consumer product you can put in the market basket." Moreover, "It is not necessary to buy a painting to do this."

Among Ratcliff's other observations were the following:

"The ways that people present themselves, certain atmospheres, are not just unpleasant but profoundly dubious. Art reflects this. Consumer extremism, defining oneself in terms of an image, is junkie faddist behavior. The image addict thinks fads are avant-garde, a way of knowing what's going on so he can get 'ahead of the game' (a market term). This is what the *Village Voice* is all about, a weekly report on the state of fads, which have begun to refer to *themselves*, rather than the world future they're supposed to be predicting. Movie and drama critics talk to each other through their columns.

"Pop Art shed a revealing light on images that tend to become objects of addiction in a consumer society. . . . 'Fast evolution' is [an] addiction to images of art. Fads are reductive and rescue the insecure personality from ambiguity and ambivalence, removing any sense of the passage of time . . . To take oneself out of the context of the world is to remove oneself from the flow of history. Faddists on a fad high claim the justification that they're in touch with the future. But fads have no predictive power other than to indicate the next fad in the many subcultures that cluster around. In the center of the faddist aura, meaning and value reside in rigid form.

"There is an obsession with 'the best'. The way people construct the world, clothes, wine, home furnishings, all make consumerism a source of redemption and justification for lacking a strong sense of self. Fads are an addiction to glamor, the high of glamor, which relieves one of the necessity to be conscious of what one is doing. Glamor is directive, projecting desires about oneself.

"In modern culture, art found itself adrift. Art is actualizing consciousness, defining the self. Serious art is a tissue of ambiguities – that's what makes it great. To 'worship' is not to serve the authentic truth of a work of art. It can only be the object of a fad. The seeming dedication of the faddist to greatness becomes its destruction. Fads are not accidental. They are unconsciously intended to dampen and destroy the ambiguity and richness of meaning that give serious art its value.

"People say, 'Manet's time is now,' 'Leon Golub's time is now.' Is Golub's time Manet's time? Will the next time be the next blockbuster show at the Met? The need to see Manet as the vehicle of some absolute value requires one to take him out of time. This saves one from all complexities, such as the upsetting one of comparing Manet with Fantin La Tour – if you think Manet is radical.

"There are other kinds of fads that can develop in the vicinity of art. Faddists rewrite the past in a reductive way, so that art history becomes the history of one artist. Thus the deification of Turner. The Minimalists saw only Piero della Francesca and referred to him in an intimate tone as 'Piero,' like 'Frank, Chairman of the Board.' In the late '50s, people

talked like de Kooning or Ted Berrigan talked. And around the offices of *Artforum*, people sounded like the *Readers Digest*'s 'Building for World Power.' Everyone was polysyllabic.

"The unpleasant part is, we are all implicated. New fads work. We need them because they provide certainty for those who feel uncertain. The desire for authority is projected onto the image, where it is abstracted to the realm where nothing can question it.

"In the '60s, magazines focussed on fads, because of the rigid style divisions in the art world. In this situation, artists must position themselves so they will be seen. Everybody, including critics, wants to get into the line of sight.

"My favorite artists are marginal. This is not something trivial. Faddish feelings, insecure perceptions that judge so many to be marginal and only a few of dubious quality to be central, makes the whole notion of 'mainstream' dubious. It is a bludgeoning word, a very cruel notion . . . flaunting oneself as being dedicated to images of absolute quality.

"In a fad, seriousness is reduced to an image. I do make a distinction between kinds of seriousness. The fad is not grappling, coming to terms, pushing further, [avoiding] risks or confrontations. Something is awry. The art world is being flooded with inauthentic images."

– Gladys Osterman

Women Artists News, Spring 1984 [Vol. 9, No. 3]

1984

'84 / #172

Postal-Modernism

It was 1984. We were pleased to have escaped Geroge Orwell's prophecy, not realizing we were already in it, only we loved it. Art was rapidly becoming a commodity whose tycoons overshadowed art's free spirits of the type on this International Mail Art panel. Today (as we hopefully await the pendulum's return swing), we can appreciate mail art as "a global network of personal expression and sharing," but this tale reminds us that it's also a way of keeping such free spirits out of each other's hair.

True to Faith Heisler's forecast, the evening did enter the annals of the genre, still being hashed over this spring in *Rubberstampmadness* [May/June '91].

"International Mail Art: The New Cultural Strategy"

Moderators: **Ronny Cohen, John Held, Jr.**; Panelists: **David Cole, Cracker Jack Kid, E.F. Higgins III, J.P. Jacob**

Artists Talk on Art, NYC; February 24, 1984

The recent International Mail Art Exhibition and the panel discussion held in its wake are likely to remain controversial within the postal art network for some time. Events described here grew out of circumstances surrounding an earlier show at Franklin Furnace.

Within the global network of mail artists, there are certain generally accepted modes of conduct, "sacred principles." The standard request for material to be sent to a mail art exhibit usually includes the words, "No fee, no jury," and "All works submitted will be displayed." This last statement was made in the open invitation to submit work to the Franklin Furnace show. The curator, Dr. Ronny Cohen, was not in any way prepared for the overwhelming response she received. And she solved the problem of too much art for too little space in the way she felt best. She chose some of the pieces, hung them, and left the rest unshown.

When postal artists objected to this selective display, the remaining works were piled up in cardboard boxes and placed on the gallery floor.

On the afternoon of the panel discussion, some of the panelists had met to consider action. They decided that because of her "censorship," it was inappropriate for Cohen to moderate the panel. A statement was composed, and the Cracker Jack Kid, a mail artist from Omaha, Nebraska, read it immediately after Cohen's introduction.

In that statement, panelists condemned Cohen's failure to exhibit everything as promised. They blasted her for "going back on her word" and removed her as moderator, giving the

position to John Held, Jr., mail artist and gallery proprietor from Dallas, Texas. The statement made clear that Dr. Cohen was welcome to remain in the room for the discussion, but that the panelists objected to her acting as moderator because she, a non-practitioner of postal art, had gone against its principles in passing judgment on work.

Cohen replied that "all artists [who submitted work] are represented." She explained that there was a space problem and that she had originally intended to exhibit the work in two batches. After many artists complained, she said, all the work was shown.

Those in the audience unfamiliar with preceding events, were confused. Cohen's rebuttal sounded plausible to those who didn't know that what she meant by all the work being shown was cardboard boxes filled with art. After some give and take with both panelists and audience, Cohen left, saying, "Have fun boys." Her entourage walked out with her.

E.F. Higgins III, a New York mail artist, explained to the audience that Dr. Cohen had recently curated a correspondence art show in a way "perturbing" to many on the panel. Then panelists began to show their slides.

J.P. Jacob, publisher of *Hype* in New York City, spoke first. He showed slides and described mail art as "our food on the table and our living politics. It's vital and it's here."

Next, the Cracker Jack Kid, before showing slides of his stamps (printed on his own hand-made paper), postal, and performance art, did a quick performance event. Having express-mailed a carton of Crackerjacks to the gallery from his home in Omaha, he now tossed boxes of Crackerjacks into the audience to be shared by everyone. This was to demonstrate the spirit of mail art, and, for some, a kind of sharing that is the essence of postal art.

Cracker Jack's slides emphasized his collaborations with other mail artists. It's important "to say 'We did it,' not 'I did it,'" he said.

A recent collaborator of Cracker Jack's, E.F. Higgins III of Doo Da Postage Works, was next. He brought an entire tray of slides, which he insisted on showing, after a while at breakneck speed, both forwards and backwards, with the same slide appearing a number of times for only an instant. Eventually he was shouted down by both audience and other panelists, who made it plain that they did not approve of his visual and verbal abuse.

Other panelists tried to speak – of how important communication was in their practice of postal art, of how the art form made geography and regional "egocentrism" unimportant. But Higgins refused to relinquish the spotlight. As David Cole (of *mc magazine*, New York City) and John Held, Jr.

tried to speak, Higgins carried on conversations with both hecklers and silent members of the audience.

When the floor was opened to questions, someone asked if it was sexist to call the art form "mail art" (homonymous with "male art"), and noted the macho-seeming action of five male panelists removing the female moderator. Those who understood all events leading to Cohen's ouster knew she would have been removed regardless of her sex. David Cole explained that he saw mail art as similar to traditional letter-writing between women because of its communicative aspect. A female postal artist made an eloquent statement about her enjoyment of and acceptance by the mail art community. Sexism, she believed, was less of a problem in postal art than in "traditional" art networks, because it lacked a male hierarchy to devalue female practitioners.

Finally, the disruptive behavior of E.F. Higgins and some of the hecklers became too much for moderator Held. A shouting match was followed by Held's leaving his seat and starting for the door. His chair was quickly occupied by one of the hecklers, and the panelists started to get up and take seats in the audience. Soon, only Higgins and the heckler remained at the panel table, and the audience broke up.

Members of the audience should understand that Higgins did not speak for the others on the panel. His abusive language and obnoxious behavior were his alone and did not reflect the views of other mail artists. The ousting of Ronny Cohen, no matter how unpleasant, was seen as unfortunate but necessary by the majority of panelists. It was not meant to be vindictive.

It is ironic that a panel on correspondence art, an art form based on communication and acceptance, became so hostile and emotionally violent. Mail art has a much stronger connection with shared Crackerjacks and toy surprises than with epithets and insults.

Author's note: This article is one person's version of what happened on February 24, representing my views alone, not necessarily endorsed by any other postal artist. In trying to convey an overview of events, I have glossed over certain specific statements, but with no intent to neglect or offend anyone.

– Faith Heisler

Women Artists News, May/June 1984 [Vol. 9, No. 4]

'84 / #173

Rice, Corn, Barling, et al., in Toronto

Women in Film, Video, Photography

Women's Caucus for Art, College Art Conference, Toronto, Canada; February 1984

College Art Week of 1984 in Toronto included two Women's Caucus panels chaired by **Alida Walsh** on women in film, video and photography. **Shelley Rice** cited layering, fragmentation, archaeological interests and concern with duration as recent themes among women photographers. **Ann Sargent-Wooster** addressed effects of money limitations for women in video, pointing out that prizes and grants generally go to tapes of broadcast quality. She showed **Dara Birnbaum**'s ominous and beautiful *Damnation of Faust* (1983), nine minutes of which cost $9,000 to produce. Sargent-Wooster suggested that there has been a dying down of explicit feminist content in women's video, but at the same time an "internalization" of ideas introduced by the women's movement. **Marion Barling** spoke about Women in Focus, a group founded in Vancouver in 1974 to produce alternative images of women in film and video. She also noted the difficulties women have in gaining access to these media.

– Adele M. Holcomb

Commentary and Lacan

College Art Association, Toronto, Canada; February 1984

With nearly 50 sessions crammed into three days of meetings, there was of course too much to choose from, but the words of **Wanda Corn** of Stamford University can stand as a challenge to the conference as a whole. Corn asked whether conference papers should speak to specialists only, or address more general issues of current values and humanistic scholarship. Was the solving of academic puzzles enough? She observed that the scope and ambitions of most College Art Association papers contrasted unfavourably with those of an interdisciplinary conference she had recently attended. Art history is threatened with a collective failure of nerve unless its goals are more ambitiously set, she said. Corn's commentary came at the end of the last session, by which time attendance was small. It should be a keynote for next year. A similar commentary at the end of every session could also revitalize debate on the nature and scope of the disciplines involved.

"Strategies of Media: Questions on Representation /Sexuality/Power," chaired by **Judith Barry** of SUNY, Old Westbury, NY, was of particular relevance to women. **Mary Kelly** of Goldsmith's College, London, in an exceedingly intricate and technical paper, argued that images of women presented in our society

cannot be transformed without first understanding their "causality and functioning." This she seeks to discover in Lacanian psychoanalytic theory, which postulates that there is no essential, given, feminine identity behind the mask, but male and female attitudes which are continually renegotiated through representation. Kelly cited current strategies of reinterpretation: the media image of the androgyn, the self-conscious assuming of the patriarchal facade in the form of an excessive femininity, and the neo-feminist solution of re-fusing the literal representation of the body, but creating its signification by absence. In regard to specifically female im-agery, Kelly discussed her insight that fetishism should not be assumed to be the preserve of the male. The mother's memorabilia of her baby may be the equivalent of pornogra-phy, acting as an emblem of desire and a palliative of loss, she said.

– Gerta Moray

Women Artists News, Summer 1984 [Vol. 9, No. 5-6]

'84 /#174

Call of the Wild Ineffable

"Beauties and BEASTS, or, What makes great art great?"

Moderator: **Corinne Robins**; Panelists: **Mary Beth Edelson**, **Leon Golub**, **Steve Keister**, **Pat Steir**

Pratt Manhattan Center, NYC; April 16,1984

In this season of public frenzy over such non-issues as the Oscar awards, and cries of "Where's the beef?" from little old ladies when obviously there isn't any and no one's got the stomach for it anyhow, I attended what I call, in my provin-cialism, "a real New York evening." Close to a hundred people gathered at Pratt Manhattan Center to hear four art-ists struggle with concepts of beauty and ugliness and such opposites to beef as "the ineffable." The occasion was the exhibit of paintings and sculpture, *Beauties and BEASTS*, which proposed to examine these two contexts and how they affect work so categorized.

I hadn't known any of the panelists by sight (being a little out of it), but when I walked into the room I knew immedi-ately which one was Leon Golub. He was a type once very common hereabouts, with the look of an oldtime '30s ideal-ist, now bald and gnomish, almost like family. There was a woman whose mass of brown hair reminded me of Rita Hayworth. She wore a black chesterfield sweeping down to the ankles of her black leather boots and clutched it around herself all evening – painter Pat Steir. The young man with a piece of gut strung through one ear, also in black, was Steve Keister. The last panelist was distinguished by many cowlicks sticking straight up from her plain brown hair, making her

look like a gawky child awakened too soon from a nap – Mary Beth Edelson.

The audience was worthy of the panel. They looked like people who liked to think, take stands, be earnest. There was a sprinkling of the fresh, unmarked faces of young students and also a heckler, who added some diversion. He was a plump left-over from the '60s, in steel-rimmed glasses, long, greying hair and a slept-in tweed jacket.

Opening statements had no relation to each other and there seemed a general lack of enthusiasm for the idea of the panel, with the exception of Mary Beth Edelson, filling in for Alice Neel. She was relieved to be classified a "Beast" and took it personally, although she said she had always been considered a beauty as a child. "Being a beast gives me license; the atti-tude about being a beast is a choice made very young. I never found beauty to be positive. For me, my priority is not being a beauty, but being taken seriously. Women thought of as beauties were not taken seriously. [M]y formative years were very Protestant, concerned with right and wrong . . . very heavy, serious, caring about race relations. Even as a young-ster, I was always trying to get a message through. I strip ev-erything away that interferes with this. I have been using the symbol of the trickster rabbit to help me, as a woman, stop being a 'good girl.'"

Golub took the bull by the horns and said *Beauties & BEASTS* was a non-subject, a gimmick, but gimmicks some-times have their uses. In terms of ideology, he said, Beauty could be harmony, sensuality, response to nature, the nor-mal. The Beast could represent the abnormal, the distorted, the frustrated, the angry, the disruptive. But whatever one decides to be, the decision is made early in life. Some artists do switch, Philip Guston, for example, and some choose a middle road.

Golub speculated about the extent to which either beauty or ugliness exists at the expense of the other – surface as against depth. It's largely a matter of temperament, he said, citing Freud's reaction formation, which is a "reaction against expe-rience, and sublimation, which transfigures experience. The choice is made very early."

Pat Steir rejected the idea of beauty as truth. Her listeners laughed when she added that today truth is often regarded as beauty. Our heckler made himself known by laughing too loudly and a little longer than everyone else. She continued, "The real truth is not approachable in Freud's terms, or Lacan's terms, except symbolically. And what we perceive as beauty at any time has to do with the time we perceive it in."

Steve Keister said, "Art establishes the norm of beauty that the culture finds acceptable."

Moderator Corinne Robins commented that we have many norms today, dating from the split at the beginning of the century when Picasso painted *Les Demoiselles d'Avignon* and Matisse painted the *Bathers*. But the panelists thought Picasso was about violence and not ugliness and disagreed as to whether *Guernica* was for or against violence. Robins

added that the bestial movement in our time expresses specific truths, not necessarily pleasant.

Leon Golub, saying that "people are complex and have complex emotions," explained that he wants to express "the tension of the moment, the interaction between individuals, which puts them on the edge." He went on to describe the duplicitousness of people and governments, the ugliness of the struggle for power and domination which has been concealed from us, and the Marx Brothers aspect of some of the schemes to destroy Castro (such as an exploding cigar). Although some in the audience "might have different ideas about the right or wrong of the 'contras' in Nicaragua, this shifting of positions, the duplicity, is what I am interested in showing."

At this point, the heckler made some comment about where Golub's paintings would be well accepted and Golub, with a big smile, said this is precisely the kind of situation he likes to portray. The moderator and members of the audience expressed displeasure with the heckler who continued making comments from the floor in a loud voice. It was decided to invite him to be part of the panel because he was too big to throw out, but he declined the offer.

Pat Steir was asked by Robins about the subject and content of her paintings and replied mysteriously that the more you dare get involved, psychologically speaking, the less you see, while the more real it is, the more abstract it is. "We see things in clichés. The more familiar a thing is, the more beautiful it looks to me. [But] once you put it on the wall, it becomes decoration."

Robins: Or invisible.

Heckler: If it's great art, it always becomes new.

Steir: That's true, but standards change rapidly. One day you're beautiful and the next day you're supposed to be a redhead and you're not. I paint what I can't describe in my poetry. It says what is terrifying.

Robins: Are you equating beauty and terror?

Steir: I'm equating nothing with nothing. [Laughter, especially from heckler.] It's not the subject that makes art beautiful or not. A work of art is beautiful when it's enduring. It's enduring when what it symbolizes is close to what it's trying to do. Art is another language, not as clumsy as the spoken language.

Beauty *per se* is always style, and according to its time, and that's why I'm not interested in it. When it's close to the elusive, the sacrifice, the forbidden (all linguistic and psychological terms) something is beautiful. . . .

I made a list: sexuality, religious desires, the socially outrageous, knowing what you shouldn't know. I don't think it begins with subject matter [when] a work of art approaches the ineffable. A strong work cannot be spoken of in any other language. It is beyond words, ineffable, not in the sense of nature, the romantic, but in terms of speakability. I bring things home that I find and a friend may say, "Oh that's nasty," but I'm using it for an aesthetic statement.

Keister said he felt defensive about his art being on the beauty side of the discussion. Edelson said, "Early on you decide you don't give a fuck or you want to be pleasing."

Steir: There's a difference between pleasing and creating beauty. Real beauty is terrifying as an insight. These two categories have more meaning because the other two artists are political.

Edelson: Political in the sense of controversial. People in power do not support that work, so it is seen as ugly.

Robins [to Steir]: Mondrian didn't have the quality of terror you're advocating.

Steir: When he did his work it was unknown and considered ugly when it first appeared.

Golub: There is a category of the ugly that cannot be resolved in the beautiful. The movie *Freaks* will always remain ugly. It deals with situations that are terrifying, that cannot be resolved. The freak is an abnormality and frightens people – just like wolves will drive away a wounded wolf because the wounded animal has become a freak and a danger to the hunt.

Heckler: Like me.

Golub: Well, if you're in the art world, everyone in the art world is a freak.

Heckler: No, I mean in the room.

Golub: No, you're just acting what I call "take-over," because you have more of a position of power back there than if you came up here to sit on the panel. [Heckler is silent.] I don't know whether ugliness in the world gets changed when it's made into art. Caravaggio painted with an immaculate technique. He makes you jump because he's still indigestible. He's showing you things that are unresolvable, but it's beautiful.

Robins: You wouldn't say that about *Freaks*, would you?

Golub: You can't say that about real life. The movie is beautiful in its resolution.

Robins: Extraordinary and beautiful are not the same.

Golub: Nothing is the same.

Robins asked Edelson about the mythic content of her work.

Edelson: My interest is in knowing the present and the past, because I'm very interested in the future. I have to look at our psychological beginnings and project them into the future, take the long view. Someone said I'm too respectful and don't take enough license . . . I am trying to break out and make my communication more forceful. What is defined in most cultures is what amplifies the group experience. That is what is beautiful. What I do does not reflect what a lot of people want. In that sense it isn't familiar. . . . I don't think my work is beautiful and I don't work for that.

In my painting, *Heavy Breathing*, there is a woman critics like to describe as androgynous, but who is really a strong woman. I thought of actual breathing exercises, refreshing yourself with breathing, and I thought, how true is that? I was feeling angry and agitated. *Heavy Breathing* is about frustration with this stupid backlash that won't go away, how it's

affecting me personally. Those are not things people really want to hear about, especially the backlashers. They say, "Oh, that's all '70s stuff."

After the panel, a quick glance at the show proved interesting. Golub's very large, bland, and indifferently rendered figures of three Green Berets did not express his interest in the psychological moment. Steir's three black versions of a chrysanthemum glowed mysteriously within the pitch, sexual and beautiful. Edelson's woman exuded tremendous power, but I didn't get any other message. The lines of her furrowed forehead flowed up diagonally across the canvas, swirling into a labyrinth, while forked flames issued from her mouth. Keister's sculpture, a three-dimensional geometric shape, hung suspended from the ceiling, covered with bathroom tiles, self contained, enclosed. It gave no message.

The most vital, inventive piece was a collection of smeared, stained drawings of real and imaginary people, made by a child. The child was not on the panel.

— **Gladys Osterman**

Women Artists News, May/June 1984 [Vol. 9, No.4]

1985

'85 / #175

Arc is Long, Vita Brevis

Now we come to the *Tilted Arc* affair, premier art topic of 1985, and a variation on our theme, in that the mutiny was by the *public,* and the art world closed ranks to defend its "mainstream."

Citizens of lower Manhattan had asked that Richard Serra's sculpture, *Tilted Arc,* be removed from a public plaza, and the Government Service Agency (GSA), which had commissioned the piece, held a hearing. The testimony, excerpted below, produced paradoxes on the scale of the work itself.

Perhaps the major paradox was that the art establishment continued to beatify the martyred Serra even as it reviled "the father" – critic Clement Greenberg – whose modernist philosophy had made Serra's work possible (indeed "inevitable"), and on whose premises Serra's Minimalism relied. Even in the 1990s, "debunking" Greenberg remains a popular college sport, and MoMA has commissioned yet another essay to explode his theories.* Yet MoMA curator William Rubin was prominent among *Tilted Arc's* defenders, urging that any consideration of removal be deferred "at least ten years."

Another paradox was how silent art's power-to-the-people contingent – the populists, political artists, muralists, "Marxists" – were in "the people's" defense. Indeed, of all the "art world" artists who spoke, only Virginia Maksymowicz dared go on record for removal.

What did go on record was the sculptor's right to "freedom of expression." As Philip Glass saw it, "a part of the community would like to deny [Serra's] artistic freedom"! Yet *dissenting* expression was excoriated. Benjamin Buchloch called those asking for removal of 1,440 square feet of rusty steel from the plaza a "lynch mob," and "vigilantes of moral and ethical codes." That is to say, in this episode, the "philistines" appear more sane, civil and honest than the culture crowd.

Serra himself argued that *Tilted Arc* had been designed specifically for the site and would be destroyed by moving. He did not quote the sculptor who said, "the idea of designing a sculpture for a particular site seems a gross limitation on the sculptor's freedom of action" ['89/#204].

All in all, testimony showed that notions of art as something to be inflicted on a mutinous populace, like 50 lashes, or a dose of castor oil that will ultimately somehow be "good" for them, remained current. Add in the sophistry and elitism of tenured professors, and, clearly, this was not art's finest hour.

*A 1991 College Art panel, "The Legacy of Clement Greenberg," and MoMA's 1990 Greenberg essay are addressed and footnoted in the introduction.

Tilted Arc Hearing

Chairperson: **William Diamond,** Regional Administrator, General Services Administration

Ceremonial Room, One Federal Plaza, NYC; March 6, 7 and 8, 1985

The following are brief excerpts from three days of public hearings on Tilted Arc. . . . *While the editors of* Art & Artists *have striven to show a spectrum of views, there has been no attempt at comprehensiveness. In almost every case, the excerpt was chosen from a much longer statement and may not represent what the speaker would have chosen as the best or most representative part of his/her statement.*

In all, 161 persons spoke for or against the removal of Tilted Arc *from Federal Plaza. Three volumes (654 pages) of testimony were compiled and published by GSA under the title, "General Services Administration, In the Matter of: A Public Hearing on the* Tilted Arc *Outdoor Sculpture Located in Front Plaza of Jacob Javits Federal Office Building."*

Benjamin Buchloh, *Professor of Art History, State University of New York:* I believe everybody should have the right to detest contemporary art, especially art like that of Richard Serra that addresses the conditions of alienation that make people detest art in the first place. While this prejudice is private, its transformation into public judgement and political action confronts us with a totally different set of questions. At least until recently, we had reason to believe that . . . vigilantes of moral and ethical codes and the lynch mob were spectres of the dark past.

Scott Burton, *Artist:* I am against removal of the piece. One argument I would like to add . . . is the issue of minority rights. If this were the work of an ethnic sub-culture, no one would dare to raise a finger against it. This work expresses the values of a minority culture and this happens to be the neighborhood, the locale in all America, of this particular culture, and if it were a racial sub-culture this [hearing] wouldn't exist.

Douglas Crimp, *Art Critic and Editor of* October: [T]his hearing is a calculated manipulation of the public of *Tilted Arc* in which we are asked to line up as enemies – on the one side, those who love it, and on the other, those who hate it and wish to destroy it. This hearing does not attempt to build a commonality of interest in art in the public realm. Although *Tilted Arc* was commissioned by a program devoted to placing art in public spaces, that program seems now to be utterly uninterested in building a public understanding of the art it has commissioned. This is not a hearing about the social function that art might have in our lives; rather it is a hearing convened by a government administrator who seems to believe that art and social function are antithetical, that art has no social function.

What makes me feel so manipulated is that I am forced to argue for art as against some other social function. I am asked to line up on the side of the sculpture, against, say, those who are on the side of concerts, or perhaps picnic tables. But of course all of these things have social functions, and one could name many more. It is a measure of the meagre nature of our public social life that the public is asked to fight it out, in a travesty of democratic procedure, over the crumbs of social experience.

Lt. Colonel Feist, *Deputy District Engineer of New York District Court on Engineers*, reading a statement by his superior officer, Colonel Griffiss: I would like to express my opinion and [the] opinion of the overwhelming majority of the Corps of Engineers employees working at 26 Federal Plaza that the sculpture known as *Tilted Arc* should immediately be removed . . .

As an artist myself, I am particularly offended by those who attempt to justify the preservation of this so-called sculpture on the basis of not interfering with or understanding the concept of the artist.

Whatever the artist's intentions, I find the work to be nothing more than a rusty wall of sheet metal completely out of harmony with the remainder of the plaza and with the beautiful building itself. Those of us who work here should not be required to live with such ugliness in the name of the artist's concept.

Franklin Feldman, *Lawyer, former Chairman of the Art Committee of the Association of the Bar of the City of New York:* If an aggressive artist can, not withstanding the public viewpoint, dictate the location of his work, it seems to me that the whole General Service Public Arts Program is in jeopardy. The program was not designed principally to benefit artists, although that may be a side result. The objective was to enrich the environment and to bring significant art to public places.

Philip Glass, *Composer and Performer:* This hearing itself seems to me outside the due process accorded to the creation of the work in the first place. When an authorized, approved, planned work of art is attacked in this way, I have to think that what we have here is a freedom of expression issue. In other words, the way I see it, a part of the community would like to deny Mr. Serra the artistic freedom which must be a part and necessary condition for his work as an artist.

Michael Heizer, *Sculptor:* This sculpture in front of this building is obviously a very successful work, because it is creating a response, and a very strong response. And it seems to me premature [now] that you have realised that, to even consider further any removal of the work. I think that now that the reaction has begun, it should be observed consciously and by everybody [during] at least a moratorium period. After these discussions, you will find that this sculpture is now also famous and you are going to have a hard time moving it.

Robert Allan Jacobs, *Architect whose work includes the Jacob K. Javits Federal Office Building and plaza:* I wonder what Michelangelo would have said if he heard this thing called sculpture had been placed in his plaza on the Capitoline Hill

in Rome . . . Gertrude Stein said something like a wall is a wall is a wall. Let's call this thing a wall, not a sculpture, and remove it from the very handsome, open plaza . . .

Joseph Lombardi, *Clerk, Court of U.S. International Trade:* The question you now must answer is why you should permit the barrier to remain as a source of annoyance to so many people. We may or may not be discussing a work of art. Art, of course, is in the eye of the beholder. However, without question, the *Tilted Arc* is a steel wall 120-feet long and 12-feet high, 1440 square feet of rusty steel, disfigured and blemished with graffiti and the evidence of your continual, never-ending efforts to remove the graffiti. It is an arrogant and domineering wall that, according to the architects [of the Federal Office Building] intrudes itself and completely spoils their original design.

If you have concern for the sculptor's right to freedom of expression, should you not also be sensitive to the artistic expression of the original architects who designed the plaza? They did not want another artist to change and alter their creation.

Virginia Maksymowicz, *Artist:* Public art is qualitatively different from gallery or museum art. A museum audience has a choice whether or not to enter the building in the first place; the public art audience, in this case the workers at Federal Plaza, *have* to live with it, every day. GSA made a mistake.

Rather than viewing the removal of Mr. Serra's sculpture as a defeat for public art, the Art-in-Architecture program should use this opportunity to revise, improve and strengthen their selection process. Public art cannot be arbitrarily dumped on a location without the input of its potential audience. Such arrogance can only hinder the Art-in-Architecture program in [fostering] respect for and understanding of the fine arts. . . .

David Novros, *Artist:* I left my studio this morning around the corner to come here to tell you that after 20 years of trying to paint on walls in public places and on ceilings in public places, the latest of which was one for the GSA in Miami, I would never accept another job if I thought I was going to have to be subject to this kind of interrogation and have to defend my work.

All that we get from the jobs is the opportunity to attempt to make something in a permanent space. If this can't be guaranteed, there is no point. . . .

Vickie O'Dougherty, *Physical Securities representative and specialist for the Federal Protection and Safety Division of GSA:* [*Tilted Arc* is] 120-feet long, 12-feet high and it's angled in a direction towards both federal buildings, Number One Federal Plaza and 26 Federal Plaza. The front curvature of the design is comparable to devices which are used by bomb experts to vent explosive forces. [*Tilted Arc*] could vent an explosion upward and in an angle toward both buildings. . . .

Shirley Paris, *Private Citizen: Tilted Arc* is the Berlin Wall of Foley Square and, like its prototype, it should have been knocked down during construction . . . It is, in my opinion, an arrogant, nose-thumbing gesture at the government, the

civil servants, and those of us who comprise much of the regular daytime population of Foley Square.

Herman Philips, *Representative of the Regional Office of the U.S. Environmental Protection Agency, and neighborhood resident of the Federal Plaza area:* There seems to be a debate about the artistic merit of *Tilted Arc,* but there should be little argument that it is in the wrong place. You've heard it before and you will hear it over and over again during this hearing, I am sure, that it disrupts the foot traffic across the plaza and because Federal Plaza attracts protesters, *Tilted Arc* has become a repeated target for grafitti.

In addition, it bisects one of the all-too-few open spaces in lower Manhattan. It places those of us who enter and leave Federal Plaza behind a 12 by 120-foot curtain, obliterating the view.

We have also read of the argument that *Tilted Arc* is so site-specific that to relocate it is to destroy it. Nonsense. One has only to walk six blocks north to the Holland Tunnel exit to another Richard Serra look-alike piece to see that *Tilted Arc* is not unique and that it is artistically strong enough to exist in a variety of locations.

Louise Reisman, *Resident, Middle Income Housing Cooperative, Chatham Green Houses, New York City:* As a citizen whose money you are spending and have spent, we have the right to say no. This piece gives us ulcers, not aesthetic pleasure. It is negative and useless. There is no idea, no humor, no educational value, no nothing. It looks barren, it is barren. It has the virtue of scrap iron.

William Rubin, *Director, Department of Painting and Sculpture, Museum of Modern Art, New York City:* The society as a whole has a stake in such works of art [as *Tilted Arc*], but certainly the consideration of any such removal should not be responsible to pressure tactics and above all not take place before the sculpture's artistic language can become familiar. I, therefore, propose that consideration of this issue be deferred for a period of at least ten years.

Mark Schulhog, *17-year-old student:* I feel it's a beautiful thing and I think many people do. As I said before, I am not an authority on whether it should be there or should not be, and I don't have any credentials as the people who have come here to speak before [me], but I feel that three years ago they decided to stick something there and it has been here for three years and it's a beautiful piece of work [that] they should leave there. It doesn't harm the community because art is something for people to look at and appreciate.

Roberta Smith, *Art Critic:* Serra is a great artist . . . the piece he has made for Federal Plaza is an exceptional example of Minimalism, that has already been very influential. The Vietnam Veteran's Monument in Washington, D.C. is a result of someone working with Serra's ideas. We have the real thing, the original, genuine article right here in our midst. . . .

Serra wanted a piece you could not ignore like a statue on a pedestal, a piece you had to look at and think about every time you came near it. It is not an escape from reality, but it does ask you to examine its own reality, its scale, its material and tilted sweep and the things around it. . . . It is not made in marble or bronze but in raw steel, strong and undiluted. It acknowledges generations of American steelworkers and the very basic fact of American industrial life in its very material.

When you really think about and look at the Serra, it tends to cast everything around it in a bad light. Its strength points at the weaknesses of the buildings around it. . . . The buildings behind it should be the real target of public outrage. They are the element that aggressively dehumanizes. This city and this nation are sinking in a rising tide of visual pollution, which this piece vigorously opposes.

Frank Stella, *Artist:* The government and artist have acted as the body of society attempting to meet civilized, one might almost say, civilizing goals, in this case, the extension of visual culture into public spaces. The attempt to reverse the effort serves no broad social purpose and is contrary to honest searching efforts which represent the larger and truer goals of society. Satisfaction for the dissenters is not a necessity. The continued cultural aspirations of the society are a necessity, as is the protection of these aspirations.

Donald Thalacker, *Director of GSA's Art-In-Architecture Program:* [T]he artist's efforts [in the Art-and-Architecture Program] resulted in the President's Award, the highest award in this land, offered, presented just 34 days ago by President Reagan for a decade of accomplishments of GSA's Art-in-Architecture Program. That final jury . . . cited GSA for its "intelligent willingness to sustain potential risks in the selection of artists." It concluded by saying that "installations that may have been judged by the press, critics and others to be difficult to comprehend are to be expected in such a courageous program and should be interpreted as an index for its continuing vitality."

John Weber, *Art Dealer:* [*Tilted Arc*] is a very important piece, I feel, internationally, in that it is one of the few pieces of sculpture in New York City – if not the only piece of sculpture in New York City – which was permanently sited with a specific area in mind. The design and the execution of that work took into regard the exact location of the work as opposed to, shall we say, somebody raising a certain amount of money and going out and buying a Henry Moore or something that can be conveniently put on a pedestal in a park, without regard to the specific situation.

Should not attention be paid to attempting to educate the general public about the work? [P]erhaps there could be some information placed nearby the piece, which could convey in non-complicated vernacular what this work was all about, instead of just depending upon people's reaction to it very coldly.

Michael Weyrboff, *First Vice-president, American Artists Professional League:* There is nothing, nothing, to justify the title "work of art" in this piece of scrap iron, and that's all there is to it.

Art & Artists, May/June 1985 [Vol. 14, No. 3] Excerpted

Post Script: *Tilted Arc* was removed, but not until Serra had sued unsuccessfully for an injunction on the grounds that removal

violated his first amendment rights. Subsequent newspaper accounts reported that concerts and other lunch-hour festivities were being held in Federal Plaza by the liberated populace. But time seems not to have healed the wounds. Art advocates still refer to the episode as a landmark example of "the public" against "art."

'85 / #176

How *Do* You Pick "Public Art"?

If the accounts that crossed my path were typical, "Tilted Arc" was not art *journalism*'s finest hour either, except for tiny *Art &Artists*. For instance, *The Journal of Art* printed a screed by Frank Stella that adopted a "news" format, but cast the story in terms of *Nazi Fiends from Hell Destroy Western Civilization*. A reader uninformed by other sources would have had no inkling of any grounds at all for removal of the sculpture, let alone any that "a person of culture" might entertain. *Art in America* ran a nine-page *cri de coeur* by Serra claiming permanent "moral" rights to his work, and by extension, its site. In a later issue, a letter-to-the-editor suggested artists' permanent rights on public or private property might not stand up in court. That was *AiA*'s entire "coverage."

During the controversy, however, New York's Sculpture Center sponsored a panel of artists who do public sculpture, four of whom prepared subsequent statements on the topic. These, appearing originally in *Art & Artists* and excerpted below, seem to have been the only published criticism by artists, however discreet, of *Tilted Arc* – or more precisely its siting and selection process. Refreshingly, they also suggest other criteria for public art than, "if they hate it, it must be good for them." (For more comments on "public sculpture" see '81/#156.)

"What Is Public Sculpture?"

Moderator: **Elisabeth Munro Smith**; Panelists: **Nancy Holt, Stephen Antonakos, Joyce Kozloff, Athena Tacha, Jay Coogan, Jackie Ferrara**

The Sculpture Center, NYC; March 28, 1985,

Nancy Holt: The way out of this situation is not at the very end (as in the Serra case), but in the beginning, in the selection process.

If you're really involved with public art, the desire is there to develop a strong sense of place, which includes the sociology and psychology of the area as well as the topography, built environment and local history. The art that emerges . . . will be integrated within its context.

Ideally, a public artist should be chosen by a committee of both local and national members who are genuinely concerned with art in the community. In the case of large commissions, where there is a need to demonstrate experience and ability to carry out a large-scale project, only one artist should be selected from a review of past work of many artists.

A contract should then be negotiated which guarantees that if the artist's first proposal is rejected [he or she] has the option to propose another. However, every effort should be made to accept the artist's first proposal. Once a proposal is approved by a committee representing different segments of the community, as well as art experts, ways should be found to introduce the artist's ideas to the local populace. This may include public display of the model and/or drawings, interviews with the local media, and public lectures.

Stephen Antonakos: The question of educating the community and the responsibilities of artists and selection committees is a very large one. The timing is always important.

At the beginning, when the artist and the site have been selected, I feel it is good for the artist and the selection committee to reach out to interested people in the community: art professionals, administrators, museum people, etc. We can talk to them, participate in panel discussions, show slides. Understanding the artist's background and ideas is the best preparation for an appreciation of new work.

Of course, an artist wants to take his ideas further with every new work, and in addition will be dealing with all the new elements of a particular site, so it gets difficult for people to "follow" sometimes. But those who are interested will.

Later on, once a work is finished, is usually when resistance occurs. This is a time when the selection committee can be very helpful, as well as the artist. They are ideal spokesmen for the work. And of course at this point, the work itself is there to help. And naturally, those in the community who want to support the work against the opposition are extremely important. Every thoughtful voice for art is valuable.

Joyce Kozloff: I like making my art for a broad audience and have learned more from the responses of people in the subways than I've ever learned from gallery-goers.

In each project I've dealt with the history of that site or city. The biggest challenge has been to communicate without pandering. I wish to involve the public in the work, and to make people more aware of their environment as a result.

Athena Tacha: Educating the community is essential. This can be done through the media, as well as through the selection process. But the artist must be willing, if she/he chooses to be a public artist, to do PR work and to educate the local people – not to disregard or offend them. The attitude of the artist, if she/he cares for the public and is sympathetic to it, will not only facilitate explication of the work, but lead to art that is compatible with public spaces to begin with. Unfortunately, the committees of art experts are often not conscious enough of public art issues to choose the right kind of artist for a community.

In relation to the present Serra controversy, I believe that both the artist and the community are right: Serra's work should not be dismantled or even moved elsewhere, since he was selected to create it for that site. On the other hand, people who work around it have the right to object to facing every day a work they find offensive to their sensitivity

and spoiling their plaza. The fault lies with the committee that chose Serra for the site. I think he is one of the best artists living today, but not a public artist. His work is appropriate for a museum's grounds, or a private collector's land, i.e., for an art-educated public, but it is too intransigent for the large public. I think this stems partly from the issues he is dealing with, and partly from his personality. As far as I can see, Serra has no love and sympathy for the common public. To be a public artist, one has to be interested in accommodating one's vision to reach the masses. Without compromising the quality of one's art, one can do that; one can find ways of expressing one's vision that are compatible with public sensitivity, or at least do not offend it.

In response to Nancy Holt's comment that ideally only one artist should be invited to create a proposal for a particular site and community: this is certainly a good way of going about it, but I think that competitions are equally good. I have won most of my commissions from competitions, and I have lost many of them too. Even when you lose, you learn something new from having made a proposal for a different site and community. In that way, public art is like architecture: architects are used to submitting their work to public competitions. I think this is a more democratic process (which is important when public funds are involved) and it gives the community a better opportunity to select something they like.

I find best the method of selection the late Doris Freedman (founder of the New York Public Art Fund) developed: A committee of art experts (local and from outside the area), which includes representative members of the community, chooses a few finalists whose work seems appropriate for that site and public. Each finalist makes a proposal in model form, and is invited to come and explain it to the community. Then the community votes on the proposal it likes best.

Art & Artists, May/June 1985 [Vol. 14, No. 3]

'85 / #177

The Art Talk That Ate New York

Another '80s workshop on spinning art into gold – and as motley a collection of speakers as one could imagine, even on such a fey topic. As it happens, my community and I recently had dealings with one of them – the representative from the Port Authority – only instead of "Arts as an Industry," she detailed why our historic district should be trashed for the benefit of the Port Authority. That report, with figures and measurements and citations, was, as we proved in court, a complete fiction, but it served the purposes of those receiving it and became fact. Such diddling is of course hardly news in city politics – or in business and real estate either, as we see increasingly in the papers these days. But in art? Let's just say the figures here sound official, for what that's worth, but don't bet the farm.

On the other hand, at least from my limited experience, Alexandra Anderson-Spivy's rundown on the workings of the art market can be taken as a marvel of acute reporting. That is, you'll love it – and relish the hindsight.

"What Price Art? The Economics of Art: An Agenda for the Future"

Co-Chairs: **Kenneth Friedman**, publisher of *The Art Economist* and **Oscar Ornati**, Professor of Management, NYU; Speakers: **Noel Steinberger, Rosemary Scanlon, William Baumol, Michael Montias, A.D. Coleman, Dick Higgins, Ed McGuire, Martin Ackerman, Marshall Kogan, Alexandra Anderson-Spivy, John Czepiel.**

NYU Graduate School of Business Administration, NYC; April 26, 1985

Titled "What Price Art", and provocatively subtitled, "The Economics of Art: An Agenda for the Future," the conference promised to explore the economics of the visual arts market, with practical details on costs and price structure provided by "national experts in economics, finance, law, public policy, art and journalism."

Noel Steinberger, V.P. of marketing at Sotheby's, the world's oldest auction firm, identified key players in the art game as the media, banks, auction houses, and galleries (notice omission of the artist).

Rosemary Scanlon, a discussant and chief economist of the New York-New Jersey Port Authority, described her recent study, *Arts as an Industry*, made to determine value and economic impact of cultural industries (including theatre, dance, music, film, TV, and visitors to NYC, but not the city's art sales or art inventory) on the metropolitan area. Her "conservative" estimate was 5.6 billion dollars. Although hard data is lacking, world-wide transactions in the visual art market are estimated at over $25 billion annually.

Scanlon's presentation was followed by floor discussion of the art customer. The important role of the press was briefly touched on as "shaping tastes and spending habits." Recent studies estimate the number of U.S. art critics at over 2,500; *Art in America* has counted more than 2,600 critics among its own subscribers. Assuming an equal number might *not* read *AiA* could bring the total number of art critics to more than 5,000.

Dr. William Baumol, professor of economics at Princeton University, and a collector himself, described the art market as an "imperfect market," i.e., not behaving in a predictable manner, as financial markets sometimes do not. Therefore, he said, "there is no rational way to assign value or to invest" (except, of course, on an aesthetic level). Price information, he said, is beside the point. An unidentified speaker contradicted him on that claim, asserting that price information is "needed for literacy and curiosity." Baumol added that "the elasticity of supply" is zero for deceased artists and "the holder of a single piece of art has a monopoly on that item," so the supply of art is fixed.

Michael Montias, professor of economics at Yale University, rejected the inelasticity theory, claiming existence of a "large supply of paintings on walls, in attics, and museum basements." New interests (and rising prices) in specific periods cause hitherto unknown works to surface.

A.D. Coleman, photography critic, added that values change, using as example that Van Gogh's painting (auctioned the previous evening for $9.9 million) was no longer what Van Gogh had painted; it has since been _certified_ as a work of art.

Dick Higgins, writer and artist, noted that "art is one of the only commodities routinely produced at a loss."

Ed McGuire added, "The artist does not profit by art, galleries do, museums do, and the collector who uses it as a tax shelter does."

Then the topic of whether or not art business and art galleries are profitable, or doing better than in previous years, was tossed around for a while. The editor of _City Business_ quoted a dealer as saying, "a good dealer is one who breaks even and puts in his basement what he thinks will increase in value." The director of the Berry-Hill Gallery dismissed this as nonsense, saying "any serious gallery" does very well financially.

Martin Ackerman, attorney, addressed tax policies and changes in tax law by which the Internal Revenue Code says, in effect, that "in death the work of an artist is valued at appreciated retail value, but in life it is valued at the cost of material. This, obviously, has caused artists and their estates to liquidate or even destroy large portions of their work to avoid these unwarranted and unfair tax burdens."

With allowable tax deductions for donations of art restricted to "adjusted costs," museums report drastic reductions in gifts from artists. The Whitney received 142 works in 1969 and 17 (of which 13 were prints) in 1970; MoMA received 47 in 1969, none in 1970. Although art collectors have not yet lost the privilege of this contribution, they frequently encounter hostile questioning by the IRS as to "fair market value." (Ackerman believes this stems from a probably well-founded IRS belief that all contributions are overvalued.)

Marshall Kogan, CEO of GFI/Knoll Industries and noted collector, mentioned the amazing growth in museum attendance since the '70s. He also pointed out that 875,000 people earned over one million dollars in 1985, suggesting that, as income rises, the value of art rises too. Kogan's recommendation to collectors was to buy "the most extraordinary piece of work available." He saw a decline in good works of art, attributing current "extreme increases in price" to this scarcity.

John Czepiel, associate professor of marketing at NYU, quoted something he had read, "It ain't art unless you have the urge to possess it."

Kenneth Friedman, co-chair of the conference, summed up: The art market is poised on the edge of profound change. This is a market moving from its cottage industry phase into something radically different. All other factors in the

economy being equal, I predict that the dollar volume of the art market will increase at a rate far better than inflation during the next decade. If this is so, we're going to need – and we're going to see – studies in everything from client service by art dealers to credit financing for consumers, from information services, to investment opportunities in the art industry.

Perhaps, however, the clearest indicator of art's new financial status is simply this conference itself. New York University's School of Business hosted a conference on "art." Footing all bills, it invited press, dealers, consultants, lawyers, collectors and bankers to attend as its guests – _but no artists._

– Cynthia Navaretta

Women Artists News, June 1985 [Vol. 10, No. 4]

The paper excerpted below, an explanation of how to "make a market in a living artist's work," was a highlight of the conference. Further details appear in Ronald Feldman's truth-in-jest advice later in the year ['85/#180].

"What Price Art? A Market of Mirrors"
by Alexandra Anderson-Spivy
NYU Graduate School of Business Administration, NYC; April 26, 1985

Art is a conveyer of status, a vocabulary of power. Men and women of wealth and influence, after they have acquired their money and power, need signs and symbols of their importance. Collecting art is often a way to gain entry into a desired social stratum. . . .

How do dealers "make a market" in a living artist's work? With virtually any new painting commanding an entry gallery price of $1,200 to $2,550 (sculpture begins a bit higher), there are price thresholds that a new or unrecognized artist must break through as he or she goes up the ladder. Assuming the dealer truly believes in the quality of the work, he [sic] must publicize this belief through exhibitions, critical reviews, word-of-mouth. . . .

Dealers try to get their artists' work seen by museum curators [and get] well-known, serious collectors to buy. Many galleries will only release works by certain artists to certain collectors, recognizing the Doppler Effect of those collections. These collectors are also likely to be on museum boards and to encourage recognition of artists they favor at those institutions. 10% or 20% discounts [or more] off quoted prices to valued customers are common. (I have heard it rumored that some sales are made at up to 80% off quoted gallery prices.) Sales to museums at far-below-market prices will permit the dealer to jack up subsequent prices. The aura of market activity can also enhance an artist's reputation and build market interest. There is a high risk-high reward factor . . . Collectors repond to the idea of buying a hot young artist's work at prices which will escalate rapidly. The idea of investing in contemporary art is rather new, and one which reputable dealers claim they do not use as a sales tool. But the media attention given such artists makes that kind of hard

sell almost unnecessary, since speculation becomes a tacit factor in everyone's mind.

About three years ago, I noticed a brand new painting by Jean-Michel Basquiat hung in the loft of a famous artist. He said, "this time I wanted to get in at the beginning. I'm tired of seeing the collectors make all the profits." In three years, Basquiat's prices have risen precipitously. Sales to major collectors also build an artist's image and thus allow his prices to rise. Once an artist's reputation is established, the auction house may play a part. Sales at auction are not only important exposure . . . they publicly ratify prices. Dealers have been known to put up a work at auction and buy it back themselves simply to establish a price. . . . If works are "bought in" (i.e., do not reach their reserve price), a certain superficial credibility of price still remains to the public at large. However, savvy collectors who follow auctions closely may then consider a picture "burned," thus making it harder to sell subsequently. . . .

Because the "value" of a new work is in fact so much a matter of opinion, those who wish to participate in the game soon discover that becoming an insider, i.e. having access to the informal as well as the formal network of information about the art, is crucial. . . . In the oddest way, works of art achieve value because certain individuals in certain sectors of the system decide they are valuable, but much of what goes on goes on behind the scenes. . . . An artist whose production is very small or who shuns the publicity machine [may not achieve] "brand name" status. [Yet] in the long run . . . mediocre pieces bring mediocre prices and great works bring ever-greater prices.

Another market factor is the "auction ring." A group of dealers interested in the same material agree not to bid against one another, assigning one to bid unopposed. After the sale they re-auction the things among themselves. [This] is strictly illegal. But, when done skillfully, it is almost impossible to uncover. Auctions have also been manipulated in another way. Dealers bid up prices of their own artists even if they themselves have to buy the work. Then they can claim the auction price as ratifier of prices in the gallery. Or it may be arranged in advance to have people (assigned to go up to a certain price) bid on a work, thus pushing up the price.

In recent years, auction houses have attracted a much wider public, often competing with the dealer for the collector's dollars, so that antagonisms between the two have surfaced. Large advertising budgets, increasing media publicity, glossy catalogues, and an aura of theatrical glamour attract high rollers to the auction rooms (recently refurbished) of Sotheby's and Christie's. [R]ecord-breaking prices are touted widely, while heavily bought-in sales are played down whenever possible. Auction houses have learned how to use the tools of modern marketing. Michael Thomas, a former investment banker, in a column about the forthcoming Sotheby's sale of pictures owned by the late Florence Gould [wrote that] "advance publicity would have us believe that the equivalent of the Jeu de Pomme or the Phillips Collec-

tion are being disgorged at auction, but by and large . . . the pictures are pretty and accessible, just the kind of thing with which rich Arabs like to decorate their Home County mansions."

The combination of hype to create demand that takes advantage of ignorant, cash-heavy, status-hungry consumers of art is hardly a new one, though it may operate more widely and efficiently than in the days of Duveen and Berenson. Policies of full disclosure for critics, scholars, and curators (to reveal any vested interest in art they write about or curate) and for dealers and auction houses might go a long way towards correcting the abuses of the art market as we know it. Meanwhile, *caveat emptor* remains sound advice.

Women Artists News, June 1985 [Vol. 10, No. 4]

'85 / #178

Il n'y a pas de Cordon Sanitaire

Artists of the 1950s were demoralized when the aroma of money and hustle entered their enclave of pure spirit. The '50s, of course, were Arcadia compared to the Brave New Art World of the 1980s. In a paper excerpted here, June Wayne eloquently, candidly, wryly, appraises today's mindset in the light of the changing culture and the unchanging risks of innovation.

"Avant-Garde Mindset in the Artist's Studio"

An address by **June Wayne**

Conference on the Avant-Garde in Literature and Art, Hoffstra University, 1985

I study the unfinished image from every angle, including in reverse in a mirror, a habit picked up making lithographs. . . . Is there a conflict between the concept and how I am expressing it? Or, God forbid, has some distraction from the art world breached my *cordon sanitaire*?

Such a breach occurred via the morning mail when the invitation arrived: The Avant-Garde in Art and Literature, 1985. I was annoyed by the subject, which is a loaded one for me. But even as I dropped the letter into the waste basket, the date of the conference was registering. I would be in New York anyhow, for the opening of my show. The visibility might be useful. I fished the invitation out of the waste basket. Expedience had me by the throat.

So began a desultory, unscientific polling of my west-coast friends to find out what "avant-garde" meant to them. Several art historians described the Avant-Garde Movement of the early 1900's, and one reserved the phrase for that usage alone. A couple of critics inquired if I meant avant-garde with a capital A or a small a, doubling the opportunity to pontificate. A noted curator mentioned every style from Im-

pressionism to now, using *original, vanguard* and *seminal* as synonyms.

Continuing my research, I invited some older artists – that is, artists of my age – to the studio for supper. After we had gossiped through the current art scandals, I disclosed that I was going to speak at this conference and needed to hear what "avant-garde" meant to them. They looked at me with shocked astonishment. To whom was I going to speak on such a foolish subject? "To critics and art historians," I told them, "maybe curators. I don't expect artists." Their surprise deepened into contempt. "It's *their* kind of subject, all right. They don't know what it means even when they use it, let alone when *we* do. *Which we never do.*" My pals were quite put out by this turn in the conversation and lapsed into derisive muttering. I had fed them for nothing, and lost status as well.

A month rolled by without my putting a word on paper. Then, at a wedding, I found myself with a group of artists, all under thirty. They were ready, even eager, to talk about the meaning of avant-garde, or about anything else having to do with "making it big out there." *New* was their synonym for avant-garde. Is Neo-Expressionism new or just a rerun? Many styles came up: Hard Edge versus Minimal; Concept versus Performance; Feminist versus Neo-Realist. Dada and Pop did not surface: they had dissolved from movements into climates. Op was missing too: it had fallen off the edge of history, as had Constructivism and the Avant-Garde Movement itself.

The young artists spoke in a mixture of street slang and art jargon: GRODY, GROSS, BAGO, JAMA, WITH IT, CUTTING EDGE, BREAKING NEW GROUND. Each was sure of OPENING A NEW FRONTIER, HAVING THE RIGHT TIMING, and KNOWING THE NEXT BIG MOVE. (No one mentioned SEMINAL, for which I was grateful.)

When my career was starting in the outback of Chicago, there was no market for the work of living American artists. By the late '30s, in a New York loft on West 21st Street, I, like the other artists, had ideas, not collectors. There were two imperatives – to paint and to get the money to go on painting. We weren't so idealistic that we couldn't have been corrupted, but there were no credible seducers. Undistracted by the possibility of success, all attention was on the work and boldness knew no limits. To show my newest painting to another artist was like showing a griffin I had caught while hunting. There were no critics weighing it, no curators measuring and stuffing it. There were no other griffins to compare it to. Isolation made the griffin possible.

By contrast, my young artist friends live in a crowded art world that they perceive as inviting, imaginative, and permissive. Certain kinds of experts run it, finding, showing, buying, selling and writing about objects that the young artists intend to make. But aside from its special costuming, the art world is actually a conventional social structure which approximates that of other industries, including science, technology, manufacturing, education, and even government.

The young artist follows a well-marked road through art school, toward grants and public commissions, into gallery stables by way of group and solo exhibitions, gathering reviews, catalogs and *vitaes* along the way. The next step is into museum and private collections, from which a place in history beckons. It is, after all, The American Dream, not discredited and tattered as in some other sectors, but rosy and achievable if only one "wants it bad enough and works hard enough."

Those of us who occupied the crude and simple lofts of frontier days saw the culture-loving population grow, moving closer and closer until it acquired all the real estate around us. We welcomed these interesting, attractive neighbors, even though from time to time they seemed a bit inquisitive, almost intrusive when they let us know, *sotto voce*, what appeals to them as art lovers, their criteria versus ours. A spartan concentration on the work became hard to hold with so many voices coming through the walls.

The artist population also has grown. Some old-timers have been recognized and make a handsome living. The rest have hunkered down, working doggedly, ignoring the neighbors, who ignore them as well. The Baby-Boomer artists have one foot in the studio and the other at openings, trying to reconcile creation with commerce, studying the art magazines for tips. Some of the young ones, fortified with a semester of career management, wander into teaching, or writing reviews, or other by-ways from which they seldom return. But famous or obscure, star-struck or cynical, the artists keep picking off the labels which trivialize what they do and imply that the verdict is in.

It seems to me that every artist is partly an innovator and partly a consolidator. The innovator, alone and self elected, pursues a private vision without the slightest assurance of finding anything worth the effort. Unlike the game that leads your pencil from dot to dot until a predetermined picture emerges, the innovator leads you, cue by cue, to a visual experience that did not exist before. On rare occasions, on faith, the innovator makes an art that stands both as hypothesis and as proof, doing it seamlessly so that concept and expression are inseparable.

But sometimes the innovator's vision presents itself in semi-realized condition as though there wasn't time enough to make the case in full. At that point, a consolidator, unburdened by the effort of discovery, may well bring the new vision to a full and even remarkable expression. In effect, the consolidator fulfills the implication of another artist's work and may even be credited with the discovery. The displaced innovator is not surprised by such a turn of events, having intuited the danger long before the fact – which accounts for the pissed-off disposition of certain artists.

Most people invent nothing at all, so they don't know how hard it is to make so much as one conceptual advance. To make two or three is protean. Marcel Duchamp provides the elegant, archetypal example: he made several contributions in a small number of innovative works that were fully realized.

Then he played chess for the rest of his life. That is pure avant-garde mindset.

When an artist invents a way of seeing that is virtually without precedent, its acceptance will be impeded in direct proportion to its strangeness. It is easier to promote a style in which familiar elements dilute the new. This is a fundamental tilt toward re-presentation of an already accepted direction. To overcome this bias, the launch and normalization of a new aesthetic will need three kinds of specialists whose interest in the artist peaks at roughly the same time: a dealer, a critic and a curator. The dealer must have capital and an international clientele. The critic must be prestigious. The curator must command the stage of a major museum and its collector/trustees. (No artist will have more than flickering visibility without these three systems in place at one level or another.) Although such a collaborative push seems failure-proof, in fact an aesthetic does not always "take" no matter how much the critic, curator and dealer appreciate the artist. So they use their chips with caution: One equivocal outcome is one too many. Even the hardiest professional can ill afford an imputation of questionable taste or a so-so eye.

A work of art that moves beyond the known must be very tough to survive the rigors of its own discovery. It will be praised for its most superficial attributes and reduced to an attractive package. An art that can withstand such implosion either has no substance at all or is so profound that it can hibernate until, rediscovered by an accident of time or passion, it unfolds to full dimension. Rediscovery may be the real discovery. Then, with benevolent hindsight, the artist is invited to the head of the line at MoMA, while somewhere in unknown territory and risking everything, another artist-innovator is riding point. . . .

Women Artists News, Spring 1986 [Vol. 11, No. 2]

'85 / #179

Bearing the Bonds of Freedom

"The Spiritual in Contemporary Art"

Moderator: **Jill Baker**; Speakers: **Noa Bornstein, Barbara Nathanson, Jean Edelstein, Sylvia Glass, Karin Swildens, Todd Friedlander**, others

Artists Equity Association, Eilat Gordon Gallery, West Hollywood, CA; December 3, 1985

45 minutes of discussion have already passed:

Karin Swildens: Today we are surrounded by acceptance. Art used to be defined and you never questioned the limits within which you were working. You learned it and then you did it, even in the Renaissance. Today you can put a blob on

a paper or a board or on whatever, and look at it with admiration, and say to yourself, "This is Art." And someone else is going to accept it as Art.

Jean Edelstein: Our culture says we have freedom. But artists in early times also thought they had freedom. When they were doing creative things, even among the ancient Egyptians, some did better work than others. That was their freedom.

Swildens: Yes, but they were not conscious of it. In those days there were rules and you could follow them and feel free without the consciousness of being limited.

Todd Friedlander: Ancient art was either decorating a temple or doing a meditative painting or had to do with magic or the supernatural. It had a purpose. The artist was employed by a culture to perform these tasks. In our own culture that's been stripped away from the artist; so now, in isolation, you're working in the studio without the purpose, without the instruction or the context. That may be freedom or it may be its opposite.

Noa Bornstein: Art has been cast out of the rest of society. We're bent on getting to the moon. . . .

Swildens: It's much easier to work in a context. It's more difficult to stay on your own and work.

Edelstein: We say people before us didn't have freedom, but they had a universal language that communicated with people. Today each artist must search and find his or her own language. . . . Then artists had symbols the whole community understood.

Sylvia Glass quoted April Kingsley's catalog essay for the New York exhibit, "Spiritualism: Transcendent Images in Painting and Sculpture," to the effect that different periods of art show spirituality in different ways:

> Art concerned with the spirit displaces many of the characteristics of other modernist art. There is no overt religious content, no humor, no irony and no deadpan campiness and it is not basically decorative or expressive. . . . Color and form tend toward dematerialization – pigment as such is de-emphasized – and the effect is closer to that of stained glass than encrusted canvas. This is largely true of the New Spiritualism.

However, Kingsley says, there are also thickly encrusted paintings, there's tremendous emotion, there's an icon, a central image. By the end of the article, "it becomes clear that the New Spirituality is not vastly different from the old one. . . ."

Audience: Are there other artists in the contemporary art field you consider "spiritual" in terms of their art?

Bornstein: Well, oddly enough, I'm going to say Chaim Soutine, who died in Paris in 1943. His painting is just full of guts and emotion, distorted, and yet for me he's got it – the essence. I would use the phrase "the Essence," the soul of our being, but that includes the mesh of flesh and soul that we are and that we struggle with.

Edelstein: Two people come to mind immediately: Rothko, who struggled his whole life to create what he felt spiritual painting to be. The other would be Matisse. When I saw the Matisse exhibit at UCLA I felt I could just go out and do

something special. He was lifted by his joy and color and that was an important addition to art.

Glass: Did anyone see the Martin Puryear show at Margo Leavin Gallery? He does large forms that sort of look as if they come from some other place . . . some kind of place that you could go into. And yet they're really not.

Nathanson: And Albert Pinkham Ryder. . . . There is always something just about to happen in his work.

– Betty Decter

Women Artists News, Spring 1986 [Vol. 11, No. 2] Excerpted

'85 / #180

The Market is the Moment

This serious-humorous examination of the art and craft of art marketing clearly engaged the panelists, who frequently all talked at once, as well as the audience, which laughed and applauded, and asked some questions, not because it didn't know the answers, but because it did. Ronald Feldman rendered a wicked riff on how the art market, nefariously, operates. But Leon Golub, self-styled "old timer," who ought to have been the most cynical of the lot, hinted at possible "substance," or other mysterious factors that defy market manipulation, or even analysis.

(And let the record show that the woman in the audience who asked if anyone besides *Women Artists News* ever looked into which artists got reviewed, and why, was not known to us – although we're glad she noticed.)

"How the Marketplace Gives Form to Art"

Moderator: **Lynn Zelevansky**; Panelists: **Dara Birnbaum, Ronald Feldman, Leon Golub, Richard Kostelanetz, Amy Newman**

Artists Talk on Art, NYC; December 6, 1985

Moderator Zelevansky introduced panelists as follows: Ronald Feldman, co-director of Ronald Feldman Fine Arts Gallery in New York since 1971; Dara Birnbaum, artist and independent producer, the only video artist in the Carnegie International; Leon Golub, well-known painter; Richard Kostelanetz, essayist, anthologist and multi-disciplinary artist, engaged in the worlds of both literature and fine arts; and Amy Newman, managing editor of ARTnews.

Lynn Zelevansky: The question, "How the Market Gives Form to Art," is one I ask not at all cynically. I think it's *the* question of the '80s and a difficult one to answer. My premise is that the drastic change in the art market over the last 20 years has effected a change in the condition of the artist as modernism defined it, that is, as outsider. The artist's life is still difficult, the speculative nature of his or her work remains the same, generating insecurity and so providing a continuum with earlier times. However, today, opportunities are far more numerous than they were two decades ago and

this seems to have reduced the artist's identification with the marginal.

In a period like this one, which is basically tolerant of all kinds of different styles, things like pink hair are vestigial references to anti-bourgeois lifestyles, rather than a real affiliation with marginality. The adoption of more conventional material values must affect the form of 1980s art, just as the artist's oppositional stance impacted on the form of earlier work. Today, references to comics, movies and cartoons ally current art with mainstream culture, rather than functioning as social commentary, or denoting an anti-high-art position as they might have in the past. Another example of contemporary art's alliance with the mainstream is the re-emergence of large painting, an emphatically material form of art, as a central issue of the artworld at the beginning of the Reagan era.

I assume that the huge growth in the marketplace influences all of us, regardless of our values or the form of our work.

Amy Newman: I think the issue is to a certain extent specious, for two main reasons. First, artists have always produced for a market of one sort or another. Nearly without exception, art aspires to a condition of creating an impact, whether commercial or ideological. I don't think the marketplace for *ideas* is any less tyrannical than the financial market. Just as many people are willing to be corrupted for reasons of moral, ideological, and philosophical influence and stature, [many] are willing to be corrupted for financial reasons. How extraordinarily rare is the artist, and I don't think I've ever encountered one, who works without concern for whether the work is recognized or discussed, even if he or she doesn't care whether it's sold.

The second reason I think the issue is specious is that for art to be interesting, the work must have something to do with its historical moment – distill or crystalize, reflect or reject, embrace or expose it. The presence of one of these facets doesn't necessarily make the art good, but the absence makes it vapid. And today, certainly in the west, the market is the moment. The culture is surely permeated with conditions of the marketplace, as the 14th century was conditioned by belief in the power of religion, and the 16th century by belief in the power of man, and the 19th century by belief in the power of science.

That said, certain factors are troubling about this relationship and I do have some random thoughts on the issue. Our culture, and increasingly that of the rest of the world, revolves around information, image and effect. This is what the marketplace trades in and what consumers consume today, even more than tangible goods. And this is why, with the frequently (but not always) ingenuous collaboration of the media, the market is so all-pervasive, and why I consider the market is the moment.

We hear frequent complaints that information, image and effect can be conveyed and purveyed with very little substance, but "substance" is a [tricky] concept in this context. Does it have any meaning beyond a certain nostalgia? Substance has profoundly different meanings in different eras,

and we're now in a different era. What we can perhaps say is that "substance" in some way confronts the questions of the human condition, and that is in fact what the best contemporary art still does – precisely when it is shaped in some way by the marketplace.

Certainly the rampant insecurity of taste and the nefarious atmosphere of financial speculation that characterize the market moment can be devastating and abusing to the artist's ego. We sometimes forget when we talk about abstractions of the market place that we're talking about people, and I guess the audience does frequently have unfair, heroic expectations for artists. [But] we all have to face moral dilemmas and make moral decisions, no matter what profession we're in.

What the marketplace is giving shape to is not the physical aspects of art, as frequently happened in previous eras, or not as much, but the more general conception of art. Art has become a generic catch-all term. It has never before subsumed so many different forms and ambitions. . . . Today we erase almost all distinctions of purpose and ambition and that [affects] the function of the market.

Creativity goes along in its myriad ways, as it always has, with different ambitions as to psychological profundity, cultural profundity, humor, decorativeness, ability to communicate, ability to intervene in contemporary life. The market tries to erase all distinctions. The levelling is certainly also an outgrowth of the '60s and '70s challenge to so-called "fine" art, which should have been and in many ways was a very valuable and beneficial process.

The challenge to rigid definitions opened a wide spectrum of experience to a new level of contemplation. [It also] had, not only the effect of making alternative investigations and manifestations more meaningful; contradictions of the original impulse made them more valuable . . . We found that the status quo of the market culture was more powerful than the challenge. So while it's certainly true, as Carter Ratcliff says, that the market is instrumental in forming the image of the artist, and that has to do with celebrity and fashion and speculation, we also can say that many of today's serious artists do have an adversarial position to the prevailing mainstream culture – the market – in that they are trying to reassert the distinctions among kinds of goals and ambitions.

Kruger, Holzer, Borofsky, Haring, Scharf, Greenblat, Salle, Longo, Clemente – they're not all aiming for the same place in our minds and our lives, as much as the market would like to purvey them all as an homogenous product. **Leon Golub:** The art market depends on glamor and scarcity, particularly today. The two work together – you can almost identify one with the other. Scarcity means that if someone wants to collect something, he or she is told there aren't too many of them. "This is a prime optic of a prime artist, and you may have to wait in order to get it." [But] scarcity makes us avid. We want it. If there's too much of something, we don't need it. Glamor is the same thing, because glamor says that some people have it and some people don't.

Certain old-fashioned romantic artists [projected] talent or genius, but today we depend on glamor. So artists outshine movie stars . . . They become, more than movie stars, people to get to know, to associate with. There are artist groupies for that gold dust, which is sprinkled on them in a psychological sense. I once tried to call Roy Lichtenstein about a project and I got the wrong number. I said, "Is this Roy Lichtenstein's home?" and the woman said, "I wish it was"!

This is not necessarily a new phenomenon. . . . Art was taken up by the Popes and the Medici – and they gave it glamor too. Art was extremely glamorous in the Renaissance. And that aristocratic aura, that notion of serving public power at the highest level, is translated into the peculiar forms of our day.

But art has always served power. Whether you serve the Roman Emperor, or the church, you're still serving power. Image makers make the kind of pictures, signs and symbols that are called for. If they get out of line, they won't get commissions . . . Most artists eventually fall into line.

The avant-garde was able to move the struggle away from the political and social aspects, which got mixed up in the 19th century, into another sphere, the so-called autonomous sphere. You could be allowed an aesthetic transgression, even if you were not allowed a political, social or public transgression. [Think of] the history of Courbet or against the history of an artist who changes the sense of form. Not that the change of the sense of form doesn't have political aspects as well, but it's more abstracted. Which is why we have abstract art. . . .

Under modernism, you get all kinds of accruals and additions, from technology, for example, TV, telephones, film, photography, satellites. These change imaging. All these accruals bounce against each other, which is part of the atomization. You get a kind of open-ended market, which does permit a certain kind of – a word a lot of people don't like – pluralism. . . .

You can take different aspects of the modern world, whereas in the medieval period, the world was one direction, and developed more or less in a vertical or linear fashion. So the market today is a special kind of market, but the conditions of control and power are still there. [T]hese accruals have weights, entropy, they all disperse at the same time. All this is going on, and may even give you some elbow room. **Ronald Feldman:** I have two sets of slides to show two aspects of the marketplace. First, the work of a particular artist. I will read criticism he has had over the years to show the conflicting nature of art opinion and the incredible perversity of the market place. The artist is Joseph Beuys.

Quote: "It would be strenuous to explain to museum goers that Abbie Hoffman was the most brilliant performance artist of the '60s and '70s and it is equally difficult to explain the similar genius of Joseph Beuys."

Another reviewer: "If there were an American artist as political as Beuys in his activities, would an American museum turn over almost its entire exhibition space to him or her? I doubt it."

Another declared a Beuys show the "worst European modern master retrospective," saying, "Beuys is in the business of selling himself. He really doesn't do anything. So his career boils down to public relations, but he has no point of view to express."

Another quote: "But when all that is said, Joseph Beuys is at the very least a valuable absurdity in a world that is locked into the status quo. As an artist, as a performer, as a politician and as an irreducible individual, he has tried all his life long to extend our notion of what it means to be a human being."

Another quote: "Nobody who understands any contemporary science, politics, or aesthetics, for that matter, could see in Joseph Beuys's proposal for an integration of art, sciences and politics, as his program for the free international university demands, anything more than simple-minded utopian drivel lacking elementary political and educational practicality."

Audience: Was that [inaudible]?

Feldman: No, that was Benjamin Buchloh. . . . But if you were reading these, and didn't know anything [else], you'd be in a lot of trouble in the marketplace.

The next set of slides has to do with corporate sponsorship of the arts. This is a brochure the Metropolitan Museum provides for corporations, to encourage them to sponsor shows in the museum. Some quotes from this brochure:

Many public relations opportunities are available through the sponsorship of programs, special exhibitions and services. These can often provide a creative and cost-effective answer to a specific marketing objective, particularly where international, governmental, or consumer relations may be of fundamental concern.

David Rockefeller says, "Involvement in the arts can give direct and tangible benefits. It can build better customer relations, a readier acceptance of company products, and a superior appraisal of their quality."

Herb Smertz, Chairman of Mobil: "We believe our involvement with PBS has persuaded an important segment of our society to look at Mobil in a new light, to be more open-minded when we speak out on issues."

Tom Messer at the Guggenheim said, "You approach corporations with projects you believe are acceptable in the first place. These tend to be the safer projects. The avant-garde stance of museums is somewhat weakened by the need to seek outside funding."

[This is a picture of] the Whitney Museum and ITT in bed together. Tom Armstrong said about the Elsworth Kelly show: "American businesses are talking themselves into new reasons for supporting the arts. . . ." Here's George Washington of Philip Morris: "We are in an unpopular industry. While our support of the arts is not directed toward that problem, it has given us a better image in the financial and general community than had we not done this."

These are two different cross currents in the market place, quite a diverse and exciting place.

Dara Birnbaum: At the recent Carnegie International, not only was I the only video artist, I was one of only four women – and probably the only person there without a gallery . . . I represent the position of many people in my peer group making an attempt to get out of the gallery system, to reach a larger public.

I did a video show, "Wonder Woman," of totally popular imagery, and put it in the window of [a commercial space] . . . After 1979, it was shown in the first film and video room at PS 1 . . . This [slide] was the opening at the Mudd Club, '79 to '80. The Mudd Club was one of the first places to open up to video. For a year, a group of us had an independent space there, to sit upstairs and talk about video. It gave you a very local feeling for a medium usually transported out of your hands almost immediately after you've created your statement . . . The Mudd Club was one of the places where this art [reached the public].

This is Grand Central Station. In 1980, 10 artists were commissioned, other people being like Jenny Holzer, to do works in the station waiting room. [At the time] it was very difficult for people in video arts to exhibit in museums or any kind of art spaces. The galleries were not really supportive except Castelli Sonnabend. Museum funding for these works had been cut. [You had to] become your own package deal. You had to make a work that, no matter where it was, the statement still read, that, like a trade show, could be put up anywhere. At Documenta 7, again, I was the only video installation . . . Here's the Art Institute of Chicago 74th American Art Exhibition. Mine is the only video work inside the show – at least in a partly-connected space, a *cul de sac*. Usually it's completely shut off, in an independent room with the separate designation "Film" or "Video," rather than saying it still belongs to the arts.

[But] at the ICA in Boston, for the first time, video was displayed on the upper floor, taking over the space, unheard of before. Another display, 21 different installations of video work was at the Stedelijk in 1984, the first time a major world museum opened up to the public the language involved in a new form of art making.

The intentions of my peer group, working either electronically or through music, are to make art as a purposeful challenge to mainstream culture. . . . This is the Whitney Biennial this past year, the first time a video installation was allowed out in the open on the fourth floor. This is the 1985 Carnegie International Exposition that just opened in Pittsburgh, again the only video in the show allowed out in the open, so the vocabulary can be associated with the other forms of work.

Richard Kostelanetz: There's a difference between literature marketing and visual arts marketing – visual arts is retail, and literature is wholesale . . . When you take a work to a dealer, he knows his regular customers. He'll make a calculation [about marketing] that is obviously kind of subtle. When you bring work to a publisher, all he knows is bookstore managers – the bookstore managers sell books. And this means lots of differences.

First of all, art is sold [one at a time] and reviews criticize it. Reviews sell literature because they publicize it to 10,000 to 100,000 customers. Art is basically sold to individual rich people who can afford to pay for large units. Literature is sold to the masses . . . The thing about contemporary visual art is that very little sells; it's remarkable that it sells at all, which makes the operation of selling visual

arts in our time very naive . . . So the major phenomenon of contemporary art in our time is the development of an extravagant market. Second is the development of an unprecedented support system for artists who don't sell. They live on jobs and grants. . .

Another development of the past two decades is the increasing gap between the commercial world and the non-commercial world. Particularly in literature, we have commercial presses and small presses. And the small press is a cultural entity whose particular function is to do what the commercial press doesn't do – but also to continue literature, which has been abandoned by commercial presses in favor of best sellers. The same thing happened in music, with the record companies getting more and more commercial . . . So they [set up] alternative music spaces, like the Kitchen. I think you get this in visual art as well. . . .

It was traditionally thought that if someone succeeded in the non-commercial world, he would jump into the commercial world. The gap has become so great, that in literature and music I can think of only two people who have made that leap in the past decade – Philip Glass in music and Walter Abish in literature. So we have, not just the development of that which is commercial, but development of institutions and a means of dissemination of that which is not commercial.

[I]t's really hard to sell out nowadays, in part because the gap between commercial art and art is so great . . . And because of selling 10,000 versus selling one, eccentricity is far more cultivated in the retail [visual] arts.

Zelevansky: I think I was misunderstood by both you and Amy. I never used the term selling out. I was interested in what Amy said, that the marketplace is the moment, and there's no way somebody, whether they're rebelling against it or not, can fail in some way to reflect that fact. I can't imagine taking the position that the marketplace does not give form to art.

Now a question to the panel: How do you create a market for an artist's work?

Feldman: I don't know – I'm waiting for the Mary Boone book. [*Laughter, applause*] Actually, I could give you a lot of ways. First, you have to pick a very nice art form: Painting would be number one, absolute top-of-the-list. Paint! If one of my kids was going to be an architect, I'd say don't do that strange thing. Paint! (Well, I wouldn't say that, but I would say paint.) What you have to do is paint something really kind of attractive aesthetically right off the bat. It can be strange, but it should be really *nice looking*. It shouldn't be too, *too* big, because then it can't get into the museum. When you're a little more known, you can make really big things – they'll find room. To market that work, as a strategy, one should have a few sold-out shows. Before they open is the best way, really, but even during would be good. Or even after, you can *state* that that happened. Even if it didn't. That word "out" is really good. When dolls are hard to get, they can run into thousands of dollars. If you sell out ten to 12 paintings, that's peanuts really – but big news in the art world.

Secondly, in order to sell out, one should pepper the art world with paintings at very low prices that no one quite knows what price they were sold for. But a high price is told to the public! That also helps – a lot of PR that this sold out at "x" high price. It's not true, but it helps a lot.
Newman: In other words, people think other people paid more?
Feldman: Yes. Very good strategy. Let them get on the waiting list.
Newman: You get one person to say, yes I paid . . . ?
Feldman: You don't have to lie, just, this is the price and everything is sold out! Nobody really quite asks, did they pay what I'm paying. The best thing then would be to have a waiting list. Scarcity is *really* good. A sold-out show gives the glamor and the scarcity at one time. If you can do that a few times in a row, that's really good. Another aspect would be to find some critics that really, genuinely like the work. They may be misguided, they may be correct, but they really have to like it, and they really have to want to plug it. Then you have to get some curators to decide they want to have it, that they really like it, or stampede [them] into liking it.
Panel: How often does this happen in your business?
Feldman: Not to me! I can make it for any artist here if you want to just *follow some simple rules*. I don't know how to make it if you make anything *strange*. I know how to live with you and show the work; but I don't know how to make it for you.

The art has to be in a form that sells. I can't stress that enough. One of my artists is now painting and I am absolutely overjoyed, because I know that I can sell it, and both of us can have a little money . . . I don't push them to paint. They paint because that naturally becomes the form they've chosen – thank god!

But recently I spoke to a New York curator, very high up, very important – who for years has been playing this cat and mouse game with me, like, I really would like to know about all your artists, and how important they are and what they're about. I'd like you to set up a slide show and I could come down and look at everything at one time. . . . So one day I made a phone call and asked, if the art I show you is not stretched or a little difficult to store or curate or put on the wall or you have to worry about the temperature a little more, or whatever, do you want to see it, can you curate it, can you collect it? Oh no, of *course* not! We didn't make the slide presentation.

And that fact does not change. So when Dara said, it was the first time [video was shown] this way, that's very important. Of course, that doesn't mean she *sold* it.
Golub: I don't think you *can* tell anybody how to make it in the marketplace. I've been in the art world a long time, I'm an old timer, and I still don't know how the art world works. I try to be very analytical [but] I can never figure out what's corruption and what's not corruption. I know what I like and don't like, although I'm often unsure about that, too. You made a comment about Mary Boone. Of course she's very successful. But she's riding a bronco, she's not riding a horse. And she doesn't know herself, I would guess, when

she's going to get thrown off. [Meanwhile, other people are] saying, if I could only I get to Ron Feldman!

I was just told about a show in a very well-known gallery. The show sold out. A man I know very well had a show at that same gallery not long ago and sold *nothing*. What made the difference? I can't figure it out.

Feldman: I wouldn't want you to confuse "how to make it" by a formula, in certain steps, with really making it because your art is terrific. I personally don't equate being famous and in many art museums and collections and private collectors stampeding with *really* making it, really being talented, really being what I would consider successful, whether that gets commercial recognition or not.

Zelevansky: Amy, how important are the magazines? How powerful are they in selling artwork?

Newman: I think magazines are, um . . .

Golub: Crucial.

Kostelanetz: In comparison to literature they are inconsequential.

Newman: They're important because they get the ideas in the work out. I don't think that necessarily influences what sells. I think what influences what sells is what other people are buying. There's a kind of snowball effect and I don't think that starts with the magazines. In fact I think the magazines are the coattails, because if someone is selling, then the magazines put that person on the cover.

The problem that has stymied me the most is reproducibility. You reproduce art that can be reproduced in a magazine. There are very strict limits to what comes across. Where you have 20 artists and can reproduce five works, you don't choose something very delicate, pale, subtle or conceptual or a certain kind of manipulated photography. You can't have sort of a vague blur on the page. The only way around that is to have art magazines that don't run pictures. That's unfortunate, but it is sort of pure.

Golub: I would think that given good quality reproductions and sufficient attention to paper, there's almost nothing that can't be reproduced. But there are always questions of the relative importance of people in the back of one's mind. I don't think the criteria are technical. If you have a big enough page, you can reproduce anything.

Feldman: As far as strategy is concerned, Amy is right. As far as *being right*, Leon is right.

Newman: There's one thing I want to add – the influence magazine or newspaper critics have, I think, is not based on the magazine or newspaper. It's based on the reputation the critic has built up. I don't think that simply by reviewing for a magazine you have the power to make or break an artist's career. I don't think those reviews and articles have that kind of importance. But if a critic has built up an independent reputation and been intelligent and consistently written about artists that people agree have emerged as significant voices, then I think the critic has a certain amount of power.

Kostelanetz: I can think of only one way reviews function in selling art and that's if someone has to justify a purchase. When I tour universities, and I go to the art museum and see a Philip Pearlstein, I know there's only one way that could

happen. The curator wanted to buy it and he came up with the Hilton Kramer review from the *New York Times* and went to his board of directors with it, and between the curator and the subsidiary support of the review, they bought it.

Zelevansky: ReViews are very important for artists applying for grants.

Golub: It's more crucial than that. I'd say there are 100 people who are important to artists – collectors, critics, museum people. They all have a shifting relation to each other; they all have certain tensions of their own [and] different kinds of nervous dependencies. . . . Nobody has 100. If you have, say, 60 % of this informed opinion behind you, you have a world-wide reputation. If you have 40%, you have a national reputation. If you have 20%, you have a New York reputation. If you have 5%, maybe a few people have heard of you. If you don't have any of these people, you don't exist – except to your friends.

What this means is that influential people out there, artists too, are determining the course of events. Now these people are not so sure in their own mind. They watch each other. Collectors watch collectors. Collectors watch dealers. Critics watch other critics. They're always ready either to jump on a new ship or leave a sinking ship. And everybody does it, just the way I do. . . . In the middle of all this, the agency that influences people, are the critics. They influence the people who influence the people.

Kostelanetz: The *New York Times* theatre critic can make or break a Broadway production with that wholesale audience. The *New York Times* art critic cannot break a production . . .

Golub: You know why? They have devalued themselves. When Kramer and Russell run off in a kind of generalized way they devalue themselves, but they still have a very powerful influence.

Kostelanetz: Is there any example of a critic demolishing an artist's reputation?

Newman: No.

Golub: I'm not going to name them, but there are artists I know who have been attacked publicly who had a very strong reputation in the '70s and who have suffered from it. It doesn't mean they don't have support, but part of the aura around them has been dissolved.

Newman: I think what we're talking about is the marketplace of ideas and I do believe critics have a lot of influence there, but I don't think they have that kind of influence in the financial marketplace. If you have 4 or 5% of art world informed position behind you, that's fine. I know artists nobody knows who are selling their work better than artists who get reviewed. They have their parents' neighbors [and] doctor's offices . . . If you're talking about the financial market, I don't think critics have a lot of influence. They have influence in the exchange of ideas.

Zelevansky: Most critics have to review what the publication is interested in. As a critic who did a lot of photography reviews, [I can say] there was a time suddenly you could not place photography. . . .

Audience: Who, besides *Women Artists News*, looks at who is reviewed? Where do those decisions get made?

Newman: It's different at all the magazines. At *ARTnews* I would generally assign critics to the gallery. If the critic didn't think the show was worth reviewing, that stood; we didn't try to get the show a good review, or get a review at all. If I sent someone to a show and they wrote a bad review, we printed the bad review.

Audience: What about advertisers?

Newman: It's pretty well known which magazines have a policy [of reviewing advertisers].

Audience: It's well known *in the trade*...

Newman: The magazines that [cater to advertisers] don't have as good a reputation with the general public. They don't have the same authority.

Kostelanetz: Are you saying you can buy a review?

Newman: Yes.

Golub: You can get in one or two magazines, maybe. If you take a medium-sized ad and your gallery has done this for a while, then there's a good chance you are in the swim and the shows will be reviewed. But you're not necessarily buying a review. I don't think you are.

Audience: How do you measure what's real and what's just people giving their opinion?

Golub: That's the biggest question in the art world! If you read the history of American art from, say, Abstract Expressionism on, you get a certain picture from one critic or historian, and someone else may give a related picture, but [neither one] is necessarily true. What we see as "history" has been taken for granted because of usage. We're told certain things and eventually we learn them. But there is such a thing as revisionism – the history of art can change. . . .

But instead of going from one thing to another, we have catastrophes. Pop Art was a catastrophe for Abstract Expressionism. Minimalism was a catastrophe for so on and so forth . . . The catastrophe interrupts the assumptions of artists that things are going to continue as they are. But how you get to that new point doesn't come from paying off critics and reviewers.

Birnbaum: This is taking a very mainstream course, for me at least. We're really in very conservative times. Leon has now at least said things can change. But I haven't heard any specifics. For example, publications such as *Flash Art* on an international level support certain art. It is nearly impossible as an independent to be reviewed by *Flash Art*. And if you don't have a gallery it is next to absolutely impossible to get into *Flash Art* in a color photo print. Many times works, performance art, film and video, that had their seedbed in the '70s haven't been able to continue in the mainstream of talk and articulation because they aren't reproduced in *any* form; they've been suffocated. There are a few small incidences of change, but change hasn't so far affected the dominant marketplace.

When I first looked toward video art [at] Castelli Sonnabend, as a youngster hanging out in the gallery, I would hear meetings on how does one sell a video disk – and are there precedents in printmaking or photography or any mechanically reproducible form. There was this idea of production in a limited number. But video to me is like litera-

ture: it should be in *unlimited* number. . . . The reason I stayed in artmaking [despite having other] skills was because I felt art could be valid as a challenge inside society.

At Castelli Sonnabend, selling video tapes, they found they couldn't do a limited edition. Can an artist sign a video tape? Where? Does regular pen work? Can you write on video tape? It'll ruin the deck you play it on. . . .

So eventually they had to make a very expensive-looking package and, in the case of Joseph Beuys, a lithograph by Beuys, signed by him, to market these tapes.

Now a group of artists decided in the '70s and '80s not to go with that part of the market. So while I'm very glad I have tapes selling in the art market for $200, $250 dollars, you can buy them for a dollar ninety-five at Video Shack. The same tapes. I'm not saying it's an answer, but it opens up issues.

Golub: It works for *you*. You have developed a philosophy and a technique to get out to this kind of public.

Birnbaum: Well, I'm one of those who has deliberately chosen a form of expression that leaves them outside the dominant marketplace.

Audience [to Amy Newman]: On what basis do you select a gallery or show for review?

Newman: I see the show myself (I used to see an enormous percentage of shows), or, if I don't see the show, based on the annnouncement, or something I know or somebody told me. In other cities I rely exclusively on the critic in that city.

Audience: Is it true that if a gallery or an artist took a full-page . . .

Newman: Not at *ARTnews*.

Audience: You say not at *ARTnews*, but that means somewhere else. Is it fair . . .

Panel: What's fair?

Kostelanetz: A critical reputation is debased if it's so obviously, blatantly for sale. But there's more *subtly* for sale. For example, take the *New York Times* Book Review. I did an analysis where I discovered that the reviews were apportioned to publishers *in direct proportion* to how much advertising they took over a period of time.

Golub: That was deliberate, you think?

Feldman: You made this survey yourself? When?

Kostelanetz: Yes, I made the survey. It's published in a book of mine called *The End of Intelligent Writing.**

Newman: And was it reviewed in the *Times*?

Kostelanetz: Yeah, Sure. [*Laughter*] That's a longer story.

Golub: He ran a *big* ad!

Kostelanetz: Their rationale is, we exist to review what's in the book stores, and we know what's in the book stores by what's advertised in our pages! . . . Here's a funny story. [An editor at the Book Review], whom I happen to know, told me, the art world's all money. I said, Oh? When you put a book on the cover of your review, what does it sell? He said 10,000 copies. And that's worth how much? Obviously a 20-dollar book is worth 200 grand gross. So I said there's no way an art reviewer can sell 200 grand of anything! That's the nature of wholesale versus retail. Bookstores are much bigger business than art business.

Feldman: But an art review appears after the exhibition is closed.

Zelevansky: That doesn't matter – it's for the *next* exhibition.

Kostelanetz: That's still different from a book review when the book is in the stores.

Golub: The *New York Times* comes out coincident with the exhibition when they do review something. And they do influence . . .

Zelevansky: And the accrued prestige is definitely part of the package.

Newman: But you're suggesting that the work shouldn't be talked about.

Golub: Nobody's 100% pure and nobody's 100% corrupt. . . . Everybody tries to manipulate the situation to their advantage, one way or another.

Audience: Reviews are an *extremely* sensitive issue for the artist, because reviews are sometimes the only payment you get. You can go a long time on a review. [*Applause*]

Dara mentioned showing video in an alternative situation . . . at Castelli and then at the Palladium and selling work at the Palladium and other clubs. I wonder whether you can take a work which involves thought and contemplation and put it just anywhere and expect it's not going to change.

Birnbaum: It depends on the work. I was one of the first people into the clubs and one of the first out of the clubs – because it didn't suit the content I wanted to get across. Lately I've decided to go back into the clubs at chosen times, because there's an audience there I wanted to address, and I wouldn't be able to get to those people if I didn't find a vehicle that had a certain kind of immediacy . . . The people I've worked most closely with felt it essential to find temporary relief from the dominant market place, which had been highly, *highly* conservative.

Kostelanetz: I have a question about selling photography. You saw it and now . . .

Zelevansky: Now there's no market. Photographers can make it in an art-world context, but the photography community at this point can no longer promote photography. The reason they make it in an artworld context is that they make very large images in color, so they can be sold for a lot more money.

Feldman: I've been on several panels [on this topic]. Every five years it convenes and appears in *Print Collectors Newsletter* . . . Some artists working with photography will not show in a straight photography gallery. It's demeaning, or it's craft, or too traditional. Others want to show or will show anywhere. This thinking is the fault of museums, because they're curated by *departments*.

Edited from tape.

*Now out of print. However, an abridged version, *"The End" Appendix/ "The End" Essentials*, RK Editions, 1979, is still available.

Post Script: In case anyone missed Feldman's irony, as some seemed to, it should be added that his advice on "making it" was tongue-in-cheek, and that his reputation among artists for support of non-money-making, especially artists' political, causes, is unsurpassed. However, the New York City Department of Consumer Affairs may have taken his remarks at face value. One official, apparently hearing about hanky-panky in the art world sufficiently in advance of an election to take forceful action, decreed that art, like other merchandise for sale in the city, must have all prices clearly marked. As the press played the story with great glee and keen appreciation of the ingenuousness (or disingenuousness) of the ruling, Ronald Feldman was among those singled out for several hundred dollars in fines – caught by an inspector without his prices posted. The regulation was subsequently contested. The dénouement is not on record.

1986

'86 / #181

Having It Both Ways

College Art week 1986 brings, as always, many versions of the way we are, were or should be. As we see, by this point the women artists' movement is organized and successful enough to have numerous networks, specialties and celebrities – although the "dominant culture" is still determined not to know much of what the women have to say. Nor is that all to be Angry about, as is affectingly conveyed in the Saturday "speakout."

"Censorship and What's at Stake for Women"

Moderator: **Terry Cafaro**; Panelists: **Diane Neumaier, Martha Gever, Beverly Nadis**, others

Women's Caucus for Art, College Art Association, NYC; February, 1986

The Caucus this year reflected perfectly the state of the women's movement. It seems only a few years ago that the wobble of hand-held cameras recorded the takeover of grungy buildings (now gentrified) by women with toddlers, who, tired of official indifference and no money, were going to will the solution with love and sharing. But the new stance is good, too, wonderful in fact. A lot of smart women are determined to define what is *really* happening. There is, however, still a lot of reacting to how *men* are. (Some day women will make choices for other reasons than a reaction to the way men think or do.)

This panel on censorship included a discussion of the use of the word "dwarf" in the title of a performance piece ("I Like the Dwarf on the Table When I Give Him Head") in the next day's "Hot and Nasty Humor Works." Moderator Terry Cafaro requested that the word not be used and that "persons of small stature" be substituted. This request was vehemently opposed by a woman in the audience who said it had particular relevance to the point of the piece, which was to be outrageous, and that the artist was herself in fact married to a dwarf and so used the term fondly. It was also noted that the word is a legitimate part of the language with specific biological meaning. The moderator rejoined that artists have a responsibility, that certain limits must be initiated. "Freedom is the right to act socially. These images don't advance our cause."

I myself found this discussion, with its advocacy of propaganda and mind control, shocking. However, after listening to subsequent panelists, I realized we are drenched in such messages and these speakers are at least on our side. Cafaro said, "It is necessary to be aware how some physical charac-

teristics are not accepted by society (short stature) and how we have bought the ideal of the perfect body."

In her opening remarks, Cafaro related two incidents of "overt censorship" from her own experience. The first concerned a work entitled, *The All-American Zipper Steal*, consisting of a "sculpted zipper flanked by tufts of steel wool." The piece was rejected for exhibition because of a host institution policy against display of nudes in a public place. However, another clearly figural, but more benign, rendering of a nude was shown. Cafaro noted the inconsistencies, which "make us once again conscious of the . . . ambiguous nature of censorship."

Panelist Diane Neumaier spoke about the continuing absence of women on faculties and editorial boards. She said those who wish to obtain tenured positions must act against their own principles to stay out of trouble. They have no voice, and no power, are exhausted from mothering students and making sure not to step on toes, too intimidated to form groups to share problems or help other women. Neumaier described obstacles to formation of a women's caucus in the Society of Photographic Education, then related an episode from her own teaching: A male student presented girlie-type photographs of nude females; when these images drew negative response from classmates, he proceeded to substitute pictures of black male body parts. When his equation of black male with female, or "other," was addressed, he switched to photographing barns.

Next on the podium, Martha Gever, editor of *The Independent Film and Video Monthly*, got star treatment as flash cameras popped and she was videotaped by a camerawoman with a large ring in her nose. Gever was dressed quietly in a dark, loose-fitting man-tailored jacket and baggy slacks. She had stylishly close-cropped hair and spoke in a low-pitched voice. The message I got from her clothing was male authority. One didn't have to ponder how she valued herself, her body, "femininity," makeup, or the myriad other measures by which one places an individual in context, even before hearing what they have to say.

Gever's paper, "Prurient Interests: Lesbian Pornography and Lesbian Sex," speculated about whether we can and should declare sexual practices part of public discourse if their purpose and meaning will be thus distorted. For instance, watching video porn on purchased tapes, she found that "the subversive intention of lesbian porn becomes subverted . . . appropriated as another aspect of male sexual enjoyment." The camera acts as the male voyeur and women play conventional sex roles. "There is lots of makeup, wigs, high heels and dresses."

Beverly Nadis told of the many trials and errors in her search for a place in art and a format for her own expression, until she found performance and political art. She wondered if one can critique from the outside, or, "must we subvert from the inside until we reach positions of economic power?" She closed on an up note, saying, do what you can, even just changing the mind of one or two people. If you work within a subculture, great. Use teaching as best you can and try not to edit yourself too much. Her talk, however, had the title, "Not so Covert: Censorship in the Everyday Life of the Artist."

Throughout the discussion, I was struck by the ambivalence of these women, and the many contradictions in their positions. It has evidently dawned that freedom has a price – it can be used against you. In fact, the culture will do with your art just exactly what it wishes. (It always has.) The speakers seem to be fighting the discovery that you can't have it both ways – determined at least to try.

– Gladys Osterman

Women Artists News, Spring, 1986 [Vol. 11, No. 2]

'86 / #182

A Pitcher about the Idea of Pitchers

"Ceramic Art Now"

Conversation between **Betty Woodman** and **John Perreault**

College Art Association, NYC; February, 1986

Within a format of interviewing each other, Betty Woodman, ceramic artist, and John Perreault, critic-curator, looked at the role of ceramics in the art world, addressed the difficulty of placing critical writing about ceramics, and questioned the functional/non-functional dichotomy.

Woodman treads the line of functionality; the pieces she brought to the symposium featured a large pitcher, vases, casserole dish, and a tea pot, all glazed in the Tang dynasty-influenced bright palette that characterizes her work. Of her enormous pitcher, she explained, "It's a pitcher about the idea of pitchers." She pointed out that, for her, the possibility of function is an advantage ceramics has over other art forms.

Perreault agreed, saying that he finds the most vital contemporary ceramic art involved with "the vessel tradition." The tactile element of clay adds another dimension to the aesthetic experience, he said, whereas the appreciation of painting is merely visual.

However, Perreault also spoke of enormous resistance to ceramics in the art world and the difficulty he has placing his

own writing on the topic in art magazines. He speculated that the production aspect of ceramics may be responsible for devaluation of the potter in the art world.

Woodman, who defines herself as a potter, replied, "many *artists* make the same things over and over," meaning that the same process in another medium carries no loss of respect. She stressed the necessity for thinking about work in context, and the importance for both students and critics of knowing ceramic history and of placing contemporary work within a larger tradition.

– Kate Missett

Women Artists News, Spring, 1986 [Vol. 11, No. 2]

'86 / #183

The Varnished Truth

The panel title says "myths," so maybe we're not expected to believe. Then it says "redefining," so maybe we are. Either way, this event might make us very skeptical about the rest of "art history."

"New Myths for Old: Redefining Abstract Expressionism"

Moderator: **Robert Rosenblum**; Panelists: **Evan Firestone**, **Roberta Tarbell**, **W. Jackson Rushing**, **Bonnie Clearwater**, **Len Klekner**, **Deidre Robeson**

College Art Association, NYC; February 1986

In 1973, the College Art Association had a panel on the New York artists of the 1950s, *The Artists' Club: The Makers' Forum Revisted.* Such Ab-Ex masters as Willem de Kooning, Adolph Gottlieb, Robert Motherwell and Philip Pavia appeared on stage to talk about the good old days and the first flowering of Abstract Expressionism. Fortunately, none of these artists was present at the 1986 panel, where not only were new myths flourishing, but art history was wiped out in the service of art-historical careerism.

The current panel traced American painting from the Native Americans to the explosive bravura of the Abstract Expressionists, particularly the major figures of the Ab-Ex period.

Robert Rosenblum explained that at first de Kooning's and Rothko's work was seen, not as art, but as the *new* – dividing the public into love/hate camps and eliciting the familiar, "my 6-year-old kid (or a chimpanzee) could do that." Rosenblum's paper described Rothko as destroying the "Cubist labyrinth" with work harking back to Turner. Pollock, he said, continued the tradition of such field painters as Monet, while his chaos evoked the tempestuousness of Ryder. Franz Kline's style was assigned roots in the Great West of Thomas Moran, and Adolph Gottlieb was found to come out of the American modernists of the '20s and '30s, such as Arthur Dove (while Dove's early style was tied to

Southwest American landscape fantasy). Lorser Feitelson and Janet Sobol, painters of the early '40s, were cited as other precedents of Gottlieb. And so it went, every artist who ever lived was kissing cousin to someone or other in this finding of "roots."

Rosenblum also described Pollock as an extension of Primitivism, finding his forms directly derived from a prehistoric bird skeleton displayed at the Museum of Natural History. David Smith's forms, Rosenblum explained, were based on the "royal bird" of paleontology. He also made a connection between Barnett Newman's "zip" paintings and the cosmological impact of William Blake. A 1945 photograph of the atom bomb's mushroom cloud was declared an "obvious" influence on Rothko!

Rosenblum concluded that Ab Ex did not repudiate '30s art so much as create a new form of 20th-century *realism*.

In the next paper, Evan Firestone told us that while Ab Ex has been considered the antithesis of American scene painting of the 1930s, there are a surprising number of common denominators between the art of the '30s, '40s and '50s. For instance, '30s critic and painter Thomas Craven praised Rembrandt, whom he called "the last of the great spiritual explorers," and considered Ryder "the greatest American painter." The Ab-Ex painters also admired Rembrandt and Ryder, said Firestone – hence a connection! Painters of the '30s, like regionalist Thomas Hart Benton and social realist Philip Evergood, were concerned with issues of the human condition, Firestone said. The Abstract-Expressionist painters were *also* concerned with the human condition. Another connection! In addition to such connections between American scenists and Abstract Expressionists, Firestone noted their shared wish to overcome the influence of the School of Paris. He managed to claim, also, that Ab Ex, like the scenists, rejected "purely formal concerns" in its commitment to "subject matter"!

Panelist Roberta Tarbell presented a paper arguing that Seymour Lipton, considered an abstract sculptor of the period, *really* intended to express content through form. Tarbell showed slides "proving" that what had been thought to be abstract forms contained images not seen before. (One remembers the childhood game of finding faces on the mountainside or in clouds.)

W. Jackson Rushing devoted considerable time to tracing what he claimed were indigenous American sources of Ab Ex. He found Jackson Pollock rooted in Native American art, citing a 1941 MoMA exhibition of U.S. Indian art which Pollock is said to have visited often. Indian pictographs and primitive symbols from cave walls appear in the skeins of Pollock's paintings, Rushing said. Not only did Pollock supposedly manipulate Indian forms, but his actual method of working on the floor was likened to the Indian ritual of sand painting.*

Bonnie Clearwater presented a paper on Rothko's Theory of Art, saying his formalist solutions advanced his work beyond formal concerns. Rothko, she said, wanted to evoke an emo-

tional response akin to one's feeling upon entering a cathedral and was convinced he had achieved that goal.

Len Klekner, who spoke about statements written by the Ab-Ex artists, quoted Barnett Newman to the effect that meaning comes "from the seeing, not the talking" and de Kooning saying, "a work of art needs a lot of talking about." (One recalls with some irony that Newman was actually the most talkative of the lot.) The statements cited, a mix of private and public discourse, in time became letters to the editor, often with many signatures making them into something like manifestos. Klekner saw the writing as another area of artistic creativity, which, although he was unable to develop a unifying theory, he felt created an environment for the work. They were linguistic extravagances, outrageous assertions, he said, meant to shock, challenge and provoke response.

Deidre Robeson discussed Ab Ex as a commodity, tracing its rise from first critical acclaim to financial success and ascendancy in the marketplace with bar graphs and lists of its now-astronomical prices.

That the urge to fabulism is a scourge of art history could be seen clearly in this event, especially in the "tracing" of "American roots." When a member of the audience pointed out that de Kooning was actually not born in this country, a panelist allowed, "*his* roots are in Holland, of course." That many of the others had old-world origins, interests and associations was ignored.

The point was also made from the audience that the emergence of New York as capital of the art world coincided with America's emergence as most powerful country. However, while MoMA mounted exhibitions of abstract art to circulate abroad, the tours were sponsored by museum trustees. There was no government backing at the time – abstract art was still considered an instrument of the communists.

In "explaining" American scenist and regionalist art of the 1930s, the panel seemed to dismiss the fact that it represented the prevailing social and economic climate – a depression. There was also a populist art of the period depicting American traditions that was considered an instrument of social change. Government support of such efforts didn't begin until later, with the Federal Art Project. It was this support which allowed the Abstract Expressionists, most of whom were employed on various public works, to make art – although they had not yet developed into abstraction.

Postwar American art mirrored the country's new optimism and prosperity. Attitudes and expectations for art changed. It was OK to be an artist – you could study art at a university, even get an MFA. Thus developed a new sensibility and a breakthrough in art. The first experimenters, gaining from and supporting each other, developed some of the most original work in the history of art. The wish to connect it with earlier American art is understandable, but the facts belie the claims.

– Cynthia Navaretta

Women Artists News. Spring 1986 [Vol. 11, No. 2]

*Although the story of Pollock's influence by American Indian art seems to be hardening into "fact," it was apparently the invention of Howard Putzel, "factotum" of Peggy Guggenheim, who, with the acquiescence of all concerned, made up an interview with Pollock to publicize Pollock's first one-man exhibition in 1944. Alice Goldfarb Marquis [*The Art Biz*, Contemporary Books, 1991] cites Ellen H. Johnson [*American Artists on Art: From 1940 to 1980*, Harper & Row, 1982] as source for this revelation about Putzel's ghostwriting. In Putzel's version, the reference to American Indian art was explained as not "intentional" on Pollock's part, "just the result of early memories and enthusiasms."

'86 / #184

Really Mad Artists

"Angry: A Speakout"

Arlene Raven, Max Kozloff, Robert Harding, Leila Daw, Moishe Smith, Lee Anne Miller, Rudolph Baranik, Jeff Perrone, J and J (Rock Bottom), Ann Sperry, Gloria Orenstein, Guerrilla Girls, Aviva Rahmini, Jerri Allyn, Mildred Pommer, Avis Lang, others

College Art Association, NYC; February, 1986

We were prepared for Saturday morning fun when red buttons to signify anger were distributed outside the door and a masked Guerrilla-woman inside the door handed out *I Am A Guerrilla Girl, Conscience of the Art World* buttons

Arlene Raven led off by telling us that raising our voices is the way to bring issues to attention, while unvoiced anger affects our sleep and causes amnesia and seething.

It seems artists have a lot to be angry about, including some things you might not have thought of.

Max Kozloff was angry about a surge of right and left wing thinking throughout society that undermines simple decencies in the art world and academia. Examples: In a New Mexico University life drawing class, a woman student, offended by exposure to a nude model, complained to the dean; the class was cancelled. In California, a woman was denied a university position when the interviewer decided she had no "social responses" (i.e., Marxist ideas).

Robert Harding was angry about absurdities in the art world. "The artist feels duped and powerless outside his/her studio. The lottery of art forces the artist to be angry on principle, or just because of being left out." To be taken seriously, he said, artists must come together, form a fellowship of artists.

Leila Daw, speaking for the anger of regional artists, claimed geography is as detrimental to art-world ambitions as gender or race. Even the Women's Caucus rejected a request to present a panel on the problems of regional artists. New York artists who visit the regions, whether known or not, get reviewed and revered in the local papers, while scant attention is paid local artists, she said. There's a sense of power-

lessness in being "regional," having one's work described as "too hermetic," "too insular."

Moishe Smith complained that printmakers are relegated to second-class status. He compared the new trend in collaborative printmaking to the marketing of ready-mades or the low end of the couturier market.

Lee Anne Miller decried the bias against the medium of watercolors, which she sees as underrated, unrecognized, and stereotyped as the medium of little old ladies who dab delicately. Tossing off the names Turner, Constable, Marin, Sargent, Homer, Burchfield and O'Keeffe, Miller pleaded for a dignified reevaluation of the medium.

Rudolph Baranik found this speak-out a modified version of the ongoing speak-outs that flourished in China "after the Revolution." He said there's plenty to be angry about, adding that anger has its own dignity, but should not be pugnacious or scrappy. He also scolded the audience for having never visited New York's Studio Museum in Harlem, for not having seen the recent major exhibition of black artists, and for not knowing the work of black artists. Most telling was his comment that, except for the black-masked Guerrilla Girls, there wasn't a black face in the packed room.

The team of J and J, a.k.a. Rock Bottom, sang and told absurd stories, shaggy dog variety, about their outsider status: nobody likes their work; dealers don't answer their letters; editors won't publish their self-written reviews; and other artists avoid them.

Jeff Perrone sent a surrogate to read his True Confessions-type statement, a litany of all the mistakes he's made in not "playing the game": avoiding seduction, not smiling more, realizing too late that the work alone is never enough, and that, historically, "sex is the best way of judging new talent."

Ann Sperry spoke movingly of the aging artist. (See her paper below.)

Gloria Orenstein's statement of anger over Ana Mendieta's death, was read by Kinetta Pearl.

The Guerrilla Girls did their thing, brilliantly, as usual. Taped messages by individual members gave the all-too familiar facts: No major exhibitions of women artists; New York galleries show less than 10% women; male artists show their work in galleries that hardly show women; MoMA showed 13 women out of 169 artists in their reopening exhibition; the Carnegie International showed 4 women out of 42 artists. The concluding line, in a purring tone was, "There's no sexism at work here?" Another taped voice said, "The art world is administered entirely by middle-aged women for the benefit of younger men, continuing the traditional role of women as wives and mothers." Still another voice reminded the audience that women artists earn one third of what male artists earn. The concluding message, in

the gentlest voice, observed that nice girls don't get angry, and, with rising emphasis, "I'm not angry. I'm pissed!"

Aviva Rahmini told a shocking story about the destruction of a mural in a shelter for abused children where she was artist-in-residence. Threatened by the strong message, as well as the truth and beauty the children had created, the enraged institution painted the work out, dismissed Rahmini, and forbade her even to visit the children.

Jerri Allyn did a performance depicting Nancy Reagan talking about cancer.

From the audience, Eleanor Dickinson voiced anger at the abuses of juried shows and distributed a handbill of proposed rules for juried shows promulgated by her college, California College of Arts and Crafts.

Barbara Levy said, "I'm chronically angry," and left it at that.

A Curator from the Whitney, whose name this reporter missed, was angry at Kozloff's equating left and right and asserted that left is for egalitarianism, right for an elite society with power for the few. She added that she is one curator who writes understandable wall labels, uses simple language, has protested admission fees, and supports causes.

Dr. Mildred Pommer, who said, "I use the title deliberately," raised her voice in anger that the "migrant labor" of adjuncts goes unnoticed. Another, somewhat confused, commentator compared art to porkbellies, and denounced the "Hollywoodization" of the Art World, adding that, no matter what it's called, whether or not she's a star, she still wants her place.

The next angry statement was, "Any artist whose videotape lasts longer than 10 minutes should have his/her MFA revoked," provoking much laughter. Another speaker decried the situation in art education: the reduction in classes and teachers, the near-elimination of art in primary and secondary schools; the loss of tenured positions at college level.

Avis Lang, one of Canada's leading art writers, is now working outside her field, she said, because she "will not play the games and will not work for the salaries available" in the art world.

Raven closed the speakout with a rousing, "Get out there and punch somebody!"

– **Cynthia Navaretta**

"Angry"

Statement from "Angry: A Speakout" by **Ann Sperry**

Artists, unlike athletes or dancers, mathematicians or physicists, improve with age. We speak of an artist's "mature style" in positive terms: Mondrian, Kandinsky, Hans Hofmann, Louise Nevelson, Mark Rothko, to mention only a few, all developed the work they are famous for well into

middle age. We recognize the late works of Cézanne, the Monet waterlilies and the Matisse cutouts as the great products of a lifetime of continual searching, constant refinement and hard work; and the last works of Rembrandt, Titian and Michaelangelo hold a revered place in the history of art. As my late dealer Dick Lerner once said: "Artists can emerge at any age – and they get better the older they get. That's one of the reasons I like being around them."

So I find myself angry, and getting increasingly angrier, at the prevalent art-world attitude that says, "Younger is better. Younger is best. Younger is it." Dealers and collectors fall over themselves trying to be the first to spot the next "hot" painter or sculptor fresh out of art school. . . .

The American corporate mentality has also been adopted (unconsciously by many, I think, to grant them the benefit of the doubt) by dealers, curators and collectors. "Over 40, over the hill," is the corporate view. We read again and again of people put out of work by the closing of businesses and factories, unable to find new jobs because they are "too old" – at 45 or 50. . . .

Artists don't retire. Like fine wine and violins, they develop, deepen and mature with age, exposing new complexities that would have been impossible when they were young. Like fine wines, they need to be nurtured, cared for and respected as they mature. And like fine old violins, they need to be continually played and exposed to an audience.

Women Artists News, Spring, 1986 [Vol. 11, No. 2]

'86 / #185

View From the Pendulum

The italic introduction and post script to this report were my own comments, written at the time. Now one additional comment seems called for: change, when it finally began, moved swiftly. By 1990, the tenor of SPE meetings had changed completely. ("The Fireworks Panel" [90/ #220] gives a fair picture of the new state of affairs – or balance of power.)

Women Photographers Organize, Photographers Apologize

Society for Photographic Education, Baltimore; Spring 1986

Until very recently, coming into the photography world from the "art" world was like hitting a time warp and being dropped into the '50s – at least as far as the role of women was concerned. Now some sectors, particularly the academic, are being brought up to date. The Newsletter of the newly-formed Women's Caucus of the Society for Photographic Education tells part of the story, excerpted here, with permission:

Such was the abysmal tenor of the National Conference and so discouraged had women been by exclusion of feminist

programming and tokenization in general that many refused to travel to Baltimore.

But some of us decided to make our determination about future SPE conferences clear. We travelled to Baltimore to meet and to meet with the SPE board of directors. As a result, and as aftermath of the havoc and ill will caused by the board's eviction of the Caucus from a meeting room at the 1985 Minneapolis conference on grounds that our women-only policy violated NEA anti-discrimination guidelines, some changes were made. The board decided it was, after all, OK for women to meet by themselves on SPE time. And, the board voted to apologize for inadequate review procedures. . . .

Thursday's opening was a fair sample of the old-school sexist predilictions of the committee, Richard Kirstel, Richard Creamer and Frank Rehak. All ceremonial speeches had been dispensed with. Rehak didn't bother to introduce himself, assuming, perhaps that the photo dance performance that followed would speak for itself. This consisted of close-ups of body parts – elbows, thighs, knees, breasts, nipples – projected from slides, while a small dance troupe executed a modest disrobing act, twirling around sheets in a style which stopped being innovative in Isadora's time, a dismal updating of the traditional voyeurism of "moving pictures.". . .

A petition was circulated by Caucus members demanding that future national conferences allocate 20% of time and money to the Women's Caucus and give it the choice of one major conference speaker.

Support for these proposals was mobilized by the conference theatrical staged Friday night. [I]t managed to surpass the previous night's performance in misogyny. Set in a bar, the "dialog" meandered on about photography, education and ungrateful youth. Spontaneity turned into a spectacle that bored and outraged even one of the participants, Evon Streetman, as well as many in the audience, such as women, men, feminists, and students. We walked out somewhere around the line "you can be a feminist and still be an asshole." Outside we had no trouble gathering signatures for our petition. . . .

At the full board meeting Sunday morning, a vote to allot the Women's Caucus 20% of time and money at the San Diego conference and selection of one featured speaker was unanimous. The board also voted to apologize, in print, for the "offensive and unprofessional presentation entitled 'The Second Generation.'"

Post Script: The achievements cited above should be contrasted to an organizational meeting just three years earlier: Robert Heinecken, the most powerful photography academic on the west coast, sat at the rear of the room, giving advice and making comments, as his adjuncts and former students (among others) attempted to organize. He had already chided one organizer, also a former student, for being on an "ego trip." Another tenured male professor sat in the center of the room, and, puffing on his pipe, controlled the rest of the discussion, telling the women-folk how to go about liberating themselves.

Women Artists News, September 1986 [Vol. 11, No. 4]

'86 / #186

They Never Said "May I?"

Carolee Schneemann, since 1964 the original, authentic, razor-sharp and *still champ* Bad-Girl Artist, also has a sly wit. She gets all kinds of mail, she tells us, "from students, from molesters, from art critics." Joan Semmel notes that she did a certain kind of imagery before David Salle, but has "never, *ever*" been able to get one of her nudes into a museum. Causes and effects of Bad-Girl Art are explored, first with slides, then in response to audience prodding. When a man asks the questions you'd ask yourself (if you were hostile), other layers of feeling and fact emerge.

"Bad-Girl Art"

Moderator: **Vernita Nemec**; Panelists: **Ame Gilbert, Diana Moonmade, Carolee Schneemann, Joan Semmel**
Artists Talk on Art, NYC; April 18, 1986

Panelists began with slides and descriptions:

Diana Moonmade: Every woman I know, when she does karate in the street, some big guy comes along and tells her how to do what she's doing, even if she's been doing it for 10 years. Instead of a masher in a bar, or a masher in the park, you've got a masher in your *kata*. So I put potatoes all over the street (they were boiled potatoes), and did *Masher Kata*, which was a performance with two weapons that were the mashers. . . .

Another performance: I'd been getting obscene phone calls – he liked to talk on my tape machine. I retaped it with three bells, bing, bing, bing, between each dirty phone call. Then I wore amplified tap shoes and a real boxer taught me how to box – and I had a jacket that said "Moonmade Champ." So I came out of the corner fighting during his dirty talk and when the bells rang I went back to the corner and got splashed with water and came back out fighting and tapping. And he kept saying his dirty things. That was *Martial Arts*. . . . This is *Ninja-cide*. I'm climbing up the building on a rope. It's from "Macho Arts," a performance I did at No Se No.

Joan Semmel: My first series of erotic paintings, begun in 1971, was in an "expressionistic" style. There was a kind of uproar when I showed them, so I decided to cool the painting down a bit . . . using photographic information and less brushy form. I showed this work in a Soho space that had windows open to the street. The area was just artists and factories then, and the factory people used to line up at lunch and ask if they could come in. So I let them, but I would get these gasps and *omigod!*, especially from the women, and finally I said you needed an invitation.

The next series was myself, the female figure, through female eyes, rather than male fantasies . . . For a political show in 1976, the dealer had to stand in front of the painting and say what this sexual work was doing in a political show, so I said, I'll paint you a diagram. You can see on the right, the parody of the de Kooning woman, and some col-

lage elements. The breast has a nursing nipple glued in with a target painted around it and the figure on the left was taken straight from a *Playboy* Magazine. It was an early case of appropriation, post-modernism, all those nice words we use now.

Ame Gilbert: Carnival Knowlege's "Second Coming" show had several hundred artists trying to define feminist pornography. One idea was that if women could bring pornography into the home without having to go to 42nd Street, we could enjoy it without feeling threatened . . . *Little Lost Kitty* is a pink pussy cat surrounded by masked sexual images, a knight in shining armor, a penis with a Little Princess finger puppet on it (*Precious Penises*), and delicate watercolors of flowers. *Crotch Shots*, has text written on women's crotches, things like, "Now, baby, stick my diaphragm in." The work was supposed to show a feminine form and I picked oral sex. I could explain why, but maybe I'll skip it. . . .

Vernita Nemec: This is my contribution to Carnival Knowledge. It led to a performance called *Private Places*, exploring teen-age fantasies. I'm 13 and I had kissed my boyfriend, and I didn't have my period for six months. I thought, I don't believe this! But my mother had said you didn't have "to go all the way" to get pregnant . . . *Pink Plaything* is part of a series about a box of 64 crayons. I made all 64 in taffeta and satin and then did surreal interpretations of what you could do with them. This is from a performance at BACA. It's Ame wearing a "Cunt Caftan" and holding a diaphragm – fan or hat, depending on how you wear it. *This is not a Condom* was a performance about birth control. BACA got some nasty phone calls about their funding being in jeopardy because of this "dirty" performance, but it was actually more political.

Carolee Schneemann: When I began *Fuses* in 1964, filming making love with my partner, I didn't know consciously what I was doing, but there was a sense of working against the prohibitions of the culture. These are orgasmic heads – the images were so startling at the time. I took a year and a half to shoot it (with a wind-up Bolex), so I could discover an image of personal sexuality, rather than male-generated pornography or eroticism. . . .

Further domesticating eroticism, this is our Christmas card, a naked greeting, in which we threw our cats as part of the greeting. That's not an erection on the man, it's just, when you jump, the penis goes up, and two flying cats. And here's the flying self: In '73 a tree surgeon came to prune an old apple tree, and when he sat down to eat his tuna fish sandwich, I was compelled to take off my clothes and try his tree surgeon's harness. . . .

This is a piece called *Interior Scroll*, in which I extract a message from my vagina, which usually has a feminist implication . . . I made a poster from the image, called *Pocket Planner for the Year '76*, and took it to the Whitney Downtown for its exhibit, "Nothing But Nudes." I thought it was an appropriate flyer for the show, which I was in. They forbade me to have it anywhere on the premises. . . .

This is a sequence from a peformance in 1982, *Dirty Pictures*, which examines what's taboo. A confessional text is

improvised and read in the context of detailed genital images, my own as usual. [Others] are from anatomy books. *They* are culturally acceptable. . . . Here, self-shot intimate body parts are juxtaposed with a pile of mail on my table that was keeping me from doing any kind of art – all kinds of odd letters, some of them with sexual implications that had to be handled delicately, from students, from molesters, from art critics. I decided the only way I could do my work would be not to write a letter back, but to produce a self-shot image.

One is my letter to the Department of Labor. I've been fired from my job, and I missed my interview with, what do you call that fascist you have to appear in front of every two weeks to get your unemployment check? So instead of writing a whole letter, I stuffed my body, every orifice, with idealized attributes, like paint brushes and typewriter ribbons, and pencils and pens. . . . Combining seemingly taboo, intimate genital or erotic body parts with very ordinary objects, you get what I call a seeping. The erotic parts sabotage the ordinary objects. . . . Here's a recent work, a domestic portrait in which the ordinary attributes of my lover, like shoes, his hand, his glasses are combined with intimate parts, again putting the bedroom in public and an equity between the erotic and the ordinary. . . .

This piece is about interspecies eroticism. I have a cat who's obsessed with tongue kissing – in the morning, when we're still in bed. I keep a little Olympus, and I just reach for it and shoot. Then I double print, so there's always a reversal or inversion of the image . . . They're printed in Xerox and then reprinted in a process called Xerochrome. If you go up close, they're astonishing, because the cat begins to lose its cat aspect, and people feel they're looking at Cary Grant.

Nemec: Is Bad-Girl Art made consciously or does it come out naturally? Women are trained in most cultures to censor themselves. Females are rewarded for good behavior from the time they're small, just as males are rewarded for bad behavior: "Isn't he cute? He's so tough." "Isn't she pretty? She's so well-mannered." Calling a thought "art" gives her freedom to turn off the censor and say what she pleases. After all the gold stars for making pretty pictures, we finally found our own voice. . . .

Bad Girl art deals with public *and* private issues. . . . Sexuality is a major concern. Sex in art is a form of activism. The female has always been the nude painted by the male artist. Now we portray ourselves. But the Bad-Girl artist is cruelest to herself. She takes off her clothes and exposes her scars and bruises. Nothing is hidden . . . Isadora Duncan danced naked. Madonna is not ashamed. . . .

All right, let's talk about being banned.

Moonmade: The Carnival Knowledge show wasn't banned, but people went after the funders. One man in particular went after Franklin Furnace's funding sources. . . It's depressing when the gallery gets in trouble for your performance, or MoMA decides not to show the work or the Whitney refuses the flyer. . . .

Man in Audience: At least you know why you got rejected. That's more than most of us artists ever find out.

Semmel: I put a sexual piece in a woman's show about 1974. I was very careful to choose one that had no genitalia exposed, but it shows the feet and hands of a man and woman interlocked. Nothing was seen, just implied. There was a petition signed by people who worked in the courthouse (which housed the Bronx Museum) to close the show. . . .

I curated a show, "Women Artists, Consciousness and Content," in the art school section of the Brooklyn Museum in 1976. The poster had a tiny, postage-stamp-sized image of each person's work. Several of them were somewhat sexual, like a Nancy Grossman piece that had a figure with a gun, head, and penis. . . . The Brooklyn Museum would not allow me to show the poster in the museum.

If one thinks of the kinds of material in art men make, with women spread out in every which direction, and at every newstand there are hundreds of pictures of women displayed in every possible position. That's called art, and shown all over the place. As soon as women started making art that showed, god forbid, a man's sexual parts, everybody got very upset. When women made any statement at all in these areas, and however mild (these were hardly shocking), there was an uproar.

Nemec: What made you get involved with this kind of work? Why make it harder for yourselves?

Semmel: You were closed out anyhow. You might as well do what you wanted.

Schneemann: In response to the question from the floor, you don't always know the degree of censorship. There's visible and invisible censorship. You may be told images cannot be shown, or you may simply be excluded from shows. You may not get teaching jobs. An image will haunt the mind of a male academic 20 years after the fact. So, no matter what degree of accomplishment you have, the fact that he once saw your cunt in some visual context can never be displaced, even when you're 80 years old! There's a prohibition, a taboo, against being explicit . . . If the Nancy Grossman piece had been done by Allen Jones, there would be no problem. It has to do with the declivity of what females are permitted to expose.

Semmel: Women react just as strongly. They'll accept the same things done by men they won't accept by women. It's a cultural phenomenon.

Moonmade: It's a cultural misogyny . . . Women who happen to work in the sex industry face that same kind of stuff in their other professions. There's a stigma that goes into all facets of femaleness.

Nemec: When men make "Bad Boy" images it's not remarked on, it's just making art.

Schneemann: It doesn't really matter what you show as such, it matters that you're taking sexuality into your own hands. That divests the male of the power to describe and invent female sexuality as the embodiment of his own desire. When women do that, they're bad, evil, castrating.

Audience: Why does society accept violence so much more than the sexual?

Schneemann: The stereotype says femaleness is tenderness, yielding and eroticism. . . . There is the male psyche we'd

call sensitive or normal, but then there's this crazy part of the male spirit that wants to fuck or blow it all up.

Gilbert: There's also a lot of censoring by the church – and a lot of violent religious imagery – martyred saints dripping blood. Some of it's a male-female thing, but I think there's tremendous influence of religion.

Moonmade: In non-western religions there are gentle and loving images. I think the violence in religion is mostly western.

Semmel: I think it's related to sexual repression in western society through the whole Judeo-Christian heritage. That [leads to] a displacement. Instead of a loving sexuality, there's an aggressive sexuality.

Audience: In my mind, this art is not so threatening, but men are more interested in it than in other women's art.

Semmel: One hallmark of modern art has always been the shock factor, from scale to content.

Gilbert: The women's movement is incredibly split over the issue of pornography. In a lot of ways, Bad-Girl Art challenges feminism. Not *my* definition of feminism, but certain popular images.

Schneemann: That's the most painful experience – my sense of giving women back an integral image of their own sexuality and their own bodies and having sex-negative feminists say this is despicable. [The idea] that there is no way to recontextualize female sexuality, particularly in a *heterosexual* context, only plays into male hands.

Audience: The sex magazines out there aren't art. But some people think the sexuality [in women's art] is immature and exhibitionist. Joan Semmel said when men do these things they don't get criticized. I'd like to know who some of them are.

Semmel: The most obvious right now would be Salle and Fischl and people like that. But there have always been men, like Picasso, who did all kinds of erotic . . .

Schneemann: Alfred Leslie.

Nemec: Tom Ottinger . . . I think panelists are saying that women get put down more for making their art than men do, regardless of the topic.

Schneemann: With Joan's work and mine, the way they punish you is to be unable to register the formal structure, the formal value.

Semmel: The slide I showed, *Mythologies and Me*, I did in 1976. I'd like to compare it to David Salle. It's a three-panel piece; it came out a little before Mr. Salle . . . But I have never been able to get one of my nudes into a museum, never *ever*. If a figure show came up, I was told they wouldn't use that kind of thing.

Nemec: When women did get this work out, it was always in some other context.

Semmel: I resent the images presented to me by David Salle. I find them demeaning and hostile to me as a woman. However, I would never think of not allowing his work to be seen in the context of art.

Audience: Have you ever felt your work was co-opted?

Semmel: That's what I've been saying . . . It's not only that you're denied credit, it's that what feeds back into the culture is, again, only the view from the male eye. They take

what you've done and use it [for] a *male* image that degrades women again. They use all the things you've opened up to reinforce what you've been fighting against.

Audience: What do you find "degrading" in David Salle's work?

Semmel: They're very hostile pictures. . . . The woman with the two dunce caps over her breasts, for instance; she's totally victimized, brutalized, and negated, sexually and personally.

Schneemann: Or, when she doesn't have a dunce cap on, she's decapitated. Or she's a lot of loose strokes with a cunt in the middle.

Semmel: Or she becomes all backside – spread out in a way that's not sexual, in that it's not enticing, or alluring. It's repulsive, a turn-off.

Man in Audience: Do you think [Salle's] painting advocates that attitude toward women? I could make an argument that he's sympathetic.

Schneemann: Well, *we* wouldn't.

Man: But it could be. I think you're reading into it. [Your interpretation] has as much to do with you as it does with the painting.

Semmel: Obviously. Everything I say has to do with me.

Schneemann: Saying, "maybe you women have it all wrong," is like whites saying for blacks when they're looking at debased images of blacks, "It's not really debased. It's just another viewpoint."

Semmel: If I use the word "nigger," a black person is going to react. I can say "I didn't mean it that way," [but] the person at whom those stereotypes are directed has a right to react. Their sense of [meaning] is probably much more right-on than all the rationalizations.

Schneemann: We recognize . . . disgust and negativity.

Second Man: In the whole tone of this discussion so far, it seems to me you're inordinately preoccupied with other people's reactions to your work. What's really important – what people think of your work, or the work itself? I would be more interested in hearing you talk about your work than . . .

Semmel: We all talked about our work.

Second Man: Obviously you're doing something which is going to be shocking or controversial to a lot of people . . . You can't blame people for reacting.

Susan Stoltz [in audience]: At the Carnegie International, every single huge work was nothing but a blatant phallic symbol [with] just one painting by a woman in the entire show . . . No matter what it is, if a man does it, it's a formalist structure. If a woman does it, it's political.

Semmel: I think Carolee and I from way back did make the work as political. We never expected it to be accepted.

Schneemann: *I* did. [*Laughter*]

Moonmade: I was in Philadelphia, doing my performances [in a working class district]. One day I read, "Carolee Schneemann coming to talk" at the Moore College of Art, 1979 . . . I went to see *Fuses*. And I walked out knowing something about myself I never knew before . . . I went around saying to people, "I just saw the most erotic film I

ever saw in my life." [But] censorship is where it's at now, even more so than a few years ago.

Schneemann: Most of my work comes from what I call "messianic naiveté." I thought, once I make this film, everyone will thank me for it. I'll be rich and famous. They'll show it in the high school lunch room. It'll be on a loop and the kids will be having their fried potatoes and they'll say, "Oh, they're doing that again. OK. Pass the ketchup." I regret to tell you, *Fuses*, the film, the projector and the projectionist were arrested in El Paso, Texas, only 17 months ago. They have to punish somebody, so it's always the poor projectionist, who's getting like four dollars an hour.

Audience: Do you have any optimism for the future?

Nemec: Some. I just read in the *New York Times* that 10 years ago there was one school that sort of had a class in women's studies, and now a thousand people are experts in women's studies.

Schneemann: But this work is so fragile, so marginalized in the culture. I have a vision of Reagan-mania. Everything I've done could be destroyed in an instant.

Third Man: I read the other day that Jean Redpath finally "confessed" to writing some two dozen Scots ballads she'd been performing as anonymous "folk art," without royalties. The reason was, when she was growing up, it wasn't "ladylike" for Scotswomen to write songs.

Nemec: They probably wouldn't have let her perform them if they'd known they were hers in the beginning.

Edited from tape.

'86 / #187

Anonymous Was a Gorilla

Maintaining their anonymity behind truly formidable gorilla masks, Guerrilla Girls played hostess at two panels one week apart. A gorilla-masked Guerrilla Girl was cover girl for the next issue of *Women Artists News*, which included an appreciation of Guerrilla Girls themselves:

Guerrilla Girls did not invent the women artists' movement, though if you missed the '70s, you might think so. But we like their style. Guerrilla Girls posters on the art circuit stick in your mind: The frilly pink letter to a European collector, the bar chart for critics, the woman's dollar . . . But the secret of GG's success, and they are a success in our minds and hearts even if the Whitney Museum hasn't yet put them on the Board, is that they knew, or learned from the mistakes of the first wave that they had to be anonymous. No person signs the manifestos, or makes her name by politicking. No one is stigmatized as "troublemaker," "militant," or "loser." Maybe no one goes to meetings just to get her name on the list, or leaves in a huff when someone else grabs credit. (Well, we're dreaming.)

On the other hand, anonymity can create problems. Unaware that GG's planned to cover these events, I had reported on both of them. We printed sections of both reports.

"Hidden Agenders, Part One: The Critics"

Moderator: **Carrie Rickey**; Panelists: **Grace Glueck**, *New York Times*, **Kay Larson**, *New York* Magazine, **Stephen Westfall**, *Art in America*

Guerrilla Girls & the Student Organization, Cooper Union, NYC, April 28, 1986

Report #1

Noting empty chairs on the platform where Gary Indiana and Carter Ratcliff, who were listed on the program, should have been, Carrie Rickey quipped, "Two of the men wimped out." (Ratcliff had in fact called from Washington, she said, "full of apologies." But no word from Indiana.)

In an opening question, Rickey asked Stephen Westfall if he thought we need "Rambo-type heroes and no heroines." Westfall said "we like heroes [but] Cindy Sherman plays heroic roles," and Sherrie Levine's "idiosyncratic survey of modernism is a heroic undertaking." Grace Glueck said male artists make more of a splash, and the fact that dealers would rather deal with men reflects the larger society. The point that prejudice in the art world reflects prejudice in the culture at large was made by Westfall and he kept returning to it throughout the evening.

Agreement was unanimous on the panel that persistence and pressure are the "solution." Glueck said, "*You must keep up the pressure!*," adding, "The first time a woman's work sells for a million dollars, that will set a lot of dealers licking their lips." As for whether "alternative" shows for women do any good, Larson said they do and that she reviews them. Glueck said they're a good way to explore new talent, but men's shows are sponsored by the establishment, hence get more attention. What's a critic to do? A suggestion from the audience: "Write about the ignominy of the art world."

– Rosie Ray

"Hidden Agenders: The Critics"

Report #2

Seeing Gary Indiana listed on the flyer for this panel was a surprise. He had recently attacked Guerrilla Girls in the *Village Voice* centerfold. It was a childish taunt, a suggestion that GGs were hanging out with celebs at Palladium. But it had a venomous edge. A grudge? An incident? Maybe he's just bitchy. In any event, having used the *Voice* platform for a free shot, Indiana evidently had second thoughts about putting himself on the line.

Grace Glueck began with some history: When the Artworkers Coalition was formed in the late '60s, the situation for women in the art world was "dismal," she said. Lucy Lippard helped "spark the protest" over the 1969 Whitney Biennial, which had 8 women, 143 men. The situation "improved dramatically" in subsequent years, but backslid about 1980, "when the feminist pressure stopped." Glueck cited MoMA's 1984 re-opening show, which had statistics "almost the same as the Whitney in 1969."

Kay Larson said things haven't actually gone backwards, but are still "appalling." However, the "conceptual situation" for women is infinitely better now than in the '60s. It is no longer acceptable for a woman dealer to say "there aren't any good women artists." We have had a "revolution in women's consciousness," she observed. "Certain avenues opened that will never be closed again."

Stephen Westfall said that despite society's current love for "Rambo-type images," there's "still a leftward-leaning intellectual strain." And, much of "the most powerful sculpture of the last 20 years" has been produced by women – Jackie Winsor, Jackie Ferrara, Alice Aycock, Mary Miss and Nancy Holt, among them. These women, who might be "embarrassed" to be lumped together, Westfall said, are "the core" of a powerful body of work.

Larson related an anecdote about German collectors who walked into an important artist's studio, and, "finding her with her baby on her arm, took one look and walked out." Women have to learn not to let such treatment pass "without raising a fuss," she said. Then she compared Julian Schnabel and David Salle with Elizabeth Murray and Jennifer Bartlett. The two women are less famous and powerful than the men, "but better artists." The "macho identity of men in leadership roles has actually been destructive to their work."

Glueck cited the *People* magazine influence, the "cult of personality" that brings attention to the artist, rather than the art. This began, she said, when *Life* magazine did a spread on Jackson Pollock, calling him "Jack the Dripper." From then on, journalists wanted artists to be stars – and "artists have been a very willing party" to the treatment. Mostly men, rarely women, got this media attention.

Moderator Rickey asked whether there is a "female aesthetic," and whether male critics are more susceptible to works produced by men, women critics to works produced by women, difficult questions that got lost in the shuffle (but who could answer them?).

Talk turned to collectors. Glueck noted that they still prefer to buy men's work, "which simply reflects the larger society – men are more important." She recalled an episode at the *New York Times* some years ago, when a male editor said, "we don't want women in top editorial jobs because women cry." It seems John Leonard replied, "and men commit suicide." (Not usually on the job of course, but then has anyone actually seen a woman crying on the job?) Glueck also noted that when women artists are married to male artists, "the woman's studio is smaller, or shared, or isn't even a studio, maybe just an upstairs space."

As to what critics can do, Glueck said, you can find women's shows. "I make a point of covering at least one woman's show each Friday." Larson: "There are things we can do, but we're not God either. It has to be there or you can't write about it." She is only allowed some 1,000 words a week, including major museum shows.

The question of which women artists are due for a major museum retrospective drew "Georgia O'Keeffe!" from the floor; Elizabeth Murray, Nancy Graves, and "Mimi Schapiro is long overdue" from the panel. Westfall said, "You'd have to throw in Cindy Sherman and Sherrie Levine. But the field is so large. I'm looking at a number of distinguished women artists right now [facing audience] who deserve more attention than they've had and are galleryless. . . . The patriarchal system is in place. Free thinking and human values supposedly prevail in art, but they don't."

Larson: There's a lot of myth in art. Museum trustees and the like may never have worked with a woman in their lives, except a secretary. It's important to keep up the political pressure, because the consensus changes.

Westfall: Art is a luxury object, so it has to go along with upperclass ideas of a luxury object. You can't insert radical content into a system that has no interest in radical content. It has to be a goundswell, starting with the smaller journals. There has to be an aura of critical hipness surrounding the work. Collectors want to know what other collectors are collecting so they can collect more of it.

A propos of a "woman artists show" at Sidney Janis, held in response to the "stink" over a Janis show with only two women, Glueck said, "In the whole existence of the Sidney Janis Gallery, they've only shown two women. It's useless for a gallery like that to put on an all-women show."

Larson reminisced about the olden days, when Clement Greenberg used "masculine" and "feminine" as terms to evaluate work. For a male artist to be seen as feminine was very bad. A member of the audience recalled that, soon afterward, Marcia Tucker became heroine curator, challenging museum attitudes, championing work by Ree Morton and Lynda Benglis. Westfall cited John Perreault as the rare male who was "a real firebrand," making women's art an issue in his writing.

And from the audience:

"Jennifer Bartlett was called a yuppie in the *San Francisco Times* because she lives in Paris and New York. Lots of men have five homes and nobody puts them down for it."

"The *male* artists don't demand that such and such a *woman* be included in shows."

"Men, just by drinking too much, can look heroic."

"The moneylenders have chased art out of the temple! The curators, critics and dealers are all playing pool together."

"If a man dies in a whorehouse, that adds to his legend. If a woman dies in a whorehouse, she has to be the whore."

– Judy Seigel

Women Artists News, September 1986 [Vol. 11, No. 4]

Hard Sell

We introduced reports of the second week's panel of dealers with a vignette titled "The Wardrobe and . . ." sent in by poet-playwright C. Rohrer:

> Gracie Mansion was very underdressed in black sweat pants, sneakers and glasses. Not only did she look very pro-feminist, she argued in favor of more exposure for women artists. . . . Holly Solomon, former actress, wore silver high heels and mini skirt. She was the centerpiece of the evening's discussion. She also suggested Cinderella as a role model instead of a gorilla. . . .

"Hidden Agenders, Part Two: The Dealers: Passing the Bucks"

Moderator: **Carrie Rickey**, critic; Panelists: **Ronald Feldman, Gracie Mansion, Wendy Olsoff, Holly Solomon,** dealers

Guerrilla Girls & the Student Organization, Cooper Union, NYC; May 2, 1986

Report #1

Again, a wimp-out, as Tony Shafrazi failed to appear. Holly Solomon opened with the comment that women don't collect art, a point she returned to as a factor in why women's prices are lower. Wendy Olsoff said women in art school don't have strong role models and thus enter their careers at a disadvantage.

Ronald Feldman, unlike the others, said he finds collectors, who think women's art is a "good investment," ahead of museums. He also blamed critics for not writing about women. How can they be taken seriously if they're not mentioned? When Carrie Rickey asked this sympathetic panel if they would encourage their women to boycott an exhibition without enough women, Gracie Mansion said yes. Holly Solomon said, "You would?" Olsoff noted that curators avoid having just one woman in a show for fear of public criticism (i.e., by Guerrilla Girls). Solomon advised women to find where their "personal power" lies, then use it. For instance, she found she is very good at dealing with banks, but was dismayed to realize that women with money are seen as dangerous. Being a woman art dealer is tough, she said.

– Rosie Ray

"The Dealers"

Report #2

Tony Shafrazi's non-appearance, Carrie Rickey said she heard by way of someone he told who told someone, was because he didn't "want to be on a panel with so many middle-aged women."

Rickey went on to observe that "most critics write about art already on view, pre-selected by galleries. Tonight we challenge four dealers to explain the systemic prejudice against women."

Ronald Feldman: There *is* definitely prejudice against women – lack of entry into museum retrospectives, exclusion from various forms of recognition.

Holly Solomon: A very big problem is the fact that women don't collect. When I opened the gallery, I had 50-50 men and women. [Now down to 75-25.] Men buy the art and call the shots at the museums. Until women support women and collect each other, things will never change. . . . In the '70s, women weren't collecting because they wanted to have jobs at museums, to be professionals. They considered collecting a dilettante's pastime. Now they have their mink coats and their Gucci's, but they still don't buy art. I can count women collectors on one hand.

Wendy Olsoff: Two of the most successful artists in my gallery are women. . . . Often couples collect and the woman has an influence. . . .

Gracie Mansion: Neo-Expressionism came from Europe – without women. Now it's somewhat better in France – I met one woman there.

Solomon: A deep chasm between American and European art began in the '70s. Our values changed radically. Theirs didn't.

Asked whether European attitudes have changed since the Surrealists, who saw women as sex objects, Solomon says, "In Paris they allow their women at the cash register." Feldman finds "some change, but not enough. European curators still harbor doubts about whether a woman can be any good. I see it in their eyes. They think I'm being sentimental if I pitch the work of a woman."

Solomon: But they only want to show the Americans who validate their art, anyway.

Olsoff: Europeans are resentful of Americans having the attention for so long. With the [Neo-] Expressionists, they think they're getting the attention back. Look at *Flash Art*, you'll see only men on the cover.

Rickey mentions "'The Queen Bee Syndrome,' women who surround themselves with handsome young men." Gracie Mansion is annoyed: "Outrageous that you can even bring this up." A Guerrilla girl in black runs across stage bottom bearing a long sign that says "Oh, Really." She reverses, revealing the sign's other side: "But I'm not Angry."

Solomon continues, "If you stand up for yourself, you're a bitch. If a man stands up for himself, it's manly. When I first started a gallery in 1975, I couldn't open a checking account without my husband's permission. . . . Even our self-image is confused. I'm trying to undo the confusion, but just succeeding meant I wasn't 'ladylike.' It was 'debasing' my husband, which I didn't intend. That's tough to deal with."

A propos of Europe, Gracie Mansion has had "a lot of support on the European market" for her women. But "the vast majority of people who collect collect for investment. They ask, 'When has this person shown? Will the work go up in value?' Given the same exposure and comparable background, the man will sell for vastly more money. Collectors assume the woman won't get collected as fast, there won't be the same demand, the price won't go up as much."

Solomon: The dealer has just so much influence, anyway. The real box office is Sotheby's and Christie's. Those auctions say what sells for what price.

Olsoff: If you show an artist and a few collectors buy the work, there's a ricochet effect. Then all the others have to have it. They have no confidence in their own taste. They ask me who else bought it. They're *listening*, not looking! I'd like to say no one else bought it, but don't you like it?

Rickey brings up the recent Guggenheim Museum survey of post-war sculpture. "Only 4 women – 6%! Look how the Guggenheim re-wrote art history." She then asks Holly Solomon if she really said women sculptors don't sell.

Yes, says Solomon: "It's much harder to sell women sculptors."

"Like what's a nice girl like you doing with that great big I-beam?"

"Exactly."

Rickey asks if she would boycott or encourage her artists to boycott an exhibition that excluded women and minorities. A Guerrilla Girl with sign floats by, but Solomon is not amused. "You don't even show your faces," she says. "I get angry when women don't show their faces."

Rickey points out that in the '70s women protesters were accused of sour grapes (or exploiting the visibility) so that "it's important to be anonymous." Solomon is not persuaded. "Do you have to be a gorilla? That's not a very feminine attitude." (That *this is the point* is the point, of course. No "nice girl" of the '80s who has any education, let alone ambition, let alone ambition in the *art world*, would ruin her career by being *feminine!*)

Rickey: Are women on a more equal footing in the East Village?

Olsoff: It's closer. Not as great a discrepancy as other places.

Mansion: But women still have to work harder and fight stronger. . . . I was an artist before I was a dealer. The men could get jobs at carpentry, work a few weeks, then quit to do their art. It's harder for women to get this kind of high-paying job. They're waitresses, secretaries, etc. They can't earn enough to take off a big block of time.

Solomon: It's also harder for women in the art world to mate. They have to make a conscious decision to have a baby.

The power of artists to help other artists comes up. Olsoff describes a show, "Open Call," curated by a panel of women who picked 20 women to be in it. But two of the women from PPOW "said they wouldn't be in the show unless a male gallery member was included. And he was." Rickey recalls that Susan Rothenberg has refused to be in European Expressionist shows unless a plurality of women were added. Feldman describes the dilemma of New York's curators, "bogged down with paper work and 'deskism,' so that now some of the best writing is from out-of-town shows."

Questions from the audience bring mention of "King Bee" curators, or dealers, "who only want pretty women around them." Mary Beth Edelson gets up to say she's tired of so

much "negative information." There are positive things. "For example, we live a lot longer than men do."

Solomon says she's been trying to find some answers in books, and she quotes Nancy Friday, author of *Jealousy:* "Women's power is in our tits." Solomon says she is "sick to death of women imitating men's power. . . Your power comes from within. Learn it without imitating men's power." She makes another point, as unpalatable to the audience as anything all evening: "The real problem is there are so many artists." Rickey adds an awesome statistic: "Today more artists graduate every year than there were in all Italy during the Renaissance."

"It's impossible to care about all that work," Solomon adds. "That's why alternative spaces aren't as effective as they were." Asked why the number of women in her gallery has dropped to 25%, she responds: "The young women aren't doing work that thrills me. I have to pay my rent. We are not given money by the N.E.A."

Then a tense exchange with the audience: A young black man taking his turn at the open microphone presents a dramatic delivery and pre-amble, adding, "I don't like white people and I live around them." But he has a friend, "an American black girl, a sister up on 125th Street, who wants the opportunity to be in Soho." What should she do? Ronald Feldman says, "She's in trouble." An audience voice says, "Go to the East Village." There's talk of problems for minorities generally. But, the young man says, "The art world is *run* by a minority."

In the shock of silence that follows, one hears the whispered explanation: "Jews." The thread of response meanders off. The panel is courteous, low key. It's not clear if the speaker expects Jews to be more responsive to problems of minorities or is holding them responsible for those problems (perhaps having taken time out from poisoning a few wells to starve an artist). The next speaker returns to the ratio of male to female.

Olsoff had said that about a third more men than women bring slides to PPOW. And, "We can tell enough from the slides to see if we're interested. 90% of the work we show is narrative oriented, often with social commentary." Ronald Feldman tells about a museum curator's struggle with his trustees, conservative elders. Trying to no avail to recommend an artist to them, he pleaded, finally, "give me a break." One old man spoke up: "We have been giving you a break. On everything."

– Judy Seigel

Women Artists News, September 1986 [Vol. 11, No. 4]

'86 / #189

Girl of the East Village Big Bang

We looked the other way for an instant in the early '80s and missed two "East Village" panels. However, this interview suggests the flavor of the scene – which, alas, faded as rapidly as it blossomed.

Interview with **Judy Glantzman**
East 2nd Street, NYC; July 9, 1986

Visiting reporters wrote about the place as if it were Beirut. The exotic populace in colorful native garb, the gunplay in the streets, the shell-shocked architecture. On a sunny summer afternoon in 1986, however, the East Village was a lark. The art was what's happening, the real estate was what's happening, the art was on the real estate and inside the real estate and talk glided seamlessly from one to the other.

Abandoned buildings in stands of two, three or five waited like drugged princesses for the renovator's kiss. A cherub-faced man smiled broadly and offered to sell you smoke and some other things you didn't recognize. At 2nd Street just east of Avenue B, if you faced south and yelled "Judy!," Judy Glantzman appeared and whisked you up two flights to her living-studio-catbird-seat over the avenue, looking uptown. But no more. She's about to return to her old West Village apartment. The East 2nd Street building was bought two years ago for $385,000, a steal for seven stories. Now the owners are divorcing and must liquidate. The building is for sale at $200,000 *per floor.*

Glantzman: Before I moved in, this was the worst corner in the city. There was a drug murder in the building. There were a thousand people on the street every night screaming their wares. There was "toilet" and another kind of heroin, I forget the name. Then the cops came in with bullet-proof vests and masks and machine guns, like Darth Vader. They went into the shooting galleries and hauled them away. They called it "Operation Pressure Point." It was like a war zone. Of course you still see them selling. They gather sometimes between Avenue A and B, but not as many. Maybe they went to Stanton Street. Maybe they went back uptown. . . .

Glantzman is well known as one of the young artists launched with the East Village Big Bang and revolving around the earth ever since. She admits success came quickly and easily, but adds that she had been out of school and painting for five years before starting to show and that most of the other artists who "appeared" at the time had been painting five years or more, too. They lived in the East Village because it was a slum – rents were low. Of course that was before Pier 34.

Glantzman: David Wojnarowicz and Mike Bidlo started it. No one was expecting anything or making any money. But it really was the beginning of everything. You went to Pier 34

[on the Hudson River at Canal Street] and found a wall or partition and just did whatever you wanted to do. The windows were out. When it rained, it rained all over. There was no lighting. You had to have daylight. But you heard about it and that's where everybody met. I met the people I became friends with. We were all serious artists who'd been working for a while. The overnight part was more the dealers. Some had no previous experience. It was a surprise for them, too. One day Dean [Savard] was selling art supplies. The next day he was running a gallery [Civilian Warfare].

Glantzman had graduated from the Rhode Island School of Design, class of 1978, then waitressed and done odd jobs:

Glantzman: I landed a seven-month spot at Cummington Artists Community. That turned it around for me. I knew I had to give full time to painting. From then on I worked one week a month and painted the rest of the time. . . . Friends bought some pieces. My father gave me $150 a month, and I lived on very little. I began painting on plexiglas because I got a batch of it free from Artists Space. I also painted on wood I picked up in the street. . . .

After the show at Pier 34, she was in a show Warren Tanner curated for the Organization of Independent Artists at Pace McGill, an important uptown gallery.

Glantzman: He'd seen me at the pier and invited me to be in this show with James Brown, Frank Young, Scott Richter and Young Hee Choi. . . . We got reviewed. It was exciting, the first taste of success. Then a friend of mine had an appointment at Fashion Moda and couldn't make it and told me to go instead. Fashion Moda gave me a show.

In rapid succession, Hal Bromm put her in a 12-artist "new talent" show with Mike Bidlo, David Wojnarowicz, Louise Frangella and Nicolas Moufarrege. Dean Savard reviewed it for New York Native *and offered her a solo at Civilian Warfare.*

Glantzman: As it happened, I'd been saving and planning for a trip to Europe, my first. The trip was set for August and the show was October. I decided not to give up Europe. I did that whole show in the month of September. . . . But I'm prolific. The work stood up.

It also sold out. Collectors brought money and Robert Pincus-Witten brought people. The East Village had been discovered. Countless group shows followed, six one-person shows around the country, and solos abroad as Europe in general and Germany in particular fell in love with the East Village.

Glantzman: It was good for me to have to push the work out, to be spontaneous. I work best that way. The year before last I did an incredible number of East Village shows; I was turning out at least 300 pieces a year. But that kind of frenzy had to stop. Nobody could keep that up. [I had] two sell-out shows at Civilian Warfare. Dean was a good salesman and hot.

Glantzman points out that, among artists, the only real infant-prodigy stories were the boy wonders, like Rodney Alan Greenblat and Jean-Michel Basquiat. And, contrary to the popular idea of many women artists in the East Village, ratios

are still low. Gracie Mansion gallery, for instance, has only 25% women. When Timothy Greenfield-Sanders made a photographic group portrait of East Village artists posed to match a photographic group portrait of New York School painters of the '50s (both titled "The Irascibles"), there were probably no more women than in the original cast – Glantzman, Debbie Davis, Rhonda Zwillinger, and very few others.

When things fell apart at Civilian Warfare and Dean Savard went out of business, Glantzman got a show at Gracie Mansion for November 1985:

Glantzman: But things had changed. I felt I had to prove myself in a way I hadn't before. A lot was riding on this. I went back to painting from life. The work became more about body form and more elaborate. . . . It was a really good show and it was a relief to be with a dealer who was so honest and upfront about money – and a good business woman. That's rare in a dealer. She's really respected. But it was my first solo that didn't sell out, even though I sold a lot. Every big piece had been on reserve at the opening, but some sales didn't come through. It was my first solo that didn't get reviewed. I had had a lot of attention from critics. Now it was someone else's turn.

And something else was looming on the horizon – "PoMo." That's the East Village term for Post-Modern Abstraction [later called Neo-Geo]. Pat Hearn Gallery was showing PoMo, as was Jay Gorney Modern Art. Peter Halley [then an artist-dealer] showed it at International With Monument. He and Philip Taaffe and Peter Schuyff were suddenly everywhere – in the New York Times and Art in America.

Glantzman: It was Reagan-esque art. It was all the things East Village art wasn't, the opposite of my way of thinking and working. It was contained, cool, neat, clean, "well-crafted." It was easy to embrace and easy to write about and it looked like "real" art, bank art, not just something wild. It was about appropriation, not emotion. That appealed to collectors. My kind of work was about messiness and looseness. The East Village had its own critics. But PoMo attracted *outside* critics. . . . There are plenty of women artists in the East Village, but in the new PoMo I don't know of one woman.

The work Glantzman became famous for was "expressionistically" painted, near-life-size figure cut-outs. In the process, she became a self-taught carpenter, acquiring a 14" electric bandsaw and electric mitre box and making her own frames. These are often integral to the work and so substantial as to be nearly architectural. Her previous work had been called everything from "mannered reflection" and "post-modern regression" [East Village Eye] to shocking, ugly and aggressive [Cologne Stadt Anzeiger]. Now she is preoccupied with new work, which is solid and elegant.

Talking about her success, Glantzman describes an "X" in the air with her finger, to represent the point where her personal style crossed the zeitgeist:

Glantzman: Three quarters of it was being in the right place at the right time. . . . Things were pretty locked up in Soho and

57th Street and this was a way of opening it up. You did the work and right away you had a place to show. Not that I didn't work hard, but it was also being there. . . . Now, though, a lot of really good artists want to move out of the East Village. It's not the way it was. Rents have gone way up and it's not happening here any more. We want to be established. It was great, but a lot of it was about superficial things. And there wasn't a sifting-out process. Now the sifting out comes.

– Judy Seigel

Women Artists News, September 1986 [Vol. 11, No. 4] Excerpted

1987

Dubious Relations

"The Relationship Between Artists and Museums"

Speakers: **David Bourdon, Richard Hennessy, Diane Kelder, Barbara Rose, Marcia Tucker**

Kouros Gallery, NYC; 1987

Learning that John Bernard Meyers, founder and former principal of Tibor de Nagy Gallery, had organized a panel discussion about relations between artists and museums – a topic of major significance in the art universe – and hoping, not necessarily for a revelation, but perhaps for some pointed commentary, we sent a reporter to the event. She was only faintly amused.

The symposium on The Relationships Between Artists and Museums was a formal display of sparring and volleying between five panelists, some of whom raised genuine questions. A few presented themselves as ideologs. Only the final speaker attempted answers.

A stiff academic history of the relationship between museums and artists by Diane Kelder, who quoted Goethe and claimed that Italy destroyed classicism, opened the event. Commencing an extrapolation of the didactic role of museums, Kelder lost her place (she was reading) and quickly closed, just damning the Whitney Museum's conspicuous relations with corporations and the Morgan Library's allowing Mobil Oil to sponsor Holbein exhibitions.

David Bourdon then addressed the overflow audience (mostly of women, mostly of stern and angry visage) and asked a crucial question. Do museums cause people to be artists? And, if so, how bad is the damage? His thesis was that because artists now have easy access to museum exhibitions, relations are casual. He also pointed out that some kind of money has to support the showcases of art. Large corporations, because of governmental tax structures, are logical sponsors. Of course, Bourdon allowed, there is an opinion behind the money, and the corporations want their tastes validated. And, since corporations are innately materialistic, greedy and commercial, they will not readily accept difficult or controversial artists.

Barbara Rose floundered on the question of how an artist achieves visibility. By means of "museum patronage," she decided, then discussed the moral obligations of art-world powers. Museums should not be in the business of certifying artists, but should remain neutral, she said, then wrapped her argument into a dead end by repeating the cultural myth that artists are by nature introverted and melancholy (Oh Vincent, lend us your ear!) and the belief that corporate

backing of museum shows is so narrow and aggressive that most great talents would be passed over in any event.

After that black vision, Richard Hennessey, in the supporting role of token artist, explained with great flair that the first thing he did upon arriving in New York was to go to the Museum of Modern Art and that made him an artist. A successful artist, albeit hand-made by museum endorsement, he thought it was OK to be in league with the power structure of, behind and around museums. This seemed a naive and self-indulgent viewpoint, both compromised and trusting. It reminded me of farmers in the midwest who endorse Ronald Reagan, while his direct influence is bringing about their economic demise.

However, Marcia Tucker was on the mark, advocating ways of manipulating corrupt museum power into a more positive result. "Of course there's corruption. Of course museums favor dead artists like Holbein who provide a predictable, finite career. Of course corporations control museums and museums control aesthetic visibility." But, Tucker added, there are working solutions that could benefit artist, corporation and museum. She suggested that museums should have a variety of curatorial standards to expand the tunnel vision of corporate influence, and curators should speak without lying. Meanwhile, she maintains that museums and collectors can engage in truthful discussion of ideas and involve corporations without losing their integrity.

Panelists then wrestled with the obvious questions, managing, finally, a ray of hope and optimism.

– Cathy Blackwell

Women Artists News, February/March 1987 [Vol. 12, No. 1]

What Happened at Rabb Hall

Re-reading the whole story in 1991, I had the thought that this 1987 College Art Conference panel may have been the high point of the women's movement in art.

Here were an emotional high in the cause of justice and intellect, profound identification with a cause, the gratifications of camaraderie, the possibility of personal gain as accomplishments accrued and barriers crumbled – all while the challenge and anticipation, that is, the fantasy of the movement yet remained.

In retrospect, we may wonder if, as in so many human endeavors, the fantasy wasn't better than the reality. By 1990, some developments seemed to push us abruptly

over the brink, past a goal of equality and justice, into megalomania — at the same time that, sadly, several of the women's institutions closed down for lack of funding.

We can but wait to see how it all comes out, aware that the varied unfolding of such fascinating stories is one of life's rewards (or punishments). I should probably add that I myself was not present at the event described here: My sense of it comes from the reports, of which I assume the accuracy (proving that the real "truth" of history is, whoever writes it up – or down – tells the tale).

"The Politics of Identity: Entering, Changing and Being Changed"

Moderator: **May Stevens**; Panelists: **Josephine Withers, Mary Duffy, Alanna O'Kelly, Adrian Piper, Pauline Cummins, Cecila Vicuna**

Women's Caucus for Art, College Art Conference, Boston; February 11, 1987

February 11, 1987, 10:45 AM, in the basement of the Boston Public Library. Artist May Stevens, in her introduction said, "The dominant culture doesn't worry about who *it* is. Its identity is self-evident and perceived as the norm. For the rest of us, who have been invisible and unheard or misunderstood, forging an identity consonant with our inner sense of ourselves can become a major challenge, sometimes a lifelong quest. And it can produce powerful art." Stevens then introduced her panel.

Josephine Withers read a paper describing the fluidity required for self-definition and change. Although she is a "tenured Associate Professor at a major university," she said, that is only a mask. Beginning as an outsider, picketing the Corcoran Gallery's all-white male Biennial, "after an extremely infantilizing eight-year experience called graduate school," she felt she had finally grown up. That is, she had undertaken "a project that no one, least of all the male establishment, had told me to do." Now, however, she sees the new National Museum of Women in the Arts as "a profoundly conservative, anti-feminist and money-driven venture . . . modeled on a corporate image of power and success." It also exploits the achievements of the women artists' movement, she said. Still, the greatest risk is to "confuse ourselves with our position in the circle."

Adrian Piper is a young woman who physically fits the ideal of mainstream American. By ancestry she is a black who chooses not to pass as white. The slides of her work were a record of attempts to break through stereotypes of white, black and woman. Her mission is to change society as a whole, so that she and others may move freely. While Withers had been spritely and inventive, Piper met us at our darkest places and forced us to share her discomfort. [See "Adrian Piper," following.]

Cecila Vicuna drew our attention by rhythmically tapping the microphone and passing strings of beads from one hand to the other, preparing us for the experience of the exile by sound. With the auditorium darkened, she presented her paintings in a distinctly Chilean palette, while describing life at the foot of the Andes. This sliver of a country, poised at

the edge of the vast ocean, became a metaphor for the marginal life Vicuna has lived as an Indian under colonial domination and as an alien in New York City. First her native religion and earth were evoked through painting. The second part of her presentation, "Exile," used poetry and sculpture. Her voice was extremely soft and soothing, forcing us to listen intently to her meditation about the history of the words *identity, I* and *id*. We also felt our distance from the center of a patriarchal society.

Pauline Cummins was the first of the three Irish women to speak. At this point the library let us down by inadequately preparing those in the audio-visual booth. One after another the sound and slides were mishandled in a way that raised the hackles of all who have ever had to deal with passive-aggressive males. The men in the booth became the "other" at whom anger flew unimpeded. The three artists never turned a hair, but did the best they could without all their tools.

Cummins's slides were made with two sheets of glass placed so that the image on the one in front complemented an image on the one in back. Her media included painting, video, poetry, voice, knitting and anthropology – she calls the form "tape-slides." Her presentation of *Inis t'oirr*, or *Aran Dance*, began with musings about shearing, carding and spinning yarn, and women knitting clothing for their men. A scrap of an Aran sweater with its cables and nubbles was turned about to resemble the male torso and then the naked torso itself began to emerge. Cummins led us to feel the torso, the penis, the desire, the pleasure in the common touch of ourselves and our creation of this "other," thus returning to woman her role as creatrix and initiator of desire.

Alanna O'Kelly, also from Ireland, left her native Wexford and traveled about the world, never losing sight of the human connections between cultures. She had heard women of Western Ireland keening at wakes for the dead and heard the same sound from women at birth, death, and protesting nuclear war at Greenham Common. She asked for the lights to be turned off. The sound she produced as we sat in total darkness rose through her womb, lungs and throat to meet infinity. She did not pause, but waited for minutes, leaving us sightless in the dark with the echoes rebounding. And then another. How she drew enough breath to last the length of each wail, call, howl or ululation was a cause of intense concern. When will it stop? We heard the voice of the Gorgon calling to us through time.

It had been announced that Mary Duffy would speak about those whose identity is threatened by being disabled. As she sat on the stage waiting her turn we did not discern any disability. When she walked to the podium she appeared poised. The two other women from Ireland rose to help her prepare microphone and lights and, in the process, her foot suddenly appeared on the stand. She was without arms. With great dignity she told us that she photographs her nude body to discern her wholeness. What we didn't know until her slides appeared is that she is a photographer of rare artistry. She never jarred, or raised her voice, or asked for special consideration. She posed, herself, not to flirt, seduce,

excite, or manipulate. She emerged as a person centered in her own being, the curves, shapes and colors of which became a poetic hymn to womanhood.

What happened in Rabb Hall at 10 o'clock on a normal Wednesday morning was not a dramatic production with script or producer, nor an academic experiment that could be replicated. It was an expression of women's experience of being women against a collapsing patriarchal structure and stereotypes. The rest of the day and into the night conference-goers asked each other, "Were you there this morning in Rabb Hall?"

– Mary Hopkins

Women Artists News, June 1987 [Vol. 12, No. 2]

Adrian Piper

Excerpts from a paper by Adrian Piper at the "Politics of Identity" Panel

Women's Caucus for Art, Boston; Februrary 11, 1987

I embody the racist's nightmare, the obscenity of miscegenation, the reminder that segregation has never been a fully functional concept, that sexual desire penetrates social and racial barriers, and reproduces itself. I am the interloper, the alien spy in the perfect disguise, who slipped through the barricades by mistake. I have infiltrated your conventions and your self-presentational styles. I represent the loathsome possibility that all of you are "tainted" by black ancestry. If someone can look and sound like me and still be black, who is safely white?

Even those who become my friends, upon first meeting, peer closely at my face and figure, listen carefully to my idiolect and habits of speech, searching for the telltale stereotypical feature to reassure them. Finding none, they make some up. "Ah," they say, "but of course your hair is wavy," or, "perhaps a certain flare of the nostrils," or, "but the way you dance is unmistakable." Or they discover my identity later, and go through a period of cognitive dissonance.

All blacks suffer under racial stereotypes, suffer the alienation of being feared, hated, misunderstood, punished for what they are not and then for what they are. Blacks who look and sound like me bring out racial discrimination in those who believe they know better, who believe they have transcended their racism. We bring out a vehement insistence, a curiosity, a compulsion to impose the stereotype at any cost, even at the cost of good manners. "Perhaps your great grandmother?" "Oh, it was your great grand*father* who was black?" (That is, "You mean white women consorted with black Africans in the 1850s?")

Blacks who look like me are also unwilling observers of the forms racism takes when racists believe there are no blacks present. . . . Sometimes what we observe hurts so much we want to disappear, disembody, disinherit ourselves from our blackness. And then we pass for white, and lie to our children about who we are, who they are, and why they have no

relatives. The southern historian Joel Williamson estimates that the actual proportion of Americans of black ancestry is not 10%, but closer to 15 or 20%. But of course most of them don't know they are black. . . .

Our experiences in this society manifest themselves in neuroses, demoralization, anger, and in art. My work is representational in the broad sense that it examines and reflects back the barriers that surround me – the tears, the presumptions, the stereotypes that impede my desire to be just a person and live my life.

Brave New Ethnology

"Reply to Piper," which follows, came in "over the transom," and was originally published with no particular apprehension. We'd always considered *Women Artists News* a forum, and the reign of terror of Politically Correct Thinking had yet to arrive.

The response was a firestorm of condemnation, apparently unanimous from the black women's community and nearly so from the white. Volleys of furious letters-to-the-editor charged racism – although that was the writer's charge against Piper. Women we'd worked with, written about and been friends with since day one stopped speaking to us. The author ruefully concluded that, in this day of outrageous art, she had at last found a taboo – criticism of a polite black person.

Sensitized by these events, I myself realized something else: The entire society has embraced a new ethnology. Whoever has any black ancestry is now "black." Vincent Canby, reviewing the 1930's movie "God's Stepchildren"[1] says of the heroine, "though black, her skin is so light that she can pass for white." What Canby *means* of course is, "though *of mixed ancestry* [or whatever term], her skin is so light that she can pass for white." It is apparently forgotten that not so long ago a woman from Louisiana who was 1/32 "black" had to go to the Supreme Court to get the designation removed from her birth certificate – an episode rightly considered a national disgrace. Now it seems she *is* black after all.

And so, according to Piper, are the rest of us! Interviewed recently in *Afterimage*,[2] Piper says, "white people . . . feel insulted by the suggestion . . . that they are probably black." However, she says, "the fact is that . . . there are no genetically distinguishable white people in this country anymore." Proof of this remarkable assertion is the "fact" that "an American who is identified as 'white' has a completely different genotype than an English person who is identified as white." That, she tells us, is because "Americans have intermarried and miscegenated so much with African-Americans." The source of these genotype "facts" is omitted, but I am even more curious about how Piper picked "*an* American" between New York's Lower East Side and San Francisco's China Town to match up with Prince Charles — and why. Beyond admiring his or her diction, what do most of us have to do with "an English person"? (I note in passing that a source almost as authoritative as Adrian Piper, *Newsweek* Magazine, says "the concept of race has no biological validity." [9/23/91])

Sad to say, objecting to this preposterousness (and its shiver-making echoes of Nazi racial "science") puts one on dangerous ground. Simply by objecting, one becomes a "racist," "insulted by the suggestion" of being "probably black." *But no one does object!* The art world enshrines this flapdoodle without demur, indeed vies to heap Piper with honors.

The same *Afterimage* interview describes *My Calling (Card) #1 (1986)*, a card Piper hands people who have made "racist" remarks in her hearing. It says, "I am black," and, "I regret any discomfort my presence is causing you, just as I am sure you regret the discomfort your racism is causing me."

But the art world is Discomfort City these days. I think of the discomfort a photograph of a crucifix allegedly submerged in urine causes many people of whatever religion (despite it's gotta-be-kidding rationale). I think of the art-world sermonizers and apparatchiks who sanctify *Piss Christ* and its maker. And I think the moral is, Modernism says the public is *supposed* to be discomforted by art. Just don't let the public discomfort artists. 3

1. *New York Times* , February 8, 1991

2. Quotations are from "The Critique of Pure Racism," an interview with Adrian Piper by Maurice Berger, *Afterimage*, October, 1990.

3. For statements about the advantages of discomfort to the public, see, for instance, '85/#175.

"Reply to Piper"

A response to Adrian Piper's "Politics of Identity" paper

Talk like Adrian Piper's is refined and polite and full of upperclass angst, but it's about as racist as anything you can expect to hear these days. It's just the other side of the coin – a grandiosity (and fatalism) about being "black." Imagine someone with one Chinese ancestor, say, like Piper's, a great grandfather (maybe in the 1850s tea trade) proclaiming her *Chinese* identity. Would that reduce a roomful of college graduates to jelly? They'd say, come off it honey, you're as "white" as I am.

But where blackness in America is concerned today (and of course there aRe awesome precedents of counting by racist whites, up to 1/64th and no doubt beyond), logic yields to paranoia.

I remember telling long-ago dorm mates at my midwestern university, when that place was pure cornfed Bible belt, that I was part black (in those days "negro"), simply as a lark, a response to my sense that they could scarcely distinguish among easterner, Jew, black. It was charming to see how readily they believed me, another case of the eye seeing what the mind believes.

But Piper projects her own obsession with race onto the environment. The "nightmare" is her own. The people I know, whatever their other sins, would be *enchanted* to discover a friend or acquaintance had something exotic in her background. Rather than turning "racist," they would leap at the chance to have a "black" friend of their own social class.

Let Piper present herself as Adrian Kelley and pretend she's actually part Irish (or part Polish, or whatever) and listen to the ethnic slurs she'll pick up. If she presents herself to Jews as Jewish (and she could certainly "pass"), she'll hear plenty of anti-Catholic remarks, and terms like *goyische kopf* and *shiksa*. At a "hen party," she'll hear men disparaged; at the men's club, women are put down. Certainly, "us" vs. "them" can be vicious and evil, but at the level we're talking about, life has worse problems.

Which brings me to my solution to the Problem of Race in America. Instead of the virulently racist insistence that whosoever has the merest drop of "black" blood is "Black," even if they "don't know they are black" and "don't look black" (shades of Hitler's notions of racial taint), why not the other way around? Declare that anyone with even the merest drop of white blood is White!

This would reduce the numbers of blacks to such a small figure (5%?) that they would be an exotic novelty, fêted and adored, as they used to be in France, before the numbers grew, and may still be in Switzerland (land of the cuckoo clock and the "Room for rent – No Italians" sign).

Meanwhile, let's remember that many people live quite contented and productive lives with no concern at all for who their greatgrands might have been. (Do the Australian descendants of murderers and thieves obsess about it?) To see "black blood" in even the most miniscule amounts as overriding is to see it as a contaminant. Early (white) racists called it the "touch of the tar brush." Sighing over Adrian Piper's theatrics is not just a dimwitted expiation of white liberal guilt, it's nonsense.

– Barbara Barr

Women Artists News, June 1987 [Vol. 12, No. 2]

'87 / #192

End of Bohemianism

The title question of this panel is the sort that rarely gets asked unless the answer is meant to be yes – and the answer for this one did seem to be yes, but . . . Yes or no, the panel articulated feelings about "success" that had ripened in the '80s.

"Has Success Spoiled the American Art World?"

Moderator: **Hilton Kramer**; Panelists: **William Bailey, Sylvia Mangold, Sidney Tillim, Robert Pincus-Witten**

College Art Association, Boston; February 1987

The most talked-about art writing of 1987 College Art week was Janet Malcolm's *New Yorker* profile of Ingrid Sischy, editor of *Artforum*. Hilton Kramer, introducing "Has Success Spoiled the American Art World?," explained how

Malcolm found Sischy not "profilable," and so profiled instead a "Cook's tour of the seamy aspects of the world [Sischy] is obliged to move in." We, apparently more accustomed than Kramer to the ways and means of artists, thought the scene sounded like just folks, and began to wonder anew about Kramer's sense of the fitness of things.

From there he segued into a depiction of the runaway art world of the last five to 10 years – the proliferation of art critics, the inflation of indifferent art and the turning of art into a commodity for the moneyed middle class.

Kramer traced the blame for the decade's art sickness to his years at the *New York Times*. Something happened in the '70s art world that was expressed by his editors: The burning question asked every week at editorial meetings was, "What's New?" But, as Kramer saw it, the impetus for this question, and what changed American journalism, was *New York* Magazine. It was *New York* that advised readers each week where to buy the 10 best hamburgers, see the 10 best exhibitions, find the 10 best artists, discover the 10 newest movements.

So Kramer's editor at the *Times* wanted to know what was new *that week* in art. The high point of his career at the *Times* was the week he answered that "no new trend was discernible in the last seven days," and the editor asked, "Is that a trend?"

Kramer advised his audience to resist sentimentalizing the "old art world," reminding us that those now-famous artists were impoverished at the time, had no public, only hostile and ignorant response (if any), no solo exhibitions until they were 40 or 50 years old, and sold at outrageously low prices. Was the American art world a finer place in the "good old days," he asked, when de Kooning didn't have an exhibition until he was 42, and Milton Avery sold his paintings for $50?

William Bailey had pondered the question, "Has Success Spoiled the American Art World?," and was prepared to say "yes, in the sense of a spoiled child." Then, with carefully weighed words, he added that the problems of the art world emanate not from success, but from a sense of failure. As the successful get more successful, the unsuccessful get, in comparison, even more unsuccessful. The gap between them widens, rending the art community. Bailey also disdainfully likened today's success for artists to the success of rock stars and movie stars. (But why not? We have lived to see moments when even women artists were mobbed by fans at openings. We'd like more – more famous women artists, more mob scenes.)

Bailey said that when he started out, "art" was what came from Europe; he himself had no expectations of "success." He made the point that most painters today still live marginally, and under increasingly difficult conditions, especially in New York. The community of artists has broken up; it is no longer possible even to share poverty. Bailey knows young and old artists who have never had the kind of success heaped today on the art world's darlings, but are instead in-

volved in the daily conflicts of the studio and haunted by a sense of failure. The talk now in Soho is only about money, while at the old shrines (museums) curators are preoccupied with enticing the fun people, as though to a disco. Bailey asked if all this "presages the decline of the West." However, it was reassuring to have him tell us this is not just New York, but all over.

Sylvia Mangold, the only woman on the panel (added, we understand, as token, at the insistence of Natalie Charkow, chair of the conference studio sessions), said success means money. She enjoys being able to live off her art. Though she lives apart from the New York world of careerism, she still faces her own problems in the studio.

In preparation for the panel, Mangold had read Suzy Gablik's *Has Modernism Failed?* and works by Willa Cather. From Cather she came away with the reassurance that success is never as interesting as the struggle (though there might be some argument on that from the strugglers), and that every artist needs to find some motivation other than money. Money brings problems, Mangold observed, expressing her certainty that most artists she knows care more about their work than about making money. But sensitive, gentle Sylvia, doubtless selected because of her friendship with the moderator and the knowledge that she wouldn't make trouble, was no match for those macho image-makers on the platform – though one wished it were otherwise. A scrappy hard-hitting woman puncturing some of the blather would have been refreshing.

If Sidney Tillim had some gift as a raconteur, his garrulous drawn-out tales might have been more appreciated. He, too, assured us, in case we didn't know, that most artists don't work just for the money, and that he, personally, doesn't have enough of it. He, too, harked back to the art world of 30 years ago. Asking himself, "Why am I here?" (at the panel), he concluded it was for his career. Tillim resumed writing some four years ago, after a lapse of 14 years, because he wasn't showing. "I just couldn't get a dealer." He was surprised when an article he wrote, "The View Past 50," got an enormous response, mostly from people under 30. Then, in an attempt to share his thoughts on the subject, he launched into a soliloquy, "The Art World Today is Like Baseball," an extraordinarily boring ramble on his life-long interest in baseball, which may of course have been less boring to a person with a life-long interest in baseball.*

The passive among us grabbed 40 winks, the decision-makers got up and left; the masochists toughed it out. Finally back to the subject at hand, Tillim proposed to document changes in the art world, as, for instance, the evolution of the Whitney Museum of American Art from humble beginnings on Eighth Street to MoMA's back yard, to Madison Avenue and its present post-modernist imbroglio. These changes, showing the movement of money and upward mobility, have occurred, he said, not just in art, but throughout modern culture. Then, before relinquishing the mike, Tillim got in yet another personal anecdote. He had sought advice from Robert Pincus-Witten about how to approach the art maga-

zines. His first submitted article was rejected (by an unspecified publication). He next decided to approach Betsy Baker, an old friend who happens to be editor of *Art in America.* His call was fielded by a young man who asked what he wanted to talk to her about, explaining that it was necessary to "prioritize topics." Tillim's topic evidently didn't make it to the top 10, because he didn't get through. Next he approached *Artforum*, where he finally got published. Running into Baker at a later date, he described his failure to reach her. She told him, "Next time just say you're returning my call."

Robert Pincus-Witten was introduced by Kramer as "the kid," but admitted to being not much younger than the others present. My neighbor whispered to me that she'd been in his class at art school and they were the same age – 52. RPW, simultaneously arch, pleasant, and snide, smiled and demolished all previous nonsense. The basic situation has not changed, he said. All artists want as much as they can get and good-looking lovers and always have. But this has no effect on art. For example, "Has success spoiled Hilton Kramer?" No, RPW assured us. "Whatever he does is not affected by his being a successful man." Reading from a column by Kramer, he quoted statements about the lack of talent among this year's famous — Salle, Fischl, Schnabel, and company – can't draw, can't paint, etc. He added that success is very revelatory of character; in fact, you can't tell what a person is until they get what they want.

Kramer then shifted the discussion to museums and their keepers, describing the enormous pressure on curators and directors to be first with the new stars and to beat the Europeans to it. Mangold questioned who holds the power, and RPW said power is in the hands of those who make the newest art – small groups acting in concert. This led to a diatribe against the gang of four, Fischl, Schnabel, Salle and Boone (speaker unidentified by now-sleepy reporter). Kramer tossed in the fact that MoMA is an ailing museum, and no longer representative, quoting Harold Rosenberg's phrase about "the herd of independent minds." Everyone, Kramer explained, thinks they're making "independent decisions," but they turn out to be identical with all the others.

Mangold said she found the volume of art being produced frightening, but another panelist reassured her that two kinds of business will surely prosper – storage and conservation.

Assorted quotes and choice lines from the panel:

Pincus-Witten: Agnes Martin's withdrawal can be seen as a strategy for self-promotion.
Bailey: Critics don't see very well; that's part of today's problem. There is the question of how well Picasso draws and how badly Salle draws. [Bailey added that he regretted having to speak ill of another artist, but was driven to it.]
Kramer: The problem with Salle isn't that he doesn't draw well, but that he draws.
Pincus-Witten: Although we think of certain galleries as central emporia for significant artists, art actually moves into the

world as a function of stylistics. Hype doesn't sell art, stylistics does. Work enters the marketplace because it sells itself, and that's what the consumer wants. Significant collections are made up of works bought by people who don't have to have things "sold" to them.
Kramer: The shift to Neo-Expressionism was the result of a strong sense by a new generation of what was missing in art; something more important than fashion and avarice, a sense that the vitality of art should be restored. Also, there are now so many artists, dealers, museums, curators and collectors, that it's tougher for an artist to get a serious review than to sell a picture.
Unidentified: At least we are finally rid of the mythical bohemianism of the lonely painter living in isolation and neglect.

Unanswered questions from the audience:
Are these phenomena of "success" aspects of some larger cultural decay? Does the success of young artists, like the success of young ballplayers, inspire other young artists? Who markets the artist?

And answered questions:
Audience: Aren't artists involved in object commodification, as opposed to writers or dancers?
Kramer: There's a whole new group of short story writers similar to the Schnabels of our time.
Audience: How does one achieve fame and fortune quickly?
Answer: It's easier if you start young.
Audicnce: Would you prefer to be a successful Picasso or an unsuccessful Van Gogh?
Answer: One lived three times as long as the other.
Audience [referring to the breakdown of the star system in Hollywood]: Can it happen in the art world?
Kramer: We all liked it better when the movies had stars, but it's not a true comparison.

Gossip:
We heard that the panel originally included Robert Hughes and Alex Katz, with the expectation of a face-off between them. Hughes, it seems, had disparaged Katz in print and Katz was furious. When Hughes cancelled his panel appearance for a trip to Australia promoting his latest book, Katz cancelled, too. The large sensation-hungry audience was disappointed.

– Cynthia Navaretta

Women Artists News, June 1984 [Vol. 12, No. 2]

*Apparently painter Clyfford Still also had a lifelong interest in baseball and also drew analogies between art and baseball which he shared with his students in California, but their response is not on record.

'86 / #193

How Not to Get a Grant

"What's Wrong with NEA Money
and How to Get Along Without It"

A paper by **Eleanor Dickinson**, "Alternative Funding" panel.

Women's Caucus for Art, College Art Conference, Boston; February 1987

Of 5,600 artists who applied to the NEA last year, only 257, or 4%, were funded, and those mostly at a low level ($5,000) Women's passivity, incidentally, prevents them from being effective at even this level. Of those artists turned down by the NEA for Artists Fellowships, 85% of the males try again; 85% of the females do not.

Another problem with NEA money is that it has become a mark of achievement in the art world. If you get an Endowment grant you get a personal letter from your local museum director; it goes prominently on your biography; you get into *Who's Who*

I am speaking as an ardent capitalist, which may offend my socialist friends, but I am convinced that empowerment for artists lies in [artists funding themselves], with the freedom to create what we please and work where and how we like, so long as we can pay for it. The grants and handouts from governments have too many strings and are too hard and time-consuming to get. I have gotten my share of grants, and in every case the money has gone primarily to the museum showing my work:

They'll pay you to spend a lot of time putting on a seminar in a museum, or organizing conferences for consumers of your art, or going to some other country away from your sources and studio to work or "improve international relations," or being a resident artist in a school for $5,000 a year, so they won't have to pay a decent wage to an art teacher. Art groups will be paid in similar fashion to put on seminars about art – but not to hire a secretary or pay the rent. And to get the grant you'll have to write 30 pages, do a budget and send 18 copies of each page to Washington, on their schedule, spend a lot of time in meetings and conferences, in learning the skills of a professional fund raiser, probably get a computer and learn how to use it to produce the data they want. The main result is to justify the employment of a lot of bureaucrats. It has practically nothing to do with getting you money to do art.

I know artists who have supported themselves by robbery, prostitution or other illegal activities. This is possibly easier in Califomia on the North Coast where one large marijuana plant will fetch $1,000. . . . If that is what you do best and you can be smart about it, maybe that is best for you. . . . There is a moral problem for non-profit art groups to survive by illegal activities, but there is the example of the Lotus: the lovely flower blooms because its feet are in the swamp.

On a loftier level, let us determine what artists and art groups have to sell:

- A high level of skills in image and idea manipulation
- Probably undeserved glamor, fashionableness, the ability to confer status
- The ability to renovate run-down neighborhoods
- The ability to identify new objects of mass consumption
- Control, with critics as allies, of the course of world fashion
- Training as risk takers and problem solvers
- Access to the wealthiest persons in the western world
- Unquestioned non-profit status
- Tax deductions for almost everything except the art we produce
- Ownership of some of the most glamorous spots on earth: lofts and studios
- Ability to change an entire town's economy into an art colony

As high priests of "Art," the new religion of the middle class, we should be ashamed that we give these powers and gifts away to be sold by others and not used to enrich and empower artists . . . If artists or art groups [thought] like entrepreneurs, what could they do?

- Make deals with realtors, bar owners, and developers to promote artists' bars and art colonies or use art studios to renovate a neighborhood for profit . . . The dollar value of Soho before the artists in the early 1970s was $20,000 per loft; in 1986 it was over $200,000. . . .
- Package tours of artists' studios and sell them to tourist agencies for cash and sales promotion.
- Attack the public school system's use of any teacher available for art classes as scabbing. . . . Insist that only professional artists are competent to teach art.
- Use the rights you have – copyright your work, thoroughly and formally and then pursue the rip-off artists. Make sure your innovations profit you. Join Artists' Equity to learn how. Remember Robert Indiana, who painted the famous LOVE? It was used everywhere, even on U.S. stamps, but he got no money because he hadn't used a copyright [©] notice.
- Sell the advice and information you have acquired with so much effort. I get many calls a week from people who want data and advice. I can sell them half-hour video tapes from my television program of professional advice for artists. After four IRS audits, Jo Hanson knows all there is to know about how to prove to the IRS that one is a professional artist, not a hobbyist. She has put the knowledge and forms into a self-published book for sale.
- Be available for portraits. Reclaim this field from photography . . . The photographic "C" print is now estimated to last about 15 years. What price for lasting through the ages in oil or bronze?
- Arts organizations must also find some product or products to sell. Grant-giving institutions won't even consider giving money unless an organization has 60% earned income. Selling art classes for children is very profitable in California, where there are no art classes in the public schools.

– Eleanor Dickinson

Women Artists News. June 1987 [Vol. 12, No. 2] Excerpted

'87 / #194

An Artist by Another Name

"The Artist and The Shaman"

Moderator: **Lori Antonacci**; Panelists: **Geno Rodriguez, Donna Henes, Lorenzo Pace, Sandra Harner**

Artists Talk on Art, NYC; February 13, 1987.

The shaman of old was a trance worker, a mediator between realities, and a healer. In the mid-1980's, visual artists in our culture began to announce that the artist is a shaman. I organized a panel to ask why artists are now attempting to take on this title and these functions. Do they have any real understanding of shamanism in primal cultures, or are they simply appropriating a new term of power because the word "artist" has become devalued? And, since our society – modern, pluralistic, and money-oriented – is the antithesis of a nature-based, community-centered shamanic culture, how would an artist-shaman function?

Considering this a fairly esoteric topic, I would have been delighted to see an audience of 75. The panel sold out – over 150 people, making it the second largest of the season. And most came, not to question the concept of a modern artist-shaman, but to testify to it. Panelists agreed with them – except for Geno Rodriguez.

Rodriguez, visual artist/photographer, co-founder and director of the Alternative Museum, said he had little knowledge of shamanism and avoided such groups: "I want to make my own magic without too much influence from other people."

Donna Henes calls herself a "celebration and ritual artist" and "an urban shaman." Best known for her *Eggs on End: Standing on Ceremony* celebrations of Spring Equinox, she says her work is really concerned with "transformation and creating hope."

Lorenzo Pace, visual and performance artist, draws on his African heritage for artmaking. "I just feel we all are shamans, and how we project our shamanic ideas and philosophies is on us."

Sandra Harner, a fiber artist, says she renders images directly from "shamanic journeys." She has lived with the Jivaro and Achura Indians of the upper Amazon and, with her anthropologist husband, leads workshops on a technique for shamanic journeying.

My own first exposure to shamanism came as a student of what was then called primitive and prehistoric art. Later, I studied techniques for shamanic journeying, and in 1985 had the rare opportunity of participating in the still-living shamanic tradition of the Huichol Indians of Mexico. That year I resumed making visual art after 10 years as a film-maker (and executive director of Artists Talk On Art). Although I try to integrate this tradition into my daily life, and find it an inspiration, I am also clear that I am not a shaman.

When panelists were asked, "what is a shaman?," most re-

plied in quite personal terms. Unconcerned with what a shaman might be in other cultures, they felt perfectly free to redefine the term for themselves. Only Harner offered a classical definition:

Sandra Harner: A shaman as his [sic] distinctive act makes the journey between the ordinary reality we know and live in at least part of the time to non-ordinary reality. An altered state or trance [makes] a spiritual connection with nature, usually through a power animal or other spirits. The shaman works for his or her community by healing and divination and other spiritual services.

Lorenzo Pace: I think we all are shamans, and how we divulge our shamanic identities is how we live our lives. . . . By walking down the street, by talking, by gazing, we go into a ritual, into a shaman's pose.

Geno Rodriguez: I misread the title, because I interpreted it as "the artist as sham-man." [*Laughter*] I think today the artist is far too often a sham-man, who learns how to put portfolios together by going to special classes and knows how to hustle at parties.

But I don't think anybody I've met in 15 years of running the museum and looking at a million slides a year is really into shamanic work, by the dictionary.

Donna Henes: You talk about a shaman working for her community. Maybe that's the difference, if there is one, between art and shamanism. I think of myself as a public servant on my better days, and claim my power as a shaman. It took me a long time to do that, and only after a certain amount of feedback and a certain amount of acceptance. I would not just say, "I'm a shaman," but *my* kind of shaman – an urban shaman in 1987.

My role is to connect people with their sense of their best self and with each other in a sense of community, even though it's a silly, temporary community, and, most importantly, with the sense that we are on the planet. I think it's important to be silly and non-threatening – that's the sha-man-trickster. I'm not sure that I'm an artist. But I am sure that I'm a shaman.

Lori Antonacci: In the tradition I follow, your entire goal is to literally find your life, to find out why and how you are living. Everyone can live in a shamanic way, in harmony with the world – but *being* a shaman is something else.

A shaman's role is to bring the spirit to the people, to shift reality, to align him or herself to the life force – the healer of everyone. But a shaman is nothing without his or her community – and must be validated by the community when what he or she does works, the healing happens, the spirits come, the community prospers.

Rodriguez: Are we saying shamanism applies to the artist today? You all feel that everyone who makes art with feathers and sticks and straw is a shaman?

I personally don't believe most people doing these things are consciously aware of what the objects mean, either to themselves or others. To me, this is like *Fantasia* – Mickey Mouse running around with the sorcerer's cap on. . . . All artists work intuitively; there's nothing wrong with that, but I don't call that being a shaman. I call that, instead of using Cadmium Light, you're using Feather Light.

Lorenzo disagreed. Although you could use the narrow classical sense of shaman for a specific culture, he said, "we've got to open this thing up." Defining an artist *in today's culture proved even more difficult. The more Geno tried to pin people down, the more discussion expanded, touching on community, healing, money, power, and pink-haired ladies.*

Antonacci: What is an artist today?

Henes: Once the role of the artist and the role of the scientist were diametrically opposed and the scientist was a sort of priest. But now artists and scientists have changed places. Art has become elitist – very rational for the most part, very logical, very intelligent. And the people who are in the farthest reaches of scientific thought, who are doing particle energy physics, are total flaming mystics. I'm more interested now in reading science than art because I find it speaks to my soul, and art doesn't speak to my soul any more.

Antonacci: You've told me art is your *cover*, because art is accepted and "shaman" isn't.

Henes: I spend days, sometimes weeks, months, in the street doing my work. If I weren't an artist, I'd be crazy. It's very convenient to say, "I'm an artist." People say, "Oh, well then."

Pace: When you begin to touch base with the spirit that's in you, then you begin to touch base with those rocks out there in the street, or those trees out there, or those stars. Then you begin to become conscious of you as that tree and as that rock, that star. . . . Labels like artist, priest, become nonexistent. I could be a rock, or tree, or the air I breathe.

Harner: I think we all have at least the potential to be artists. Whether we choose to become artists or call ourselves artists, is something else again. It's also true with shamanism.

Doing traditional core shamanism, our experience [in workshops] has been that about 90% of the people can make this shamanic journey without altering consciousness with drugs, and have a personal vision. It's a part of our human endowment we've lost touch with.

Antonacci: You've said that as an artist, one could reach ecstatic states.

Harner: Absolutely. And that ecstatic state brings you back to it again and again and again.

Rodriguez: Everyone is using words at random however they want to define "artist." Every time I get on a panel and somebody asks what is art and what is an artist, we have shit bricks because no one is prepared to say. I want a definition from everybody. I'll tell you my definition: an artist is a person who makes art.

"What is art?" I think art is a by-product of a people's culture, and a people's culture is a by-product of a people's health, education and social well-being. Now that gives me a parameter to define an artist – whether a good artist or a failing one.

Antonacci: But why are artists talking about being shamans? I suspect that why we're discussing this is right now the word "artist" means very little in our culture. Perhaps we're trying to redefine it.

Pace: When you walk down the street, and you see a rock, and you say, "Hey, what's happening, Rock?," and the rock says, "Hey, how you doing?". . . that rock respects you and

you respect that rock. That [communication] is the essence of an artist. You get into a visual or verbal dialog with that energy.

Antonacci: Can you get into a dialog with paint?

Pace: It's exactly the same. Once you begin to respect that paint, and that paint maybe talks back to you and you talk back to it, all that energy comes through it.

Audience: How does that apply to the definition of an artist?

Pace: Basically we're all artists – just by being, living, breathing.

Audience: I think what you're talking about is people who have the ability to release energy. Some people are able to get it off their fingers so strong it has a healing quality. An artist puts paint on canvas. It's the same kind of energy transfer.

Audience: I want to address why there are so many people here and why such an interest now in this topic. I think there's a real hunger. People have been starved, cut off from intuitive knowledge. There is an intuition in all of us that knows, just knows, that this is real, that this is true.

Pace: I agree. You can call me whatever you want, but we've got to heal this planet, and doing that, heal ourselves.

Rodriguez: I keep hearing the words healer and healing. Who's healing what, where and how? I'm very happy to associate myself with all of you. I'm interested in the spiritual aspect of art rather than the commercial side, but there is a whole larger community that – whether we like it or not – affects us.

I don't know that in terms of art I see too much healing for anybody. And if there is any healing, it's for the culturally elite, the economically elite – because they're the ones that go to these pristine white rectangles, even the one I run.

I just told a group of students that if you aren't wealthy, if you don't have a baby trust fund, or money available, you shouldn't be an artist. Because the minute you've got to start thinking about making money from your art, you're a prostitute shaman.

It's the ladies with pink hair* who say art touches everyone. Bullshit! Art doesn't touch people who can't get rice and beans on their plate. Art doesn't touch Archie Bunker. He wouldn't give a damn if the Metropolitan Museum burnt down. So, when we talk about healing I've got to wonder who we're talking about except ourselves.

Harner: In a traditional culture, the shaman is not a full-time job. The shaman is something else as well, like a mother, a farmer, a shoemaker. But a shaman is able to handle, with excellence, both worlds, that spiritual world and this ordinary reality – getting it out to galleries.

Audience: I disagree with Geno that when we use feathers and bark to make art we're not aware of their meaning. You underestimate us. I think someone who chooses those particular materials is definitely conscious of their meaning.

Henes: I couldn't agree more with Lorenzo that we have to heal the planet. But I'm also interested in healing my community. Even with a zillion different ethnic groups and a billion different neighborhoods . . . we have to reach for what connects us all.

Rodriquez: Can you tell me how you heal the planet?

ROBERT PINCUS-WITTEN **TRUE FORMALISM IS A TOOL FOR SERIOUS ANALYSIS OF**

Henes: What I do personally is facilitate enormous public celebrations of seasonal changes, celestial events, in city settings . . . to connect people. They're always outside, always with passers-by, and I would say my largest audiences are homeless people, alcoholics, teenagers skipping school, bag ladies and mental patients. I do not have much interaction with pink-haired ladies.

On Spring Equinox, for example, it's possible to stand an egg on its end. By the laws that make the universe run, without our help, despite our help, it works. And you get thousands and thousands of people standing up their little eggs. And they realize, walking down Wall Street, that it's the first day of Spring.

Antonacci: Is there another way to be powerful and to have some effect besides getting shows and those mundane art world things?

Rodriguez: When people painted bison in the cave, the guy who painted the bison was a very important person. You didn't mess with him, because maybe then you didn't eat. With the advent of democracy, anybody can be an artist. You just pick up a brush and say, "I'm an artist." But there's this crazy thing we call supply and demand. We're talking about healing with our art, but first we've got to put it somewhere.

You want a show, you want to sell, and so you become what I said, the artist as sham, rather than shaman. We start selling out one way or another so we can heal. In the end, instead of having the shamans or the artists in the center, you have the dealers in the center and the artists going around them.

To do what Lori is talking about – getting out there and healing – perhaps the solution is not to think in terms of making art for the art world or the galleries or the museums. But unfortunately, you need money. If I had my choice, I would be renting huge billboards on the way to Long Island so all the suburbanites could get healed. And I would have the first museum called The Underground Museum, because it would be in the subways.

Audience: The artist right now is the visionary, the dreamer. She has new ideas, new ways of communicating. There's an energy, an emotional experience the people around us can feel. That's why we have become so attractive to the women with pink hair. They miss that energy in their own work, their own lives.

– Lori Antonacci

Edited from notes and tape.

*There seems to be some disagreement about the meaning of pink hair. In "How the Marketplace Gives Form to Art" ['85/#180], Lynn Zelevansky called it a "vestigial reference to anti-bourgeois lifestyles, rather than a real affiliation with marginality." In other words, pink hair as anti-bourgeois symbol. At the present event, speakers and audience have been using the term "ladies with pink hair" precisely to refer to bourgeois women. That this designation for a group exactly the opposite of Zelevansky's is an expression of contempt is apparently understood by all and challenged by none. Clearly, culture coding by hair color is not yet an exact science.

The Clement Greenberg Story

Whoever has come this far should need no introduction to Clement Greenberg. As philosopher-in-chief of "Greenbergian formalism" he personified everything the "mutiny" was about. But one would have to be stony-hearted indeed not to find the old man who discovers his name now everywhere "an epithet" somewhat poignant. And it's possible that the Greenberg variations are no less true than the judgments of those who became critically correct by hindsight. Daniel Grant's interview-overview includes Greenberg's own hindsight and disclaimers, as well as a rare appreciation of his contribution to contemporary vision. It's also as fair, interesting and descriptive as any Greenbergiana in print. Still, another issue does arise obliquely.

In 1973 a writer named Sophy Burnham published a gossipy exposé of the daily corruptions of the art world and its then-battening institutions. The art world, of course, despises all outsiders except rock stars and Native Americans, and Burnham's near-misses and misspellings (like Bracque for Braque!) were hardly endearing. So it was not surprising that her book, *The Art Crowd*,* drew mixed contempt and rage, even from such an Olympian figure as Harold Rosenberg ['75/#2].

Perhaps, though, outsider Burnham saw some things more clearly than the regulars. She saw that what is normal in the reviewing, exhibiting, selling, publishing and museumifying of art would land, say, a commodities broker or a salesman of parking meters in jail. In other words,

An art magazine publishing an article by a critic who is a friend, spouse or relative of the artist should state the relationship in the author's squib. This is a common journalistic practice. . . . Only in the art world do we consistently find the relationships between critic and artist disguised.

Equally important

A critic should never accept paintings as a gift or at a reduced rate from an artist about whom he writes. If, having accepted a painting, he decides at a later date to write about that artist's work, he should either return the picture to the artist or donate it to a museum . . .

Despite the cataclysms in art and art theory since Greenberg's era, certain routine practices apparently remain routine. We see here that in 1987 Greenberg could still call the attention of an interviewer to the fact that his personal collection was "all gifts."

*Sophy Burnham, *The Art Crowd*, David McKay, 1973, p. 307. For the hyper-abuses of the hyper '80s, see *The Art Biz*, by Alice Goldfarb Marquis, Contemporary Books, 1991.

"Clement Greenberg Revisited"

NYC; April 9, 1987

The woman, a docent at the Washington, DC, National Gallery of Art, was explaining to a group of visitors how some Renaissance painter had created the illusion of three-dimensionality on a flat surface. The words crystallized some ideas in my mind, and recalled a passage Clement Greenberg had written in 1954: "From Giotto to Courbet, the painter's first task has been to hollow out an illusion of three-dimensional space on a flat surface. One looked through this surface as though a proscenium into a stage."

Whether the docent had read this or any essay by Greenberg or just picked up these Greenbergian ideas from other sources was beside the point. The point was that yet another group looking at art was hearing, like the RCA dog, the "master's voice." Now attacked and denied by almost every art critic of note in the country, Greenberg was again vindicated – as he is almost every time someone steps into a museum, either by the way the works of art are presented or the explanations they are given.

Greenberg himself has seen better days, and my interview with him at his apartment was filled with his complaints about being misread and misquoted to bolster someone else's position in the art world. Some of these remarks were aimed at specific writers – Donald Kuspit, Rosalind Krauss and Tom Wolfe in particular – though maybe some were intended for me as well.

Beyond that, Greenberg now seems to deny most of what is taken as common knowledge about him: that he posited a theory of modern art and measured artists against it ("I defy anyone to find an aesthetic in what I've written"), that he promoted certain artists ("I never promoted anyone. All I ever did was talk about what I liked"), and that he viewed art in an historicist manner. Either way, the remarkable fact is that Greenberg's ideas are still as hotly debated and as widely expressed as when he wrote regularly. In addition, he has defined for his detractors what an art critic is and does.

Any critic who has ever knocked an artist's work can expect to hear, "The critics hated the Impressionists, too!" And it's true. Many Parisian art critics of the 1860s and 1870s labelled as "lunatic" and "imbecile" the work of the best artists of their time. But those critics have long been forgotten, their criticism only recalled to show how wrong they were, and, implicitly, how powerless their condemnations.

Indeed, most critics have a short and shallow presence in the public's consciousness. But one contemporary figure stands out – Clement Greenberg. At age 78, he is no longer the commanding figure he cut during the 1950s and '60s as the unofficial dean of contemporary visual arts. Nevertheless, years after his semi-retirement, his name and ideas still generate passionate debate.

He now lives rather quietly on Manhattan's Upper West Side, his living room filled floor-to-ceiling with large paintings ("all gifts," he tells a visitor) of artists he favored in his heyday: Helen Frankenthaler, Kenneth Noland, Jules Olitski, Jackson Pollock and Larry Poons, among others. No longer writing regularly, as he did for almost 20 years in *The Nation* and other periodicals, or organizing exhibits of contemporary art, Greenberg lectures at universities from time to time and writes on certain artists.

In the 1930s, when he began writing about art, Greenberg reflected, "I started to see modernism as art about itself, but no one was writing about art in these terms. Critics wrote about layout, color, composition, line or else they wrote about art in a very romantic way. It all seemed very unsatisfactory to me." He learned modern criticism less from other writers on art , he said, than from literary essayists, especially T.S. Eliot.

Greenberg was no more pleased with the way museums presented art. "Museums just put pictures up on a wall to be appreciated." The theme was, "'these are the great works of art.' But they looked like random choices to me."

Literature was Greenberg's first interest, and when he began publishing in the early 1930s, he wrote primarily about books and authors. "I only took one course in art history in college (Syracuse University) and that was 'Art Over the Ages.'" After college, he studied painting at the Art Students League and even had an exhibition or two. "I still paint on my own, or draw from the figure, but not in a serious way."

At times, it appears there are two Clement Greenbergs – one who is quietly lionized, the other regularly and openly vilified. There is little question of the importance of the first Clement Greenberg. His ideas have become so much a part of the mainstream that they are no longer identified with him, but assumed to be common knowledge.

These ideas include the notion of modernist painting as not creating the illusion of three-dimensionality, but reflecting painting's inherent flatness; of the subject of painting being its medium and the tensions between its colors and forms. These ideas, absorbed into the teaching of art at universities and art schools around the country, led two generations of Americans to view art in these terms.

Greenberg saw a trend to general flattening of the painted image and a growing concern with its medium beginning with Manet, continuing through Cézanne and Picasso, leading to Abstract Expressionism and, finally, Color Field painting. Most modern art museum curators and directors have organized their collections along this Manet-Cézanne-Picasso-Pollock axis. Artists not in this line of development, such as German Expressionists, Dadaists, Surrealists, American Regionalists and other representationalists, usually get less museum space; they are implicitly viewed as minor in comparison.

Greenberg brought to his discussions of modern art some of the studio talk he had heard in lectures by painter/teacher Hans Hofmann in the late 1930s. His early thought was also strongly influenced by the writings of Karl Marx and other socialists, and Marxist phrases and analogies peppered his essays, and still, to this day, his conversation. However, his interest in political and economic issues ends at the door of art, where he acknowledges himself an "elitist." Marxism, he said, "has nothing to say about art." When other critics "bring social and political factors into the discussion of art," he objects vehemently:

> Social factors don't help anyone understand a work of art, though they do affect the production of art in a variety of ways. There are traditions in art, and they have a continuity, and that continuity has to be pointed to. You have to look at art as art. . . . [T]here has always been an autonomous logic to the development of art through history, affected only momentarily, but not very deeply, by events outside art. [This logic] isn't always clear, but it's there. You can see it if you look carefully.

Greenberg met Jackson Pollock in the early 1940s and was immediately attracted to what he called "a genuinely violent and extravagant art" that did not lose "stylistic control. . . . What may at first sight seem crowded and repetitious reveals on second sight an infinity of dramatic movement and variety" [1946].

For almost eight years, Greenberg touted Pollock's work, from the early swirling to the later drip paintings, and the critic's star seemed to rise with the artist's. He later moved on to highlighting the more chromatic wing of the Abstract Expressionists – Robert Motherwell, Barnett Newman, Jules Olitski, Larry Poons, Mark Rothko and Clyfford Still – as well as what became known in the 1960s as the Washington School of Color-Field painters, including Morris Louis and Kenneth Noland. No art critic before or since has had such a phenomenal string of successes in identifying the major artists of the time or done so over such a long period.

In time, a vision of what modernist art is, and what modernist artists must do, emerged in Greenberg's writing. This vision had a great influence on many who read the essays, as well as those who hadn't read them, but received "Greenbergian" ideas at one or more removes. "It seems to be a law of modernism . . . that the conventions not essential to the viability of the medium be discarded," he wrote in 1955. Ten years later, he wrote that "flatness, two-dimensionality [is] the only condition painting shares with no other art, and so modernist painting oriented itself to flatness." These and related concepts were seen as the laws of modern art, though now Greenberg claims he was "only describing the work of the best artists of the time," not prescribing for artists.

Greenberg points out that Tom Wolfe, in his book *The Painted Word*, "has me telling Morris Louis that flatness is everything, as though you would tell an artist that, or Morris had to be told that, or the drying up, silting up of illusionist space hadn't been going on for years."

If the first Clement Greenberg is the critic whose ideas have become part of the art world's mainstream, the other has become the focus of unrelenting attack by those who would dethrone his ideas and values. "I'm through with Clement Greenberg," Rosalind Krauss declared before announcing her allegiance to structuralist criticism. Another critic says Greenberg's taste is "academic" and "sectarian," complaining that he "degrades criticism to the status of fashion-picking." Critic Donald Kuspit decries "Greenberg's assumption of a constant modernist premise in the best art – as though that alone made it best."

Now, however, Greenberg contradicts many of those suppositions:

> It is often said that I deny the importance of content or that I'm opposed to representational art and only accept abstract art. [In fact] I long for deep space – my prejudice is to very closely seen representational art – but it's not present in the very best art.

Although discontent with Greenberg ranges from his dismissal of artists not in the Manet-Cézanne-Picasso-Pollock axis to his formalist approach to criticism, generally there is no quarrel with his ability to spot quality. However, Greenberg feels that little of "the best art" has been created in the last 25 years. He sees much celebrated art since the mid-1960s as a step back from achievements of the Abstract Expressionists and Color Field painters:

> With Pop Art, Minimal and Conceptual art in the 1960s and 1970s . . . artists were producing nothing but occasional minor, inferior work. It's said that I dismiss Pop Art and all the others wholesale, but that's not quite right. I do compare them to Abstract Expressionism or the best art since the '50s – and then I dismiss them.

Claiming that "Jules Olitski is the best painter working today," Greenberg added that contemporary art has failed to emerge from the 1960s – "it's all Pop in spirit, everything you see."

Part of Greenberg's legacy is the impression he has given those who follow of what one must do to succeed as a critic. His attachment to certain artists, especially to Jackson Pollock, has led subsequent critics to attempt to find their own up-and-coming artists to promote, though none have had anywhere near the same success. Greenberg's polemical writing style has given rise to a breed of skilled arguers who view discussing art as a battle of theories. His association with a certain group of artists – or rather, a certain style – has begotten followers whose interest in art appears to end with those their own age. Nevertheless, subsequent art styles have merely added to, rather than supplanted, the momentous change in thinking that began in the 1940s and '50s when he led the charge.

In the long run, art critics have very little influence with collectors and artists. Some may gain a certain footnote longevity due to a coinage, such as Louis Leroy's "Impressionism," Roger Fry's "Post-Impressionism," or Lawrence Alloway's "Pop Art," but most are forgotten long before they are dead.

The new crop of writers today, whether they tend toward neo-Freudian, neo-Marxist, French structuralist or some other brand of eclectic art criticism, will take on Clement Greenberg before their first painting. This tribute to the power of his ideas and connoisseurship has left him feeling bitter, isolated and besieged:

> My ideas are simplified and distorted. People discuss [them] not with a concern for truth, but just to set out a position in opposition. A lot of good it did me praising Pollock. Pollock now is a culture hero and, whenever my name is mentioned, it's almost always like an epithet.

– Daniel Grant

Art & Artists, June/July 1987 [Vol. 16, No. 3]

1988

'88 / #196

And Now a Word from Captain Bligh

It takes a little work to understand the title of this panel, "Contemporary Art in Context: Points and Views," but when you get it, it seems like an OK idea. As it turned out, however, the major message about "context" was the panel itself, and clearly an unintended one. Which is not to say snippets of thought didn't manage to slip through the ambiance, or that Arthur Danto didn't reward our patience with an excellent insight about the difference between the way we are and the way we think we are. (Too bad his books are in such convoluted prose.) But another question remains, and I do not consider it by any means trivial: How did the panelists all know to wear black?

"Contemporary Art in Context: Points and Views"

Moderator: **Ingrid Sischy**; Panelists: **Rosetta Brooks, Arthur Danto, Kay Larson, Kenneth Franchen, Allen Sekula; Amy Taubin, Helen Winer**

Museum of Modern Art, NYC; February 29, 1988

A museum functionary completes his lavish introduction by telling us how fortunate we are to have Ingrid Sischy with us now that she has left *Artforum* and can do *anything she wants.* Sischi says "Good evening," and then lapses into an uncomfortably long silence, apparently rattled at finding herself center-stage in a chromolith version of "The Last Supper": the long table draped in crimson velvet, the spotlight haloes behind each head, the acres of deep velvet backdrop pleating up toward Heaven, the panelists left and right in black, flanking her wholesome bright jacquard. The tableau is Apostles of Modernism, *religico luxe* – MoMA's idea of how to stage art talk.

However, if the sound system had reached the rear third of the auditorium, the truly maddening, as opposed to the merely sappy, part of this sold-out event would have been mitigated, at least for those of us in that section. As it was, all but the strongest voices were drowned in luxury – every inch of the elegant space being draped, carpeted or padded in materials to muffle sound. Equally muffling, of course, was the fact that principals seemed to have nothing they wanted to say – or the energy to say it.

Ingrid Sischy introduced architecture critic Kenneth Franchen by asking him to tell "what critical boats you've been on." Clearly nettled by the awkward phrase, Franchen replied, "I hadn't expected boats, a metaphor that puts me all at sea already," then launched into low-voiced, uninflected

architecture talk, of which only "historicism," "tactile values," "the tectonic," "the poetic of construction" and "laocoonic [Lacanic? laconic?] words of Greenberg" could be heard.

The audience several times cried out "speak up" and "louder," a plea nearly always doomed, as it was here: Sischi brings her mouth close to the microphone and asks in a firm voice, "Is this better?" The audience, relieved, sighs, "yes!," whereupon she drops the microphone and lapses into her little voice. Amy Taubin, beseeched to "speak up," snaps, "I can't yell and read!" There are no more requests.

Helen Winer made these observations: "Things seem to have radically changed in the last eight or nine years. In the '70s, the best art had little commercial potential. It couldn't be owned or transferred easily. Artists took different paths. Conceptualists altered our understanding of what could be done in art. In the '80s, most substantial art has been presented in galleries. . . . The art dealer makes decisions in support of the artist's career and ongoing work." Then, "this may sound a little vague, but it's in fact very specific," whereupon she became too confusingly vague to follow.

Next, Rosetta Brooks explained to this audience of art professionals that "the role of the critic over the last 10 years has changed along with the culture. Fine art has moved into the mainstream, but the role of critic changed from [when] the artist was working in isolation. The strange phenomenon called 'the art market' changed the relationship of artist to dealer, critic, public and market. . . . In Wall Street terms, art is a product to sell and resell. . . . Art as a product evolved beyond the imagination and took its place in the mainstream of culture. Critics entered into collaboration with collectors, dealers and artists, and lost their independent function."

Brooks cited David Salle's "division of the world of criticism into the critic who sets up a relationship with the art and the journalist critic, the 'complaining' critic, who doesn't have any relation to the art as a thing in itself, but to the art *world* – dealers, critics and [inaudible]." However, "one of the few people who said all the things I'd like to say about art was Michael V. . . [inaudible]."

The subway rumbled nearby; the polite, totally silent audience strained to hear; Brooks's soft, gentle, uninflected voice promised to get to a point, but did not, rambling on, wafting parts of thoughts and non-thoughts, like: "If the artist takes the work seriously it behooves me to take the art seriously."

From Amy Taubin, film and video critic, the following could be heard: "Independent film and video have no economic value; they can't be sold or make their money back. . . . About 1960 Jonas Mekas tried to make a fiction film like Hollywood, but couldn't as an independent film-

maker. The resources available to him were inadequate to make a fictional world. . . . There's no place to show independent video: It's not very attractive to people to go out of the house to look at a TV set. . . . Since we've learned to listen to music vertically (stacked sound tracks), could we develop the capacity to look at visual images organized vertically?"

My notes on these fragments are scalloped with "ummm . . . ummm . . . ummm," representing both Taubin's audible pause fillers and the murmur of her inaudible words. The audience started to tiptoe out.

The next speaker, Allen Sekula, said he would read "an excerpt from something I wrote ten years ago," which he was now "embarrassed by" because it was "dated," but "obviously not embarrassed enough not to read it."

When a man celebrated for delving into *meaning* reads aloud to literate adults a paper that has been in print for 10 years, that clearly has meaning of its own – such as the lack of urgency of the topic at hand and the irresistibility of an invitation to speak at MoMA. But when he speed-reads what is in fact a complexly-argued essay onto the tabletop in a wee half-swallowed voice, I wonder about his common sense. Still, the few words I could make out seemed quite up-to-date: "incessant self-promotion," "celebrity pantheon," "charisma of art stars," "careers are managed," and "high art becoming a specialist colony."

Kay Larson was virtually audible, a great relief. She said, "David Salle equates 'complaining critics' with journalists, but I think Salle is a complaining *artist*, extremely brittle about responses to his work. He would prefer nothing but adulation. In fact, a 'journalist' critic is more likely to have a direct, immediate response to art than someone doing more extended theoretical analysis. . . . In the early '70s, the language of criticism had spiralled off and failed to connect with the reality of the art. Now, appropriationists have appropriated that language of the early '70s, using it as parody or farce."

Larson said she currently uses "the term 'humanism,' although it's a terrible term, to mean art with a connection to human beings," adding that there's no such thing as an artwork that's "a thing in itself." Now, she said, "the issue facing both artists and critics is how to expand the audience without losing some of the critical point or edge."

Arthur Danto (entirely, comfortably, audible at last): "I've seen films showing people in a storm, with the wind and waves, then the camera draws back and you see fans, and people throwing water – that's our situation. We are tossed at sea on dry land. A remarkable stability in art wants to represent itself as unbelieveable chaos. . . . We've inherited the theory that art is in constant conceptual revolution, that each moment will bring something to transform art. But I think the age of conceptual transition is over.

"Both circumstances are connected to the market. The market prevails by the propaganda of something totally new and revolutionary – that is, something which *must be bought*. The

critic has a tough time because that hype has to be resisted. One must have a very cold eye, see what's being represented, instead of what's represented as being. . . . The paradigm of a critic is someone like Clement Greenberg, who discovered people no one knew and demonstrated them to be great artists, and also had a great *theory*. [The art arena now] is very well explored. We may find artists who fell through the cracks, got lost in the market, or are undervalued, but they won't transform our idea of art."

"I'm a journalist. I think I write primarily for myself. My way of responding to the world is by writing about it. I can scarcely wait to leave a museum to get home and start writing about what I saw. Everybody would be better off if they did what I do – go home and write about it."

In discussion that followed, Franchen insisted that "formative criticism has a set of values," as opposed to "criticism that doesn't declare its posture," adding, "I really think it's necessary to declare one's position," but did not audibly declare his own.

Sischy asked Danto, "Would you say you would be able to describe your sense of something you felt was contemporary?"

Danto replied to this intricate question, "The '80s are just about played out. I think it's very contemporary to think about it being the end of the decade, to try to formulate something from that . . . I think five swallows probably do make a spring."

In philosophy, Danto said, "all the positions are known and have all been occupied for millenia. In art, the 20th century has been remarkable for using itself up conceptually, to the point that there's nothing more to do."

Trauben disagreed, with, at last, a flash of feeling: "White patriarchal discourse is used up, but a whole range of positions outside that discourse remains. In the '70s, it looked like an exciting discourse was developing outside . . . For me, the '80s don't exist, because that stopped. People outside the mainstream of patriarchal discourse [now] have difficulty working. That doesn't mean all the positions have been occupied."

The only comment in my notes that isn't concerned with acoustics says Danto's claim that there's "nothing more to do" in art shows the *critic's* limitations, not art's. At the very least, new technology (electronics, synthetics, whatever) will spur art, as it always has. Just as we no longer have the vast new territory of a continent to consume and must change attitudes about land use, we may no longer have vast new artistic territory to consume. But re-claimed territory and recycled material can make sublime art, as the Chinese and Japanese have shown for milennia. Besides, if a critic can't think up a new movement before it occurs, we should rejoice. The critic isn't *supposed* to tell us where art's going (Greenberg's mistake), but to reflect when it gets there. Danto did imply that the equation of "new" with "good" requires a modifier of skepticism; I wish he'd talked more about that.

277

The evening seemed to be terrible, not in spite of being at MoMA, but *because of* being there. As the last moments showed, the Hans Haacke setting didn't stifle *all* thought, and Danto's comment about a "remarkable stability in art" representing itself as "unbelievable chaos" was a lagniappe for an evening that sorely needed one. Still, I wonder who the "Michael V." was who already said everything Rosetta Brooks wanted to say about art. Maybe I could buy the book.

– Judy Seigel

Edited from notes

'88 / #197

Collins and Milazzo Speak English

No appearance of Collins and Milazzo would be complete without a sample of the discourse to which they owe their fame. So here, for the record, is a swatch from a Collins and Milazzo John Gibson gallery wall label of 1987:

> The significance of THE NEW POVERTY is articulated in terms of actively bracketing (rather than merely indicating reflexively) a shift in the culture away from the commodity discourse, with its, by this time, exhausted, exploitative (in some cases) and (media) exploited rhetoric centered on consumption and simulation, geometry and abstraction (a discourse, which when presented initially in THE NEW CAPITAL . . . was neither rhetorical nor restrictive), toward a discourse whose concerns include the more impoverished dimensions of value and human worth – dimensions that have, in fact, been inadvertently and advertently, impoverished or diminished by this very discourse.

Milazzo has been even lusher alone, as these lines from his 1983 "Semblance and Mediation" show:

> Mediated style drives the objectual projection from the catastrophe of primary meanings to the modal continuity of obstacles . . . From the staggering chrysalis of ostension, there emerges a terrorized privacy mediated by the plush catastrophe of auxiliary meanings. . . .

But this is only for background. Read on.

"The Trouble with Interpretation/Evaluation of Art Today"

Speakers: **Donald Kuspit, Collins** and **Milazzo, John Baldessari, Marcia Tucker.**

School of Visual Arts, NYC, March 17, 1988

The recent surge of art and cultural theory has led to confusion, but also to re-evaluation and re-opening of issues. This symposium about interpreting and evaluating art today was "an attempt to make sense of the reigning chaos" and to find new working meanings for art discourse.

The focus of the evening was on power and power positioning in the culture industry, as speakers attempted to examine these relations and their effects – issues that have been in the air for some years now. For the most part, speakers were coherent, and the deluge of terms ("simulation," "simulacrum," "signification," for instance) that pepper post-modern texts was missing. But prescriptives were also absent, even when solicited by the audience.

It was generally agreed that the traditional function of the critic as legitimizer has been destabilized, since artists themselves have now assumed this role. But it was also agreed that criticism as a whole is trivialized when art is made merely to illustrate theory, while the written message appears somehow more inspired than the art.

Speaking from the position of artist/teacher, John Baldessari emphasized the detrimental effect of such careerist strategy by developing artists. They operate by current formulas and the "utterance of banalities" they hope will become marketable. The current situation, Marcia Tucker observed, is complicated by a "trashing of theories," post-modern theory included. Ideas that make one think can also be dangerous, she said, when they are turned into formulas. But when Donald Kuspit asked Baldessari if he felt that discourse affects art, Baldessari replied, "Not discourse, but the money market."

Placed in a manipulated culture, seeking to comprehend their position and their options, both artist and critic must "problematize," or question, the myths by which they are controlled and note their contradictions. If, as the panel suggested, the strongest critical practice now resides in the art itself, this could indicate not so much a new order as an opening out.

The relationship between the art object and culture was underscored by Tucker's response to a question about transcendence in art. She cautioned that such values must be considered in terms of our limited western experience. Transcendency for us is not necessarily transcendency for someone else. For example, she cited the Komar and Melamid portrait of Hitler cutting his toenails, and wondered how that might be received in tribal New Guinea. In this context, one is reminded of instances of "primitives" asking for return of objects removed from their culture and exhibited as "archeological finds" in ethnographic museums, where they are specimens defined by institutional constructs.

Baldessari noted the screening process (for example, marketability) in our own cultural order that determines which art gets shown and therefore discussed critically. This shows the need for radical experiment to find ways to give art broader access to power and institutions.

Collins and Milazzo noted a "crisis" in criticism that reflects "a crisis in lived experience." Milazzo emphasized evaluating the "difference between what we see and what we know." Tucker cautioned about the need to indicate where you're coming from in criticism. Being a feminist, she says, is one aspect of her judgement. One must acknowledge, then question, one's judgement, she said, while also questioning the current operative discourse.

Although the dialog of the evening seemed politically "correct," it was clear that the speakers did want to recognize their limitations, to allow a more porous approach, to understand the "other," and to open out the field. What's needed is more sensitivity in accessing ideas as they filter through one's own perceptions.

The event drew a packed house – a typical art crowd but more or less polite – that hung in till the end.

– Kenani Dower

Women Artists News, Summer 1988 [Vol. 13, No. 2]

'88 / #198

If MoMA is like Bloomingdales, Try the Frick

"Four Decades of American Art"
"Preview panel discussion" for the opening of the Parrish Museum show, "Drawing on the East End: 1940-1988"

Moderator: **Hilton Kramer**; Panelists: **Elaine de Kooning, Jane Freilicher, Francesco Clemente, Joe Zucker**

Parrish Art Museum, Southampton, NY; September 1988

In the dozen years I've gone to panels at the Parrish, I've never seen anything like *this*. Every seat was sold at $5 per and howls of protest from those turned away at the door could be heard as far away as Bridgehampton. The attraction, needless to say, was the all-star line-up.

Reviewing my notes on Hilton Kramer's introduction, I find no mention of drawing, the ostensible subject of the panel. He began with what he called "a little anecdote."

The anecdote: "I quote from a memo of [Philip] Guston's in which he denounced Ab Ex as a sham and a lie. And though Guston was different from Stella, Stella, too, denounced Ab Ex as pitiful, impotent and washed out, in his Norton lectures at Harvard." End of anecdote.

Then Kramer asked panelists how their goals differed from the artists who had preceded them and what other artists, past or present, had been important to them. Panelists spoke in alphabetical order:

Francesco Clemente: My formative years were not American, but European. My work developed geographically, by traveling and looking back. I never had a favorite artist from the past. For me, paintings were banners of the community. [T]he only artists who mattered, then as now, were the leading artists. I have been spending a lot of time in India, where there still exists a society of teachers, not schools, of art, and long relationships between teachers and students. My history

is one of delusions; I have admired different people in different periods and then moved on to others.

Kramer: What role did Italy play in this geographical outlook?
Clemente: The art scene in Italy is very individualistic – eclectic artists of great elegance, but too detached. In the late '60s, information was filtered through a small group of leading artists. It was a word-of-mouth process. As to what was going on elsewhere, work was relayed through a direct line. We found out what Jasper Johns was doing by looking at Jannis Kounellis's work. I decided to be a painter in front of Cy Twombly's work. Twombly was living in Italy then. His openings were deserted.

Elaine de Kooning: All the artists I knew of were dead when I began to think of myself as an artist at the age of eight. I thought of artists as glamorous and thrilling. For the next 10 years I looked at paintings in the New York museums, copying from them and having passions for different artists (which never left me). But I was eclectic. I also liked comic strips; one day I'd be looking at El Greco, the next day comic strips, finding them all equally fascinating. I didn't know there were American artists, and I assumed all artists were dead, that only illustrators (whom I greatly admired) and comic strip artists were still living.

When I was one year out of high school, I went to an Italian art school, Leonardo da Vinci, in New York. There I met a man who took me to a show of American abstract artists. I was thrilled and, although I found the work strange, I immediately responded to it. The man told me that the two best abstract artists, his best friends, were not in the show. I met them – Bill de Kooning and Arshille Gorky – a month later, and knew I had zeroed in on the red hot center. I started to study with Bill and go to museums with Gorky. [Asked by Kramer whether artists today are as interested in drawing:] No, Bill and Gorky both drew all the time as an integral part of their work.

Jane Freilicher: I came onto the scene during the celebratory period of Abstract Expressionism. It had swept away the earlier image of American painting, which seemed very dusty. This new painting was heroic. It had a high ethical standard, it was making an aesthetic statement and it created a bridge to European painting. It gave us the freedom to use the medium without rules. Even working from nature was still action painting.

To be an artist you must be a megalomaniac, creating your own world, and still have a conviction of reality for the spectator. My painting is the art of small increments rather than sweeping gestures. Ab Ex was not suitable for me . . . there was still unfinished business in the art of Europe – for instance, Matisse. All the artists still hung out at MoMA, learning from the great European artists. Today there's a lot of commentary about art history in paintings.

Joe Zucker: I attended the Chicago Art Institute, going to various classes there from the time I was five or six years old up through high school. It was lonely being an artist, in museums much of the time (in the days before there were crowds). The Institute was a leader in showing new work and bringing in artists-in-residence. The Second City psy-

chosis was true for many artists who felt they had to leave *physically*, teach elsewhere or even go to New York. But Chicago and the Institute were unpressured and a valuable experience.

I, too, finally left for New York; I spent 15 years in Soho in intense communication with artists, and for the last six years I've been living in East Hampton cherishing my isolation.

Kramer: I'm impressed with how important a role museums play in artists' lives. I was surprised when visiting the Matisse show in D.C. on four different occasions, I always saw New York artists there. I don't see them in New York museums.

de Kooning: I feel art images and books are a more powerful and greater influence on artists now than museums.

Kramer: That's why I don't include reproductions in *New Criterion*. People always want to discuss the secondary experience (of the reproductions) even if they haven't actually seen the show.

Zucker: I still relish being alone with the pictures before and after the crowds.

Freilicher: Museums are like department stores. MoMA is now like Bloomingdale's, no longer a welcoming experience.

de Kooning: The Frick is still empty.

Kramer: Most of us can remember when museum experience was different. In the '40s there was never anyone around, not even guards. Now it's entertainment; we have to fight harder for our experience in looking at pictures in museums.

Zucker: In 1969 and '70 we were on the steps of the Met asking the museum to support the strike at Kent State. Students today don't think of museums in the same way – they're industrious and work hard.

de Kooning [quoting 1973 article by Mercedes Matter]: "Art education is a farce, a package deal. [The] student gets the compensation of a degree for giving up training he really wanted to have." The visual arts have moved so far, students must study to become visually literate.

Zucker: The Art Institute had vigorous training in drawing, drawing from skeletons and casts.

de Kooning: That had nothing to do with the study of the great masters.

The floor was then opened to the audience, and in spite of Kramer's warning that he would accept only questions, not statements, four out of five made their stand before being brought under control:

Audience: The increase in the number of people usurping the artist's loneness in museums is the result of more people being educated in art.

Freilicher: I doubt that. People are not going for the same reasons they used to go. The art world has become a media event. There's a lot of hype now about art.

Audience: I'm a beginning artist and I have found there's a lack of formal training for students. I feel like I've had to teach myself.

Audience: I'm intrigued with what I've heard. When artists are painting, what role does looking at images [paintings] of the past play in their work?

de Kooning: The images are stored and serve as stimulation – part of one's education.

Audience: Can you give a student artist a program of drawing, one way of teaching drawing that will satisfy every artist's needs?

Kramer: Yes, you can teach drawing, in the same way that you can teach people to put sentences together – even though you can't teach eloquence. There is verifiable evidence of the fact that drawing can be taught.

de Kooning: It's teaching how to analyze.

Audience: You all had a passion for art at an early age. What is the compelling thing that moves or inspires you to begin your work?

Zucker: I had but one inspiration. But I have a structure for living as an artist each day coupled with fortitude, professionalism and fear.

Audience: Has the role of the artist changed in society? How do you see your own role as an artist?

de Kooning: The artist's role has changed since my student days. Now, being an artist is a way of making a living, then it wasn't.

Freilicher: For some, being an artist is necessary. I don't know what purpose it serves. You're stuck with it if you're an artist.

Zucker: A lot of it you do for yourself.

Kramer: For this non-artist, the role of the artist is to bring an account of the world and to reduce it to a more philosophical function. But that wouldn't account for why artists create.

– Cynthia Navaretta

Women Artists News, Winter 1988/89 [Vol. 13, No. 4]

'88 / #199

Ivory Tower Condemned

"The Roles & Responsibilities of Artists & Writers"

Moderator: **Helen Rattray**, publisher and editor, *East Hampton Star;* Panelists: **Elaine de Kooning** and **Larry Rivers**, artists; **William Gaddis**, writer; **Kathy Engle**, poet, director of *Madre*; **Alan Pakula**, film director/producer; **Walter Bernard**, graphic designer; **Claudine Brown**, attorney, community relations, Brooklyn Museum; **Howard Dodson**, director, Schomburg Center for Black American Culture; **Lukas Foss**, composer.

The Sag Harbor Initiative, Sag Harbor, NY; October 9, 1988

The Sag Harbor Initiative, now in its second year as an annual weekend intellectual retreat, focuses on big issues, such as "The Deepening Chasm of Class," "Reversing the Erosion of Justice & Tolerance (in Race & Religion)," and "Transcending the New Polarizations in Age & Sex." The arts theme, pretty lightweight by comparison, developed out of a discussion among the moderator and writer-teacher friends.

The original concept of intellectuals' retreat was refined to address the role of artists and writers in our society, on the premise that artists have been seers and could show us what we might not otherwise know.

Elaine de Kooning said an artist works in solitude, but is always aware of an audience – whether immediate or 50 years hence. Walter Bernard confessed to doing work for hire, illuminating the message of a client, but said his commitment is first and foremost to doing good work. William Gaddis, considered a writer's writer, writes for a relatively small audience and his books have a message. Howard Dodson believes intellectuals have retreated from society – progressives, conservatives and neo-conservatives alike. Lucas Foss said artists used to live in an ivory tower, satisfied to create for each other, but the media have persuaded them that unless they're *out there*, they don't exist. He added that people fighting for a cause are often opportunists looking for attention, and that basically artists want love. Kathy Engel said she could not imagine a living artist not being political, but the *how* of political could vary. She was certain artists have a *responsibility* to be communicators.

Here it was noted that three other panelists (one a movie star) were missing because they were on political tours. Larry Rivers said he had a reputation for being provocative, but was now provoked by what other panelists had said. Whereupon he described being asked to cover up nudity in a painting he had loaned to a show in New York's Penn Center Plaza, which he had refused to do. Several of us in the audience waited in vain for him to tell what had actually happened – that other paintings of nudes were removed from this show in a public lobby because they offended building occupants.

Moderator Rattray asked about popular versus fine art.

Bernard said his design work would be defined by a magazine's readership: *Time's* six million readers or *The Nation's* five thousand. He prefers to work for *The Nation* because it's a feeder magazine, that is, the mass media pick up ideas from it. Lucas said, "There has been a change in our perceptions. Once hearing someone was a great talent was of great interest. Now hearing someone is successful is of great interest."

Elaine de Kooning said artists are always asked to contribute paintings to causes, and never say no. She does her work, she told us, and then considers several free-floating anxieties, such as homelessness, loss of rain forests, etc. In the '50s, she noted, artists' reputations were made by other artists; now they're made by consortiums to protect market value. From the audience, Betty Friedan, one of the founders, said the Initiative was an attempt to reverse that. Artists used to have a sense of social responsibility, she said. Now they retreat for fear something won't sell. Lukas asked why we demand leadership from artists – artists also have to be misfits. In any event, a work of art may change our lives. Gaddis insisted "artists and intellectuals are not in retreat. It is an issue of education and military spending, mere millions vs. billions."

At this point the audience stormed the microphones, and, as is the way of such audiences, asked few pertinent questions while those with axes to grind used their time at the mikes to grind them.

– Cynthia Navaretta

Women Artists News, Winter 1988/89 [Vol. 13, No. 4]

'88 / #200

In the Manner of Melon and Guggenheim

"Your Own Museum"

Moderator: **Hilton Kramer**, critic, editor, *The New Criterion*; Panelists: **Eli Broad**, Los Angeles; **Elaine Dannheiser**, New York; **Lewis Manilow**, Chicago; **Wilhelmina Holladay** and **Laughlin Phillips**, Washington,.DC.

Guggenheim Museum, NYC; October 11, 1988

Hilton Kramer began by saying the idea of your own museum might seem trendy, but actually it's rather traditional. For example, the Barnes Foundation combined one man's legal, moral and polemical ideas with his vanity or ego trip. Mr. Barnes had John Dewey and Bertrand Russell advise him, feeling safe that neither one knew anything about art. Moving on to the Phillips Collection, "an historical presence" and one of the most beloved private collections, Kramer told a charming story of going to Washington many years ago to look at the Bonnards for a research project. Not finding any on display, he inquired at the desk. After a hurried phone call, the receptionist asked him to wait a few minutes. Duncan Phillips appeared shortly, listened to Kramer's request, and then invited him to his home – adjacent to the gallery area – for lunch. There, Kramer had a delightful afternoon and private viewing, still fondly remembered.

Laughlin Phillips, son of Duncan Phillips, said theirs was not a case of a collection converting to a museum. The idea of a museum came first. Duncan Phillips had started writing about art and collecting modestly to overcome his grief at the loss of his father and brother. He conceived the idea of establishing a museum as a memorial, and spent 1918 to 1921 amassing a couple of hundred paintings, displaying them in his house. For almost 50 years he and his mother were the sole support of the museum. He poured himself into it, following his strong interest in color and artists' ideas, choosing paintings that "enhanced life." Although Duncan had rejected an offer from The National Gallery of Art to take over the collection, in Laughlin's tenure the museum has had to change from private to public institution. Now 95% supported by public and grant funds, the Phillips

Collection is considered the first museum of modern art in the country.

Elaine Dannheiser, president of her own foundation, is a collector on an ambitious scale, who has no intention of establishing a museum. Having collected for 35 years – living artists and emerging ones – she displays her collection in a Tribeca loft used also for dance and performances. Anyone who calls and makes an appointment may see the collection. Dannheiser says, since the collection is still in its infancy, it would be presumptuous to think of its future placement, but she loves being part of what's happening today.

Lewis Manilow's collection is not a museum, but a sculpture park outside Chicago. He selected a prairie site so the sculpture would not be nestled in nature, but in a tough landscape suitable for large works. All the pieces are sited by the artist. Manilow has a deal with the university [Governors State University] for maintenance; his responsibility is to deliver the art. Facilities like his have increased with the boom in contemporary art, Manilow said, adding that existing institutions don't have room for this kind of collection. However, he intends his private collection of paintings to go ultimately to Chicago museums, so works he has had "the privilege of owning" will hang with other great works.

Eli Broad established a museum based on his own collection. In 1984, the Eli Broad Family Foundation began to build a collection of contemporary art of the last quarter century, most of it by artists not even known prior to the '70s. The Eli Broad collection is not open to the public, but is a resource for public institutions – a lending library of artworks available to museums or comparable facilities all over the world. A study and research center has recently been added. Museums can no longer afford to buy the best, Broad said. They also lack space for permanent acquisitions, and cannot respond to the speed of the art market. In the last three years, the Foundation has loaned 150 works from the collection and also purchased pieces for museum collections, taking a big step toward solving perceived museum problems.

By way of introducing Wilhelmina Holladay, Kramer said hers was the only museum to have a political focus as its *raison d'être*. Holladay said she was not sure about that. Her collection was started because she couldn't find any information in existing histories about women artists whose work she had purchased. Thus it became her goal to have a collection *and* the documentation. Some years ago she had been ready to give her collection to a museum, but was persuaded by several Washington museum directors that it had a special focus and should be kept intact. With an anonymous contribution of $1.5 million, she was able to purchase the building that became known as "The Women's Museum." Holladay insisted the Museum for Women in the Arts is not *her* museum, and that she only contributed her collection "to heighten awareness of the accomplishments of women so they can take their place in major institutions."

The museum has 450 founders (donors of more than $5,000) and 9500 members (many of them also contributors) from every state and 25 countries. "It also has the high-est renewal rate of any museum in the country," Holladay said. "Members strongly identify with the museum." Kramer asked how many of the 9500 members are interested in art and how many are interested in the politics of the feminist movement. The audience booed him for that, but Holladay, having done her homework, quickly responded, "the average member is 50 years old, has an income over $50,000, is well educated, Jewish, and interested in the arts."

Kramer speculated that panelists might have had difficulty forming an attachment to existing institutions – although several of them had been actively involved with museums. Dannheiser said she did her own thing to avoid the bureaucracy of museums. Manilow wanted to provoke public response to the works in an unusual, non-institutional setting. He also mentioned Arthur Sackler and Norton Simon as precedents. Broad said he's a good innovator and likes to start things rather than be manager or custodian. Although he's an individualist, he also supports existing institutions. Kramer expressed the fear that the public must eventually pay for all these "museums," that all these innovators will be sending a delayed bill. Private people, he said, create collections and assume the government will eventually maintain them. When collections are given to an institution, money must be raised for buildings to house them. Government is expected to ante up. Also, every newly created foundation collection has a staff curator who is frequently curator for the private collection as well. Dannheiser said she is it: curator, registrar, and door person. She wants to make her own mistakes. Holladay said she has so many applicants for jobs that even the telephone operator has a degree in art history, giving Kramer the opportunity to respond that it sounded like exploitation of women.

With the standard moderator's admonition that only questions, not statements, would be accepted, the floor was turned over to the audience. First question was, "Why doesn't Kramer like the Museum for Women in the Arts?" Kramer replied that most of what he sees there is "of poor quality." Next from the audience: "If there is a trend to establishing a museum of one's own, what are existing museums not doing that created this need?" Broad said museums might do a better job of selling collectors on giving them their holdings. Manilow repeated that existing institutions around the world have little space to take in all the collections. Replying to a question about whether existing institutions had approached any of the panelists, Phillips confirmed that his father's museum had rejected the National Gallery's proposal. Dannheiser said her collection just mushroomed, so she had to look for a larger space, and that no museum has ever pursued her.

Panelists were also asked what they thought of the practice of donating a collection with the proviso that it be hung intact, rather than absorbed into the museum's holdings. Broad said he doesn't believe a collection should be separated in a private wing. Asked if tax laws are more or less favorable to establishing one's own museum, Manilow said he has no complaints with current tax laws. Broad said now there is less economic benefit in giving a collection to museums.

Kramer referred to a previous panel in which museum directors had said money is drying up and contributions are in jeopardy. But all museums continue to expand, he observed, so the claim may be exaggerated. The audience asked why Kramer is so opposed to public dollars going into museums. He denied such opposition, insisting that the issue simply has not been addressed, and should be. At present, he said, the public pays but is given no choice. But at one point he said U.S. government funds shouldn't be used to support museums because the public shouldn't have to "pay for something they didn't ask for."

It's heartening to know Mr. Kramer thinks the public shouldn't have to pay for things they didn't ask for, like the Pentagon and Star Wars. But he seems not to know that most polls show the public ranks support for art almost above apple pie and motherhood.

– **Cynthia Navaretta**

Women Artists News, Winter 1988/89 [Vol. 13, No. 4]

'88 / 201

Post-Simulation Decadence

"Has Cynicism Replaced Meaning in Art?"

Moderator: **Robert C. Morgan**, artist, critic; Panelists: **David Antin**, poet, critic; **Dara Birnbaum**, **John Miller** and **Joseph Nechvatal**, artists; **Ingrid Sischy**, critic.

School of Visual Arts, NYC, October 13, 1988

School of Visual Arts panels have a tradition. Starting an hour before the event, cohorts traipse into the amphitheater and the hall fills, as more people show up than there are seats. All eventually fit in, perched behind the speaker's table, crouching on the floor below it, or standing at the door. The "Cynicism" panel was no exception. The crowd, however, was unknown to me; I didn't recognize any of the big-name artists who often attend these events. Had the theme struck too close to home? Or did it present fewer ironies than the competing Bush-Dukakis debate on TV at the same hour?

To Ingrid Sischy – the last person on the panel to talk, but the one listened to most attentively – the question, "Has cynicism replaced meaning in art?," was contestable in its implication that, as she put it, "you can collapse what has happened in art with what is happening in the culture." She rejected the idea that you can make analogies between the kind of current art that works with "the illusion of an illusion within an illusion dominant in mass media and the lie and bullshit of presidential politics." As for mass media, she rejoiced in its use by the ACT UP (Arts Coalition To Unleash Power) group, which she called "a genuine artists' collective confronting the AIDS issue and looking for

alternative representations of that subject." She considers the *Names Quilt* one of the most important visual objects being created today.

Sischy also objected to the implication that critical consciousness (an artistic attitude) is the same as cynicism. That is a highly conservative point of view, she maintained, typical of critics who are implicitly against art and artists (she mentioned Hilton Kramer and Robert Hughes) and who find today's art old-fashioned, or all hype. She asked, "Why criticize how much money artists get? Is the alternative that after you're dead someone else gets the money any better?" She pointed out that, because artists have been doing well, the "Art against AIDS" exhibition was able to raise a great deal of money, and concluded, "We can lose a lot by collapsing art and the culture at large."

Among the other speakers, several found it useful to illustrate what they perceived to be cynicism with vivid examples, which, by the way, seemed to disprove the theory that meaning in art disappears when cynicism takes over. Dara Birnbaum offered video excerpts from the TV show "Saturday Night Live" and clips from the movie *Good Morning Vietnam.* John Miller quoted from Oscar Wilde, including his line, "the advantage of socialism is that it would relieve us of the need to live for others." David Antin used Raphael's *The School of Athens* to show that it's nothing new for successful artists to avoid ethical issues: "If you were working for Pope Julius, you would have to think about the necessity of cynicism in a world where naked power, treachery and greed dominated, a world very much like ours." From a slide of Duchamp's 1919 fake check drawn on the "Teeth" bank and given to his dentist in lieu of payment, a piece which the dentist later sold back to Duchamp for far more than his original bill, Antin inferred a more disturbing manifestation of cynicism. "This gesture reduces the art act to speculation in money," he said. "If this be so, then Ivan Boesky's leveraged buyouts become heroic acts. You borrow money from your friends in order to earn more and pay your friends back after you've become successful." He concluded, "that's what the candidates for the presidency are also doing."

Antin, a brilliant improviser, was the most entertaining speaker. He loves a crowd and can spellbind the young – and the not-so-young, too. That's partly because he is a cynic, not in the way the new generation understands cynicism – as a posture of immorality and unconcealed greed – but the not-born-yesterday skeptic. Another reason for Antin's appeal is that he turns complex thoughts into catchy proverbs, such as, "cynicism equals knowing better and doing worse knowingly." And of course, he is a humanist. He asked, "When we speak of cynicism, are we talking about the great cynicism that has invaded contemporary quiltmaking? Of course not." And he insisted that, while there are terrible artists who sell out, the artist is still someone who does the best he, she or they can. (Like Sischy and Birnbaum, Antin did not use notes, but spoke extemporaneously.)

Robert Morgan and Joseph Nechvatal presented texts animated by an apocalyptic Baudrillardian perspective, quoting

profusely from the Frenchman's terminology. Moderator Morgan phrased his fears thus: "What has evolved over the last ten years is a mythological present, a hyperreality, where TV and cinema influence the look of history and where history as a significant evolution of human events has been eclipsed." Nechvatal proposed "post-simulation decadence" and "metacynicism" for an inspired new vision.

Between the lines – often dense and delivered in deadpan monotone (a cynic might well wonder who wrote the papers read*) – I thought the speakers resented mass media's competition with the creative artist. On the principle "if you can't lick them, join them," artists have adopted (or in fashionable terms "appropriated") media style and methods and the resulting objects and images are treated as ironists once treated humans, namely caricatured. But whereas caricature of humans *disfigures* human features, in order to reveal the manipulative effect of media on objects and images, it has been necessary to exaggerate their desirability (making the art desirable too). So current artistic irony is no more like guerrilla warfare than the various "isms" of earlier times resembled war. Faced with the loss of their role as subversive elements in society, artists, including those on the panel, have become confused and ambivalent: capitalistic gain does not seem sinful any more, yet they still have a strong urge to resist mass-media manipulation.

*Participants had been assigned *Critique of Cynical Reason* by Peter Sloterijk as prior reading.

– Michele Cone

Women Artists News, Winter 1988/89 [Vol. 13, No. 4]

'88 / #202

Solo Searching

"Interpreting '80s Criticism:
Do We Still Mean What We Said?"

Moderator: **Ronald Jones**, artist and critic; Panelists: **Peter Schjeldahl**, poet and critic, *7 Days*; **Stuart Morgan**, critic and editor, *Artscribe*; **Donald Kuspit**, critic and editor, *Art Criticism*; **Roberta Smith**, critic, *New York Times*; **Peter Halley**, artist and art theorist

School of Visual Arts, NYC; December 1, 1988

Moderator Ronald Jones began the discussion promising that "the '80s changed theory and the function of criticism in major ways," but the panelists did not address the history of '80s art criticism. Instead, each discussed his or her own criticism as a personal quest.

All seemed to see their occupation as a solitary one; they did not allude to the community of artist, critic, and reader/viewer, nor discuss their position in an art world structure in

which they saw all others embroiled. They seemed to see their project as happening in a vacuum, far from the currents of a commodity-influenced art world, a pure reflection of their solitary and romantic search for meaning and subjectivity in a world where this no longer seems possible. They cast their critical concerns as a search for what eluded them in the culture of the Reagan '80s.

Peter Schjeldahl was searching for sincerity: "Speaking of personal truth is contagious . . . Sincerity is a hard attainment in this society . . . I look for the quality of the artist's caring." Stuart Morgan was seeking the self; he believes in "the intuitive and impressionistic approach," is interested in whether he himself is sincere, and said, "I am surprised at the strange person I find in my writing."

Peter Halley, looking for cultural continuity and connections, saw himself writing criticism "in reaction to the muddled state of affairs in the art world" at the beginning of the decade. He wanted to write a history placing art within an "interdisciplinary cultural matrix." Roberta Smith, the only woman on a panel which never mentioned gender or feminism as issues for the '80s, was seeking authority: "I want a sense of rightness, credibility and integrity." Donald Kuspit, the senior member of the panel, sought a sense of subjectivity which might overcome the feeling that the culture has turned into nothing more than the creation of capital: "Art is capital, we are involved in a capitalist system; to escape, we must deal with . . . the difficulty of subjecthood in this culture. [I] use a post-modern analysis on the problems of being a subject in our time."

While the panelists described using their critical work to consolidate their sense of self – for example, Smith said, "I explore my own sensibility as I explore the art of others," and Morgan said, "My project is my personality" –they seemed curiously uninterested in this aspect of their project in terms of history, theory or the '80s. Only Kuspit noted that capital creates a "glamorous hyperreality, a seamless image of selfhood."

Panelists remarks seemed generally to reflect the crisis in personal identity and cultural meanings many believe stems, at least in part, from the cultural hegemony of the white western male and the attendant appropriation, or disregard of the subjectivity of the *other*, that is, everyone else. This hegemony seemed to be duplicated in a panel whose participants, except one, were white and male. The impact of race, gender, sexual identity and feminism was not discussed; class was mentioned only in terms of the art market. These factors, which are key to an understanding of the self within society, seemed to be non-issues for these panelists and their critical practice.

Money and power, which most artists at least think of when they think of art critics, did not seem to affect the self image of these critics or their ideas of the critic's role in the art world. They often spoke of their critical projects as a dialog with themselves. Indeed, it was sometimes unclear whether they were searching for meaning in themselves or in the art they reviewed.

However, as touching and old-fashioned as all this may have been, it was marred by a failure to acknowledge their own position of power in the art market, despite recognition of what they seemed to accept as an intrinsic antagonism between critic and artist – an antagonism that became apparent during the audience-panel discussion. While the artists were uncomfortable with the critics' power to judge, the critics seemed to feel that the possibility of artists "making it" and achieving great wealth more than balanced whatever power they themselves had.

The artists in the audience, obviously not comforted by Morgan's previous assurance that "a lack of critical attention doesn't make an artist a bad artist," challenged the critics' apparently unquestioning complicity in the power structure of the art world. The critics gave no direct answer, rather, Kuspit, quoting Foucault, reminded them that "power is diffuse." Smith added, "If criticism is the artist's support system, then it is bad criticism." A panelist summed up the critic's responsibility, "to judge and to be judged by their judgements." Finally, Morgan summed up the discussion period with the observation that, "Our embarrassment is the entertainment value of the evening."

– Flavio Rando

Women Artists News, Winter 1988/89 [Vol. 13, No. 4]

1989

'89 / #203

Whose Rapture?

This seems like the first College Art panel on the topic of rape in art. Given the events and focus of the wider culture, it may not be the last.

"Images of Rape in Western Art from a Feminist Perspective"

Moderator: **Eleanor S. Wootton**; Panelists: **Jean Gillies, Eva Keuls, Arlene Raven**

Women's Caucus for Art, College Art Conference, San Francisco; February 1989

Bad enough that artists or their patrons have had a taste for scenes of rapine; the final insult occurs when writers describe the art in ways that disguise the brutality and humiliation of actual rape.

The women on this panel, specialists in art history, women's studies and classics, viewed these facts from several perspectives. They collectively gave a knee in the groin to art-history survey writers, who, for example, rhapsodize on the rendering of flesh tones while ignoring the inherent horror of the subject matter.

Classicist Eva Keuls recounted the legal background of ancient Athens, where adultery might be punished by death, while rapists were merely fined. In Greek mythology, as we know, rape by gods was a common theme, frequently depicted on vases in imagery that influenced later Western art. Keuls also showed slides of vase paintings in which aging female slaves were cruelly exploited sexually by their young masters. These were likely true-to-life scenes, revealing acts that were part of the youths' maturation and enculturation in a society where women were generally regarded as property.

Moderator Wootton [in a paper excerpted below] lambasted our "most noted" art history text writers, who "show no evidence of sensitivity to violence and suffering." She enumerated the euphemisms, such as "seduction," "the act of love" and even "marriage," applied to scenes that are obviously rape. Observing that to protest can be harmful to one's career, she deplored the effect of such disguised language on young students.

Jean Gillies added examples of 19th-century European sado-eroticism in art, some of which crossed the Atlantic to appear in "captive woman" imagery in the Americas. Arlene Raven showed how the work of contemporary women – Suzanne Lacy, Ana Mendieta, Nancy Spero and others – provides a counter to the romanticism of rape. Annie Shaver-Crandall,

in the audience, advised speaking directly to publishers of objectionable textbooks.

Checking texts in my own library, I found descriptions of "voluptuous" and "melodramatic" violence and much description of form, with scarcely a word about content. I also found a comment that a scene suggests "rapture rather than rape." Whose rapture?

In recent years, Susan Brownmiller points out in *Against Our Will*, "rape and other crimes of violence have been reported with increasing frequency at formerly protected citadels like the college campus." The rate of increase is increasing. As Wootton admonished, "To retain ideologies that support rape is contrary to the well-being and survival of women."

– Sylvia Moore

"Glorification of Rape by the 'Big Three,' But If You See It From Women's Eyes, It Doesn't Seem a Romp at All"

Excerpts from a paper by **Eleanor Wootton**, "Images of Rape" panel

Women's Caucus for Art, College Art Conference, San Francisco; February 1989

Ovid's *Metamorphoses* has probably been the most frequently consulted mythological source for both painting and sculpture. Examining it from a feminist perspective, one finds rape a consistent theme. In the 250 tales, there are some 50 rape or attempted rape events, among them some of the most familiar images in Western art, including the sources for *The Rape of Europa* by Titian, *Jupiter and Io* by Correggio, *The Rape of the Daughters of Leucippus* by Rubens, *The Rape of the Sabine Women* by Bologna (and later, Poussin and David), and *Apollo and Daphne* by Bernini, as well as his *Pluto and Proserpine*. The myths as recounted by Ovid and interpreted by the artists well describe the insensate brutality of the act of rape and the dehumanization of the women portrayed.

Something happens, though, in much of the traditional contemporary interpretation, which is the concern of this paper. The failure to perceive and discuss the actual content of such works of art, often by the most popular and best selling writers, reflects the dominant patriarchal values and attitudes of our culture. This failure preserves and reinforces the ideological acceptance of men's rape of women, which maintains a state of jeopardy and violence against women in our society.

The well-known works I cite are those most often included in college survey-level art history text books. . . . The issues of the violation of innocence, the violence itself, the brutality and suffering are not addressed. The descriptions offered and

the opinions expressed to the reader are rapist/male-identi-fied; and, most incredibly, with the presumption that their viewpoints are universally accepted. [E]uphemistic language is employed, and rape, the seizing and forcing of women to submit to sexual intercourse, is described as an "abduction," "seduction," "visit" [or] "marriage."

Another classics writer, Florence Mary Bennett, describes the killing of Amazon Queen Pentheseleia by Homer's Iliad "hero" Akhilleus, who then rapes her corpse, as a "romantic situation." Akhilleus, western literature's first necrophiliac, is further described by Bennett as [Pentheseleia's] "lover."

Not just to criticize Greek "gods" and "heroes," but to bring the mortal Christian "saints" into the arena: early on (4th Century, Common Era), Saint John Chysostom, Patriarch of Constantinople, tells how he met a woman in the forest, raped her, and then was so overcome with remorse that to atone for his sin he threw her over a cliff! A more recent pa-triarch, Edward Mullins, in a rather clumsy effort, *The Painted Witch* (we are tipped off by the title), tries to com-fort his readers with an assurance that "to admire a rape does not necessarily make us potential rapists." (Male audience presumed.)

[E]specially disturbing, to me, is the implicit approval and/or justification of rape by the "Big Three" writers. Of Poussin's *The Rape of the Sabine Women*, Horst Janson writes,

> Poussin . . . believed that the highest aim of a painting is to represent noble and serious actions. These must be shown in a logical and orderly way – not as they really happened, but as they would have happened if nature were perfect. [Remember, this is discussing *The Rape of the Sabine Women*.] Before Poussin, no one made the analogy between painting and literature so close. [H]is method accounts for the cold and over-explicit rhetoric in *The Rape of the Sabine Women*.

Janson lets the reader know his feelings for the event, for he does present a brief justification in his earlier description of Bologna's *Rape of the Sabine Women*: "The city's (Roman) founders . . . took the women away by force, and thus en-sured the future of their race." Similarly, Helen Gardner in-forms her readers that the "Romans took wives for themselves from the neighboring Sabines." Of course what the Romans "took" were not "wives" but Sabine women. To the likes of Janson, Gardner and Frederick Hartt, the win-ners in history get and deserve the prizes. Hartt tells us,

> The subject is lofty, for the abduction of the Sabine women by the bachelor Romans assured the perpetuation of the Roman race; the conception is powerful; the com-position effortless and natural for all its references to an-cient and Renaissance statuary figures and groups; the style is beyond all praise.

. . . Too often the viewpoints of the "Big Three" are used to reinforce similarly held socially destructive opinions in academia, and the penalty to those who challenge such ide-ologies can be professionally harmful. Such was my experi-ence during my doctoral residency earlier in the 1980s when I privately confronted my graduate advisor over his descrip-tion in a large survey course of Titian's *Rape of Europa* as

"erotic." This was in support of an undergraduate student who had protested his interpretation. Ideologies which up-hold, justify or glorify violence against women are often a part of the hidden curriculum in academia and are present in society in general; to retain ideologies which support rape is contrary to the well-being and survival of women.

Women Artists News, Spring/Summer 1989 [Vol. 14, No. 1-2]

'89 / #204

Value Added

Future generations researching the good old days at Col-lege Art may take this panel for a distillation of its mo-ment, as it casually splices ideals, philosophy, jargon, celebrity and non sequitur with talk of art-as-money. We see also the intense longings, the search for uplift, the demands for salvation that are increasingly deposited in art. (The most interesting discussion of the panel ad-dressed whether they belong there.)

Nine years earlier, in what was for me one of the most poignant moments in this book, a student in the audience at a "post–modernism" panel told how artists were making art to oppose nuclear annihilation. A panelist then ex-plained gently (*very* gently, given the ironic, even caustic, tone of the evening) that such real-world activism would in fact be the *opposite* of post-modernism in art ['80/#132]. Now, at the "Moral Imperative" panel, a speaker tells us "a new link" has been established between post-modernism and ethics – but then fails to explain what that link might be, indeed, in some uncommonly elusive passages, seems to prove the opposite.

Well, clearly there's room for argument.

"The Idea of the Moral Imperative in Contemporary Art"

Moderator: **Mel Pekarsky**; Panelists: **Amy Baker Sandback, John Baldessari, Luis Camnitzer, Suzi Gablik, Jeff Koons, Robert Storr.**

College Art Association, San Francisco; February, 1989

The heartening part was that this high-sounding title, having nothing to do with how to get your work shown or reviewed, had possibly the biggest turnout of any session at this year's College Art.

Moderator Mel Pekarsky noted that,

> The words "art" and "morality" have been aimed at each other for a very long time, but never so much as now, and never with such broad multiple definitions of each. Both words are seen often in good and bad company in this post-modern, pluralist unsacred end of the 20th century (or "McSacred," as Peter Plagens has called it). And I wonder if either of these words had even the same mean-ing in, say, Rembrandt's time; art's meaning is now per-haps as multiple as its varieties, and the definitions of "moral" laid at art's doorstep are equally myriad and pro-vocative, for example:

Paul Goldberger discusses the "morality" of Michael Graves's designs for the Whitney Museum addition in consideration of Marcel Breuer's original (assumedly moral) structure.

Names themselves – like Richard Serra, and in different ways Robert Mapplethorpe, Andres Serrano (and Jesse Helms, too) – are touchstones for any number of serious and complicated considerations.

And the relationships between artist, critic, dealer, collector, patron – everyone in post-modern capitalism's changed art world – have provoked shelves of articles and books on "art and money" and "art and business" [while] James Rosenquist says of Art Money, "it's become like drug money"

Then, too, it seems fashionable to call the personal as well as aesthetic morality of the artist into question . . . Cellini never had it so tough from Vasari !

And the current relationships between the art community and the rest of humankind have frequently and rightfully been questioned . . . Andrew Kagan writes of the "moral emptiness of [contemporary] art" and says, "But what is becoming increasingly disturbing is the fact that we have for so long lacked even the climate, the attitudes of high seriousness and commitment in art" . . . Donald Kuspit considers the artist as activist, weighing "the human and political potential of activist art" to which many have indeed turned, while Alberto Moravia states categorically, "Art cannot politicize itself without committing suicide; in politics, terrorism is always anti-cultural, and in art, the avant-garde is always terrorist."

And William H. Gass in his essay, *Vicissitudes of The Avant-Garde*, sub-titled, "In Search of a Worthy *No*" [says] "There is nothing that a group of this kind can do that such a group once honestly did. . . To live is to defend a form . . . It might be defended still, if painters refused to show, composers and poets to publish, every dance were danced in the dark. That would be a worthy *no* – but it will never be uttered.". . .

This panel will begin with the premise that the first decision an artist makes when starting to work in this post-modern, pluralist end of the 20th century is a moral one; that is, if you can paint whatever you want (since nobody cares what you paint or if you paint at all until you're a commodity), the first decision is what to paint. This is diametrically opposed to pre-modern art, which was preceded by "need" and "commission" with the style usually universal and content pre-ordained. . . .

To show that Abstract Expressionism had been a movement of moral strength and conviction, Pekarsky quoted Barnett Newman recalling the '40s in the '60s:

We felt the moral crisis of a world in shambles, a world devastated by a great depression and a fierce world war, and it was impossible at that time to paint the kind of painting that we were doing – flowers, reclining nudes and people playing the cello. At the same time, we could not move into the situation of a pure world of unorganized shapes and forms, or color relations, a world of sensation. And I would say that, for some of us, this was our moral crisis in relation to what to paint.

Pekarsky then quoted John Baldessari as talking of "trying to get back to bedrock in his work, trying to strip away all the non-essential and thereby arrive at *choice* through this reductivist approach; choice, which seems such a fundamental issue of contemporary art."

In his own work, Pekarsky said,

I have "risked," I suppose, a large number of embarrassing paintings in trying to arrive at an iconography I could believe in – and believe worth painting. In the process, format as well as form became a concern for a while, in addition to subject or content, and led me into an involvement with public art: trying to make art that belonged to everyone but was nobody's property . . . to not make tradeable objects; to play with the idea of large landscapes on walls in the real, urban landscape. . . These concerns immersed me in the questions we're here to discuss today.

Then he quoted British sculptor William Turnbull on public sculpture commissions: "The problem with public sculpture is with the public, not with sculpture. The idea of designing a sculpture for a particular site, even if chosen oneself, seems to me a gross limitation on the sculptor's freedom of action."

Pekarsky ended his introduction with, "If you can paint whatever you want, what do you paint? Does it matter?. . . If you can paint whatever you want, isn't there implicit in your decision great power? . . . And no small byway – what should the critic be doing these days? What's the critic's responsibility, moral or otherwise? I have yet to see a critical program equal to facing the millenium with honor."

Amy Baker Sandback's opening was not promising: "There's no such thing as moral art, just moral artists. Words are only symbols for ideas, not fixtures of thought. Their powerful meanings are shaped by public and private perceptions and fine-tuned by considerations . . . more down-to-earth than the spiritual'Moral' and 'Art' are both valid symbols of important contemporary concerns – the first has to do with the maker and the second with what is made."

Sandback said that preparing for the panel, she had consulted her dictionary. In the 10-volume *New Century* she found six columns of tiny print for the word *moral*. The words *aesthetic* and *art* took up one column, and *imperative* a quarter of a column. *Moral* was followed by *morass*, a swamp. Sandback concluded that "moral is a noun related to ethics, pertaining to right and wrong, manners and custom; to the mind as opposed to the physical; part of a truly developed healthy intellect."

She then said in a tone of great authority that she is "all for moral persons who happen to be artists, and for moral viewers," which she and the audience seemed to feel was a valuable insight. However, she went on with a sharp, cogent and *honest* (albeit unfashionable) commentary:

The role of the contemporary artist as new-wave guru, and the perception that artmaking provides an inside track to a special truth denied the rest of humankind is a dangerous role for all concerned. Artists are as flawed and sometimes as brilliant as academics, doctors or bricklayers. No style is necessarily moral, no subject matter is necessarily correct, no political message or religious symbol necessarily renders great art. Piggybacking an aesthetic to a cause may indicate an important aspect of a personality or maybe marketing or simply a stylish ideological trick. Bad artists can produce masterpieces as well as the obverse.

If morality is an imperative of art, how do you approach an erotic Shunga image of strange sexual contor-

tion or the photographs of artists such as Mapplethorpe, Witkin or any other sometimes disageeable talent [or enjoy] a lyrical Matisse knowing it was done during the Occupation? . . . I believe in art and its ability to make magic even when it's ugly or anguished or performed as an intellectual exercise and even when it's dumb and lovely. Morality is a judgement that serves no aesthetic purpose."

Sandback's final comment was, "Being able to speak well of your work is good for business."

John Baldessari told an anecdote about running into Jeff Koons in New York and mentioning a profile on Koons in a recent *Los Angeles Times*, in which a critic who ordinarily writes on Rock and Roll criticized Koons's work, applying different standards of morality to it than would be applied to music. Koons's comment was, "Gee, you'd think she thought I was Mark Kostabi or somebody." (The audience found this retort hilarious; it brought the house down – perhaps something about the word "Kostabi.") Baldessari took this as evidence that, "Art is the last bastion of morality."

He continued, free-associating:

> When I think of morality I think of money. [T]here was a period when poster sizes got smaller until you just had little cards being mailed out with discreet type and you'd go into a gallery or museum and it would be hard to see the work, and, as Lucy Lippard has said, "It's hard to read things on the wall when you've got a screaming baby under your arm." Now they're getting bigger again; people like to have stuff [posters] – stuff sells. Sculpture went from ephemeral materials in the '60s and '70s to where now everything is in bronze – it's durable and can be handed down. Your investment is protected; it won't disintegrate in 20 years. . . .
> Art is now equated with money and they all want to have all the news on Art. You can't even get into a panel anymore. Art is reaching a point where it may be interchangeable with money – art as a medium of exchange. [But] if art didn't sell we wouldn't worry about it so much. If Schnabel's paintings didn't sell, they might be more interesting. They are less serious because they sell for so much money. Anselm Kiefer seems to be very moral and serious, but with his prices going up, we start to question his seriousness. When money comes in, it starts to cast doubt. I had an argument in a New York bar with a friend who said "Koons's art caters to the lowest common denominator," but [Koons] seems to perfectly reflect our culture. I'm very suspicious of anyone who tells anybody what kind of art they should do. An old dealer friend in Germany said art should have no message. I feel I *should* do what the culture needs, but I'm bored with the idea. I'm paralyzed in front of the question of what is the right Art to do . . . Do what one does best – like athletes. Find out what your weaknesses and strengths are and work on the strengths.

Baldessari said with students he works on strengths and tells them to forget their weaknesses. He believes moral purpose is "using all the strengths you have."

Luis Camnitzer, an artist originally from Germany who has lived in Uruguay, said a friend, after reading the paper he was about to present, warned that it was very pious, but it was too late to change it:

We live believing we are artists, but we are actually ethical beings sifting right from wrong. To survive ethically we need a political awareness to understand our environment . . . Packaging is all. Thoughtless substitution can create the same havoc as when detergent is packaged as perfume. "Manipulation" of the viewer has negative connotations [so] we always avoid it when describing art processes, using euphemisms like "composition" and "design." The shift of the action from ethics into aesthetics allows for the delusion that only those decisions pertaining to content have an ethical quality. [But] most of our art is socially muddled, even when it functions in the market. The explicit wish of most artists is to live off their art production, but they have mixed feelings regarding the question of money as unethical.
 Lately a new link has been established between ethics and post-modernism. The post-modern label serves to co-opt and unify some artistic expressions. Post-modernism can be seen as a demoralization of some anti-formalist tendencies, relacement of some conservative contexts and a re-internationalization of what threatens to become a nationalist fragmentation in art. Art is still far from being an ethical affair. We rarely challenge in depth the parameters which define art or the technical constraints offered by art history.

Surely the "parameters which define art" *are* challenged six times a day by every MFA student in America. But this paper seems less "pious" than murky, or let's say overly succinct, leaving us to wonder what "re-internationalization" does, what "the technical constraints of art history" are, how one would "challenge" them, in depth or not, how such *technical* constraints become *moral* issues, etc., etc., etc.

Suzi Gablik said that as a critic in the late '80s she is concerned with understanding our cultural myths and how they evolve, what it means to be a "successful" artist working in the world today, and whether the image that comes to mind is one we can support and believe in:

> Dominance and mastery are crucial to our notion of success . . . The Art Industry is inseparable from the giant web of our cultural addictions to work, money, possessions, prestige, materialism and technology. Unless efforts are made to reassess our relationship to the present framework and its practices, new patterns won't take hold. Vested interests will insure that they are maintained as before. If we want change, we need to evolve new ground rules for the future. The moral task before us is to identify which approaches to art make sense in today's world. Aesthetics views art as something autonomous and separate, as socially non-functional, existing for its own sake. The best art is made for no good reason and is valuable for its own sake. Ortega y Gassett said, "a work of art is nothing but a work of art, a thing of no transcendency or consequence." Once fully conscious of how we've been conditioned to follow a certain program, we can begin to surrender some of these cultural images and role models as personal ideals and the possibility then opens for actually modifying the framework and not just being immersed in it.

Gablik described the project of Dominique Mazeaud, an artist friend living in Santa Fe: "The Great Cleansing of the Rio Grande River." Once a month she and other friends meet to clean pollution out of the river. Gablik showed slides of the work and read excerpts from a diary of the ongoing project.

One entry records picking up as much as 103 pounds of broken glass in a single day; others ponder how the strange miscellany of objects finds its way into the river. The artist calls her journal entries her "riveries."

Gablik quoted Caroline Casey: "Nothing which is not socially and ecologically responsible will make it out of this decade alive." She concluded, "Moving away from the competitive modes of institutionalized aesthetics is one way of not perpetrating the dominator system. Forgoing its rites of production and consumption, its mythology of professionalism and its power archetype of success, only then can we begin to evolve a different set of ground rules for the future. But the willingness to make this systems shift is the beginning of recovery."

Jeff Koons, who showed a history of his work from 1978 to the present, said there is a great shuffling and shifting of power now in the art world, but that he's an optimist and believes things beneficial to humankind will be "absorbed into evolution" and "things that are negative will be destroyed." Koons said he has always been "at the service of his art," explaining that his work on Wall Street was to finance his art. White middle class kids use art for social mobility as some ethnic groups use basketball for social mobility, he said, and, "just as basketball players become front men, so do artists." Koons was very funny and appealing, despite intermittently feigning modesty and becoming sanctimonious over his slides.

Robert Storr, a contributing editor to *Art in America,** started to paint because he needed a hobby, and found it was fun. He quoted Picasso that "the best art is always fiction," adding that "the religion of art is not religion, the spirituality of art is not spirituality, the humanism of art is not humanism, and between those terms, in that negation, is the reasonable place to start." As for morality,

> The consciousness of artifice is the one thing for which the artist is morally responsible, not to be a sucker for his/her own ideas and sincerity and not to ask anyone else to be one either. . . . Rather than commandments, I would put forth two propositions for the audience: Never trust anybody who says he's telling it straight from the shoulder [and] never trust a kidder.

For the question period, Pekarsky gave the usual warning, "No manifestos, only questions," but, beginning by recognizing his friends in the audience, or those whose names he knew, he was rewarded mostly with manifestos. Then came questions like, "Can you maintain your morality in New York's glitzy art world?" Gablik responded, "Transformation of one's own consciousness and the place where that transformation is most important is New York and anyone undergoing such a change should get to New York fast."

Another statement-question was, "Careerism is related to morality and Koons said on Wall Street he faced a daily handling of moral issues, and that he felt free when he left the business world for the art world, because it was free of those issues, and yet here we are discussing it." The response to that was, "Careerism is meaningless until given meaning by

the speaker," which seemed to satisfy the questioner. Someone asked why the person "cleansing" the Rio Grande didn't work with local governing agencies, such as environmental protection, another started with, "an artist is one who produces masterpieces." That question and several others were rejected outright by the panelists who said they couldn't deal with them.

Perhaps I'm the only one who found much of these talks (transcribed practically verbatim above) or their relation to the issues baffling. The standing-room-only audience was rapt throughout, and at conclusion couldn't stop applauding.

– Cynthia Navaretta

Women Artists News, Spring/Summer 1989 [Vol. 14, No. 1-2]

*As of 1990, curator of painting and sculpture at MoMA.

'89 / #205

Post-Hippie, Pre-Millennium

A day of three panels, "Beyond Survival: Old Frontiers/New Visions," was organized by Cassandra Langer and sponsored by the New York Feminist Art Institute Women's Center for Learning.

Panel I: "Beyond Survival"

Moderator: **Arlene Raven**; Panelists: **Lowery Sims, Robert Storr, Nancy Chunn, Nancy Fried**

NYFAI Women's Center for Learning at Cooper Union Great Hall, NYC; April 1, 1989

Arlene Raven's definition of "Beyond Survival" was that all the panelists were breathing during the height of feminism and all are still alive today.

Describing her early life as an artist in San Francisco, Nancy Fried explained that she was a hippie in the early '70s, making dough reliefs in her kitchen. These depicted events in her life, with everything clearly labeled, like cartoons. Having never gone to art school, she didn't know what she was "allowed" to do. Her life changed at 30, when she met performance artist Jeri Allyn. After Allyn recovered from her shock at meeting a 30-year old who had never masturbated, she gave Fried a book, telling her to study it and also to go to Los Angeles, to the Woman's Building where the most exciting art was being made by women. Fried did as advised, then moved to Los Angeles, and eventually to New York, while continuing to work as a sculptor.

Fried's work has changed drastically in the last few years, now influenced and driven by her fight for survival after a double mastectomy. Perhaps no other artist has documented and "gone public" as she has. Two years ago, following surgery, Fried started to make small *ex voto* figures of herself – breastless. As she got better and could use her arm, the pieces

got bigger. Some months later, she had come to terms with the condition, even accepting that she could still feel sexually aggressive.

Nancy Chunn said that although she knew Fried in California, she didn't know she was an artist until she saw her again in New York several years later. Chunn described herself as the other side of the coin of "new feminism." She had a "power position" as an administrator at an art school during the late '60s, "when a group of New York (male-dominated) people came out and took over the existing institution and turned it into Cal Arts." In those early days, she was conflicted when CR groups were scheduled for the same time as faculty meetings. (Chunn seemed to hint that she was responsible for the scheduling.) But when she had to make a choice, she always opted for the faculty meeting, or "the male-dominated structure," remaining "a closet artist."

Musing on the coincidence of two different tracks for two people named Nancy (Fried and herself) now sitting together in 1989, Chunn said she always wanted to be three things: "human being, woman, artist." Now, at 48, she feels she really missed out in her art education, having only "a limited concept of what art is." While she worked at Cal Arts, she was "totally intimidated" by both the art shown there and the feminist program.

She also kept pretty busy changing husbands; by the time she quit Cal Arts she was up to number 3. Leaving that "power position" (at Cal Arts) behind, she turned to waitressing, surprised to find how much more money she could make in a "powerless position." Finally she began to paint again, but here's the twist – she depended on husband number 3 to tell her what to paint – chair, person, etc. Knowing nothing about technique, she just layered the paint on. When friends saw the work, she assured them she didn't do it: "He did it; it was his idea." At her first show at the Woman's Building, she had to be restrained from putting her husband's name on the paintings and "felt like a total fake because he wasn't getting credit." To make things difficult for herself, she did a whole body of work using just her left hand.

Chunn finally made the big trip to New York in '78 to follow a new boyfriend. The trouble was, without husband number 3 to give her ideas, she didn't know where to start making art. The breakthrough came when she used the boyfriend as subject matter, making many small Pauls from 1980 to 1983. Eventually, to overcome grief from the multiple losses of father, cat and dog, she did a "series with angels traipsing around the dead corpses" and so succeeded in working out her personal life. Then, to break out of the diaristic vein, she started a series of animals, titled "Predators." Next, coming upon a book of maps, she had "a great idea" – combining maps with other subjects. Another chance encounter, this time happening on heavy construction equipment catalogs, she added those to her image inventory.

Now, having succeeded in eliminating her diaristic approach, Chunn makes only two to three paintings a year, maps of a sort. Fear of flying inhibits her travel, so she focuses on reading about the country of her choice, then makes the paint-

ings as "a way to create a homeland for people who don't have a country of their own, such as the Kurds."

Robert Storr said he finds danger in the fact that many of the women he encounters in his teaching are very conservative and reacting to the '60s-'70s generation of artists, whom they now perceive as old fogies. "Conservatism is deeply ingrained in them . . . they believe apathy is the only honest policy and that collective action is dangerous. . . . We must recognize this group and the women's movement must focus on building a better multi-racial world."

Lowery Sims quoted a recent announcement from the Snug Harbor Cultural Center, a statement that the "institution does not discriminate against women or minorities." Sims said the art world is still making excuses for itself, but "these groups will be in the majority by year 2000."

When comment was invited from the audience, Mary Beth Edelson said essentialism and deconstructivism are not what's going on in the women's movement, but only in men's talk. The terms, she said, are layered on top of the women's movement as a patriarchal gesture.

A young woman from the audience closed the event by saying there isn't a women's movement anymore.

– Cynthia Navaretta

Women Artists News, Spring/Summer 1989 [Vol. 14, No. 1-2]

'89 / #206

In Search of the Women's Movement

Panel II: "Old Frontiers"

Moderater: **Joanna Frueh**; Panelists: **Emma Amos, Miriam Hernandez, Mary Lum, Gloria Ortiz, Jeff Perrone**.
NYFAI Women's Center for Learning at Cooper Union Great Hall, NYC; April 1, 1989

After a poetic salute to "Old Frontiers" by Joanna Frueh, Mary Lum memorialized Bill Olander, "who was a great champion of artists destined for neglect." Lunn then told about her membership in a two-person group in college, Double Agent, for which the qualifications were to be an artist, part Chinese and have an affair with a particular art professor known for his choice of tall blonde students. However, she and her friend met only the first two qualifications. This fun activity ended when another art teacher suggested that the two of them become librarians and her friend transferred to library school. Lum's current art is an examination of language, the everyday spoken language of power and the language of the powerless, with which she identifies as a Double Agent, that is, neither Asian nor white.

Gloria Ortiz said the artist in the studio is engaged in two actions – "his [sic] being and his [sic] painting."

Jeff Perrone, although present on the platform as a sculptor, said people were always asking him what he thinks of artist X. Since over the years X changes, Perrone finds he has little to say. When asked about older artists, such as Johns, Pollock, Picasso, he also never has anything good to say. When pressed that surely there must be some artist he likes, he replies that if they want him to be passionate they must leave traditional European painting. His sources of inspiration and the work he likes are women's art, Third World art and Third World women's art. (He admits to the ability to rub people the wrong way.) Perrone is a great admirer of those women's groups which have organized around a concept. He also salutes the Guerrilla Girls for the power of women's laughter, and the newest group, ACT UP, inspired by G.G.

Emma Amos believes that to continue painting in her studio in the face of current conditions is a "political act." Her latest work is full of fear and anxiety, and, as always, of figures flying or falling through the air. She thinks "it's a good idea to know how to fly and fall." The figures are always clothed; she's "not free enough to do otherwise." Amos has mixed feelings: "Things are as bad as ever and not getting better and one article about black artists does not constitute change." Yet she is also optimistic that something can happen to change the status quo.

Lum said that the sculpture department at her school has five male professors but the suggestion of having a woman on the faculty is met with great resistance.

An audience member said "things are not getting better; it's not in culture's interest to change. But we must be stubborn and continue to work." Then, addressing Perrone, she asked, "Is your inspiration by Third World women exploitation or co-option?" Perrone answered obliquely that "progress has been made . . . the number of women artists who have learned to play the men's game since the '70s has greatly increased. But it's not clear whether they're playing that game or another." His question for the successful was, "Has the art world changed or has the work changed?"

Amos, discarding her earlier optimism, said bluntly, "things are not getting better – they're possibly worse. Many black women no longer want to be in shows or organizations with white women."

Audience: Feminism is now a dirty word What can we do?

– **Cynthia Navaretta**

Women Artists News, Spring/Summer 1989 [Vol. 14, No. 1-2]

'89 / #207

A Less Perfect World

An exchange at the end of this panel reminds us that visual artists have been held responsible for public causes in a way musicians, for instance, or mathematicians, have not. Women in the audience challenged this *extra* imperative of art.

Panel III: "New Visions"

Co-moderated by **Nancy Azara** and **Cassandra Langer**; Panelists: **Dore Ashton, Camille Billops, Eleanor Heartney, Margo Machida, Carol Sun.**

NYFAI Women's Center for Learning at Cooper Union Great Hall, NYC; April 1, 1989

Cassandra Langer opened this last session of the day saying, "We're here to explore why we've moved as far as we have and made so little progress in the last 20 years, and to discuss the possibilities for the '90s."

Co-moderator Nancy Azara noted that the New York Feminist Art Institute has for five years had to call itself NYFAI/ Center for Learning, because funding sources, as well as women and men, are afraid of the word "feminist." Azara said, also, that NYFAI survives on the kindness of one person, who provides rent-free space and rental income from the basement.[1] She added that she has "spent a lot of time thinking about what would interest women of color" enough to bring them to the center, and has put ads in the *Amsterdam News* and *El Diario.* NYFAI women want not only to "talk to ourselves, but to reach out to all of the art community."

Dore Ashton said she believes "art transcends national and cultural boundaries," although people use certain alibis to explain "their blinker vision." With these alibis, she said, "a number of artists refused to participate in boycotts that were organized against international exhibitions sponsored by unstable governments."[2] Ashton quoted Beaudelaire as saying, "when a critic is faced with the work of an unfamiliar culture, change must be wrought in himself," and he must "not bring his own cultural baggage to bear," meaning in this case, on China. Writers, she said, "have become accustomed to thinking of something called the Third World as 'other' and thus it becomes a condescension. The Third World exists as an ideological construction of the West. An intelligent critic must educate himself [sic] and expose himself [sic] to various communities and try to understand the working premises. There are no guidelines."

Ashton described her experience in writing the introduction to a catalog for a black painter's exhibition. She quoted the artist, assuming that his early milieu had something to do with his work. "He was furious. He didn't want to be evaluated as a black painter." Then the artist did something "unforgivable." He had the museum take that part out. But, Ashton said, other black artists didn't want to be evaluated by values of the white middle class, and either way she was

jumped on for racism. "Each critic must grapple with these painful problems and with his own standards. She must enter their psychological climate and engage herself in others' territory and take it into account. She must listen as well as look. There must be a full spectrum of opinion in the arts. There are no rules or standards."

Ashton believes quality is crucial and inherent in the work. She doesn't believe in relativism or the so-called human sciences as critical arbitrator. She concluded, "Blatant racism is muted or hidden [everywhere] but must be combatted on every level."

Camille Billops said she doesn't go to meetings anymore; she finds them too depleting. Her need, she said, is to get in touch with her own racism, her own sexism. "We're all loaded with these things that trigger anger and hate. I think of the world as divided into perpetrators, facilitators and victims. All of us can be these things at different times, and when you think of it that way you don't have to be a victim." She described a complex world cycle of domination, whereby one country destroys a natural resource to sell to another country, where it is further changed and passed on.

"Black people's racism makes them ill," Billops said. "Several members of my family died in their early 40s of stress, alcohol and anger, just from feeling hateful." Billops thinks reviews of black artists are "victim articles – they don't talk about art, but the fact that the artists have survived. We should learn to ask individuals, 'what is the effect of racism (on you), class (on you), homelessness (on you).'"

Margo Machida is the first person in the Northeast to teach contemporary Asian-American art history. She spoke of the need to put Asian-American art in its historic context, for cultural interpretation of identity in transition. "Being an artist is not enough. In the present environment to be solely involved in producing art is to cede control over the context and also the content of how one is represented. Only by entering the interpretive arena, writing and lecturing, can one combat the feeling of alienation." But, "there are no institutions of museum stature devoted to Asian-American work. Most current and historical material remains uncatalogued; its history doesn't exist as a university discipline. . . . We need to affirm we are a multi-valued society composed of numerous different and co-equal communities in parallel framework.

Carol Sun has found that, "People not that much younger then me say they don't know what the point of the women's movement is. I say they must be living in a bubble – not reading newspapers, not looking at galleries." She added that her art school environment [Cooper Union] was not conducive to identifying with her own roots – either Asian or being from New York.

For Eleanor Heartney the issue really is, "How does one negotiate through the art system as it exists today. . . . Critics are not independent agents. If you want to deal with ideas and issues in major magazines, you must work in a subversive manner, because the real function of art magazines is to

be the trade journals of the art world [and] to serve the art world."

Even so, "The art world's network of power doesn't include all artists." The magazines are supported by galleries; they address collectors and must deal with the news – artists in major galleries, "so artists in alternative spaces don't get noticed." Heartney says she can't always deal with the issues she's interested in and must play with the system, writing for a whole range of magazines. It is "difficult to keep one's function as critic separate from serving as PR person for galleries and artists."

Since the magazines "don't provide space for exploring things outside of the mainstream, there's no place for today's topic, inter-racial framework. Magazines are almost exclusively devoted to work of white artists. Art sometimes feels like the creation of luxury items for a privileged class." However, "there are a number of artists now doing things that are opening ways for others to enter the art world. Some are even bypassing the system with original public art aimed at audiences not ordinarily familiar with art and others are involved with our environment."

Responding to an audience question, Billops said, "The energy of art in New York is about money and mostly white males. We think we're going to be a part of it, but it's an elitist system, and each group has its own system. Even I, as a black artist, can't get into the Studio Museum – it's as elitist as others within its own parameters.

She added that she has her own fantasy that she can do whatever she wants and not waste energy trying to get into a system that won't let her in. For instance, she puts out her own publication; her energy goes there instead of "sitting around bitching." She suggested artists publish themselves, because "no one else is going to do it."

Langer added, "they're never going to let you in the door, so you might as well open your own door; start your own publications, organize symposia."

Ashton said, "Crimes our government commits are purely racist. People should be activists, not sit in schools and teach theory, they should be out there and march." However, she said she hasn't found artists, "including Third World artists, concerned with anything other than how to make it in New York." She is also "annoyed at being trammeled by feminist art theories."

A member of the audience said that at a recent conference in Palermo women artists discussed, not only women artists' issues, but world issues such as famine, homelessness and day care centers.

From the audience, Susan Schwalb asked, "Why is the creation of a day care center relevant to being an artist? What's the matter with making art? Is it an either/or, get out on the firing line or you're part of the problem?"

Joan Semmel followed with, "We're asked to sacrifice ourselves on the altar of general virtue and we have done that. The feminist movement has been out in the forefront in

terms of making bridges and women have done it together and are asking for empowerments within the professional areas they operate in. That doesn't negate their participation or activism in other world issues."

Mary Beth Edelson said, "Dore Ashton is putting a terrible burden on women asking them to be all things to all people and to be all-sacrificing. We should not give up the art world and go off and create our own [world], which is what they want us to do. We can and should do both."

Emma Amos added, "I want to do my own work; I can't be a perfect person. You're asking too much; we can't drag everyone else along with us." In response, Ashton said, "the labor movement went to hell when it stopped addressing cultural issues. I don't think only women must – but all human beings must be concerned with other human beings . . . just as I am not one of the hot shot critics because I chose an independent way. Artists can't have it both ways if they want to to be part of a movement."

Camille Billops asked the audience how many of them gave to charities. After a show of hands she named environmental groups and the frightening facts they expose, adding that knowledge of the dangers to the environment prevents her from just doing her art. "We have to care about the rest – the art comes with it." Schwalb said she has spent 20 years in the women's movement, that when she worked for the Women's Caucus in Boston she made less art. "What about making beautiful art that makes you amazed instead of horrified?"

– Cynthia Navaretta

Women Artists News, Spring/Summer, 1989 [Vol. 14, No. 1-2]

1. New York Feminist Art Institute closed in 1990.

2. "Unstable governments" is apparently a code phrase meaning fascist or communist dictatorships.

'89 / #208

Is It the Future Yet?

Talk about mixed media! Leon Golub imagines a future where artists "take up genetic engineering to make their own creatures." But Kim Levin is a realist. "What good is it to have test tube babies?," she asks, if we can't live in the environment. George Ennenga insists, "chaos is great," because "it leads to a sense of wonder and discovery." Jim Carse reports that Chinese emperors kept themselves politically safe by distracting scholars and thinkers with technology. He sees a parallel today, with the brightest young people also preoccupied by technology. Carter Ratcliff cherishes painting as "the embodiment of our culture." Painting will not take part in technological evolution, he says, because it "*sees itself* as technologically outmoded" and refuses to change.

"Humanism 2000: Fast Science, Fast Society. What Role for the Arts?"

Moderator: **George Ennenga**; Panelists: **Jim Carse, Kim Levin, Leon Golub, Carter Ratcliff**

Artists Talk on Art, NYC; April 7, 1989

George Ennenga: In sci-fi films, there's usually a sub-plot, where one member of the mission is not a human being; he's an android! But we don't know which one . . . Recent developments in genetic engineering and artificial thinking make some of our age-old convictions of what it means to be human a lot less compelling than they used to be.

For the Greeks, human meant the animal who could reason. But today, we have machines that do that a lot better than we do . . . Another example would be that even if we don't honor our parents, at least we have them, but there may be a time when there will be people who don't have parents.

Tonight we'll try to take on what kind of society can have such a re-defined man [sic], and what role artists can play in such a society.

Leon Golub: I will take a pessimistic view, given how I visualize the world. Our society is certainly getting richer and more developed, although at least 50% of the world's population is hungry.

[But] in highly developed areas of extreme technological sophistication, new theories and developments follow each other at an accelerating pace. Human history gets faster all the time. So the world is changing right under our feet. We are going to be the last of the "hand" people, as everything becomes technologically coerced. . . .

Science Fiction was always ahead of science in projecting all sorts of amusing and horrific possibilities we knew couldn't take place. But now, science fiction has a hard time keeping up with science. Science [starts] to move faster than the imagination. We are on the verge of genetic revolutions of which we haven't seen even the beginning . . . There's a real possibility of transformation of the species, which is frightening. I think that will affect artmaking, too.

Carter Ratcliff: I'm sure it will affect artmaking, but I don't know that it's possible to predict how. Think back to the World's Fair and [its] experiments and ideas about art and computers just 20 years ago. None of them have a purchase on the present. So I don't think we can predict how art will evolve. I don't see anything predictive in contemporary painting and sculpture and I don't see any way for those mediums to become predictive or take part in this evolution that they all sort of fear and hope for, without changing, becoming something else. . . .

The inability of, say, a painting to change and take part in varieties of technological evolution is [because] the medium refuses to change. But it has a great deal of meaning for us as [it is]. Whether painting is a still life, or Leon Golub's Contras, it's conservative. What's interesting to me now is not the painting that *sets out* to resurrect conservative values or hold on to the past, but that *sees itself* as technologically outmoded – which it's been for I don't know how

many decades, or centuries. It accepts that, promotes it as a virtue.

One of the embodiments of [our] culture is painting. I stress painting, because that's what I look at. That's not to say anything about a particular painter, or abstraction versus representation, or acrylics versus oils, or whether you put '50s chairs on the surface. I'm not talking about any stylistic point, but about the medium as a medium and the power of certain traditional mediums to play a traditional role. . . .

Ennenga: People involved with computer science think it doesn't really matter what you call intelligence – "human" or "tree," or "x." If it has intelligence functions, it doesn't really matter if it's "human" or not. [But] if a computer doesn't understand a sentence and just follows the command automatically, somehow or other, you sense that, like the android, there's something wrong. I don't think, however artificial intelligence develops, it will be able to catch that tender matrix . . . this incredible combination of parts that comes out human.

Kim Levin: I'm having a problem with the assumption of this panel, which is that "progress" is good and that everything is going to be better in the future with all these miraculous technological inventions. When Leon said he was going to take a pessimistic view, I thought, "this sounds interesting." But his presentation was rather optimistic. What good is it to have test tube babies in an environment where nobody is going to be able to live, when we have holes in the ozone layer and toxic rain and oil spills destroying the fish and the birds?

"Humanism" itself is the problem – we are so self-centered we don't realize that the animals and the earth and plants and atmosphere are our support systems. [We may be] good and kind and gentle, but we're also greedy and acquisitive and destructive and we are destroying our support system. We shouldn't confuse inventions with wisdom. I don't think humans are any smarter than they were 5000 years ago. We are a barbaric culture, probably the most barbaric that ever existed, in terms of the planet.

Jim Carse: Science has become extremely skilled at predictive thinking [but] has never been able to predict advances in science. It cannot predict itself. The reason is that science is in itself an art. If we understand it as creativity, I think we are much safer with it than if we understand it as some kind of methodology that really gets to the truth of things. . . .

What I see happening is an enormous digitalization of our lives, a society by the numbers. [But] we have a deeper, if not darker, fascination with technology. Joseph Needhams, who has written on the history of science and technology in ancient China, points out that the most successful emperors were those who found ways of having their scholars and thinkers preoccupied with technology. With people thinking about machines and other technological problems, the emperor had a politically safe environment. I'd like to suggest that technology is one of the ways of keeping our society in order. We preoccupy a lot of bright young people with how to make machines – machines of play and of war (if there is a difference). This distracts them from a deeper creative im-

pulse . . . Therefore I see the function of art as to de-digitalize society. Make it a mess again. Forget progress. We haven't progressed much beyond Shakespeare or Sophocles or Lao Tzu or Confucius. . . .

We can be ruled by people who have almost no sensitivity to art, or more likely, a hostility to art. One of President Reagan's first acts was [an attempt] to eliminate the National Endowment for the Arts. You felt he just couldn't wait. There's been eight years of hostility toward art. But maybe worse, would be a government of artists. So much chaos! I wouldn't want an artist to grow my food! But there is a road in between, a society in which art is encouraged. . . We have to call, not for artists to rule us, but people with a deeper sensitivity to the artistic community.

Audience: It doesn't matter what the role of the artist is. What matters is the future of the earth. Scientists and rich people control the earth – so I'm for activism.

Audience: How do you tell the difference between human beings and artists? In the 1960s, there was the Art and Technology group that tried to establish that everyone is an artist.

Ennenga: Everyone is an artist. Some work on painting, some with a Macintosh, some with words, some with banking arrangements. The point is making it happen in the most beautiful way for everyone.

Golub: Art has always served power. It was not a disengaged activity. It has moments of appearing disengaged [but] artists served kings and popes and the capitalist class and the universities. And they serve self-aggandizement. Artists can be bought. It happens all the time. We can't think of the artist as such an ideal type. As trend-setters, artists support the system and it supports them. [They] get things from it.

Ennenga: Art brackets and comments on other activities.

Golub: If you take art out of the 20th century, you have removed an essential in what the century has to say and what it signifies. The art of the early century has been related to relativity and psychoanalysis. The constructivists projected a more perfect world that didn't come to pass . . . When artists forego lasers and take up genetic engineering to make their own creatures, there could be some extraordinary things – and visually beautiful.

Carse: But Soho is already weird enough.

Ratcliff: Painting can be, is, a conservative medium . . . in the sense of conserving things or of digging our heels in. Even in fashion or popular music or the fringes of architecture there is resistance of this kind, which tends to privilege the image, if not the fact, of the individual, the self, and autonomy . . . as a spiritual or psychic digging our heels in against forces that seem larger than one's self.

I'm interested in painting and poetry, as opposed to rap music or something else, because these fine-art traditions are the points where resistance is strongest, the most refined, because these traditions have longevity and the highest degrees of self-consciousness. . . . It seems to me painting is a particularly good way to make this kind of stand, because of the richness of the tradition, and the richness of current practice.

Levin: People say of a show, "It's not dealing with the issues," or "they're dealing with the issues." But what issues? One person may think the issue is what color next to what color, what shape of stroke, and someone else might think the issues are social, political and revolutionary. So art isn't one thing.

Audience: How often do you review shows that aren't your issue?

Levin: I feel responsible to review shows that concern issues I feel drawn to.

Ratcliff: One of the worst things a critic can do is feel responsible to whatever the hot issues are in the art world, because those are the issues designed to serve its worst aspects, chiefly market aspects, but also social aspects. The art writers I admire try to define the issues beyond what's handed to them in a press release or by an aggressive artist. So, do you respond to the "issues" current in the art world? Absolutely not!

Audience: What do you think about decay and chaos in the midst of all this progress and technology?

Ennenga: I don't know much about decay, but I think chaos is great. It's what many people find bewildering and mysterious in the creative arts. It leads to a sense of wonder and discovery. . . .

Edited from tape.

'89 / #209

The Fever Peaks

In April, 1987, *New York* Magazine ran a story on "Art Fever," picturing socialite art collectors on the cover and evoking the hum of art rapidly transmuting into gold in the text. By 1989 the business press was routinely showing graphs that proved the superiority of art over stocks as long-term investments, and art-talk events across the land took on the flavor of "Cashing In" (a panel held, please note, at a business college). Apparently only artists not cashing in (the majority) and museums priced out of the market failed to celebrate.

This panel discussion may have been one of the last such celebrations. By spring of 1990, art auctions at Sotheby's and Christie's had dropped to half their expected totals, and a work by Julian Schnabel had gotten no bid at all – to the delight of the audience, which laughed and applauded as it had formerly applauded megaprices (though whether that had been in praise of itself, the buyer, or just expensive art was never clear). By January 20, 1991, the situation was so acute that *The New York Times* Magazine made it the subject of a feature story, "Soho Stares at Hard Times." As author James Servin pointed out, with the financial world reeling from ills that ranged from the S & L crisis to the falling dollar, there was an "erosion of confidence" and "the art market unraveled with astonishing speed." The newly "dire economic climate,"

he said, brought gallery closings, consolidations, layoffs, lowered prices, and a roster of painful "adjustments." It may also have brought, besides comfort to artists who had failed to cash in, a new topic for panels in business colleges, and articles in the business press – although not noticeably as of this writing.

"Cashing In: Art as a Commodity"

Moderator: **Gail Levin**, art historian, professor at Baruch; Panelists: **Roslyn Bernstein**, professor of English and Journalism at Baruch; **Jeffrey Brosk**, artist; **Jeff Koons**, artist; **Hilton Kramer**, critic; **Suzanne Lemakis** and **Jennifer Vorbach**, curators of Citibank collection.

Baruch College, NYC; October 26, 1989

Roslyn Bernstein argued that paintings had always been appreciated for their trading potential, not their aesthetic value, but that art is now a major item in the financial pages of the business and general press. For example, the *Business Periodical Index* for 1984-85, had 20 articles on art, five of them specifically about art as investment. The 1986 Index showed a 30% jump in articles on art in every kind of business magazine, including the *American Economic Review*. By 1987, the number had increased to 40, under various "Art" sub-headings, including 13 articles just on art as investment. These included "Is the Art Market About to Peak?," several analyses of why the stock market crash (October 1987) didn't affect the art market, and even an investor's "Post-Crash Portfolio" in *Contemporanea,** an art magazine, which encouraged investors to reach for certified bargains in art. From June 1988 to July 1989 there were 50 articles on art as investment, including several a week in the *Wall Street Journal*, many of them with detailed information on auction prices.

Interviewing a writer at *Business Week* about that publication's interest in the art market, Bernstein was told it was because "art follows money." *Business Week* also pointed out that auction houses, recognizing the importance of media, now pay more attention to journalists, entertaining them at lunch, and so forth. The source saw the Warhol auction as a turning point. "Reporters may not know a Matisse from a Picasso but they know all the players." Important collectors from business and society are well-known to readers as well. Business press coverage of art made it respectable, gave it "credibility." It also fueled sales, convincing investors to buy. A writer at *Fortune* said that magazine is concerned with management and art is not high on their interest list, but *New York* Magazine launched a new feature last year: a "Best Bids" column that reports on the auction scene and advises what's hot.

Jennifer Vorbach described a collector who five years ago didn't know the names Warhol or Picasso and is now an art dealer. She asked, "When does your knowledge of its value interfere with your pleasure in living with the art?," and showed examples of paintings that presumably illustrated this conflict. However, the relation between the question and

her examples was dubious. She added that interviews and articles about auctions of famous art rarely cite a profit motive. Heirs often sell to pay taxes or divide assets. She also noted that, if one compares the entire art business of about 20 billion dollars annually to the insurance business, which is probably in the hundreds of billions, art seems a relatively small world. However, Vorbach concluded that art is a "commodity with a difference – which makes all the difference."

Jeff Koons said he hears a lot of talk about commodification of art, but he himself has never tried to commodify his art. In spite of some guffaws from the audience, he explained, "I work with materialism to meet the needs of people and to communicate ideas. Art has not been as great a commodifier as other industries." Then he added, somewhat opaquely, "Art is an undefined profession; the capital base can be made into something new by artists." Koons disclaimed any cynical gesture, maintaining that he keeps his "prices strong so they will be taken as politically serious statements."

Hilton Kramer's premise was that the craze to collect art resulted from so many other pleasures being forbidden: "Life has become austere and collecting art is one of the few things you can't die from. Artists have always exchanged their work for money – it didn't become a commodity 15 minutes ago. And it really wasn't better when artists were starving. The only difference is that today people ignorant about art are spending money on it."

When Kramer wrote his column for the Sunday *New York Times*, the paper had 1.6 million readers, but he claimed perhaps only 200 to 300 people read his articles, adding that "the number of people now knowing about art is probably not much larger." Today, he said, "We no longer have commanding figures in art, people under 60 who create a standard and provide a kind of leadership. In the absence of leaders there's a chaotic situation." In the 1980s, "the two most fretful issues are politics and money. Artists addressing political issues in their work are making a lot of money. (What other society would take Leon Golub seriously?) Money is now the principle substitute for art."

Kramer doesn't "begrudge people spending large sums of money on art, because what else have they got? They have meager lives and writing checks is their religion. Artists who induce themselves to believe they are satirists of the commodification of art have also joined the flock of people who don't know anything about art except how to receive checks for it." Kramer concluded, "Let's sit back and watch the carnival go by."

Jeffrey Brosk said there is a stratum of artists working with major issues whose work is overlooked by the press. He, for instance, makes works for specific sites that are usually demolished after three months. He looks at his art as a process: whether the piece remains or is destroyed, he learns from each, and carries the information on to the next. (He has also done some permanent pieces.) Brosk didn't make any direct contribution to the subject at hand, unless the non-saleabil-

ity (and by extension, non-commodification) of his work was intended to be relevant.

Suzanne Lemakis buys art for a corporation she omitted to name but described as conservative. [Subsequent inquiry established it as Citibank.] She said businessmen,"the philistines," would like to know more about art, but also impose restrictions on her buying. For instance, she "can't have anything in the collection that would either offend or require high maintenance." The function of corporate art, Lemakis said, is to "please the troops; to make everyone happy in their offices and public rooms." Corporations started collecting art to advertise their businesses. "Even in the 1930s, corporations commissioned artists and [supported] the arts," she pointed out, citing IBM's start in 1939. "When abstract art became American in the '50s and '60s, it, too, became acceptable." Corporations don't buy as a hedge or as investment, and they never buy "on the cutting edge. . . . In fact, when works of art in a corporate collection become very valuable, they create a problem in insurance and protection."

In response, Kramer commented that "when a work of art goes into a corporate collection it's taken out of circulation. Lemakis replied that a good corporate collector lends work to museums. (Considering the preponderance of safe prints in her corporation's collection, there may not be much demand.) Kramer also complained that the Roy Lichtenstein commissioned for the Equitable Building lobby was like an advertisement for Lichtenstein. Jennifer Vorbach added that it was a safe choice, part of the "buy-another-Stella syndrome."

Moderator Gail Levin quoted dealer Phyllis Kind's opinion that we are going through a *fin de siècle*, a decadent time, that artists are making things for the commodifiers to buy. Jeff Koons asserted that he did not believe art is "bankrupt" and that the artist will continue to be a communicator. Jeffrey Brosk said art is reflective of the times – pop music, architecture, etc., are all associated with money. Kramer disagreed with the end-of-century theory, but wished we were at the end of the 19th century instead. "What's going on in the art world has everything to do with the world economic situation," he said. "In the last decade there has been a tremendous increase in wealth. Art has entered the area of popular investment."

Bernstein pointed out that not so long ago there were 200 art galleries in New York; now there are over 600, many of them tax write-offs or vanity galleries. Kramer reminded the audience that "in 1890 people weren't buying Cézanne – he had only one show – but were buying Gérome and Bougereau." And, he added, they're "now buying them again. Garbage then and garbage now." Today, "the economic system produces people who can't read or write. [T]hey've substituted an attachment to the visual."

Levin asked Koons why he doesn't make editions of 100 instead of his usual three. Koons said it would "reduce the seriousness of the art." Besides, "if something is rare it's a more sexual experience."

On the topic of price in contemporary art, Kramer said there are many distinctive works on the market for $2,000 and under – drawings, for instance. He recalled a panel some 30 years ago, in 1958, when "a dealer said, 'today one can't buy a work of art for under $1,000' and the audience gasped." Brosk recommended that for real values collectors should look at slide files of artists not represented in galleries.

When a member of the audience said to Koons, "You said you paint for the needs of people. I thought an artist painted for himself," Koons responded incoherently. Kramer pointed out that the press plays a significant role in the dynamics of the market, especially the auction market. He had tried to persuade the *Times* not to run auction news on the front page, but failed. Someone addressed Kramer's claim that there are no modern masters, suggesting that because contemporary artists now cash in early, they fail to develop. Kramer replied, "we've become a valueless society – this is a time of crisis."

The event had begun with a huge audience, but as it played itself out, discussion degenerated into trivialities and wrangling, with most "questions" (or accusations) directed at Koons. People started to leave and soon we did too. Still, as telling as any comment this panel could have made, was the fact that, less than three weeks later, auction news drove world events off the front pages:

In a 12-day period, art sales exceeded a billion dollars. There were sales totalling $232 million one night and $270 million the next. Among other records, some 124 works – Impressionist and Modern – sold for more than $10 million each and close to 150 works sold for more than $1 million each. An auction house spokesperson said, "the art market is alive and well . . . and even more solid than six months ago."

– Cynthia Navaretta

Women Artists News, Winter 1989/90 [Vol. 14, No. 4]

Contemporanea ceased publishing in 1990

Update: In 1991, Jennifer Vorbach, now a vice president of Citibank's "art advisory service" (i.e., the department that lends money for investment in art), told a reporter that the number of requests for credit had gone from more than 10 a week in 1989, to "maybe two" in 1991, "but from more financially solid people." Other investment bankers reported that "the speculators who drove up art prices in the '80s have run far away," and modern art currently "makes most bankers queasy." Few are willing to lend for art at all, and Japanese investors have almost completely left the market (although one broker said he'd still rather "lend against a diversified collection than a Park Avenue co-op"). Prices for *decorative* arts have apparently held up, but right now, far and away the most profitable "art" investment is baseball cards. [*New York Times*, 11/22/91]

'89 / #210

Dance Paradise

Although the questions may seem familiar, the tone and content of this discussion of dance criticism have the ring of art criticism of the '50s. Contrast, for instance, panels on visual arts issues just before and after this one. This might be explained by saying dance can't be commodified – but then they said conceptual art couldn't be commodified.

"The Uses of Criticism"

Moderator: **Richard Elovich**, Director of Movement Research; Panelists: **Tere O'Connor**, **Stephen Petronio**, **Elizabeth Streb**, choreographers.

Ethnic Folk Arts Center, NYC; November 27, 1989

The eighth annual presentation of the Studies Project promised "enlightening inquiries on the how and why of dance." Its advance promotion raised such questions as, "Has criticism shifted away from theoretical discussion toward careerism, artists' marketing devices and critics' self-promotion? What do we expect from criticism? Do critics have an impact on critical issues – or future bookings? How is the artist responsible? How is the critic responsible?"

To one who has recently attended some dozen or more similar discussions in the visual arts, this sounded very familiar. Certain that artists in all disciplines have the same problems, I attended with some curiosity, but few expectations of surprise.

After my usual diet of visual-art-talk, however, this event *was* a surprise. Panelists were not just intelligent and articulate; they presented a wide range of attitudes about their expectations vis-a-vis the critic's responsibility, and with a refreshing diversity. There were many dance critics in the audience (I identified eight – on a rainy night in an out-of-the-way location), some from major publications, such as the *Voice* and *Seven Days*, as well as other articulate choreographers and dancers. They were willing to listen to the panelists and tried hard to be helpful, not authoritarian. Discussion was never hostile, the tone rarely adversarial or accusatory; only one panelist occasionally showed anger at critics – but in a most poetic way. There was enough good feeling, even after panelists had voiced their dissatisfaction with the artist-critic relationship, for everyone to engage comfortably in an informal dialog of audience and panelists. When critics spoke from the audience it was in a conversational, rather than a defensive, manner. Some explained things, like Joan Acocella, who went to great lengths to explain why she and her editor considered it important to use some 40% of allotted space to provide background for the general reader.

Unlike the visual arts, which abound in specialized periodicals and are routinely covered in the daily papers, dance has only a few periodicals, and those were described as "embarassing." Dancers are therefore totally dependent on

dance columns in the general press. Tere O'Connor said he wants the audience and readers (via the critic) to know how his work is made and should be perceived, to understand what is different about his dance. Instead, he said, reviewers rely on certain words and phrases, frequently using "obfuscation, obscurity and theatrical devices" instead of noting "the cultural commentary." He raised the issue of the critic's function – whether to sell work or discuss issues.

Elizabeth Streb, the iconoclast of the group, wanted critics "to describe with adjective and adverb, to place issues in a cultural and historic context; to judge whether something is good or bad and to speak about *movement.*" She believes "a new language is needed to talk about movement or motion." She also decried critics who buckle under their editors' constraints, praising the critic in the audience who, after being constantly squelched by her editor, quit and started her own dance newsletter.

Stephen Petronio was the type most familiar in the visual art world, slipping easily from poetics to rage at the power of critics. "Dance is a kind of compounding of meaning, and by naming things you unravel them." His focus was on the conflict of the critic's role: sitting on government panels distributing money, while also writing the reviews that determine the dance company's reputation. "Yet, the critic needs the dancers to exist." On the other hand, he pointed out that most reviews are written after the performance (usually one night only), so they don't actually have much effect on attendance at the event.

An audience member noted that reviewers tend to write about a performance as an isolated phenomenon, rarely in context of a larger dance world. She, too, agreed that a new language is needed. Streb, whose choreography incorporates an extraordinary amount of daring athletics – pushing the dancer's physical abilities to the limit – complained that, although academic dance education has an existing language about structuring and making dance, it has nothing yet about the intricate balance of bones against gravity and has paid little attention to the influence of space.

Acocella suggested an ongoing informal discourse between dancers and critics. There was some polite discussion of the issue, with Streb finding it "dangerous" for critics and artists to "intersect." O'Connor was in favor, and in spite of his earlier comments, added that "art criticism can be informative." It was generally agreed that there is not just one kind of critic, but a whole range of critics.

Although the dread word "commodification" was mentioned once during the evening, I think the dance world is still safe. By comparison to the huge money-making machine of the visual arts world, theirs is still paradise.

– Cynthia Navaretta

Women Artists News, Winter 1989/90 [Vol. 14, No.4]

'89 / #211

Dennis Hopper Day

"Art in the '90s: The Impact of the '60s"

Moderator: **John Hanhardt**, curator, Film & Video, Whitney Museum; Panelists: **Dennis Hopper**, actor, filmmaker, photographer; **Allan Kaprow**, artist; **Nam June Paik**, video artist; **Yvonne Rainer**, filmmaker.

New York University, NYC; December 6,1989

The mob would have done credit to a rock concert. It made last year's turn-out at the Parrish Museum – which impressed me so much at the time – look like a desert island. Of course, as soon became obvious, it wasn't the look-into-the-future title that pulled the audience, but celebrity superstar, Dennis Hopper. Throngs laid seige to the entrance. Long after all seats were filled, they still lined up, hoping to catch the doorkeeper's attention – just like the club scene. And, like the club scene, those who did get in were filled with satisfaction and excitement, just in being there.

In his introduction, John Hanhardt called the '60s a touchstone, a critical decade of social and cultural change, an era of new technology, filled with the expectation of change. The speakers to follow had all gotten their start in that breakthrough decade, he said. Dennis Hopper "left us with lasting images of the '60s . . . taking extraordinary photographs of the west coast art world." Nam June Paik came to New York in the '60s; Yvonne Rainer founded the Judson Theatre* and was an innovator in dance, "revealing movement without decoration. Since the early '70s, she has engaged us as a leading American filmmaker." Allan Kaprow "is synonymous with the Happenings of the '60s."

Nam June Paik spoke briefly, with great wit, and then presented a sneak preview of his latest works. The imagery was gorgeous, the electronic technology dazzling and the colors such as one sees only in dreams. As a form of *leitmotif*, Joseph Beuys appeared at intervals, holding a mike, forcing sound up from his throat with his hand, until upstaged by Amy Greenfield, performing either as the female featured in multiple images or the figure rolling in mud.

Dennis Hopper told of his early life, acting in Shakespearean plays at the Old Globe Theatre in San Diego from the time he was 13 years old until he went to Hollywood at the age of 18. Discovering that his ideas of acting were not what acting was about, he decided that visual artists could express themselves more freely, and became a "gallery bum," haunting the art scene. He claimed to have been one of the first on the west coast in the early '50s to appreciate the Abstract Expressionists, and saw his first Franz Kline at the home of actor Vincent Price. Hopper's personal thumbnail view of art history was, "after David, the photograph was invented and then there was Impressionism. . . . Finally in America we had Abstract Expressionism – artists using paint as paint.

Rosenquist in 1961 was the first one to break the picture plane."

Hopper was king at this panel; he could say anything – trivial, foolish, mysogynistic – and most of the audience laughed with delight. An intelligent-seeming woman next to me joined happily in the appreciative laughter when Hopper said his wife was "in the American tradition, getting everything in the divorce." From 1961 to '67, Hopper took photographs of artists he knew, including most of the Pop artists and others on the west coast; he had several *Artforum* covers during this period.

Yvonne Rainer read a paper she had given at the Maryland Institute of Art last spring. It was the most serious and pithy address of the evening, but the audience was restless. They were there to be entertained, not to think, and Hopper was a hard act to follow. I especially liked Rainer's line, "the early '60s abound in gestures of refusal."

Allan Kaprow, who listed himself on the program as "Un-Artist," showed slides of his innovative installations of the '60s. He said he didn't like the celebration of bygone eras, and believed "progress is still possible – art is a kind of message."

The promised question period didn't work. A couple of desultory audience queries were followed by a long unfocused diatribe from a member of the audience, forcing Hanhardt to close the session, which he did with the hopeful thought that "the '90s may be very innovative; a new dream may emerge."

The audience may not have been able to formulate questions, but everyone was sure appreciative. They giggled and laughed at everything.

— **Cynthia Navaretta**

Women Artists News, Winter 1989/90 [Vol. 14, No. 4]

* Rainer was one of a group of five or six (including Dunn, Forti, Cage, etc.) who founded the Judson Dance Group in 1960; she presented her first fully choreographed evening in 1963.

'89 / #212

Before the Gold Rush

"Art as a Way of Life"

Moderator: **Ahmet Gursoy**; Panelists: **Bruce Dorfman, Audrey Flack, Leo Manso, Philip Sherrod, Joseph Solman**

Federation of Modern Painters and Sculptors, Art Students League of New York; December, 1989

To celebrate 33 years of association between the Art Students League and The Federation of Modern Painters and Sculptors, the League and The American Fine Arts Society sponsored an exhibition of work by current Federation members. A forum on "Art as a Way of Life" was one of several activities aimed at revitalizing old ties between the organizations.

The two hours of the forum were a long two hours. The audience, advised to direct their questions at specific panelists, insisted on addressing all five members; and the members obligingly answered all questions – even those they declared "stupid" or "self-serving." However, when the panelists spoke about their lives as artists and about the lives of their artist and non-artist friends, the talk took on the warmth and truth that comes from people sharing the hard-earned knowledge of their experience. Such knowledge cannot prevent new artists from making mistakes or taking some knocks, or erase those experiences the naive have already bumped up against. But it can break down the feeling of being isolated in the struggle; it can dispell the undermining belief that the difficulties in art's journey are unique, dumped by fate on our individual heads alone.

All the panelists felt a calling to art early in their lives, as young as age three in one case. None thought the life of the artist carries the inherent privileges or mandatory vows of poverty. They agreed, however, that the artist does have a responsibility to "add to society," not just reflect it [Flack].

Audience: Does the public have the right to be critical, to give approval to art with public funds?

Audrey Flack: Something terrible is going on now. Art has become a business. When I became an artist, art was a calling. You didn't think you'd go to Wall Street. When my mother learned I was going to be an artist, she was upset! She would ask me, "How many paintings do you need – 50? 60? Stop." Society is collapsing along with the collapse of the artist. The artist who chooses to be an artist is not in the power structure right now A person will kill their best friend and tack them to the wall. The idea is not making beauty, a vision, expression of life – it's about shock. Artists can wake up and create worlds everyday. You can work out your whole life through art; nobody can tell us what to do. But then you have Chris Burden – he mutilates himself. And the artist who cut off pieces of his penis and had it documented. He died! Is that art?!

Audience: Is it true that you "went to the streets" to paint?

Philip Sherrod: On Eleventh Avenue in high heels? Yes, I arrived in New York in '59 and what I saw on walls of galleries and museums was a stigma, a fixity moving to an intellectualism. I distrust intellectual jargon, not intellect. The only life left that I could respond to was the jungle, the flashing lights, the taxis, the curb level. I left the studio. I went to the street to respond to the movement that's out there. Where do I paint? Upper West Harlem, down in Brooklyn. Where do you live? I'll come paint there.

Audience: As artists, don't you put your ear to the ground to hear what's coming commercially? If what you're doing doesn't sell, what do you do?

Flack: Kline, Pollock – they didn't worry about it. How did I do it? I had more jobs that I got fired from. I know many artists (I won't name names because I don't believe artists should speak badly of one another; it's hard enough being an artist) who won't take a chance any more because their art is so successful. So they keep repeating the same thing. Don't lock yourself in the attic. If [not selling] starts to kill you, go on to something else.

Bruce Dorfman: Acceptance of risk. One does whatever is necessary. If you work all day, you paint all night. You lose your right arm, you use your left arm. [If you don't sell] you keep working. With a gallery or without. When artists get overwhelmed, they shoot themselves. But so does everyone else.

Joseph Solman: I worked on the WPA project. I painted for six years, uninhibited. When that folded, I worked a half year and painted a half year. I did seasonal jobs. One benefit to being an artist – you can never be fired and you can always quit.

Audience: How do you feel about teaching? Are you really giving all you can?

Leo Manso: If I didn't enjoy teaching, I'd look for work elsewhere because the pay is better. I enjoy working with people one-to-one. I'm stimulated to think and respond and to give . . . To see somebody grow is a tremendous satisfaction. But I only like to teach twice a week because I need the time for my own work.

Audience: What are some of the issues you've noticed in your work over ten years?

Manso: In the '60s I was interested in Buddhism, philosophy. I did paintings with a meditation notion. I returned to landscapes after a visit to the Himalayas – landscapes were my original interest. Better work comes from inside, but it's probably affected at first by the outside.

Flack: I'm best known as a Photo-Realist painter. For years I was working day and night. The work was getting better and better. I was in a frenzy, I was seized, overpowered by a passion. I kept going. I got sick. I think I was dying. For three years I was seriously ill. I changed my way of eating and used Eastern thinking. I continued painting, had a show, and then I began sculpting. I'm happy. I want to live. I don't want to die. I don't offer that as a way of life. I prefer the balanced life.

Audience: How important is exhibiting your work?

Dorfman: Very important. At some point you will; whether you'll get to see it or not . . . People are washed out by an insistence on their right to have the work shown.

Manso: Important, not for ego but for feedback. I have sought to be part of a cooperative. I was in one with John Ferren and Philip Guston. It's better if artists band together.

Sherrod: I've done 4,000 canvases. I'm so deep in my own image. I'm a small space curator. I am buried in myself; that's my fault. I need a new studio in addition to the floor I have in a building.

Solman also read excerpts from Chardin's lectures to the academy, from Goncourt's journals, and Flack read a dialog between herself and Jimmy Ernst called "Bad Work," from her book *Art and Soul* (now in its third printing). The books were for sale and most of the audience lined up to buy a copy.

– Kate Gleason

Women Artists News, Spring/Summer 1990 [Vol 15, No. 1-2]

1990

'90 / #213

Transforming-Art-History Week

College Art Week 1990 in New York City was, according to official sources, the biggest and best-attended ever. Tuesday through Sunday, those with the stamina could visit more than 150 scheduled panels, speeches, parties and openings, not to mention the "meat market" (job interviews) and two floors of publications.

Griselda Pollock, one of the stars in what was clearly the Panel of the Week (see #214 below), also delivered the Women's Caucus keynote address. Titled "Can Art History Survive Feminism," it ringingly called on feminists to examine "truths largely ignored in art history." But speaking informally from the dais before launching into her prepared address, Pollock shared with the expectant crowd a truth of *recent* art history – she and the Women's Caucus had engaged in some hard bargaining over her fee. It was, she admitted in the manner of the Cheshire cat, a large one, and indeed it was subsequently confirmed to be the largest ever paid by the Caucus.

In other words, celebrity, desire and marketing have thus been hinted at – but so far remain, also, in the "truths largely ignored" category.

"Can Art History Survive Feminism?"

Keynote Address by **Griselda Pollock**, Professor of Art History, University of Leeds, England

Women's Caucus for Art, College Art Conference, NYC; February, 1990

A decade ago, in the preface to their book, *Old Mistresses*, Griselda Pollock and Rozsika Parker urged that art history take account of the differences between women's and men's "relation to artistic and social structures." Pollock is still hammering at this theme, addressing how "women's assumptions and thoughts" are given inadequate consideration by art historians and critics. Bringing to bear her personal history as a professor at a provincial school that can tolerate liberal diversity because of its marginality ("nobody cared"), her Marxist, feminist viewpoint ("more important are women and their lives") and feminist scholars' theories, Pollock explored whether art history can or should survive feminism. Warning that our training and the institutions shaping our viewpoints predispose us to the status quo, Pollock insisted we must claim our identity by proclaiming our differences. Ending art history does not mean ceasing to analyse art, but exploring how our different backgrounds and assumptions shape our analysis.

Part of the talk was devoted to Gauguin's painting, *Spirit of the Dead Watching*, in which, Pollock argued, Tahitian ancestor worship is reduced to superstition and a native woman's body is "burdened" by male aggression. In Paris, critics discussed the painting as a "brown Olympia," comparing it to Manet's controversial work. This, said Pollock, is a racist fiction. In Tahiti, where the bodies of women were available for "artistic colonization" by white European men, local customs were dishonored when Gauguin used the 13-year-old girl as model, servant, and mistress by means of a mock marriage.

Pollock's approach from the viewpoint of the "other," whether in terms of race, class or gender, reveals truths largely ignored in traditional art discussion. The incorporation of diverse viewpoints can only strengthen art history by making it more insightful, honest and comprehensive. Perhaps art history as it has been practiced until now cannot survive feminism, but a probing, enlightened feminism could transform art history so that its survival would be ensured.

– Sylvia Moore

Women Artists News, Spring/Summer 1990 [Vol. 15, No. 1-2]

'90 / #214

Most-Talked-About Panel

"Firing the Canon" was a "challenge to the hierarchy and patriarchy" of art history by some of the field's most stellar figures. The *New York Times* called it "a highlight of the conference" [2/17/90] and covered it accordingly. That attention assumes extra significance when we recall that, at the onset of this "mutiny," women's panels were hardly mentioned in the press, let alone featured. The fact that a full-dress "firing of the canon" was sponsored by the College Art Association jointly with the Women's Caucus is another clear sign of changes wrought by talk.

Sylvia Moore's overview of the five papers delivered is followed by my own dissent on one and appreciation of another.

"Firing the Canon: Feminism, Art History and the Status of the Canonical"

Moderator: **Linda Nochlin**; Panelists: **Griselda Pollock, Arlene Raven, Linda Hults, Michele Wallace, Mara Witzling**
Women's Caucus and College Art Association, NYC; February 1990

Facing a packed ballroom, Linda Nochlin announced that gender would be at the heart of the discussion to follow – as if anyone could doubt it. The panel, eagerly awaited by feminists from the moment of its announcement, carried one step further the WCA "Questioning the Litany" series, to consider the overthrow of assumptions, "stated and unstated," that govern our approach to art history. As Nochlin put it, a scholarly discipline and its canons "stand or fall together." In the wake of recent political movements, the very concept of canonization is being questioned.

Fresh from her Women's Caucus keynote address the previous day, Griselda Pollock discussed the idea of the canon as a selective tradition, structured for the exclusion or subordination of those outside the established norm. She used a drawing of a peasant woman by Van Gogh to demonstrate the multiple meanings – sexual, social and political – revealed when one adopts an anti-canonical stance to a work of art.

Linda Hults took a similar approach to examine a painting by Rembrandt, an artist endlessly "heroized and romanticized." Bringing in questions of the double standard and the ambiguity of conventional morality, Hults connected the way Rembrandt conceived his Death of Lucretia to his relationship with his common-law wife, Hendrickje Stoffels. The recognition of how an artist's personal concerns influence the form of a work can lead to a deeper understanding of both artist and work.

Arlene Raven's talk on women artists reminded us, with wit and insight, of how stereotypes persist and how some artists, like Georgia O'Keeffe, have been "caught in the crossfire." Raven showed several provocative photos of O'Keeffe taken by Steiglitz, and discussed how the "tireless promotion" of O'Keeffe as a woman "perpetually on fire" and of her imagery as sexual in nature brought about her canonization and distorted the true values of her art. Even when we ourselves have helped to create canons, concluded Raven, we still must fire them.

Mara Witzling took the stance that women artists should be added to the existing canon, but also that the canon should be "deconstructed." (A prize for the most overused term at the conference would surely go to "deconstruction" and its derivatives.) Witzling compared a quilt by ex-slave Harriet Powers to Michelangelo's Sistine Chapel ceiling fresco. Both, she said, present a complex program in the service of a "grand spiritual vision." Witzling called for the "improvement of a canon that does not include a work like that of Powers," and recommended that we not "limit definitions of human creativity."

Michele Wallace ended the program with remarks about the exclusion of black artists from the canon. Resentful of modernists' borrowings from African art and the refusal of Euro-

peans and Americans to acknowledge, not only their debt but even the existence of an African-American culture, black artists can only hope that the visual arts will follow the example of music, where cultural interchange is freely accepted. The canon, said Wallace, must be subverted.

Nochlin called this session "uncanonical," since it represented no single position or methodology. Although the presentations were generally scholarly in approach, in many ways this and other sessions I attended owe a debt to "speakouts" and consciousness-raising meetings of previous years. Feminist scholars have found their voice, and some have found a place in the art-historical power structure. Whether at the center or beyond the fringe, may they continue to fire those canons.

– Sylvia Moore

Women Artists News, Spring/Summer 1990 [Vol. 15, No. 1 & 2]

Firing the Canon – and Going off Half Cocked

"Differencing the Canon" by **Griselda Pollock**, a paper from the "Firing the Canon" panel
Women's Caucus for Art, College Art Conference, NYC; February 1990

Anticipation was high. The ballroom was packed. Folks were literally hanging from the rafters – or at least dangling over the balcony. And sure enough, almost immediately, star panelist Griselda Pollock revealed herself to be the Uri Geller of art history. That is, she set out to persuade us, by misdirection and suggestion, that the poor tormented Vincent Van Gogh we used to know and love was a bent spoon – a member of the "Protestant aristocracy" and a "Dutchman with money" whose "bestial fantasies" abused and humiliated women. The audience loved it.

The evidence consisted, so far as I could tell, of one drawing, Van Gogh's 1885 "Peasant Woman Stooping" (elsewhere called "Woman Working in the Fields"). This, said Pollock, is "a drawing I hate." Why? Because it might be used to "legitimate Van Gogh's bestial fantasies." A slide of the work remained on screen throughout Pollock's citations of psychoanalytic literature to prove that lower-class women of Vincent's day represented the erotic and bestial in upper-class male fantasy and her concomitant argument that the rear-view, bent-over position of the drawing was unnatural and perverse, a "violation of the working-class woman" paid to pose for it. *Upper-class women*, Pollock said, were depicted "upright" in the 19th century, and flashed slides of Victorian cabinet photographs of matrons in dignified poses on screen to prove it.

Minus the blue smoke and mirrors – Pollock's hypnotically rapid delivery, blonde beauty, bodacious British accent and air of absolute assurance – objections crowd the mind. There's the fact, for instance, that *all* women in proper portrait photographs of the period were shown "upright" (men,

too, for that matter). Working-class women may have worn borrowed or rented finery, but they stood just as erect and dignified as the minister's wife. Indeed, 19th-century commercial portrait photographs had virtually no other format than the standing or seated frontal pose.

Before our very eyes, then, Pollock has transformed the conventional stance of formal photographic portraiture into a standard for farm labor sketched by an avant-garde painter.* She has also conjured up a world where upper-class artists may hire only upper-class models, although working-class artists might be permitted to hire working-class *or* upper-class models, and upper-class artists could perhaps hire working-class models to pose in upper-class positions. But that's all small potatoes, as it were. Artists and models are relics of a cottage industry of the past. This is the age of mass media – of film. Think of all those slave and gladiator movies: abuse of a cast of thousands, legions of workers made to shave their heads and grovel in the dust wearing loin cloths made of tea towels, humiliated with every insult and punishment Hollywood could devise, men as well as women violated for pay. Of course some extras may have had upper-class origins, but even so, Ms. Pollock has her work cut out for her.

However, if the issue is *depiction of women*, not hiring of models, upper-class women have always as a matter of course been depicted in every imaginable and not a few unimaginable poses, including flat on their backs and naked in postures of all sorts of submissive and lascivious abandon. (And appear that way still in half the perfume and liquor ads in America. I wish someone would talk about *Ralph Lauren*'s fantasy.)

Which brings us to the psychoanalytic insights. I will take second place to no one in my love of psychoanalytic insights. However, as I understand the discipline, constructs such as "rear view," "lower regions," etc., can be assigned symbolic meaning in the abstract, but to interpret an individual psyche, analysts look for *patterns* of revealing behavior. Here Pollock's misdirection amounts to fraud:

"Peasant Woman Stooping," the supposed "evidence" of Van Gogh's "bestiality," may be the only such female rear view he ever did. It's certainly the only one Pollock showed and the only one I could find in print. Since Pollock did her PhD on Van Gogh, I assume she would know of any others and have dished them up pronto. At the start of her talk, she flashed a montage of stooping-worker drawings on screen just long enough for "people working, several views" to register, then whisked them away. *Why were these other views less significant?*

Scanning Van Gogh books at MoMA, I find a drawing of a similar stooping woman, "Peasant Woman Binding Wheat," but *seen from the front!* Another book shows "Peasant Woman With a Pitchfork," also similar and *also from the front.* That's two right there – twice as many as the evil rear view. There are, in addition, several versions drawn *from the side.* It seems Van Gogh worked the theme through 360 degrees. But wait! There are stooping *men*, too. Meyer Schapiro's 1957 book, *Van Gogh*, includes, not the incrimi-

natory "Peasant Woman Stooping," but a *man* in a virtually identical rear view, which in my German edition is titled, "Grabender Bauer," or "Digging Peasant." Is this a homoerotic bestial fantasy? Was the working *man* abused?

As devious as Pollock's turning one drawing into an oeuvre, is her silence on the artist's own vehemently declared feelings. A salient fact of Van Gogh's life and a major part of his legend, avowed at length in his letters to Theo, and the topic of a new book by Andre Krauss (*Vincent Van Gogh, Studies in the Social Aspects of His Work*) is his strong identification with working peasants. He idealized the poor, "seeking in work the nobility of mankind." Certainly his conscious intent was to exalt the beauty and dignity of farm workers of both sexes. If he had frequently portrayed women in suspect poses, that might indeed suggest a significantly different, unconscious agenda (a common enough phenomenon). But as far as I can tell and *as far as Pollock showed*, "Peasant Woman Stooping" is a single instance.

She, however, addresses nothing so mundane as the artist's conscious feelings and intentions. Hers is a different agenda – the sweeping assertion of guilt-by-class, determined at birth. Van Gogh may have identified with the poor and lived in poverty, but to Pollock he is an "aristocrat." That he himself would have been crushed to hear his drawing called the "violation of a working-class woman" just adds to the fun. (Pollock used the "Peasant Woman Stooping" drawing at a Columbia University panel as evidence of "violence against women," to the disgust of my friend Angie, who says the figure is not abused, but "powerful and beautiful.")

In her introductory remarks, Linda Nochlin noted that, although "the very existence of the canon is now questioned," we can show "how it works to maintain existing relations to power." Griselda Pollock opened her paper, too, with a reference to the canon. She asked, "Can feminists be art historians?" and speculated that "an identification with past forms and judgments" may make it impossible. The impediment in this case, however, is her own prior agenda, a Procrustian doctrine into which she shoves the world.

The enthralled reception of this concoction shows that fake facts, sleight-of-hand and razzle dazzle can carry the day even among scholars. For a season or so they do seem to "bend the spoon." A lot of us have been impatiently awaiting the chucking of the canon, or at least its drastic revision. Sadly, this sample of the "feminist scholarship" proposing to replace it makes the canon look good.

– Judy Seigel

Women Artists News, Spring/Summer, 1990 [Vol. 15, No. 1-2]

*To restate the obvious, I quote a description of Victorian portrait photographs: "There is a religious quality . . . Being photographed was a rite . . . Existence itself . . . had to be presented with the dignity and balanced propriety that the age gave to all its endeavors. . . . There is no movement. Gestures are at a minimum. . . ." The portraits were, in sum, a "stereotyped [and] false . . . presentation of reality." [Steven Halpern, *Aperture* 19:1]

And to again restate the obvious, flashing such a photograph on screen in a now-you-see-it-now-you-don't microsecond, so we get the image, but have no time to consider its real meaning, and to airily make this a criterion for Van Gogh's dream of a new painting, is absolutely to import the tricks of the carnival sideshow into academia.

"Looking High and Low: Harriet Powers's 'Bible Quilt' and the Sistine Chapel Ceiling"

A paper by **Mara Witzling** from the "Firing the Canon" panel

Women's Caucus for Art, College Art Conference, NYC; February, 1990

Checking the full title of this paper in the program, I see again Griselda Pollock's title, "Differencing the Canon." I will not say a thing, not one thing, about "differencing" as a verb, although I'd suggest calling it "Abusing the Psychoanalytic Method for Fun and Profit." Anyway, Mara Witzling's "Looking High and Low: Harriet Powers's 'Bible Quilt' and the Sistine Chapel Ceiling" did just what it promised, clearly, without tricks, and entirely unpocked by eruptions of critical code words – a rare beacon in academia.

To see the two grids side by side on two giant screens – the quilt, hand-appliquéd by the Georgia sharecropper and ex-slave; the ceiling, painted by Michelangelo for the pope – was an immediate revelation. After remarking that the so-called "marginal" work by the "minor" artist was in the non-canonical medium of "stitchery and rags, rather than the canonized paint and marble," Witzling set out an array of similarities and analogies between the two, from their grid format and Biblical contexts to the fact that both were "breakthroughs in their respective media [and] transcend previous limitations of their genre." Of course it was no surprise to learn that the quilt has yet to be accorded the canonical status of the ceiling. Witzling said it took her 25 minutes to find it "tucked away in a hidden corner at the lowly courtyard level" of the Boston Museum of Fine Arts.

What did suprise me was the heat with which two African-American Ph.D.'s in the audience discussed the paper afterward. Their perception had been, not that Witzling showed the quilt to be as great a work of art as the painted ceiling – the bold premise, convincingly argued, that I heard – but that she had disparaged the quilt, calling it "only cloth and thread," not even stating, let alone arguing, its greatness.

Thus is proved yet again (if proof be needed) the subjectivity of all perception. Grace Glueck, covering the panel for the *New York Times* [2/17/90], quoted Witzling's description of the quilt's "powerful visualization of a cosmology and innovative use of materials [comparable] to a work as highly positioned within the canon as Michelangelo's Sistine Chapel ceiling." (For once the *Times* agrees with me.) My guess is that the objections arose from a certain territoriality – perhaps another prohibition in the making. If "upperclass" artists can't do working class models, can white scholars do black artists?

Canons, of course, are being "fired" all over, not just at the College Art Association. In fact, there's a report of backlash at the Modern Language Association. It seems Richard Levin of SUNY Stony Brook has dared to say that "suppression of feminine influences" is *not* "the root cause of tragedy" in Shakespeare, as feminists have claimed. ["A Traditionalist Takes on Feminists Over Shakespeare," *New York Times* 3/4/90.] In his opinion, Shakespeare wrote "about individuals making fateful and fatal errors as they confront . . . ambition, greed, vengeance, vanity and jealousy." In art today, as in the larger world, "difference" is confronting orthodoxy. But as our art dramas unfold, it becomes clear that a "differenced" regime can be as arrogant and confining as the original.

– **Judy Seigel**

Women Artists News, Spring/Summer, 1990 [Vol. 15, No. 1-2]

Art of Our Time

"Dangerous Transgressions: Showing Our Teeth"

Moderator: **Lenore Malen**; Panelists: **Faith Wilding, Mira Schor, Carolee Schneemann**

Women's Caucus for Art, College Art Conference, NYC; February, 1990

Lenore Malen began by considering the dictionary definition of "transgression." Meaning literally "to step across," the word bears a close relationship to "perversion," which the dictionary defines as "turning the wrong way." "Taken to its extreme," Malen said, "transgression can be very dangerous." This is why all societies impose taboos – essentially laws that enable humans to live together safely.

Many taboos concern sexual behavior, since sexual fantasies that erupt into action can disturb the social order. Malen finds significant differences in sexual fantasies between men and women. Men's fantasies often center around a voyeuristic view of the naked woman, but are, at the same time, underlaid with an unconscious conflict between viewing the woman as the object of sexuality and as the object of procreation. The force of this repression can express itself in rage and a wish to humiliate, an attempt to reverse the feeling of infantile powerlessness. Women's sexual fantasies, on the other hand, often involve unexpressed desire and love for other women (the mother) as well as for men (the father).

Artist Faith Wilding showed slides of her own and historical artworks utilizing images of what she called "dangerous fluids." Especially in Christian iconography, the symbols of blood and milk – from Christ's wounds and Mary's breasts – are frequently combined. The blood of Christ is offered as the drink of eternal life; the milk from Mary's breast is given the child Jesus and all humans, for earthly life. It was not

uncommon for religious painting to depict female saints suckling at the wound in Christ's breast. This mingling of life and death touches deep contradictions about simultaneously fearing and longing for the mystery of death. Such images are disturbing, but perhaps more so for males than females, since women's menstruation regularly reinforces the notion of blood as symbol of life-giving force.

The mingling of blood and milk, of death and life, transgresses fear. Malen paired an historical painting of St. Agatha, a martyr whose breasts were mutilated, with recent sculpture by Nancy Fried about her mastectomy. Wilding also showed work by Frida Kahlo (who, she said, lived out in her body what most women fear), Suzanne Lacy, Leslie Sills, Cindy Sherman, Alice Neel, Eva Hesse and others, as well as her own images of suckling mummies.

Mira Schor talked about different transgressive acts: the kind that get accepted and the kind that remain transgressive. She pointed out that some artists gain points by being transgressive, citing Eric Fischl and David Salle as artists adopting the "bad boy" mode. Women like Karen Finley, who shoved yams up her ass and shit on stage, have utilized such assaultive, bad-boy techniques as well. But, Schor asked, must transgression always be violent, loud and profane? Not necessarily. Angelika Festa's red-costumed performance, for example, successfully disturbed the day-to-day street activities on Broadway and Prince Street without sound or motion. Schor also mentioned Barbara Kruger, Ana Mendieta, Louise Bourgeois, Cindy Sherman, Nancy Fried, Ida Applebroog and Judy Chicago as artists whose work is quietly but insistently transgressive. The blatant cunt imagery of the finely crafted and definitely non-bad-boy *Dinner Party*, for example, transgresses social and aesthetic norms in spite of its beauty.

Then, Schor asked, is all art that transgresses such norms transgressive? What about Jeff Koons? Schor made a distinction: While Koons knows his objects are ugly and self-consciously uses that ugliness as a stance in relation to modernism, Chicago perceives her images as having aesthetic integrity. She wishes to undermine and *change* society's notion of artistic beauty, not merely comment on it. The question now becomes, Schor said, whether Koons will appropriate and reproduce *The Dinner Party*.

Schor views her own work as transgressive in both form and content. Some is made of paper, but meant to be touched by viewers, which leaves many people uncomfortable about the art's fragility – a metaphor, she said for her experience of the female body. Some of her imagery utilizes unlikely anatomical pairings, such as the ear and the penis, specifically referring to the Virgin Mary's impregnation through hearing the word of God. Not surprisingly, such artwork has encountered censorship problems.

Carolee Schneemann has also come up against censorship throughout her long career. Going through slides of her work, she noted that in the '60s, when in her words, "gender issues were different," she felt it essential to position her body "in the center of inherent contradictions." She showed

stills from *Fuses*, a film using images of lovemaking, but physically altered by scratching, baking, painting and collage. (*Fuses* was recently shown in Moscow.) But why, she asked, is the manipulated film considered nontransgressive and an ordinary 16-mm black and white film of the same material considered pornographic? She used slides to illustrate archetypal sexual imagery in art and the paradoxes of contemporary western society's attitudes to such images.

For example, a non-western split circle stone, representing a cunt, is not taboo in the museum context, either is a nonwestern flute clearly made in the shape of a penis. But contemporary western images of the same kind are. Schneemann drew parallels between the archetypes and her own work. *Infinity Kisses*, a series of snapshots of herself tongue-kissing with her cat, bears a striking resemblance to an image of an Egyptian priestess exchanging the breath of life with a lion cub. Schneemann emphasized that she came across the ancient images after the conception of her own artwork.

Audience comments included concerns about misinterpretations of sexual imagery. Schneemann replied that it is sometimes necessary to "go out on a cliff," taking the risk that meaning will become integrated into the culture. Schor felt that most artists dealing with such imagery don't set out to be transgressive. Artists must be aware of their audience, she said, to assess whether or not they're being misinterpreted. Another audience member said "cunt art" not only made her feel uncomfortable because of the socially unacceptable imagery, but that, as a woman, such imagery made her feel exposed and vulnerable. Schneemann responded that she was trying to be aggressive about that vulnerability.

Ironically, one of the most transgressive events during the panel might have been the quiet gurgling of a baby in the audience. At one point, Schneemann asked the mother to leave with her baby. At the panel's conclusion, several women used the incident to propose a truly transgressive action (an intervention that would disrupt the existing social order): that the WCA make childcare an expected and integral part of its conference.

– Virginia Maksymowicz

Women Artists News, Spring/Summer 1990 [Vol. 15, No. 1-2]

'90 / #216

Rampant Phallocentrism

"Beyond the 'Essentially Feminine':
Race, Class and Female Identity"

Moderator: **Patricia Failing**; Panelists: **Cassandra Langer, Adrian Piper, Trinh T. Minh-Ha**

Women's Caucus for Art, College Art Conference, NYC; February, 1990

The panel was to discuss whether concepts of the "essentially female" are constructs of the patriarchy and whether accentuating diversity among women artists might be beneficial. In an honest and intelligent talk, Cassandra Langer addressed the "rampant phallocentrism" and "compulsive heterosexuality" in our art and culture. She believes lesbians are particular victims of such repression, since "most books are written as if lesbianism does not exist." Just as families may conspire to hide a member's sexual preference, historians often deny the facts of a lesbian artist's biography, she pointed out, although these facts may be crucial to an authentic understanding of her work.

Only recently, Langer said, have writers begun to deal with artists' lives more openly. Today's lesbian artists are "hungering for a heritage," but "women's passion for women" is still denied or branded "deviant." How, then, can the lesbian artist find truth of expression or have her work fully understood?

In a reasoned, yet poetic approach, Trinh Minh-Ha quietly called for multiple viewpoints, embracing not only the center, but the fringes of artistic endeavor, allowing for diversity and change. Quietly but forcefully she gave us the parable of a woman forced to move from place to place who found herself enriched by the experience of continual departure and arrival. The implication was that marginal status by reason of race, class, gender or sexual preference can enhance one's comprehension of experience and creative response.

Having been forced to choose between the keynote speech and this event, both of which dealt with incorporating marginal experience into the mainstream, I had missed the first two speakers. I found it ironic that the panel was forced into a position of marginality by programming.

– Sylvia Moore

Women Artists News, Spring/Summer 1990 [Vol. 15, No. 1-2]

'90 / #217

Dealers Talk Shop

Phyllis Kind says casually, "It's much better to have a show sold before it opens." Max Protetch also refers in passing to times when "the work is all sold before the show." Thus we learn, if we didn't already know, that in these precincts, it is – or was – not uncommon for a show to be sold out before the event.

Five dealers from the upper reaches of the New York art scene talk shop. The moderator, with an insider's knowledge of where in the gallery business the bodies are buried, asks pointed questions.

"Artists and Dealers: Myths and Realities"

Moderator: **Gil Edelson,** lawyer and vice-president of Art Dealers Association of America; Panelists: **Robert Conway** (Associated American Artists), **Phyllis Kind, Max Protetch, Holly Solomon, Dorsey Waxter** (Andre Emmerich), dealers

College Art Association, NYC; February, 1990

If you could suspend your cynicism and forget real life and what your dealer, or your friend's dealer, actually did and said or didn't do and say, and forget the newspaper stories and the courtroom scandals and, finally, stifle your yearnings to crawl into the lap of one of these unreal people and live happily ever after in a bliss of creativity, this panel was swell. It went on until the stroke of noon, with no time for questions. However, just as the principals were maneuvering their brisk departure, a distraught woman appeared at the dais and, in tones of anguish, explained that she'd just that moment heard about the panel and begged to be told "what happened." Of course this was not possible, not least because nothing "happened," except another rivulet in the ocean of words about selling art had flowed its two hours away. In fact, I missed the first hour myself, but here's what I heard in the second:

Moderator: How do you set prices?
Max Protetch: I like the idea that the market sets the prices, which it does to some extent. I like the idea that you can manipulate prices – the only place it's legal. If the work is all sold before the show, you could raise prices, but it's good to have a waiting list. If someone's doing very well, it's good to raise prices 20% a year. Artists looking for long careers want a stable income. I give an advance on sales based on last year's sales.
Phyllis Kind: For a first show in 1970, a price might have been $300 to $500. If it sold out, I'd raise prices. For a first show in 1990, maybe $3000 sounds really inexpensive. It also depends on how prolific the artist is. It's better to have Mr X hanging somewhere between Miro and Picasso than accumulating in someone's garage. Someone else sees it and asks what is this, stops and looks. . . . Collections can be more important than museums. In Chicago, visiting museum curators [go to see private collections]. It's a matter of course for dealers to be invited to visit prime collectors. That's why

prices should be low at the beginning to encourage collectors to take a chance. . . . Our job is to see when someone comes in that they don't just *do* the gallery on rollerskates. Our job is to try to engage the person with the thing.

Conway: Artists have said to me they want to double or triple their prices because people aren't taking them seriously. Unfortunately, that may be true in today's inflated market. I advise artists to resist connection of sales with quality. Prices at auction have nothing to do with the quality of the object.

Kind: Raising the price in the beginning does *not* encourage people to buy.

Protetch: It's the law in New York that you have to post your prices. So then other artists come in and see what prices an artist is getting. The pressure to equalize becomes very awkward. Artists do tend to value their careers in terms of prices. That's very unfortunate. . . . Dealers are supposed to balance the interest of the artists and the client. It's hard, but you can do it. A good dealer will.

Solomon: Some artists have become historically eminent because of exhorbitant prices. This creates a problem. There is the idea that getting hundreds of thousands of dollars makes the artist historically important. . . I'd like all galleries to post all prices on the wall at two million dollars. Then we could all make special deals.

Moderator: Do you make special prices?

Conway: Special prices are made all the time. I prefer to suggest it. The obnoxious client asks what's the price, then, "what's your best price?" I've never met the person before and they want to take money out of my pocket. We give discounts to institutions, relatives of the artists and those who have supported us over the years.

Protetch: Another difficulty – take Saatchi – artists got very uncomfortable when Saatchi got too much of their work. They can control the future of one of your artists by dumping them. Thomas Mann [another dealer] buys a lot of a person he likes. But some day he could have control over an artist's career.

Holly Solomon [on artists' need to be in NYC]: You have to ask yourself, "Is my work different than, but just as good as so and so's?" What's so essential about New York City is that it gives you that reality.

Max Protetch [speaking of contracts with artists]: We have letters of agreement, not really binding, but just so you remember what you said, not what you meant.

Robert Conway: Everything is verbal, nothing written.

Dorsey Waxter: With some it's just a handshake, others have written contracts. It depends on the artist. [As for how often the artists show] there's a real danger in making paintings just for an exhibition. Some artists show every 18 months to two years, some every three years, depending on output.

Moderator: When an artist is in your stable, you pay all the costs of their show including photography, announcements, opening, and so forth, and get commissions. I understand it's usually 50%, except 40% for very important artists.

Kind: The total costs of running a gallery, especially insurance, have risen dramatically. It's not really possible on 40%. Now 50% is usual, except if you've had an artist at 60/40 for a long time, that stays.

Protetch: Paul Maenz is a good [German] dealer and doing very well. He asks 70%.

Solomon: He just closed the gallery.

Protetch: He's probably making more money dealing privately . . . Costs of running a gallery are astronomical. But if you're very fair to an artist and he [sic] is very successful, he'll be fair to you later on.

Kind: There is no school of art dealing, and I unfortunately didn't do it right. I feel one of the major functions of a gallery is archival. If you come into my gallery and ask about Jim Nutt, I can show you everything he ever did, with good color reproductions. I have a room for study by high school students. Sometimes this *work* is interrupted by the possibility of a client. We're busy keeping everything up to date, shipping out shows, taking clients to lunch. Then someone comes in and wants to *buy!* . . . European dealers used to start out buying a lot of an artist's work, then making a profit as prices rose.

Moderator: Traditionally, European dealers bought the work. In the U.S. now, artists consign the work and the dealer gets a commission. In the late '50s, Sam Kootz always said how hard it was to sell young artists. Even older artists like Hans Hofmann [weren't big sellers]. So Kootz met Picasso in Europe and Picasso said, "Sam, I'll send you some paintings to sell." That's what Kootz lived on. . . .

How important is the review, and who would you want to review your artists?

Waxter: A good review is good, it will be discussed. But I've only seen a bad review affect sales a few times. It still brings people into the gallery to see the show. It's the review *during* the show that brings in people. It's very important to have a current review in the area to bring people in. Other publicity is *very* useful in selling the artist – a body of material to use as a selling tool for the artist. It's *very* integral to the gallery business.

Kind: Yes, we all want to be in the *Times*, but the general press – *Newsday, Vanity Fair*, and so forth – have an impact, also on those very reviewers!

Moderator: People say critics don't know anything anyway. How good are the critics and how important is being bought by certain collectors?

Kind: Richard Flood was my ideal writer. Then he discovered that being paid $50 to write a full-page article and teach at RISD was impossible.

Solomon: Writers get paid disgustingly little and so must be very, very devoted. . . . Sometimes critics' judgements are valid and sometimes not. It's very hard to write reviews every week.

Moderator: How important are the critics versus certain collectors?

Protetch: You have to distinguish between reviewers and critics. There are very few critics now because they don't have a place to write. The *New York Times*, for example, just wants positive reviews. A good review in the *New York Times* is great, really great for the artist. It changes their career. Michael Brenson sometimes gets really excited about an artist. That's wonderful.

Moderator: So you agree that the *New York Times* is the most important. What about collectors?

Solomon: They read.

Kind: I used to say red dots are like measles – contagious. Like at a flea market, you run to get something before your friend gets it. But it's much better to have a show sold before it opens.

Moderator: Do you influence curators and museums? How?

Solomon: We all work hard at what we do. We don't have another life. We get eaten up by our work. All we know are curators and critics and artists. Who else do we know? But I do think the real power is the artists. I've always believed that and always will.

Conway: If I were influencing a curator I'd think the curator wasn't doing his or her job. I look to them to be more scholarly, more reflective than I, to have a wiser, more balanced view than mine.

Kind: I always try to get a curator to look at other work when they come in to see a particular artist. Curators from Kalamazoo or wherever do eventually move up. They may one day be at a bigger museum, even MoMA. There isn't a curator who doesn't come to New York at least two or three times a year. We do a big service for them. They use us as resources.

Solomon: Sidney Janis's advice when I opened was, "your big job is to teach curators." Because we go to studios we're a big source of information. A dialog starts to happen with people who care about what they do.

Moderator: There has been a very dramatic rise in prices. Is this also true in the primary market, for the artists in your gallery?

Protetch: Artists who are hot and established are doing very well and so are their galleries. Those in other categories aren't and their galleries aren't. People are buying for different reasons than they used to. Art is now thought of in terms of investment.

Moderator: Do they buy because they love the art?

Waxter: Not many people say they're buying for investment. I would discourage that. The reason to buy the art is because you love it. Price is related to one's comfort level. I try to discourage investment, but people spending large sums may want to know the *risk*. I try to be informative as to whether it's a good value for the money or not, to show the artist's track record.

Moderator: But how much speculation is there?

Solomon There's art in art history, then there's art that becomes a commodity. We all know a lot of people are using art as a commodity. But there's still a thing called art history. It's always right. I believe in art history.

It was noon, end of panel and no time for questions. But one woman rose bravely from the audience with a statement in defense of teaching – a response to the dealers' disparagement of having to teach instead of making a living from sales. Applause.

– Judy Seigel

Women Artists News, Spring/Summer, 1990 [Vol. 15, No. 1-2]

'90 / #218

Don't Smoke!

"Obscenity Reconsidered"

CAA Convocation Address by **June Wayne**

78th Conference of the College Art Association, NYC; February, 1990

The 1990 College Art convocation address was delivered by June Wayne, artist, lithographer, writer, and founder of the Tamarind Lithography Workshop. The following is excerpted.

In the last forty years I have witnessed many epidemics of artist-baiting. They peak around election time like flu viruses. The cities change, as do the artist-victims, but the identical epithets – pornographic, subversive, sacrilegious, immoral – are hurled at abstraction, Expressionism, Surrealism, Minimalism, every style of art and every kind of artist. No one is immune when a demagogue is on the rampage. . . .

In the last two years the arts have been battered in Washington. Even though the Arts Caucus fights for us, political tactics are predictable – one deflects an attack with a compromise less painful than the blow itself. Sometimes even well-intentioned compromises become dangerous over the long term. I will mention two.

A compromise made in 1969 has come home to roost in the museums. The three most powerful visual arts organizations representing museums and academia, in unified testimony before the Senate Finance Committee, traded away the right of artists to tax-deduct their gifts to museums in return for continuing deductibility for art collectors. That precedent enlarged itself into the eventual loss of *all* market-value deductibility of art gifts in the Tax Reform Act of 1986. Now that collectors compare their profit at auction to the cost of philanthropy, the national patrimony comes up short.

Another compromise took place when the National Endowments for the Arts and Humanities were created in 1965. In framing that legislation some people argued for a National Arts and Humanities Foundation modeled on the National Science Foundation, with the autonomy and permanence that the sciences enjoy. The Johnson White House, alas, preferred to keep the arts and humanities on its own short leash. Certainly temporary Endowments were better than none at all: later legislation could make them permanent. But follow-up legislation has not appeared and the Endowments have been so well run for 25 years that they have seemed like fixtures in the national landscape. We took them for granted. Now their "temporariness" is the jugular vein that the radical right is going for.

To keep the Endowments equal to the past is to equal the runt of the litter, both in funding and in the hazards of annual budgets and reauthorizations every five years. The slightest shift in the political wind can blow them away at any time. . . .

In my opinion, the radical right does not intend to abolish the Endowments: It prefers to mutate them into anti-intellectual agencies. Already the Endowment for the Humanities is whisper-close to the Military/Industrial complex. Surely the wife of Secretary of Defense Dick Cheney was not the only historian in the United States qualified to chair the Humanities, although, according to a quip making the rounds, she is the first to enjoy a nuclear capability. The appearance of nepotism alone should have produced a more sensitive appointment, but putting that aside, Lynne Cheney's mindset comes clear in the new regulations she issued for content control in academic research. . . .

Let's consider [Senator Helms's] outcry that "taxpayers should not be forced to pay for art that is obscene, sacrilegious, or offensive to anybody in any way." He says that isn't censorship: Artists are free to make any art they want to make, just not with the taxpayer's money.

[H]as he forgotten that the majority of taxpayers oppose tobacco subsidies? Not at all. He has no need to be consistent. His sheer ubiquity scares the hell out of people, and camouflages his central interest – the pushing of an addictive substance, tobacco.

The majority of taxpayers, who, I repeat, oppose tobacco subsidies, have been forced to support tobacco to the tune of one billion, nine hundred million dollars in 1988 alone. Of the 21 states that still grow tobacco, the six biggest producers received 91% of that enormous sum and Senator Helms assures a lion's mouthful for his state. Compare California's 35 cent tax on each pack of cigarettes with North Carolina's 2 cent tax. Now that's obscene!

Every year millions of taxpayer dollars are spent to increase the use of cigarettes in third-world countries. That's obscene!

Compare the combined budgets of the Endowments – about $340 million dollars (including the raise proposed by President Bush) – to the 65 *billion* dollars we spend for medical care and loss of productivity of Americans with cigarette-related diseases in 1988 alone. That's obscene!

What art image can boast of killing even one human being, let alone 390,000 Americans dead of cigarette-related diseases in 1988, a massacre possibly to be equaled or surpassed for '89 and '90 when the data are in. . . . How do we wean Colombia of raising coca leaves if we can't wean North Carolina of raising tobacco? That's obscene! . . .

Doesn't Washington recognize that the American people have seen Watergate, Iranscam, Jimmy Swaggart and the Bakers, the HUD Hearings, the Savings and Loan scandals, the homeless, the crack babies, the crime on the streets? What photograph, sculpture or painting can shock anyone who has been *conscious* during these last 20 years? . . .

As I was preparing these remarks, The CAA *Art Journal* [Winter, 1989] arrived with John Wetenhall's excellent article, "Camelot's Legacy to Public Art: Aesthetic Ideology in the New Frontier." I lived through the era when the

Kennedys changed the climate of the nation to favor the arts, but I didn't know that John Kennedy wrote some of the language that caused that change. Thanks to John Wetenhall, I will paraphrase a couple of President Kennedy's sentences . . . replacing the masculine singular with the gender-neutral plural. He would do the same were he writing today:

> Artists, however faithful to their personal vision of reality, become the last champions of the individual mind and sensibility against an intrusive and an officious state.

We, assembled for this Convocation, are a great reservoir of talent and intellect. We have the habit of long-term thinking. We have the habit of honest problem-solving, without which one cannot be a scholar or an artist. We must insure that the arts, the humanities and our people *in fact* enjoy the freedom of thought and expression that is the aspiration of this sorely troubled world.

Women Artists News, Spring/Summer 1990 [Vol. 15, No. 1-2]

'90 / #219

Language of Power

Imagine the Mothers Superior of the two strictest convent schools in the world comparing notes: The girls may not drink soda, wear silk, play music, polish their nails. Just prayer and contrition. Mary Kelly and Griselda Pollock appeared together recently to agree that art may have no "gesture," no "paint," no "pleasure," no "Baudrillardian tendencies." Just "cultural warfare."[1] In the "Subjects of History" symposium outlined here, the girls are not even allowed to *desire*. Clearly, we've come a long way from Walter Sparrow's "tenderness and grace" of a woman artist's "nursery nature."[2] The vocabulary alone is a serious engagement. Cassandra Langer "deconstructs" this new language of power.

1 "Mary Kelly and Griselda Pollock in Conversation," *Parachute* 62
2. Quoted at "How the Art World Views Women Artists" [See "Before 1975."]

"Subjects of History: Mary Kelly"

Speakers: **Laura Mulvey** and **Isaac Julian**, filmmakers; **Parveen Adams**, critic; **Hal Foster** and **Griselda Pollock**, historians; others.
New Museum of Contemporary Art, NYC; March 1990

"Subjects of History" was a day-long symposium focusing on the work of Mary Kelly and the issues it raises about the history, art and politics of the past 20 years. The exhibit, Kelly's *Interim*, a work five years in the making, was organized under the intimidating titles of *Corpus, Pecunia, Historia* and *Potestas* [Body, Money, History and Power]. This use of Latin is telling: although Kelly challenges the structure of the patriarchy, she adopts its language.

Latin seems very popular of late among artists stamped by Minimalism (eg., Robert Morris in his recent show at Leo Castelli). Kelly's Latin titles and her use of Roman numerals to identify the separate parts of *Interim* suggest that, in matters of art and feminist theory, she wants the audience to believe, *Roma locuta est; causa finita est.* [Rome has spoken, the case is concluded.] Since feminist theory is deeply committed to questioning, this attitude is disturbing.

The air of authority was further reinforced by the symposium, "Subjects of History." In Hans Christian Anderson's "The Emperor's New Clothes," the child cries, "But the Emperor has nothing on at all!" This was my first impression on walking into the Kelly exhibition and my last after listening to the symposium speakers. The whole enterprise wears Lacanian theory like the Emperor's new clothes.

The work is Kelly's attempt to come to grips with what feminist theoretician Naomi Schor calls the "Linguistic Critique" – a symbolic order centered on the Phallus. According to Lacan and the Lacanians, there can be no such thing as "the woman," because "woman" hasn't really been discovered in language, language being still "male."

Substituting screened photographs of clothing, i.e., shoes, leather jacket, a handbag, a nightgown, a dress, for the image of woman's body, Kelly seems to have reached an impasse with the linguistic representation of woman, leaving her still, in Laura Mulvey's words, "tied to her place as a bearer of meaning, not a maker of meaning." In *Corpus*, for example, Kelly attempts to "invoke" woman's body without literally representing it, supposedly dodging the traps of voyeurism and exhibitionism. But the intended feminist critique is undermined by the unmistakable authority of western male language (including visual images), which makes its experience the measure of all things.

Viewing it, I wondered if the texts would be strong enough to disrupt the visual discourse set by the objects themselves. For me, the answer was No. The representations of clothes are supposed to stand in for the body, but the actual images (grainy, glossy, slick, manufactured and difficult to read) refute Kelly's claim that the textures suggest skin and the folds gestures.

Kelly wishes to deconstruct cultural stereotypes psychoanalytically, and casts her metaphor according to the Lacanian notion that "absence figures desire," that what *isn't* there is desired. But this Lacanian "woman" is highly theoretical, more a matter of faith than reality. Certainly the symposium's attempts to explain *Interim* show they did not consider the viewer intelligent enough to figure it out for herself, or they felt the idea was so tenuous it required explanation.

Both symposium and catalog led me to think Kelly presumes to speak for "women." But what women? Who speaks in this text and for whom? When it comes to class, the stories are white middle-class narratives manufactured by the artist. So I ended up reading Kelly's art as conservative and bourgeois, at best invoking no real change, at worst somehow affirming the collective authority of patriarchal modernism.

Kelly uses a narrative, made up of statements and anecdotes, to reveal women's observations on their representation by society, by themselves and in relation to motherhood and aging. Taken from the point of view of upper-middle class white women, they are, I suppose, truthful for her collective version of these women. Her focus, however, seems to be on the most trivial aspects of aging – bathing suits, hair appearance. So another big question is, to whom is this piece directed? Certainly not the variety of feminists and lesbian feminists I worked with during the decades of the '60s, '70s and '80s. For a work supposedly dealing with class, race and gender, there is very little access unless one is an upper-middle class, educated person with an interest in psychoanalysis. No one else could decipher the web of connections between text and images and their associations. This is hardly the voice of Everywoman.

Pecunia claims to be a series of "seductively finished steel units containing narrative adapted from classified ads, personals and fictional genres" in a format inspired by the "racks of cards found in greeting card shops." It is divided into *Mater* [mother], *Filia* [daughter], *Soror* [sister] and *Conju* [wife] – the socio-familial roles for women in patriarchal society. I am particularly bothered by the look of *Pecunia*, which embodies the best of minimal sculptors Donald Judd and Carl Andre. My question becomes, does the intervention – covering these hard, unrelenting masculine forms with romantic phrases that reek of desire, really disrupt the canon of style, or is Kelly in collusion with these man-made styles?

As Anna Chave put it, "manufacturing objects with common industrial and commercial materials in a restricted vocabulary of geometric shapes," artists gain "the cultural authority of the makers of industry and technology." I would suggest that any patriarchally educated artist, art educator, art student, art historian, critic or just ordinary person will have problems reading Kelly's images any other way. For anyone not up on poststructural, deconstructionist, psychoanalytic and feminist theoretical critiques, the text simply doesn't intervene enough to disrupt the modernist visual discourse of control and force.

Moreover, the collaboration between museum and artist, the socially sanctioned, organized, institutional activity, symbolizes the status quo – not gaps, breaks and cracks in the whole. Both the space and the installation pay unwitting tribute to the "as is" value system of both museum and tradition. This is not an "elsewhere" (to use Teresa de Laurentis's concept of moving from theory into feminist practice).

The symposium also was manipulative, as if Kelly were coming from some position of privilege or moral superiority that her audience did not share. The viewer is constantly referred to some authority in order to be taught what the sections of *Interim* mean. The audience is not invited to participate in a

discourse, only to be instructed. In other words, Kelly and the New Museum in fact repeat many of the characteristics of patriarchial power they ostensibly challenge.

– Cassandra Langer

Women Artists News, Fall, 1990 [Vol. 15, No. 3] Expanded slightly from original.

Sources of quotes: Laura Mulvey, "Visual Pleasure and Narrative Cinema," *After Modernism: Rethinking Representation*, Ed. Brian Wallis, New Museum of Contemporary Art with David Godine, 1984; Anna C. Chave, "Minimalism and the Rhetoric of Power," *Arts* Magazine, January 1990; Teresa de Laurentis, "Technologies of Gender," *Technologies of Gender*, Indiana University Press, 1987.

'90 / #220

The Fireworks Panel

To fully appreciate the new order at the Society for Photographic Education, it might help to compare the tone of this discussion with the women's frustration just four years earlier, as they struggled for some purchase in a group that had always been sublimely (and sublimely unconsciously) male ['86/#185]. As Catherine Lord reminds the 1990 audience, in the "good old days" there was only one woman in the organization; she was not invited to speak in public and no record remains of anything she said.

"The Practice of Photography: Education, Gender and Ideology"

Moderator: **David Jacobs**; Panelists: **Catherine Lord, Patty Carroll, Bill Jay, Diane Neumaier, Allan Sekula, Ken White**; Discussion leader: **Esther Parada**

Society for Photographic Education Conference, Santa Fe, N.M.; March, 1990

Held in response to tensions that have been building within the Society for Photographic Education (SPE) because of increased influence of the Women's Caucus, this was probably the most talked-about event of the 1990 SPE conference – dubbed ahead of time "the fireworks panel," despite its academic-sounding title.

David Jacobs introduced the panel by outlining its format: both he and Catherine Lord would present 20-minute papers. The other panelists, in alphabetical order, would have 10 minutes each to respond. The remaining time would be open to audience discussion.

"There's no more loaded set of issues than those surrounding gender in our culture," Jacobs began, "Feminists are questioning with increasing vigor the canons of literature, history, art and music, and philosophy as well." He went on to describe the events surrounding recent misunderstandings developing in the SPE:

Few issues within the history of SPE's Women's Caucus have created more hard feelings than the closed meetings of the caucus in recent years. . . [The Philadelphia] sessions were open to anyone who wanted to come, so there were lots of women and a handful or more of men. There

was no agenda. . . . Those discussions were undertaken, frankly, in good faith and there was a high level of candor about sexual discrimination at various people's home universities, sexual harassment, pay inequities. . . . Someone asked for all the tenured professors in the room to raise their hands. There were about a half-dozen men . . . and about 30 or 40 women . . . and every man in the audience was tenured . . . only one or two of the approximately thirty women were tenured. . . . Well-meaning men[1] held forth at some length about how the women might best organize and constitute themselves. More than once they veered into monologs which were at times . . . condescending. And it seemed to me that what was being played out there was very deep cultural patterns of discourse that extend considerably beyond a particular moment in Philadelphia. . . . My presence as a man demarcated a fundamental difference of role and power, and whether the difference was perceived or actual was largely immaterial. My intentions, to a large degree, were subsumed by my presence.

Later in the discussion, a well-known female photographer was speaking about her travels and travails – a series of non-tenure-track teaching positions. She spoke of the economic and personal difficulties of this lifestyle, the insecurities, the impact upon household and child-rearing relationships, the financial and emotional strain, the meager rewards of the life of the scholar gypsy. . . . She mentioned ways in which male senior professors had kept women separated from significant policy shaping at various universities and how women could be competitive for teaching positions but much less competitive for tenure-track positions. At this point, one of the men in the room interrupted and insisted that she name names. She refused. He persisted. And she promptly lost her voice as well as her composure. Few of us in the room knew at that time that the woman was a Visiting Professor in a department in which the man held tenure, and that she was a candidate for a tenure-track position in the same department – a job which ended up being awarded to a man. It was little wonder in these circumstances that she wilted under his insistence that names be named.

The discussion moved on, but I believe this incident made a lasting impression on many in the room. It became clear to me that the things that needed to be said by women and minorities simply could not be said in a mixed group. . . . The cultural baggage we carried into that room could not be transcended with any measure of good intentions. . . . Following the Philadelphia conference, the door of the Women's Caucus closed and has remained closed ever since. . . . The simple truth is that, for a multitude of reasons, some recent and some reaching far back into history, discourse changes when the sexes are mixed.

Catherine Lord's presentation began with an attempt to recall what some have termed "the good old days" of the SPE. "I'm too young," she mused,

to remember the really good old days of 1962 and 1963 when, so far as I can tell, only one woman was involved in the organization. In the classic relation of woman and photography, she was photographed at our first conference but evidently no one asked her to speak in public or bothered to record anything she said in private. But then those were also the days when one had to be invited to join this organization. Nor was I heavily involved in photography early in the '70s when those few women who

wanted to contribute to the cause were allowed to help with functions like collecting tickets at national conferences. I'm too young, I guess, to remember the days when photographs were photographs, when history was history, students were students, teachers were teachers, men were men, and women weren't there!

The first national SPE conference that Lord attended was in 1980 – the conference at which the Women's Caucus was born, sparked, among other things, by an impromptu protest during a presentation by Les Krims a few years earlier.[2] "None of us," Lord remembered, "had the faintest idea of how hard the next ten years would be . . . not just hard, but slow, interminably slow, frustrating, unfair, hostile, humiliating, expensive, time-consuming and exhausting. [N]either did we know how extraordinarily generous women and men inside and outside this organization would prove to be."

During the past decade, the Caucus has helped to change the organizational structure of both the SPE and the conference planning, which until then had mostly been selected by one person with informal advice from the board. "Conference proposals are now openly solicited," Lord said, "and reviewed by panels balanced in terms of gender, race, geographical programs and practice. In effect this means that one person or one small group can no longer succeed in capricious exclusion by posing as the arbiter of photography's standards of excellence." Moreover, the SPE publication, *exposure*, now has an editorial board and has opened its pages to a variety of differing scholarly approaches to the medium, a move that has some long-term members worried.

Lord tried to address that discomfort:

> Some women and many more men are confused and distressed by the Caucus, believing that it is changing photography in ways that will deprive them. Many feel excluded. Some feel afraid. . . . Feminism is about representation and about relations of power. Its analysis overturns precisely the positions of privilege to which even the most sympathetic of men have always been able to return. . . . While a good number of men in the SPE have welcomed the changes brought about by the Caucus's increased visibility, some have not been the least bit sympathetic.

Then Lord quoted a paper written by Bill Jay and distributed at last year's conference in Rochester. Jay wrote:

> The SPE, the only organization in the U.S. for photography education has been captured by a minority group of radical feminists, pseudo-Marxists. . . . These fascists of the Left have through intimidation diverted the SPE from topics of critical and historical importance to the medium. They use scurrilous feminist propaganda, vulgar remarks, personal attacks and savagery to tear down reputations, scar and deface history. . . . Further, these teeth-clenching revolutionaries, this nasty little pimple on the face of photographic education, aren't even real artists or real photographers.

Lord countered this attack by pointing out that, first of all, there are "precious few Marxists around these days" and that "most women in the Caucus aren't particularly sympathetic to a Marxist approach." However, she said, SPE conservatives "multiply and blur all Marxisms and all feminisms in

order to produce a single, invisible enemy." The resulting confusion not only makes it hard for men in the SPE, but for the women not in the Caucus to understand the issues at hand. Lord admitted that she was "worried about the residue their conservative rhetoric will leave in our future on the possibility of transforming what has been a hierarchy into a plurality. . . . Put boldly, the stakes are how we will survive. Either we create a network that addresses differing investments in photography that can be reflected in many different ways, or we reconstruct the privilege of a 19th-century guild in preparation for the 21st century."

Former SPE board member, Patty Carroll, corroborated that everyone in SPE seemed to feel "excluded, put upon and misunderstood," but reminded the membership that such social contention is reflective of the society-at-large, not restricted to a small group of professional photo-educators. "We are probably not the enemy," she cautioned.

Bill Jay, whose aforementioned paper led to this panel, was given time to defend his position, although it did seem that the opposition was stacked against him. "In spite of what Catherine Lord has said," he opened, "I'm not fearful of losing my power because I've never had any and I've never desired any, unlike perhaps many of the women in the Caucus." Jay continued:

> It's no contradiction for an individual to be passionately, vociferously adamant in debate but simultaneously aware that other viewpoints, indeed completely contradictory viewpoints, may have validity. In the same way, an artist can and should be 100% committed to personal expression and have the ability to step back and see the insignificance of it all in the cosmic scheme of things. . . . A decision to stand in one band of the spectrum means that we are blinded to other bands . . . The practical results of choice becoming cause are complexities turning into slogans. . . . We live in a society of single-issue politics in which the word tolerance is tainted and free speech can only be accorded to like-minded individuals. . . .
>
> Catherine Lord asked the right questions: Why the Women's Caucus posed such a threat. . . . Why is it a successful irritant? What motivates the actions of conservative men? What motivates the actions of women who disassociate themselves from the Caucus? . . . But her answers are way off the mark. The real answers, in my opinion and in the opinions of many colleagues both male and female, have very little to do with issues of feminism. Most, like myself, object to the Women's Caucus for reasons which are more akin to issues of commonality, relevancy . . . fair representation and collegiality. [D]iscrimination is not unique to women or even racial minorities. . . . I resent the implication that I cannot understand female discrimination because I'm a white male. You should have grown up in a poor country family in England as I did, and then attend a rich kids' grammar school, followed by a career in the arts and photography to discover the meaning of class discrimination. Overt, hostile, patronizing, and inhibiting every day of an early life. All of you, I'm sure, could tell similar tales of discrimination because you're fat, short, tall, smoke, or, worst of all, are an intellectual in a family, school or culture which despises education and intellect. . . .

I did not join the SPE to engage in left-wing politics. There are plenty of special groups which are more highly efficient and influential in that area of human activity. Many like me don't find much of relevancy to our interests in photography and/or education in the SPE anymore. . . . As I wrote last year, the crucial issue is not one of representation, but of balance. It's not one of ideology but of mature rational discourse, which tolerates opposing viewpoints, but opposing viewpoints are not tolerated. . . . Even the areas where the Women's Caucus should be most complimented – the role of women in the medium's history – have been informed less by accuracy and understanding, and more by the distortion of information in the service of a cause. . . . I am appalled by general assertions that are made through willful ignorance. . . .

Jay concluded by noting that,

Since the dominance of the Woman's Caucus, the conferences haven't been much fun. . . . It was an annual rite of spring to pack a university bus with students, drive across country, and spend days with missed colleagues around a swimming pool, sharing frustrations, minor triumphs, and, above all, recharging the creative battery, plugging into a real community of kindred spirits. . . . Now it's like a dull, depressing, irrelevant committee meeting where the central issue is political correctness . . . and my rejection of SPE has absolutely nothing to do with issues of feminism, which can be and are fascinating and relevant. . . . The SPE is a bore because the people who dominate it are boring!

Diane Neumaier countered Jay's accusation of faulty scholarship on the part of feminist critics and historians by citing, among others, Sally Stein, Catherine Lord, Deborah Bright, Jan Zita Grover and Abigail Solomon-Godeau. She went on to lament that, despite their rigorous research and prolific production, such women "are treated as marginal by the few who attack us." Allen Sekula tried to place the panel discussion in a historic and social perspective by outlining how "photography constituted itself as an art practice, in the United States in particular, through a rather persistent resistance to modernity." Finally, Ken White brought discussion down to specifics and reported on how women photographers are faring at his own institution (three women becoming tenured faculty at the Rochester Institute of Technology during the last twelve months).

During the discussion period, Brian Palmer, a young black photographer, who said he was the "only domestic student of color" in his MFA program, urged both the Caucus and the SPE to address issues of race and cultural relevancy. (Concern with ethnic and racial minorities was touched upon earlier, as well, by Catherine Lord.) He complimented *exposure*, for featuring writers like Deborah Bright who addressed "the multiplicities of the histories of photography," and elaborated on how important this kind of research is: "I wasn't in the graduate program to contribute to how photography had been constructed, which is basically on the exclusion . . . of perspectives that don't neatly fit into this MoMA kind of discourse. . . ."

Barbara Jo Revelle admitted she was the photographer referred to by David Jacobs who had backed down under the

interrogation by her departmental colleague (and supervisor), Robert Heinecken. Now tenured at another institution, she felt that the last ten years had made some difference, but noted that problems that still exist in academia and can be exacerbated by Bill Jay's kind of rhetoric. In fact, the paper Jay wrote and circulated last year had been used by one of Revelle's colleagues to try to persuade the Dean that she, "with her Marxist, radical feminism," was ruining the school's photography program.

Many differing positions, some opposing the actions and philosophy of the Caucus, were presented by both men and women, but no confrontation erupting into anything near "fireworks" occurred. Montreal photographer Judith Crawley, however, recalled that anger over such issues can explode into physical violence, as happened recently when an "angry man" went into an engineering school at the University of Montreal, and shot and killed 14 young women, who, in Crawley's words, "were breaking a traditional barrier by studying engineering." She reminded all present, "He stated clearly that he was killing them because they were feminists."

– Virginia Maksymowicz

Women Artists News, Fall 1990 [Vol. 15, No. 3]

1. Having been at that meeting, I would say, "*ostensibly* well-meaning men." (See my comments, '86/#185.)

2. The presentation may have featured Krims's *Incredible Stack O' Wheat Murder* series, photographs of nude young women streaked with blood and arranged fetchingly on the floor near a stack of pancakes, presumably stabbed or shot to death, which at the time were considered significant art photography.

'90 / #221

A Taste for the Big Picture

In which bigger is declared still better and talk about Abstract Expressionism still draws a full house.

"Abstract Expressionism: Other Dimensions"

Moderator: **Josephine Gear**, Whitney branch director; Panelists: **Dore Ashton** and **Irving Sandler**, art historians; **Charles Seliger**, artist; **Jeffrey Wechsler**, "Other Dimensions" curator and assistant director, Jane Voorhees Zimmerli Art Museum.

Whitney Museum at Philip Morris, NYC; November 13, 1990

The panel, like the exhibition of the same name at the Whitney extension where it took place, was held to "investigate the role of small-scale painterly abstraction in American art from 1940 to 1965" and to determine whether "lesser-known artists have been overlooked because they worked exclusively in small formats."

Jeffrey Wechsler opened by explaining to the large audience, which included many critics and historians, that the current exhibition was a reduced version of the original show that had traveled to several venues. As for the title concept, he

said, "Ordinarily one thinks of vast canvases as representative of Ab Ex; this exhibition is the other side. Many of the Ab-Ex artists, including Pollock, made paintings of less than 36 inches – the major painters worked at times in small scale, and some lesser-known worked only in small-scale."

Irving Sandler called it a revisionist show that has revised accepted notions of Abstract Expressionism. "The achievements of Pollock and Rothko may have been because of large scale. Artists who worked small may have wanted to induce intimacy, [but] size was important. Rothko, Still and Newman evoked sublime and exalted images, creating a sense of vastness. [T]hey achieved vision with color alone – color is at its best when used in large areas. Pollock's bodily inventions forced him to work in large scale. Big pictures offered challenges; large canvases replaced French painting. The great image of Ab Ex is the size of the brush – house-painter's size. There was also then an appetite for large paintings."

Dore Ashton said that scale differed from size – 5' x 5' was really not so large – and that she saw many small-scale paintings at the Tanager Gallery in the early '50s. Wechsler suggested that the perception, "Ab Ex is large paintings," has become the reality. Museums, perceiving the paintings of the period as large, show only their large ones, although they may own smaller ones, too. Sandler said the label Ab Ex is confusing.

Charles Seliger, the only artist on the panel, appeared to be present only to talk about himself, and, given the opportunity, to complain of the scant attention he has received. (His works are small). Sandler comforted him by saying "there was a taste for the large picture."

Opening the floor to the audience, Sandler fielded the first question from someone who expressed the desire "to understand quality." Sandler said he bases judgements on his "own perception." He "looks as hard as he can, sees a lot and responds." As to why there were only 15 artists in his book (*Triumph of American Painting*), "There were other artists, but I chose those 15 for their attitudes towards their own group." Wechsler threw in, "small-scale painters were quiet, non-aggressive types."

At this point there began a series of scatter-shot questions and statements, mostly from women in the audience, such as: "How viable is Abstract Expressionism at this moment?"; "Susan Rothenberg, Elizabeth Murray, Freya Hansel all have the same impulse"; "What happened to the women of Ab Ex?"; and "Ann Gibson is working on a book on women of Ab Ex." In an attempt to mollify this outburst, Ashton cited the Pollock/Krasner show, saying "she wasn't neglected; Krasner was the inferior painter. And another woman, Sonia Sekula, had a breakdown." Throwing a crumb, Ashton finished with, "I was married to an artist who was ignored."

In sum, Wechsler argues that small is important and neglected, but his is not an entirely disinterested view. On the other hand, who else has come up with anything new about Abstract Expressionism lately?

Irving Sandler dismisses the concept, but then *his* investment is in the large works, subject of his several books. His "arguments" – brush size, color and "Ab Ex is large paintings" are not necessarily persuasive – perhaps just a restatement of belief. In this context, a quote from Rothko comes to mind: "To paint a small picture is to place yourself outside your experience. . . . However you paint the larger picture you are in it." Still, this doesn't explain anything beyond the obvious: Yes, bigger really is – *bigger.*

– Cynthia Navaretta

Women Artists News, Winter 1991 [Vol. 15, No. 4]

'90 / #222

The Buzz Spector-Marcia Tucker Report

Marcia Tucker has been a presence throughout this book, sharing her own adventures and transformations since the first women's panels at College Art in 1973 – being a feminist curator at the Whitney Museum, getting fired for making waves, founding her own museum (doesn't everybody?). Here she reflects on her personal involvement with art and artists and describes operations at the now-flourishing New Museum.

Buzz Spector, artist, educator and writer, contributes a fond reminiscence of Harold Rosenberg and remarks on recent transformations in the role of the artist. We have come so far, he points out, that artists now control much of their own discourse. Indeed, "fully a third of published writing in the art magazines is done by working artists." But then Tucker takes some of that back. She is, she says, "interested in challenging the idea that the artist's own intentions are essential to understanding the work. [They are] not something I necessarily equate with the meaning of a work of art."

Since she has just finished saying that "as a woman" she has been spoken for "far too often to do it to anyone else, much less to artists," a tougher audience might have given Tucker some explaining to do. A tougher audience might also have challenged her statement about the purpose of art: "Art is supposed to make us think, and that often may not be pleasurable," she says.

Since thinking may be one of the most pleasurable human activities, we must take that statement as shorthand for something else. Tucker's example is a Richard Tuttle exhibit where "people were incensed, enraged," because the work consisted of "little pieces of rope or wire or pencil."

But that, in modern-art time, was long, long ago. Today, what's more likely to be "not pleasurable" is art addressing certain issues, that is, social, political, or moral issues, and with a certain slant, that is, our failings as people, citizens, society, culture, nation and epoch. As I see it, however, what's *really* not pleasurable is the assumption such art makes that *we* are less wisely moral than the artist..

Nevertheless, many ideas about the purpose of art have been implicit – and explicit – throughout this book. Speakers at a sculpture panel ['81/#165] saw art as helping to "fill the void" of loss at the center of the culture and to bridge the distance "from cultural meaning" (which sounds quite pleasurable). Hilton Kramer said the "role of the artist is to bring an account of the world and to reduce it to a more philosophical function" ['88/#198]. This is similar to Buzz Spector's view (and also sounds quite pleasurable).

Of course in the bad old days of formalism, thoughts about art were not permitted to range outside the inside of a painting. The idea that the artist provides "an account of the world" is refreshingly different from that restricted view, and Tucker's stance, with its overtones of chastisement, is different again. There have also been many artists throughout these pages for whom the function of art is their extreme joy in making it (although they certainly hope others will feel joy in seeing it). So, at least on this issue, the answer to "Who Speaks for the Artist?" would probably be, "Which Artist?"

"Who Speaks for the Artist?"

Buzz Spector and **Marcia Tucker**

"Art in Context," a panel series at Atlanta College of Art; Fall 1990

Buzz Spector: When I was a student in the MFA program at the University of Chicago, I was very fortunate to study with Harold Rosenberg, [taking] his "Ideas and Issues in 20th Century Art" course along with doctoral candidates in art history or philosophy. I did in fact feel quite out of my depth, and asked Mr. Rosenberg after the first class if there was a sort of special curriculum for working artists. He said, "Well, Mr. Spector, we don't give idiot's discounts."

The working artists were expected to think just like the other seminar participants. The challenge itself made me think a lot about a question I asked myself in 1977 that I find still valid today – what it means to be a working artist. It means speaking up, perhaps to a greater degree than practitioners of the past ever had to do. A number of global circumstances encourage this transformation of the role of the artist, [in particular] the relationship between the practice of visual art and the practice of philosophy.

The relationship has been transformed . . . from the production of objects of delectation and contemplation of codified instruction in accordance with the texts of our culture . . . to one which is entirely dialectical. In other words, a lot of art being made today is about the language of its own embodiment. A lot of art today is very much engaged with the terms of its own critique, and a lot of art today involves the use of materials customarily thought of or organized outside the realm of art. . . .

In *The Anxious Object,* Harold Rosenberg talked about a transformation of art in terms of a transformation of the profession of artists. He said, "The entire social basis of art is being transformed, to all appearances for the better. Instead of being, as it used to be, an activity of rebellion, despair, or self-indulgence on the fringe of society, art is being normalized as a professional activity within society. For the first

time, the art formerly called vanguard has been accepted *en masse*, and its ideals of innovation, experiment, dissent have been institutionalized and made official. Its functions are being clarified in relation to accepted practice in decoration, entertainment, and education, and the rewards to be won in art by talent and diligence are becoming increasingly predictable.". . .

I think that the social acceptance Rosenberg considered a problem [in the '60s] is abating now, as the political and religious right that challenges the institutions that support and encourage art gains a larger audience. [I]t's in the shadow of the anguished debate over the NEA and of the attacks on individual artists and movements in art that we come to ask this question with a certain fear and anxiety as well. Who speaks for the artist, indeed?. . .

I teach at the Art Center College of Design in Pasadena. In the context of studio critiques, I encourage my students to maintain control over the language describing and interpreting their work . . . the most important thing they can do outside of the actual production itself. If you have the language to describe your work adequately to other people, you have also described your art adequately to yourself. You have given yourself the means as an artist to see the discrepancies between that language and what it is you're actually making in the context of the studio.

Over and over, I encounter students who have very grand intellectual and ideological agendas and yet produce work which seems to be about very different concerns, or about no particular concern at all. And I see the essence of my responsibility, not to manufacture talent where there is none; [as a teacher] you just try to get out of the way and let talent work. [B]ut it is possible to reveal to students how they often blind themselves to the failings in their work by explaining them away, so that the explanation needs to be grafted onto the otherwise incomplete art object. So first of all, the "who" an artist speaks to is himself or herself. . . .

A couple of years ago I was on a panel in Knoxville, Tennessee, where I was asked to present some reflections on my own apparently unique status as a visual artist who wrote critical essays, and I had to point out that my situation wasn't unique at all, that fully a third of the published writing in the art magazines was done by working artists, and the percentage of writing done by working artists in the smaller, regional art magazines is much higher. Sometimes in a given issue of the *New Art Examiner,* every single piece of writing would be by someone who was also making art. More than ever, artists not only read criticism but write it, and address their critical writing to other artists.

This also reflects a difference in the agenda of criticism. The Baudelairean criticism of the 19th century was addressed above all to literate sensibilities seen as being something other than part of a community of artists. Now a lot of critical writing is addressed . . . to other working artists. We make the art for each other, we write about the art and judge the art for each other. I do it because I see myself as a part of a community of artists, who are the most passionately engaged public for a work of art.

In "Contemporary Art and the Plight of Its Public," [Leo Steinberg] begins with a linked set of anecdotes, about the dismay of the Impressionist painter Paul Signac at the sight of a painting by Henri Matisse: Signac was incensed at Matisse's abandonment of form and composition and color and line, so that he had created this sort of *beastly* painting. That anecdote is followed by another one, about Matisse's horrified response to Picasso's *Demoiselles d'Avignon,* in which Matisse's condemnation of Picasso almost exactly mirrored Signac's complaint about his own painting of a few years earlier. And of course the connection between the three figures is that they're all working artists . . . So who speaks for the artist? And to whom do we speak? I think we speak to ourselves, and that it is the aim of our activity, our practice, that the self to which we speak be as large, as gracious, as adept as possible.

I'll close with a brief reflection, again from Harold Rosenberg: "The adeptness of the artist's mind, achieved through devouring problems of art, is the ultimate art product. Its evidences are what confer value on particular works of art. In the course of engagement, a mind is created. Apart from that, every kind of excellence can be copied."

Marcia Tucker: As a woman I have been spoken for far too often to do it to anyone else, much less to artists. So what I'd like to do is discuss what I consider to be the ideal relationship between an artist and a curator or critic. The relationship of artist and curator should be one of equals. It should be an exchange of ideas, skills, information, attitudes, and work. [I]n the good old days you went to somebody's studio and would actually put your feet up and have a cup of coffee and a two-hour conversation about the work, but also about the ideas generated by the work, about your own work as a curator, about the world at large, about politics, back to the work again, and both of you would leave feeling bemused, exhilarated, provoked in certain ways. Today a studio visit has turned into something that more resembles career counseling. "Where should I take these?"

I don't like it and I don't want to do it.

When I was a child . . . I had a fantasy – you know, if the good fairy comes and grants you one wish, what would that wish be? I've always had exactly the same impulse, which is to let myself down through the top of somebody else's head, and sort of line up my eyeballs and bellybutton and get my hands inside theirs and the feet inside and look out through another person's eyes; even a couple of seconds will do it. [Asked] why I do what I do, I realized that as a curator that's the closest I can come to being myself and also looking out at the world through another person's eyes. Anyone who has organized a show or who has worked with one artist for years knows that you actually see differently as a result, and if you can change the way you see, you can change who you are. . . .

But I believe that the curator or the critic should provide something for the artist too, other than a new career opportunity . . . a new perspective. Many years ago, at the Whitney, I did an exhibition for Lee Krasner, now deceased. She was a tough one to work with. She had not really had a

major exhibition in America. . . . Artists get notoriously nerve-wracked around this moment. So I told her she could not come in until I told her that she could, and that would be a day before the show opened. She finally came in wrapped in a fur coat, very elegant, and wouldn't talk to me. In her sweep through the room, she came to rest against a wall in the back, with me following her around like a puppy wanting to know what she thought, and she sort of looked around and she muttered, "I'm a pretty damn good artist, aren't I?" So this is what you really want.

. . . I'm interested in challenging the idea that the artist's own intentions are essential to understanding the work, because I no longer take biography as meaning, that is, the artists, frankly, usually don't have the foggiest idea of their own intentions until way after the work is done, and then it's only when somebody who wants to buy it asks, "What is this about?" and you've got to come up with something real fast. (I'm joking but I mean to be quite serious.) My friends who are artists have told me – and I believe this is true for all of us who struggle to be creative – that the works of art which are most important to us are whatever really surprises us. Not the thing that tells us what we already know, but something that genuinely surprises us. So the artist's intention is not something that I necessarily equate with the meaning of a work of art. . . .

More often than not, I am wrong, completely, devastatingly wrong about some things. More often than not I see incredible things, and I do not have the wisdom or the knowledge or the humility to recognize what I am seeing. Curatorial experience indicates that we can only see what we are already interested in . . . I really believe that a good eye – that famous thing, a good eye – is less important than a good (and an open) mind. I think that the ability to understand and make public your own position, where you're coming from [and your own limitations] is critical. . . . So I would like to see that disembodied voice of authority that most texts are written in eliminated – at least from my writing, which is a lot harder than I thought it would be. I went to a traditional graduate school in art history, and it took me about 20 years to get rid of the "One must . . ." and I'm still working on getting rid of the 75 footnotes.

"Expertise" is a term I hate, because experts are involved with what they already know, and the only interesting thing for me has to do with what I don't know, or else I wouldn't be involved with contemporary art. I would say that most critics, most curators, most museum professionals, and most collectors – I love to make sweeping generalizations! – are basically involved in a power struggle with the artist. They consider artists to be nuisances, and they prefer dead artists to living ones . . . It is of course also true that artists' behavior can be appalling, and there is no reason to give artists room for rudeness where you wouldn't give it to anyone else.

The role of the institution is to tell the public what to think while confusing them. Institutions may provide you with labels that make you feel like an Alzheimer's victim, or docents or lecturers who make you feel like a genius in comparison to them. We do not provide comfortable chairs; we

do not provide an atmosphere that makes you feel welcome at all, starting at the front desk where you don't know what you're supposed to do. Do you pay the fee? How much is the fee? Will you be embarrassed if you only pay a quarter? In other words, the role of the institution is that of Authority.

I'm very interested in something that the critic Jane Gallop talked about in *Reading Lacan.* In her introduction, she said that her manuscript had been sent to a reader (she doesn't say whether the reader is a man or a woman) who sent it back with two comments, one that "Ms. Gallop should not write about something she professes not to understand or know about" and second, that the reader was opposed to the generic use of the term "she" rather than "he." And Jane Gallop answers these in her preface by saying, "Why on earth should I want to write about something that I totally understand?" Also, Lacan is really intentionally incomprehensible on some level, leaving interpretation open to the reader as a deliberate strategy, and, she says, "Women have always been bilingual, I thought I'd give men a chance to be bilingual as well." But . . . a profoundly feminist and important endeavor might be "to relinquish authority from a position of authority."

This is not somehow in the nature of an institution. When your board wants you to do long-range planning, it's very hard to say, "Well, we are doing long-range planning that will insure that we don't have the foggiest idea who we are or what we're going to be doing in five years."

Audience: Marcia, I wanted to ask you about organizing "The Decade Show" and whether any new ideas grew out of that.

Tucker: The first thing we learned was, you have to have a really good supply of Gelusil and Valium. . . . We all came out friends, but I think it was miraculous, because we have such different constituencies, and such different needs, and such different ideas of being a museum. The humbling thing for me was to realize that no matter how radical the New Museum thinks it is, *so what?* I mean, it's only radical for a small group of people, it's only interesting for a small group of people. [We learned] we could not and must not ever speak for any other constituency or group.

[But] whenever the press saw a flaw in the exhibition, they blamed it on The New Museum . . . They perceived us as being stronger than the other two institutions. I found that racist, since there was an absolutely equal collaboration . . . All three museums decided to organize a bus to go up to Harlem, and we found that the community in Harlem thought it was outrageous that mostly white people from downtown would need to be bused up instead of taking the subway. So that was perceived as racist also. In the performance series, there was an artist named Michael Smith who presented what I thought was a scathing critique of white culture at the Studio Museum in Harlem. I was squirming every minute. People in the Studio Museum's constituency found it terribly offensive because he talked about a busload of his worker colleagues coming up to Harlem and going to Sylvia's. They said it would have been appropriate to do that piece in a white institution but not in a black institution. . . . At the end we all sat down and talked about some of the

things that unsettled us, and some of the things we didn't like and where things didn't work, as well as what *did* work, and what we enjoyed most. What that did was give us an incredible basis for continuing collaboration. . . .

Audience: We're doing a lot of talking to each other, but we do in fact speak a tribal language. There is a whole vast community that is outside of ourselves, and some of the things that we're noticing today, as we go through these obscenity trials and the challenges to the NEA, is that the greater community is saying to us, "What the hell are you talking about?" . . . We need to speak to each other, just as doctors and scientists and so on need to speak within their tribal language, but it's imperative that we get more people coming into the museums, to get the museum going out, as street theater did in the '60s and '70s. . . . We in the art community have become quite elitist, which is not necessarily where we started out. . . .

Spector: As an artist I intend my work for the widest possible audience. It's my failing if it doesn't communicate. But the question of what a general public is needs answering. . . . In *The New Criterion,* which is a magazine whose political sentiments I don't happen to share, there was an analysis of museum-going which chilled me because I felt it was completely valid. It said that more people go to museums now than ever – the problem is that they go for different reasons. They go perhaps with different expectations. [The article] condemned the entertainment industry of art, condemned the conversion of what was supposed to be a very serious, scholarly activity into entertainment. I'm sort of aghast at that attitude, which would seek to preserve a narrow, hermetic, highly elitist, scholarly framework of art – for an activity which has always brought me pleasure, and I would hope a certain pleasure on the part of people experiencing it, which has nothing to do with a scholarly endeavor and everything to do with celebrating the vitality of life, the persistence of memory, and the value of sentiment.

Tucker: I certainly don't believe in art being relegated to an elite and an academic place, but I also am very wary of art as entertainment, because I think the greatest function of art is – aside from moving us and sometimes pleasing us – to make us think, and often that is not a pleasant thing, it doesn't sit well, it doesn't help us to feel good. Very often you walk out of an exhibition feeling extremely distressed and unsettled, not only by the subject matter, but by an unusual handling of material. I remember when I did an exhibition for Richard Tuttle, people were incensed, enraged, that this man would use little pieces of rope or wire or pencil, that the work wasn't substantive. So I think it's important to separate the functions of art and entertainment, insofar as entertainment is supposed to make us feel good, and art is supposed to make us think, and that often may not be pleasurable.

. . . When we did an exhibition called "Homo Video," recent videotapes which explored questions of sexuality and gender preference, we had an audience that didn't generally go to art museums, and to see this show, they had to walk through a retrospective of the work of Hans Haacke. We were trying deliberately to get very different communities

involved. "The Decade Show" had yet again a different audience. [M]aybe slowly they'll begin to mix. . . .

But I don't want to talk to people who don't care at all about art, just as I don't want to talk about feminism to people who are convinced that women should stay at home and raise babies. I don't want to begin my discourse on that level because I'm exhausted and I've spent so many years doing it. So who's going to do that? In some ways the answer comes down to education, and it comes down to very early education. We are so neglectful of children . . . People in museums usually put the education departments in the basement, and they do all their multicultural stuff back there in the education department instead of in their programs. And until education becomes woven into the fabric of what museums do on every single level, it's not going to change. You're going to have alienated youngsters knowing that this stuff has *nothing* to do with them.

Art Papers, March-April 1991. Excerpted

APPENDIX

A Personal History of ArtistsTalkOnArt

by Lori Antonacci

As an artist coming to New York City from Chicago in the spring of 1974, I thought I knew all about modern American art. Then, browsing in Doubleday's on Fifth Avenue one night, I came upon a copy of Fred McDarrah's *The Artist's World* – a photographic history of the New York art world of the '40s and '50s [E. P. Dutton & Co., Inc., NY, 1961]. It was a revelation.

In the art history classroom, contemporary American art had been a story about individual "stars" and competing art movements. No mention of the Cedar Bar, Tenth Street or The Club.

The more I read, the more I realized there were whole chunks of "history" missing from the textbooks, and I felt cheated. Artists had, just a few short years before, created their own community. One I had never heard about. One I wanted very much to experience.

I knew two other artists in New York. Bob Wiegand was a painter, then exploring video, who had been a member of The Club during its last days. Doug Sheer was a video artist just young enough to have missed it.

"Why isn't there a place like The Club today?" I asked.

"Because that was a different era."

"Why can't we create something similar?"

"No one wants to talk any more."

"I do."

"Artists are too busy just trying to survive."

"There's no affordable space."

"What about that place on Greene Street?"

"What if we're the only three artists in New York who want to talk?"

"Maybe now's the time."

Bob was teaching and house-sitting in the country that summer. Doug and I were unemployed, and frequent visitors. Talk was cheap, and we kept at it.

In the fall, Bob tried the idea out on three other friends. They became the rest of our steering committee and first board of directors: Bruce Barton, a painter; Irving Sandler, art historian and critic; and Corinne Robins, art writer and critic. Bruce had been an unofficial member of The Club, Irving had programmed panels for The Club during its last five years, and Corinne was writing about the next generation of artists.

After two meetings of the committee, the idea had a name: ArtistsTalkOnArt. (The words were deliberately run together in the German style of naming something to literally reflect what it was.) Bob persuaded Robert Perlmutter of Pearl Paint to give us $200 in start-up funds. An artist named John Hart had a space on Greene Street called the Open Mind he'd let us use. Artists Charles Leslie, Silvi Pruitt and Larry Tierney of the Soho Artists Association lent us their mailing list – all 300 names.

And it turned out that artists did want to talk. In just a month, we organized seven panels – featuring Louise Bourgeois, Peter Frank, Valerie Jaudon, Larry Rivers, Joan Semmel, Athena Tacha, Tony Robbin, and James Wines, among others.

The first night, January 10, 1975, 92 people packed the space for a panel titled "Whatever Happened to Public Art?" The second panel, "Fantasy and the Figure: Rhino Horn," drew 90. The third, "Eroticism in Art," attracted a crowd of 155 which stretched out the door and into the street.

The idea of artists having a place to get together and talk in an atmosphere of support and conviviality can be traced back to the soirées of the Impressionists in the mid 1800s and the informal evenings of the Cubists after that. In New York, during the 1930s and '40s, artists talked wherever they could gather undisturbed – at the Waldorf Cafeteria, Huberts, Rikers and the Chuck Wagon. They also talked at The Subjects of the Artists School, organized by Robert Motherwell and Barnett Newman in 1948, and its successor, Studio 35, which was absorbed by The Club. They talked about what artists have probably always talked about – art and aesthetics, past and present, styles, sensibilities, life, culture and politics.

We consciously intended to continue this tradition. But although our immediate inspiration was The Club (even to panels being held on Friday night), we were also determined that ArtistsTalkOnArt would be different in one important respect. The Club had been a private, membership organization, run by only a few people, open only to members and guests. ArtistsTalkOnArt would be a democratic organization and an open forum, where anyone from the art community might organize programs, and anyone – artist or not – could come, listen and join the discussion.

These goals were reflected in everything we did. A panel format was chosen to discourage the creation of stars. Tea and coffee were served throughout the evening to encourage socializing. We solicited program ideas from everyone we knew. A program committee of peers (at first the original steering committee) was formed to review and approve suggestions. Once approved, the organizer was given *carte blanche* on content and participants.

We preferred to err on the side of inclusion. In the first 10 years, about 80% of programs suggested were approved. Even when a psychiatrist wanted to organize a panel on psychiatry as an art form, we didn't say, "no." We said if he could get at least three artists to discuss the subject, we'd approve it. He never called back.

Once a program was approved, our volunteer staff (again, initially the steering committee) provided the promotion, the space, and as much guidance –suggesting panelists, clarifying titles, and such – as needed. Anyone who signed the mailing list got a flyer. And everyone was treated as equally as possible.

Panelists, no matter how famous, spoke for free (in later years, there have been small stipends for all). All artist-panelists started the evening showing slides of their work, because that was the introduction that mattered. This requirement was waived only when artists appeared on panels with critics. No one wanted to tempt a critic to review the slides.

Although there were no hard and fast rules for running a panel, we did make a number of strong suggestions: be sure to include women (remember, this was the '70s), go through slides quickly, don't read boring statements. But we didn't insist. We let organizers and panelists do what they wanted, and we encouraged the audience to recognize its power – to respond and shape the process. Everyone paid the same admission, even the press. The low fee (at first $1, now $4) not only kept the programs accessible, it made the audience less likely to look on speakers with awe – and freer to vote with its feet.

If slides dragged on too long, panelists might find the room half emptied by the time the lights went on. Individuals or groups who felt left out, for whatever reason, were not shy about taking the moderator to task. When a 1984 panel on "International Mail Art" decided to depose its moderator for the sin of "curating" a show, we didn't intervene. The audience stayed and cheered.

In the early years, there were heated debates on the steering committee about dealers and critics. ArtistsTalkOnArt was supposed to be a place where artists were free to talk. Dealers, it was felt, already had too much power, and little propensity to share it. Artists often felt intimidated in their presence.

We never banned dealers, but it was a year before anyone suggested we invite one – Ivan Karp. He appeared alone because, although he was one of the very few dealers with a good reputation among artists, we decided to reverse roles and put *him* on display. Ivan being Ivan enjoyed every minute of it ['76/#24]. It was two years more before a dealer appeared on the same panel with artists. None was ever invited to sit on the program committee or the board of directors.

Critics were another matter. Some were considered allies – two of them on the steering committee – and some not. They appeared on panels from the very beginning and were

often on the program committee, but outnumbered by artists at least 20 to one.

The first year we moved three times: from the Open Mind (closed) to Global Village's second floor screening room on Broome Street (too small), to Jazz musician Ornette Coleman's studio, called Artists' House, on Prince Street (sold). We started our second year at the Soho Center for Visual Arts, and since then have been at Landmark Gallery, Soho 20 Gallery, 22 Wooster Gallery, and Soho Photo Gallery – all donated spaces. Despite several invitations to become part of galleries or other arts organizations, we have retained our independence and our allegiance to the community at large.

Our notion of who makes up that community has evolved over the years. The first year, we took "art community" to mean primarily visual artists, since the majority of participants and suggested topics dealt with painting and sculpture. As time went on, different topics were suggested and new people joined the program committee. Our concept of community widened to include performance, film and video, printmaking, graffiti, and crafts, among other disciplines.

New formats were introduced to meet new needs. Open slide screenings and performance evenings now present artists of many kinds. One-on-one artist interviews provide a closer look at people who have shaped the community. The diversity of aesthetic, political and cultural views discussed over the years is apparent in the panels of this book. Indeed, one could say that a *new* community of intellectual inquiry is created each evening, with each new topic.

Today, ArtistsTalkOnArt remains the only ongoing panel series in the New York art community run by and for artists, open to all artists, art disciplines and topics. It is also the only panel series programmed just a few months in advance, to reflect what's truly on people's minds. In 17 seasons (1975 through 1990-91), It has presented 368 programs: 345 panels, 14 open screenings, and 9 special programs. Over 2,600 artists, critics, curators, administrators – and dealers – have participated, speaking to a cumulative audience of some 38,000.

The cast has changed over the years, but most of the founding figures remain. Bob Wiegand, Irving Sandler, Corinne Robins and I are now members of the board of advisors. Doug Sheer and Bruce Barton are still on the board of directors, along with a whole new generation of artists. While our sense of community continues to evolve, the democracy, independence, artist-centeredness, diversity, accessibility and spontaneity of ArtistsTalkOnArt have not changed. As topics come and go and return again, we artists keep on talking – defining ourselves, our art, and the world we live in.

Lori Antonacci, multi-media artist and co-founder of ArtistsTalkOnArt, was executive director of the organization for ten years and president for 13 years.

TO SAVE MANKIND, THAT WOULD INVOLVE RISK. PAUL GEORGE DAVID SALLE IS A COMPLAINING ARTIST . . . HE

AFTERWORD

At the close of 1991, an acute malaise swept through the women artists' community, rousing it from torpor, at least temporarily. Two major panels held just four days apart testified to this re-awakening – or caused it.

The title of the first should in fact have warned off the wary: "Representation and Value: What Role Will the Languages of Feminism Play in the Artworld of the Nineties?"[1] But so great was demand for tickets that the location had to be changed in advance to a larger auditorium: there were some 1000 paid admissions. The second panel, "Who Cares About Feminism: Art and Politics in the Nineties,"[2] packed A.I.R. Gallery to overflowing.

Many in the second night audience (estimated at 300) had been at the previous discussion. Somehow, they managed to ventilate the general frustration and disappointment with the prior event without being divisive, critical, unsisterly, complaining, or disrespectful of some of feminism's most illustrious figures. That is to say, in my opinion, they failed to say what had to be said. The theme of the rest of the evening was frustration with the culture at large.

Here was Barbara Zucker, who created a stir 16 years ago, when she said, "I hope there won't be any more women's panels and I hope this is the last one I'm on. . . . I don't think feminism is the real world any more." ['75/#16] Zucker is now less optimistic (as which of us is not), but manages to formulate a new *modus vivendi*:

When I was younger I did not understand the cyclical nature of feminism. Nor did I understand that I would have to address it for the rest of my life. I could not have conceived that the things we worked for, not as artists, but as women, would be reversed. I did not want to consider that abortion could again become illegal and I never thought that women would put their bras back on.
. . . Feminism grows and erodes simultaneously. My view of things was highly simplistic. The thing I didn't get was that we had choice, that we *have* choice. Style is fun, bras give support, and wearing lipstick does not mean that you've capitulated.
[But] another thing that I could not factor into this picture, was what my level of exhaustion would be. And my need to withdraw. . . I remain an everyday feminist . . . My mission is to try to continue to educate myself, so that I can be aware of my behavior, even when I can't always act on it. . . .
I am capable of, but also unwilling to educate men. That's for some of you to do. I love many of them; I live with one; but I'm simply too tired and angry to deal with the task.

Besides, most of them don't want to know what I would have to tell them. . . .
Now I think that Sisterhood is provisional: We are sisters when we need each other. Like the virus which learns to be immune to the drugs which combat it, society learns to be immune to feminism (and to many other isms). We must invent new tactics to combat chronic male thought patterns which exist in the external world, but much more insidiously, within ourselves.

Joan Semmel, however, is having none of this weariness. Still, she has bad news for some women artists:

It's a myth that you can make "personal" art good enough to be recognized. "Art" is chosen by a couple of guys. We must identify ourselves as women if we're going to be acknowledged.

But she has good news, too, and delivers it with her old fire:

Every time we get out there, things change. We have to be willing to take defeat and come back on the next round. It's amazing that we did as much as we did in such a short time.

True enough. But it's also true that ground *has* been lost, in the culture at large and in the visual arts. As I see it, that's partly our own doing – or *non*-doing.

We have been quiescent in the face of two destructive trends, one in the women artists' movement and its near opposite in the wider culture. To begin with, women artists in recent years have ceded "feminist" discourse to an elite of professional jargonizers, purveyors of what Robert Storr called "fetishized opacity." Too much of Panel Number One consisted of such abstruse, theoretical, hectoring and remote utterances, made doubly remote by being cast, for no reason, in terms of the future. The speakers, celebrities of the feminist talk circuit, delivered more-or-less set pieces that had been delivered many times before — and could just as well have been mailed in. (A welcome exception, Catherine Lord, was immediate, engaged and effective.)

This is not an isolated episode, but a trend of several years' time. The result is that, increasingly, the energy of the larger corps of women artists is neutralized. Many women manage to believe that something is being achieved, or gotten at, with this heavy theorizing and that the future is in good hands – even if they don't exactly follow the arguments– so they relax and turn to other matters. Others, less credulous, are repelled by the sanctimony, scolding and irrelevance – and also turn to other matters. A few may even conclude that "feminism" is "bunk."

Meanwhile, back in the mass media, women are being undermined from the opposite direction, by a visual culture that shows them almost exclusively as tricks or vamps, even flat on their backs in an astonishing array of circumstances and positions (why are they waving their legs in the air?). If they are by chance seated or standing, their legs are spread, the pudendum is boldly accentuated, often with mysterious "highlights," like arrows pointing to ground zero. Athletic *and* non-athletic types wear leotards with legs cut so high and wide that, when the camera frames the interior thigh crease (as some law of modern publishing seems to require), the gooseflesh where the pubic hair was shaved has to be airbrushed out. When the face is visible, the eyelids droop in a squint – art-director code for intense female sexuality. At times the representation is simply a set of wet, silicone-plumped lips. At other times, in another increasing trend, the body beautiful is nude.

The products and services routinely purveyed through this gyno-flesh are not just the expected beer, whiskey, perfume, lingerie, fashion, movies and health clubs, but *everything*. A how-to-crochet pamphlet shows a pixieish blond squatting with her legs spread, the camera aimed at her crotch. A medium-core-porn Calvin Klein jeans ad finally sparks a boycott, which seems not to catch fire. Calvin Klein has apparently divined that women *like* to be depicted *in flagrante* and will buy the jeans that say so.

If they don't, *where are the protests?* Imagine the ruckus if African-Americans were shown everywhere eating watermelon. When a Japanese toothpaste package with a rather bland geometric motif purporting to represent "black" features was included in a New School design show a while back, it sparked an academic riot that made it to the *New York Times* two days running.

In mainstream America, the media culture has been persuaded to give up the blatant negative stereotypes of African-Americans that once prevailed. The ragged pickaninnies and happy barefoot darkies that were a staple of the post-card culture of the past now appear only as collectors' items, or in specialty archives. This is not to say the mass media show blacks as fully and congenially as they show blondes, but that there is change and a growing awareness, even some attempt at tokenism. Not so with the depiction of women. Indeed, each year the raunch level rises.

This is *not* harmless!

In our culture, the people with power wear clothes. The men in our media imagery wear suits and exude authority. The women exude mostly erotic body parts. Both sexes internal-

ize these images of who and what they are (hence, perhaps, the "insidious" thought patterns "within ourselves" that Zucker mentions).

Whether women's pudenda are *really* how to sell, or just a stereotype of how to sell, is beside the point. The point is that we have not made such usage counterproductive. Think what "animal rights" people did to the fur industry. Clearly, we care less about women than about bunny rabbits!

The traumatic Hill-Thomas hearings of the previous month were a touchstone at both panels. But considering the image of women we are handed every day, it's not surprising that women's *words* are discounted – *by women* as well as men!

On the first day of summer, 1991, I opened the *New York Times* Weekend section to find reviews of eight artists' shows [6/21]. All eight were male. Of the three works illustrated, one was a still life; the second was an intimate portrait of a woman's head and frontal torso by George Segal; the third was an even more intimate portrait, a rendering by Alfred Leslie of a female nude – shapely and young, of course, but with her legs so widely spread that one knee and ankle were on a level with her shoulder – if that can be pictured. All seven works in the show were life-size female nudes, the article told us, presumably in comparable positions, and with similarly dewy-eyed tender-morsel looks, that is, edging into soft porn. In other words, this depiction of "woman" was reviewed generously, seriously, respectfully, by the leading newspaper of the country, the one dealers tell us is our single most influential art publication – by a wide margin ['90/ #217].

It's hard to believe no woman artist had an interesting show that week. If so, it would probably be because the norm in art is still women's bodies, usually naked, as subjects; men, usually clothed, as artists. It goes without saying that my letter to the editor pointing this out was not printed. Where is the rest of the protest? At about the same time, Lee Friedlander's photographs of female nudes (more naked ladies, again in slightly-more-grotesque-than-usual positions) were shown at MoMA and widely reviewed. Of the reviews I saw, only one, by Kay Larson of *New York* Magazine, protested the subject *on principle*. The publicity photo for the Edward Weston show at the International Center of Photography last summer showed the aging photographer's adorable young wife – also with her legs spread. (I could go on and on.)

In other words, while feminism's goddess theoreticians noodle their stylizations of abstruse rhetoric and concoct "languages of feminism" of the *future*, no one protests what's

in front of their eyes. That may be from fear of being called "frigid bitch" – or "feminist." It may also be because younger women have been born into this atmosphere and do not understand its meaning and effect. It so happened that the *Times*'s lone female art critic was a speaker at Panel Number One, and two of the reviews in the all-male issue I speak of were hers. Yet nobody mentioned the topic. What does this woman on such a panel tell us about "feminism" of the future?

At Panel Number Two, a woman in the audience said she thought we needed a new word, not "feminism." She suggested "womanism," to the groans of the assemblage. But "feminism," like "liberalism," is a fine word, and an important – indeed a necessary – force in the culture. It must be proclaimed and extended, not abandoned.

We might start with Susan Faludi's book, *Backlash, The Undeclared War on Women* (Crown, 1991). A devastating analysis of how the media have skewed our social and moral view of women, it could do for "the next stage" what Betty Friedan, et al., did for the first. Meanwhile, the good thing about the Hill-Thomas hearings may be that, for a while at least, we'll hear less "I'm so tired of the women's movement."

And, again, meanwhile, it becomes all the more important that the struggles, arguments, insights, triumphs (and false steps) of women artists *so far* be on record – and included in the larger record of art.

J.S.

1. "Representation and Value: What Role Will the Languages of Feminism Play in the Artworld of the Nineties," held at Cooper Union, November 10, was sponsored by the Drawing Center, and organized by Deborah Kass, with Barbara Bloemink moderator; Anna Chave, Laura Cottingham, Catherine Lord, Roberta Smith, Marcia Tucker, Michele Wallace and Judith Wilson, speakers.

2. "Who Cares About Feminism? Art and Politics in the Nineties," at A.I.R. Gallery, November 14, 1991, was moderated by Eleanor Munro, with speakers Maren Hassinger, Joyce Kozloff, Grace Stanislaus and Barbara Zucker.

HISTORY DOES NOT EXIST UNTIL IT HAS BEEN RECORDED. THALIA GOUMA-PETERSON

Index

Boldface page numbers indicate panel titles or speakers.
Underlined page numbers indicate authors of individual reports
(indexed by last page of report).

ALLY HAS A FEMINIST IMPLICATION. CAROLEE SCHNEEMANN **WOMEN WILL ACCEPT THINGS DONE BY MEN THAT THEY WON'T ACCEPT BY WOMEN.** JOAN SEMMEL **AS SOON AS WOMEN STARTED MAKING ART THAT SHOWED, GOD FORBID, A MAN'S SEXUAL PARTS, EVERYBODY GOT VERY UPSET.** JOAN SEMMEL **WHEN MEN MAKE "BAD BOY ART," IT'S JUST MAKING ART.** VERNITA NEMEC **THERE ARE A LOT OF ARTISTS IN PHILADEPHIA, BUT THEY'RE NOT AS GOOD AS NEW YORK ARTISTS.** DIANE BURKO **HISTORY IN L. A. LASTED AS LONG AS LAST MONTH'S ARTFORUM.** LOREN MADSEN **I WAS DRAWN TO NEW YORK BY THE MYSTIQUE OF THE BIG CITY. I FOUND IT.** TED THIRLBY **MY TASK IS TO AVOID GETTING CATEGORIZED, BECAUSE WHEN THE CATEGORY IS OVER — YOU'RE FINISHED.** JUDITH LINHARES **AFTER THE '50S, ARTISTS WERE THE OUTSIDERS, AND THE DEALERS, OR WHOEVER, WERE THE INSIDERS.** PAT PASSLOF **POWER IN THE ART WORLD IS IN THE HANDS OF THOSE WHO MAKE THE NEWEST ART — SMALL GROUPS ACTING IN CONCERT.** ROBERT PINCUS-WITTEN **THE ARTISTS OF 10TH STREET THOUGHT THEY WERE IN THE DRIVER'S SEAT, BUT SLOWLY THE POWER BROKERS TOOK OVER AND THE ARTIST WAS EITHER IN THE TRUNK OR UNDER THE WHEEL.** NORA SPEYER **CONCEPTUAL ART, LIKE THE VIRGIN BIRTH, IS COMPLETE IN IT-SELF. IT DOESN'T CALL FOR CRITICISM; IT CALLS FOR WORSHIP.** HILTON KRAMER **THE PUBLIC DOES NOT WANT ITS ARTISTS TO ACT AND DRESS LIKE ORDINARY PEOPLE, BUT TO REVEAL THEMSELVES BY EXTERNAL SIGNS.** RICHARD SHIFF **THE AVANT-GARDE FOR ME ISN'T REALLY THERE.** JOAN BROWN **NEITHER DAVID SALLE NOR ERIC FISHL COULD SUSTAIN THE TENSION IN HIS WORK IF SOME OF MODERNISM'S PROHIBITIONS HAD NOT REMAINED SUBLIMINALLY PRESENT.** KAY LARSON **EMPHASIS ON MOVEMENTS MAKES ARTISTS DIMINISHED AND INTERCHANGEABLE. IF ONE DROPS OUT, ANOTHER CAN BE BROUGHT IN.** BUDD HOPKINS **TRUTH IS ENTIRELY AND ABSOLUTELY A MATTER OF STYLE. ART, VERY FORTUNATELY HAS NEVER ONCE TOLD US THE TRUTH.** OSCAR WILDE **NO BLACKS, NO HOMOSEXUALS, NO COMMUNISTS, AND NO WOMEN!** "CLUB," MEMBERSHIP COMMITTEE **WOMEN HAVE THEIR MINK COATS AND THEIR GUCCI'S, BUT THEY STILL DON'T BUY ART. I CAN COUNT WOMEN COLLECTORS ON ONE HAND.** HOLLY SOLOMON **MUSEUM TRUSTEES MAY NEVER HAVE WORKED WITH A WOMAN IN THEIR LIVES, EXCEPT A SECRETARY.** KAY LARSON **EUROPEAN CURATORS THINK I'M BEING SENTI-MENTAL IF I PITCH THE WORK OF A WOMAN.** RONALD FELDMAN **EUROPEAN COLLECTORS ARE MOTORCYCLE FREAKS.** AUDREY FLACK **EUROPEANS ONLY WANT TO SHOW THE AMERICANS WHO VALIDATE THEIR ART.** HOLLY

SOLOMON **THE VAST MAJORITY OF PEOPLE WHO COLLECT COLLECT FOR INVESTMENT. A MAN WILL SELL FOR VASTLY MORE MONEY THAN A WOMAN.** GRACIE MANSION **THE FIRST TIME A WOMAN'S WORK SELLS FOR A MILLION DOLLARS, THAT WILL SET A LOT OF DEALERS LICKING THEIR LIPS.** GRACE GLUECK **THE MINUTE YOU'VE GOT TO START THINKING ABOUT MAKING MONEY FROM YOUR ART, YOU'RE A PROSTITUTE.** GENO RODRIQUEZ **WE ALL HAVE TO FACE MORAL DILEMMAS AND MAKE MORAL DECISIONS, NO MATTER WHAT PROFESSION WE'RE IN.** AMY NEWMAN **COLLECTORS HAVE NO CONFIDENCE IN THEIR OWN TASTE. THEY ASK ME WHO ELSE BOUGHT IT.** WENDY OLSOFF **THE REAL PROBLEM IS THERE ARE SO MANY ARTISTS.** HOLLY SOLOMON **MORE ARTISTS GRADUATE EVERY YEAR TODAY THAN THERE WERE IN ALL OF ITALY DURING THE RENAISSANCE.** CARRIE RICKEY **MODERNISM IS NOT A BENIGN PHILOSOPHY. ITS MOVEMENTS CAME INTO BEING IN ATTEMPTS TO DESTROY THEIR PREDECESSORS.** HAROLD ROSENBERG **THE FLEA-MARKET FINDS OF TODAY WILL BE THE CLASSIC FOLK ART OF TOMORROW.** IRA JOEL HABER **IF WE SEE MODERNISM AS A BROAD AND COMPLICATED TRADITION, THERE IS NO USE FOR THE TERM "POST-MODERNISM," EXCEPT AS A SALES GIMMICK.** JOHN PERREAULT **POST-MODERNISM IS SYNONYMOUS WITH FUN.** TIM WRIGHT **IF YOU'RE HAVING FUN, YOU CAN'T BE SERIOUS.** PETER VON BRANDENBURG **IN POST-MODERNISM, IT IS THE AUDIENCE WHICH IS UNDERSTOOD AND DECODED, RATHER THAN THE ART.** DAVID SALLE **INSTEAD OF BEING A SCULPTOR OR A PAINTER, ARTISTS TODAY SPEND THEIR TIME BALING HAY, OR CUTTING DOWN TREES TO PUT IN GALLERIES.** GLENN O'BRIEN **THE WORLD IS THERE, IT MAKES NO SENSE TO REPRODUCE IT.** ERNST LUDWIG KIRCHNER **IF I PAY ATTENTION TO SOMETHING, I'M GOING TO CHANGE IT.** DAVID SALLE **I WANT TO BECOME ONE WITH THE EARTH AND GO INTO IT.** ANA MENDIETA **WHAT HOPPER PAINTED BEST IS ARCHITECTURE, THE PLACE MAN AND NATURE MEET.** APRIL GORNIK **IF GUY PÈNE DU BOIS WAS PAINTING NOW, USING THE SAME KIND OF FIGURATION TO EXPRESS DAILY LIFE, IT WOULD BE ABSURD.** MICHAEL MAZUR **IF SOMEBODY WANTED TO PAINT HOPPER NOW, AND FOUND AN OLD GAS PUMP, IT WOULD JUST BE STUPID.** PAUL GEORGES **I HAVE A LOT OF SET RULES, A LOT OF DO'S AND DON'TS, BUT AFTER A FEW YEARS THE DO'S AND DON'TS START TO SWITCH SIDES.** PAUL WALDMAN **I'M NOT CRAZY ABOUT PEOPLE, SO THAT'S WHY I USE PHOTOGRAPHS.** ROBERT LONGO **WE ARE A BARBARIC CULTURE, PROBABLY THE MOST BARBARIC THAT EVER EXISTED IN TERMS OF THE PLANET.** KIM LEVIN **I'M NOT AN ARTIST. I'M JUST IN THIS FOR MONEY AND A GOOD TIME.** JUDY NYLON **PROGRESS IS STILL POSSIBLE.** ALLAN KAPROW **MORE**

About the Editor:

After graduating from Cooper Union, Judy Seigel was a free lance illustrator and painter before becoming a photographer. She has exhibited in all three fields, and been featured many times in "mainstream" as well as art photography magazines. Seigel is in the permanent collection of the Museum of Modern Art, on the photography faculty at Pratt Institute, and teaches at the International Center for Photography. She has also lectured extensively about manipulated photography and her own work. A founding editor of Women Artists News, she was active in the art-talk events described here – as speaker, moderator, organizer and reporter. In addition, she has written for other publications, ranging from the *Village Voice* to *exposure*, the journal of the Society for Photographic Education.